Praise for *Producing for TV and New Media, T*

Eric Scholl
Associate Professor, Cinema and Television, Columbia College Chicago
"This is easily the most complete overview of the television producer's job and responsibilities. Required reading for all of our TV students."

Evan Meaney
Associate Professor, Media Arts, University of South Carolina
"*Producing for TV and New Media: A Real-World Approach for Producers* is an invaluable education for those interested in becoming a successful producer. Comprehensively examining current trends and standards, the authors help to prepare their readers for any production scenario, big or small. I would consider this required reading for anyone interested in media. From new-to-the-game web-producers looking for tips to seasoned pros looking to take the next step, the [book] offers something for everyone."

Sasha Waters Freyer
Professor, Photography and Film, Virginia Commonwealth University
"The focus on new media, new markets, deliverables, and the legal ins-and-outs of producing make *Producing for TV and New Media* the most comprehensive book addressing the newest challenges of the small screen, and of our increasingly mobile, multiplying home screens, in ages."

Ashley Maynor
Director, Library Lab, New York University
"I was very impressed with how the book covers so much ground—from technical aspects of each stage of production to legal and licensing issues. The interviews and conversations with pros in the field, which comprise a full chapter of the book, are especially insightful and help to make this text unique."

Producing for TV and Emerging Media

Gain a thorough understanding of the nuanced and multidimensional role producers play in television and emerging media today to harness the creative, technical, interpersonal, and financial skills essential for success in this vibrant and challenging field.

Producing for TV and Emerging Media, Fourth edition is your guide to avoiding the obstacles and pitfalls commonly encountered by new and aspiring producers. This fourth edition has been updated to include:

- "Focus on Emerging Media" sections that highlight emerging media, web video, mobile format media, and streaming media
- Sample production forms and contracts
- Review questions accompanying each interview and chapter
- Interviews with industry professionals that offer practical insight into cutting-edge developments in television and emerging media production
- Fresh analysis of emerging media technologies and streaming media markets

Written especially for new and aspiring producers with an insight that simply cannot be found in any other book, this new edition of a text used by professors and professionals alike is an indispensable resource for anyone looking to find success as a television or emerging media producer.

Cathrine Kellison was a member of the Producers Guild of America, the Writers Guild of America, and the Independent Documentary Association, and won numerous industry awards, including two WGA awards for Outstanding Achievement. She passed away in 2009.

Dustin Morrow is a filmmaker, author, programmer, and tenured professor of Film at Portland State University. He has also taught at Temple University and the University of Iowa and was an editor and director of short-form projects and series television in Los Angeles, working with such clients as MTV, Fox Sports, and the Discovery Channel.

Kacey Morrow is a media artist, scholar, and tenured professor of new media design at Western Washington University. She has years of experience as a motion, print, and multimedia designer in Chicago, and her videos have appeared in several film festivals and exhibitions nationwide.

Producing for TV and Emerging Media

A Real-World Approach for Producers

4th Edition

Cathrine Kellison
Dustin Morrow
Kacey Morrow

NEW YORK AND LONDON

Fourth edition published 2021
by Routledge
52 Vanderbilt Avenue, New York, NY 10017

and by Routledge
2 Park Square, Milton Park, Abingdon, Oxon, OX14 4RN

Routledge is an imprint of the Taylor & Francis Group, an informa business

© 2021 Cathrine Kellison and Taylor & Francis

The right of Cathrine Kellison, Dustin Morrow, and Kacey Morrow to be identified as authors of this work has been asserted by them in accordance with sections 77 and 78 of the Copyright, Designs and Patents Act 1988.

All rights reserved. No part of this book may be reprinted or reproduced or utilised in any form or by any electronic, mechanical, or other means, now known or hereafter invented, including photocopying and recording, or in any information storage or retrieval system, without permission in writing from the publishers.

Trademark notice: Product or corporate names may be trademarks or registered trademarks, and are used only for identification and explanation without intent to infringe.

First edition published by Willan 2008
Third edition published by Routledge 2013

Library of Congress Cataloging-in-Publication Data
A catalog record has been requested for this book

ISBN: 978-0-367-42454-1 (hbk)
ISBN: 978-0-367-42453-4 (pbk)
ISBN: 978-0-367-85306-8 (ebk)

Typeset in Helvetica Neue LT Std
by Apex CoVantage, LLC

CONTENTS

Acknowledgments		viii
About the Authors		ix
Introduction		xi
Chapter 1 •	What Does a TV Producer *Really* Do?	1
Chapter 2 •	Television: Its Past, Present, and Future	19
Chapter 3 •	The Big Idea: Script and Project Development	51
Chapter 4 •	Connecting the Dots: Breakdowns, Budgets, and Finance	76
Chapter 5 •	Welcome to Reality: Legalities and Rights	98
Chapter 6 •	Pitching and Selling the Project	120
Chapter 7 •	The Plan: Pre-Production	143
Chapter 8 •	The Shoot: Production	172
Chapter 9 •	The Final Product: Post-Production	198
Chapter 10 •	It's a Wrap! Now, the Next Steps	225
Chapter 11 •	Conversations With the Pros: Producing in the Real World	244
Sample Forms		318
Index		362

Acknowledgments

This book would not have been possible without the valuable input and assistance of many people, generous with their time, their knowledge, and their support. The authors would like to thank, in no particular order: Allie Clayton, Joan Johnsen, Jonna McLaughlin, Becky Teitel, Simone McLaughlin, Jeffrey McLaughlin, Jackie Muldower, Adam Wager, Michael Krepack, Ashley Cooper Kerns, Joanna Kerns, Nicci Marciante, Daisy Montfort, Kyle Roe, Noah Workman, Alexandra Palmieri, Alex Holson, Jaclyn Paris, Sharon Badal, Stephen Duncombe, Evan Fairbanks, James Gardner, Rich Henning, David Irving, Jon Kamen, Al Lieberman, Lynn McVeigh, Linda Oken, Andrew Susskind, Justin Wilkes, Mark Berrettini, Sarah Andrews-Collier, Karin Magaldi, Devon Allen, Alison Heryer, Cristina De Almeida, Don Caristi, Mischelle L. McIntosh, Mary Beth O'Connor, Eric Scholl, and Evan Meaney.

We would also like to thank the good people at Focal Press, most especially Alyssa Turner, Emma Tyce, Elinor Actipis, Carlin Reagan, Polina Khentov, Simon Jacobs, and Priscille Biehlmann; all these people have been partners in the many editions of this book.

And for their unwavering, unconditional lifetime of support, we can never thank Lisa Molinelli, Mark Henry, John Clayton, Robert Morrow, and Sandra Morrow enough.

Producing for TV and Emerging Media: A Real-World Approach is the end result of collaboration, experience, curiosity, a bit of good luck, and a lot of hard work—a formula that's remarkably similar to producing for television and emerging media. Welcome to the journey.

About the Authors

Cathrine Kellison's career as a writer/producer spanned two decades and included an eclectic range of projects—from a CBS special to a PBS documentary, from corporate image pieces for IBM to behind-the-scenes celebrity interviews for MGM, from a kids' piece on recycling to educational films for teachers. She produced, wrote, and/or directed hundreds of hours of broadcast and non-broadcast programming for television and various avenues of emerging media.

Starting as a writer of feature-length scripts in Hollywood, Ms. Kellison moved into producing for NBC and, later, United Artists in New York City as Director of Creative Services. She then went independent, starting her own small-but-meaningful production company, Roseville Video. Ms. Kellison taught producing for television and film at New York University's Tisch School of the Arts before moving over to NYU's Gallatin School of Individualized Study and School of Continuing Professional Studies.

Ms. Kellison was a member of the Producers Guild of America, the Writers Guild of America, the Independent Documentary Association, and won numerous industry awards, including two WGA awards for Outstanding Achievement. She passed away on September 2, 2009, four years after being diagnosed with colon cancer. In one of her short films, she said that when death came, "I will have consumed every second, blessed most days, cursed a couple." She lived more fully than most people can ever dream to, and she's missed every day by the thousands of people she touched—students, colleagues, collaborators, artists, friends, and family. This book is respectfully dedicated to her memory.

Dustin Morrow is an award-winning filmmaker, bestselling author, film programmer, and educator. As a media artist, his works frequently explore relationships between landscape/space and personal, communal and cultural identities; music and the moving image; intersections of traditional cinema and experimental media; the actor-director relationship; and genre filmmaking. He received his MFA in filmmaking from the University of Iowa and is currently a tenured professor in the School of Film at Portland State University. He has also taught at Temple University and the University of Iowa.

Among his works are the feature films *Black Pool*, a thriller set against the political conflict in Northern Ireland that was shot in Dublin, Belfast, and the U.S.; *Everything Went Down*, a contemporary musical that was the subject of a TED Talk and a huge success on Hulu; *Matchmaker*, a documentary shot in Ireland about the world's largest singles event; and an anthology of short films examining Irish identity entitled *Firinne: Searching for Ireland*. He also directed the limited-run dramatic podcast serial *Short of Breath* and more than thirty short films, which have screened and won awards at festivals around the world. He has received grants for his work totaling more than half a million dollars.

Morrow's book, *Kathleen Turner on Acting: Conversations About Film, Television and Theater* was recently published by Skyhorse Press and became an Amazon bestseller. It was reviewed positively by *The New York Times*, endorsed by filmmaker Sophia Coppola, and was featured on *Salon*, *Larry King Now*, *Good Morning America*, and

About the Authors

CBS This Morning. The audiobook, narrated by Morrow and the legendary actress, was released by Audible.

Before re-entering academia, Morrow was an editor and director of short-form projects and series television in Los Angeles, working with such clients as MTV and the Discovery Channel, and filmmakers like Spike Jonze, Michael Apted, Guy Ritchie, and Steven Soderbergh. Morrow was the first Director of the Greenfield Youth Film Festival in Philadelphia, one of the largest youth-centered film education programs in the U.S. He was also the founding Director of the Portland Music Video Festival. As a passionate advocate of study-away education, Morrow has designed and directed programs in London, Dublin, Northern Ireland, and New York City. He has programmed for several film festivals and is an in-demand speaker at conferences, festivals and workshops nationwide about issues related to film and media production and scholarship. Learn more about his work at *www.dustinmorrow.com*.

Kacey Morrow is a media artist, designer, scholar and Professor of New Media Design at Western Washington University, teaching in the Department of Design with a focus on motion graphics, digital video, user experience, web and interaction design. Prior to moving to Western Washington University in Bellingham, Washington, she was a lecturer at Ringling College of Art and Design in Sarasota, Florida, teaching in the Graphic and Interactive Communications Department.

She earned her MFA from the University of Illinois Champaign-Urbana in Graphic Design/Narrative Media and received her BA from the University of Iowa in Graphic Design with a minor in Cinema and Comparative Literature.

Her award-winning short experimental videos have appeared in numerous film festivals and exhibitions nationwide, including the highly acclaimed Seattle International Film Festival and Atlanta Film Festival. She co-wrote the third edition of *Producing for TV and New Media* and illustrated the book, *Kathleen Turner on Acting: Conversations About Film, Television, and Theater*. Marrying her love of design, music, and film, she founded the Bellingham Music Film Festival and frequently does design work for the Bellingham-based nonprofit, Pickford Film Center. Kacey also stays involved in discussions about design and digital media by attending and presenting at conferences and workshops internationally. Prior to her career in academia, she has years of professional experience in Chicago as a motion, print, and multimedia designer. Learn more about Professor Morrow's projects at *www.kaceymorrow.com*.

INTRODUCTION

Know what you don't know.
> **Stephen Reed, producer interviewed in Chapter 11**

If ever there was a succinct description of the producer's role, "know what you don't know" defines it best. To succeed as a producer, you become a lifelong learner—constantly researching, asking questions, and listening. Not stopping until you know what you don't know.

There isn't one producer in any area of television or emerging media who has all the answers, or has mastered the tricks of the trade, or grasps the nuances of each and every detail on the producer's to-do list. Although producers share certain skill sets, each genre in which the producer works is different. Each project requires a unique result from its producer. This book strives to lay out the producer's many roles and options, and the steps generally taken in producing quality material. As importantly, there's an almost philosophical approach to the people skills required in producing: communication, understanding, respect, and a sense of humor.

There's no doubt that emerging media takes us on an exciting trip into the unknown. Its potentials and risks grow exponentially. The expansion of emerging media content and delivery systems is the subject of countless panels and articles, yet it's still in its infancy. We're in the vortex of what could possibly be one of the more transformative eras in human communications.

Television is the mentor of emerging media content, and at almost a century old, TV has shaped our world for generations before us. Television now is pervasive. It reaches literally billions of people around the globe; for many of them, TV is their sole source of information and entertainment. So regardless of our own viewing habits, TV has had a resounding impact on the data, the culture, changing trends, and the economics that inform our world.

Yet, TV initially was dismissed as simply a passing fancy. Over subsequent decades, its detractors have been harsh and outspoken, insisting that TV caters to the lowest common denominator, that it barrages us with negative impressions, controls the content and delivery of news, manipulates cultural trends, and encourages viewers to contribute to the consumer society.

But the tides are turning. Current research increasingly points to television as a vehicle that, when used intelligently, can actually make its viewers smarter. We can make thoughtful choices that lead us to navigate complex narrative plots, explore ethical issues of relationships that are central to reality programming, compare and contrast political platforms, learn a language and explore its culture, and in general, pique our appetite for further exploration.

And joining in, emerging media. It's fast on its way to going beyond traditional television, into uncharted territory. Within this range of viewpoints, it's indisputable that

these media offer opportunities that are virtually limitless. Here's where the producer enters the picture.

TV IS THE PRODUCER'S DOMAIN

A flatscreen, a computer monitor, a cell phone—each is simply a mechanical device that can receive digital signals. Each is similar to a blank canvas that's ready for the artist's brush. It's the role of the producer to create an image on the screen—painting that canvas. The producer can stand up to television's critics by using creative vision, technical know-how, and a rather extraordinary set of skills to produce unique content and to open new directions.

TELEVISION LIVES WITHIN A HISTORICAL CONTEXT

Few periods in human history have been as dramatic or as enlightening—or as uncertain—as the present. TV and the Internet are both reflecting and shaping what is happening in the world around us, and flooding us with data and impressions. It falls on the producer, and of course the viewer, to become educated about it all.

Television has over a century of creative and technical history behind it that's rich in insight and provides a foundation for programs that we watch today. In America, we can see echoes of Steve Allen's 1950s late-night humor and hosting style in shows hosted by Jimmy Fallon and Stephen Colbert. Legendary performances on the BBC and dramatic U.S. series *Playhouse 90* and *Hallmark Hall of Fame* upped the ante for superior acting, writing, and directing that is still seen every night in dozens of network series and premium cable programs. Early children's television gave us *Mr. Wizard* and *Mr. Rogers*, paving the way for *Sesame Street* and *Dora the Explorer*.

Yet television's detractors target, rightfully, the predominant themes of competition and humiliation in reality shows, or the evening news broadcasts—once reported by courageous pioneers in journalism like Edward R. Murrow and Walter Cronkite—in which news is constricted by upper-management dictates, or focuses primarily on the sensational and shallow. Tabloid programs and adults-only channels have lowered the bar of constraint, as mature content seeps into family programming; concurrently, the vital issues of censorship and essential freedom of speech are challenged by political and economic pressures. The pros and cons of television are in constant flux, and with emerging media beginning to dominate the arena, the debates will surely continue to flourish.

So where does it all go from here? What is television's future? Where does emerging media factor in? That answer is up to the producer. The producer can choose to go with the flow, or dare to divert the direction of that flow.

TV IS A UNIQUE MEDIUM

Recently, both business and academia have held the word "television" up to the light: Is television that wide screen in front of your couch? Or is TV what you watch on your laptop or on the handheld device you take on the plane? They're all capable of playing the same rerun of *Seinfeld*, or tomorrow's weather forecast.

It doesn't matter. An effective producer can take advantage of the newest delivery systems or stick with traditional television, but the skills needed for producing remain constant. The producer continues to create compelling entertainment, in-depth information, or educational content. Once a stable industry unto itself,

television is now smack in the middle of a radical transformation as it merges with emerging media.

The TV set continues to be a staple in most households. It's a familiar voice in the background; an antidote to loneliness. As with a family member, we can enjoy it, tune it out, argue with it, or laugh out loud. We don't have to leave the house, hire a babysitter, or pay the high price of admission for feature films and documentaries—we'll eventually see them on our TV set.

THE PRODUCER IS AT THE CORE

Some producers are responsible for bringing an entire project to life, from a simple concept through development to its final broadcast or distribution. Other producers work on specific areas of a project and are a valuable part of a larger team of producers. The parameters of the producer's functions cast a wide net: producing is the least understood job in television. It's also the most demanding and time-consuming of media jobs, and yet a natural-born producer loves (almost) every minute.

The skills needed to be a producer are rather like the tiny pixels in a television image. Each skill deals with detail, and each detail is important. Like pixels, it takes thousands of them to create an image on the TV screen.

This book explores each stage of producing a project:

- Stage One: The Idea (Project Development)
- Stage Two: The Plan (Pre-Production)
- Stage Three: The Shoot (Production)
- Stage Four: The Final Product (Post-Production)
- Stage Five: Next Steps (Wrap-up and Distribution)

Producing isn't just about mastering the details. A producer also has a clear vision of the "big picture": the current marketplace, the changes in technology, audience demographics, the trends of the day. A producer reads the industry publications, actively watches programming in specific genres, and seeks out opportunities to learn more, to gain an edge.

PROFESSIONAL OPPORTUNITIES

According to the U.S. Bureau of Labor Statistics, employment in media production industries has grown at a rate nearly twice that of all other industries combined. Media production is an undeniably competitive field, but many jobs are available. Demand for content comes not only from networks, cable and premium channels, and satellite, but also from burgeoning emerging media, such as the Internet, cellular technology, video-on-demand, and gaming, along with non-broadcast venues.

And the international market continues its consumption of the latest hit show or newest format idea, primarily from America, Japan, China, and the United Kingdom, increasing its audience base and advertising revenue. As an industry, television and emerging media both offer a range of options to the producer—from a staff position at a national network to working with a news producer in a local television station, from segment producer to working on a network show as a writer/producer. Producers in video may opt for being freelancers, or independent with their own small companies that produce content for broadcast, corporations, documentary channels, or educational distribution. Like the industry itself, the options for a producer are expanding on a daily basis.

THE PRODUCER IN THE DIGITAL DOMAIN

Producers now work exclusively in the digital domain. Most of the producer's integral tools are digital—the computer with its software for writing and editing, the cameras, the formats on which to capture the image and record the sound, the editing and mixing systems, and the technology of the delivery system. Each aspect of production and post-production processes takes full advantage of these technological advances. We now live and work in the digital domain; this book focuses on these digital tools and on the producer's relationship to them.

ORGANIZATION OF THE TEXT
The Roles of the Producer

A producer's role is as much about working with people as it is about the many phases and details of producing. The producer may have a marketable skill such as writing or directing, but the inherent role of the producer depends on collaboration with others. The strength of this relationship between the producer and the creative teams, the crew, the talent, the client, the vendors, and the dozens of other people along the way is what propels and accomplishes the five stages of production just listed.

The primary purpose of this book, then, is to look closely at this teamwork, and to explore the ways in which each individual on the producer's team functions. What does a director of photography bring to the project? Will you need a location scout? How does the script supervisor make your job easier? At what stage do you hire the editor? Should you consult an entertainment lawyer for each contract? Most importantly, do you have the necessary "people skills" that can keep this team together?

There are five overall stages of producing, and inside this book, 10 chapters are devoted to this journey. The reader gets a step-by-step explanation of the producer's jobs, from the initial idea for a project to its final distribution process, from concept to contract. Along the way, we will examine the intersection and adaptation of the skills required of a producer of "traditional media" in an environment of new and emerging media.

Chapters 1 Through 10

Each chapter delves into a specific area of producing, from an overall perspective on the many jobs and titles of a producer, television's history, its current state, and its possible future, to the five stages of producing a project, the details of budgets and breakdowns, legalities and rights, pitching and selling, and the ever-important people skills.

Each chapter opens with talking points that cover the highlights and main points of that chapter's material. Anecdotal evidence of the subject explored in that chapter will join with memorable quotes and excerpts from the professionals' interviews in Chapter 11, as well as commentary on the personal side of producing, in sections labeled "On a Human Level." In addition to emerging media-related material layered into other sections of the book, each chapter also features at its close a "Focus on Emerging Media," which looks at new trends in and provides practical instruction for approaching production in transmedia, emerging media, and online entertainment.

Chapter 11

This chapter offers interviews with high-profile, experienced television and new-media producers, academics, and other industry professionals. These contributors talk

candidly about their jobs: what they do, how they do it, the people they work with and depend on, their day-to-day functions, and the balancing act between their professional and personal lives. Their producers' titles range from executive producers in network television to independent producers of documentaries or non-broadcast material. Industry professionals share their insights ranging from legal issues to festival submissions.

Just like a compelling guest speaker in the classroom, or a mentor in the workplace, each shares his or her stories from the trenches. Each offers a unique perspective on producing.

Added Features

Throughout the first 10 chapters in the book, each contributing producer and industry professional from Chapter 11 shares pertinent information through:

- **Top Ten Lists**: The top 10 aspects of professional success as noted by its contributor
- **Sound bites**: Salient excerpts from the interviews in Chapter 11
- **Graphics**: Charts, formats, forms, and maps
- **Quotes**: Some of the best global, media, and historical minds offer their thoughts
- **Focus on Emerging Media**: The challenges for producers of emerging media are explored in depth

The Glossary

The words or terms of the language of television, emerging media, and communications are explained in the glossary. Each of these words is italicized in the text, referring the reader to the glossary.

Note to the Reader

You may be a student of television and its convergence with emerging media, and you've enrolled in a plan of study that explores the role of the producer. Or, you have an idea you think could be expanded and broadcast. Or you may be an experienced producer who is actively involved in producing content and who can benefit from an updated approach to the technical and creative aspects of producing your project.

Regardless of the category into which you fall, this book has been researched, designed, and written for you. It is the first book of its kind to fully explore both the "big picture" and the small details of producing for both television and emerging media. It can be part of an overall curriculum, or it can provide helpful creative and technical guidelines for the independent producer. This text aims to present the realities and possibilities for the producer, one who is ready to devote time, energy, and passion to producing quality programming and content in this extraordinary period of media expansion.

Put simply, this book promises to help you know more about what you don't know.

CHAPTER 1

What Does a TV Producer *Really* Do?

THIS CHAPTER'S TALKING POINTS

I The Producer's Domain

II Defining a TV and Emerging Media Producer

III The Many Roles of a Producer

IV Producers' Titles and Job Descriptions

V The Need for People Skills

VI Focus on Emerging Media

I. THE PRODUCER'S DOMAIN

Television has affected—and reflected—the culture of global communications for over a half-century. And now, the explosion of emerging media is demonstrating a similar impact, as it bursts onto the scene with innovative possibilities and real challenges. Even the very word itself, "television," takes on new meaning. As we enter this extraordinary era of media transition, traditional television programming, viewing habits, advertising models, and delivery systems must inevitably change with the times.

TV and its emerging media counterparts must be fed, and it's the producer who feeds them. The producer is central to every aspect of a project—from the wisp of an idea to a tangible piece of work. In theory, a producer has unlimited potential to educate and entertain. But the trade-offs are intensive hours, stressful demands, and myriad responsibilities.

The demands of viewers and the appetites of commerce require a continuing stream of unique programming, or *content*, for television and emerging media to survive. This content can range from sitcoms on NBC and TV movies on Lifetime, to internal corporate training videos for IBM, or segments for CNN cable news; from one-minute "webisodes" for mobile devices, or an intricate video game, to 24/7 content for online channels—regardless of the delivery system, each of these content formats has a producer in charge. The producer must satisfy both the client and the viewer, and utilize the talents of the cast and crew, manage the budget, possibly write the script, and master dozens of skill sets.

A producer's job description combines art with craft, commerce with technology, and leadership with collaboration. There is arguably a producer's personality and mindset that comes with the territory; some people who want to be producers are naturals;

others may simply not be right for the job. So, whether you become a producer, or work with producers, or simply want to adopt a valuable producer's skill set, you can start by exploring the many layers of responsibility and creativity involved in producing. This chapter, as well as those that follow, examines the producer's vast domain, its benefits and challenges, and reveals what a producer needs to know about the many phases of a project's development.

> I love bringing talented people together. There's no greater feeling than standing on a shoot, sitting in an edit, or watching the final product on TV, knowing that you as the producer pulled together an incredible, hard-working group of people to create something.
>
> **Justin Wilkes, excerpt from interview in Chapter 11**

An effective producer is a multitasker, regardless of the content or its delivery system. A producer might not only research, write, and produce a program or segment, but might also shoot it, edit the footage on a desktop system, mix the audio, design and add graphics, or write and record narration or voice-over. The increasing availability and low cost of equipment, along with decreasing budgets, make these skills both valuable and necessary to the producer.

A producer's talents cover a broad spectrum—from creative to technological, from the first hint of an idea to its final broadcast, from finding finances to marketing. In this chapter and throughout the book, we'll explore the producer's role: finding, writing, developing, and pitching an idea; budgeting a script; negotiating a deal; securing financing; planning, shooting, and editing; and creating a team of talented people with great attitudes.

> Producers are risk takers, who seize an idea, run with it, and convince others to follow them.
>
> **Gorham Kindem, *The Moving Image***

Clearly, this book can't cover each detail of every producer's job, although most major points are discussed. For everything you'll explore in the following chapters, there are dozens of books, websites, and seminars that target these specifics in more detail. Each bit of knowledge adds to the producer's arsenal. A good producer never stops learning.

II. DEFINING A TV AND EMERGING MEDIA PRODUCER

> I'm a producer. I do whatever is necessary to turn an idea into a finished product. That means at different times I've been a salesman, director, film editor, casting director, creative consultant. I've even driven the bus.
>
> **David L Wolper, *Producer: A Memoir***

Without a producer, there is no project. The producer propels the project from an unformed idea to final broadcast or download. He can nurture the project from conception to distribution and might also be the writer, director, and/or the source of the financing. At various stages of production, he may bring in other producers who can help in handling the hundreds of details that need supervision or polish.

The producer is usually the first one on a project and the last one off. She is essentially the overall project supervisor. She gets the project off the ground, and then supervises every step of its development and production. Not every producer originates the idea; often, a producer is hired to work with a network or production company after an idea has been created and sold. Some producers do it all themselves, others are part of a producing team. It's work that's exciting and exhausting.

The job of a producer of television and emerging media is different from a film producer's job. Conventional wisdom defines feature films as the director's domain, theater to be the realm of the actor, and TV as the domain of the writer and the producer (or showrunner). In most cases, the feature-film producer acts as the liaison between the studio and the production, providing a support system for the film's director: increasingly, producers shepherd their own scripts or projects, hiring the director and cast, and overseeing the film's integrity, production value, and marketing.

In television and emerging media, the producer is the governing force who often doubles as the director, unless the project is heavily actor-oriented, like network episodics, sitcoms, and drama. The producer usually hires and fires the director, writers, key department heads, actors and other talent, crew, and anyone else needed to bring the project to life. The director in television generally makes more of a technical contribution, working with the talent and crew on blocking and lighting and rehearsing lines, or is in the control room, making camera decisions on a live or prerecorded show. But the producer makes the final decisions; the buck stops there.

> I carried my tape recorder with me everywhere as a kid. I had this odd fascination with recording things and playing them back. I taped everything. I even brought my video camera to school. By the time I was old enough to try and figure out what I was supposed to do for a living, all I really knew was I wanted to continue this process of recording something and making it into something else.
> **Matt Lombardi, excerpt from interview in Chapter 11**

Who and What Makes a Good Producer?

> These digital cameras now? People can make a show—make a movie. That's what I like. The industry is just so hard to get into, you know, unless you have a lot of money. Now, people that have an idea of some kind of media that they want to share can put things on YouTube—the sky's the limit now. It's wide open for people to be as creative as they can possibly be
> **Sheila Possner Emery, excerpt from interview in Chapter 11**

If you're eager to meet challenges and can multitask and handle a steady stream of demands and questions, if you are slightly type A or obsessive-compulsive and like to run a tight ship while still having fun, you have the makings of a good producer. Combine those qualities with creativity and flexibility, an openness to new ideas and information, a genuine respect for all kinds of people, and an ethical and profitable approach to business—if this all sounds like your personality, you could wake up each day excited to go to work as a producer.

The majority of working producers truly enjoy their job. They like its random nature and welcome the challenges. The job fits their personality. Some producers are calmer or nicer or more organized than others; some act badly, others can inspire. As you read the interviews with contributing guest speakers in Chapter 11, you'll see that producers tend to choose this work because it genuinely excites them.

A good producer:

- ■ *Is a problem-solver.* A producer anticipates what's needed, and solves problems rather than creates them. He's smart and plays fair. He's a nurturer and an arbitrator, and can be both a leader and a team player. He's a risk taker with contingencies for any predictable scenario—he has a plan A, plan B, and even a plan C.

- **Is the master of multitasking.** Whether the project is a low-budget documentary or an expensive weekly drama, the producer balances dozens of tasks at once. She might be an entrepreneurial executive producer who secures the financing and makes deals, or a producer commissioned by the executive producer to work on aspects of the project, such as segments, post-production, music, and so on. She might also be working in several stages of production at once.
- **Is an intermediary.** The producer who's wise enough to be on set regularly (even though he may not be needed) becomes the point person for the director, the DP (Director of Photography), the actors, and the crew members who rely on his leadership. The producer balances the needs of the network or client with the needs of the talent and cast.
- **Wants to know everything.** A good story and useful information are both at the core of a producer's craft. The world of producing changes daily, so the producer researches everything at her disposal—books and magazines, the industry trade papers, newspapers, the Internet, plays, biographies, art and history, and philosophy. She looks for ideas that interest her and that might also appeal to a wide audience. Her goal is to understand where the media industries are going, as well as to keep current with what is popular now. She watches TV and explores emerging media.
- **Enjoys the process.** The producer is comfortable doing business *and* being creative. He doesn't need to know how to do everything—like write, direct, edit, create sound design, and light and design sets—but he does know how to hire the best people to do those jobs. He creates a loyal and talented team who can all work toward a common goal—creating a compelling story.

To paraphrase Gertrude Stein, a producer is a producer is a producer. The needs of each individual job may fluctuate, but the skill sets on most jobs are similar. A good producer can produce almost anything—a two-hour documentary, a half-hour sitcom, streaming online video, a 30-second commercial, a mobisode, a corporate image piece, even a music video. The projects may differ in content and length. They may require skills in producing a specific kind of program or content; but the creative, financial, technical, and interpersonal skills required are similar for all producers.

III. THE MANY ROLES OF A PRODUCER

> To see it from the outside looking in, it was always exciting to me. Anything in this business that helps you learn, to me, is always interesting. It's never the same, it changes every day. It's not a job where you go, "Okay, I've got to do that for another eight hours." You know what's coming, it's always about being prepared for what *could* happen.
> **Bernie Young, excerpt from interview in Chapter 11**

The producer in television and in emerging media has the power to educate, entertain, and emotionally move an audience. But developing a project takes time and energy—a lot of both. No matter what its length or content, each project goes through the following five stages of production, and the producer plays an active role in each stage.

The Five Stages of Production: From Idea to Wrap

Stage One: The idea (project development)
Stage Two: The plan (pre-production)
Stage Three: The shoot (production)

Stage Four: The final product (post-production)
Stage Five: Next steps (wrap-up and distribution)

Stage One: The Idea (Project Development)

Your idea might be a full-length script or a simple one-paragraph treatment. During the five stages of production, this idea is developed, fleshed out, and hopefully produced. In the project development stage (explored in Chapter 3), the entrepreneurial producer often, though not always:

- Either writes or finds source material to option, or obtains all rights to found content. This material can be an original idea, a script, a book, a story on the Internet, a newspaper or magazine article—a producer can find material from many sources.
- Evaluates the project's initial costs, funding sources, and likely markets.
- Develops the idea, first into a story synopsis and then into a formal proposal, or pitch, for getting financing or development funds.
- Oversees the development of the idea. In dramatic programming, this might include writing the show's *bible* that covers the overall narrative arc, with plot lines and character sketches for a season of shows in a series.
- Develops a rough estimate of the budget.
- Pitches the project. Raises network or client interest. Obtains financing that covers the project's initial development or that spans the entire project. A development deal can range from simply developing the script to producing a pilot.
- Negotiates and obtains contracts for licensing fees and other legal aspects of the project's distribution or broadcast.
- Selects, interviews, and hires a director who shares the project's visions and can deliver on schedule. Not every project requires a director; often, the producer may fill this role.
- Selects and hires a writer or team of writers (staff and/or freelance) to develop the idea further.
- May consult with and hire additional producers, associate producers, and/or a production manager.

Stage Two: The Plan (Pre-Production)

By now, the original idea has taken a more tangible form. It can provide a kind of blueprint for the research and hiring of the essential crew members who will take it to the next stage. In the pre-production stage (explored in Chapters 4 and 7), often, though not always, the producer:

- Is the principal point person for the financing and/or distribution group. Is involved in negotiations, contracts, rights, and union discussions. Secures rights and permits for locations, music, and other elements.
- Breaks down a script or treatment into a rough budget estimate.
- Continues consulting with the director on aspects of the script and production.
- Depending on the scope of the project, hires and consults with the line producer, location manager, director, cast, DP, production designer, post-production supervisor, editor, musical composer, and graphics and special effects personnel, as well as essential crew such as camera operators, audio recordists, lighting designers, and other production areas such as makeup, wardrobe, props, construction, transportation, catering, and more. The director may or may not be involved in the hiring process.

- Hires and supervises legal consultants, accountants and auditors, production coordinators, office managers, script supervisors, producer assistants (PAs), and interns, among others.
- Supervises the completion of the shooting script.
- Scouts and approves all locations (often with the location scout, director, and/or DP).
- Consults with the production designer on sets, construction, props, and the overall look of the production.
- Consults with the DP and director on shooting format and gear (Red, DSLR; HD, 24P, P2, film, 4K, etc.).
- Breaks down the shooting script to prepare the overall shooting schedule, call sheets, and production report forms (usually with the line producer and/or production coordinator and/or executive in charge of production).
- Negotiates with appropriate unions on contract and fee agreements.
- Prepares all contracts and deal memos, or oversees them after the unit production manager (UPM) has compiled them.
- Signs off on the final budget.

Stage Three: The Shoot (Production)

Stages one and two lead to the actual shoot, where the vision of the project can now be captured on tape or memory card. During the shooting stage (detailed in Chapter 8), usually although not always, the producer:

- Is on set or on call, always available.
- Consults with the writer(s) and supervises any changes.
- Works closely with the line producer.
- Works with the production designer and approves all aspects of the project's overall look, tone, and mood.
- Consults regularly with the director, on-camera talent, production designer, and other key department heads.
- Screens the dailies with the director (and often the editor).
- Prepares, balances, and/or approves the daily or weekly cost estimates.
- Stays on top of any press or publicity material generated and carefully supervises what's appearing in the media about the project.

Stage Four: The Final Product (Post-Production)

The footage has been logged and loaded into the computer, and now all the pieces are ready to be joined together in the editing room and audio facility. At this stage, it's unlikely that you can reshoot additional footage, so it's up to you to make it work through careful planning for the shoot and post-production. During the post-production period (which you'll explore in Chapter 9), usually but not always, the producer:

- Often screens and logs all footage, and supplies the editor with a "paper cut" (see Chapters 4 and 9) that acts as a script for the editor, with notes, time-code references for footage, and reel numbers and logs. Lists all graphic elements and audio components.
- On most projects, is fully present during editing or comes into the editing room on a regular basis to review the editor's work in progress.
- Continues as the point person for the network, client, or producing group regarding issues of the final cut, timings and show lengths, standards, and practices. Keeps track of all other delivery requirements.

- Keeps a close eye on the budget. Post-production can be one of the least controllable financial aspects of the project.
- Selects, negotiates, and books post-production facilities, such as editorial houses and editors, stock footage facilities, audio studios, composers and/or stock music supervisors, graphics houses and designers, and so on.
- Is familiar with all footage, selected takes, B-roll, cutaways, and other elements needed in the edit. May work closely with an assistant who's familiar with the footage.
- Regularly supervises the editor. Is responsible for the final cut, depending on contractual agreements.
- Works closely with the musical composer and/or stock music supervisor.
- Supervises audio sessions including narration, dubbing, ADR, foley, rough mix, and final mix.
- Works closely with the graphics designer(s) on show titles, in-show bumpers, opening and end credits, special effects, and other graphic design elements.
- May organize and conduct focus groups or audience testing and supervise any editorial changes that could result from their responses.
- Signs off on the video master of the final cut for client delivery.

Stage Five: Next Steps (Wrap-up and Distribution)

The project is edited and ready to go, whether for broadcast, online, and/or for a client. Still, the producer must deal with several vital details. In the wrap-up stage (explored in Chapter 10), often but not always, the producer:

- Pays and reconciles all outstanding invoices.
- Finalizes all legal contracts and other issues still outstanding.
- Reconciles all budget issues and submits a final report to the client.
- May distribute copies of the final product to key personnel on the production.
- May be involved in advertising and promotional campaigns, including on-air promos, online advertising and PR, print ads, Internet blogs, and grassroots campaigns.
- May consult with the network or production company on publicity, such as special events, public relations photos and artwork.
- May work closely with the network or production company on securing international broadcast, copyright issues, ancillary rights, licensing, and so on.
- May coordinate press activities by carefully controlling what material is appropriate for release to the press.

Why Become a Producer?

A producer's job demands hard work over intense periods of time. Yet most producers genuinely love their job, partially because they find its demands to be stimulating. Producers work their way up from different places—some begin as interns, others as a PA, a secretary, a production coordinator, or an assistant. Some producers make the transition from their former careers as lawyers, writers, directors, actors, agents, or managers. Still other people have the financing and entrepreneurial passion to fund projects independently.

Over the last few years, universities have recognized the value of curricula that focuses on producing for television and emerging media. Their classes can be excellent sources of information, ideas, and discussion; yet, as you'll read in Chapter 11, many important aspects of producing can be learned only on the job and in the trenches. Out there in the real world, television and emerging media continue to evolve on a daily basis.

> I do think there are a lot of creative advantages to television—the immediacy, the amount of financing, funding—making it vastly superior to film, particularly now in cable television.
>
> **Brett Morgen, excerpt from interview in Chapter 11**

Many producers started off as writers or directors or actors who had an idea for a project they wanted to see actualized. They wanted to brand their idea with their own unique voice, and because they wanted that voice to be heard, they refused to relinquish control over the development of the idea. They chose to become producers so they could protect that idea's vulnerability and actualize their original idea. They saw their vision to be rather like a fragile newborn, one who is sheltered by legal, fiscal, technical, interpersonal, and creative knowledge. Reinforced by these assets, their vision can grow and thrive.

Creativity, Clout, and Control

Every producer works toward some kind of payoff. The payoff can be financial, creative, experiential; ideally, it's all of these. That payoff is more likely to occur if the producer uses the components of *creativity*, *clout*, and *control*.

Television writers, for example, seldom have enough clout to be guaranteed that their script will be produced and aired as they originally wrote it. For the most part, writers—even the best of them—are regularly hired, used up, fired, then replaced.

But when writers can understand the producer's skill set, or even take on the producer's role, they can dramatically increase their control over their project, especially if they can develop a reputation as a strong producer who is also creative, and who can write and/or direct.

This overall concept of originating and nurturing an idea can be explored through these three very different lenses.

Creativity: Inspiration and Creative Skills

Your idea is the creative essence of your project. As its producer, you may write it yourself, or you have found an idea that's been originated by someone else. Then, after you've legally secured it, you develop it and flesh it out, and finally, you make it come alive.

Your team may be small or large, but it's a vital creative component. This team brings together the writers, actors, directors, crew, and production designers whose visions are aligned with yours. You're creating and building a team of talented people who share your passion, reflect it in their work, and bring positive *creativity* and energy into the process.

Clout: Networking and Contacts Skills

The cliché hasn't changed: it's *who* you know, plus *what* you know. Networking has become a way of life, so you can research opportunities to meet people at festivals, organizations, school clubs, openings, charity events, and dozens of other events in your locale. If nothing currently exists, exercise your producing skills by putting on networking events or organizing film/TV festivals. Create an online presence—write a blog, tweet, create profiles at Facebook and LinkedIn, start a Vimeo or a YouTube channel. The opportunities to connect with like-minded people in an online world are endless, as social networking creates new visions and versions of community.

You can sharpen your producing skills when you know who's who, and who does what the best. You can follow the trends in television and emerging media, and research who's financing them and in what ways the projects are financially viable. When you keep on top of media industry news, follow the smart blogs, and observe the ebb and flow of current trends, you are stockpiling your own clout.

Control: Business Skills

You have a vision and it deserves to thrive. Your job is to protect it. You can research the legal requirements like copyrights, contracts, deal memos, and other forms of negotiation (see Chapter 5) that can protect your idea and the whole project that revolves around it.

You can master the numbers when you fine-tune your skills in breaking down a script, in budgeting, costing out, rough estimates, daily costs, and so on. Research budgeting software, and research online sources for shortcuts and hints on budgeting.

You also want to understand and know your audience, both domestic and global. What are their interests and their demographics, such as age, income, ethnicity, and education? Who are the media companies that reach out to those audiences, and how can you form a relationship with them?

In this era of technological revolution, research the changing equipment in production and post-production—they're both vital to your project. Although the delivery systems that include broadcast television, mobile devices, cable, the Internet, and video gaming systems are increasing exponentially, they all need content to go out to the viewer—as a producer, that's where you come into the picture.

IV. PRODUCERS' TITLES AND JOB DESCRIPTIONS

Unlike other areas in television, such as writing, directing, or acting, the producer doesn't fall under the protection of a union in the same way that a writer, director, and/or actor does because the producer is generally in charge of the project, rather than at the mercy of higher-ups. The producer determines and maintains the budget, negotiates with these unions, and adheres to their guidelines.

Although the Producers Guild of America (PGA) offers benefits to producers with varying titles and levels of experience, their contractual and legal parameters aren't currently comparable to those in the traditional unions such as WGA, DGA, and SAG.

Producing historically has attracted the entrepreneurs and the rebels, people who tend to be risk takers and self-directed, along with a few control freaks here and there. Most producers are genuine—hard-working and passionate. And there are also the wannabes—those who crave the title but don't do the work that goes along with it.

This title of "producer" becomes a negotiating tool, and often it is given out freely as a reward. It's not uncommon for a so-called producer to know very little about the intricacies of producing. Instead, he may be a major investor—or a minor con artist—who wants to flaunt his credits without doing the hard work. Because there is no official governing union that controls the assignment of the producer title, a network or production company can bestow it on actors, agents, managers, or anyone else who has had some part in putting the deal together. However, the PGA has taken on the watchdog role over the allocation of producing credits; the desired outcome is a more stringent control over who gets what credit and title.

Producers' Titles

In both nonscripted and scripted television, and in emerging media, producers can also be writers and/or directors. From show to show and from genre to genre, producers' titles and their job descriptions can vary considerably.

Following is just a taste of producers' titles.

Executive Producer

This is the murkiest of all producers' titles because it covers the gamut of descriptions. It generally designates the person who makes the deals, finds the finances, and/or puts the package of writer, director, actors, and/or crew together. Usually she sets up and controls the budget. She may hire various crew and cast and can be in charge of other producers for one or more projects. There may be several executive producers and co-executive producers on a single project. For example, one may be the liaison between the network and the press, another deals directly with talent and creative, a third with budgets and business planning.

On a financial level, the executive producer might have single-handedly financed the project, even mortgaged her house to develop it, or she may have had just one brief meeting with an investor who said yes. She may be actively on the set and in the office every day, or may show up only at the wrap party. The lead actress could demand the executive producer credit as part of her contract, and so could her husband or manager.

> **The Top 10 Things You Need to Be a Good Executive Producer**
>
> 1. Loyalty to the host and show that borders on insanity
> 2. A long fuse
> 3. A small ego
> 4. Attention to detail
> 5. Organizational ability
> 6. Ability to make a split-second decision
> 7. Learn to take a joke
> 8. Pick your battles
> 9. Good listening skills
> 10. Snappy dresser
>
> Barbara Gaines, *The Late Show with David Letterman*, excerpt from interview in Chapter 11

Showrunner

The term *showrunner* is informal, and not credited as such. The showrunner is responsible for the overall creative direction of a series, and often he may have the title of executive producer. The showrunner may be the original creator of the show and/or the writer of the show's storyline overview, "the bible." He is usually the primary writer, and/or manages and guides other writers in creating the scripts; he often may rewrite scripts and make sure they're delivered on schedule.

The showrunner on a reality show, a talk show, news, specials, and so on may not always be as involved in the writing and may be more involved with generating, selling, and/or managing ideas. He may also be very involved in pitching a

new show idea to a network, casting the actors, and staying on top of a very long list of elements needed to produce a weekly show. Most important, the showrunner maintains the essential vision of the show. A showrunner can be a writer, a producer, or both and has the power to hire or fire, shouldering the burden of the show's success or failure.

Producer (Senior Producer, Supervising Producer)

She can be an entrepreneurial producer or a producer commissioned to come in at any stage to work on the project. Either way, she starts the ball rolling, usually from concept to broadcast, by initiating ideas and hiring and coordinating crews. She can also be the writer and/or the director, or hires them; casts the talent; and supervises and controls the budget and the technical and administrative aspects throughout the project. This producer oversees contracts and negotiations, and she may receive a percentage of the final profits, if any, as well as a regular salary.

Associate Producer

Also called the co-producer or assistant producer, she is the producer's right hand and does specific jobs that the producer assigns. Her work can be on the creative side, such as helping to set up interviews on a talk show, and can also lean toward administrative tasks, such as making production schedules, allotting budgets to departments, booking talent and/or crew, research, interviewing talent, finding locations, and more.

Line Producer (Production Manager, Unit Production Manager, Producer, or Co-Producer)

The nuts and bolts of producers, the line producer is most involved in the day-to-day operation from the beginning to the end of the project. He keeps budgets on track and compares estimated costs to actual expenditures. The line producer represents the administrative side of television and turns ideas into reality by figuring out the logistics of a project. He keeps the production on schedule (set constructions, props, wardrobes, talent releases, etc.), breaks down the script into a storyboard and its components for production, and decides the sequence of shooting that's most cost-effective. He works closely with the producer(s) in various aspects of location scouting, transportation and lodging, and dozens of production details. It's a vital job—the line producer helps the executive producer, producer, and director do their jobs much more smoothly.

Staff Producer

Generally hired on a permanent or per-project basis, the staff producer works in a network or production company as an employee with benefits. Her job usually involves producing an ongoing aspect of the show that's assigned to her—it could be her task to interview potential guests, research stories, track down licensing information, secure locations, and more.

Segment Producer

In magazine format shows, news broadcasts, talk shows, and reality-based programming, the segment producer is assigned to one of several stories aired within the program and may produce his own segment. Some shows may have several teams comprised of a producer, PAs, a camera operator, and an editor who work together on their segment. He may also be one of a growing group of producers—the producer-editor, or *preditor*—who research, shoot, and edit their own pieces.

Independent Producer

Also called *independent contractors* or *freelancers*, she may own her own company with a capable infrastructure and work on projects for a network, another production company, or a variety of clients. She might have a complete staff, or hire on an as-needed basis. She usually pays her own insurance, benefits, taxes, and other expenses like overhead and equipment.

Field Producer

This area of producing refers to a producer who is "in the field" or at a location some distance away from the primary producer. Many companies in New York or Los Angeles, for example, have a roster of field producers who are located around the country or abroad. He can be on the scene faster and less expensively, and can work flexibly in a variety of fields like sports, entertainment, and news.

Session Producer

Often a producer is needed to supervise and produce a recording session, an interview, a voice-over recording, a satellite feed, or other producing necessities. She keeps it on track, is aware of the time used, the length of a shoot or recording take, and generally maintains close quality control.

Post-Production Supervisor

A producer in the post-production stage is familiar with the footage to be edited and keeps logs of where the footage is and on what reel numbers. He may create a paper cut or storyboard of the editing order of the shots, with their time code and reel locations. He keeps track of the graphic and audio elements; supervises all edit, graphic, and audio sessions; and works closely with the editor and, later, with the sound designer throughout the final stages of post-production.

V. THE NEED FOR PEOPLE SKILLS

> Balance? Oh, I've heard of that. . . . It comes and goes. There are times in television when you're completely overwhelmed. You've got to pump it out every eight days, and it's not always great. You get scripts thrown back at you by the networks sometimes. You get a ton of notes at all times. You're having to please a lot of different people, and you have fights, but you have to pick your battles.
>
> **Scott A. Williams, excerpt from interview in Chapter 11**

A producer's creative and business skills are essential to the success of a project. So are vital people skills—they are an equally compelling facet of a strong producer's approach to the job. It can't be emphasized enough: A producer can do nothing without a team. The producer builds his team on the talents of writers, directors, crew, actors, editors, composers, and so many more. Without these people to actualize the project, a producer is useless. He needs people skills not only to attract qualified people to the project, but to keep them motivated and collaborative.

A strong producer relies on the following skills while working with dozens of people involved in bringing a project to life:

> ***Collaboration.*** A strong producer embraces collaboration and encourages teamwork by supporting each member of the team and encouraging open discussion.

Communication skills. These skills are vital for effective relationships. Without them, you risk misunderstandings, even chaos in your project. Communication is either *verbal* (the choice of words as well as the tone and volume of our voice) or *nonverbal* (facial expressions, body language, gestures).

Verbal. Is *what* you said the same thing as *how* you said it? You say you're not mad, but your tone of voice says otherwise. Say what you mean.

Nonverbal. Do you look at people as you talk or listen, or are you distracted? Does your body language say that you are nervous or inattentive, or calm and in control?

Conflict management. Conflicts happen all the time, especially in the high-stress world of media. No matter how hard we try to solve them, some conflicts are inevitable and can't be resolved. But most conflicts can be *managed* effectively if you can grasp the cause of the conflict and deal with it. As the producer, you are also the peacemaker. Not everyone has to like one another, but they're professionals, who have a job to do. Sometimes it's up to you to mediate.

Emotional intelligence (EQ). In this growing field, initially developed by Daniel Goleman, a person's emotional strengths are considered as important as his or her intellectual abilities. A high EQ is measured by a producer's ability to show genuine empathy, respect, positive leadership skills, and sincerity for the team.

Learning styles. We are seeing impressive research over the last few years that focuses on how we learn, both cognitively and emotionally. Researchers have identified over 20 different ways that people absorb information and learn. They're all effective. When you can understand the different ways in which each member of your team learns, you can strengthen the bonds of communication.

Most of us have one predominant way in which we absorb information:

Visual. This person learns best by reading or looking at information, and then creates a mental picture from the data.

Auditory. In this case, a person absorbs information better when it comes through hearing the spoken word or audio. The auditory learner generally has strong listening skills and verbal abilities.

Kinesthetic. To the kinesthetic learner, information is best conveyed through ways that are physical, spatial, or sensory, such as charts and 3-D modeling.

Each of us tends to be either one or the other:

Analytical learner. The analytical learner understands information best when it's presented as sequential, linear, organized, and delivered one step at a time.

Global learner. The opposite of the analytical learner, this person sees the big picture first, then breaks it down into smaller and more manageable details.

Here, too, we tend to fall into one of two categories:

Goal-oriented. This type of person tends to stick with a task, with no breaks or lulls, with an almost single-minded focus until the job is done.

Process-oriented. Here, the process and the journey of reaching the goal can be as engaging as the goal itself.

Multiple intelligences. This originally was researched and revealed by distinguished Harvard professor Dr. Howard Gardner. His research reveals at least a dozen distinct predominant intelligences that each of us can claim, such as a strong musical, mathematical, spatial, or athletic intelligence.

Listening skills. The ability to simply listen to another person is a real skill that can work wonders. Being attentive, not interrupting, and acknowledging that we hear the other person can be a real challenge for some people. As we suspend

our own need to talk and control, we can genuinely listen, and make people feel truly valued.

Leadership skills. As the team's leader, the producer recognizes that the team is made of individuals. Each member of the team has his or her own emotional needs, learning styles, problem-solving strategies, communication approaches, and personal issues that can influence professional function. Leadership comes with the producer's territory, so treat the position with respect for those you're leading.

The producer benefits—as do the team members—when the needs of the team are taken into consideration. With a goal of creating harmony, the producer models behaviors and viewpoints that set a tone for the project and all its stages of production.

Some of the essential leadership skills and ideals that the producer can embody are:

Commitment. If you don't believe in your project, don't expect anyone else to. Stand firmly behind it.

Credibility. Though you want people to respect you, don't let your need to be liked get in the way of getting things done.

Delegation. Hire the best people you can find, and learn what they do. Then, leave them alone to do their job. Check in regularly to confirm that the project's vision remains intact.

Motivation. Producers don't expect praise (and seldom get it), but they know how to lavish it on their team when it's genuinely earned. Find ways to show your thanks.

Ethics. The value of *ethics* in producing is more about strength of character than a spiritual or religious mandate. A producer who assesses his or her own ethical framework is more likely to create a project that's under control, stimulating, and a positive experience.

Accountability. Because you're in charge, you're accountable to your team. It's their project too. Keeping up with changes in technology, creative trends, and the business of the TV industry is also part of your job.

Honesty. Your word is solid enough to build your reputation upon it.

Objectivity. You can listen to criticism without taking it personally and can hear all sides of an issue.

Patience. Respect the fact that people work at different rhythms with varying working styles.

Personal balance. The demands of the job can take over your "other" life. With the right perspective and determination, you can have a professional *and* a personal life.

Willpower. Stress during production can result in producer burnout caused by too many long hours, too little sleep, a diet of junk food, and the temptations of smoking, alcohol, drugs, and negative relationships. Save your energy.

Relationships. You can cultivate new friends who share your passion for producing while staying close to your most important supporters: friends and family.

Daydreaming. Occasionally, make the time to take a walk, a mental break, and a few deep breaths. Find a source of peace: meditation, painting, yoga, laughing.

VI. FOCUS ON EMERGING MEDIA

Television and video for emerging media have been changing rapidly in recent years. With technology advancing constantly, producing in this part of the industry gets easier and more competitive. Producers have access to inexpensive higher-quality

equipment and editing software. Broadband is faster, video compression has improved, and new viewing platforms have been invented. This in effect creates a larger audience and new opportunities for additional revenue.

This rise in web and interactive video has increased quality competition. The best web and interactive video producers are great storytellers. They also embrace technology and value the relationship with their audience. Producers pay attention to who is watching, listen to what they say, and grow and maintain viewership. The essential steps for an emerging media producer are to plan, produce, distribute, promote, and monetize. There are several types of producers that fall under the umbrella of Emerging Media.

Broadband Producer

This person is usually completely responsible for the project's vision, which may include concept, format, and character creation. They have significant authority over the majority of the project and make key decisions at each phase, including story development, selecting writers, and securing rights and financing. In the pre-production stage, they are responsible for assembling the key members of the creative and technical teams and approving final script and schedule. Unique to a broadband producer's role is the development of an integration/compression plan of broadband material for digital distribution. Attention is given to the final quality of the video, testing compression, frame rate, color depth, and bit rate across various broadband platforms.

Video Games Producer

A producer in the world of video games can participate across the full life cycle of the development of a product. They manage day-to-day operations and work with both the creative and technical teams, such as software engineers, marketing managers, lead artists, content leads, and project managers. The video games producer also collaborates with various departments to develop the original concept and continue to refine and test the product. They oversee the five phases of video game production, which are pre-production, production, testing, gold mastering (final release), and maintenance. Considering content, characters, technology, market positioning, and profit across all of these phases, the producer ensures a comprehensive development plan is maintained.

Digital Visual Effects Producer

The visual effects (VFX) producer is responsible for the visual effects budget and schedule. They are the authority on business, administrative, technological, and creative visual effects duties across pre-production, production, and post-production. The VFX producer may oversee several visual effects coordinators and assume many of the day-to-day tasks, prioritizing the project's needs, and exercising independent judgment within the VFX sphere of the project.

Digital Animation Producer

In a fully animated production, the digital animation producer oversees the entire development process from the concept's inception to its execution. They conceive or select the original premise that corresponds with the particular media platform in which the final product will be exhibited. They secure the writer(s), the necessary rights, and the financial backing. During pre-production, they assemble the creative team, which typically includes the director, cinematographer, co-producer, animation

supervisor, production manager, and production designer. Specific to the role of animation producer, they may also choose the voice talent and approve the final script, boards, and animatics. During the production and post-production phases, the producer is usually the point person for financial, marketing, and distribution plans. They also consult with the director and other key creatives throughout the entire process.

Quite often there is overlap in animation, visual effects, and live action in a production. For an animation producer in a project that isn't fully animated, they are responsible for the creative direction, budget, and schedule of the animated sequences. They often report to a visual effects producer, a video games producer, or a line producer, depending on the type of project.

Interactive Television Producer (ITV)

An interactive television producer oversees the vision, storytelling, production, and audience engagement of an interactive television project. They are responsible for both the creative and financial aspects of the production process. In the early phases of development, they may develop the initial concept and characters, and select the format, writer, and interactive strategist, while supervising the creation of the production "bible" and script. Since these projects can become complex with access to ancillary content such as video, graphics, and interactive voting/polling, and texting, the producer is responsible for assembling a strong creative team, including the director, production manager, director of photography, composer, and editor. The producer's main roles are to approve and supervise the budget and schedule while overseeing the uniquely different delivery requirements, distribution dates and various platforms, and standards and practices affiliated with interactive ancillary content. In the final stages of the project, the producer typically consults on publicity and promotional campaigns as well.

Virtual Reality Producer

A virtual reality producer manages both creative and technical teams and oversees an entire virtual reality production from conception to final delivery. These immersive productions can range from interactive games to 360-degree videos. Experience with various software platforms, developer communications, and the VR landscape is beneficial. In the planning stage, a virtual reality producer develops the content strategy, budget, and timeline, forms a diverse team, prepares marketing strategies and a release plan, and defines the project scope, including the technical specifications. Serving as a liaison between development teams, designers, and production and post-production staff, the producer manages all milestones ensuring they are on time and of high quality. The producer oversees project quality assurance by testing and reviewing prototypes, while measuring deliverables against the project scope. Throughout the project, they are also responsible for educating non-technical stakeholders on the limitations and possibilities of VR to best manage the needs and expectations of both the audience and client.

Digital/Interactive Producer

Depending on the context, the digital producer role may also be assigned the title of interactive producer, multimedia producer, web producer, or online producer, but the primary responsibilities are similar. This includes the coordination, supervision, and strategic development of digital products and services from concept to completion. The digital producer creates, develops, deploys, and maintains Internet-related projects, such as interactive websites, digital campaigns, web and mobile applications,

online video and other media. Some of the core responsibilities of a digital producer are similar to those of a traditional television producer, such as developing a creative brief, keeping a project on time and on budget, managing a diverse team, maintaining client relations, and assessing the project performance. Collaboration with both creative and technical teams made up of developers, designers, and content strategists is unique to the digital producer role, as well as being familiar themselves with the relevant tools and technology.

Social Media/Digital Content Producer

A social media producer or digital content producer develops and distributes appropriate and timely content through various social media platforms and websites. Social media teams are sometimes on the smaller side, often residing within a marketing department, and therefore may have somewhat limited resources, suggesting that the producer become their own technical advocate and gain familiarity with the nuances of the different platforms. Social media producers may work with both written and visual content, including video, photography, animation, and graphic design. They develop and execute multi-platform social campaigns planning strategic distribution schedules across the different channels. Producers are also responsible for tracking and measuring the success of a campaign, providing metrics to assess the success or failure of the project. Web platforms and audiences are constantly evolving; therefore, a social media producer needs to keep their finger on the pulse, seeking appropriate and trending new channels, new apps to measure engagement, and new ways of producing content.

Transmedia Producer

This person is responsible for a significant portion of a transmedia project experience. This ranges from the story creation, planning, and development, to the production and translation of narrative continuity across multiple platforms. Possible integrated platforms could include film, TV, Internet, comics, mobile devices, and so on. They develop interactive methods to engage the audience with the narrative on various platforms at different points in the roll-out strategy. Transmedia producers may be brought in at the beginning or in the middle of a long-term project to help analyze and facilitate the life of the project.

Mobile Producer

This role is assigned to a person completely responsible for the life-cycle of a mobile production. They typically develop the concept for the production, select the writing staff, secure the financing, and supervise the development, all with the knowledge of what's best suited for a mobile platform. Much like other producer roles, during pre-production they assemble the key members of the creative and technical team, participate in vendor selection, and approve the script, schedule, and budget. During production and post-production, they will supervise and provide consultation for daily operations, while serving as point person for financing, distribution, and marketing.

On a Human Level. . .

As the producer, you are at the core of a project. You encourage collaboration and provide strong and balanced leadership. You know when to step back and let people do their job. You model patience, humor, and a clear vision of the project, supplying creative direction while balancing the pressures of the budget. You are generous with your flexibility and encouragement, while staying connected to the realities of the budget

and time constraints. In spite of the long hours and often grueling situations, you're focused and relaxed—or at least you appear to be.

SUMMARY

A good producer knows about the elements of producing. He or she might also be talented as a writer, director, or editor. As a storyteller, an entrepreneur, a risk taker, a producer has strong leadership skills and works well with a team. Another sure sign of a skilled producer is an understanding of the larger context of television and its offshoots, including its past history, current status, and future potential. You'll learn about all three in the following chapter.

REVIEW QUESTIONS

1. How do producers in TV and emerging media differ from film producers?
2. List three important skills and traits of a good producer. Explain why each is helpful.
3. List one role the producer plays in each of the five stages of a project's development.
4. Define "clout" in producers' terms.
5. What does the line producer do? How is this job different from other producing titles?
6. List two reasons why "owning" your emotions can help in managing conflicts.
7. What areas of producing might be impacted by a failure of leadership? A failure of ethics?
8. Define three learning styles outlined in the Learning Styles section that best describe your own, and give examples.
9. How can delegation skills contribute to the execution of a project?
10. What have you learned so far about being a producer? Has it affected your interest in producing?

CHAPTER 2

Television: Its Past, Present, and Future

THIS CHAPTER'S TALKING POINTS

I Television Is a Unique Medium

II How Television Works

III The Impact of Human Vision on Television

IV The Creators of Television

V Television's Evolution

VI Television's Transitions: From the 1920s to the Present

VII Television Merges With Emerging Media

I. TELEVISION IS A UNIQUE MEDIUM

> Television is our culture's principal mode of knowing about itself
>
> **Neil Postman,** *Amusing Ourselves to Death*

Television wields an undeniable impact on the lives of literally billions of people around the globe. Clearly, it influences how we view and shape our culture, an influence that can be very positive or deeply distressing. Until the Internet reached a saturation point, media historians would have been hard-pressed to name another medium of equal importance—the printing press, perhaps, though printed matter was limited to those few elite who could read and write. Morse code, the telephone, the radio, the cinema—each medium incorporates and improves upon what preceded it.

Television arguably embodies a compilation of the best of these earlier media—access, affordability, interactivity, the aesthetics of film's look and sound, the imagination of radio, the reach of the telegraph. The content range is diverse enough to appeal to any viewer; the technology constantly improves upon itself; and its fiscal viability attracts all aspects of commerce—in short, TV rules.

TV is more everywhere than ever before. It's accessible in the remotest areas—just bring a simple generator and a portable satellite dish into an isolated village, for example, and suddenly the world opens up for people who have had little exposure to the outside world and fewer educational opportunities. Television in urban settings offers hundreds of channel options; it commands a place in corporate boardrooms, classroom discussions, and hospital operating rooms—the venues are endless. Now any location with access to the Internet also has access to thousands of hours of television programming.

Since the 1950s, television has been recognized as the primary global catalyst for social and political dialogue; its convergence with the Internet and other venues compound its potential as an agent for change. And ever-lowering costs of digital technology and ease of use have had a visceral impact on how we learn and communicate.

Virtually every American home has at least one TV set, and more than 40 percent of Americans own three or more. Now, people around the world can also "watch TV" on their laptops, iPods, mobile devices, and gaming devices, and the list of gadgets keeps growing. This transferal of delivery systems on which we can watch TV is referred to as "place shifting." We have shifted from just watching our TV set at home to now seeing whole episodes of our favorite series on our computer, or webisodes on our mobiles, or news and weather in a taxicab TV or on iPods, or a game console. It's a whole new game.

But television itself still lives primarily at home base. It is a facet of our day-to-day lives that we can enjoy alone or with a group. We can plan parties around it or ignore it completely. Its presence in the background feels like a source of human contact, another member of the family: familiar, frustrating, inspirational, somehow comforting. With its combination of intimacy and immediacy, television is, for many of us, a primary connection with the world.

TV provides us with a unique environment in which to entertain ourselves. We can choose from hundreds of options on our media menu: from drama to comedy, endless movies, from sports to news to do-it-yourself. We may get this content via transmission towers, cable, satellite, and now cyberspace. The quality and production values of what we watch can vary from superior to truly mediocre, but the choices are ours to make, and for the producer, this flexibility creates vast opportunities.

In the past, a viewer was captive to the clock: if a favorite show aired at 9 p.m., the viewer rushed to the couch to catch the show before it began. This was "appointment viewing"—keeping track of what favorite shows were airing and on what channel, day, and time, then having to be there at that exact time.

Now place shifting and time shifting are creating real waves of excitement, as well as gloomy moments of uncertainty. We can no longer depend on the traditional business model of television that focused primarily on the confluence of ratings and advertising dollars. As television and emerging media expand their reach, and run parallel and even converge, these old models of commerce and creativity are radically changing.

Yet the new models of success have short track records, and most remain speculative. Will television remain the same, with the pluses of interactivity? Or, will TV somehow morph into solely Internet, with TV-quality content? How will it become financially viable? What is the new advertising matrix? Will the novelty simply wear off after a while, with just one or two victors?

Television provokes contention and controversy. Its critics argue that the full potential of television as the great communicator may never be reached, or that the fiscal control that media conglomerates hold over television programming prevents objective news reporting, or that entertainment programs pander to the lowest common denominator. Ultimately, the validity of these arguments rests on the shoulders of the producer with the skills and the passion to put these criticisms to rest.

II. THE IMPACT OF HUMAN VISION ON TELEVISION

Watching TV—how complicated is that? You'd be surprised. Watching TV involves several steps. First, as we look at an image on the screen, this picture stays imprinted

on our retina for just a fraction of a second. This phenomenon is known as *persistence of vision*; as we watch a sequence of rapid images at the right speed (30 frames a second for video, as compared to 24 frames a second for film), an illusion is created of a complete and uninterrupted picture.

Aspect Ratios: 4:3 Versus 16:9

Since 1941, standard American TV sets were designed to display an *aspect ratio* of 4:3, with its familiar almost-square shape that is a bit wider than it is tall. More recently, *high-definition television* (HDTV) has vastly improved our enjoyment of viewing television. An HDTV set has a larger aspect ratio of 16:9 that better accommodates the way our eyes naturally see an image. With HDTV, we see more of what is in our field of vision. It gives the image a finer resolution, with more clarity of detail and about twice as many pixels and lines (1,080) as traditional NTSC images.

Regardless of how or where we watch it, television is firmly established as part of our daily culture. TV is no longer confined to the living room; now, it's in the office, the supermarket, dentists' and doctors' offices, a bank line, on airplanes, on trains, and in New York City taxis. In order to really explore this phenomenon called television, let us visit its rich and tumultuous history.

III. THE CREATORS OF TELEVISION

If it weren't for Philo T. Farnsworth, the inventor of television, we'd still be eating frozen radio dinners.

Johnny Carson

The Battle Over Television's Paternity

When we explore television's first wobbly steps, determining the "truth" of its ancestry can be as fuzzy as its first broadcast images of Felix the Cat. For instance, there is the question perennially debated by TV historians and aficionados: Who can legitimately claim the title of the Father of Television? These are the primary contenders:

- In 1884, German engineer **Paul Nipkow** designed the primary component of early mechanical television systems called the *scanning disk*. The disk was punched with holes that created a spiral from the outside into the center, and each hole vertically scanned one line of an image. Each line was then transmitted to a selenium cell, transferred to an electronic signal, and recreated in the receiver by a similar disk. Nipkow called his early conceptual design an "electric telescope," although he never actually built the device itself.
- In 1897, German physicist **Karl Braun** invented the first cathode-ray tube, which forms the basis of most modern TV sets.
- Russian **Boris Rosing** was also exploring the cathode-ray tube by 1906. He has been credited with discovering the theory for electronic television via wireless transmission in 1911 by using the Braun tube and the research of other scientists and engineers. One of Rosing's students was **Vladimir Zworykin**, with whom Rosing created "very crude images" and whose work would be integral to the advancement of television.
- Often called the pioneer of mechanical television, **John Logie Baird** was a Scottish entrepreneur with an engineering background who was the first to transmit a moving image using a mechanical television system in 1925. His public showing of "television" in Selfridge's department store in London was viewed as only blurry silhouettes. Three years later, Baird had so improved his system that the BBC (British Broadcasting System) adopted it for the broadcast of

experimental programs. By 1930, the British public could either buy Baird kits or ready-made TV sets to receive these broadcasts.

- Widely crowned as the "true" father of electronic television, American **Philo T. Farnsworth** was a Mormon teenager who conceptualized the technology of television while plowing his rural fields. By the age of 21, Farnsworth had designed the first all-electronic television system, patenting it in 1927 and holding its public premiere in 1928, broadcasting a short film. His "Image Dissector" camera pickup tube recorded moving images that were coded through radio waves, then reconfigured back into a picture on a screen. Farnsworth's invention in tandem with Zworykin's "Iconoscope" (see later) combined to create all-electronic broadcasting in 1939, although bitter litigation between the Radio Corporation of America (RCA) and Farnsworth's company historically has eclipsed his essential contributions to television.
- Another contender for the title was **Charles Francis Jenkins**, whose wealth and intelligence enabled him to develop "radio movies to be broadcast for entertainment in the home." In 1925, he broadcast a toy windmill as a moving silhouette over a five-mile distance to Washington, D.C. His "Radiovision" depended on Nipkow's scanning disk as its basis.
- **Vladimir Zworykin** was a highly educated Russian immigrant whose research was financed by the powerful RCA and who is often credited with the Father of Television title over Farnsworth. His research contributed to RCA's domination of the infant television market by first manufacturing TV sets, then setting up the National Broadcasting Company (NBC) to provide programming that could be viewed on these TVs. Zworykin's efforts resulted in the *Iconoscope*, an early electronic camera tube that he patented in 1923, as well as an all-electronic TV receiver that utilized a picture tube, called a *kinescope*.

The work of these early inventors and scientists clearly shows television to be the result of continuous experimentation, labor, and the passion for realizing their vision of "distance seeing." Yet, the possibility of communicating ideas via images has intrigued thinkers throughout human history. In ancient Greece, Aristotle was convinced that we were surrounded by invisible particles that combined to form images of matter. He was unable to prove his own theory, yet this vision has propelled over two millennia of experimentation, and television stands as one concrete actualization of Aristotle's curiosity.

Today, the programs that we watch seem effortless in their execution—the acting and writing and image and sound all appear seamless and easy to duplicate. We could write *this* show ourselves! How hard could it be to make a show like *that*? Yet the making of any program relies on a complex system of factors: a program needs a good story, and it needs producers, writers, directors, actors, and a complete crew. It requires money to finance it and time to complete it and hopefully a guarantee that it will air or reach the desired end user. A TV show depends on camera and audio equipment to record the image and the audio, and then it relies on technology to transmit the picture and sound. It must have satellites, cable, electricity, and hundreds of other components to complete the broadcasting process.

This broadcasting process that we viewers take for granted has been the result of the labors of some extraordinary and driven people, as you'll see in the next section.

IV. TELEVISION'S EVOLUTION

As far as I'm concerned, you can't say you love a field and not have any interest in its history, its evolution, its mistakes, and its accomplishments.

> You can't be cutting edge or do anything new if you don't know what came before. You have to be curious about how things worked years ago, how they work in other countries, what traditions and formats were used and why. Being informed is being serious about what you are doing
>
> **Sheril Antonio, excerpt from interview in Chapter 11**

Guglielmo Marconi played a key role in the invention of television. A bright and wealthy Italian inventor, Marconi discovered a method of transmitting Morse code over limited distances by using electromagnetic waves. In 1896, Marconi's "wireless" telegraph crossed the globe soon after he first telegraphed the letter S, in Morse code, across the Atlantic Ocean, over 2,000 miles away; he claimed responsibility for *the broadcast*—a transmission of sound waves that could move in all directions, follow the earth's curvature, and be picked up by a receiver on the other end.

An ambitious young Russian immigrant named **David Sarnoff**, who worked as an office boy at Marconi's company, astutely realized the potential of Marconi's growing company. Taking engineering classes at night, Sarnoff quickly mastered this new technology; in just a few years, he became a governing force at RCA and is now known as one of the founding fathers of NBC.

The dawn of the twentieth century ushered in the concept of "distance vision" at the 1900 World's Fair in Paris. During the First International Congress of Electricity, a Russian named **Constantin Perskyi** was the first person known to bring the word "television" into the public's consciousness. This dim concept was already taking root in the minds of other inventors and scientists around the globe.

Early Television and Commerce

> Television was the most revolutionary event of the century. Its importance was in a class with the discovery of gunpowder and the invention of the printing press, which changed the human condition for centuries afterward.
>
> **Russell Baker**

In America, the television industry began with the radio. At the end of World War I, General Electric joined forces with three powerful companies—AT&T, Westinghouse, and United Fruit—to form a company known as the Radio Corporation of America, or RCA. As the popularity of radio took hold worldwide, the initial goal of the alliance was to manufacture and sell radio receiver sets. Although the original company eventually unraveled, RCA survived as an independent company.

In 1926, the National Broadcasting Company (NBC) became a wholly owned subsidiary of RCA. The overwhelming popularity of the NBC radio audience soon necessitated a second radio network; the two networks were soon dubbed NBC-Red and NBC-Blue. By the early 1930s, RCA was gathering more resources and power with its manufacture of radios and two networks of radio programming along with a growing number of national stations. More significantly, RCA controlled the talent contracts of the most popular radio stars, writers, and producers of the era. NBC ruled the airwaves. Yet as NBC gained supremacy, Columbia Phonograph Broadcasting System (CBS) was formed. Now NBC and CBS were rivals, and the concept of network competition was born.

Television was taking hold in other countries as well, most significantly in the United Kingdom and Germany. In 1925, both John Logie Baird in London and American Charles Jenkins held public demonstrations of television. By 1929, Baird Television

Ltd. (via the BBC) transmitted primitive images through mechanical television, scanning a scant 30 lines. That same year in Berlin and Potsdam, Germany, Fernsehsender Paul Nipkow experimented with transmitting pictures, and eventually broadcast from 1935 until 1944.

V. TELEVISION'S TRANSITIONS: FROM THE 1920S TO THE PRESENT

Television began as a TV set, the product of technology; the entertainment and programs followed later. In labs around the globe, talented scientists, engineers, and inventors were driven by their vision and passion to design components that would ultimately be brought together as television.

Television's Early Systems: Mechanical Versus Electronic Television (the 1920s)

Television: Greek (*tele*, far) and Latin (*video, videre*, I see) = Far I see

Early television was primitive, with limited audio and an image that was small and blurred; transmission was erratic at best. It was based on a *mechanical* system with a rotating scanning disk as its basis. An image was first scanned mechanically, then transmitted mechanically. The transmitted image was received on a set—again, mechanically. The design for the scanning disk had been invented by Paul Nipkow 40 years earlier and became the foundation for other mechanical television systems being explored by inventors like Baird, Jenkins, and others.

Charles Francis Jenkins successfully transmitted an image that was mechanically scanned in 1925, the same year that **John Logie Baird** transmitted pictures in his lab. Two years later, **Dr. Herbert Ives** of Bell Telephone Labs introduced his television research program by transmitting an image of a tap dancer on top of a New York skyscraper, which was carried through phone wires.

Another engineer, **Dr. E. F. W. Alexanderson**, demonstrated a television system that operated on revolving mirrors; in 1928, his first regular broadcasts on W2XB began in Schenectady, New York. Unfortunately, very few people owned the Alexanderson TV sets that were necessary to watch the telecasts. That same year, Baird Television proclaimed the first all-mechanical television system, in color. This system appeared to be satisfactory at the time; it would be several years before investors would fund research for a better way to capture, transmit, and receive an image by using electronics and moving away from the cumbersome mechanical system.

By the end of the 1920s, there were at least 15 experimental television stations in America that transmitted limited programming via the mechanical television system. In fact, all television stations in America were called experimental until a commercial licensing system began in 1941. But when the crash of Wall Street in 1929 devastated the country, most research into television came to a dead halt.

Although groups of engineers and scientists continued trying to refine the mechanical television, research into *electronic TV* was energizing television technology. The basis for this new all-electronic system was the cathode-ray tube, originally explored by early inventors such as **Boris Rosing** in Russia and **A. A. Campbell-Swinton** in England.

Ultimately, it was **Philo T. Farnsworth**'s extensive work with his Image Dissector, along with **Vladimir Zworykin**'s Iconoscope, that converged as the genesis of modern

television. Millions of research dollars were invested by RCA; with the entrepreneurial genius of **David Sarnoff** behind it, RCA victoriously developed a television system that was powered by electricity. By the late 1930s, both the camera and the receiving TV set were electronic, making mechanical television a thing of the past. The first all-electronic TV set had a 14-inch tube and was manufactured by DuMont in 1938. It was called "The Clifton."

Although television could now be transmitted and viewed in a few limited areas in America and England, radio continued growing in popularity; television was barely a speck on the public's horizon. Live radio shows and their beloved stars were wildly popular; as a business venture, radio was inexpensive to produce, transmit, and receive. Television was still considered a speculative venture. Its costs were high: TV facilities had to be built and programs written, cast, produced, and paid for. TV sets were not only expensive, they were hard to find, and only limited programming was available for viewers.

Yet the *idea* of television was thrilling: an image could actually come into our homes—no longer were we limited to the movie theater. Television was like radio, but with a picture. This TV ideal was offset by its primitive reality. The images were blurry, the audio was scratchy, and the picture barely visible on available two- or three-inch screens. Many sets even came equipped with an attached magnifying screen.

In 1928, NBC's experimental TV station—W2XBS, which later became WNBC—debuted with its broadcast of a blurred image of Felix the Cat, made of papier-mâché, rotating on a slow turntable. CBS followed a year later with what could generously be called the first television "spectacular," which featured George Gershwin playing the piano, New York mayor Jimmy Walker, and singer Kate Smith. But television continued to be cynically regarded by most Americans as just a passing fancy.

Television's Experimental Steps (the 1930s)

> Television is the newest and most controversial wonder child of modern science and industrial ingenuity, and because it appeals to both the eye and ear simultaneously, television may make the greatest possible impression on the human mind
>
> **Eleanor Roosevelt**

On the other side of the Atlantic, television was making similar inroads. In 1930, John Logie Baird installed a television set in the prime minister's official residence to premiere *The Man With a Flower in His Mouth*, Britain's first TV drama. TV in the United Kingdom had its official launch in August 1932 with the beginning of BBC One when Baird's company merged with the BBC, although Baird TV had begun regular transmissions three years before using BBC transmitters. A television revue called *Looking In* was broadcast in 1933 by the BBC, although as in America, the limited scan lines made the image a chore to watch. But Baird and the BBC continued their efforts. In 1936, regularly scheduled programs were being transmitted from Alexandra Palace in London to less than a thousand people in the immediate vicinity. Even though by 1939 TV viewership had grown to almost 40,000 homes, the escalation of World War II forced broadcasters to shut down operations for several years.

In other parts of Europe, Germany and France began limited broadcasting in the 1930s. German television began as electromechanical broadcasts in 1929 but transmitted without sound for five more years. And France's first official channel debuted in 1935 at a primitive 60 lines, though by the end of the year, the channel was broadcasting from the Eiffel Tower in 180 lines. The tower's transmitter was sabotaged, and

French television was subsequently seized by the German occupying forces in 1940. The Germans' 441-line system merged with Vichy radio, resulting in the formation of Fernsehsender Paris; it resumed limited programming until August 1944, when both Paris and its television channel were liberated by the Americans.

In Canada, the Canadian Broadcasting Corporation (CBC) was formalized in 1936, eventually adopting the NTSC 525-line standard of its American neighbors. It was not until 1952, however, that the CBC began television broadcasting; its Montreal station transmitted in both French and English, and its Toronto flagship station in English.

Elsewhere around the globe, other countries were making their own approaches into the myriad possibilities of television: Poland, in 1937, was still convinced that mechanical television was the route to take, and by then, France had switched over to an electronic system. A year later, the Soviet Union began limited transmissions; by 1939, Japan, Italy, and Poland were all broadcasting primitive pictures using the all-electronic system. Mechanical television was officially obsolete.

Behind the scenes in the United States, the government was reviewing the technical advances and the ethical ramifications of both radio and television. They measured their effects not only on the public but also on business. In 1934, Congress established the Federal Communications Commission (FCC), whose purpose was to patrol the airwaves with the understanding that because the airwaves were essentially owned by the public, all private businesses that controlled and owned radio and television stations must be regulated and issued licenses in order to use these airwaves for profit.

A landmark breakthrough came in 1936 with the introduction of coaxial cable. This transmission device was constructed of a hollow tube enclosing wires that transmitted electrical impulses of different frequencies without combining them. This prompted the FCC to create the NTSC (the National Television System Committee). Comprised primarily of engineers, the NTSC researched and recommended a comprehensive set of standards for electronic television that was adopted in 1941; the majority of these original guidelines are still in effect today.

As it had with radio, RCA expanded its energies into building and selling television receivers, or TV sets, and then created programming that consumers could watch on the sets they purchased. The theme of the 1939 World's Fair in New York City was "The World of Tomorrow," and it was an ideal forum for NBC to be the first network to broadcast a head of state, President Franklin D. Roosevelt. Although television had been pushed into the background by radio for over a decade, the World's Fair provided RCA with a promotional spotlight that planted the desire for television firmly in the country's consciousness.

Television in the Trenches (the 1940s)

> I believe television is going to be the test of the modern world, and that in this new opportunity to see beyond the range of our vision, we shall discover a new and unbearable disturbance of the modern peace, or a saving radiance in the sky. We shall stand or fall by television—of that I am quite sure.
>
> **E. B. White**

While the war in Europe was intensifying and dominated everyone's attentions, people stayed glued to their radios; it ruled every waking hour and connected Americans to the battlefields with an urgency that diminished research into television. Increased

war efforts forced TV stations to make cutbacks in spite of early hopes for television's advancement.

In 1941, the Federal Communications Commission sanctioned the broadcast of commercials on television, but soon were forced to reduce commercial TV's air time from 15 hours a week to four hours. At the time, stations primarily transmitted sports events, news and live theater, as well as war-related information and training. There were fewer broadcasts as employees went to fight in the war, and available programming was reduced drastically; many stations stopped transmission altogether. Even manufacture of TV and radio sets was halted from 1942 until 1945.

Radio still ruled the airwaves. NBC had become so popular that the company was forced by the FCC to divide its extensive radio shows (and limited experimental TV programming) into two networks, the Blue and the Red. The Blue network transmitted programs that were more cultural in content, like drama, music, and thoughtful commentary, whereas the Red network favored entertainment and comedy. Eventually, almost 250 stations across the country received programs on NBC's two networks. Fearing the possibility of a monopoly, the FCC ruled that one company could no longer own more than one network. RCA was forced to sell its Blue network in 1943, and shortly after its sale, it was renamed the Blue Network Inc. A year later, it became the American Broadcast Company (ABC) but would not be seen as a viable television network until the late 1940s.

In 1941 both CBS and NBC officially became what we now call "commercial television," replacing their former titles of "experimental" stations and allowing the broadcast of TV commercials. Television advertising was born when Bulova watches produced the first TV commercial. But these sets weren't cheap. In 1941, a brand-new four-door Chevy sold for $895, and an 8" × 10" RCA set cost $395.

The fledgling DuMont Television Network had also begun limited broadcasting, and by 1942, it was one of the few sources for TV programming as the Big Three (RCA, ABC, and CBS) cut back. This innovative network from New York City, formalized as a network in 1946, was the creation of Dr. Allen B. DuMont, one of the original pioneers in electronic television who had premiered his innovative and high-quality TV set at the 1939 World's Fair alongside RCA.

DuMont was equally as creative in his programming directions as he was in his technological advancement of television sets. The DuMont Network was determined to provide comedy and entertainment for Americans that could help to combat the stress of war by introducing many of early television's legends, including the brilliant comedian Ernie Kovacs, ventriloquist Paul Winchell with his dummy/sidekick Jerry Mahoney, and Fred Waring's famous Glee Club. However, because the network had been forced to broadcast on a lower UHF frequency than the standard VHF, the growing popularity of the other three networks finally forced the DuMont Network off the air in 1956 after 10 memorable years.

Television After the War

Finally, World War II drew to a close. Research that had focused on television's potential benefit to the war efforts ultimately thrust the United States into the forefront of technology and creative programming. America's major competitors at the time were England and Germany, both of which essentially had stopped all research during the war years. American companies were exploring and refining color TV; CBS developed a color disk that could be placed over the black-and-white image. But ultimately it was

NBC that perfected the technical ability to make a TV set "compatible," meaning that a color broadcast could also be watched on a set that was a black-and-white receiver.

By the mid-1940s, the country's nine original commercial (nonexperimental) TV stations had expanded to 48 stations and in 1948, sales of TV sets had grown by over 500 percent. Most viewers, over one million of them, still watched TV in public places like bars, restaurants, and hotels, or in stores that sold TV sets. Shows like *Howdy Doody* and *Meet the Press*—the latter still broadcast today—debuted on NBC in 1947, and the first televised World Series was broadcast on both NBC and the DuMont Television Network.

As the chaos of the war settled down, television research reemerged in earnest in other parts of the world. In 1946, the Soviet Union launched commercial television, and Nicaragua became the first country in South America to transmit television. Three years later, Cuba became part of the global television broadcasting linkage in 1949. The BBC resumed broadcasting and rather than becoming a commercial entity, chose to charge all owners of TV sets a licensing fee. BBC broadcast the 1948 Summer Olympics and, a year later, premiered *Come Dancing*, which ultimately would have a 46-year run.

In spite of radio's ongoing popularity, it was clear that TV was rapidly catching up. It offered the additional sensory advantage of seeing images as well as hearing them, giving viewers the ability to watch and hear sports and dance and music in action, to experience news as it happened, the beauty of scenic locations, works of art, the facial expressions of an actor, the pratfalls of a comedian, and a politician's eyes.

TV played up radio's lack of visuals with the introduction of image-based shows such as *The Texaco Star Theater* with Milton Berle in the fall of 1948. "Uncle Miltie's" energy, unique humor, and famous guests revolutionized television programming and vastly expanded the number of people buying TV sets. At the time, the average cost of a television set was $500, though an average annual salary was less than $3,000. In 1946, only 10,000 TV sets were in use; by 1948, more than 400,000 homes in America had sets; and four years later, 19 million TV sets were in active use. By 1956, 85 percent of American homes had sets.

Television's Golden Age (the 1950s)

> **Recipe for an Average TV Program**
>
> 1 cup of Sponsor's Requirements—sift gently
> 2 tablespoons of Agency Ideas, carefully chilled
> Add ½-dozen Staff Suggestions, well-beaten. However fresh and flavorful, they will curdle when combined with Agency Ideas, so they must be beaten until stiff
> Stir together in a smoke-filled room and sprinkle generously with Salesmen's Gimmicks. Cover the mixture with a tight lid so that no Imagination can get in and no Gimmicks can get out, and let stand while the costs increase
> 1 jigger of Talent—domestic will do
> Flavor with:
> Production Problems
> A pinch of Doubt
> And, if you have any, a dash of Hope

> Fold ingredients carefully together so they can get into a small studio. This requires a very light touch as the slightest jolt will sour the results. Line the pan with Union Regulations—otherwise the mixture will stick. Place in oven with your fingers. Sometimes it comes out a tasty delicacy, and, sometimes, it's just cooked.
> **Mrs. A. Scott Bullitt, President of King Broadcasting Co.,
> in a speech given in 1952**

The 1950s justifiably has been called the Golden Age of Television—in retrospect, that phrase is almost an understatement. It was a magical time in television's transition from scratchy images and wispy potential to a solid undeniable force.

On the heels of Milton Berle's show, which ran until 1956, came Sid Caesar and *Your Show of Shows*, a 90-minute weekly comedy show that featured groundbreaking humor, clever writing, satire, sketches, and acting. Although its final episode was broadcast in 1954, its influence has rippled indelibly through eras of television humor in shows like *Rowan and Martin's Laugh-In* and *Saturday Night Live* decades later.

Ed Sullivan was a rather stiff master of ceremonies with a dry delivery, yet his early show, *Toast of the Town*, and later, *The Ed Sullivan Show*, made entertainment legends of young talent such as Dean Martin and Jerry Lewis, Elvis Presley, Ingrid Bergman, and the Beatles.

The Birth of Madison Avenue

Advertisers recognized television's value as a marketplace with which to sell products. As they began to invest their revenues in the creative aspects of this new medium, the technical designers and engineers were keeping pace by building sound stages, facilities, and transmitters. Radio stations, fledgling television stations, and newspapers were lining up to buy TV licenses, while producers, directors, and writers were busy creating the next big show.

It was virgin territory for engaging personalities like Faye Emerson, Perry Como, Gene Autry, William Boyd, and hit shows like *The Lone Ranger*, *Hopalong Cassidy*, *Howdy Doody*, *Meet the Press*, John Cameron Swayze's *Camel Newsreel Theatre*, and *Kraft Television Theatre*, which aired on both NBC and ABC. Television's Golden Age had begun.

With the end of World War II, the economy essentially had recovered and stabilized, and television became so popular that magazines regularly featured articles on home decorating with the TV set as the centerpiece. The dining room table had been replaced by frozen dinners on a TV tray, and *TV Guide*, launched in 1953, was on the American coffee table.

The Era of Creative Drama and Breakthrough Comedy

TV producers and writers freely adapted their ideas from radio and traditional theater. For example, TV news consisted of the anchor simply reading the newspaper and news wire reports into camera, with none of the visuals and sound effects in today's news broadcasts. CBS and NBC created legendary dramatic television with innovative anthology programming such as *Kraft Television Theatre*, *Studio One*, *Playhouse 90*, *Philco TV Playhouse*, *General Electric Theater* (hosted by Ronald Reagan for eight

years), and *The United States Steel Hour*. By the mid-1950s, there were 14 live-drama series from which to choose. Early television was transmitted live, broadcast from the studio directly to the viewer with all its visible glitches and mistakes—there was no censoring capacity of a seven-second delay or possibility of a second take.

As programming boundaries expanded, television shows and the creative minds behind them got bolder. Brilliant young comedic minds like Ernie Kovacs and Sid Caesar wrote witty and irreverent material and used TV's technology to produce special effects that played with the material at hand. Television was moving away from simply adapting traditional radio formats to creating innovative programming concepts that were tailor-made for TV broadcast.

Yet with all its creative departures, the technical limitations of live broadcast prevented the production and transmission of a show from any location other than television studios in New York City. This changed with the introduction of videotape in 1956; it allowed programs first to be taped, edited, then broadcast from a wider range of locations, and viewers experienced much clearer sound and picture.

Videotape made it possible to record and archive programs; it was electronic, more flexible, and less expensive than film. Prior to videotape, the only way to record a broadcast had been to place a film camera in front of a television set and actually film the live broadcast. The result was called a *kinescope*. The first broadcast use of videotape was a segment in color on the eccentric, taboo-breaking *Jonathan Winters Show*.

The Wide Reach of Cable

Coaxial cable, which originally had connected only New York and Philadelphia, eventually worked its way to the West Coast. Its cross-country completion was celebrated in the fall of 1951. NBC could now broadcast coast-to-coast over its 61 stations. The same year, the first experimental color TV transmissions were attempted, but they failed because black-and-white sets still couldn't pick up shows that were transmitted in color. Although CBS had developed a color disk that could be placed over the black-and-white image, it was NBC who ultimately perfected the technical ability to make a TV set compatible, making NBC synonymous with "compatible color."

The creative borders of television continued to expand, as the dramatic long-form productions gradually took a back seat to shows like Jackie Gleason's *The Honeymooners* and *I Love Lucy* with Lucille Ball and Desi Arnaz. These shows captivated viewers with their familiar and lovable ongoing characters. *I Love Lucy* was also the first show to have "repeats," introducing the lucrative concept of *syndication*, where repeats of a program could be sold and rerun on various stations. By 1960, only one of the original drama series was still broadcasting, as the sitcom genre dominated the airwaves.

Quiz shows were another popular genre in the 1950s. Shows like *Twenty-One*, *Tic Tac Dough*, *The Big Surprise*, *You Bet Your Life* with Groucho Marx, *What's My Line?* and *The $64,000 Question* swept the ratings, as Americans enthusiastically played along with the contestants. Then, a contestant on *Twenty-One* admitted to being provided with the answers to the questions. The genre was permanently tainted and mutated to milder shows such as *Queen for a Day* and *Let's Make a Deal*. As an antidote to the scandal, strict FCC regulations were put in place that are still enforced on similar shows today.

The FCC Steps In

The overall technology of television was getting more sophisticated and significantly cheaper. As the sales of TV sets flourished, movie theaters and the Hollywood studio

system felt threatened by this burgeoning medium. Television's explosive growth alarmed the FCC, too. The mounting technological sweep and TV's ethical questions hadn't been anticipated, and the establishment of monopolies was only a matter of time. In 1948, the government stopped issuing any additional broadcasting licenses. Instead, they focused their resources on harnessing the rapid expansion of television as a powerful business and cultural force to be reckoned with.

It took the FCC four years to draft and finally agree upon a statement of principles that would govern television and the standards by which it operated. In 1952, TV's political and electronic complexities were regulated by a set of guidelines that set new standards for flourishing areas of television, as well as for future media advances that then were only theoretical.

The FCC guidelines included the assignment of *very high frequency* (*VHF*) and *ultra-high frequency* (*UHF*) channels. These new standards for engineering and technology applications defined public service and educational programming, and dedicated certain channels to be used only for educational and public access. It took the FCC over a year to review the various color systems that were still experimental, finally agreeing on one color system that could be transmitted by all the networks and received by all color TV sets.

As television's popularity increased, its reach was still limited, so cable TV was launched in 1950 as an effort to provide television to homes in rural areas that were unable to receive broadcast signals because of their distance from major transmission towers. When cable TV finally provided the programming, television dealerships in these rural areas grew exponentially.

The Battle of the Big Three: NBC, CBS, and ABC

In 1951, the merger of ABC with United Paramount Theatres created a huge leap in creative programming that catapulted the young station into direct competition with NBC, CBS, and the renegade DuMont—who in the long run couldn't survive the competition and went off the air in 1956 after 10 years.

The remaining Big Three networks battled for domination, vying for advertising dollars, viewer ratings, and programming originality. This competition led to the development of the "network system" that included production services for writing and producing programs, sales, and distribution of these programs to the network affiliates as well as to their *Owned and Operated* (*O&O*) stations, and generating advertising dollars with which to subsidize the network.

Television's Early Influence on Politics

The first political TV ads had an explosive effect on television viewers and could well have changed the outcome of a national election. In 1952, presidential candidate Adlai Stevenson bought 18 half-hour time slots, hoping to get his political message across to the American people. But a half-hour proved to be way too long and tedious for most people to watch, and viewers got angry when his speeches interrupted their favorite shows. His rival, General Dwight D. Eisenhower, wisely made his TV ads short and sweet, brief 20-second spots that aired before or after popular shows like *I Love Lucy*. The sway of these ads is speculative, though Eisenhower did win the 1952 presidency.

It was during the 1952 political convention that the term "anchorman" was first used, describing Walter Cronkite's convention coverage for CBS. His intelligent and thoughtful observations on the political arena won him the title of "the most trusted man in

America." Cronkite's nightly broadcasts emphasized television as a source of trustworthy news and information for most Americans.

TV bore witness to another breed of politics called McCarthyism. The House Committee on Un-American Activities (HUAC) had begun their investigation of the film industry in 1947 as part of their sweep for "Communist infiltrators." This witch hunt soon spilled over into the television industry. Dozens of writers, producers, actors, and directors suspected of having left-wing tendencies were fired and blacklisted, preventing them from being employed anywhere. CBS required its employees to sign an oath of loyalty, yet it was that network's esteemed journalist, Edward R. Murrow, who ultimately broke the back of McCarthyism. In 1954, Murrow exposed Senator Joseph McCarthy with the legendary quote: "His mistake has been to confuse dissent with disloyalty." Within months, McCarthy was censured by the U.S. Senate. Television had effectively ended his reign.

The Glitter of the Golden Age

The Golden Age of 1950s television saw the creation of *I Love Lucy* in 1951. This was the first sitcom shot with the now-standard three-camera setup, along with family shows such as *The Adventures of Ozzie and Harriet* and *Father Knows Best*. In 1952, Dave Garroway hosted the new *Today Show*, the first magazine-format program. One year later, *TV Guide* began publication. The country's first "adult western," *Gunsmoke*, began in 1955 and ran for 20 years. *The Mickey Mouse Club* put ABC on the map as a youth-oriented network in 1955. The teen hit of the decade was *The Many Loves of Dobie Gillis* with Warren Beatty and Tuesday Weld; and Rod Serling's sci-fi series, *The Twilight Zone*, aired from 1959 to 1964 on CBS—the first network to introduce 30-minute soap operas rather than the traditional 15-minute dramas; both *As the World Turns* and *The Edge of Night* began airing in 1956. *Broadway Open House* with Morey Amsterdam was the first late-night variety show, setting the stage for *The Tonight Show, Late Show With David Letterman*, and many others.

Television's International Expansion

Globally, television gained real momentum during the 1950s; the exposure to international culture and politics opened borders that previously had been ignored or closed. The establishment of television stations in Mexico and Brazil in 1950, and Argentina a year later, gave South America an international presence. European television in 1951 expanded to Denmark and the Netherlands, and TV transmission returned to Poland. In 1957, Portugal and Finland were transmitting programming, and by the end of the 1950s, more than 60 other countries would establish their own television broadcasting.

Canadian television adopted several aspects of American television when the Canadian Broadcasting Corporation (CBC) began transmission in 1952. It chose the U.S. NTSC standard of 525 lines, for example. Its first two stations premiered within two days of one another—one broadcasting in English only, the other in both French and English.

British television launched the BBC version of *What's My Line?* and premiered a delightful variety of original programs, from *The Flowerpot Men* and *Hancock's Half Hour* to *The Sky at Night, Quatermass and The Pit, Blue Peter, Grandstand*, and an adaptation of *1984*. The establishment of ITV brought commercial television to the United Kingdom in 1955, with *What the Papers Say*. And in 1953, over 20 million viewers in England alone joined the rest of the world as they watched the coronation of a young Elizabeth II.

The First Television Society (the 1960s)

By the 1960s, Americans had become the first television society. Both the subtle and overt influences of television visibly permeated the culture—over 90 percent of American homes had at least one television set. The three networks—NBC, CBS, and ABC—transmitted to around 200 affiliate stations, most in major metropolitan areas.

The networks produced the vast majority of their programming in their Los Angeles and New York studios, seldom subcontracting any productions out to independent producers or filmmakers. The network system included the program sponsor (soap products, automobiles, cigarettes) along with an advertising agency that created the commercials designed to sell these sponsors' products.

By 1960, there were 640 *community antenna television* (*CATV*) systems that delivered all available channels from nearby metropolitan centers to more isolated areas. These fledgling independent and public television stations were new and inexperienced, and made little impact on the big networks that targeted their programming to a mass audience.

An Era of Firsts

The first television satellites to transmit transatlantic images in 1962—Relay and Telstar One—heralded a new kind of immediacy in news gathering, and delivered the news of the world to the world, like the assassination of President John F. Kennedy and the Vietnam War. Seven years later, more than 600 million people around the globe were transfixed as they saw the first TV transmission from the moon on July 20, 1969. People everywhere realized they could now be connected in real time, experiencing events as they happened.

In the United Kingdom, the BBC transmitted a diverse range of program offerings to its viewers, from game shows and soap operas to drama and innovative comedy. Known affectionately as "The Beeb" and "Auntie," the BBC had only one significant competitor, the commercial station ITV. The night that its sister station BBC2 was scheduled to be launched in 1964, a fire in a power station caused a citywide power failure and delayed the premiere by a day. The original BBC TV later became known as BBC1. Because BBC2 was the first British channel to use UHF and 625-line pictures, its picture delivered a much higher picture resolution than the previous VHF 405-line system.

British programming in the 1960s was innovative and memorable, reinventing some genres and creating others with shows such as *Monty Python's Flying Circus*, *Doctor Who*, *Top of the Pops*, and ITV's *Coronation Street* and *The Avengers*.

Television as a New Business Model

Globally as well as in America, the television industry attracted producers, writers, directors, and actors who had previously worked only in film. There were many advantages to working in this medium: the exposure of TV was much wider than that of the average motion picture; millions of people watched TV regularly and seldom went to movies, and it was more cost-effective to produce programming for television than for film.

Particularly in Hollywood, the major film studios saw the potential of television as the next logical step for their films after a traditional theatrical release, and channeled money into building departments that could develop projects exclusively for TV. On Madison Avenue, advertising agencies had become a remarkable creative force,

funneling huge sums into creating television campaigns, slogans, and commercials for television.

It wasn't until 1964 that the FCC finally approved RCA's color system in America, opening the airwaves for broadcasting programs in bright, highly refined color. Although CBS had first originated the color system, RCA quickly flooded the market with black-and-white sets that could also receive programs (in black-and-white) that were broadcast in color. By the mid-1960s, NBC was producing the majority of its prime-time programs on color film.

Television's Technological Firsts

The 1960s produced some technical elements that we now take for granted:

- ***Electronic character-generator.*** Also known by its brand name of *chyron*, it could create opening and closing *credits* as well as superimpose words over a picture and *lower-thirds* that can spell out the speaker's name, occupation, and/or location under his or her picture on the screen.
- ***Slo-mo.*** The ability to first record a picture on videotape (say, of a baseball play), and then replay it in slow motion, repeatedly.
- ***Other equipment and technology***, such as color videotape machines, videotape cartridge systems, portable small cameras known as "mini-cams," and remote-controlled operation of radio and TV stations' transmitters.

Television Shapes the Political Landscape

The growing influence of television was incontrovertible. When a charismatic, articulate John F. Kennedy debated an unshaven and shifty-eyed Richard Nixon on television in 1960 in the "Great Debates," the disparity between the two men was obvious, magnified by a new special effect called a *split screen* used for the first time during the debates. Interestingly, audiences who only listened to the debates on the radio picked Nixon as the winner.

Television featured prominently in national tragedy as well. Almost every American, 96 percent of the population, and much of the world, mourned the death of JFK by watching his funeral on television after his assassination in 1963. Days later, when Kennedy's suspected assassin Lee Harvey Oswald was murdered on live television by Jack Ruby, its stark immediacy stunned the world.

TV Reveals the Horrors of War

The Vietnam War was the first war we watched almost as it was being waged. The first satellite link to Asia revealed the harsh truths of the front lines and fanned the flames of American and global dissension. When CBS aired a report that exposed the cruelty of a group of U.S. Marines in a Vietnam village, President Lyndon Johnson angrily attacked the network as being unpatriotic. In a brave counterattack, Walter Cronkite produced a documentary in 1968 on the state of the war, saying: "It is increasingly clear to this reporter that the only rational way out will be to negotiate." A defeated President Johnson reportedly said, "If I've lost Cronkite, I've lost middle America."

TV Boldly Reaches Out

The relevance of the TV documentary broke new ground in the 1960s, with intelligent and courageous exploration of issues from civil rights to communism. One memorable example was NBC's *The Tunnel*, the filmed escape of East German refugees who had carved tunnels under the Berlin Wall. Other 1960s highlights included the debut of

ABC's *General Hospital* in 1963 and rival soap *Days of Our Lives* on NBC in 1965. The Beatles made their legendary first appearance on *The Ed Sullivan Show* in 1964, and a year later, Bill Cosby became the first African-American actor to costar in a continuing drama, *I Spy*.

Congress created PBS (the Public Broadcasting System) in 1967, which, two years later, debuted the iconic *Sesame Street* for children. In 1966, NBC became the first all-color network; it premiered the made-for-TV movie genre with shows like *Columbo*, *McMillan and Wife*, and *McCloud* that featured continuing lead characters. Humor got a needed boost with shows like *Rowan and Martin's Laugh-In*, *That Was the Week That Was*, and *The Smothers Brothers Comedy Hour*. Each reflected the chaotic era of the 1960s, using bold satire and irreverent wit that pulled no punches and challenged the censors.

Over the span of this decade, more than 70 countries established their own networks and transmission systems. Massive countries such as the People's Republic of China and smaller ones such as Haiti, Iceland, Israel, Ireland, and Uganda all now had access to the world around them.

Television in Transition (the 1970s)

I've always had a feeling that any time you can experiment, you ought to do it. Because you never know what will happen.

Walt Disney

In the wake of Woodstock and the Vietnam War, television grew bolder in the 1970s. Programs reflected the social and emotional changes of the Woodstock Generation, outspoken and outrageous. In 1970, the networks cancelled at least 30 series that had been hits in the 1960s and replaced them with a new approach to programming that was targeted directly to a younger audience.

All in the Family was the first prime-time sitcom to bring hotbed issues like racism, bigotry, and sexism into America's living rooms. *The Mary Tyler Moore Show* proved that a single professional woman could succeed on her own, addressing pertinent issues facing the working woman in the workforce. *Bridget Loves Bernie* was not only a forum for ethnic comedy, but it also showed its stars in the bedroom. *The Partridge Family* added popular music to the sitcom genre.

A new genre of programming emerged in prime-time drama, as viewers entered the professional and personal lives of doctors, lawyers, cops, and detectives in shows such as *Kojak*, *Starsky and Hutch*, *Baretta*, and *M*A*S*H*. The genre of the "super woman" forged new icons in the 1970s with *Charlie's Angels*, *Police Woman*, *Wonder Woman*, and *The Bionic Woman*. Their characters reflected the burgeoning woman's movement, as sitcoms *Laverne and Shirley* and *Phyllis* provided working women with a playful dimension of fun.

The 1970s ushered in a new level of immediacy in news reporting. Sony developed the Portapak video camera that revolutionized *electronic news gathering* (ENG) with its portability and low cost, and it combined with satellite relay and distribution systems to transmit footage directly to the news stations.

This decade also saw the emergence of cable channel services that offered more specialized *niche programming*: movies and specials on HBO, children's shows on Nickelodeon, live broadcasts from the House of Representatives on C-SPAN, sports on ESPN, and Ted Turner's "superstation," WTBS. Cable television became increasingly popular for specific events like baseball and basketball games and hockey in

areas with a loyal fan base. By 1971, New York cable, for example, had over 80,000 subscribers.

Television in the 1970s heralded such classics as *M*A*S*H*, which first aired in 1972 and ran for 11 years, and the mini-series *Roots*, which focused on African-Americans and their ancestors, attracting a record-breaking audience of 130 million viewers. PBS, created in 1967, unveiled unexpectedly popular hits such as *Upstairs Downstairs*, *Masterpiece Theatre*, *Nova*, *Crockett's Victory Garden*, and *The French Chef With Julia Child*. *Mork and Mindy* unveiled the whirlwind who was Robin Williams, and in 1979, *Knots Landing* brought the steaming sex and ongoing intrigue of daytime soap drama into prime time. *Saturday Night Live* and *The Phil Donohue Show* became programming models, actively relevant today. During this time the FCC ruled that shows broadcast during the Family Hour (7 to 9 p.m.) must be "wholesome" for family viewing.

Technology Marches Into the 1970s

Advancing technology resulted in a consumer-friendly *video cassette recorder* (*VCR*) in 1972, followed four years later by Sony's Betamax VCR (selling for about $1,300). By the next year, RCA had introduced a competitive standard, VHS, which eventually would dominate the market and push Betamax into obscurity. The improvements in fiber-optic cable in 1970—delivering 65,000 times more data than copper wire—vastly improved television delivery to American homes.

Although television by now was considered part of the everyday world, another 30 countries joined ranks and adapted broadcasting to their own transmission standards. Africa saw more of a media presence as stations were established, including those in South Africa, Tanzania, Lesotho, and Swaziland. The Middle East launched stations in Qatar, Bahrain, Oman, and Brunei among others. In Japan, the show *Abarembo Shogun* was launched, a series that would prove successful for 25 years.

Television was solidly an international mainstay, but most programming came from America or the United Kingdom. British audiences lost *Monty Python's Flying Circus* in 1974 but gained *Fawlty Towers* a year later. The range of BBC and ITV programs continued to expand with popular shows like *The Goodies*, *Open University*, *Last of the Summer Wine*, and *Grange Hill*.

Television Merges With Electronics (the 1980s)

Television! Teacher, mother, secret lover.

Homer Simpson, *The Simpsons*

With the widespread popularity of VCRs, viewers could now buy and rent movies, or record their favorite program on VHS tape and watch it at their leisure. Video stores popped up in every neighborhood with movies and video games to rent. This translated into the gradual evolution of television from a passive medium to a more aggressive, interactive device. The impact of the VCR was especially harsh on advertisers who grew apprehensive—now, viewers could completely tune out Madison Avenue's expensive commercials with a push of the fast-forward button.

Creatively, producers tuned into television's potential to reach an audience with innovative programming that was enhanced by special video effects, sophisticated video editing systems, and eye-pleasing uses of texts and fonts, moving logos, digitized backgrounds, page turns, multiple pictures on one screen, and layering pictures on top of one another. At first, the editing costs were high and time-consuming, but by the mid-1980s, these video effects became easier to produce and less costly.

The Impact on the Youth Market

Competition between the networks increased in the 1980s with the emergence of popular new cable outlets. Ted Turner founded the Cable News Network (CNN), an all-news channel, in 1980, and eight years later, Turner premiered TNT. Bravo was the first cable network dedicated to film and performing arts. In the fall of 1981, MTV went on the air with the defiant logo, "I want my MTV!" It was the first station specifically targeted to the growing youth culture, showcasing the new music video format, that promoted recording artists and their labels, and influenced the creation of programs like NBC's music-centric *Miami Vice*, airing in 1984.

The Expansion of Social Issues in Television

The smash hit of the 1980s featured an upper-middle-class African-American family, the Huxtables. *The Cosby Show* ran from 1984 to 1992, and like *All in the Family* a decade earlier, the show used humor to examine racial and gender differences, bigotry, values, and family dynamics. It not only brought NBC back to number one in the ratings, it ushered in an era of African-American sitcoms, like *A Different World*, *The Fresh Prince of Bel Air*, and *In Living Color*.

The Oprah Winfrey Show in 1986 became the first major talk show to be hosted by an African-American woman. And sitcoms with underlying cultural issues were ratings bonanzas—shows like *Roseanne*, *Saved by the Bell*, *Growing Pains*, *Three's Company*, *Who's the Boss*, *Facts of Life*, and *Diff'rent Strokes*. *Live Aid*'s 16-hour global satellite broadcast of musical artists and cultural icons raised millions of dollars for famine relief.

The theme of "independence" ran through the television industry in the 1980s. The birth of a fourth network called Fox Broadcasting Company challenged the iconic Big Three. Because of complex differences between its structure and that of ABC, CBS, and NBC, Fox was able to slide under the radar and create its own singular identity.

Independent production companies on both U.S. coasts broke away from programming stereotypes and developed episodic drama that was thought-provoking and examined real issues through dimensional characters and multilayered plotlines. Shows such as *Hill Street Blues*, *Cheers*, *St. Elsewhere*, *Cagney and Lacey*, and *L.A. Law* stunned and provoked audiences, and they paved the way for more intelligent and mature programming, along with higher network ratings.

Television competition in the United Kingdom heated up in the 1980s when Channel 4, Sky Television, and S4C joined the solid ranks of BBC1, BBC2, and ITV. *EastEnders* on BBC1 began in 1985, and *Doctor Who* ended after 26 years on the air in 1989. Both *Thomas the Tank Engine & Friends* and *The Bill* premiered on ITV in 1984.

Global television made inroads into lesser-known countries and territories in the 1980s. Vatican City, for example, started broadcasting in 1983, the same year as Andorra, Nepal, and the Seychelles. Another 20 stations were launched in areas such as Western Samoa, Belize, Burma, and South West Africa.

Television Moves Toward Digital Technology (the 1990s)

Cable and satellite gave people greater accessibility to global events happening in real time. In 1991, the world watched the Persian Gulf War unfold as America dropped "smart" bombs on Baghdad. Three years later, millions of viewers were riveted to cable news stations, watching the saga of O. J. Simpson—from the white Bronco freeway chase to the infamous final verdict.

The popularity of cable had a direct impact on the major networks as Fox and two new stations—UPN and the WB—reached wider and younger audiences in 1995, using improved cable technology and direct-broadcast satellite (DBS).

As competition grew between cable and networks, the focus of television programming became increasingly unconventional and volatile. Talk-show hosts such as Jerry Springer, Jenny Jones, Maury Povich, and Ricki Lake explored raw topics with confrontational guests and watched their ratings soar. Cable sex shows and adult cartoons were in sharp contrast to a more sophisticated crop of made-for-TV movies dealing with mature issues like changing family values, gender bias, AIDS, homosexuality, and domestic abuse.

In response to increased violence and sex on TV, the public and subsequently the government forced the broadcasting industry in 1996 to adopt a rating system for every show: TV-Y, TV-Y7, TV-G, TV-PG, and other ratings labels. Newer television sets were equipped with a V-chip, which could be programmed to block those programs the set owners thought were unsuitable.

The Potential of High Definition Television

The emphasis on *high definition television* (*HDTV*) grew substantially in the 1990s. The broadcasters saw that images transmitted in digital HDTV were sharper and clearer than traditional *standard definition television* (*SDTV*) transmitted by analog signals; HDTV sets were bigger, with a 16:9 rectangular shape, and more than twice the cost of SDTV sets.

The inevitability of HDTV was confirmed in 1997 when the U.S. government allotted $70 billion worth of broadcast spectrum to its TV broadcasters. This gave each broadcaster an extra channel to transmit programs in digital high definition along with their analog signals. The goal of totally phasing out SDTV broadcasting was originally set for 2006 (later extended to 2009), by which time all broadcasts would be totally digital. The mandate also required that after this cutoff date, all broadcasters must give back their original channels (extra broadcast spectrum) to the government.

As personal computers became more user-friendly and less expensive in the 1990s, the popularity of the Internet illustrated the potential of interconnectivity between computers and TV, creatively and economically. Experiments in digital audio and video, fiber optics, and HDTV moved from theory to actuality, and digital technology promised to energize the TV industry's future.

The Big Three Continue to Dominate

In the 1990s, NBC dominated the ratings with shows such as *The Cosby Show*, *Mad About You*, *Seinfeld*, *ER*, *Cheers*, *Friends*, *Veronica's Closet*, *Golden Girls*, and *Frasier*. CBS offered popular programming with *Murphy Brown*, *Murder She Wrote*, and *Everybody Loves Raymond*. And ABC aired popular shows like *Home Improvement*, *NFL Monday Night Football*, *The Practice*, *NYPD Blue*, *Who Wants to Be a Millionaire?* and *Roseanne*, which featured the first "gay kiss" on television.

Other shows like *Ellen* and *Will and Grace* challenged sexual stereotypes. Each major network had its own version of a news magazine—*Dateline* (NBC), *20/20* (ABC), and *60 Minutes* (CBS). PBS debuted *Charlie Rose*, and Bravo premiered *Inside the Actor's Studio*. Both became iconic classics and consequently targets of late-night comedians. The *X Files* and *Star Trek: Deep Space Nine* brought hard-core sci-fi fans back to television.

British television in the 1990s added Channel 5 to the growing roster of stations. Programs from the United Kingdom would eventually be adapted for U.S. and other international audiences, with shows like *Who Wants to Be a Millionaire?* In 1992, *Absolutely Fabulous* saw its debut on BBC One, and two years later, 20 million people tuned into the *National Lottery Live*.

The Transformation of Television in the Twenty-First Century (the 2000s)

Television in the dawn of the twenty-first century reflected the unimaginable reality of terrorism with the attacks of September 11, 2001, and in the weeks and months that followed. Cable and network news covered the ensuing wars in Afghanistan and Iraq, as well as the increase of international debate on the rights of America's involvement in world politics. News broadcasts relied more heavily on graphic elements and musical effects and added a running "ticker tape" below the anchors to cover additional news not included in the broadcast itself.

TV Gets Smarter, Funnier, and More Cynical

Comedy is a welcome relief in times of political crisis, and shows such as *Everybody Loves Raymond*, *Friends*, *Cheers*, *Frasier*, *Sex in the City*, *The Simpsons*, *Will and Grace*, and *Whose Line Is It Anyway?* appealed to all age groups. Episodic series such as *The West Wing*, *ER*, *Lost*, *Boston Public*, *NYPD Blue*, *Desperate Housewives*, and *24* continued to broaden political and cultural themes and storylines. HBO saw a dramatic increase in subscribers and in Emmy awards with *The Sopranos*, *Six Feet Under*, *Deadwood*, and an impressive roster of quality documentaries. Talk shows reached out to broader audiences and topics with *The View*, *The Rosie O'Donnell Show*, *Ellen DeGeneres*, *Sharon Osbourne*, *Oprah*, *Dr. Phil*, and *The Martha Stewart Show*.

Roughly 25 percent of American viewers under the age of 24 got their primary news and information from the satirical "fake news" show, *The Daily Show With Jon Stewart*. The lines between political parties blended and blurred with *The Colbert Report*, and Bill Maher and Dennis Miller continued their rants against the establishment. Social satire stayed alive and well with *South Park* and *Saturday Night Live*.

Children's television targeted diverse audiences with dimensional writing and production value on Nickelodeon, Noggin, and PBS with shows like *Zoboomafoo*, *Dora the Explorer*, *Zoom*, and *Sesame Street*. Advertisers were attracted to sponsor shows aimed at the growing market of "tweens," teens, and young adults with shows like *Buffy the Vampire Slayer*, *Ally McBeal*, *Hannah Montana*, *Gossip Girls*, *The Hills*, *Dawson's Creek*, *The O.C.*, *Felicity*, and *The Real World*. "Format" shows that started in other countries came to America, reconfigured as *American Idol*, *Survivor*, and *Big Brother*.

The Onslaught of Reality Programming

Arguably, the most influential and contested genre in the 21st century has been the reality show, also called unscripted programming. Shows such as *Trading Spaces*, *Dog Whisperer*, *The Apprentice*, *The Bachelor*, *American Idol*, *The Amazing Race*, *Survivor*, *Extreme Makeover: Home Edition*, and others have been ratings bonanzas. The seemingly global appeal of reality programming intrigues television scholars, and the considerably lower costs of producing these shows delights broadcasters. It has spawned several all-reality channels, and at least 250 reality shows have aired, are scheduled for air, or have left the airwaves in less than a decade.

The unparalleled success of the reality genre once again illustrates the power of the consumer. The TV viewer can be fickle and highly discerning, with tastes and loyalties that shift with each season. A program that feeds water-cooler conversation one week can be old news the next week, easily replaced with a better show. Networks give their shows only a limited time to succeed and cancel them if they don't perform well in their first few airings. Unlike the networks, cable and premium cable stations have more latitude in creating targeted programming that appeals to specific demographics and interests, though their budgets are lower. The changing horizons of television content in both broadcasting and "narrow casting" give producers new areas to explore in the future, and in many respects streamline the production process, giving producers increased power.

The Surge of Delivery Systems

Now, emerging media adds new dimensions of possibility: the delivery systems, programming ideas, technology advances, and changes in the ways this all gets paid for. In many parts of the world, for example, the Internet will take a while to catch up, whereas television is firmly established in their cultures.

One thing *is* clear about television's future: No one has a clue. Even the word "television" is now in question: Is watching a show on our computer or mobile device or game box the same as watching the identical show at home? Are all these experiences still called "watching TV"? Are Netflix and Hulu television? Is television defined by what mechanical device we watch it on, or by the show we're watching?

In fact, television currently exists in a convoluted state of excitement, panic, invention, uncertainty, and innovation, and its equilibrium is constantly shifting. Almost all American homes have at least one television set; most homes have two or more, and there are over two billion TV sets around the globe.

It's estimated that the average American consumes dozens of hours of media a week. We can watch hours of TV on our laptops, tablets, mobile devices, or game boxes; though TV sets are everywhere. In almost all parts of the civilized world, most countries have dozens, even hundreds of channels, received via cable, satellite, the Internet, or an antenna on the roof. Most international cities also offer programming through mobile devices, video on demand, pay per view, television on the Internet, and physical media.

And the technological momentum is only picking up speed. The merge of television, film, the Internet, and digital speed is coming together in dynamic ways that are both exhilarating and challenging to producers.

The traditional television business models of the movie studio system and the Top Three networks have essentially been replaced by consolidations between big business and film and television powerhouses, often called the *conglomerates*. Entertainment, news, and information content is voraciously demanded by, and fed to, the international markets, and the end result is a vast entertainment industry worth billions, in any currency.

The control by these few powerful conglomerates spreads over vast domains: from television stations and theme parks to movie studios, from newspapers to home video and publishing, from motion simulator rides to sophisticated video games and Internet networks. They're all connected through commerce, with real consequences on our expanding culture. The implications of the conglomerates' influence on the viewing public have sparked vigorous debates, and it is a vital subject for more exploration and study by a committed student of television.

VI. TELEVISION MERGES WITH EMERGING MEDIA

This is truly a golden age of content production (not sure we can even call a lot of it "television" anymore) and as the major studios form their own independent streaming units, like Disney, NBC, WB with HBO Max and the rest, there is more need for writers and producers than ever.

Mark Verheiden, excerpt from interview in Chapter 11

Television has traditionally involved watching our favorite programs at a specific time on a TV set in our homes. But traditional TV was *then*, and this is *now*, an era of time shifting, place shifting, and unique and varied content—thousands of programming hours are at our disposal.

Television is now controlled by the consumer. TV is totally flexible. It can be searched, manipulated, stored, and accessed at the viewer's whim. It is multichoice, able to be customized, and has almost total interactivity. It can be watched when and where the viewer chooses. The viewer is now in control.

The future of television relies in part on emerging trends in technology, but the primary function of television always comes down to storytelling. The stories it tells may range from the harsh reality of a news story to the narrative fiction of episodics and sitcoms; a compelling and engaging story will always trump technology, no matter how cool or revolutionary the handheld device, or gadget, or size of the screen.

The Transformative Trends in Television

Regardless of how good or bad the storytelling, digital technology is evolving at an exponential speed. What was considered visionary a year or two ago is, in some cases, already out of date. But as of the writing of the fourth edition of this book, we can look at technological advances that show real promise in transforming the horizons of television and emerging media.

Interactive TV (ITV)/SmartTV

Interactive TV is realized in one form known as a SmartTV, which is a device with built-in Internet access offering more advanced computing ability and connectivity than a basic television set. This can include online interactive media, user-generated content, "catch-up TV" (like Hulu), over-the-top content (like Netflix), as well as on-demand streaming media. The SmartTV has similar functionality to the Internet and applications that smartphones do, hence the title. It puts the power in the viewers' hands and allows them to search and find content like they would on a phone or a computer. They can search through a variety of content including movies, music, photos, and videos, through cloud storage or external hard drive, and still have complete access to television on a local cable TV channel, a satellite channel, or online.

Over-the-Top Content (OTT)

OTT is a form of video and audio online delivery, free of the Internet service provider controlling or distributing the content itself. As is the case with subscription-based streaming services like Netflix, Hulu, Amazon Prime, Disney+, and HBO Now, this type of content arrives from a third party. These services can be accessed via several platforms with Internet connectivity such as computers, tablets, phones, Blu-ray players, game consoles, and set-top boxes, such as Apple TV, Amazon Fire, or Roku. Most of these platforms allow for video on demand (VOD) and have time-shifting capabilities.

Digital Media Receiver (DMR)

This is a device that, by connecting to a home network and through the use of a helpful user interface, allows viewers to access, search, and browse a variety of digital media including video, music, and photos. This media can be accessed from a personal computer, other networked media servers, or cloud storage (virtualized online storage by a third party), and played back on the television. Popular devices include Apple TV, Roku, and Chromecast; and the same technology can be found in Xbox 360 and Playstation, Blu-ray players, and SmartTVs.

Video on Demand (VOD)

VOD is a system that gives its user a variety of ways in which to watch video, film, and user-generated content. It searches, selects, stores, and screens content, either by downloading it to a set top box to watch at the user's convenience, or by streaming it in real time. American VOD systems can also deliver content to computers and mobile devices, on demand and virtually instantaneously.

Digital Video Recorder (DVR)

DVRs and devices like TiVo allow the user to time shift. They can be programmed to record several programs, which are then stored on a hard drive so that the user can choose when to view them. DVR is generally combined with a digital TV service and can be accessed, played, rewound, and paused at will. DVRs also provide menus and guides that tell the viewer how to access a program and usually supply specific facts about each show, like actors, director, tag line, and other facts.

HTML5

HTML5 is the latest version of the hypertext markup language used for structuring and presenting content for the web. With HTML5, two new tags to the HTML standard language were added: the video and audio tags. This allowed for direct embedding of video and audio content into a web page, which allowed for much easier access across multiple browsers and platforms for the end user to watch and listen to media.

Advanced Video Coding (H.264/MPEG-4 AVC)

With faster broadband technology and the introduction of HTML5, and in effect the continuous growth of streaming video, good video compression has become essential to balancing the quality of the image and the time it takes to achieve that image. H.264/MPEG-4 AVC codec is one of the most common formats for video compression, recording, and distribution of high definition. It is known for being a standard codec for Blu-ray discs, streaming Internet services like YouTube, Vimeo, and iTunes, and HDTV broadcasts. This codec provides good video quality, compression, and speed. With continual advancements in technology, High Efficiency Video Coding (HVEC) has been designed as a successor to AVC, supporting 8K resolution and providing better data compression with the same level of high-quality video.

Ultra-High-Definition Television (UHDTV/4K/8K)

As mentioned earlier in the chapter, television sets advanced from standard definition to high definition, widening the aspect ratio and transmitting sharper and clearer images. Technology has continued to improve upon resolution with the development of 4K and limited 8K digital video formats. Both formats are still 16:9, but have much higher resolution and enhancements in dynamic range and color space. 4K refers to a horizontal display resolution of approximately 4,000 pixels, which is double the

previous resolution of HDTV with four times as many pixels. The 4K content is most commonly found on major streaming services, YouTube, Blu-rays, and some cable and satellite providers. At the time of this edition, 8K is not as prevalent, but this format is approximately 8,000 pixels wide and 16 times as many pixels as HDTV, producing almost hyper-realistic images.

Extended Reality (XR)

Extended reality is an umbrella term describing the spectrum of immersive technologies that merge physical and virtual environments. Ranging from most to least immersive, such technologies include virtual reality (VR), mixed reality (MR), and augmented reality (AR). VR completely immerses a user in the digital world through VR headsets such as Oculus and HTC Vive; MR merges the real world with the digital world through VR headsets such as Microsoft Hololens; while AR overlays digital information onto the real world via smartphones, tablets, or AR glasses.

All these technologies may expand exponentially, or may die a quick death in the shadow of another more powerful system. At the core of it all, ultimately, they must survive fiscally.

New Technology Introduces New Programming

With new technologies comes a new type of programming. Traditional long-form cable television is still king, but faster broadband and Internet TV possibilities are converting a larger number of people into "cord-cutters." Viewing habits and lifestyles are continuing to change and more people are interested in a meaningful interactive viewing experience. With different viewing devices like phones and tablets, people will better interact with their television and will also want more short-form professional content on these devices. Generally, most people want their content immediate, organized, and easily accessed. This could be through voice control, gesture, filters, and search engines instead of traditional channel numbers.

Web Channels

Channels are popping up on the web and with a new type of programming for short-form "pro" television. One place this can be found is YouTube, where popular web series can host their episodes and hold a partnership with YouTube. The YouTube Partner Program provides resources for creators to improve their skills in production quality and distribution. It also helps build larger audiences through additional promotional tools and monetizes the content through various ad formats. These brand channels allow marketers to carry their look and feel across the YouTube interface, and to directly branch out to the brand's website, Facebook, Twitter, and more. It creates a destination page on YouTube, makes viewing each episode in succession easier, and creates a stronger relationship with the viewer.

Each major network has a YouTube channel; however they generally show only exclusives, program excerpts, behind-the-scenes spots, and sneak previews. Popular television channels in their respective genres are National Geographic, History Channel, Science Channel, CNN, and BBC News. Some branded YouTube channels originated as their own stand-alone "web channels" online, such as FunnyOrDie and CollegeHumor. Celebrities are exploring this middle-market, which consists of original content that is higher-quality video production than most things online, but less expensive than what's on your cable television. This gives them the freedom to experiment and be creative in a different environment. The first groundbreaking video on FunnyOrDie, *The Landlord*, starred co-founder Will Ferrell and was a viral sensation

with millions of views. Webisodes are traditionally shorter than television programming, running anywhere from 3 to 15 minutes. They can be downloaded, streamed, shared, commented on, and viewed more frequently.

There is endless opportunity for user-generated content (UGC) on YouTube as well, which provides options for smaller productions outside the mainstream media. This type of platform and type of media consumption draws a younger audience who become devout fans of so-called YouTubers, who embrace the lo-fi, authentic, personable approach to storytelling. The most popular content on YouTube of this type includes video game walk-throughs and live play, how-to guides and tutorials, product reviews and unboxing videos (in which consumer products are opened on camera), vlogs, sketch comedy, shopping sprees/hauls, educational videos, parodies, pranks, and funny animals (of course). The YouTube channels with by far the most subscribers (at the publishing of this book) are an Indian music label and Bollywood production studio called T-Series, and PewDiePie, a Swedish Internet comedian who primarily offers video game walkthroughs and comedic content. Both channels have over 100 million subscribers and billions of views. YouTube has become the launchpad for the next generation of producers, filmmakers, and celebrities, allowing them to find their unique voice, directly connect with their audience, and monetize their content.

Streaming Services

Over the last decade, there have been many phrases revolving around the current state of television such as, "Cord-Cutting," "The Golden Age of Television," "Peak TV," "The Wild-West Era of Streaming TV," and "Streaming Wars." It has been an exciting and disruptive time, to say the least. YouTube has been streaming content since 2005, and Netflix and Hulu began streaming two years later. "Cord-cutting" has continued to increase, while each year more people cancel their cable and satellite subscriptions. This shift allowed people to save money, binge their favorite syndicated shows, and later enjoy new original series produced for these platforms. In 2013, Netflix released its first slate of original content, including *House of Cards*, *Hemlock Grove*, *Arrested Development*, and *Orange Is the New Black*. A year later it was the first streaming TV network to snag several Emmy nominations in categories such as drama, comedy, and documentary. In 2016, the service became available worldwide in close to 200 different countries, gaining enormous international reach.

This "Golden Age of Television" gave rise to a period of unprecedented creative freedom for producers. The production quality is high in shows such as *Stranger Things*, *Mindhunter*, and *The Crown*. There are unique narratives told in shows like *The OA*, *Russian Doll*, and *BoJack Horseman*. Niche audiences are targeted and underrepresented voices are heard in series such as *Orange Is the New Black*, *Dear White People*, and *Transparent*. This new format has streamlined the process of development for producers. With no advertising demands, they are allowed to freely create the show they envision with less upfront financial risk. Shows no longer bound to traditional time slots can vary in length and types of content. This can range from a 15-minute short music film for Thom Yorke by filmmaker Paul Thomas Anderson called *Anima*, to a two-hour concert film by Beyoncé called *Homecoming*. There have also been a number of unique, wildly successful mini-series such as *When They See Us*, *Wild Wild Country*, and *Making a Murderer*. Documentary, stand-up comedy, and anime, in addition to the traditional drama, comedy, and kids shows, are the most popular original series on streaming services. A revival of beloved network shows, like *Fuller House*, *Arrested Development*, *Queer Eye*, and *Gilmore Girls: A Year in the Life*, have also found a new home and a second chance. Streaming can also expand opportunities for

YouTube series such as the aforementioned FunnyOrDie shorts. There are many avenues for content within this new distribution method.

In an era of "Peak TV," there is a great deal of competition and demand for viewers' attention. Netflix alone averages more than one new original TV show or film for every day of the year. This continual high volume of new material has also led the industry into "the Wild-West Era of Streaming TV" and what are known as the "Streaming Wars." There are over 300 streaming services on the market to choose from. The big media companies have finally embraced the Internet after years of trying to keep customers tied to their cable packages. Disney+, Apple TV+, HBO Max (owned by AT&T), and Peacock (owned by Comcast) have joined the streaming game in offering various packages. It is less of a risk for big media companies due to their other service offerings. For example, Amazon Prime Video is bundled with Amazon's online retailer, Apple can combine TV+ with its news and music services, while Disney can build upon its franchise through theme parks and merchandise. Endless niche streaming services add to this broad landscape as well with channels like Shudder, The Criterion Channel, BritBox, BET+, DC Universe, ESPN+, and Noggin. There is something for everyone.

Many critics are skeptical of how these "Streaming Wars" will play out. If Netflix keeps investing in original content, will they stay on top and weather the storm? Or will the competition put a dent in its number of subscribers? Is there room for everyone? Disney+ had over 10 million subscribers on day one, but Netflix, Hulu, and Amazon have been in the game longer. Average consumers are both excited and frustrated by choice and have financial limitations on their number of subscriptions. With these large media companies and niche channels distributing their own content, consumers are having to purchase multiple packages with different pricing tiers instead of the one-size-fits-all experience Netflix provided when it was the only game in town. The distribution methods are becoming reflective of early cable bundles. However, the decentralization of streaming still allows consumers to mix and match what they want to watch, when they want, and where they want. The only questions are, at what cost, and with how much ease?

Interactive Television

Audiences of streaming television have more control and choice than ever before in what, where, and when they watch something. They can now also decide what might happen within those stories. The technology is rapidly advancing to allow for more complex interactions, and in this competitive landscape, streaming services are looking for new ways to capture and keep their audience's attention. These interactive stories are strongly influenced by game design with the method of using nonlinear branching narratives, otherwise known as the "Choose Your Own Adventure" approach (named after a popular series of children's books). This puts the viewer in the driver's seat and makes them an active participant in how a story unfolds. The primary differentiation from games for interactive television, however, is to still focus on the storytelling, bringing the viewer back to the main narrative thread at key points, keeping the story seamless and consistent, while focusing on character and emotional engagement.

Netflix's first foray into interactive content was through children's programs, such as *Puss in Book: Trapped in an Epic Tale*, where Puss falls into a magic book of fairy tales and the viewer must make choices to help him escape, and *Buddy Thunderstruck: The Maybe Pile*, where the user chooses what terrible stunts the stop-motion animated rat terrier takes on. Both of these had choices with low stakes, and children are a great audience for more active engagement. The interactive components were presented in

a number of dual choices throughout the episodes, allowing viewers 10–15 seconds to make a decision with their remote, game controller, or a touch of the screen. If they couldn't decide, Netflix would automatically choose for them and continue the story.

The next step for Netflix was to test out interactive adult content with the release of *Black Mirror: Bandersnatch*. Set in 1984, the film follows a young programmer who begins to question reality and spiral out of control as he develops a branching narrative computer game. The story reflects the nonlinear medium and becomes very meta, asking who is really in control—the viewer, the storyteller, or even Netflix itself? Netflix states there are five "main" endings with variants on each, spawning millions of unique story permutations. Five-and-a-half hours of footage are provided, but viewing experiences that reach an official ending marked by rolling credits range anywhere from 90 minutes to two and a half hours. In Chapter 11 of this book, Producer Russell McLean states, "[The producers] were giving up a huge part of the storytelling to the viewer, and their challenge was to try and make it rewarding to all the viewers, no matter what choices they made."

While interactive television won't replace traditional linear narrative, it provides another option for engagement. Audiences can choose to passively absorb content or become co-author depending on their mood. In the future, expect to see interactive television branch into different genres for various niche audiences. We will also most likely see it on more streaming Internet services. Technology advancements may speed up buffering time, increase functionality cross-platform, include voice or gesture control, and possibly integrate artificial intelligence or virtual reality to tell more immersive stories.

Mobile/Vertical Video

Several social media platforms are occupying a space between television and social media on mobile phones, reaching their audience through a multitude of contexts. Viewers could be watching television while commuting to work or school, on a lunch break, or in the comfort of their home. These mobile series are developed to embrace the behavioral nature of phone usage, considering anything from the ergonomics of how someone holds their screen, the vertical aspect ratio, to the competing context in which someone may be watching. Successful series aren't simply longer-format shows shrunken down to fit a phone. They are developed and designed to celebrate the mobile medium's form and function.

There are several social platforms developing content for mobile, such as Snap Originals for Snapchat, IGTV for Instagram, and Facebook Watch. The originator of producing content strictly for mobile is Snap Originals. They put a large focus on original scripted and unscripted programming. They also partnered with companies like NBC, CBS, ESPN, Discover, and A&E to deliver different series in various genres covering news, sports, lifestyle, game shows, and dating. The original scripted shows span drama, romance, mystery, horror, comedy, and docu-series.

The story structure of these short mobisodes are stripped down to an essential narrative arc, grabbing the attention of a primarily young audience right away and keeping them there for approximately five minutes. These shows are mostly fast-paced, highly visual, and binge-worthy. Snap Original seasons usually run 8–12 episodes with shows released daily. They are shot vertically with many close-ups and stacked split-screens. Most Snap Originals incorporate the theme of mobile devices into their narrative or visual aesthetics to further immerse and connect with their audience. A series produced by indie filmmakers the Duplass Brothers, called *Co-Ed*, following freshmen roommates through college, is told nearly entirely through FaceTime conversations,

chat screens, and GPS maps. The characters in the horror micro-series, *V/H/S* and *Dead of Night*, turn the phone camera on themselves in an homage to *The Blair Witch Project* and *Cloverfield*. Viewing these shows through the mobile phone alters the POV, creating a sense of empathy and intimacy that television may not be able to provide.

Snapchat and other social media platforms are studying user behavioral patterns from their applications to assist in building long-lasting engagement. They are also trying to figure out how to navigate this fast-paced new media landscape. Mobile series may utilize more mobile technical features such as augmented reality or social engagement. Series such as *Endless Summer* and *Class of Lies* explored augmented reality with a feature called Portals, where the users can swipe up from an episode and walk into the scene to interact with the objects and characters and immerse themselves in a 360-degree environment. *Endless Summer* also invited its viewers to swipe up during a critical scene to record and post their reaction in order to initiate a shared experience within the app.

Since these applications do not necessarily have "airtime" to fill, we will see where this new area of the industry heads next. It is a great opportunity for young and upcoming producers to jump in and get a foothold, while it is also an exciting space in which established producers can experiment.

Extended Reality (VR, MR, AR)

Immersive storytelling can be experienced across a wide variety of platforms including headsets, glasses, web, mobile, and gaming consoles. There has been consistent improvement in headset technology, making it more accessible and purposeful for consumers. This includes the affordability, resolution, comfortability, and available content. Users can play games, watch 360-degree videos, create, explore, and interact within virtual worlds. This approach to storytelling has the ability to change human behavior and perspective, while also creating a sense of place and empathy.

Virtual reality 360-degree video content can be found in many corners of the television industry. It is most successful and prominent within sports, music, travel, and journalism. This type of content is somewhat easier to shoot with less "staging," and it can transport people to a unique space they wouldn't otherwise be able to visit. You can visit places as remote as the Okavango Delta in National Geographic's four-part *Okavango Experience*, to navigating all seven continents in Discovery's *TRVLR* 36-episode series, to witnessing firsthand the lives of displaced refugees in *The New York Times' The Displaced*. Each of these organizations have their own VR application, and *The New York Times* also launched *The Daily 360*, a series that produced a 360-degree video every day from somewhere in the world.

Short and longform fiction has also been developed for VR. This content has been distributed on individual applications via headsets and as episodic series via streaming services like Hulu or YouTube. *Dispatch* is an example of a short episodic animated series that was distributed via Oculus and created by the VR studio Here Be Dragons. Using minimalistic design, suspense, and the power of sound, four 6-minute episodes tell the story of a long and harrowing night for a police dispatcher. Hulu also threw its hat in the ring by distributing VR comedic shows like a five-part sketch comedy, *Virtually Mike and Nora*, and an interactive choose-your-own-adventure about attending a 10-year high school reunion called *Door No. 1*.

Another distribution channel for fictional shows may also be considered as a form of transmedia. Popular shows such as *Stranger Things*, *Peaky Blinders*, *Mr. Robot*, and *Legion* all created XR extensions. *Stranger Things* and *Peaky Blinders* extensions

are both realized in games, with the former being a mobile augmented reality experience where users explore the fictional world of the show *The Upside Down*, much like Pokémon Go. The latter is an extensive VR game utilizing artificial intelligence to allow characters to react to a player's gestures, movement, and voice. *Mr. Robot* and *Legion* both found ways of harnessing the power of VR and MR via immersive popups at Comic-Con. Attendees could enter the spaces and minds of their favorite shows and characters via VR and MR, while also entering themed physical pop-up installations like a recreation of the *Mr. Robot* computer shop and apartment, as well as a building reminiscent of a hospital and prison for *Legion*. In the *Legion* pop-up, they used a mixed reality Hololens headset and included actors integrated within a real-life set.

While VR has come a long way, the medium does have its drawbacks for the producer and consumer. One of the main challenges related to the production aspect is the lack of control over the viewer's attention and which way they might drive the narrative. The 360-degree videos also have a string of limitations, including no camera movement, reduced number of cuts, hidden crew and set, and shots placed at the natural average height of a viewer. The technology still has room for improvement to elevate the user experience by addressing cameras, stitching software, resolution, weight of headsets, tethered devices, affordability, and shared experiences. This will directly impact the consumer and the popularity of the medium by increasing the comfortability of the headset, and thereby decreasing nausea and feelings of isolation.

Transmedia

Another dynamic form of programming is transmedia. Transmedia is the act of telling a story across several platforms while engaging the audience through various forms of participation, interaction, and collaboration. This type of storytelling allows for a highly enriched story experience beyond passively viewing a show in the living room once a week. With access to so many available platforms, a story can unfold over time and space and better integrate into our daily lives, while the overall story experience can be greater, more cohesive, and rewarding for the viewer and profitable for the producer.

Transmedia can be used to blur the lines between story and promotion as seen in decade-spanning franchises like Marvel. It is also a chance to attract new audiences while allowing die-hard fans more opportunity for discovery, exploration, and participation. These extensions expand the story world by providing more back story, side stories, and possible prequels inviting different audiences in at various touchpoints.

One early and more elaborate example of transmedia storytelling was the show *Lost*. Producers developed alternate reality games (ARG), *Lost Experience* and *Find 815*, to help keep viewers engaged during and between seasons. It began by airing a fake commercial for the fictional Hanso Foundation that then prompted people to call a phone number, which then led them down the trail of discovery online through fictitious websites of companies mentioned on the show. Several more iterations of this continued during the show, revealing information into the mythology of *Lost* through hidden links, voicemails, videos, forums, and so on. The experience even infiltrated the real world through a comic book, an event at Comic-Con, and chocolate bars.

Other series have since embraced the full power of social media. *SKAM Austin*, based on the original Norwegian series *Skam*, was distributed on Facebook Watch. It released episodes unfolding in what appeared to be real time on the social network, while also creating real social media pages for the characters who interacted with each other when the episodes would air. This approach made the series feel very real and aimed to truly connect with its viewers.

HBO is a great supporter and innovator of transmedia storytelling. They have transmedia producers on all original projects. *Silicon Valley* launched original websites from character points of view and created apps that the characters discuss in the show. They also produced a VR experience where users could unlock hidden Easter eggs inside a full-scale rendering of the house. *Westworld* also created an in-world website, character chat-bot, mobile game, virtual reality experience, and real-world immersive installations. They developed an extensive website, *Discover Westworld*, where you can explore the different worlds, make a reservation, learn about career opportunities, and chat with a host. As the story unfolded, the website would adapt in response to the developing narrative. A real-world physical popup that took place at Techcrunch Disrupt involved real actors who served as hosts distributing brochures and booking cards with appointment times. The VR portion of the experience integrated CGI, 360-degree live action, and real world object interaction to put the audience in the shoes of a visitor at the imaginary theme park. Other immersive physical extensions took place at Comic-Con and SXSW. The latter, "Life Without Limits Weekend" was highly extensive. The creators took over a ghost town outside of Austin, hired a cast of 60 actors, 6 stunt people, 5 bands, and 6 horses. They wrote a 444-page script of different intersecting narrative branches playing out over a two-hour loop. Participants were given juicy roles to play, secrets to unlock, and Easter eggs to discover. After making their reservation, choosing a white or black hat, and busing to the town of Sweetwater, they were thrust into the fully analog experience of *Westworld*.

Successful transmedia approaches will expand the mythology of a show, curate an invested fan culture, and tell a story beyond one screen. Each medium requires different thinking, and it is up to the producer to coordinate and unify the experience across a multitude of channels to create a holistic story world. Producers need to consider the potential spreadability, continuity, and extractability of the world they create. Encouraging viewers to dive deeper into a story, they need to focus on different avenues for immersion, participation, and personalization. Understanding these concepts is essential for a producer today because every story or brand spans across several interconnected media platforms with opportunity for innovation.

On a Human Level. . .

You've explored the facets of television's evolution—as a storytelling medium, and its technological and cultural growth—and you've also imagined its potential. You could parallel the growth of television with your own development as a producer: each step you take depends on the step you took before it, how well you understood it, what lessons you learned, and how you choose to apply it all to your own progress, professionally and personally.

SUMMARY

This chapter has barely touched on television's rich past, its transitions, and the unlimited possibilities of the medium's future. Within its short life span in human history, TV always moves forward, and at such a rapid rate that even its definition is now being re-examined. As you explore the plentiful resources for further study, each adds more depth to your resources as a producer, and arms you with the experience and wisdom of TV's early pioneers as well as its visionaries.

In the following chapter, you will begin to focus on the essential core of any project—its story.

REVIEW QUESTIONS

1. What do you consider to be the most pivotal events in television's early experimental years?
2. Define *persistence of vision* and *pixels*. What is their connection?
3. Choose three of television's creators and discuss their contributions to television.
4. Choose one decade in television history. In your own words, discuss its progress, the risks taken, and the technical and creative advances that specifically characterize that era.
5. Choose one highlight in TV history that you feel is significant.
6. What is the FCC? The NTSC? What roles do they play?
7. Pick one fact from each decade that may have contributed to your desire to be a TV producer.
8. Identify one of your favorite programs and trace its ancestry back to earlier television programs.
9. What are your own speculations about the future of television technology? Creativity? Economy?
10. What is a "cord-cutter," and how have evolutions in technology enabled them?

CHAPTER 3

The Big Idea: Script and Project Development

THIS CHAPTER'S TALKING POINTS

I Think It

II Write It

III Develop It

IV Focus on Emerging Media

I. THINK IT

The thinking, researching, soul searching, criticism, doubt, recognition, quiet victory—it's the process behind the story. The story is king. Always. This principle applies to a dramatic series or a sitcom on a major network, a cable news show, a mobisode, podcast, a short film on YouTube, even a 30-second commercial—storytelling is always at its core. All genres want to tell a story that is compelling and engages the viewer.

The markets for story ideas are proliferating. Traditional TV venues are expanding into hundreds of channels and networks, running parallel to new formats for content that are introduced into the marketplace—VOD, Blu-ray, the Internet, mobile devices, and video games, to name a few. Add to this an impressive market for such nonbroadcast areas as corporate image and training videos; sales presentations; domestic and global video conferencing; teaching tools in education, medicine, and science; do-it-yourself videos; and satellite media tours. This massive market can be satisfied only by producers and writers with ideas.

Producers in television stay in touch with what is currently going on in TV, and what might be aired in the future. They watch television, and they read the regular publications and industry trade magazines that deal with the TV business. Producers who work in emerging media are aware of constantly evolving directions by reading online sites and blogs, attending conferences, subscribing to magazines and weekly trade papers, and joining online communities that share information. As you begin to put the many pieces together, the intricacies of TV and emerging media become clearer and more accessible. And more fun.

The Global Demand for Content

America and the United Kingdom traditionally have supplied the majority of programming for the global marketplace. More recently, many international markets have become less dependent on this content and are producing more shows locally. But

the viewing public can be fickle—shows could be a hit in one country and a flop in another, or can make much more money internationally than in a country of origin. In some cases, hit programs are syndicated or repurposed; in other instances, the idea for the show, known as a *franchise*, can be a huge seller, as in the case of *Survivor* and *American Idol*, both of which began in Europe.

The very nature of a producer's job requires constant updating and lifelong learning. Producers increase their worth by researching and watching international television and other forms of online media; whenever possible, they'll view it in its original language. This adds a considerable depth to their abilities as a producer, and as a writer as well.

The Harsh Reality of the Marketplace

The metamorphosis of your rough idea into a tangible end-product can be a real challenge. The research can be daunting, the writing itself often agonizing, there isn't always a positive payoff, and the competition is intense. The majority of television shows are written by seasoned television veteran writers—they not only have the experience and understand the necessary nuances of writing for television, but they are trusted and familiar entities to the executives with whom they work on a daily basis.

Very few TV shows come from the minds of beginning writers. This often translates into business as usual for the viewer, and it is comfortable for the executives. The following statistics vary from year to year, but they're accurate enough to test your commitment to writing and developing your idea:

- At least 100,000 scripts are written each year and very few are good; most are written quite badly.
- Of these 100,000 script ideas, only about 10,000 get pitched to people in a position to develop them for broadcast.
- Maybe 250 to 300 of these 10,000 get to the finished script development stage.
- Fewer than 10 percent of those 250 to 300 are ever shot as pilot episodes.
- Depending on whose statistics you believe, maybe half of these pilots get aired and even fewer continue on as series.

Emerging Media's New Frontiers

As discouraging as these statistics are, they are just that—statistics. Hundreds of shows over television's history were huge hits in spite of opposition from critics, executives, investors—*Seinfeld*, *Lost*, and *Ugly Betty* were considered real risks at first. Their triumphs remind us that passion and talent is hard to quantify or consign to a spreadsheet.

Just as importantly, the potential of emerging media is challenging and breaking the rules laid down in television. In this emerging media frontier, the producer is encouraged to expand the boundaries, share unique ideas, and carve out new territory.

Ideas for Programming Are Everywhere

> There is no wasted job, no wasted time for a writer. Life experience is everything. Without it, what is there to write about? If you're working at a McDonald's and you're an aspiring writer, you can write the greatest story about the French-fryer that anyone ever wrote. When I was in my twenties, I was in a very big hurry—I wanted to succeed yesterday. But what I know now is "get a life," continue to work out there in the world,

continue to write, and know that everything you do is material for your work.

Scott A. Williams, excerpt from interview in Chapter 11

Maybe you have what you think is a saleable, viable idea for a TV show, or a clever piece that is perfect for an online series. Or maybe you have strong writing skills, but haven't yet found an idea that engages you. Here are just a few sources to help inspire some exciting programming ideas.

- ***Friends, family, colleagues, or fellow students***. Some have great ideas but can't write. Adapt their ideas into tangible formats.
- ***Total strangers***. People you meet on a plane or at a party; everybody has an interesting story.
- ***Newspapers and magazines***. Big city or small town papers report rich stories from real life.
- ***The Internet***. Hundreds of websites focus on how to write and pitch scripts, plot suggestions, as well as links, blogs, chat rooms, social networking sites—all are rich with ideas.
- ***Libraries***. Find out what books or plays are not restricted by copyrights and are in the *public domain*, such as works from authors such as Jane Austen, Charles Dickens, and Shakespeare. Adapt them, or "borrow" freely.
- ***Book expositions and fairs***. Publishers large and small promote their books and authors; find ideas among them. Option the ones you think you can develop. (There's more information about your legal options in Chapter 5.)
- ***History***. Truth is as interesting as fiction. Write an imaginary character in a historical situation, and imagine what could have happened if. . .
- ***Biographies***. Why are famous people interesting? Read biographies for story ideas. What techniques and skills made them succeed?
- ***Let genius inspire you***. Read great books, both narrative and nonfiction, and see if they inspire any ideas in you. Something a character does or says might compel you to take a different direction that becomes your own.
- ***Your creative well***. Inside your active brain is a whirlwind of ideas. Tap into your own dream world, for instance. Try some techniques, like giving yourself a creative suggestion or story problem to solve, right before you go to sleep. Keep a notebook or an audio recorder with you and jot down ideas, not only after dreaming, but while walking and working. Listen for snatches of interesting conversations, a sight gag, or an incident you see on the street. The more you tap into this fountain of riches in your brain, the more ideas that are available to you.
- ***Listen to your "running tapes."*** Founded in semiotics, we each have them: these attitudes or beliefs about our appearance, health, fashion, entertainment, politics, aging, race. As a writer, you can emotionally or ideologically tie yours into a viewer's "running tapes" and create a convincing connection.
- ***Popular search engine keywords***. One trick used by some web series producers is to seek out what the most popular search engine keywords are on YouTube or Google or other popular video websites. Then you can use that as inspiration for your web series content and automatically appear higher in the search results for most viewers.

Successful businesses have mission statements; a dimensional producer has a *vision* statement. Author Laurie Beth Jones calls this "a picture of how the landscape will look after you've been through it. It is your 'ideal.'" Whether the idea you want to write about is your own original concept or one you acquired from someone else, your vision statement helps you define the effect you want make on a viewer.

> You have to have the willingness to collaborate, and definitely the ability to tell a story. At the end of the day, you're telling stories. You have to be able to structure a story so that someone knows what you're talking about. In the news field, the challenge for a news producer is that 9 times out of 10, you are writing a story for someone else's voice. One of the functions of a news producer is to write a story and collaborate with the on-air talent. If you don't have the writing skills to write a story and collaborate with someone who may have a different vision for that story, you're not going to be very happy.
>
> **Matt Lombardi, excerpt from interview in Chapter 11**

II. WRITE IT

> The difference between the right word and the almost-right word is the difference between the lightning and the lightning bug.
>
> **Mark Twain**

If there's one skill that separates a good producer from a great producer, it's the ability to write. The television industry has been built on a strong foundation of producers who started as writers—each had an idea they were passionate about, one important enough to nurture and protect. They wanted it ultimately to reflect their passion and weren't willing to give up control to a production company or network that could destroy it. These writers adopted the skills of a producer so they could protect their vision.

Increasingly, emerging media is attracting TV and film writers and producers. They're creating projects and innovative ideas for the Internet and for elegant, sophisticated video games. They are taking chances, redefining the aesthetic language of emerging media, and exploring the financial pros and cons.

The Writer/Producer

In the entertainment industry, the writer/producer can be a major player. He is known as a *hyphenate*—a creative person with two (or more) specific skills who, as a result, can do twice as much work (and often earn twice the money). The title and the job can change with each show and its circumstances. As you learned in Chapter 1, the producer's titles can range from executive producer or showrunner, to co-producer or associate producer, to line producer or consulting producer—each depends on the individual project.

As the public's demands for new programming and content keep changing and evolving, producers are challenged to find bright new ideas. They capitalize on popular formats and topics that can satisfy viewers' demands.

In addition to spinning a tale, the script serves several other purposes. Producers, directors, actors, and crew members all depend on the script as a blueprint to provide the structure for the construction or creation of their part of the project. The producer also needs a script to create a budget, breaking it down into specific departments, or accounts, as you'll see in Chapter 4.

Writing for TV Versus Film

Whether you're writing the script yourself or working with a scriptwriter, you want to know what elements make a script work. Writing for television is not the same as writing for film. One essential difference is the people at the core of the story. In a feature

film, the characters and their storylines are introduced, the story begins, peaks, and ends, and everything is resolved. When the movie is over, so is the story.

Yet in most genres of TV programming, the characters and their storylines continue—both are ongoing and familiar to the viewer. TV writers capitalize on that endurance by first creating strong storylines and then constructing lasting characters, writing plots around them, building on their reactions, and constantly testing them. Viewers rely on this familiarity with the characters and their storylines. The audience gets to know them well and brings their own cumulative memories and experiences of the show to each episode.

Art theorist Steven C. Pepper has called this phenomenon "aesthetic funding," adding that "a late perception in a series . . . carries to considerable degree the results of previous perceptions as its constituents." Simply put, an episode of *Game of Thrones* that we're watching now is enriched and added to by previous episodes of *Game of Thrones* that we've seen already. Each viewing adds to the experience, and is part of the viewer's aesthetic fund. It provides a meaningful context for the intimate details and character traits, and gives every aspect of the show an extra significance.

> In television, I find it more rewarding, because you write something and it's being shot in a couple of weeks. It's a great, great feeling to write and rewrite and create with real live actors and directors and technical people on a real live set. And in a few more weeks, it's airing on television—so your rewards are more immediate.
>
> **Scott A. Williams, excerpt from interview in Chapter 11**

Television and Emerging Media Programming Genres

As a producer, you may be interested in developing a project in any of the following genres of either television and nonbroadcast programming, or for the growing number of delivery systems:

- ***Reality/nonfiction***. Documentary, makeover, competition, biography, nature, travel, "making of," interviews, discussion, how-to.
- ***Sitcom***. Family, teen, smart, silly, spin-off characters
- ***Episodic drama***. Police, law, forensics, medical, firefighters, family, political, edgy, young adult.
- ***News***. Local and national news, entertainment, politics, weather, magazine format, special news reports.
- ***Children's***. Cartoon, educational, puppets, classroom
- ***Talk***. Daytime, late night, women's issues, sports
- ***Soaps***. Daytime, prime time, novellas
- ***Sports***. Event coverage, games, playoffs
- ***Game and quiz shows***. Words, numbers, trivia, all competitive
- ***Movies of the week***. Network and cable, multipart or one-off
- ***Infomercials***. Cable and nonbroadcast, from weight loss to makeup to vacuum cleaners
- ***Corporate***. Corporate image, training, industrials, promotional, conferences and conventions
- ***Advertising***. Commercials, trailers, promos, added-value and special features.
- ***Music videos***. Broadcast, point of purchase, special features.
- ***DVD/ Blu-ray***. Commercially released films and TV series, do-it-yourself, specialty, events, games.

- **Webisode.** Web episode, usually short, of a TV show that's streamed or downloaded
- **Podcast.** Episodic series of video or audio usually subscribed and downloaded to a computer or mobile device.
- **Video game consoles.** Games that are either streamed, downloaded, or on disc
- **Transmedia.** Multiple platforms and formats using digital technology to tell a story.

From Idea to Script

The purpose of art is to lay bare the questions that are hidden by the answers.

James Baldwin

A script translates an idea into a specific format that can act as a blueprint for production. It includes many or all of the following components:

- **A strong story.** One that grabs the viewer's attention and holds it.
- **An amazing hook.** Something unique about the story: a character, a location, a texture is edgy and different and stands out from the others.
- **A protagonist.** The traditional hero who is somehow unique yet familiar, vulnerable yet courageous, someone about whom the viewer can care.
- **An antagonist.** A bad-guy role, the villain, someone who creates conflict, tension, and challenges the good guy or the overall plot in some major way.
- **A buddy.** The main character has a friend, colleague, or sibling who's a sidekick or performs essential functions, like the conscience, the helper, the smart one, the comic relief—often, the character who's sacrificed in the end.
- **A challenge.** The character(s) must confront a challenge and either wins or loses in the process.
- **A conflict.** The character must make moral choices and each option has consequences. Plus, the conflict must be resolved in a way that convinces and satisfies.
- **A contradiction.** A situation that seems good but turns out to be bad, or vice versa.
- **A demon.** Something that happened to the character before the story starts (in the back story) that haunts and influences his or her actions now.
- **A heartstring.** Romance, vulnerability, and sex all help the viewer understand and bond with the characters and their lives.
- **An "up" ending.** Happy or resolved endings sell, regardless of how real life is lived; they often show some form of redemption or measurable growth of the character that satisfies the viewer.

Length

In commercial television, the scriptwriter must also factor in commercial breaks. These breaks include regular commercials, promos, and other material supplied by the national and/or local station affiliate. Depending on the station, a one-hour show actually consists of only about 44 to 48 minutes of programming, along with 12 to 16 minutes of breaks. The script is generally about 50 to 55 pages long. A half-hour show runs 22 to 24 minutes with 6 to 8 minutes of commercial breaks. The traditional guideline is that a little more than one page of script equals one minute of onscreen action, although this can vary with the genre and style of writing.

Commercial Breaks

When a show goes to commercial, that interruption needs to be seamlessly integrated into the storyline without losing action or suspense or pacing, while still maintaining

the plot's thread. The same applies to coming back into the story from the commercial. Unless you're writing for noncommercial television, these breaks come with the territory. Count the number of breaks in a TV show that's similar to yours. How often do they come? How long are they? How does the story line move in and out of the break?

Dramatic Plotlines

Starting with the genius of classic thinkers like Aristotle, and continuing through to the postmodern teachings of dramatic writing, the big idea of the story is what's most important. This action is more important than the characters and is what determines who they are and how they react. A compelling story revolves around action that's bigger than life and greater than its players.

A plotline has two distinct movements, according to Aristotle:

> By Complication I mean all from the beginning of the story to the point just before the change in the hero's fortunes; by Denouement, all from the beginning of the change to the end.
>
> **Aristotle,** *Poetics*

The Complication

This involves all that's happening in the plot along with any kind of back story that connects to the plot. It starts as the plot's beginning until something changes in the hero's fortunes.

The Denouement

From that moment of change until the end. It develops as a cause-and-effect of the complication, takes time to unfold, and continues to the very end.

Most dramatic series, and many comedy series, rely on the A-B-C structure, shown here, and interweave three story lines.

- *The A story*. Propels most of the episode's primary storyline, or main idea.
- *The B story*. Focuses on primary and/or supporting characters; often they carry over into subsequent episodes.
- *The C story*. The comic or soft-hearted relief that deflates tension.

Acts

> [A] whole is that which has beginning, middle, and end.
>
> **Aristotle, from** *Poetics*

Aristotle's *Poetics*, the classic primer on the elements of dramatic writing, mandates that for a story to be compelling enough to arrest the audience's attention, it must have a beginning, a middle, and an end.

- *Beginning*. There is an event or action that sets the plot in motion. It's initiated by the hero/protagonist or the villain/antagonist, and it happens early. There may be a back story—what Aristotle calls the *prologue*—that involves what happened before the story begins and is connected to the action in the beginning. This back story might set a tone, introduce characters, and reveal a location.
- *Middle*. Here, the event or action in the beginning results in the direct cause-and-effect of that early thing. In the middle, the hero—or sometimes the villain—must make moral choices; relationships and characters develop; we see increased conflict. The middle motivates the plot to come to a specific change in the hero's fortunes or misfortune. This becomes the turning point that leads to the end.

- **End**. The pace picks up, vital questions are answered, conflicts get resolved, and the story comes to a climactic and usually viewer-satisfying end.

In television and in much of the content created for emerging media, the main story does follow Aristotle's advice for a beginning, middle, and end—but there are also subplots and themes that run throughout the life of the series. These may or may not be addressed in each episode, and don't always end.

Having a beginning, middle, and end to a story doesn't necessarily mean the same thing as having three acts. Though most half-hour TV shows are divided into three segments, and the majority of one-hour shows into six, some forms of programming might be spaced into four or five parts: a teaser and four acts, or it could run to five acts. Some shows may add a short end tag, too.

- **The teaser**. Three to five pages, with a plot setup that hooks the viewer
- **Act 1**. 13 to 15 pages (the beginning)
- **Act 2**. 12 to 13 pages (the middle)
- **Act 3**. 11 to 12 pages (more of the middle)
- **Act 4**. 11 to 13 pages (the end)
- **Tag**. One to two pages (wraps up a plotline or teases the next episode)

Sitcoms

Generally, sitcoms tend to open with a funny teaser and have two or three, even four acts. A few sitcoms break this mold and use the A-B-C structure, earlier. Other sitcoms might devote their half hour to one main story. *Seinfeld* was quite a unique concept in that each episode usually featured four plotlines that resulted in one conclusion and satisfied all four conflicts.

Script Formats and Styles

Most writers prefer to begin writing their scripts by first outlining their overall Big Picture idea into acts or segments. Then, they might expand that into a treatment form before they finally flesh out the story in a full script format.

Outlines are shorter than full scripts and can provide a clear map for the writer to follow. It can also help to highlight story problems early on. An outline is usually one to three pages, almost a sequential laundry list of the show's beats that is used by the writer as a basic guideline. Some writers use 3" × 5" index cards, pinning them on a cork board, to help them organize their scenes, then translate that to an outline on paper. Other writers take a more high-tech approach, employing screenwriting software that allows the writer to create and manipulate virtual notecards. This software can be particularly useful in emerging media projects as it divorces linearity from the process.

A **treatment** traditionally is written in a narrative form rather than in script form. It might run from 3 to 10 pages, sometimes longer. In most cases, development executives read the treatment only for the nuances of the primary story idea. If they are interested in what they read, they'll ask for a full script. You can find more information about treatments in Chapter 6.

A **script** should be easy to read, should follow a very specific script format, and is written with language that is sparse but interesting—many scripts are a delight to read. These formats have been agreed upon as industry standards; if you decide to use a different format in the hopes of appearing innovative and unique, you're only branding yourself as an amateur. Several software programs are widely used by writers, like Final Draft and Celtx, and some shareware is available online.

The basic guidelines for writing a script are:

- It is neatly typed with no erasures, scribbled notes, or correction fluid.
- Each page has one-inch margins and paragraph separation.
- The paper is simple 20-pound, white, and 8½ × 11 inches.
- It's printed on only one side.
- Each page is divided into frequent paragraphs so the words don't run together.
- Scripts are usually typed in Courier New or Times New Roman, with a 12-point font. Avoid other fonts that are overly busy or pretentious, another sure sign of an amateur.
- Each page is numbered with a numeral followed by a period in the upper right corner.
- Each page is double- and triple-checked for spelling, punctuation, and grammar.
- The finished script is bound in plain card-stock covers with brass brad closings.

Formatting Your Script

A script for a film or television show generally follows the rule of one script page per one minute of on-screen action. That's not always the case, but it's close. There are a few other commonly agreed-upon elements in formatting a script to keep in mind:

- ***Story Title***. You want your project to be noticed and remembered; its title is a big part of creating a good or bad first impression. When possible, keep it short and descriptive. Your title can say a lot about the show, either directly or in its nuance: think *Black Mirror*, *Stranger Things*, *Big Little Lies*, *This Is Us*, *Brooklyn Nine-Nine*. It can also signal the show's tone or direction.
- ***First Page***. There is no one rule for the format of the first/title page, though usually the title is written in all caps, and centered in the upper third of the page. Under the title, type "by" the original author, which also is centered. Subsequent writers may receive credits in descending lines. There might also be the contractual mandate that "Based on the novel by . . ." follows. Generally, the date and the color of the script's revisions pages are listed; in the lower right corner might be the author's representative, with a contact phone number and/or email address. In the lower left corner, type the copyright symbol, the year, and the author's name. The WGA website provides additional updated information.
- ***Formatting: Film or A/V Script?*** A script for television, emerging media, and nonbroadcast is usually formatted in one of two basic styles, depending on its content, its genre, and its delivery system(s). It can follow the traditional **film screenplay** format used in writing films and television dramas (as seen later), or it can be in **A/V** (audio/visual) format (see later), using two, three, sometimes four vertical columns.

Here's a short scene from a TV drama that uses the **traditional film script format**:

The same idea written as an **A/V script** is formatted in landscape format rather than portrait, with at least two columns. This format is used in many nonfiction television shows, commercials, corporate image, music videos, games, how-to, and other programming genres:

You can add other information to this format. Some producers prefer the format with the two vertical Audio and Visual columns, so they can add other columns for graphics information (lower thirds like name, location, title), transitions (a dissolve or wipe), and time duration (the length of a sound bite, narration, or visual action). Any voice-over or narration is written in the Audio section.

Camera Angles

Few writers add written descriptions for camera angles (such as CU for Close Up) or directions (such as Camera Pulls Back) except when it accomplishes a specific story-related action. Even then, there are ways to convey emotion and emphasis within a scene without employing descriptions of camera angles and movement. The use of camera angle description usually lies within the realm of the director and the director of photography, worked out during pre-production. If you do include camera direction in your script, it's likely to be ignored—visually interpreting your script is the what the director and director of photography are paid to do!

Script Components

A strong script provides the reader with a clear format and brief descriptions of the action. Your script also includes dialogue that reflects the characters and their part in the main storyline. Good dialogue gives important plot information, reveals characters' motivations, and propels the flow of the story line. Following are a few components of compelling dialogue.

- Dialogue should create the illusion of reality, not reality itself. Conversation in real life can be tedious and boring.
- Each word and every line advances the plot, explains the character, or provides further story exposition.
- When dialogue is used sparingly, less can be more. Pure silence at the right time can be eloquent.
- One perfect adjective is better than two or three that are not.
- Adding action to a character's dialogue creates momentum and is usually preferable to talking heads that don't move. An actor can be talking or yelling as he jogs. Sitcoms, for example, tend to place their primary sets in a living room in front of a staircase and/or the front door (think *The Cosby Show* and *Two and a Half Men*). This provides more momentum—a set with multiple entry and exit points allows for characters to inject more action into the comedy.
- By knowing your characters and how they speak, you can add nuance with speech patterns, or unique phrases that only he or she would use.
- Read your dialogue out loud to yourself. Record it into an audio recorder. How honest does it sound to your ear when you listen?
- An honest writer is a rewriter. Even the most seasoned will rewrite until they're satisfied. They can usually sense when it works—it's a gut feeling. By trusting your own intuition and pushing your ego and over-think aside, you can more authentically review your work. If you're still not sure, show it to another writer, a professor, or someone who can be totally honest with you.

The Spec Script

Some writers have gotten into the entertainment and media industries by writing a *spec script*—a script written on speculation, one with no guarantees of being seen or bought. Its primary purpose is to showcase your writing talents—if it sells, that's icing on the cake. Most spec scripts are written for a current program or show that is popular; one that you like and watch regularly. Your lawyer, agent, or an inside connection who—if it's positively received—then sends it to development executives or other producers or partners who may be looking for writers with talent and innovative ideas.

A good spec script can be a major factor in a hiring decision. In writing a spec script, the writer is first a researcher. If you're writing a script for a specific show, you want to know that show inside and out. Study the characters, their histories, and how they

speak. Watch at least a season of the show and you'll get its overall perspective and its nuances. What is the rough format of each episode? How many story arcs and commercial segments are in each episode?

Create a plotline that has not been used before on the show but that remains faithful to its overall story line and its characters. If you decide to send a spec script for a specific show to an executive who works on that show, keep in mind she is familiar with each of the show's elements and will quickly spot any story flaws that are unfaithful to the show.

Working With Other Writers

Writers in television take various approaches to their work. Some work best alone and prefer the solitude, and others write better with one or more partners. Many writers are on staff in a show and are a part of larger writing teams, usually from 6 to 10 writers. Finding the writing style that fits your personality is integral to your creativity and to your own brand of discipline. As you'll see throughout this book, virtually every aspect of television involves other people. Television is a highly collaborative medium, so by talking to other writers and producers, joining a writers' group or starting one, taking a class, and reading books about writing for television and emerging media, you can expand these vast creative horizons.

Writing With a Partner

Having a partner with a different viewpoint can be a stimulating combination. You bounce ideas off one another, experiment with dialogue, and discover plot counterpoints and narrative beats. Often one person originates the dialogue and another acts as the wordsmith. Writers have varying skills, and when they're combined collaboratively, the results can be exciting.

A script is a valuable commodity. If it sells, you can both be paid—sometimes, paid a lot. But before you pitch your idea, you and your partner must discuss the pertinent details of your partnership. For example, talk over how you'll share writing credits, future percentages and profits, and who's doing what aspect of the writing process. Write these details down in a deal memo (a process you'll explore in Chapter 5), and sign it. This can prevent hard feelings or disagreements between you and your partner in the future.

Working With a Writing Team

A writer can be hired as a staff writer on a specific TV show or can be a member of a group of independent writers. In both cases, a successful writing team creates the script from the many details contributed by each writer. On most established shows, the writing team is closely supervised by the showrunner, who acts as the head writer and team leader throughout the life of the series.

As a staff writer on a show or series, you are likely to enter into a contract situation that spells out the parameters of your pay, credits, time frame, responsibilities, length and genre of the show, and so on. The WGA website (www.wga.org) can give you specific pay scales for various writing situations. If you're working on spec with an independent team of writers, clarify everyone's specific responsibilities within the group and put together a deal memo between all the contributing writers. You can find further information about deal memos and other contracts in Chapter 5.

Working With an Agent

Professional writers usually have an agent. This agent may be from a boutique agency and represents the writer, promotes and either options and/or sells the writer's work,

pitches scripts or ideas to producers, negotiates contracts and subsidiary rights, and looks for other possible venues for the writer's work.

Another form of talent agency is the larger, more powerful packaging agency; these represent actors, directors, and often producers, as well as the writer. They put together whole creative packages that ideally bring all these talents together: a great script, just the right actor, and the director who can pull them all together. An established talent agency, such as CAA or ICM, acts as the middleman between buyers and sellers.

Each kind of agency has its advantages and its drawbacks. But the bottom line is that your agent believes in you and your material and can provide essential access to the right people. Agents usually take a commission of 10 percent, sometimes more, for their services, which can include finding a buyer for your script, getting you a writing job, and/or negotiating final deals.

Yet finding an agent can be a frustrating catch-22 for new writers. Typically, an agent is interested in representing only established writers, so how can you establish yourself without an agent? If you already have some kind of track record, have sold a script, or have the promise of a sale, agents will pay more attention to you. You can research literary agents through the WGA and online.

If you strongly believe in your project, research agencies, or specific agents, then use polite persistence to make contact with an agent you think is right for your project. It can be challenging to get an agent to read your script and hopefully represent you, but it isn't impossible. Many a writer has gotten an agent by not giving up.

Working With an Entertainment Lawyer

Lawyers who specialize in entertainment and media are aware of the current trends in the television industry and can see the potential payoff from emerging media and their new delivery systems. Because they have strong connections with producers, directors, actors, and other writers, as well as domestic and global market opportunities, they're in the position to bring these elements all together, similar to the packaging agency.

As you'll see in Chapter 5, lawyers can charge by the hour or by the project. These fees can vary significantly, depending on the lawyer and the project's demands. Some lawyers may stay with a project from start to finish, and are a permanent *line* in the project's budget. For a low-budget project, producers can often find reasonable or free legal advice from organizations of volunteer lawyers, university law departments that offer programs in entertainment law, on the Internet, and from sources listed throughout this textbook.

Working With a Manager

The same way that agents and lawyers are well connected, managers are skilled in networking. Unlike agents, however, managers are not required to adhere to the same restrictions that regulate legitimate writers' agents. If you have a manager who makes a deal for you, you'll still need a lawyer or agent for final legal negotiations. Managers generally charge a 15 percent commission.

III. DEVELOP IT

The script development stage refers to the early phases of a project in which you and/or a writer can polish your rough idea into a treatment, proposal, and/or script format.

During the development stages, a producer considers potential directors, crew, talent, and the overall budgetary issues within the project.

This **development phase** can have several scenarios. Here are three of the most common:

1. You are developing an idea that is either your own original premise, or it belongs to someone else and you have legally optioned it for a period of time.
2. A production company or a network has put up development money for a writer(s) to develop and flesh out your idea.
3. A private investor sees the potential of your idea, gives you partial or complete funding, and expects a cut of any profits.

Each development phase has its pros and cons:

1. In the first scenario, you own the idea or have optioned it; no one else controls it. You may have control, but you're also financially responsible for its ownership.
2. In the second example, someone else's money is involved, which gives them more control, but at least you're not using your own money.
3. In example three, investors have little assurance that the script or project will sell. They may demand a high return on their investment, often two to three times the initial investment. But it may be worth it for the security that their investment provides.

The phrase "development hell" refers to a script's development getting stalled at various stages, languishing for months or years, and often not getting made—or changing drastically over the course of its development. Sometimes these delays are caused by a conflict of ideas, the sudden firing of an executive, a cut in the budget, an actor who demands a bigger part, or simple dissipation of interest.

Protect and Control Your Idea

Before you fully commit yourself to developing a project, you must first legally protect it. If you are not legally protected, you could be wasting your time developing an idea for which you have no rights. Submitting an idea that you don't legally own can invite a lawsuit. In Chapter 5, you can find more information on the following legal issues:

- If the idea belongs to you, protect it.
- If the idea belongs to someone else, buy or option it.
- If a book, short story, article, or other material is the basis for your story, get the rights from the author or his or her legal estate.

Ownership and control are both important concepts for a producer. Let's assume you have an original idea that you think can be developed into a program concept. After you have fleshed it out into a treatment or script format, your next step is to legally protect it.

If you're understandably concerned that your idea could be plagiarized, you can legally protect it. Most companies to whom you would submit your project will insist that you sign a submission release before they will read or consider it. You can find more information in Chapter 5.

- ***Copyright it***. Go online for forms at www.copyright.gov or call the hotline at (202) 707–9100. In either the end titles or on your cover page, list the copyright notice; for example, © 2019 CKNY Productions. (The date indicates the year of

first public distribution.) Send the paperwork, which is a nonreturnable copy, with a check or money order via certified mail. You will receive a certificate of registration and a registration number.
- *Register it*. You can register either your treatment or script by mail, with the Writers Guild of America, or online at www.wga.org. You'll be charged a reasonable fee to register it, and WGA holds the registration for five years. You can reregister it then for another five years.

If It Is Someone Else's Idea, Buy or Option It

Imagine that a colleague of yours has written a script that has real potential. You may be considering producing it, or at least developing it further. But first you must either buy the full rights from your friend, or agree on an *option agreement* that gives you the exclusive rights to develop and pitch the idea, and possibly to purchase these rights. An option is taken on a script for a period of time, usually six months to a year, during which time you are the only person who can legally develop and pitch the idea.

If you have found a short story, novel, magazine article, Internet story, or another source for your script or project, determine who holds the copyright and negotiate any rights involved. You can option the rights to adapt it, or purchase these rights completely. If you can't find the original writer or copyright holder, an entertainment lawyer or professional copyright search company can help you locate the owner of the copyright. You must be satisfied that no one else has optioned it. Be sure that there are no outstanding liens on the work. As we'll discuss later in this book, the additional platforms used in emerging media have made intellectual property law significantly more complicated than it used to be.

Find the Best Market for Your Idea

The potential markets for your program and project ideas are expanding rapidly in this digital revolution. Traditional television networks and cable are being eclipsed by online networks, home entertainment options, videogame consoles, and more. Nonbroadcast demands are rising, too, for material in the fields of corporate training, education, advertising, how-to, and industrials, just to name a few. The venues for your content are endless.

But you've got to sell the idea first. Breaking into the business of entertainment and media can be a real challenge. Yet, every successful writer and producer did it somehow—why should you be an exception?

These industries continue to evolve, and though there are no set formulas, the following descriptions give you several directions in which you can go:

- Every network, movie studio, cable broadcaster, and most production companies have at least one executive, if not an entire department, devoted to development. They're looking for ideas: treatments, scripts, books, articles, news stories, short films that can be made into a series. Then, they work with either their own production department or with an independent production company to further develop the idea.
- Networks, cable broadcasters, and other buyers of content often develop and/or produce their own programs in-house. For example, NBC Universal may produce a show through their own production arm. Often, they may buy a property and then repurpose it for one of their other media branches, such as Bravo or MSNBC. They might make a short version of it for release as a webisode, sell it to an international syndicator, or release it on Blu-ray or VOD.

CHAPTER 3 The Big Idea: Script and Project Development

- The network or cable channel may rely on independent production companies with whom they have a strong relationship and lucrative history. These companies work closely with the development executives to script, cast, shoot, and do post-production for sitcoms, episodic dramas, reality, animated, streaming and downloadable content, and more.
- The frontier of new and emerging media is still wide open. One direction is that of talent-owned Internet content companies. Spurred on by the 2007–2008 WGA strike, a number of professional writers turned away from TV and film and moved over to the Internet to create new kinds of programming. Here, the writers generally own the copyright and can go anywhere they want with the content. A show, for example, might debut on the Internet, supported by advertising or subscription. It creates a real viral buzz and gets enough hits to warrant taking it over to network TV. The writers form the company and own a stake in any future profits.

When pitching your project to a specific venue, be certain that it is the right fit. You wouldn't bring a soap opera to a sports channel, or a music video to an all-news channel.

- If you want to interest a production company in your idea, make sure that company has experience in, and enthusiasm for, projects like yours. You can locate production companies by watching shows you like or that are similar to your own idea; look at the show's opening and/or closing credits for the production company's logo, and then research it. What is its history? What's their success rate? Read *Variety* or *Hollywood Reporter* or go to several online resources to see what shows are in production—they list the names and addresses of the production companies involved. You can also go to www.wga.org and click on the TV market list.
- If you want to pitch your idea to a specific network or cable broadcaster, watch the programming shown on that channel. Be aware of what they may be developing for the future as well as their current programming. And if you do find an "in" to pitch your project, be really sure that your idea is well-suited to their programming history and their audience.
- If you want to create a project that engages your audience, understand who that audience is. Research projects that are similar to yours. What were their overall ratings? Who were the show's advertisers? What was the breakdown showing male/female, ages, backgrounds, incomes, education, spending habits, and other statistics? Compile real data showing that your project can generate revenue.
- Most content buyers who do agree to read your idea or take a pitch meeting will ask you to first sign what's known as a *submission agreement* or a release. This protects them from any claims you may have later if you think they've stolen your idea. Each organization has its own regulations. And very few will accept unsolicited material; most accept proposals or take a pitch meeting only after they have been contacted by an agent or lawyer.

Getting a Pitch Meeting

One consistent thread runs through most traditional development departments: they almost always work only with writers who are known commodities. These writers (and producers) have experience and credits, are usually members of the Writers Guild of America, and are reliable. Many also have specialties—one writes beautifully about family drama, another knows the worlds of medicine or the law or politics. When one

of these established creatives (writer, producer, director) has a promising project idea, he or she usually:

- Calls an agent, an entertainment lawyer, or an executive in the development department of a network, a studio, or a production company for which the idea is best suited.
- Sets up a pitch meeting (see Chapter 6) in hopes of convincing everyone to commit to further development.
- Pitches the idea verbally in the meeting.
- Gives the executive a *leave-behind* fact sheet about the project (see Chapter 6), including story synopsis, the creative team, potential talent, and more.
- Hopes that the development executive likes the idea enough to take it to an executive further up the ladder who either approves it for further development or rejects it.
- Understands that if it is approved for development, the executive in charge works with the producer and/or writer on refining the idea. It helps if the producer is also the writer, but if not, the executive and the producer find a writer they both like. Sometimes, a showrunner is brought in at this stage to help guide the vision and hire writers.
- Is emotionally prepared if the project hits a brick wall. As part of the process, the project details are discussed by the top executives. Some might be the development heads, and others are in charge of their shows that are currently airing. These executives could have deals with producers around these existing shows that include guarantees of future buys. This means that the executives may have promised to buy more programming from the same producers who are producing their current shows. To make sure they have enough content for each TV season, they tend to overcommit to these suppliers. This translates to fewer available time slots or less money for developing new projects. But economic pressures are changing the old models; fewer pilots are being commissioned and less development money channeled toward traditional television. Instead, all eyes are looking forward to producing content for the new delivery systems.

Getting in the door to pitch your project often depends on your connections. An agent, manager, lawyer, or referral from a colleague or friend can provide an opportunity for a pitch meeting or at least a phone call. Or, you can take a chance. By researching the network, cable, or studio, or the production companies and who they produce for, you could find the right person to approach with your idea. If you send it, if that person reads it, and if your idea is right, it could signal success. If not, focus on other opportunities for your project.

Potential buyers and development executives seldom have the autonomy, interest, and/or funding to *greenlight* (agree to start developing) ideas from producers or writers that don't have a proven track record. However, there are venues that are more receptive to innovative projects. The recent proliferation of new markets and delivery systems has created a demand for programming that can be supplied by independent producers and production companies with exciting and compelling ideas—ideas that generate revenue.

The Role of a TV Pilot

Seeing a pitch evolve into a TV pilot can be a producer's dream come true. But the statistical chances of that pilot getting picked up to go to series are as slim as the pilot getting made in the first place. Traditionally, a pilot for a one-hour series can cost from $3 million to $7 million, so out of the hundreds or even thousands of pitches heard

annually by each network's development executives, only about two dozen are finally produced by each network. Of these, just five or six pilots ever make it to broadcast.

Traditionally, network and cable executives followed a programming routine: ideas usually were pitched in the fall, then rewritten, scrutinized, and recast, and the pilots finally shot in time to be presented with grand hoopla to the networks affiliates' meetings during the May "up-front" presentations. The ones that made it through that gauntlet went into full-time summer production, filling the order just in time to premiere in early fall.

However, all that has been changing. Some series have reversed the old order and now debut during the summer months, or at the beginning of the new year. Many cable channels and some premium channels hear pitches, develop and shoot ideas, and air their pilots all year round. It's steadily moving toward a 52-week programming schedule.

In today's global economy, most networks and cable channels are no longer investing significant development money into expensive pilots, going instead with short demos or animated storyboards to present their story ideas. These demos, or presentations, focus on the actors and the writing, and are a fraction of what a traditional pilot costs.

Many companies are changing the way they've always done business, limiting their orders for pilots to one or two, cutting back on their extravagant up-fronts in May, and investing more money into developing content for new cellular and online media.

The Impact of Budget on an Idea

TV is all about business. It is an industry driven by advertising or subscription revenue and must have significant profits to survive. Although cellular and online content is still testing the waters about how best to be monetized, billions of dollars, pounds, Euros, and yen are being pumped into emerging media. Your idea may well translate into a business opportunity from which these content providers can profit. No matter how creative or innovative your project is, it is also a vehicle for profit.

If your project idea is expensive to produce, that's already one strike against it. A vital part of the producing process is maintaining your creative vision while operating on a tight budget. For example, if you hire union actors, you wouldn't write speaking lines that aren't necessary: an actor with a spoken line costs more than hiring an extra who says nothing. Minors under 18 must have a tutor on set, which involves extra money and paperwork. A virtual set can cost a fraction of what it takes to build and dress a real set. Each aspect of your project costs money, so look for ways to cut costs without sacrificing the quality of your story.

Basic Budget Categories

As you write and develop your idea, these main categories with their many departments are part of most projects' budgets:

- Screenplay and/or story rights
- Talent
- Crew and equipment
- Director
- Producer(s)
- Legal rights and contracts
- Locations and sets
- Wardrobe and makeup

- Special effects
- Post-production
- Music
- Miscellaneous items like overhead, contingencies, insurance, finance charges, etc.
- Advertising and marketing costs

Experienced writers keep their plotlines simple. Unless they have the luxury of a large budget to play with, they try to avoid storylines with complicated locations, extravagant sets, expensive stars and large casts, explosions, stunts, expensive post-production concepts, and other extras that expand the budget. A solid story line can usually survive without them.

IV. FOCUS ON EMERGING MEDIA

I always see myself as a writer first, but producing is how you can have an impact on the final written product. Unlike feature films, where the director guides the process, writer/producers are the creative guide in television. And the jobs overlap on every front. Working through a budget can dictate how a story is presented, casting decisions can impact how a character evolves, a rainy day can require hasty rewrites . . . dealing with that is all part of the writing/producing job.

Mark Verheiden, excerpt from interview in Chapter 11

Web Versus Broadcast

There are several differences between web video and broadcast television that you should consider when planning your web video production. You can't control how the audience will see your final product due to video compression, various bandwidths, screen resolutions, and screen sizes. Knowing your audience will help anticipate their needs and assist in guiding your production. Another difference in producing for the web is that your audience is now fairly web-savvy. Anyone with web access and a camera can produce web video. Therefore, your concept needs to be innovative, high quality, and potentially viral to rise to the top. With the amount of web video competition, your idea needs not only to look professional and bring a new perspective, but to have a successful distribution and marketing plan. None of this will matter if no one gets to see it.

Think It

When trying to develop a web series, research what is out there so you don't waste your time recreating something that already exists. If you do find something similar to your idea, figure out how to make yours better. Consider counter-programming and offer a show that is shorter, more frequent, or more humorous. You will also want to research your audience and decide what viewers you want to attract. In the web video realm, it's more about going after smaller, targeted, niche groups. Then you can cater your content to them and have more loyal subscribers. Research what genres are popular online. Comedy and humorous videos have risen in viewership among adults through such web channels as CollegeHumor and Smosh. Educational and political videos are very popular as well—Ted-Ed and Vice are great examples. Various production styles will also inform what type of show you want to produce. They can greatly impact the cost of your project. For example, using a studio can be less expensive due to the consistency and control of the production process. A screencast style can be affordable as well since it requires only voice talent and computer screen recording.

Write It

Writing for web video is similar to writing for broadcast. The producer should begin by writing a treatment, which is a single document that defines the concept and summarizes the approach to production. It formalizes the creative process and can be shared with others throughout the production. Define the goals and parameters for the project from your core message, audience, desired outcomes, budget, and longevity of the project. In this document, you should also be able to clearly identify the concept, theme, and objective. After you develop a writing treatment, you should write an "elevator pitch," a description of your project that can be presented in the time it takes to ride in an elevator, roughly less than 60 seconds. When producing a web series, it is much less clear to whom you may be pitching. The pitch may be directed towards a standard broadcast network, web channel, social media application, subscription service, popular vlog, crowdfunding campaign on Kickstarter, or for any investor interested in your subject matter. After deciding who the pitch is for, the elevator pitch can also be used to compose promotional materials during the development process.

Script It

Scripts for most web videos are not that different from broadcast. The principal difference, as with broadcast scripts, is in the type of production. Dramatic productions are always scripted and use the same standard format. Variety shows and talk shows may script only parts of the production and allow space for interviews and schedule time for intros and advertisements. The dramatic script will typically include dialogue and screen directions for the actors and describe location, suggest action, and provide detail for the lighting. These types of shows also usually have a "bible," which is a document that provides the "storyworld" for the video including the backstory of the plot and characters. Scripts may vary depending on the type of production, but are always a great way for you to manage your project and a great starting point for communicating with actors and the heads of each department so they know what is expected. They can then anticipate the characters' motivation, equipment, scheduling, staffing, and other creative requirements.

Big Ideas for Streaming

Writing and producing for streaming services invites more creative freedom than network television. This medium allows writers to branch out from traditional narrative structures and upend convention, while sharing their unique voices and world view. More pragmatically, it also has more flexibility in terms of language and adult themes while being free of typical "time-slots" and the inclusion of commercial interruptions. Streaming shows also often have high production value and sometimes big names attached to them, which is essential in this competitive industry. Additionally beneficial, some services like Netflix have gone global, allowing many shows to reach an international audience. However, your show may still ultimately get fewer eyes on it due to the amount of unique content competing for viewers. These series may also have a shorter life span than a network franchise that runs for decades. Many producers still favor the shorter runs, upfront support, and creative leeway.

Netflix accepts only submissions from licensed literary agents, or producers in which they already have a preexisting relationship. Netflix finds new content by receiving

pitches for shows from these parties, maintaining relationships with the creative community and talent agencies, purchasing finished works at film festivals, or generating ideas internally by hiring writers and creatives. Netflix also leans towards shorter seasons of around 10 episodes per season, and unless a show is a blockbuster hit, it usually won't last longer than three seasons. Netflix is a very data-driven company. Most of its decisions are based upon their undisclosed data, including the decision to have fewer episodes and seasons in a competitive landscape. Their algorithms can also inform the writing of a show, providing notes on what works with an audience and what doesn't based upon the collected hard data on how viewers watch things. For example, viewers tend to like to binge-watch their shows, so if a series isn't binge-worthy, it may not be as successful on streaming.

When writing and coming up with your big idea for a streaming service, include a script logline of one or two sentences that summarizes your TV show's core concept. Make sure it stands out from the rest, displays a unique world, and shows people something they have never seen. The pitch package will include a finished traditional pilot script to go with the logline to give a sense of your writing style and trajectory of the storyline. You may also want to include a show bible that explains the goals of the series and all its touchpoints. Share the primary narrative arc and the most significant elements that make your show unique. When developing your concept, you may also want to consider what the streaming platform can get out of it. Are you trying to fit their current market or attract a new audience? How does it fit into their lineup?

Writing and Developing Other Forms of Emerging Media
Mobile/Vertical

When writing and developing a mobile series, user behavior, context, and the medium itself need to be considered. Mobile applications like Snapchat follow user behavioral patterns to help determine the length of a show and series, when to release it, and what content will be successful. They also take into consideration the context in which people may be watching—they could be commuting, on a lunch break, hanging out with friends, or lying in bed. They could be holding the screen in their hand with their thumb hanging over it. And notifications could be popping up. These shows should integrate seamlessly into the lives of the "smartphone-as-first-screen-generation." They aren't competing with the longer-format shows on Netflix or Hulu. This short-form content should naturally fill in the gaps of people's daily routines. Snapchat, Facebook Watch, and IGTV are attempting to occupy a space between the active participation of social media and the relaxed passive engagement of traditional television.

Seasons are generally 8 to 12 episodes released daily and the episodes are approximately five minutes in length. A series isn't just an hour-long episode broken into 12 pieces; each episode has a narrative arc. Due to the short format, however, a story is usually stripped down to the essential elements and paced quickly. The goal is to grab the audience's attention right away, keep them there, and leave them at the edge of a cliffhanger. This type of daily installment resembles the nature of a classic "soap opera," which is known for its fast pace and getting people to tune in the next day.

When considering themes for this type of media, the content usually references the smartphone itself and plays off of its features. Many Snap Originals incorporate these features into their narratives and visual aesthetic. This could include shifting the POV using the smartphone's camera, displaying conversation via chat bubbles, or grounding people via a GPS map. Highlighting these mobile features creates a unique and direct connection to its viewers that a television cannot achieve. The platform's targeted young audience base also provides a chance for greater diversity in

the content, creators, and talent of these shows. Recently successful diverse shows include *Growing Up Is a Drag*, which follows three real-life drag stars, *While Black With MK Asante*, about what it means to be young and black in America, and *Dead Girls Detective Agency*, which centers around an all-female cast and is produced by women.

With relatively shorter commitment, smaller budgets, and easier production setup, mobile series are an attractive entry point into producing. Both upcoming producers and veteran filmmakers can benefit from this low-risk and experimental new format, while reaching a potentially global audience of millions.

Interactive TV

Writing a nonlinear interactive production is no easy feat and varies greatly from a traditional script format. For shorter and simpler productions, like children's programs, you can use a writing technique called the "string of pearls." Your story has a main spine and narrative arc but branches out into different possible endings. However, when developing longer format productions and more complex adult interaction, this may not be enough.

When writing the first adult themed interactive film, *Black Mirror: Bandersnatch* for Netflix, Charlie Brooker had to generate the script using an open source tool for interactive nonlinear fiction called Twine. It helped manage multiple story branches and was easier to share with the actors and other stakeholders than a traditional script format. The physical script running around 157 pages, as opposed to their usual 65 pages, would take people forever to navigate through and was written more with filming in mind than readability. With Twine everyone could essentially "play" the script and experience it how a viewer might. There ended up being 250 segments, five main endings, with possibly a million different permutations. The project became increasingly more complex as Brooker kept adding new variants; therefore, Netflix developed an in-house tool called Branch Manager that they plan on using for future interactive projects as well. More dynamically, Branch Manager could map every permutation of the story and use what is called "state tracking" technology to track viewer choices as they move through the experience. This allows choices they made previously to show up again in the narrative and more seamlessly return them to where they once were. This creates a more meaningful experience for the viewer, demonstrating their involvement as the story unfolds.

One of the biggest challenges for a creator of interactive content is relinquishing control. You can't predict which order things will go in or how a viewer will respond at each turn. *Bandersnatch* had this struggle built right into the core of its premise with the main character losing control of his choose-your-own-adventure video game, creating a very meta experience for the developers and audience. Everyone was left asking, who was in control? Was it the lead protagonist, the writers, the viewer making choices, or Netflix themselves?

Many critics have made comparisons of this "lean in" experience to video games. This is definitely a blurry line. The main difference to keep in mind when developing a project is that you are creating a cinematic experience for a streaming entertainment platform, not a video game for a gaming platform. The story and character development always come first. Cohesion of character is important. The character and his motives have to be consistent, and all of the endings need to have a level of truth to them. There should be no "right" or "wrong" endings. There should also still be a central spine to your narrative that connects your branches and keeps the viewer grounded.

Another critical component to consider is the balance of audience decision-making, complexity of that decision, and overall pacing. Give viewers enough options that they feel in control, but not so many that they feel overwhelmed or paralyzed. Increase the complexity of the decisions as your story progresses to allow them to adapt to your system and become emotionally invested. Figure out the correct pacing between decision-making moments. When should they happen, and how often? You don't want your audience to be bombarded with insignificant choices, but you also don't want them to forget they are in the driver's seat. Ensure that the transitions are seamless for your viewer, so you don't take them out of the story. Finally, make sure each branch you write when developing your project is essential to the core of your story, because each new branch increases budget costs and production time.

Virtual Reality

Similarly to interactive television, the creator has a lack of control in virtual reality and even more specifically 360-degree video. As soon as someone puts a headset on, they become the storyteller, and the author becomes the world builder. You cannot predict or control how someone will move through the experience you provide. The best writers and producers embrace the unknown and construct worlds that encourage curiosity and utilize the entire 360 degrees. When deciding what story to tell in VR, first choose a story that *should* be told in VR or could *only* be told in VR, and not something just for the novelty of it. Consider telling a story that creates empathy, transports people where they can't go, or allows them a shift of perspective. Think about your target audience and the type of engagement you want. Do you want an experience that is passive, active, open, or a combination of all? This will help determine the length of the project as well, which can range on average from a few minutes to around 20 minutes depending on the audience, their experience and intentions, the type of story, and the quality of the headset.

Writing a VR script is still in its infancy, but there have been some common approaches to the formatting among pioneers in this area. Many will write with six dimensions in mind. A virtual reality space has six different planes including a front, back, left, right, up, and down. Writers will insert a color-coded map of the space on the script with corresponding colored text to indicate where certain actions, dialogue, and transitions are taking place. Another consideration for a nonlinear script is to map out what the storyline might look like in multiple directions to ensure a successful experience on all accounts, in case the viewer isn't looking where you intended.

Embracing this freedom of exploration will definitely make for a better story, but there are some attention-grabbing techniques you can employ to help guide your viewer. In no particular order the following methods have proven helpful—motion, spatial audio, light, narration, graphic elements, social cues, and forced perspective. Forced perspective aligns the center point of the frame where you want it to be at the start of each scene. You can also implement a guided experience where a central character sort of takes the viewer by the hand. Find the balance of providing guidance and allowing freedom of exploration, however. Aim to create presence and agency for the viewer. Presence can be achieved through the consistency and believability of the world you create. Giving the audience enough context to the physical and social aspects of the space helps encourage participation and confidence.

Some critics compare the VR storytelling experience to theater. In a live theater performance with an ensemble cast, you can't guarantee where your audience will be looking at a particular time; therefore, the entire act has to be effective at all times and from each vantage point, instead of just focusing on one particular person or action.

Writers and producers with a theater background understand the dynamic and choreographic nature of VR.

Transmedia Storytelling

The whole is greater than the sum of its parts.

Aristotle

Much like virtual reality, transmedia storytelling places the viewer in a more immersive story world. How does a producer even begin to approach a complex storytelling experience such as this? Very carefully. The process is an iterative one, revisiting the overall structure at several points. You will need to have an overall vision, including your story and the experience itself. The audience, their involvement, and platforms need to be defined.

Story and experience. The story and the overall experience need to be in harmony and to tell the story to the right audience, on the right device, at the right moment. The story still requires the basic principles of a strong narrative, including characters, location, time, plot, genre, etc. Figure out what story you want to tell, how you want to deliver it, and if the audience will affect the outcome. To create a rewarding experience, you need to consider the timing, platforms, location, and level of engagement. Gauge the level of importance of the overall narrative, audience participation, real-world integration, and gaming to your story. Make sure each piece of the experience fits together seamlessly, continuing and expanding the story at each point. Try writing your story for the platform you feel most comfortable with, using a traditional dramatic structure, and expand from there, always keeping your higher concept in mind.

Audience, Participation, and Engagement. A very important aspect of all storytelling is defining the audience. What platforms would your audience use, how big is your audience, and how can they be reached? Decide how much involvement your audience should have in your experience. The fear of many producers is the lack of control and potential for an undesirable result if the audience is allowed to author the story as well. Therefore, you need to decide how much power the audience is allowed, what long-lasting effect they would have on the evolution of the story, and how much of the experience exists in the real world versus the fictional world. In order to comfortably engage your audience, design a self-sustaining ecosystem. When given the permission and resources, the audience is allowed to generate new content or assume preconceived roles and therefore evolve their own personalized experience of your story. You can gauge how much participation you want your audience to have—it can range from fairly passive, like watching TV, clicking "Like," and tweeting, to more active, like playing a game, remixing a video, or making a "real world" phone call.

Platform Selection. While planning a content strategy for audience engagement, you can also consider how you might appropriately select platforms for each stage of the experience. Platforms can range from YouTube, iTunes, and tablets to traditional TV, mobile phones, and comic books. Your project should quietly integrate into your audience's daily routine with minimal disruption. In order to figure out how to disperse your story across multiple platforms, consider the strengths and weaknesses of each and consider the timing and access to each platform relative to the next. Would a phone number lead us to a website, or vice versa? Think about which medium is more passive or interactive, and which is more personal or shared. Would you rather watch a long-form TV show on broadcast television or your mobile device? Would you rather do a scavenger hunt in real life or on your TV? Consider making your platform selections based upon revenue opportunities, cost of delivery, viral and social possibilities,

ease of lifestyle integration, timeliness and popularity of platform, and roll-out schedule.

The platform timing and motivation of the audience is one of the more complex aspects to transmedia. How do you know where to begin, which platform to go to next, and when? How do you motivate your audience to jump from one platform to the next in your carefully crafted plan? Roll-out strategies depend on your business model, resources, and project objectives. Audiences will be motivated to cross platforms if it is easy and rewarding for them to do so. An example would be to integrate an online component during a performance. It is easy to do and rewarding by enhancing the live experience communally, instead of being given a flyer to type in a web address later on your own. Make your content king, so people will not want to miss the next chapter in your story, and make it easily accessible. A great example of a web series roll-out strategy might be to have less expensive secondary media like a website or forum, and a comic book as an additional media platform providing mid-episode fixes. You can then alternate between these platforms on an appropriate time schedule, which reinforces engagement and builds audience by adapting to different consumption habits. However, make sure each medium is satisfying in its own right, so consuming all the media would be optional and enriching rather than a burden. This strategy can work for funding as well. One part of the story could be sponsored to pay for another platform, while another could be free, and another audience-paid. Any combination of these methods will work.

What's next? Networks and producers are trying to push the boundaries of programming and to consider multi-platform engagement and interactivity with their shows. They realize that in today's landscape of fragmented media, engagement and more valued content is instrumental for the survival of TV. However, the next challenge is for the authors to let go and push collaborative storytelling, where the audience is allowed to fully participate and contribute to the plot in a meaningful way. The future of transmedia is more than just seeing a show, tweeting about it, buying the DVD, and going to the website. It requires true engagement in someone's life, telling a story across multiple platforms. This innovative storytelling will inspire new programming, revenue opportunities, and social experiences.

On a Human Level...

The writing process is painful for some people, exhilarating to others. Taking a vague idea all the way through to a producible script is a triumph when it's finally done, yet that journey comes with pressures and uncertainties. You worry that when it's read, people may not understand it or may respond with rejection or, worse, apathy. Your calls and query letters go unanswered. It seems endless.

But just turn on your TV set, or laptop, or cell phone, and you'll see a program or show or commercial—behind it is a producer and a writer. Every project went through some form of development process, and most everyone survived intact and only mildly bruised.

SUMMARY

Throughout this chapter, you've weighed the harsh realities of developing an idea against the promises of success that lure writers and producers into producing for television and new forms of media. In the next chapter, you will explore how these ideas translate into the real world of budgeting.

CHAPTER 3 The Big Idea: Script and Project Development

REVIEW QUESTIONS

1. Devise a comprehensive strategy for informing yourself of current trends and producing deals in the television and emerging media industries.
2. What are four good sources for story ideas?
3. Write a vision statement for your life and another for a project idea you have. In what ways do they connect?
4. Compare writing for television and writing for online video channels.
5. What is your favorite television genre? Why?
6. Write a sample five-minute scene for any genre, using a professional script format.
7. Name five components of dialogue that you find compelling. Why?
8. Would you rather write alone, with a partner, or as part of a writing team? Why?
9. What is the importance of legally protecting your idea? How can you protect it?
10. Name six major story components that could impact your budget. What are some low-budget alternatives?

CHAPTER 4

Connecting the Dots: Breakdowns, Budgets, and Finance

THIS CHAPTER'S TALKING POINTS

I Break Down the Idea
II Budget the Idea
III Find the Financing
IV Focus on Emerging Media

I. BREAK DOWN THE IDEA

Budgeting is most every producer's nightmare. Mistakes get made, blame gets tossed around. Making a budget for your project obligates you to predict the future. It requires you to examine each aspect of your project, give it a face, and assign it job descriptions and a set of parameters. Without a realistic budget, your project faces confusion and failure. Budgeting can be daunting, even for seasoned producers; yet with time and some practice, you can understand and eventually master the budgeting process. As a guideline for this process, you can research budgeting software programs like Movie Magic Budgeting.

Designing a budget is a process during which the producer evaluates the project's vision and then translates that vision into time and money. Costs for any aspect of a budget can have an enormous range. If a dozen producers were to budget the same script, each would come up with different totals and calculations. One story can be told in many ways, and the best budgets emerge from solid research and cost comparisons, studying other producers' budgets, talking to people with budgeting experience, and practice—lots of practice.

The now-classic television series *Friends* first started with six unknown actors who were paid modest salaries. But by the time the show left the air, each actor had become a big star, earning $1 million per episode. Although these stars boosted the audience and advertiser appeal, the talent budget alone was $6 million per episode. Other costs rose, too, as producers created new swing sets and added guest stars. Ultimately, its high ratings, and subsequent sales to syndicators and international markets, justified NBC's increased costs. Because money is *always* at the core of every television show, the producer's job is to achieve the best quality for the lowest cost and highest profits.

Understand the Big Picture of Production

[Y]ou have to be flexible. You have to be willing to roll with the punches, you have to believe in what you are doing and believe you can do it. If

someone is telling you something is impossible, it is usually not. Anything is possible. There are some things that are impossible for budgetary reasons, but there are always compromises and ways to make your vision come to life.

Tom Sellitti, excerpt from interview in Chapter 11

The producer works closely with people who can transform script ideas on paper to a dimensional finished product. The producer may work with a small two-man crew or might build a large team with other producers, writers, director, actors, and talent, a substantial production crew, heads of key departments, and others outside the immediate team such as lawyers, insurance agents, accountants, public relations, representatives. The list can be impressive. Regardless of whether the production is large or small, the producer (or a team of producers) is at its core, delegating, supervising, supporting, and making decisions throughout the project.

Create a Production Book

A good producer has a high regard for organization. Producing is all about details, and keeping those details in order makes the job easier. An essential tool in that organization process is called a *production book*. A production book is a paper-based and/or digital record of a production, from conception to delivery. Basically, any document related to a production should be filed in the production book. Producers generally keep a separate production book for each project, a three-ring loose-leaf binder with tab dividers for each section. Depending on the size of the production, the production book could be a single binder, or boxes of binders. It's not uncommon for the production book on a simple 30-second TV commercial to swell to hundreds and hundreds of pages. Finding room to store them after a project's completion can be a challenge. Many producers have moved to a digital-only format because of the size of the paper-based books. Production books are incredibly useful pre-production tools—assembling a thorough, well-organized production book means that you've planned your production as best you can, and hiccups and challenges when it comes time to shoot will be minimized. Production books can also be useful long after a production has been wrapped and delivered, as a reference tool for future productions. On that production from several years ago, do you remember that location that was so interesting to shoot in, or that editor who was so easy to work with? No? Dig out the production book!

Just a few of the many documents that should go into the production book:

- A contact list including names and phone numbers for producers, talent, crew members, director, catering, vendors, and other essential contact information
- The script and all versions and revisions
- Daily shot lists
- Shooting schedules and call sheets
- Production reports after the project wraps up
- Scene breakdowns
- Storyboards
- Props and art breakdowns
- Wardrobe, hair, and makeup breakdown
- Transportation details
- Meals and craft service plans
- Location agreements and shooting permits
- Releases and clearances for talent, locations, art work, etc.
- Deal memos with crew
- Insurance information

- Budget (optional—most budgets are confidential)
- Inventory (video stock, props, wardrobe, etc.)
- Equipment list
- Miscellaneous

Break Down Your Script

The script is the blueprint for your budget. And whether you've got a full shooting script for a sitcom, or just the bare bones of how you'll shoot a documentary, it's the source of your budget.

- Allow yourself or your writer(s) adequate time to develop your script. You don't want to frantically rewrite it on set, when time and money are at a premium.
- Most scripts must get final approval from development executives or clients, which can result in additional changes to the script or overall project restructure. The time required for the writer(s) to complete any rewrites is an added budget item. Most scripts require some tweaking and several revisions. Include money in your budget to cover an outline, a treatment, and at least two rewrites before you start shooting

The Breakdown

Every script is a compilation of scenes, and each scene has certain requirements that cost money. Does the scene call for three actors, or only one? Is the scene being shot with multiple cameras and lighting, or just one handheld camera using available light? What props or greenery or furniture are in that scene? Every component has a direct relationship to the budget and the shooting schedule. A *breakdown sheet* helps the production staff to understand what is needed in each scene. It can be compiled by hand or by using special software. It makes the process easier and provides a concise blueprint that helps to make the scenes work.

The breakdown is fully explored in Chapter 7 and includes any or all of the following categories:

- The scene number and name
- The date of the breakdown sheet
- The project title
- The page number of the script
- Location (on set or on a real location)
- Interior or exterior (shooting inside or outside)
- Day or night
- Brief scene description (one or two lines)
- Cast (with speaking parts)
- Minors (often require tutors, overtime, etc.)
- Extras (no speaking parts, either in the scene or in the background)
- Special effects (this ranges from explosions to blood packs to extra lighting)
- Props (anything handled by a character in the scene, like a telephone or pencil)
- Set dressing (items on the set not handled by the character)
- Wardrobe (any details that are pertinent to that scene, like a torn shirt)
- Makeup and hair (special effects, like wounds or aging, wigs or facial hair)
- Extra equipment (jibs, cranes, a dolly, steadicams)
- Stunts (falls, fights, explosions requiring a stunt person and stunt coordinator)
- Vehicles (picture cars or other vehicles used by characters in the scene)
- Animals (any animal that appears in the scene comes with a trainer, or *wrangler*, who takes charge of the animal during production)

- Sound effects and music (anything played back on set, like a phone ringing, music for lip-syncing, or music the actor is reacting to)
- Additional production notes

Storyboarding

Storyboards are not necessary in each project, but they can be useful organizational tools. *Storyboards* are simple, cartoon-like sketches of each scene in a script. They're numbered boxes with a drawing inside; each box refers to a scene or shot number from the script. When the image or camera angle changes, so does the content of the box.

Each sketch is a rough portrait of the scene being shot: the location of one character in relation to another, the framing, the surroundings, the colors or lighting in a scene. Storyboards can be a real advantage to a production as a kind of shorthand for the director, producer(s), director of photography (DP), art director, production designer, and others. See Chapter 7 for an example of a storyboard.

Prior to the shoot, the producer, line producer, and/or UPM go through the script. They make a rough sketch of each scene (often with the help of a storyboard artist or storyboarding software) that details every camera setup in that scene. Usually storyboards contain minimal black-and-white line drawings, although they can be in full color photography or even animated.

For unscripted programs, storyboards can help the production team to visualize and structure a location so that it looks natural but includes optional spots to place cameras or microphones.

Now it's not uncommon for productions to employ animated storyboards, called *animatics*, especially for technically complicated or expensive sequences, like an action scene in a program that will require visual effects. There are several established software programs that produce animatics.

Storyboards can be excellent visual tools for presenting an idea for a project—producers often pitch and sell their project ideas by using imaginative storyboards as persuasive selling tools.

Shooting Schedule

Imagine that your show costs around $5,000 a day to shoot and you have a 10-day shooting schedule. You need to budget $50,000. But what if the lead actor breaks his foot? Your shooting schedule goes off course and extends to 15 days, and now you've got a $25,000 difference to come up with. You can prepare for this kind of emergency by padding your budget whenever possible, adding an extra 10 percent contingency to your budget, and/or giving yourself extra shooting days in your overall schedule.

The shooting schedule is a key component in creating a budget. It isn't unusual for the cast and crew of a one-hour TV drama series to work 16 hours a day; some shows shoot as many as 12 to 18 script pages each day. This translates to shooting a feature-length script in two weeks—an incredibly tough schedule. Additional fine points about structuring shooting schedules are in Chapter 7.

Cross-Boarding

Several prime time television shows, both narrative and unscripted/reality, now shoot with a method known as *cross-boarding*. Using this approach, the producer shoots scenes, consecutively, from two or three different episodes that all take place on the

same set or location. In other words, in Episodes 110, 113, and 117 of *The XYZ Show*, Tommy and his kids are in the kitchen. Their lines are different, and so are the wardrobe and the story lines, but they all take place in the kitchen set. It is much more cost-effective to keep the crew in place and the set dressed and lit so that all three scenes can be shot in the one location.

II. BUDGET THE IDEA

Each producer has his or her own approach to budgeting. Some television producers divide their budgets into three main categories: *pre-production*, *production*, and *post-production*; and others distribute their costs into two sections: *above-the-line* and *below-the-line*.

Producers also factor in *indirect costs*, like legal fees, accounting services, insurance premiums, taxes, and a contingency that covers unforeseen costs. Some charge a direct *markup fee*, which is a percentage added to the costs that cover office and personnel overhead. Other producers might hide their profit margin in other ways, such as inflated crew costs and facility rentals. The overall goal is to make a profit in the long run, or at the very least, not to lose money.

Larger productions tend to have budgets extensive enough to require budgeting software and spreadsheets; smaller productions might need only a page or two to keep track of their costs. As the producer, you'll look for the right budget template that works best for each project, or work closely with the production manager or the line producer in keeping track of daily costs and the overall budget.

Budgeting Costs: Two-Part Versus Three-Part Formats

The budget form that a producer uses to keep track of the production's costs is a personal decision. There are several formats, and some excellent software. Most fall into one of two categories:

- Three-part budgets: Pre-production, production, and post-production
- Two-part budgets: Above-the-line, below-the-line

Three-Part Budget

Most television and emerging media producers find it easier to look at their costs by dividing their budget items into three major categories:

- Pre-Production
- Production
- Post-Production

Budget Costs: Pre-Production

Costs tend to be lower and more controllable in this first stage of a project. Budget items usually include the producer's fee for either writing or working with a writer; taking meetings; hiring crews; casting actors or talent; coordinating stunts; planning the shooting schedule; booking hotels, meals, and travel; and generally planning the project's overall development. In larger projects, the producer supervises other producers who deal with many of these details.

The script is an essential component of the project, which calls for the producer to work closely with the writer(s) in the pre-production stage. Budgeting for a writer can be done in several ways. For example, the producer and writer might agree on a flat fee that covers all aspects: developing the idea, writing the script, and any revisions.

A writer might also be paid in stages, such as 30 percent of the agreed-upon fee after signing a contract, 30 percent with the first draft, and the remaining 40 percent paid after final acceptance. In this case, the fee may include a specified number of revisions. If that number is exceeded, additional fees for extra revisions may be negotiated as part of the contract. Writers may also require the assistance of a researcher or other resources as part of the story development.

Other pre-production costs can include designing storyboards, consultant fees, casting fees (casting director and facilities), space for talent rehearsals, production staff, and production assistants along with a coordinator and/or manager and an AD staff, office rental, location scouting, messengers and shipping, meetings, and meals. Any sets must be planned, constructed, painted, and moved to a sound stage that needs to be scheduled, and paid for. If the shooting is in a foreign location, research each country's requirements for locations, permits for shooting, currency exchange, and more. Careful pre-production planning is vital and saves money and time for the overall budget of the project. You'll find more details about pre-production in Chapter 7.

Budget Costs: Production

When the producer has thoroughly mapped out everything needed to shoot the project, the production phase can be the quickest and least problematic part of the project. The script has been researched and finalized, the crew and equipment have been hired, the talent has been cast, the key departments heads have submitted their department's requirements with estimated costs for production, contingency money has been put aside, and the many other details have been finalized so that the actual shoot can begin. In the following section, under Budget Lines, the majority of production crew members, equipment, and materials are outlined. Chapter 8 also explores the many specifics of production, too numerous to list in their entirety here.

Budget Costs: Post-Production

This is traditionally the most challenging area for producers to accurately budget. As you'll learn in Chapter 9, there are many factors in the post-production process to consider. These include the many hours of footage that need to be screened, logged, and organized in the editing system; the skills and style of the editor, and the costs for the editor, post-production facility, the audio mixer, and the audio facility; any graphics, artwork, animations, text, captioning, credits, and other design effects; music, narration, voice-over, sound effects, sound design, and even foreign language translation.

Two-Part Budgets

Not all producers like the three-part budgeting system. In some television projects, commercials, and more elaborate, big-budget television series or specials, the producer might use a format that's similar to a feature film budget. This format divides the production costs into two areas:

- Above-the-line
- Below-the-line

Above-the-Line Budget Costs

These costs are project-specific fees or salaries paid to the creative personnel (producers, directors, writers, and actors, depending on multiple factors including union affiliation, time required, special perks, and star power). Above-the-line fees are paid in several ways:

- **Union fees**. If the writer is a member of the Writers Guild of America (WGA), that fee is stated in the WGA contract with the producer. The same applies to a director who's a member of the Directors Guild of America (DGA) and to a Screen Actors Guild (SAG) actor.
- **Daily or weekly fees**. The personnel agree to a fee to be paid daily or weekly.
- **Flat fees**. Often a producer agrees to pay a fee to an above-the-line creative in installments: one-third upon signing a contract or deal memo, one-third on completion of principal photography, and the final one-third when the project is completed.
- **Producer fee**. Because the producer is usually the person deciding how fees are paid, this fee can vary. The producer(s) generally takes the project from start to finish, and works longer than most everyone involved. Some producers take daily or weekly fees, others work on a flat per-project fee. A producer might also *defer payment* until the project is sold, in exchange for a bigger fee at the back end of the deal. More experienced, savvy producers can structure their contracts to earn extra profits or bonuses in addition to their salaries if the project succeeds.

Below-the-Line: Budget Costs

These costs tend to be more predictable, covering the technical crew and their equipment, resources, and standard expenses such as overhead, insurance, and more. Below-the-line personnel can be union or non-union; this depends on whether the company behind the project is a *union signatory*—the production company has agreed to adhere to all the unions' regulations. There are several unions that cover professionals such as writers, directors, actors, camera operators and audio engineers, grips and gaffers, makeup and hair, wardrobe, and others.

A note about unions. Membership in a union doesn't necessarily imply quality or experience, nor does it mean the opposite. It does mean that union members are protected by strict rules that include hours worked, overtime, meals and breaks, benefits, and pension and welfare (P&W). Non-union members can be more flexible with the hours they will work, they aren't paid benefits, and their rates tend to be more negotiable than union members who often are bound by rate scales. Non-union members can be as qualified as union workers, and often, union members will work on non-union jobs.

Costs: Estimated Versus Actual

In addition to using one of the two previous formats, the producer keeps a separate budget that shows at a glance two aspects of spending the project's money:

- Estimated costs (what the producer *thinks* a budget item will cost)
- Actual costs (what the item *actually* ends up costing)

On some budget templates, the "estimated column" might be called "budgeted costs." Many budgets add a third column to the right of the first two that lists the "plus or minus" amounts (also called "over and under" or "the variance"). This figure represents the difference between the estimated costs and the "actuals." This plus or minus column provides an instant readout on the running costs and lets the producer know if the budget is on track or if adjustments need to be made to keep costs in line with the budget.

Estimated Budget Costs

In the early stages of developing your project, you may be asked by a potential buyer or investor for an estimated budget that details the predicted production costs. Drawing up this estimate and putting specific figures on a still-sketchy idea can be a

real challenge, especially for a beginning producer. Often the script hasn't been written yet, and there isn't enough hard information as a basis for a budget. If you need to create a rough budget estimate, consider one of the following options:

- Ask about the client's financing parameters. Most are experienced enough in the business, and have an amount in mind that they're willing to spend. For example, they may have only $300,000 to spend, but your budget estimate is $350,000. You might be able to trim your budget down by $50,000, or you can justify the reasons behind your estimate and convince them to raise their offer by $50,000.
- Give the buyer choices: a Plan A budget that reflects everything on your production wish list, and a Plan B budget that covers fewer extra effects, locations, and other items that add to a budget.
- The buyer may be willing to give you a small development fee for expanding your script, research, location scouting, or doing a script breakdown.
- A buyer may be so dedicated to your project that they can find additional money from other budgets; others may feel passionate but genuinely not have the funds. Often their commitment to your project can motivate you to pare down your budget as much as possible and to somehow make it work.
- Don't be afraid of walking away. If, for example, a buyer won't budge from a $200,000 offer and you're quite sure that your budget of $300,000 is realistic and professional, you can politely refuse their offer and look elsewhere. The skills of negotiation can be developed over time; meanwhile, an agent or entertainment lawyer can be a tremendous asset in deal-making.

Actual Budget Costs

This sample project budget has several columns. One is labeled "actuals" and the other is labeled "estimated." The figures in the actuals column represent what was *actually* spent, rather than what was originally *estimated* (seen in the other column).

Consider the example of a producer who budgets enough money to cover a three-day shoot on a beach. Suddenly, an unexpected storm shuts down the entire production for all three days. The production has stopped, but the talent and crew are still receiving full pay, by contract. After the storm passes, the producer shoots the necessary scenes for three additional days. In this example, the original estimated costs called for three days of shooting while the actual costs were for six days. This extra time and salary have to be covered in the budget, somehow. Sometimes other areas are padded, or a 10 percent contingency is added to the overall budget.

Researching Budget Costs

Putting a budget together relies heavily on research. The producer must make phone calls, research online sources, compare prices, talk to other producers, and keep up with the industry trends. It also helps to look at other producers' budgets to see how they have calculated their costs.

Almost every item included in a budget can have a low-to-high price range. Say you plan to shoot a TV documentary with a small two-person crew that includes one video camera, various microphones, and their operators. The costs for a professional crew could range from $1,000 to $50,000 per day—literally! In this case, the lower costs would cover a crew that specializes in shooting news, interviews, and documentary material. In the world of high-end commercials and episodics, these costs can be considerably higher.

While budgeting any project, the producer takes all these variables into consideration, with the goal in mind of creating the highest-quality product for the least amount of money. He or she finds the best people, equipment, services, and locations, and makes it all work within the budget.

Creating a Working Budget

When you break down your script or your treatment to determine specific factors that contribute to a realistic budget, look for these components:

- **Number of pre-production days**. To develop the script, scout locations, and interview/hire talent and crew
- **Number of shooting days**. On set and/or on location—what sets are needed, what locations and where, your *shooting ratio* (how much material shot compared to what's actually used in the final version); which talent and crew are working on what days, their costs, equipment rental charges
- **Number of post-production days**. Log and screen footage; notes on editing script; plan and complete graphics; overall sound design; edit; the final mix

Budget Templates

An effective budget outlines each and every category involved in every phase of the project. Each category in the budget is known as a *budget line*, and each item has its own line on that budget. There's a line for a producer, for props, for equipment rental, for every item.

There is no one standard budget form that's used by all producers, but there are several pieces of software that make it easier to budget. Depending on the project, a budget could be under a page, or up to a hundred pages. As previously mentioned, some budgets are separated into above-the-line and below-the-line costs; other budgets are divided into pre-production, production, and post-production categories. But all budgets must clearly specify what money gets spent, and where.

The Top Sheet

Most longer-form budgets begin with a *top sheet*—a brief summary of the project's costs in each department. It gives the producer a valuable overview of the budget at a glance.

The Detailed Budget

A *detailed budget* addresses every aspect of the project's production. Each detail in a script or project translates into a cost that's part of a key budget category, or *account* or *account line*. These accounts include all the departments and all their expenses—salaries, material, equipment, overtime, and more. Budgets tend to be confidential, seldom distributed to anyone but the producer, director, line producer, and/or the production manager. A detailed budget varies in length, depending on the project.

Budget Lines and Categories

When creating a budget for a project, you might include any or all of the following categories:

- **Producers**. Each project has at least one producer with specific responsibilities. The primary producer is usually at the helm of the project from day one and gets paid until the project is completed. His time must be budgeted for meetings, pitches, and day-to-day development in the beginning, all the way through

CHAPTER 4 Connecting the Dots: Breakdowns, Budgets, and Finance

production and post-production, and continue through consulting on marketing and distribution at the project's end.
- ***Screenplay and/or story rights***. If the script isn't the producer's original script, then she pays for the rights to use someone else's story, script, article, book, or idea.
- ***Writer(s)***. Regardless of the source of the idea, a writer or team of writers is usually hired to flesh out the idea or refine an existing script.
- ***Director***. If you're producing an actor-heavy dramatic project, you may hire a director to work with the actors, similar to a film director who has experience, vision, patience, and the ability to work fast. He may be expensive but can save you money over the long run.
- ***Casting directors and expenses***. Casting involves both principals and extras; expenses involve casting space, taping and equipment, meals, PAs, etc.
- ***Actors***. Well-known stars can escalate a budget, but their names attract viewers and sponsors. Unknown actors charge less, and with the right script, director, rehearsal time, and network promotion, they can create a hit show. Minors require extra fees, including on-set tutors, overtime, and other perks. Agency fees are also part of the budget to consider. For union talent, you'll need to add roughly 30 to 35 percent for pension, health, and welfare, FICA, Medicare, FUI, SUI, Workers Comp, and fees for the payroll service company.
- ***Talent perks***. Stars often demand extra benefits such as a personal makeup artist, a wardrobe stylist, a physical trainer, special trailers, travel accommodations, secretaries, and nannies.
- ***Crew***. A crew can consist of one or two people, or hundreds. It depends on the project as well as any necessary union regulations. Basic personnel might include camera and audio operators and their assistants, a director of photography, an assistant director, a prop master, a wardrobe designer and supervisor, a producing designer, electricians (gaffers), grips, a stylist, a script supervisor, scene artists, set designers, carpenters, still photographers, a location scout, craft service, stock and materials, an ambulance or paramedic/nurse on call, a tutor for children, choreographers, stunt coordinators, parking coordinator, catering crew, and others depending on the project. If you're paying the crew through a payroll service rather than as independent contractors, include an additional 18 to 22 percent for each crew member's check for fringe benefits.
- ***Staff***. The project usually employs production secretaries, administrative staff, production assistants (PAs), and interns who are assigned to areas in which they're needed.
- ***Locations***. Costs for locations can include scouting fees, transportation, hotels for cast and crew, meals, location and permit fees, and equipment rentals. A location can be less expensive than building a set, although locations can have their own challenges: audio problems that can't be controlled such as airplanes and air conditioners, or inadequate electrical power for cables and lights. Foreign locations create additional costs such as varying personnel rates and wages, travel expenses, taxes, and currency exchange rates. However, these costs, when compared to domestic costs, might still be less expensive.
- ***Set construction***. Sets can be elaborate and handcrafted, they can be computer-generated, or they can be minimal and simple. Set design can require a production designer, set designer, construction costs, and personnel such as artists, painters, carpenters, and others.
- ***Hair and makeup***. The needs of this department depend on the project's talent requirements and size of the cast, including supporting characters, children, and

extras. Special effects, such as fake blood or wounds, toupees, hairpieces, or wigs are also taken into account.
- **Wardrobe**. The clothing and costume needs of each actor—from principal actors to background extras—is carefully designed, maintained, and kept track of. This can require a wardrobe designer, supervisor, and often assistants.
- **Period pieces**. Recreating another time period automatically increases the budget in virtually every below-the-line area including locations and sets, wardrobes and props, researchers, and production designers.
- **Special effects**. This category includes extra costs for things like explosions, stunts, smoke, special lighting, car chases, gun shots, and rain. This category might also include animals and picture cars used in the shoot. Additional insurance is also part of the cost.
- **Music and sound effects**. Most programs include show themes and filler music that has been composed especially for the program, as well as additional sound effects and voice-over narration. Occasionally, a sound track or theme song can become a popular hit. For lower budgets, stock music is an excellent alternative.
- **Transportation**. Hauling equipment, cast, and crew from one location to another requires trucks, vans, and other vehicles, along with tolls, parking, gas, insurance, and vehicle maintenance.
- **Equipment**. This general category might include camera and audio equipment, cranes and jibs, walkie-talkies, generators, lighting, fans and air conditioning, memory cards, gas and electric, etc.
- **Meals**. Keeping everyone fed and energized is essential to any production, large or small. Make sure there's at least one full-sized healthy meal per day. Keep a table stocked with healthy snacks and fresh fruit or veggies, a bit of junk food, and refills of coffee, tea, and plenty of water.
- **Security**. In many cases, a production needs security guards to protect equipment, keep talent isolated from fans, for crowd control, and generally to keep an eye on everything.
- **Post-production**. This area can be cheaper when producers and directors know how to shoot less footage by editing "in their heads," to log and screen their material, and to have a game plan for the edit room. Costs include format transfers, codec licensing, data management and storage, transferring footage into an editing system, the edit system itself, the editor, music and sound design and audio mixes and engineers, and graphic elements.
- **Animation**. If a show contains animated portions or is entirely animated, this budget line can be complex and might include artists, designers, colorists, software operators, and a variety of other personnel and equipment. Animation studios located in other countries can keep costs down.

Additional Budget Lines

The producer also factors in expenses such as office overhead, petty cash, finance charges, insurance and special riders, and payroll, accounting, and legal costs. Additional expenses could include music licensing, stock footage, stock music, and research fees, transcriptions, and foreign translation.

- **Office overhead**. Whether you're renting an office space or using your apartment as a production office, you've got daily operating expenses. They include rent, electricity, telephone (cells and land lines), faxes, high-speed Internet, copy machines, a monitor for screening demo reels and your own footage, and basic supplies like paper, pens, and staples. Shipping and messengers can add up, too. The standard overhead fee is 8 to 10 percent, depending on your location.

- **Petty cash**. Get into the habit of keeping track of petty cash. By using a Petty Cash Report form, you can keep track of your costs (and receipts) for meals, taxis, tolls, copying scripts, and various odds and ends that can inflate the budget.
- **Finance charges**. If you're paying for anything with a credit card, remember to factor in the monthly interest. That 4 to 21 percent can be significant on a large monthly bill. The same goes for production loans, car leasing, and other costs.
- **Payroll services**. When you make your budget, you'll factor in fringe benefits for crew and talent payroll. You can pay them in one of two ways: the first is through a payroll company who will take out fringes like taxes, workers' compensation, and other fees and charge a payroll service fee. Or, you can pay people as independent contractors. You don't take out any money, and they're paid on a W-9.
- **Accounting fees**. Often a production hires an accountant or accounting service to keep track of all daily and weekly costs for the production, and to issue regular reports on the budget's progress. The accountant regularly pays all personnel and takes out taxes when necessary; pays the accounts for union costs, agents or managers' percentages, pension and welfare; and pays any other costs.
- **Legal fees**. Attorney fees can be nominal, or they can be significant. Almost all productions require releases and contracts with the creative teams, the talent, the crew, and other personnel, as well as negotiations with sound stages, facilities, and other businesses needed in a production. Although producers can often handle these areas, a lawyer may be brought on board to take care of more complicated issues. Many contracts are simple enough to be drafted by the producer using a deal memo (see additional information in Chapter 5). More complex contracts and negotiations require consultation with an entertainment lawyer. A lawyer can bill by the hour or ask for a flat fee that extends over the project; legal fees generally account for 2 to 3 percent of the budget.
- **Music licensing**. Costs for music can be prohibitive. They could include a composer, lyricist, musicians, and recording studio costs. Factor in licensing fees with the music publisher and the recording company. This can be a real test of patience for the producer; you'll find more in-depth information in Chapter 5 on music rights clearances.
- **Stock footage**. To save the costs of an original musical composition or preexisting music, producers often rely on stock music that is royalty-free and cost-effective. The same applies for stock film or video footage that has been bought by a stock footage company and can be licensed. You'll find more information in Chapter 9.
- **Research fees**. Depending on the project, a researcher or team of researchers might be an integral part of the process, especially in the case of fact-based programming, documentaries, news, and some reality shows. A researcher can be a staff member or a freelance professional, depending on the complexity of the research needed. Sometimes interns can help—and they're free.
- **Transcription**. Many producers prefer to work with written transcripts of interviews and documentary footage that are word-for-word transcriptions, often with time-code references. In some cases, a translator may be needed who's also a transcriber.
- **Translation**. Certain projects might require a separate audio track for translating the dialogue into another language. This requires a translator to do the actual translation, a narrator to read it, a director or producer to oversee the audio session, and often subtitles.

- **Advertising and marketing**. Both paid and free publicity is vital to the success of a show. This could include a still photographer to take publicity shots as well as a publicist to make sure the stills are featured in articles or ads for the project. Other costs could include promos, printing and distributing posters, flyers, direct mail, online, newspaper and magazine advertising, as well as hosting screenings and entering festivals.
- **Contingencies**. Most productions run into a problem somewhere: the location could fall through at the last minute, an actor gets sick, or the footage is lost. A professional budget builds in a contingency amount of roughly 10 percent of the budget.
- **Insurance**. As the producer, you must absolutely protect your production and yourself with insurance. It's a necessity: you could lose everything from one lawsuit. All independent producers and production companies protect themselves with a Comprehensive General Liability insurance policy that includes liability and workers' compensation.

 In most U.S. cities and states, a Certificate of Insurance (COI) is necessary to get a shooting permit. Often, a $1 million minimum is required. Insurance coverage can cost from $3,000 and up per year, depending on what and where you're shooting; some entertainment insurance companies are willing to insure a production by the day or for the duration of the project. Globally, insurance costs and legal requirements for insurance vary considerably. Insurance for your specific project could include:
 - **General liability**. Protects you against claims of bodily injury, property damage, and vehicular damage that's additional to auto insurance. You might also add riders or special coverage for stunts, explosions, cast insurance, props and sets, extra expenses, third-party property damage, equipment loss or damage, faulty stock, faulty cameras or audio equipment, excess liability, union insurance, animal injury or death, and more.
 - **Workers' compensation**. Covers temporary or permanent loss of cast or crew (whether they're hired on a temporary or permanent basis), and pays for hospital and medical, disability, and possible death benefits. The rates depend on the nature of the work.
 - **Entertainment package**. In addition to the insurance policies, producers can also cover their project with extra insurance riders that protect against bad stock, lost or damaged camera masters, video or film processing, lost or damaged props, sets, equipment, wardrobe, extra expenses, and third-party damage. Other coverage includes bad weather, demands by an actor, excess liability, aircraft and watercraft, animals, vehicles, political risks, and unique sets or props.
 - **Errors and Omission insurance (E&O)**. Insurance that protects the production against lawsuits involving authorship and copyright issues such as plagiarism, unauthorized use of ideas, characters, titles, formats, or plots. It also covers invasion of privacy, slander, libel or character defamation, and copyright infringement. It defines a clear chain of title: who wrote what, and when, and who ultimately owns any rights to any aspects of your project.
 - **Institutional and educational insurance**. In some cases a college, university, or public or private school might provide insurance coverage for enrolled students' class productions. This includes general liability insurance as well as insurance for video and audio equipment and third-party property. This insurance seldom covers a project that is shot in a foreign location, uses explosives or moving vehicles, depends on stunts, or other liability-prone components.

> Insurance is a big item. . . . There is a bundle of insurance coverage that a picture needs. It needs liability insurance, it needs property insurance, general liability if you smash your camera through someone's plate glass window, or if someone trips over a cable, or if you've rented a car and have an accident during production. Then, there is producers' liability, or Errors and Omissions, that protects against claims arising out of the content and copyright trademark, and libel and privacy claims.
>
> J. Stephen Sheppard, excerpt from interview in Chapter 11

Hiring Union Versus Non-Union Talent

There are pros and cons to each option. **Union members** are generally assumed to be professionals with experience. However, unions dictate specific rates and rules for working conditions to which producers and the union member must adhere. There is also extra paperwork, as well as payments such as P&W, benefits, and other costs.

Non-union talent and crew can be as experienced and professional as union members without the restrictions of a union governing their work. Producers often pay their non-union crew the same rates as they would pay a union member, without having to deal with paying benefits or doing extra paperwork.

Often, union members will work on a non-union production, although they can be in violation of their union depending on the situation. There are several unions that a producer may deal with, depending on the circumstances of the production. These unions can be found on the Internet, and include:

- Writers Guild of America (WGA)
- Directors Guild of America (DGA)
- Screen Actors Guild (SAG)
- American Federation of Television and Radio Actors (AFTRA)
- National Association of Broadcast Employees and Technicians-Communications Workers of America (NABET-CWA)
- International Alliance of Theatrical Stage Employees (IATSE)

III. FIND THE FINANCING

In some projects, it's up to the producer to bring in the financing. It can be challenging for even a veteran producer to secure enough money to develop and complete a quality project.

Possible Sources for Funding Your Project

Once you have created a rough budget for your project, you can now focus on raising the funds you need. As you'll learn in Chapter 6, one of the more effective tools is a solid *business proposal* that you can offer to potential financing sources, who could include:

- ***Private investors***. You can approach people you know—friends, family, coworkers, fellow students, neighbors. Or, you can find business people you've never met who see the economic promise in your idea, are looking for tax advantages, or simply want an ego boost. Ideally, your project will be successful, and your investors can see a return on their initial investment. But you don't want to promise anything that can't be delivered. Assure investors that you will do your best to pay back their good faith in you, if not their monetary investment. Some

investors are happy simply to be on set and watch the shoot, or to get a small walk-on part in return for their investment.
- **Grants**. Grants are a source of money that could prove beneficial in funding phases of your project, such as the initial research, writing, and/or post-production; some may cover the entire budget. Grants are awarded by public and private foundations. You'll find more information on grants in Chapter 10.
- **Public foundations**. Various categories of financial aid and grants are given out to filmmakers, depending on the nature of their project. Organizations like the National Endowment for the Humanities (NEH), National Endowment for the Arts (NEA), the National Science Foundation (NSF), and the American Film Institute (AFI) are better-known sources, though each state and local government also offers funds for projects that fit their grant's requirements.
- **Private foundations**. Most large corporations earmark specific funds to support projects in the public interest, and not by accident, to elevate their own public image. They may fund part or all of a project, or underwrite projects that they want to be associated with. Public television might air a special or a series that is partially or fully sponsored by a public or private foundation.
- **Bank loans**. Avoid investing your own money if you can. However, if you're determined to make your project, and you know that you can pay the loan back later with interest, it might be possible to get a bank loan if your credit allows. If not, the bank will require a cosigner or collateral such as a car, house, or something else of value that you own.
- **Credit cards**. You may have a healthy credit rating and can afford to take out a cash advance to pay for production costs. But before you do this, add up the extra interest costs on the advance, and be sure that you can cover the payments. You don't want to lose your valuable credit rating if you can find another financing source.

Options for Self-Funding

Depending on the project you're developing, you may choose to bypass the more traditional approaches and produce it yourself, owning and controlling it. This approach is risky, of course. It could deplete your savings and ruin your credit. Or it could be a risk that totally pays off.

Producers can subsidize their projects with their own money. Or, they can find investors, corporate sponsorship, foundation grants, bank loans, donations, barter goods, or exchange services. For smaller budgets, producers put together fundraisers and online auctions, sell stocks, throw keg parties, and come up with imaginative and creative ways to pull together the money.

Make a list of the people who could help you. Be clear about what you need. You may want them to finance your entire project, or simply to cover development or post-production costs. Maybe they can donate their services (like set construction or seamstress) or give you food to feed the crew, or props or wardrobe or transportation.

In many cases, people will exchange goods and services for a courtesy credit or special thanks at the end of the show. You can also offer *deferred payment*, giving them an agreed-upon sum if your project hits a specified profit point down the line.

Your list of potential contributors could include any of these people or organizations:

- Family and relatives
- Friends
- Other writers and producers

- Fellow students
- Former elementary or high school students
- Coworkers
- Independent TV/film/emerging media volunteer organizations
- Writers
- Directors
- Producers
- Lawyers
- Agents
- Managers
- Investment brokers
- Actors
- Restaurant or deli owners
- Local stores
- National chains
- Social networking sites

Crowdfunding

In recent years, crowdfunding via the Internet has become a popular means of raising money for projects across all media. Thousands of records, web series, and films have been successfully crowdfunded. Crowdfunding usually involves the use of a crowdfunding website like Kickstarter or IndieGoGo, along with the promotional power of social media like Twitter and Facebook, allowing producers to reach out directly to their audience for contributions to the production of the work. The producer writes a pitch and produces a pitch video describing the project, why it needs funding, and how any money raised will be spent. This pitch is hosted on a crowdfunding site like Kickstarter, which, in return for hosting the project and providing the mechanism to collect the money from the funders, takes a cut of the total amount raised. In addition to posting the pitch and the video, the producer also promotes rewards specific to the crowdfunding campaign, which are offered to funders at different pledge levels. For example, if you created a web series and sought production funds through Kickstarter, you might offer, for a $25 pledge, a T-shirt with the web series' logo, and for a $50 pledge, a physical copy of the first season of the series once it's produced. Many of the pitch videos and the rewards offered have been very creative, and some media projects have raised hundreds of thousands of dollars through crowdfunding. Once the domain of smaller, struggling independent artists, crowdfunding websites have quickly gone mainstream. Colin Hanks, Whoopi Goldberg, Spike Lee, and Zach Braff are among the many celebrities who've funded their films on Kickstarter.

Crowdfunding may sound easy—put your pitch video up on Kickstarter, email your friends, and wait for the money to start rolling in, right? Not quite. Crowdfunding involves a lot of marketing, a lot of time, and hard work. Not every project is well suited to crowdfunding, and any producer considering crowdfunding would be wise to do a lot of research first on what makes crowdfunding campaigns successful, as well as to closely study crowdfunding campaigns that have easily reached or exceeded their fundraising goals. Kickstarter and IndieGoGo archive all projects run on the sites, so it's easy to go back and look at those that did very well.

Some basic crowdfunding tips:

- Make sure your project is suitable for crowdfunding—not every film or web or TV series will be something that a general audience will want to personally invest in.

- Set your fundraising goal carefully. Both Kickstarter and IndieGoGo will take a chunk of your final earnings (totaling somewhere around 10 percent). Kickstarter will not award you any of the money you've earned unless you reach the fundraising goal you set for yourself, while IndieGoGo will take a larger portion of your pledges if you fail to meet your goal. For example, if you set a goal on Kickstarter of $5,000, and you receive $4,975 in pledges, you don't get a dime. So, you might be thinking, why don't I just set my goal really low? This is actually a dangerous practice as well, as setting your goal too low leads your audience to believe that you don't need the money you actually need. That is, when they see that you meet your too-low goal, they'll stop pledging. Consider carefully your reach before you set your goal—how many people are likely to contribute? Do you anticipate lots of support from the general public, or is most of your funding likely to come from friends and family? Many projects have failed because of unrealistic expectations on the part of the producers.
- Make your rewards creative, interesting, and not too costly to fulfill. If you offer, say, a framed poster at the $50 reward level that costs you $35 to print, frame, and ship, then you aren't grossing much money at that donation level.
- Make a compelling pitch video. Most of the successful projects on Kickstarter have creative, interesting, personal and passionate videos. The video is especially crucial for film, TV, and web video projects. If you are raising money to produce a web series, and you can't make a professional-looking pitch video, then you won't inspire confidence in your potential pledgers that you can produce the series itself. Also of note is that Kickstarter looks at the videos and the rewards for examples of exceptional creativity and uses that to select its featured projects. Becoming a featured project on Kickstarter gives you access to thousands of people who would never otherwise have found your project.
- Update your campaign regularly. Tell your pledgers how the campaign is coming along, and how the project is developing. Let them know that there is a human being behind the campaign keeping a close eye on things.
- Begin promoting your project and your crowdfunding campaign before you launch. For most projects, it takes a while for word to get out about a crowdfunding campaign, and crowdfunding campaigns typically have only a few weeks to meet their fundraising goals.
- Select the length of your campaign carefully. You might think that the longer a campaign, the better, but data from Kickstarter shows that the highest number of successful projects were run at its shortest allowed length of time, 30 days. Many crowdfunding campaigns will be so long that a potential pledger will see that they have a lot of time left to make a donation, think "Oh, I will get around to it later," and then ultimately forget to pledge or lose interest in the project. Crowdfunding campaigns can also run out of steam after a while—there are only so many times you can post a link to your campaign to your Facebook page before your friends get sick of seeing it. Thirty days is an optimal time limit because it retains a sense of urgency throughout the campaign, and it motivates people to pledge when they first learn of the campaign and to share the campaign with their friends before the clock runs out.
- Have a plan to market your campaign to an audience beyond your friends and family. Of course, your friends and family will contribute, but how are you going to reach the general public? At any given time, there are thousands of projects on Kickstarter and IndieGoGo—how do you plan to stand out?
- Arrange for internal plants (sometimes called "Angel Investors". These are people (usually friends and family) who will contribute early, as soon as the project goes online, so the campaign seems to get off to a good start. People are more

likely to contribute to projects that have some momentum, they want to fund projects that appear likely to succeed in reaching their funding goals.
- Thank every one of your project's backers. Send each one a personal message. Ask them to help you spread the word about your project to their friends, coworkers, and family. Involve them; make them feel a part of your project.
- Budget your time carefully. Running a successful crowdfunding campaign is very time-consuming. Prepare for it to be much more work than you anticipated.

Bartering, Clever Negotiation, and Tips to Save Money

An effective producer calls in favors when necessary, knows how to negotiate and barter, and cuts costs wherever possible while still maintaining quality. Here are just a few creative directions you can consider as alternatives to spending real money.

Expectations

As anyone who's been working in this business for a while can attest, it isn't what it used to be. Back in the day, there was generous money for budgets, more relaxed shooting schedules, nice perks we could count on—a free lunch, if you will. Now every client expects more work for less money, shorter shooting schedules, final products adjustable to all delivery systems, and an end result that's not competent, but brilliant. This is an industry-wide phenomenon, felt not only by producers but by everyone working in media production. As the worldwide economy has crashed, purse strings have tightened, and while it hasn't been as hard-hit as most industries, media production has not been immune. Advancements in technology are also to blame—when a client sees that an edit, a sound mix, and visual effects can be produced on the same small laptop computer, they might expect that those tasks can be performed by the same person. But an editor is an editor, and a sound mixer is a sound mixer—they're different skills. As technologies continue to advance, more positions at all stages of a production will fold together, and creatives will be expected to be more versatile.

Negotiation

A producer can often negotiate better rates. Few unions will agree to lower the rates for their members, but there may be exceptions. Sometimes non-union actors, crews, writers, and directors, as well as equipment rental houses and post-production facilities, may be willing to negotiate. Offering them the employment security of several days or weeks of work can provide an incentive for reduced daily or weekly rates, or a flat fee for the duration of the project. Some people are willing to work for half-day rates. Another potential area of negotiation involves product placement, in which a product is placed in such a way that it's visible to the viewer and integrated into the scene. A fee is paid for this service.

Deferred Payment

A project may have a modest budget, but everyone involved wants it to succeed. To save money, a producer might offer a *deferred payment* to some or all of the people involved. This means that when (or if) the project eventually makes money, all who agreed to defer their salaries are paid when it makes money later, often with interest or bonuses on top of their original salary agreement.

Courtesy Credits

A producer can often negotiate with airlines, hotels, restaurants, and other providers of goods and services, simply by giving them an acknowledgement in the end credits of the program. For example, you might see "round trip travel provided by British

Airways," or "hotel accommodations provided by Marriott Hotels." These are known as *courtesy credits*.

Money Back

Occasionally, after the shooting has been completed, a project may end up with items that can be sold for cash, returned for refunds, or exchanged for services. Items might include unused stock, wardrobe, props, furniture, plants, equipment, building materials, wall hangings, furniture, and more.

In-Kind Donations

An inventive producer can save substantial costs in the budget by asking for donations of goods or services. Some classic examples of *in-kind* donations that are offered either at a lower rate or for free include no-fee locations, food and beverages from a restaurant or grocery store, vehicles, software, supplies, film or digital stock, and more. Legal and accounting services, databases and computers, telephone and Internet, and post-production facilities are other in-kind services. This generosity is traditionally rewarded with a *courtesy credit*, which acknowledges and thanks the contributors by listing their names or businesses in the project's closing credits.

IV. FOCUS ON EMERGING MEDIA

> If you can schedule and budget for a film, you can schedule and budget for an interactive project. You need to have the right variables and you need to get the right information. Keep in mind that it always takes longer than you think.
>
> **Lance Weiler, excerpt from interview in Chapter 11**

Budgeting for Web and Mobile Video

Web and mobile video budgets are not the same as those for standard broadcast television, feature films, or commercials. With access to more affordable equipment and software, web and mobile video is a bit more approachable for an independent producer. The secret to success with budgeting for web or mobile video is in efficiency. Figure out how to do more with less. In order to do this, know your objectives, have a plan, make sure your team is on the same page, and execute the plan with the minimum number of resources. For example, some web video experts are known to shoot up to 25 webisodes in a day, depending on the simplicity and duration of the video. In the time it can take to produce one or two episodes of traditional TV, you can shoot an entire season of approximately 12 episodes for a mobile app series.

Keep It Short

One way to maximize your budget is to keep your videos short. It would be better in the long run to have several shorter videos than one longer video. Web videos are typically between 3 and 10 minutes long and successful mobile app episodes run around 5 minutes. They are usually consumed during downtime or on-the-go. If you have a video that runs too long, you can always turn it into two parts since web and mobile video is most often serialized. Another way to produce efficiently is to keep your concept and production simple. You can retain production value that is acceptable for the web and still shoot for time. For example, shooting everything in a studio setting rather than switching locations is a time-saver. This will guarantee you get your video to your audience on schedule and will be easier on your pocketbook.

Equipment and Multi-Tasking

Other important aspects of budgeting for web and mobile video production include lighting and audio. Even if your budget is small, these are not areas to cut corners. With poor lighting, your video could appear grainy and blurry online, especially after having to go through web video compression. And the quality of your audio capture can make or break your project. Invest in a prosumer camcorder with a good lens, a standard light kit, and a professional-quality microphone. Your crew for a web or mobile show might possibly be a smaller two- or three-person crew, so you will have to make sure your team is multitalented. They should be able to run lighting, audio, and camera, and everyone will have to learn how to work with what they have on location in a more grassroots style of shooting.

Hosting

It's also important to budget for the maintenance and distribution of the video after it is created. Once you produce the show, you have to compress it, host it, share it, and hopefully monetize it. There are multiple options for hosting your web video, including the largest video hosting site, YouTube. There are free hosts, but they generally offer a smaller amount of storage and lower bandwidth and may insert ads into your video without sharing revenue. You can choose this method if you are on a very tight budget, but you pay (or don't pay, as it were) for what you get. Because you are working with video, you will definitely want a lot of storage and unlimited bandwidth. You don't want to keep your viewers waiting. If your show is getting a lot of traffic and has made it big, you may consider using a dedicated host/server. If you or your company has the ability to run your own server, you could consider self-hosting as an option. In order to help you figure out what hosting plan to budget for, it's important to first identify your audience. Estimate how many people will watch each episode and how many videos you want to have available at a time. This will help measure the total usage you think you will need along with the total storage.

It's important to remember that your web videos will likely not be viewed only on computers, but on mobile devices, and not all hosting solutions will be mobile device-friendly. For example, YouTube works on nearly all mobile devices, Vimeo works on some, and embedded QuickTime files work on almost none.

Along with these needs, you should also look for hosting plans that offer more customization. Web-based feed generation tools (RSS) and social media integration such as Twitter and Facebook connections are essential. Customizable players are also important, so you can control how the video plays. In order for you to measure the success of your video, statistics are an important feature as well. Some web hosts offer this service, but if they don't, Google Analytics is a great free option. Statistics will help prove the success and reach of your video to advertisers and better identify your audience and their habits. You will be able to see how many have watched your video, when they watched it, where they watched it, and which platform they used, as well as to compare over time and between episodes, and much more.

Get Help

Another area you may budget for is working with public relations firms or teaming with media partners to help you get your video seen. Make sure all parties involved understand the priorities and approach to sharing your video. You may also want to invest in search engine optimization. You can try to tackle this service yourself, using keywords, tagging, and submitting your URL to Google and Yahoo, or you can pay someone to get you to the top of the list in all search engines.

Transmedia Business Model

Due to the larger and more complex nature of a transmedia project, a clear business model needs to be developed. A producer needs to set a clear summary and goals and to apply boundaries to the project. To keep things in perspective, they also need to develop a criteria for success and set the scope while they track the decision-making for each individual platform. Setting a cost and revenue breakdown, organizing a team, and developing a schedule for production and release are also a part of the producer's role. A diverse team may consist of an executive producer, transmedia producer, head writer, platform producer, writer, creative director, marketing manager, and community manager.

The cost and revenue breakdown will depend largely on the scale of the project and how it is delivered. One of the most unique aspects of a transmedia business model and production bible is clearly defining the different platforms and their range of channels or services offered. For example, if one of the platforms is a mobile phone, the range of channels could include texting, apps, AR, GPS, and a QR code. Identifying these services and what goes into producing for each of them will help guide the development of the production because each component will require a specific build or type of content. Defining your audience and various platforms will also help decide what funding methods are more appropriate. For example, audience-pay and pre-pay financing are great for revenue—official sites, iTunes, and local events use this method. However, sponsored financing is better for spread, attention, and credibility, as seen on YouTube and Spotify.

Virtual Reality Key Cost Considerations

In the realm of virtual reality, production costs will always vary dramatically depending on the type of project you are producing. For example, a 360-degree video is different from an interactive graphics engine-driven project. When determining your budget, there are many facets of the production to consider. After you have identified your audience and worked out the narrative, you determine if it is a 360-degree live action video, animation, or graphics game engine-driven product. You will also want to decide the level of interactivity. This will help determine who is on your team from writers and software engineers to directors and talent. VR producers need to be agile and innovative when forming the right teams for the right jobs.

If producing for 360-degree live action shoots, you will need to decide what cast and crew are a part of the shoot. Also account for the necessary equipment, which can range from high-end 360-degree video systems to more affordable and DIY monoscopic systems, as well as the necessary hardware to edit and stitch content. Lighting, dollies, drones, and audio equipment need to be considered as well. Deciding if the content will be in 3D or mono will alter the budget. The 3D option is more attractive for headsets but takes three times as many days in post-production and doesn't appear on desktop and mobile. Either way, you need to account for complex post-production, because it is time-intensive to correct, stitch, and composite the footage. According to the VR production company Visualize, a one-day shoot can result in 5 to 15 days of post. From the planning stages to post-production, these are key considerations on the budget, but ultimately you need to determine the final delivery platforms. Is it for headsets or flat screens? This will inform whether you need to build apps for distribution and which ones. There are different apps for Google Cardboard, Gear, Oculus, Vive, HoloLens, web apps, and so on, which all require a different level of investment in development.

On a Human Level...

Feeling comfortable with the budgeting process can be daunting, especially in the beginning. Your original idea seems to pale in the dark shadow of a "dollars-and-sense" scenario. The reality of money can dampen your initial enthusiasm and even create an urge to back off the project altogether. It's common to have "math anxiety" over budgets, or to become impatient. Refine your organizational skills and understand the value of details. Stick with it, and know that even the most experienced producers, no matter how good they are, share your feelings.

SUMMARY

The only thing more challenging than finding the money is managing it, once it comes in. Creating a budget and sticking to it takes discipline, ingenuity, experience, and patience. Each project brings its own requirements, frustrations, and mistakes. Yet each also brings you closer to mastering the skills of budgeting. As you become more familiar with the budgeting process, your next challenge is to explore the legalities of the project. The next chapter guides you through the legal odyssey.

REVIEW QUESTIONS

1. What is the first element of "reality" that you must consider when developing a project?
2. What is the purpose of a production book? A breakdown sheet? A storyboard?
3. Define *cross-boarding*. Give an example of its use.
4. Identify the key differences between hiring union and non-union crew employees.
5. What are estimates versus actuals? Why is it helpful to track both throughout a project?
6. What is a budget top sheet?
7. What are three areas in which a lawyer can be of assistance to your project?
8. Name several ways in which budgeting for web video and transmedia projects differs from budgeting for traditional TV productions.

CHAPTER 5
Welcome to Reality: Legalities and Rights

Let us never negotiate out of fear. But let us never fear to negotiate.
<div align="right">John F. Kennedy</div>

THIS CHAPTER'S TALKING POINTS

I Own It

II If You Don't Own It, Get Permission to Use It

III Protect It

IV Double-Check It

V Focus on Emerging Media

I. OWN IT

Your idea is a precious commodity. For it to develop, thrive, and ultimately succeed, this idea must be protected. It's the producer's responsibility to provide this legal protection. With a common-sense understanding of entertainment law, and an awareness of the contracts, agreements, and rules that are integral in each stage of producing your project, you can provide this protection. A deal can start with a hearty handshake and a verbal promise, but ultimately you want to make sure it's backed up with solid legal documentation.

This chapter explores the legal side of producing. Its purpose is to offer many of the legal basics that every producer should know. However, it is simply a guide, and a beginning producer should also consult other sources for backup or additional information: an experienced entertainment attorney, books and resources, publications, the Internet, or a legal aid service for further in-depth legal and business information.

In this chapter, we explore the primary legal aspects involved in producing—owning or optioning the story material in your project, protecting the many components of your project, and then double-checking all these elements. When you've done all this, you have given your idea, and yourself, legal protection and the freedom to move forward.

The Entertainment Lawyer

Whether you are new to producing or have years of experience, you want a strong alliance with an entertainment lawyer. He can help protect you and your project before you enter into any kind of binding agreement. Entertainment law is highly specialized, and a certified entertainment lawyer is not only competent in state and federal law but

is also familiar with the complex wording of contracts, releases, agreements, and dozens of other legal documents.

In addition to reviewing the legal documents involved in your production, some entertainment lawyers can be a big help in pitching projects or making valuable connections with financing sources, production companies, directors, even talent. The lawyer can open doors for you by sending an introductory cover letter to the networks, studios, and production companies. Most executives won't take a pitch unless they know that you have legal representation. And if your agent or other representative sells your work, the lawyer subsequently drafts and coordinates the contracts.

Lawyers get paid in several ways: by the hour, by the project, for a flat fee, or as an ongoing line in the project's budget. Some lawyers might take a lump sum up front, either as a *retainer* (not used toward any fees; this money is paid simply to retain the lawyer), or as an *advance* that the lawyer works off on an hourly fee basis. Discuss the fee structure with your lawyer at the beginning of the first meeting, and come prepared with a list of questions. Each minute you waste costs money. Whatever the amount, sound legal advice is worth the investment and could save your project significant costs down the line. In many ways, the entertainment lawyer could make the difference between your project's success and its failure.

If you can't fit the cost of an entertainment attorney into your budget, look for a legal aid organization in your area. You might consult with universities that have legal departments, or contact groups such as the Volunteer Lawyers for the Arts. There are boilerplate contracts available in books, articles, and information online; many can be customized for your project.

Intellectual Property Law

For producers, virtually every project involves an aspect of intellectual property that is covered by a set of laws. Any product of the human intellect—a creation of the mind—that is unique and has some value in the marketplace falls under the term *intellectual property* (or IP). This includes literary works, music, sculpture and art, inventions, images and symbols, and unique names, as well as publicity rights, unfair competition, and misappropriation. In essence, intellectual property rights allow an artist the freedom to be creative with the promise of ownership that protects his or her work from being used by others without compensation or recognition.

It's important to understand that each country is bound by its own IP laws. Just because one country operates under a specific set of laws by no means assumes that other countries follow suit. There is no sole worldwide copyright law, for example; each country has its own set of laws. And because the laws vary widely from country to country, we focus primarily on American laws and on some British law in this book. Readers living in other countries can consult their local legal experts and sources. In America, intellectual property law includes:

- **Copyright law**. Protects creative or artistic expression of an idea.
- **Trademark law**. Protects distinctive symbols used in relation to services or products.
- **Patent law**. Protects inventions.

Copyright Law

Maybe you've got a great idea for a TV show: some college kids live together; their daily experiences are filled with fun, romance, and conflict. OK. So far, it's just an idea,

and not a particularly original one. Anyone can use it. This rough idea is the *core creative concept* at its most basic.

But when you define the number and gender of the students (three British guys, two American girls, and one Indian girl), give them specific names and background stories and individual characteristics, put them in a four-bedroom converted carriage house in Camden Town in north London, and then write a defined script that fleshes out these details, you've created the *expression* of this core idea. It's this expression—the script with its details—that is protected by copyright.

A copyright protects works that have been created and preserved in any tangible form of expression—such as written works, video and film, photography, music, multimedia, software, drama, pantomime, choreography, motion pictures, and sound recordings. It's a right that is granted to the author or creator of "original works of authorship" and includes having the exclusive rights to exploit his or her copyrighted work, with the sole privilege of multiplying copies, publishing, and selling them.

Copyright Protection

Essentially, once you have translated your idea from your mind onto a fixed medium, like a piece of paper, a canvas, computer, or photograph, it's automatically copyrighted; it doesn't necessarily require official copyright registration to protect rights of the copyright holder. The advantage of officially registering a copyright (see later) is that it provides specific evidence of its valid exact copyright dates and ownership, and gives the copyright holder (the artist) an advantage in seeking statutory damages, loss of profit, and/or attorney's fees.

Copyright Symbol

The symbol of a copyrighted work is © and should be affixed to anything you write, produce, draw, compose, and create. A copyright forbids only actual direct copying. If a writer or musician creates work that has an idea similar to, but not an exact copy of, someone else's, it will generally not be considered an infringement of someone else's copyright. It can only be the actual expression of that idea that's protected.

Copyright Terms

The terms of most American copyrights now last for the lives of the authors plus 70 years after their death. Most films and stills that are less than 95 years old are also copyright protected—the best way to verify a copyright is to do a copyright search with the Library of Congress. Copyrights that have expired allow those works to fall into the *public domain* (meaning they are no longer protected by copyright law and can be freely adapted). Many producers and writers have adapted or overtly copied the works of major writers, artists, and musicians available from this rich repository—the public domain.

However, not everything can be copyrighted. Only the expression of a creative or artistic idea can be protected. Ideas, titles, themes, or general concepts aren't protected by copyright law until they are written down, filmed, painted, or somehow made tangible. Facts are also unable to be copyrighted. You can't copyright the facts of a person's life or a historical event, but you can copyright your *expression* of that idea—the script you have written about the person or the event. Rights are usually not necessary when your project involves a public or historical figure, although there are always exceptions.

The area of copyright law is a complex one, riddled with legal potholes. So should you have any doubts about who holds the copyright to a work that interests you, it

will save you valuable time and money—and potential lawsuits later—to verify its legal rights holders early in the process.

Work-for-Hire Clause

In both America and the United Kingdom, a producer or writer or other creative who is employed by a network, a production company, or other media employer is usually working under a *work-for-hire* agreement. This states that the employer owns the copyright to the work that the employee developed while in their employment. This is the usual trade-off when the employer does the hiring and pays the bills. In some cases, the producer can negotiate for revenues from foreign broadcast rights, syndication, home video rights, merchandising, books and publishing, and other possible bonuses, depending on the terms of the employment contract.

Once a work has actually been created and translated into tangible form (book, film, portrait, still), it is considered legally protected. When a copyright notice © is attached, this requires that anyone wanting to use your work must contact you for licensing fees and permissions. To copyright your work in America, call the U.S. Copyright Office in Washington, D.C. at (800) 688-9889, or register your work online at www.copyright.gov. The fee to register is under $50.

Fair Use Defense

Under its terms, the Copyright Act allows for some legal exceptions to U.S. trademark and copyright laws, situations in which copyrighted material can be used without the copyright holder's permission. This clause is known as *fair use*. When a producer uses another person's copyrighted material—like a film clip or video footage, art, photographs, or music—in specific circumstances, the producer isn't required to have the copyright owner's permission. The producer can claim the defense of fair use, which declares that the work has been used in a reasonable, "fair" manner that poses no competition to the copyright holder's finances or reputation.

The fair use defense is generally claimed when the public interest is served. This can apply to news reporting, review, analysis and criticism, teaching or scholarship, and commentary. One example is the use of a short music segment or a film clip in a documentary or a news piece. Fair use often applies in parodies of material, either to make a social comment or for humorous effect; it's usually considered fair use if it's clear that the parody is just that—a parody.

But fair use may not always apply, and it can easily be misused or misinterpreted. As included as part of the Copyright Act of 1976, there are four determining factors under which the fair use defense can be considered. These factors include:

- The purpose and character of the use, including whether such use is of a commercial nature or is for nonprofit educational purposes
- The nature of the original copyrighted work
- The amount and substantiality of the portion used in relation to the copyrighted work as a whole
- The effect of the use upon the potential market or value of the copyrighted work

Fair Use for Documentary Filmmakers

In November 2005, a statement of best practices in fair use was released after long discussion, debate, and research. The study was compiled by an impressive group of legal experts, scholars, filmmakers, universities, and media-based organizations. *Documentary Filmmakers' Statement of Best Practices in Fair Use*

(centerforsocialmedia.org/fairuse) was born of the frustration felt by documentarians who, when they finally located the right footage that could best tell their story, weren't legally allowed to use it. Either the copyright holder would not give permission, the licensing fees were exorbitant, or the copyright holder could not be located, despite all efforts.

This group organized their thinking around four classes of situations that filmmakers consistently deal with in every phase of production. In each case, it's possible to apply the fair use defense; they include:

- Employing copyrighted material as the object of social, political, or cultural critique
- Quoting copyrighted works of popular culture to illustrate an argument or point
- Capturing copyrighted media content in the process of filming something else
- Using copyrighted material in a historical sequence

Fair Use in the Digital Domain

The previous statement provided succinct guidelines for documentary filmmakers. Another statement was released by the Center for Social Media and the Program on Information Justice and Intellectual Property that provides similar situations of the fair use defense for online content producers. This study, called *Recut, Reframe, Recycle: Quoting Copyrighted Material in User-Generated Video*, outlines its methodology and research results, including in-depth details and provocative examples of the nine categories in which the fair use clause might apply. The easy-to-understand study can be found at centerforsocialmedia.org/recut along with specific examples for each of the following nine categories in which fair use can be considered, under the U.S. copyright law itself, to encourage the production of culture:

 I. Satire and Parody
 II. Negative or Critical Commentary
 III. Positive Commentary
 IV. Quoting to Trigger Discussion
 V. Illustration or Example
 VI. Incidental Use
 VII. Personal Reportage or Diaries
 VIII. Archiving of Vulnerable or Revealing Materials
 IX. Pastiche or Collage

Fair Use in User-Generated Content

As the name suggests, UGC (user-generated content) is produced by amateur filmmakers, with a smattering of professionally produced content, and is contributed to an online UGC site by anyone with the skills, time, and the right equipment. Another description for UGC videos is viral videos—videos that are clever, evocative, edgy, informative, or in some way have spread virally, by word of mouth and email. There are literally billions of UGC videos spiraling through cyberspace and being shared in every language and in every country.

Avoiding Copyrighted Material

To protect themselves against possible copyright or trademark infringement, some producers insist on blurring out recognizable logos, artwork, or posters on the wall behind an actor, brand names on a T-shirt, or products with obvious logos. If they're given a choice between one piece of footage or music that is copyrighted versus a

better one that isn't cleared, producers might take the safer legal route. Their understandable paranoia often constricts their creative and narrative reach, yet they feel they must play it safe. Quality and passion for the project is sacrificed as a result.

Because fair use is an area of the law that's consistently ambiguous, it's currently under close scrutiny by producers and broadcasters. It raises important issues of free speech and creative freedom, especially in the United States in relation to the concept of free speech. Fair use is actually a defense to a finding of copyright infringement, an assurance that the defense is valid and legal. It's always prudent to consult an entertainment lawyer who has experience with issues of fair use; she can often negotiate rights for a lower fee, or can assure the network or insurer that your fair use claim is valid and legal.

The concept of fair use can be speculative. Most U.S. networks, distributors, and Errors & Omission (E&O) insurers require that the producer provides documentation that protects them from possible lawsuits or copyright infringement arguments. Insurers aren't risk takers by nature, and if there's litigation, it's up to the producer/defendant to prove that the use of the copyrighted material was indeed fair and not a copyright infringement. The cost of legal fees can be so exorbitant that it dissuades producers from using material that legitimately falls under the fair use defense.

Conversely, taking risks can prove successful, and much cheaper than paying research fees and licensing costs. The nature of our litigious society can be daunting, and the creative rights of artists, filmmakers, composers, and others linger in a legal abyss as dedicated people with true conviction on both sides battle it out. An increasing number of filmmakers are willing to test the limits of fair use in order to preserve their freedom of expression.

One popular alternative to the "all rights restricted" copyright is the Creative Commons license. Creative Commons is a nonprofit organization that provides copyright licenses that allow for varying degrees of protection, from a license that allows for practically any re-use and re-appropriation of a protected work to licenses that offer more restricted re-use and re-appropriation. For example, one license allows users to re-use the copyrighted material at will, provided they give credit to the original creator. Creative Commons licenses encourage collaboration and the trade and expansion of media works. For more information, visit creativecommons.org.

Trademark

The overall purpose of a trademark is to protect the consumer—to distinguish one product and/or service from another. An organization, individual, or other legal entity may choose a name, a word, a phrase, a symbol, design, logo, image, or combination of any of these components and simply use it. It can also be filed with the U.S. Patent and Trademarks Office, which further protects the holder in any formal procedures. When it is registered, the holder can use the symbol ®. You can learn more about this at www.uspto.gov.

The indication of a trademark is the symbol connected to it (™). A trademark includes any word, symbol, name, or device that distinguishes certain products, services, or items from another like it. Trademarks serve as a source of origin: you may prefer Heinz ketchup, or Kellogg's cereals, or Cadbury's chocolates—each is identified with an aspect of quality assurance. Brands, consumer goods, even buildings and well-known landmarks can be trademarked. So can a movie title. In almost all cases, you don't need permission from the trademark holder if a trademarked item appears in your piece. If, on the other hand, you plan to refer to this trademarked object in

a negative or derogatory way, they may pursue legal avenues to make you stop, to charge licensing fees, or to slap you with a lawsuit. To check if something is trademarked (or patented, as discussed next), check with the U.S. Patent and Trademark Office.

Patent

When the U.S. Patent and Trademark Office grants a patent to an inventor in America, it gives the right to the inventor to prevent other people from making, using, offering to sell or selling, or importing the invention. It can be a machine, a process, or a manufactured article and must be new, inventive, useful, and/or industrially applicable. The term of a U.S. patent is usually 20 years from the date on which the application for the patent was filed. Patent laws and clearances are seldom an issue in television or emerging media production.

Public Domain

After the U.S. copyright of material expires, it usually falls into a free use area known as the *public domain*. There is an appreciable amount of available literary material, music, photography, and other artistic expression that is no longer protected by copyright and can be freely used by producers. This material includes works by literally hundreds of authors, artists, composers, lyricists, and others.

Public domain material is appealing to producers and broadcasters because the rights to use it are free. However, although the material itself may be in the public domain, it may have been adapted or used by someone else, and that expression of the original work has been copyrighted. For example, the music of Chopin is in the public domain, but if the London Philharmonic Orchestra records it with their arrangement, their musicians, and their unique interpretation, they own the copyright, and their recording cannot be used without their permission. Your option is to record the music of Chopin with your own musicians, paying only them and not the composer. Make sure any work you might be considering falls completely and legally within the public domain status. You'll usually need to show documentation of this clearance as a requirement for getting production insurance.

Orphan Work

A producer isn't always able to locate the holder of the copyright for a film clip or piece of music. Sometimes, it isn't clear if the material actually falls into the public domain category. This kind of undeclared material is known as *orphan work* and creates a legal nightmare for the producer. There is potential risk in using this material without permission, but if the producer has genuinely pursued all avenues available to find the copyright holder—and provides clear documentation and backup of all efforts and intent—that can be strong proof of diligence if there are legal ramifications later.

Writers Guild of America Registration

Producers and writers often protect their work by registering it with the Writers Guild of America (WGA), the primary union for television and film writers. Registering thousands of scripts each year, the WGA registration establishes the completion date of a literary property, which includes written treatments, outlines, synopses, and full scripts that have been written for radio, theatrical, television, motion picture, and emerging media. The registration provides a dated record "of the writer's claim to authorship" of the registered literary material. WGA, similar to copyrights, cannot protect a title. This registration is valid for up to five years, and it can be renewed for another five

years. A non-WGA member can register a script for a small fee. Check the organization's website, www.wga.org, for more details.

The Myth of the Postal Registration

In this scenario, a writer finishes her script, puts it in an envelope and seals it, takes it to the post office, and sends it to herself via registered mail, keeping it unopened. She's now confident that she can prove when, and where, she established the origin of her work.

This is an urban myth, and U.S. courts don't recognize this method of proving ownership or date and time of its origin. To prevent any litigation, you're best to register your project at www.copyright.gov. In some countries such as the United Kingdom and the Netherlands, however, this "poor man's registration" has a bit more legitimacy and is recognized in some courtroom dealings. A copyright is a better alternative.

II. IF YOU DON'T OWN IT, GET PERMISSION TO USE IT

> In the course of the life of a project, you have to start dealing with third parties, with other people. If a book, for example, is going to be the basis of a movie, or if there is somebody's story, somebody's life rights, or if you need to get particular access to a building or certain circumstances—these are all obvious triggers for a conversation with a lawyer. When you start dealing with third parties, you have to make arrangements with them, and you have to get certain rights or permissions or clearances from them. That's when it probably makes sense to start talking to a lawyer and make sure that you are getting what you need—and that you are not getting more than you need, and not overpaying for more than you need.
>
> **J. Stephen Sheppard, excerpt from interview in Chapter 11**

If you didn't create your project idea, it is owned by someone else. If you want to use it, you first have to get permission. Permission to use it might be granted for free or for a fee, and for a specified amount of time. This applies to almost every aspect of your project: the script, the music, clips, images, photographs, products with brand names, props, and more. It is the job of the producer to legally protect every single component with some form of permission attached.

Licensing

When a body of work—a screenplay, a drawing, a piece of music—has been copyrighted, the rights to use it in a project must be either paid for outright or *licensed* for a fee. The producer (or the producer's employer) pays a fee for the right to use this copyrighted material. The financial involvements and legal aspects of licensing are highly complex; they cover artist representations and credits, copyright, promotional approvals, and much more. We will explore some of the primary areas of licensing, next, as you continue to research updated information and changes, even consult with legal experts, in the ever-evolving landscapes of digital and emerging media.

Brand licensing can also be a highly lucrative opportunity for a producer. A cooking show, for example, sells the license of the show to spin off other shows for its host, cookbooks, cooking magazines and websites, a line of food items or cooking tools—all bearing the brand of the cooking show.

However, the area of licensing is a highly specialized area. It requires specific contracts, including elements of exclusivity, duration of use, definition of media, insurance,

and more. In addition to talking with an entertainment lawyer, producers can consult with a company that specializes in rights and clearances. Both are experts whose advice is almost mandatory when considering the area of licensing.

Literary Rights and Clearances

Your storyline might rely on the use of material such as books, online research material, manuscripts, articles, treatments, outlines, newspaper columns or stories, and biographies and autobiographies, as well as adaptations, theatrical plays, or public performance rights. If you don't control all the rights involved in your project, you have no legal foundation upon which you can develop it. You will need to either:

- **Option the rights**. Negotiate for exclusive, limited rights to the project in return for a fee or agreement.
- **Buy the rights**. Negotiate to buy and permanently own all ownership rights.

Imagine that you have a novel you want to adapt into a two-hour network broadcast special. Your first step is to contact the author's publisher, agent, or attorney, or, if the author has died, the representative of the author's estate. Then, you'll write a compelling letter that outlines your project and the significance of the requested material to your project. You may want to option the material for a limited period of time (six months to two years, for example) so you can generate interest, raise funds, and develop the project. Or, you may want to buy it outright, in perpetuity, and hold worldwide rights for all media. Both options are open to negotiation and require discussion between you, your attorney, and the holder of the copyright.

Music Rights and Clearances

Most producers thoroughly appreciate the impact that music can have on a project: an identifiable theme for the show's opening credits, mood music through the show itself, end music for the closing credits. Music can inject suspense or humor or sorrow, and is yet another expression of your creative vision.

But music can be legal quicksand for a producer. Unless you are using original music that has been scored especially for your project, you must get *clearance*, or permission, for *a license* that grants you the right to use any preexisting musical compositions and recordings that are owned by someone else. If your music hasn't been licensed, it could mean delays, lawsuits, and even the possible termination of your project. For music rights clearances, by all means check either with an entertainment lawyer or with a music clearance service.

In almost every country, music falls under that country's specific copyright protection. It falls on the producer (or a music clearance service or lawyer) to determine who owns the copyright, to negotiate for permission with the copyright owner to use it, and to pay the fees that are necessary to get the clearances. Some of the larger networks and cable channels have blanket license agreements, though these agreements don't cover each and every piece of music; each still needs to be researched.

Music Licenses

There are two kinds of music licenses in the United States. Most preexisting and/or recorded music requires that you get both:

- *A sync (synchronization) license*. Gives you the right to "sync up" or match a song or music to your visual image. The publisher represents the composer of the music (the person who wrote and/or arranged the music) and the songwriter

(the person who wrote the lyrics, if any). The publisher owns and grants the right to include the actual composition or piece of music that is synchronized to the picture. The songwriter(s) of that composition assigns his or her copyright to the publisher who shares any royalties; the songwriter(s) might also retain rights to grant the license. Some compositions can also have multiple publishers who own portions of it. These all need clearance.

- ***A master use license***. Gives you the right to play a specific recording in your content. The record label owns the actual audio recording—the performance of the song the way it was recorded in the studio. The label owns and grants the right to include a specific recording of the composition in timed relation to the picture or image. The artist(s) might also need to grant a separate license. Some recordings may include "samples" of other recordings that also require clearances.

Music License Fees

The range of fees you'll pay to use licensed music can boggle the mind, and strain the budget. A popular song's license can range from free to a couple of thousand dollars for a documentary, all the way up to hundreds of thousands for a car commercial airing worldwide.

If you would like to license a song for a production, the artist and the record label will minimally request:

- Detailed information about the project
- A synopsis of the project
- Its genre and length
- Its overall budget including the music budget
- The creative team (the producer, director, actors, and narrator)
- Any funding or donors
- Profit or nonprofit status
- Any distribution plans
- Information and address for the licensee

Music Cue Sheets

Producers—and anyone else involved in the process of music licensing—use a form known as a *cue sheet* for listing each time and place that music appears in the program. This is necessary to calculate fees that must be paid either to ASCAP (American Society of Composers, Authors and Publishers) or to BMI (Broadcast Music Incorporated), who use these cue sheets to identify the publishers and composers who are to be paid and what percentage of the royalties they're entitled to receive.

A music cue sheet lists:

- The title of each composition
- The use and timing of each music cue
- The composer(s)
- Publisher(s)
- Their performing rights affiliation

Music Venues, Geographical Territories, and Time Periods

Both the publishers and the record labels want to know how you plan to use their music. It's how they can assess the rights and fees involved. For example, fees charged for music used in a network prime time broadcast are different from those for

music used in an educational nonbroadcast venue. One fee amount might be charged for use, say, on a PBS show, but if that show goes to Blu-ray or the web, additional fees and rights issues could apply.

Publishers and record labels also want to know what geographical territories the rights cover, such as only North American rights and/or world rights, and for how long you want to retain the license (a specific time limit or for perpetuity). Publishers require the title of the composition, its writer(s), and its publisher(s); and record labels require the title of the recorded track, the performing artist, and the source of the recorded track.

Live Music Performances

If you have plans to shoot a performance where live music might be played, or if there is any inclusion of a song's lyrics in the script, make sure you have all the necessary clearances before you shoot the performance. Before you go into the post-production phase, clear all music you intend to use in your opening main credits, montages, background songs, musical underscore, end credits, or anywhere else in the program. The Internet is an excellent source for access to performers, recording artists, songs and compositions, publishers, and recording labels. In some cases, you can actually submit your request for clearances over the Internet.

You may find, after all your research and negotiation, that you are denied clearance to use the musical composition or a recording. The copyright law gives the final say to the owner(s). If you choose to move ahead without clearance, you're liable for copyright infringement and possibly other claims as well. Both ASCAP and BMI regularly monitor television and film as well as other media looking for potential copyright infringement. Their job is to protect the composers, artists, publishers, and record companies from being deprived of the benefits they're entitled to.

Alternative Sources for Licensed Music

Original Music

It often makes sense for a producer to totally bypass the expenses involved in buying licensed music and instead hire a composer to write and record original music. A talented composer often owns his or her own studio and equipment and can work closely with you to create a music track that compliments your vision and production. Many universities have departments for musicians and film and television composers. Young composers are often eager to get experience and projects to add to their demo reel; they can provide a real energy and originality to your project for much lower fees. In certain cases, a student can work on your project as an independent study for which he or she can get school credit.

You can consider hiring a composer on a *work-for-hire* basis. Here, all publishing and recording rights for any music composed specifically for your project by the composer belong to you. In exchange, you'll pay a fee and work out your contract details, including screen credit, soundtrack residuals, and other details that could be involved down the road. If you do have music composed specifically for your project, you want to avoid any music that could bear a strong resemblance to a well-known piece. Even this might attract a lawsuit.

For any of these options, work closely with an entertainment lawyer and/or a music clearance company. Both have established links with licensing departments who can navigate the system quickly and legally. For more complex projects involving music rights, you can hire a music supervisor whose job it is to find the right music and then to research clearances.

Stock Music

A viable option to licensed prerecorded or original music is *stock* music—also known as *production* music—that has been composed and recorded especially for a stock music house. It's considerably cheaper and is generally *royalty-free*. This means that the producer usually pays a one-time fee for a one-time-only use or for an unlimited use of stock music, depending on the terms agreed upon. The music's rights have been cleared for sale. The prices tend to vary, depending on the music's end use—a nonbroadcast one-time use is much less expensive than use in a prime-time network drama, for example.

The variations of available stock music are impressive, covering all genres, emotions, rhythms, and timing. As technology gets more sophisticated, composers can simulate the sound of any instrument, from an entire classical orchestra to a single acoustical guitar. Most music libraries also provide sound effects, which are often referred to as *needle drops*. The range of available effects is staggering—from different bird and cricket sounds, to engines, gunshots, footsteps, screams, laughter, applause, and thousands of other choices. In most cases, they are quite reasonable to license.

Stock Footage

Similar to stock music, *stock footage* includes photographs, film, video, images, animation, and clip art that has been catalogued and archived and is available for a fee. Depending on its end use, the footage can be licensed and often can be purchased and/or come royalty-free, from hundreds of organizations that sell:

- **Archived footage with a historical focus.** Usually shot in 16- or 35-mm film, footage includes historic events, old newsreel footage, documentary material, clips, or whole programs from early films and television.
- **Stock footage specifically shot for resale.** Generally shot in high-quality video or film, stock footage can be an excellent and inexpensive alternative to costly aerial shots of cities or landscapes, time-lapse footage, or establishing shots such as the front of Buckingham Palace or the Hollywood sign.

Stock footage can also provide a realistic-appearing background for blue-screen backgrounds, used in creating virtual sets.

Network Footage Clearances

For your project, you may want to use a clip of footage you've seen in a network or cable show, in a movie, a news broadcast, or online. To get the legal right to use this footage, contact the Rights and Clearances (R&C) department from the broadcaster; this department focuses on rights and clearances and handles requests by producers to license their footage.

The R&C department first considers the source of the request, how the clips will be used, what fees to charge, and the details of the licensing agreement They also determine that the clips are not denigrating their company in any way, and that they own the legal rights to the material.

Some networks or production companies can charge as much as $200 per second or as little as $25, depending on the exclusivity and content of the material. Other fees can be considerably more, or a lot less, and occasionally might even be free. This depends on several factors: Will this footage be used for broadcast or nonbroadcast? Online, in Blu-ray sales, or for corporate training? Is the request coming from an educational, nonprofit source, or from a rival broadcast network that might profit by

featuring the footage in a program? What geographical territories does the use cover? For how long is the footage being licensed? The combination of answers to all these questions will determine your final fees and rights.

The Right of Publicity

This area of the law addresses our basic right to prevent someone from using our name, our image, or our voice for commercial purposes, or for any reason, without first getting our permission. Even a celebrity look-alike or sound-alike can be fertile grounds for a lawsuit. Although the right of publicity usually affects celebrities who have been exploited without their permission in advertising or in some other form of media, it can apply to any of us.

Producers are especially diligent in this area, knowing that each state has its own laws. You'll get written permission (a talent release) from every person you may be shooting or recording, from regular citizens, to politicians and well-known public figures. Make sure that this release is easy to understand.

III. PROTECT IT

> The most important thing is to know your audience, and also know that probably any idea you have, there are a hundred other people with that same idea and you'd better have something unique and special about your particular take on it. There is not an original idea—there hasn't been since I've been around. There are just reinterpretations of things, and particularly nonfiction, where you can't copyright an idea.
>
> **Brett Morgen, excerpt from interview in Chapter 11**

In the world of ideas, new projects can simultaneously erupt from different pockets of the collective unconscious. Your sitcom pitch about modern-day pirates, for example, may be unique to you, but the network has already been developing a similar idea for months. It happens all the time.

Both Sides of Plagiarism Protection

Because of their understandable aversion to plagiarism lawsuits, the group or network that you're pitching to will ask you to sign what is known as a *submission release*, especially if you aren't represented by an agent or lawyer. Essentially, this release says that you are the legal owner of the material you're pitching, that you have given them your permission to read and consider your pitch and to share it with others in their company, that they are under no obligation to use the material, and that if they are in the process of developing a project similar to yours, it's a coincidence.

First the Pitch, Then the Protection

This group, after hearing your pitch, may decide to greenlight it, and you shake on it. After you've celebrated, get back to reality and get every detail between you and the interested parties in writing. An agreement between professionals is more resilient when it's detailed on paper. If you don't have a written contract, it is almost impossible to receive any kind of compensation if the details are later questioned.

A traditional contract between a producer and a client specifies:

- How much time you all agree that it could take to develop, write, shoot, edit, and mix your project
- How much money that time is worth

CHAPTER 5 Welcome to Reality: Legalities and Rights

In most cases, the client prepares the contract. The onus is on you and your lawyer to ask for explanations or changes.

Before you consider drafting any contracts, agreements, deal memos, or releases, talk first with your entertainment lawyer. If you don't have a lawyer, research similar agreements in books and on websites, or talk with experienced producers. Find the format and wording that you can understand, adapt it to your specific project, and keep it short and to the point. Brevity can prevent misunderstandings.

> The ultimate goal of a contract is to articulate to the parties what the understanding is between them in such a way that you never have to look at it again. It's to describe the understanding between the parties. It's a very valuable process. What happens in drafting contracts is that I will write something down and send it to the client, or to the other side, and very often they say, "I can't agree to that," so it's a very good thing that we wrote it down that way. So then we change it to what you can agree to or what you think you are agreeing to.
>
> **J. Stephen Sheppard, excerpt from interview in Chapter 11**

Most Common Contracts

The following contracts are those you'll most likely encounter during various stages of producing. As with any legal aspect of entertainment and producing content for media, you can benefit by consulting with a lawyer. In time and with experience, you'll understand contracts and their contexts.

- **Deal memo**. This is the most common legal deal-making document, used by most producers in most circumstances. It is short and sweet, written in more casual language as a one- to three-page letter between the producer and whomever she's hiring. It outlines names, job descriptions, fees, start and stop dates, any mutual expectations, county and state of legal jurisdiction, any additional pertinent information, signatures, and dates. A longer, more formal agreement is sometimes used, called a *letter of agreement*.
- **Long form**. When a deal memo isn't sufficient, as for a license agreement or distribution deal, or for a more complicated negotiation, the project may require a long form. It is usually a long 20- to 70-page document, written in formal legalese, and it attempts to present the positions of all concerned participants.
- **Literary releases and options**. A clearly defined outline of the assignment of any literary rights from the copyright holder to the producer, the project, and/or its major participants.
- **Writer employment**. This agreement is between the producer and the writer(s) and outlines the writing and/or revising of a final script for a specific project. It usually follows the WGA contract formats.
- **Director's employment**. Similar to the writer's contract, terms of the director's employment following DGA guidelines are outlined.
- **Pay or play clause**. An added clause, usually part of a deal memo between the producer and the actor(s), writer(s), and/or director. It is a guarantee that the producer will pay all agreed-upon fees, even if the producer is taken off the project or the project is cancelled.

Contracts for Television and Emerging Media Versus Film

> TV is a fickle business. I'm only good for the length of my contract.
>
> **Tom Brokaw**

In signing a contract for a film project, the producer makes a commitment to work on that one project. Put simply, when the film is completed, so is the contract. It's seldom the case in TV. By contrast, television and emerging media contracts usually require a commitment to the entire run of a series unless your project is a one-off program, which is often the case with pilots. You may start a TV project with a short deal memo that details the essentials of your deal—such as compensation, screen credits, the duration of the project, and so on. A more in-depth, long-form agreement may follow as the success of the project becomes apparent. Contracts for employment on a series and in most aspects of network and premium cable negotiations can be complex, and most rely on long-form contracts.

Fees and Compensation

Financial compensation for the producer, especially for the independent producer or production company, is obviously an important issue to consider. The range of financing can be considerable; for example, a major network pays more money than a premium cable station, which pays more than a standard cable channel, which pays more than a startup online or other emerging media format. Is your project a single documentary, a multipart reality series, or a sitcom? A movie of the week, or a one-camera attempt at creating user-generated content? Each has varying costs and profit margins, and each pays the producer fees and profits based on different fee structures.

Each project has its own budgetary parameters. Compensation for the producer depends on overall budget costs like foreign locations, big stars, complicated rights clearances, animation, and dozens of other elements that are then balanced against any revenue that could be generated through ancillary opportunities. There is no set fee structure, and each deal is on a per-project basis. Some deal structures promise bonuses, others a fee for coming in under budget, or ahead of schedule.

The Three-Phase Deal

For smaller independent producers and production companies, the client—like a network, cable channel, or other end user—first agrees with the producer on an overall total estimated budget. The client then divides the total budget into three distinct phases of payments to be made to the producer over the life of the project.

- *Phase One*. When the initial contract is signed by the producer and the client, one-third of the budget goes to the producer to allocate to the project's needs.
- *Phase Two*. After all principal photography has been completed, the client gives the second third of the budget total to the producer.
- *Phase Three*. When the job has been completed, and all guarantees satisfied, the producer receives the final third.

The Step Deal

Sometimes, it's not feasible to guarantee a writer that she will be the writer of choice for the duration of a project. Sometimes the script just isn't taking form, or the form it's taking isn't what the producer is looking for. So the writer is replaced, or additional writers are brought in to add dialogue or action or to develop a subplot or theme. It's commonplace for the producers to protect themselves and their project by entering into a "step deal" with the writers.

The step deal process divides the fixed payments into various steps, or phases, of developing a script. Each step along the way allows for review and evaluation and gives notice to the writer that the producer can put an end to the relationship after any

step. It's not uncommon for more than one writer to be working on one idea simultaneously; all the writers are working under this similar step deal. All the details of any on-screen writing credit(s) are negotiated on an individual basis.

This is a general overview of the step deal process, though each deal has different requirements:

- **Step One**. Here, the writer usually authors a **synopsis** of the idea. He is paid, whether or not his idea is bought. He may or may not be asked to take part in the next step.
- **Step Two**. The writer completes a full **treatment** of the story and is paid for her work whether it's accepted or not.
- **Step Three**. Generally, one writer is given the go-ahead to develop the **script**. In some cases, additional writers may be paid to write dialogue, relationships, or other elements.

Fees and Funding, Rights and Territories

Often a network, cable channel, or other end user/client gives the producer the full budget amount needed to complete a project and bring it to broadcast or distribution. The producer negotiates a license fee with the buyer that outlines how much they will pay, how many runs they get, and so forth. If there is not enough money to make the project, or if the network is contributing only a percentage of the budget, it's up to the producer to find the remaining money.

Coproduction financing is an example of one funding source. Though this doesn't apply to all projects, the producer sometimes grants the license for specified rights to the end user, who can then transmit the program or content domestically, over a certain time period, and in clearly defined territories. The producer still owns the project and retains all the rights connected to it, other than those granted to the domestic network.

The producer can then negotiate with broadcasters or end users in other countries for additional monies to fill the budget gap. This gives the broadcasters the rights to air the project, but only for a specific time in defined territories. Coproduction financing can be a complicated process. Everyone involved wants as much as possible out of the deal, like home video rights, emerging media rights, extensions of territory and broadcast time periods, and net profit splits. This is another area where an entertainment lawyer or coproduction specialist is an essential component of the producer's team.

Most Favored Nation

Some projects are works of genuine passion and commitment, but they have a bare-bones budget. The project's success is more important to everyone involved than their salaries, especially in documentaries and independent productions. Joining the pack are ventures into emerging media and delivery systems. All the players—the producers, actors, writers, directors, and financial participants—value the importance of the creative direction and story content enough to take equal salaries.

When, for example, the casting of a project is based on a *most favored nation* (MFN) clause, this ensures that equal opportunities are extended to all parties involved. Everyone has agreed to receive the same salary, and they get equal treatment in terms of work conditions. They might also agree to alphabetized on-screen credits rather than ranking their names by star power and/or salary levels. Everyone gets the same amount and shares equal parity. Salaries under MFN generally tend to be union scale

plus 10 percent. MFN can also apply to a soundtrack; when one artist agrees to take a specific fee for use of a song, all other artists also agree to the same fee for their songs.

Insurance Coverage and Policies

In the same way that the producer protects her project legally, she also wants to protect it financially. This is where insurance comes into the picture. Because producing for television and emerging media can be an expensive proposition, and often in the firing line of possible litigation, insurance is always included in the costs. This, like entertainment law, is a complex aspect of producing; most producers consult with professionals who specialize in this financial arena.

One form of protection is a *completion bond*, a form of insurance sometimes required in television, corporate, and new-media production. The bond guarantees to the parent company or client that you can complete the job, and that you will fulfill all the requirements of delivery. Bond holders can legally take over much of a project's control. They can fire the crew and do whatever else they feel will bring the project back on track.

After the producer submits the shooting script, the budget, shooting schedule, the financing plan, and the bios of key production personnel, the bond company reviews them and meets with the producer and director to discuss ways the project will be produced. The primary requirement by the completion bond company mandates that the producer and the team bring the project in, on or under budget and by a specific date. The costs for the completion bond usually runs around 3 percent of the budget's total.

Other insurance coverage could include *workers' compensation* and *liability insurance*, as well as extra insurance riders that might cover a variety of contingencies, like stunt work, foreign locations, equipment, and other aspects of production. Although this is more common in filmmaking, some networks or distributors require this extra protection. You'll find more detailed information in Chapter 4.

IV. DOUBLE-CHECK IT

Reviewing and checking each legal document is a vital part of the producer's job. Some documents require extensive research and review by an entertainment attorney, although the majority of contracts, releases, and clearances are standardized forms that are preprinted or available on software program templates.

Find the Right Attorney

You want an experienced attorney who is reputable, knowledgeable, and respected within the media industry. Using a lawyer simply because he or she is inexpensive can cost you in the long run. Deal directly with any legal challenges in the beginning of the process, rather than ignoring them until it is too late. Any delays could result in stunningly expensive court fees.

If you don't have access to an attorney and instead rely on shareware template forms, make sure they are current with legal rulings, relevant to your specific needs, and written in language that you can follow.

Review Releases, Clearances, and Permissions

If you haven't gotten a signed release from an on-camera talent or a signed location agreement, or have neglected to obtain permission to use a film clip that your program

depends on, your project could be terminated, or become the magnet for a lawsuit. It is the producer's responsibility to cover all these bases, whether you are an independent producer or on a work-for-hire contract.

Check All Production Contracts

Each specific job requires a new set of contracts. Double-check the details in an often-wordy contract between the producer and the production company, network, or end buyer before it's signed and finalized. Make sure that it is accurate and that it mirrors the deal you think you have agreed on. If the wording is unclear or ambiguous, consult with a lawyer for clarification.

Location Agreements

Because owning a studio or location can be an expensive proposition, producers generally lease or rent spaces in which to shoot. They rely on location scouts to find and secure locations to avoid studio costs; they may need locations like a private home, a public museum, a restaurant, a school cafeteria, a city street, a country meadow, a senior citizens home. Using this site that's owned by someone else requires a location agreement between the owner of the property (or the owner's agent) and the producer.

Agreements With Unions

If you—or a production company you're working with—is a *signatory* to any of the media-related unions (described in the following), this means that you have agreed to use only active dues-paying members of that union in your project. It also means that you can't use *creatives*—writers, actors, directors, crew, or other union members—who are not union members; you as the producer face possible fines or other repercussions.

Unions are the bargaining agents for the on- and off-screen talent in television, film, and some emerging media. The major unions are:

- The Screen Actors Guild (SAG)
- The Directors Guild of America (DGA)
- The Writers Guild of America (WGA)
- The National Association of Broadcast Employees and Technicians–Communication Workers of America (NABET–CWA)
- The American Federation of Television and Radio Artists (AFTRA)
- The American Federation of Musicians (AFM)
- The Producers Guild of America (PGA)
- IATSE

These guilds and unions provide specific services to their members. They take care of payments of residuals, based on a contractually agreed-upon percentage of a project's profits; they also make payments to the members' pension and health plans. They have established specific rules and regulations around their members' work rules, timetables, and work conditions; they also take part in negotiations and arbitrations on the part of their membership. This is all good news to the union member; it's less fun for the producer, whose project's costs and paperwork load are considerably higher when unions are involved.

As you'll see in Chapter 7, the producer's focus is delegated to negotiating with unions and drafting and signing various agreements that outline the terms of the project, job descriptions, fees, contracts, and schedules—just a few of the project's ongoing details. Know the union rules and follow them. When you're hiring, be very clear about your status as either a signatory company or a non-union shop.

On-Screen Credits

Every deal memo or contract outlines the union member's specific screen credits at the opening and/or closing of the show. Negotiation for proper screen credit might include how the credit is phrased, proper spelling, font style and size, how long it stays on the screen, and whether the person's name is by itself or part of a group of names, among other contractual details. This also applies to any advertising on posters, on-air promos, and so forth.

Most programs give screen credits that might include produced by, film by, directed by, story by, written by, and composed by, as well as credits to executive producer(s), and associate producer(s). There may also be extra attention to the opening logo(s) of the production companies, the presentation credits, the executive producer(s), and a longer list in the closing credits that include a "special thanks" section that gives courtesy credits to people and companies who have contributed goods or services, copyrights, and other legally mandated information. You can see examples of credits lists by watching programs similar to yours or by checking specific union-related websites.

Ancillary Revenues

The producer seldom gets rich from ancillary revenues, partially because the formulas used to make the overall calculations are intentionally obtuse and vary with the network, channel, production company, or other end user. The producer's financial participation is usually based on net profits, a tricky area that can be difficult to pin down or audit. Although there are exceptions to this "formula," here is how it works in most cases:

1. The network/end user adds up all revenues from the project, as well as any extra sources of income that total the net profits. Networks and most end users are experts at "creative accounting," so net profits are seldom profitable to anyone but them. The producer is wise to get as much money as possible up front, in salaries, lines on the budget, and other *perks*; whatever extra money comes at the back end is icing on the producer's cake.
2. The network/end user deducts a distribution fee from this net profits total. This fee is paid to itself or an outside distributor for home video, foreign sales, and other ancillary licensing. All production costs, which could include each phase of production, insurance, overhead, services, costs for promotion, and more, are also deducted.
3. The network/end user divides any profit that might still be left between the producer and themselves. The producer usually receives a much smaller percentage than the network, but over time and with experience, producers can negotiate deals that benefit them as well as the network.

Making the Deal: A Final Checklist

- ***Get it in writing***. Protect yourself with ample documentation. Follow up an oral promise with a written memo or email version of the points made and agreed upon.
- ***Take notes***. In a meeting or on the phone, take notes and date them.
- ***Keep a paper trail***. Even in this electronic age, keep hard copies as well as computer backups of correspondence and memos sent and received, and dated. Keep each draft of any screenplays. If you've made some form of contribution to the story, follow that up with a brief memo outlining that contribution—dialogue, story line, theme, subplot, location, etc.

- **Register your work with the WGA**. This is a valuable verification of your ownership; register it before you begin to pitch it around.
- **Check out potential buyers**. Be objective and realistic about excited interest in your project. It may be wonderful, but the people may not be. Check them out thoroughly—search the web, ask other filmmakers, do a credit check.
- **Don't make the first offer**. See what the other side has to offer first. And never sign any binding contracts without thoroughly dissecting each point with your attorney.
- **Keep each promise you make**. If you can't keep it, don't make it.
- **Don't be afraid of negotiation**. In most cases, it is expected.
- **Always try for a win-win**. In this ideal scenario, everyone is happy, and no one sues.
- **When in doubt, hold it out**. Should you suspect that you may not get paid what you originally agreed upon, you can consider holding onto all video, film, or digital material until you've cashed—and cleared—their check.

V. FOCUS ON EMERGING MEDIA
Copyright in the Digital Age

We are in the midst of the digital age. We are not only producing our programming digitally, we're also transmitting it through a multitude of digital delivery systems. We're no longer limited to traditional television broadcasting in thinking about ways to express ourselves through digital media.

People who were previously satisfied to just be passive viewers are now actively contributing their ideas in tangible form to the thousands of online sites that feature *user-generated content* (UGC). The legal parameters for online material are being closely studied and scrutinized by lawyers, producers, traditional networks and cable channels who are setting up online tributaries, music providers, and others. This rapid expansion has created new and challenging legal scenarios for both content providers and content deliverers; at the moment, several factions of legal experts, seasoned filmmakers, and producers are looking closely at best practices for these intellectual property laws and their applications in these new digital territories.

It's a complicated, muddy challenge, as networks, studios, and record labels endeavor to stop online pirates, while those pirates try to stay one step ahead of the corporations whose work they are co-opting.

Some artists and companies have learned to live in a kind of harmony with the infringers. Musicians' work can get prominent exposure when it's appropriated by a popular remix artist like Girl Talk. The major film studios can get mountains of free publicity from fan-made websites and from fan tribute videos on YouTube. Lucasfilm, owner of one of the most lucrative products in world media, the *Star Wars* franchise (and now part of the Disney empire), has generally been very easygoing in their dealing with fans' appropriation of the characters and plots of *Star Wars*, so long as the infringers are not reaping any financial rewards from what they are producing.

Litigious action on the part of the major record labels, studios, and networks has occasionally resulted in public relations nightmares. Fans turned on Metallica after the popular rock band filed a lawsuit against the file-sharing website Napster and more than 300,000 fans who downloaded their songs (Newsweek famously referred to them as "Cyber Narcs"). Fans revolted against AOL-Time Warner after the corporation sent threatening letters to children who put up not-for-profit Harry Potter fan websites.

And the Recording Industry Association of America (the RIAA), representing the major record labels, has been frequently criticized for legal tactics perceived by many as aggressive and bullying.

The Digital Millennium Copyright Act

The Digital Millennium Copyright Act (DMCA) was passed in 1998. Its intent is to monitor, filter, and protect online platform providers (such as social networking sites and user-generated content sites) from litigation, allowing them to promptly remove content if its copyright has been infringed upon. It also criminalizes the unlawful digital distribution of copyrighted works and criminalizes any unlawful attempts to circumvent anti-piracy measures.

Currently, two Internet areas in particular have attracted great attention, and both deserve closer scrutiny:

- *Social networking sites*. These online sites provide a forum for social networking, connecting people with one another via pictures, music, video, blogs and video logs, message boards, and music.
- *User-generated content sites*. Content that is the original creation of someone, or that has been re-edited from other sources, makes up the majority of user-generated content sites, such as YouTube, Vimeo, and seemingly hundreds of others that pop up each week on the Internet.

The Great Challenge of Online Media Piracy

The two primary purposes of copyright law are to protect an author/artist's capacity to obtain commercial benefit from their works, and to allow that author to control how his or her work is distributed and used. While the digital media revolution has undeniably made media production easier and more democratic (that is, more people than ever before can obtain the tools at a reasonable cost and learn the basic skills to produce a piece of media), it has also made it infinitely more difficult for producers to track and control the dissemination of their works.

In the pre-digital age, if a video pirate wanted to bootleg a film or a TV program, they would have to make analog copies of it, resulting in a serious loss in quality. Digital media can be copied with no generation loss—a copy can look exactly as good as the original. And the Internet has enabled that copy to be shuttled around the world through thousands of peer-to-peer networking portals with very little, if any, supervision or policing.

One developing issue in the litigation of digital/online piracy is the failure of most judges and juries to fully understand the complicated technical details of producing and delivering digital media, and their subsequent inability to deliver informed verdicts. Because of their complexity, many cases that actually go to court spend so long there that the cases become prohibitively expensive for smaller independent producers, and thus verdicts often unfairly favor large corporations that can afford to litigate.

Perhaps the greatest challenge ahead of content creators seeking to protect their works from copyright infringement is not to find ways to technologically protect the works, or to sue websites that enable illegal file sharing, but to change the cultural mindset of the Digital Natives, the first generation of people to grow up with access to the Internet. This generation of young people does not fully understand that the media that they consume must be paid for, that albums and movies aren't free, that people make their living in the media industries, and sales revenues are required to keep

those people employed and to keep the industry healthy. The next few decades will no doubt see some major shifts, both legally and culturally, in the landscape of digital/online copyright infringement.

On a Human Level . . .

As an effective producer, you understand the value of making everyone feel that they are being treated fairly—and that includes you. Yet the pressure of making everything fair, and legal, can create an emotional detachment from the people with whom you are making the deal. Stay conscious of this: being a good producer requires being empathetic, involved, and emotionally balanced, as well as staying objective.

SUMMARY

The legal component of producing is as important as the creative, technical, or budgetary needs of your project. In many ways, it is the *most* important part. We live in a litigious society, and an overlooked detail can lead to production delays, even lawsuits. But you can't be expected to know everything, especially as you first embark on your career in producing. So, it's worth the investment to have an entertainment lawyer—and an arsenal of legal textbooks, resources, and templates—on your side.

Now, with all the legal aspects taken care of, you can move more knowledgeably into pitching and selling your idea, coming up in Chapter 6.

REVIEW QUESTIONS

1. Why is legal documentation important to a producer?
2. What are the responsibilities of an entertainment attorney?
3. What are three areas of intellectual property?
4. What's the difference between a copyright and a trademark?
5. How can you legally protect your own project idea?
6. What are the steps you'd need to take if you wanted to use a Top Ten album or single as music for your project?
7. Pose an imaginary situation in which a most favored nation clause could benefit your project.
8. Name three types of production insurance.
9. What's the primary difference between a contract for a film and one for TV or emerging media?
10. Why are screen credits included in a contract?
11. How does the Digital Millennium Copyright Act protect content producers?

CHAPTER 6
Pitching and Selling the Project

THIS CHAPTER'S TALKING POINTS

I Pitching and Selling: The Big Picture
II Research the Pitch
III Create the Pitch
IV Pitch the Pitch
V Keep Pitching
VI Focus on Emerging Media

If a story is in you, it has got to come out.

William Faulkner

I. PITCHING AND SELLING: THE BIG PICTURE

Your idea for a project is great. You're confident that it's a perfect fit for NBC, or HBO, or maybe it could be a breakthrough online series. But you have to sell it first, and selling your project is a real challenge. Because getting the green light might depend entirely on your pitch, this pitch process can be stressful for even a seasoned producer.

In reality, a pitch is just a sales job: you're appealing to someone in a position of power who can approve your project, possibly fund it, and who stands to benefit from its success. In most cases, a pitch has two parts:

- *A written pitch*. Also called a proposal, prospectus, or pitch on paper (POP). In some cases, it includes a detailed business plan, put together by a professional.
- *A verbal pitch*. A face-to-face, in-person meeting where you get a chance to share your idea, project your confidence, and confirm your ability to produce it.

Before you translate your idea to paper and rehearse your pitch, take a moment to explore the bigger picture of both television and emerging media.

It's All About Business

TV and emerging media can both offer a wealth of creative rewards and opportunities for the producer. But commerce is always involved—profits must be the bottom line whether it comes from advertisers, a subscription base, or from an expanding range of other revenue streams. You want your project to be a business opportunity for other

people as well as for you. Can it generate high ratings, online hits, advertising or subscription revenue, critical acclaim, ancillary markets, and an international reach?

Know the Market

When pitching your project, you want to be sure you're pitching it to the right place. Is the network, cable channel, production company, streaming service, online site, or other end user the right venue for your project? Research everything you can about the person or organization to whom you're pitching—their current programming, the company history, what they've paid for similar content, and other details that tell you if this is the right fit for your project.

You benefit by keeping in touch with current projects that producers have sold, and to whom. Read publications and research online sites that target the television and emerging media industries such as *Variety*, *The Hollywood Reporter*, and others. When you first start out, it can be overwhelming—the sheer number of names, companies, broadcasters, production companies, and online sites and delivery systems, but you'll soon recognize names and companies that appear across many of these publications. You can find resources on the Internet that focus on new online sites and ideas, the TV business, chat rooms, and blogs.

Don't ignore the rest of the world. The majority of international markets depend primarily on American and British programming. Some shows that might do only moderate business in their originating country can generate significant profit from international markets. Although the trend is moving toward more programming being locally produced in these markets, they still depend on outside providers. Watch programs produced in other countries, and research the global marketplace: it's a potential goldmine for your project.

II. RESEARCH YOUR PITCH

Writer Dashiell Hammett once advised another writer, Raymond Chandler, to "make it sound fresh." As a producer, you want your project to be unique and have a hook, an originality, that appeals to a viewer. Even if it bears some similarities to an existing show, you want your idea to have its own voice and to offer a solid business opportunity. There are few original ideas anymore, merely their unique reinterpretations. But these interpretations can take on a life of their own with an inspired and capable producer behind them.

When you give your pitch, the development executives or clients are paying attention to your idea, but they're also looking just as closely at you as its producer. They want to see your professionalism, your passion, and your potential to follow through on the project. Do they want to spend months, even years, with you as you all develop the project together? Do you convey confidence and enthusiasm for your project, or could you be seen as a loose cannon who's not capable of collaboration or taking criticism? You want your image to be that of a professional, flexible producer who can be both passionate and realistic.

Pitch to the Right Place

You want your project to be a comfortable fit with the end user's branding, programming schedule, public image, overall vision, and financial capabilities. You wouldn't, for example, pitch a children's cartoon show to a documentary channel, or a sports show to a classic-movie channel. You also don't want to pitch a big-budget, high-concept idea to a low-budget online startup or public access channel.

Do your research before you go into a pitch meeting. You want to know their brand, their logo, their mission statement, the demographics of their audience, their primary advertisers or subscribers, and their budget range.

> I think the most important thing for [young television producers] is to understand that you can take the same pitch to about nine different places, but you need to alter that pitch for each place. So I think a lot of times when people come up with ideas, it's really helpful to know to whom you're pitching. Know which networks serve what audience, and is there a way to change certain aspects of your pitch so it appeals to different networks?
>
> **Brett Morgen, excerpt from interview in Chapter 11**

Get Your Pitch in the Door

After you have researched where you want to pitch, your next step is to find the right person working there to whom you can direct your pitch. There are no set rules or protocol about who will or won't take a pitch. Some people will take a pitch based solely on someone's recommendation. Others might see your written pitch material, and ask to see your *demo reel* as the next step. On occasion, your emailed or faxed pitch might reach the right person who'll ask you to send follow-up material, even the script.

Following the traditional scenario, television development executives usually take a pitch meeting *only* if your lawyer or agent has paved the way with a note or phone call. This assures the executive that you have representation and some credibility. Generally, you'll be asked to sign a *submission release* before they will read the pitch or meet with you.

But the traditional model is changing. Now, independent production companies, large and small, are more often the development vehicles for new projects. They have the valuable connections with the networks and bigger cable channels; they also have the in-house resources to produce a project. Newer, younger cable channels and emerging media companies are more open to taking a "cold" pitch, looking for exciting and edgy material.

Who Do You Know?

Make a list of the people you know or the people they might know who could connect you to an insider for a pitch meeting, or an investor who might help fund your whole project or at least its initial development. This list might include:

- Family and relatives
- Friends and colleagues
- Fellow and former students and professors
- Actors
- Writers
- Directors
- Producers
- Lawyers
- Agents
- Managers
- Investment brokers and accountants
- Professors
- Other professional and creative people

Maybe you've already given a pitch but the project wasn't picked up. Or you may live in an area far from the offices of a network or cable channel. In both cases, you do

have options. For example, you can approach an independent production company that has produced projects similar to yours that might air on the channel or site you have targeted. If the company likes your idea, it may agree to act as an "engine" for your project, pulling your project behind their established working relationships. You can find the names of these production companies in the opening and/or closing credits of a program and research them online.

Potential Markets

Our current media climate involves the gamut of delivery systems—from traditional television to the revolution in streaming media—and the result is an almost unlimited marketplace. TV and its many formats, the Internet, video on demand and Blu-ray, cellular technology, portable media players, video games, streaming services—the list grows exponentially. And each one requires content.

Each market has its advantages and its drawbacks. As a producer, your job demands ongoing self-education: finding in-depth technical, creative, legal, and fiscal information; researching books and online information and articles; talking to producers, professors, and international producers and buyers; taking advantage of classroom instruction; and attending professional conferences and seminars that focus on television and emerging media. Producers interested in succeeding are lifelong learners—it comes with the territory.

Motion Picture Studios

In addition to producing motion pictures, the major film studios produce television programming. They're also developing a strong web presence and exploring other delivery systems for their content. Ideas for programming might start with the studio's executives, or they could come from independent producers or production companies, or from packaging agencies, or a number of other sources.

A network, in most cases, pays a *license fee* to the studio for producing the series for them, and gets the exclusive rights to broadcast the first run of the series along with limited reruns. The studio traditionally retains ownership of the property and can eventually sell it to cable, syndication, or to other markets. Often, a studio and a network, such as Sony and F/X, will coproduce a project with one or more independent production companies.

The guidelines for monetizing online content are far fuzzier. The advertising and business models are all over the map in this young digital era, while the studios, networks, and production companies negotiate with the major unions and discuss among themselves just how best to proceed.

Major Broadcast Networks

By selling your idea to a broadcast network, such as NBC, CBS, ABC, Fox, or the CW, you are likely to be well paid because your program reaches an audience of many millions. However, networks are under pressure by advertisers to bring in high audience ratings and to adhere to certain constraints and formulas, so each network has a Standards and Practices department with strict guidelines that dictate parameters for a program's themes and creative risk-taking.

Cable Channels

Cable channels such as Discovery, the History Channel, A&E, National Geographic, or MTV are also advertiser-supported, yet tend to have lower production budgets with more creative leeway for the producer. Ratings play an important role, but they are

measured in much smaller increments than those of the networks. Advertisers tend to create their ads around specific niche interests and demographics; they can object, or withdraw ad sales if they disagree with programming content. Cable's creative latitude allows for storylines that incorporate more sex, violence, and adult content than the networks.

Premium Cable Channel

Creative control is a key benefit to most producers. You're more likely to have that control from premium cable channels, like HBO and Showtime. Although their budgets tend to be lower than those of the networks, they don't have advertisers to harness them. Their subscriber base is a loyal one, and their ratings aren't as big a concern as they are for the networks. There are few boundaries on adult content or complex themes, and a series like *Weeds* or *Dexter* can attract a large audience base that stays loyal to the channel beyond the life of the series.

Public Television

The traditional role of public television has been to air educational and entertaining programming via independent, noncommercial, local, and national public television stations. Public television is funded by individual memberships, private corporations, and grants, as well as city, state, and/or federal funding. A station can acquire programs that have been independently produced, or it can partially or fully fund and develop a project. Budgets are generally medium to low, and each station adheres to specific standards for the programs it broadcasts. Many producers find that if their project is aired on a local public television station, it can subsequently be picked up by other local or national stations.

Production Companies

A network or broadcaster might have its own in-house production arm, though most also work closely with independent production companies that produce programming for them. These recognized producers are trusted by their clients and act as the engines for smaller production companies and independent producers. They can usher your project into the network, and also offer their experience, staff, and facilities after you have mutually agreed on your involvement, credits, payments, and ongoing interaction with the project. Production companies might be small, local companies, or larger businesses that are listed in the opening and/or closing credits of a television show, the Internet, or in *Variety* or *The Hollywood Reporter*.

Local Television Stations

Most local and regional television stations have limited budgets and depend primarily on pre-produced programming supplied by a network, a syndicator, or producers of paid-programming infomercials. Many stations produce their own programming—children's shows, daytime talk shows geared mostly to women's interests and social issues, home shopping, local weather, how-to shows, news, traffic, and information. A producer can often raise funding from local advertisers that pays for the entire cost of production; this adds an extra appeal to any smaller station to consider your idea more positively.

Syndication

Most programs in syndication have already been broadcast on the networks and now air on local stations. Frequently sold in five-day-a-week *strips* by syndicators, they are usually classic favorites such as *Friends* and *I Love Lucy*. Shows can also be designed

and produced for the syndicated market, airing on local stations in whatever time slot the station chooses. Occasionally, a show starts in syndication and is popular enough to get picked up by a network or cable channel. Budgets for syndicated shows vary considerably, as do the sources of funding.

DVD/Blu-ray

Some programs are first broadcast on a network or cable station or online, are aired a second, maybe a third time, and then go into syndication or reruns. Entire seasons of most hit shows are also often repackaged and sold in DVD and Blu-ray sets. These rights may be solely for home video, with other rights belonging to airing online or other repurposing of the material.

VOD

VOD, or video on demand, is available everywhere. Perhaps it's a recent film on your cable delivery system, like Comcast; it can be the latest episode of a hit show downloaded from iTunes or Netflix and viewed where you choose; you can download thousands of choices directly onto your phone or into an Apple TV or Xbox. Some viewings are free, others are inexpensive to rent or buy.

Direct Mail

This is a growing market for producers who have raised enough money to produce their project through grants, private investors, or other sources but cannot find a broadcast venue. The project may be too politically inflammatory, or it has an adult theme or a specific niche market like home improvement or exercise. Look for online sites and distribution companies that specialize in selling specific projects and genres to clearly defined markets; they can help sell your project. Research the company, making sure they're legitimate and their contracts valid.

Self-Distribution

By far the most ambitious option for selling your project involves distributing it yourself. With the potential reach and marketing possibilities of the Internet, it's possible to reach a tremendous audience. Your how-to-play-golf program, for example, can be promoted, ordered, paid for, and tracked, all online. If you're willing to allow users to download your project for a fee (or for free), the Internet takes care of it all. You might also find advertisers to place banner ads on your website, or to embed short commercials.

But this method can be time-consuming, and it requires not only an entrepreneurial mindset but an initial startup fund, a lot of research, and infinite belief in your project. You could see results—and even profits—if you can navigate the duplication, marketing, mailing lists, and networking, along with the packing and shipping, accounting, and phone calls. Explore successful models of self-distribution before you take the plunge.

There are many phases of a program's potential revenue stream, and each should be spelled out in the contract between the producer and the buyer. Some independent producers create projects specifically designed to be sold to a home video distributor who then markets and sells directly to home video markets like video stores and online sites.

Emerging media markets continue to expand, and although they vary tremendously in technical scope and accessibility, they all rely on content—an out-of-home ad in the

back of a taxi; a mobisode on your cell phone; an alternate reality for a video game; a short film on your portable media player; an ongoing online series. The delivery systems vary, but the integrity of the content is the same.

Understand the International Marketplace

A solid project has the potential for two rounds of audience exposure and income. The first round begins with domestic broadcast or market, and the second extends to the global marketplace. Europe, Latin America, Japan, and Australia are a few of the larger markets who regularly license or buy American and British episodic drama, comedy, children's TV, family shows, and a range of documentaries and reality shows. These markets are generally managed by specialty distributors.

However, there has been a shift in this traditional approach to the international market over the last few years. With advances in technology and increased programming demands from a more sophisticated international audience, local producers and investors are being attracted to creating programming for their specific local and regional needs.

Countries that once acquired programs and series from the United States or the United Kingdom are now producing their own programming. The popular trend is to adapt American and European hit shows that are packaged and sold as formats to fit local protocol, tastes, language, and subtle change. In some cases, local broadcasters may "borrow" key elements as they produce their own version. They create a loyal audience base with shows produced in their own language that are entertaining and reflect local cultural and social issues.

American producers often choose to shoot their projects in other countries such as Canada, where tax incentives and strong currency exchange rates are offered. Several television movies and series use the excellent facilities and experienced crews in places like Prague and New Zealand. Animated shows routinely send their complicated illustration work to Korea and China. The phrase *runaway production* describes the cost-cutting approach taken by American productions to go outside the country for shoots and locations, production personnel, services, and facilities.

The international marketplace continues to fluctuate. The emergence of new media and the merging of large media companies; the presence of the Internet; the mercurial environments of advertising and sponsorship; domestic and international political shifts; economic downturns—these can all affect the sale of your project to the foreign market. With research and time, and by consulting experts in this field, you can evaluate, and hopefully master, the global market.

III. CREATE THE PITCH

The pitch on paper reflects the tone and face of your project. Its graphic format is the first impression the reader sees, and its words and ideas become the "voice" the reader hears.

The Cover Letter

A cover letter generally introduces your pitch. Sometimes known as a *query letter* that accompanies your proposal, it's the recipient's first impression of you and your project, and it plays a strategic role in enticing a potential buyer to consider your proposal.

In some cases, the cover letter can be a stand-alone sales vehicle. It can convince a client, a development executive, an independent producer, or an investor to read your

proposal. It might excite them enough to take a pitch meeting with you, prior to seeing anything more fully developed in writing.

Anyone to whom you might send a proposal probably receives dozens of similar pitches every week, so you want your cover letter to be brief. You also want it to stand out and reveal several things about you and your project that the proposal doesn't:

- The cover letter sets a tone for the attached written proposal.
- It tells a potential buyer why he or she should be interested, financially and creatively.
- It creates enough interest for the reader to read your attached proposal.
- It gives selected highlights of the proposal, like a short promo.
- It reflects *you*: your personality and your voice, and your passion for the project.

You want your cover letter to reflect your professionalism and confidence as a producer, and as importantly, your own personality. Like its author, each cover letter is different, but most follow these simple guidelines:

- If you've been recommended or referred by someone important or known to the recipient, say that right away. Mention in your opening sentence that he or she was kind enough to recommend you.
- Make your first paragraph an attention-grabber, just like a good novel. But overly dramatic is a turnoff.
- Reduce your complex ideas into simple, brief sentences. Each word counts.
- Keep the letter to one page, maximum. Avoid distracting fonts or amateur graphics.
- Allow for margins and open white space; don't crowd your words. Make it easy to read—not everyone has young eyes. Use 12-point Times New Roman or another simple font.
- Use good paper, professional letterhead quality.
- Use a high-quality printer for your copies.
- Make sure you've spelled the person's name and company correctly. Confirm his or her title if you're using it in your letter.

Writing the Cover Letter

Some producers compose their cover letter before they actually start on the written pitch. Others do the opposite, taking the tone of the pitch and echoing it to some degree in the cover letter. When you sign your cover letter "Sincerely," mean it. The cover letter is a business document, but it's also an opportunity for you to demonstrate your passion for and commitment to your pitch. Above all, be courteous and thankful—people want to work with people that they like. There are enough egomaniacs in the media industry already. Here is a sample cover letter.

Your letterhead [Your name, address, city, state or region, country, zip code; email, fax, phone, mobile]

Date

Ms./Mr. [development exec buyer, investor, etc.]
Title
Company

> Address
> City, state or region, country, zip code
>
> Dear Mr./Ms. ___,
>
> At the suggestion of [So-and-So], I'm enclosing a proposal for my television show [or other content] called **It's a Hit** [title], a half-hour [or other length] program about two teenage golf caddies who use their tips to form a rock band in the clubhouse basement [the show's one-liner]. The Chaos Brothers have expressed strong interest in playing the lead roles. [Emphasize any talent with name value attached to your project, such as stars, writers, directors, etc.]
> The story's theme of teenage joys and relationship demons expressed through music [very brief synopsis] bears some similarity to your excellent documentary series on boy bands [make reference to the development exec's former track records] last year. Your production company [or studio, network, independent producer] could be the ideal group with whom to partner in making **It's a Hit**, well, a hit.
> As the producer [and/or writer and/or director] of this project, my background complements the project because [your very brief bio and connection with the story]. I feel strongly that it's highly marketable, appeals to [your project's main target group], and can result in profits and satisfaction for all concerned.
> I'm honored that you're taking the time to consider my project. I look forward to hearing from you at your convenience [and/or to having an opportunity to pitch you in person].
>
> Sincerely [cordially, respectfully, best regards],
>
> Signature
> Printed name
> Title (if any)

The Written Pitch

The professionally written pitch reflects certain industry standards—its basic format is short and sweet, dramatic, and directly to the point. It is selling your idea.

Your pitch is a direct reflection of your project. Also called a *proposal*, *prospectus*, or the *pitch on paper* (POP), this written pitch is a powerful tool. It can make the difference between your project fading away or being successfully produced. Most importantly, a good pitch gives an investor, development executive, end user, or online entrepreneur good reason to trust you with their money.

As with the cover letter, a good pitch attracts the reader's attention and reflects your professionalism. It avoids fancy confusing fonts and complex graphics and instead follows the "three font rule" by using no more than three fonts throughout. Any graphics—such as photos and art work—illustrate an important character or theme, emphasize the words, or show a product. Its pages are bound by a spiral or stapled. Some producers print their proposals using the landscape format, rather than the upright portrait format. This approach makes it easy to hold and use as a great presentation tool during your verbal pitch.

The Basic Elements of the Pitch

- Unlike the cover letter, don't personalize your written pitch. Avoid using the phrases "I think" or "I want to accomplish."

CHAPTER 6 Pitching and Selling the Project

- Write it in the present tense: "the project **is** an exciting exploration of college life," not "the project **will be** an exciting exploration."
- Look for creative ways of infusing the pitch with your ideas, vision, and passion without overworking it.

Each project is different, and each producer takes a unique approach to writing a solid, strong pitch. Most producers integrate any or all of the following components into their written proposals, and they infuse the document with their own individual styles of presentation. The basic elements of a pitch are as follows.

The Title Page as First Impression

This first page tells a mini-story. The title is usually in the largest font, followed by words in smaller font:

- The title
- Genre and length
- The log line
- Author(s)
- Graphics if any
- Name and contact information of agent/lawyer/representative
- WGA registration and/or copyright notice

The Title

A good title can create a memorable impression. It can reflect a genre or mood of your project. *Survivor* and *Ugly Betty* and *24*—each title is short and memorable, sets a tone, and often tells a story in itself.

Genre and Format

Is it a sitcom? Reality show? Episodic drama? Is it a half-hour or one-hour series, or a one-off that airs just once? The page that follows the title page repeats the title at the top, and quickly moves to genre, format, and log line.

The Log Line

(One-liner.) Your log line is a mini-version of your story. It explains the plotline—or parts of it—in just a few words. It can be a snappy appetizer that grabs people's immediate interest. Rotten Tomatoes is an excellent source of log line examples, as are movie and TV ads, promos, movie trailers, and user-generated content sites. Countless shows have been greenlit from a simple but dynamic log line.

Star Value

If a well-known star, director, writer, or producer has shown any interest or a real commitment to your project, highlight that fact in your proposal. If you own exclusive rights to a book, or if you have rare access to a real-life story, this is also valuable information to include as an extra attraction. Your project could also be right for a specific actor who may have his or her own production company. Research this information and approach the company with your proposal. Convince them: you have something no one else has.

The Synopsis

A well-crafted synopsis is easily read and understood. It gives some character detail, but not too much. It gives a direction of the story arc but doesn't digress. It also moves the reader's emotions in some way—anger, sorrow, hope, humor. A synopsis, when done right, confirms that there's a good story at the core of your project.

The Synopsis as Storyteller

The synopsis provides one chance to impress its reader. A couple of narrative paragraphs must reveal the dimension of character, the arc of the story, the clarity and passion of Aristotle's "single issue." The synopsis brings your story to life; it also gives a glimpse into your writing skills. You want the story elements to be organized and to flow smoothly from one segment to the next. As outlined in Chapter 3, you can write your synopsis in the classic three-act format, just much shorter.

The Presentation of Information

You've designed your title page and written a synopsis. Now what? You still have other information that's integral to your project and are genuine sales points. But there are no rules about what order you present them in.

Ideally, after your title page, you want to present your story—pull in the reader with the power of the narrative. Then follow with the other components that bring the story to life. Remember, this is a sales pitch—it's not your life story. It's brief, and it cuts to the chase, while still being eloquent and unique and compelling. Every choice is made thoughtfully—from the choice of your font to the use of graphics, from your choice of the right word to the paper stock to the binding. Each detail reflects your project and reflects you as a professional. Here are some components of a project that you may or may not want to include in your pitch.

Connection to the Project

Are you the producer, the writer, or both? Did it grow from your personal involvement in the story? Maybe you once worked for the FBI and now you want to create a series based on your own stories and experiences from that job.

Comparisons

Producers often compare their project idea to hit shows—maybe they say their project is just like *James Bond* meets *Desperate Housewives*. But what does this really mean? It says derivative, copycat, and safe. Too many preexisting images block a new impression. But if you say something like, "Five women escape the suburban slump and charter a yacht. The fun really starts when they meet the sixth passenger." Give your idea its own identity. Occasionally, you can simply imply a resemblance; for example, "in the spirit of . . ." or "in the tradition of the timeless classic . . ." Your idea should be strong enough to speak for itself and to have its own log line.

The Cast List

Talent or hosts who are well known can lend credibility and quality, as well as appeal to international markets in which the talent is popular. If they're unknown actors or a real-world cast, flesh out his or her character and each relationship to the others.

Style

Emphasize your project's unique stamp. Talk about production design, lighting, the elegant designer wardrobe, and exotic locations. Or stress its realistic approach and edgy noir look.

Research

Is your project reality-based, a documentary, or does it requires extensive research? Are rights clearances involved?

History of the Project

Your project may have its genesis in a book, a stage play, a friend's real-life adventure, or your own creative epiphany. Sometimes, how it started isn't important enough to include in the proposal.

Production Schedule

Provide a short breakdown of your production schedule, including the proposed number of days or weeks needed for pre-production, production, and post-production; how and where you'll shoot; locations and/or constructed sets; and a general project overview.

Creative Team

Devote a brief sentence or paragraph to each key person involved in making your project come to life. As the producer, your own bio should reflect your experience, jobs, awards, professional affiliations, education, and people who can be contacted as references. If you are a student, mention any experience you may have had in television, film, or emerging media, as well as your course of study, pertinent classes, internships, study abroad programs, and independent studies that have added to your skills as a producer. Mention areas that make you more unique, such as fluency in other languages, computer skills, athletic abilities, and travel experience. All this being said, keep it short!

Demographics and Market Description

Create a need for your show. Look for projects like yours that are already on the air and making money, or conversely, provide evidence that there *isn't* anything like your project out there, with convincing arguments for why there should be. Use industry publications, newspapers, and the Internet for credible resources.

Global Markets

International sales can be impressive, and vital to a project's potential sales. Does your project appeal to other cultures' customs, views, and traditions? Can it be dubbed and/or subtitled in other languages? Audiences in every country have their own tastes, so research the markets that routinely buy American or British products as well as the show genre you are pitching.

Budget Top Sheet

The top sheet, or *budget summary*, represents a brief overview of your more detailed, estimated budget. It's a general idea of what your project could cost. Neither the top sheet nor the budget should be included in the proposal unless it specifically has been requested. If you do make a deal, most end users rework your initial budget to suit their company's financial parameters.

The Financial Benefits

Though the financials are seldom included in a pitch, they can be vital when seeking investors. Financials might include a distribution plan, an in-depth financial statement, any tax breaks, projected profits, and the means of transferring funds from an investor to the production account. This area is best handled by an attorney and/or an experienced accountant.

The Video Pitch

Some producers choose to make a mini-version of their project to use as a sales pitch. They'll shoot one pivotal scene from their script, or produce a five-minute "trailer" that

paints a portrait of the project. But there's a caveat to taking this approach: It must be good enough to showcase your creative vision and technical abilities. Don't expect people to depend too much on their imagination and look for something that just isn't there in quality of acting, lighting, production values, and, especially, in the story.

Each pitch is unique. Each takes its own approach. You can weave any of these elements into your pitch, either by using a bullet-point laundry list approach, or in short paragraphs accompanied by graphics. There is no single template that is used by everyone, so without going too far outside the professional box, make your pitch reflect the voice and tone of your project.

> Now for the pitch itself. We're big fans of not sending our pitch materials ahead of time and instead showing up with a simple, but well art-directed pitch book that takes the reader through the concept. We'll usually talk through the pitch and refer to the book as we go. Occasionally we'll use a piece of video or still photos to capture the essence of what we're presenting. The power of a pitch book shouldn't be underestimated. Basically, until your show is produced, the pitch book *is* the show. Everything from the overall look and feel, to the writing, to the design should be reflected in the book. It becomes a great presentational tool and a great way to solidify your own vision of the project.
>
> **Justin Wilkes, excerpt from interview in Chapter 11**

Next Steps With Your Pitch

When you've finally finished your pitch, and before you show it around, legally protect it. Although a document technically is protected by copyright the moment it is written, you can also register your copyright by filing the proper forms with the copyright organization in your country, or register your treatment or script at WGA, either online or by mail. You can review how to best protect your work in Chapter 5.

You may have legally protected the ownership of your project, but most development executives or other end users will insist that you sign a *submission release form* (see Chapter 5) before they'll agree to read your proposal, especially if you aren't represented by an agent or a lawyer. This document protects them from any plagiarism charges you may bring against them later.

What plagiarism charges? Well, let's say that you've got a terrific idea you want to pitch to a major youth-oriented network who wants an online series to increase its presence in the under-25 market. Your story focuses on modern-day pirates who rob from rich yacht owners and give the booty to the poverty-stricken in Cuba and Haiti. It's funny, adventurous, and a great star vehicle. But the network execs insist that you first sign a submission release—unbeknownst to you, they've got a couple of projects already in development, with pirates as their centerpiece. They don't want you to come back later and accuse them of stealing your idea, but they also don't want to lose your idea if it turns out to be better than the ideas they're developing. There just aren't a lot of brilliant and original ideas out there, and often, bright minds truly do think alike—and at the same time.

Other executives will accept a pitch only from your agent or entertainment attorney, though a few may take unsolicited material that is mailed or hand-delivered and will give it to their readers first. Having an "inside contact" is also an effective way to bypass the usual requirements.

CHAPTER 6 Pitching and Selling the Project

IV. PITCH THE PITCH

Whatever you can do or dream you can, begin it. Boldness has genius, power, and magic in it.

Goethe

Without the ideas and motivation of producers, there would be nothing on television, little to watch online, and most Internet and television executives would have no product to sell. So, these buyers stand to profit as much as you do—probably much more—when they can buy, develop, and transmit your project. Your goal is to prove that your project is viable, and that, as its producer, you are focused, passionate, and competent to produce it. Your goal as producer is to inspire confidence all around.

The media world is a small one; everyone knows someone who knows someone else. Seasoned producers know that today's secretary can be tomorrow's big shot who doesn't forget how you treated her back in the day. The guy who answers the phone might also make decisions for the boss, field calls, give feedback, and often write script coverage to see what makes the next round and what gets tossed. How you treat all these people now can get you work later when they've got their boss's job. If you don't give them respect, they can make sure you never get another chance with that company again.

Your intuition and sense of timing is also important. Certain times of the year are death for getting a pitch meeting, or an answer to your query letter. Winter holidays, the summer months, and religious holidays can be dead zones for an aspiring producer to try scheduling a pitch. Instead, ask the assistants or secretaries what times and dates they can suggest. They know their boss's schedule and moods better than anyone.

The Verbal Pitch

Having your written pitch is the first half of the producer's sales job. The second half is your verbal pitch, and it's just as important. The verbal pitch can effectively convey your passion, your professional skills, and your ability to handle the project.

After you've finished your synopsis, begin thinking of it as a script for your verbal pitch. Shorten it into a few punchy sentences: describe your main plotline, the hero and antihero and their journey, the conflict, the resolution. What are your important back stories, and what can you leave out of the pitch? Knowing these basic elements makes it easy for you to succinctly tell a story—an excellent skill for a producer.

The average pitch meeting is short and sweet, with only a few minutes for you to make your sale. The most effective pitches immediately grab the attention of the person or group you're pitching. If they like it, you may be asked to give a longer version that expands on the short pitch or to answer specific questions.

However, not every producer is comfortable giving a verbal pitch; this skill is a unique gift, one that can be a natural gift, or one that's developed. Following are a few approaches to the fine art of pitching.

Prepare Your Elevator Pitch

The elevator pitch is a metaphor for your ability to "own" your project so thoroughly that you can pitch it easily and convincingly, any time and any place—even in the 45 seconds it might take to ride from one floor to another with the president of a television network or film studio.

Practice your pitch, over and over. Clock it with a stopwatch. Make your friends and family listen to it. You should have your pitch down. It should be succinct, clear, and compelling, uncomplicated by back stories, ideals, or irrelevant quirks. Your pitch should grab a stranger's attention within seconds. An elevator, a lobby, a festival, a party, crossing the street—there are people everywhere who might be just the right person to hear your pitch. And to buy it.

Energize the Pitch

Anyone who's in a position to greenlight your project has heard hundreds of pitches, so you want your pitch to shine and to stand out. You want to capture their attention with your idea and with your presentation. As you work on developing your verbal pitch, concentrate on your communications skills, starting with eye contact. Find a balance of enthusiasm and calm in your voice. Keep your body language loose and relaxed, even if that's not how you really feel. Focus on your breathing, and keep it deep and regular.

Memorize the pitch so you can give it without notes, but speak naturally and clearly. Use a timer as you practice to keep the time in mind. You want to keep it down to two to three minutes, even less if possible. Your genuine enthusiasm and confidence can control the meeting when people are as comfortable with you as they are with your project. Forget about yourself, and think about the people who are listening to you as fellow human beings.

There are several approaches you can use in the actual pitch meeting. You can simply talk it through, be direct, and be yourself, occasionally referring to graphics or ideas from your written pitch book. Maybe you act out a short scene, or use a storyboard presentation, or screen a short demo piece, or even use a few well-chosen props. However you choose to deliver your pitch, do what fits the project and your personality. But remember that this is all about selling your idea—so sell it. Don't give it away.

Sometimes, your idea really IS good, and the pitch was equally as successful. But the executive isn't interested because the company has tried a similar idea and it tanked. Or they don't have the budget, or the right scheduling slot for the type of show you've pitched. You can always ask them if they're looking for other ideas, and have some ready to pitch, just in case. You don't want to be known as a one-idea producer, but as one who's a source for many project ideas.

Work With a Partner

If you're pitching with a partner, practice who will be doing and saying what, and in what order. But keep it natural. It doesn't have to be like a Las Vegas routine unless taking that approach is genuinely relevant to your project. Rehearse your roles before the meeting, and come in relaxed, respectful, and enthusiastic. You can have fun with this without draining the energy in the room.

Remember: you may have come to pitch only one idea, but sometimes the people you're pitching may not like your original idea, or they're already in development on something similar. Have one or two ideas ready to pitch, just in case. And you can always entertain the possibility that they might also be interested in you as a producer (and/or writer) for other projects.

The Follow-Up

If you do get a pitch meeting, or even a courtesy phone call from someone in power, email them or send a brief thank-you note for their time. Ask them for any useful

feedback they may have from the meeting. If you're not sure if they're interested in working with you, follow up with a phone call or email. You can be respectfully assertive, but not aggressive. Don't come off as a pest by calling every other day. Know when to move on to the next possible buyer.

V. KEEP PITCHING

> Nothing in this world can take the place of persistence. Talent will not; nothing is more common than unsuccessful people with talent. Genius will not; unrewarded genius is almost a proverb. Education will not; the world is full of educated derelicts. Persistence and determination alone are omnipotent. The slogan "press on" has solved and always will solve the problems of the human race.
>
> **Calvin Coolidge**

The people you pitched usually know what they're looking for, and their suggestions are valuable; they could improve your idea or propel it toward a possible development deal. They can also help you sharpen your pitching skills, or give you valuable references to other buyers.

If the people you've pitched to continue to say no, they usually mean it. Even if they initially seem to be receptive, don't get too excited—this could easily change and often does. If you haven't heard from someone who expressed interest, let a few days pass before you call to check in. Some producers let a week or two go by. It isn't personal. These are busy people who are swamped with work and are considering other producers' pitches and ideas. But if your weekly calls go unreturned for several weeks, take the hint.

Every project you see on TV, online, and on other emerging media formats represents a deal that was agreed on by a buyer and a seller. The producer may have taken the first deal that was offered, or pitched the project to several other places before finding the right one. The negotiations may have been straightforward or highly complex.

The producer is often tempted to hold out for a better offer, believing that you should never accept the first offer or that a sweeter deal could be waiting in the wings. How do you know that the first offer isn't the best? Ask other producers, your attorney, or an accountant. But act on the offer, one way or another, while it is still active and fresh in a buyer's mind.

The Demo Reel

Most producers have a smashing, up-to-date demo reel and send it out to multiple sources when they're looking for work. They edit and regularly update their demo reel, which is a composite of their best work, with short clips and excerpts skillfully assembled. Demo reels are most often distributed online, and help form an overall impression of a producer's ability, experience, and creative approach. Most demo reels don't exceed 5 minutes, 10 at the very most. The first couple of minutes should be good enough to keep the viewer from fast-forwarding or hitting the stop button.

The Pitch Reel

The pitch reel differs from the demo reel in that the pitch reel is created to pitch a specific project, where the demo reel pitches the producer him- or herself. The pitch reel may include spec footage, like a scene from the series/film, or a trailer, or it may feature the writer and/or director discussing the project. In most cases, the pitch

video can demonstrate the tone and the aesthetic better than any pitch on paper. The pitch reel can be screened as part of an in-person pitching session, or find a home online. For many examples of pitch reels, look at the popular crowdfunding websites Kickstarter and IndieGoGo. Those sites require the producers who launch projects there to upload short videos explaining or demonstrating their projects. Some of these pitch videos, like the very clever Kickstarter one Jocelyn Towne made for her independent film *I Am I*, can be as good or better than the work they are promoting. Like the demo reel, the pitch reel is very short, and should run no longer than 5 to 10 minutes.

Networking and Connections

In most situations, real success depends first on *who* you know. *What* you know comes next. Most producers' jobs or project financing comes through connections, colleagues, friends, or friends of friends—ultimately, your reputation backs up their recommendations. You may be smart, creative, and motivated, but you're somewhat hindered if you don't have contacts.

Get to know people who are in the position to help you in as many ways as you can. As you'll see in Chapter 10, you can expand your sphere of connections, and experience, when you:

- Offer to work on student films or independent projects.
- Find internships or apprenticeships.
- Search the Internet for the newest sites and online channels.
- Join media-oriented social networking communities.
- Start your own blog and talk to other people on theirs.
- Volunteer for and/or attend television and film festivals.
- Go to media-centered panel discussions and social mixers.
- Join TV-related organizations.
- Subscribe to industry journals and publications.
- Attend continued education programs that focus on TV, emerging media, and media studies.

VI. FOCUS ON EMERGING MEDIA
Pitching Is Similar

> Except for having more creative latitude in terms of subject matter (a show like *Ash vs. Evil Dead* would never have existed in a network-only world), the pitch process hasn't really changed much since I started. It's about explaining the concept, your vision for the show, the characters and where the stories will lead. We can include more bells and whistles these days, thanks to technology . . . but otherwise it's about the material and the people.
>
> **Mark Verheiden, excerpt from interview in Chapter 11**

Selling to a Streaming Service

Most of the streaming services do not accept unsolicited submissions. They only accept pitches through licensed literary agents, producers, distributors, attorneys, managers, or entertainment executives with whom they have an established relationship. Streaming services like Netflix will also employ a content acquisition team that is always on the lookout for new material. They will purchase finished work from film festivals or tradeshows that serve as marketplaces for television. Additionally, they also produce their own shows internally.

In order to sell your pitch to a streaming service, you can go two routes. You need to first find a distributor or sales agent for your series. They will attempt to make a deal with Netflix on your behalf. You can also take your series to festivals and television tradeshows to hopefully grab the attention of the Netflix creative content acquisition team. Either way, it helps to network with people in the industry who have connections with different streaming services and keep up with this ever-changing market.

There are pros and cons to selling to a streaming service. You get production costs covered upfront and most likely a licensing fee for two to three years depending on what you negotiate. Since streaming services do not have to support the interests of advertisers, there is a great deal of creative freedom for producers. Streaming shows have also raised the bar in quality content, as evidenced by numerous Emmy Awards. It is an attractive seller's market since there is a "streaming war" going on. Each major streaming platform has spent billions of dollars on content, providing ample opportunity for producers (and possibly a big paycheck). On the flip side of the coin, however, the more shows that are developed, the more difficult it is to be seen and to find an audience. This is especially true if the service doesn't provide a deep marketing commitment. Some services like Netflix may not be very transparent with the data on how your show is performing and what level of marketing support they will provide. They are much more likely to market a show heavily if they made a larger investment or are self-producing the content. Some platforms like HBO and Apple are using this to their advantage to steer producers and talent away from places like Netflix, with the idea that since they air fewer and more curated shows, they can offer more attention and support for a series.

Streaming Licensing Deals

Netflix handles different licensing agreements to develop its "Original Content." It uses the term "Original Content" for many series and films, but it doesn't always completely mean "original" the way you might think. The term is used to delineate between content that is exclusive to the platform and those that are made available for streaming after first being released elsewhere. For example, *Stranger Things* is self-produced by Netflix, *Narcos* is licensed from another studio, and *Riverdale* played on network TV but streamed first on Netflix.

Netflix purchases series at a rate of the cost of production plus around 30 percent in licensing fees, but it usually retains most of the future licensing rights. This is attractive for producers, since the platform offers way more money up front to cover their budget. The downside is that Netflix then owns the content and any future revenue opportunities, which can be quite lucrative if the show becomes a big hit. This could include worldwide licensing rights, syndication, product placement revenue, or merchandising. Production companies do get additional bonuses if their show makes it to a second season or beyond. However, most shows don't make it past three seasons. Netflix benefits from more new shows which bring in additional signups to the service. If a show hasn't broken out by the third season, then there probably isn't much room for growth. For a similar reason—trying to compete for an audience's attention—the seasons are also often shorter than network television series, at around 10 episodes per season. Since most producers are paid per episode, this could mean they are making less money than if they were working on a weekly network show with a standard order of 24 episodes. The payoff of having a lot of money upfront, creative freedom without interference, and the opportunity to develop high-quality award-winning work still seems to outweigh some of these financial setbacks.

Making the Transition From Web

With new technologies come new markets for entertainment. *The Guild*, a pioneer in successful web series production, sets a great example for web video producers who are trying to explore several markets. The show started out with a very strong fan base and was supported by donation from a PayPal button on the website. Later they were able to package DVDs, premiere on Xbox Live, sign a deal with Netflix and iTunes, and launch a new original-content YouTube channel called *Geek & Sundry*. The producers also turned down opportunities to be picked up by broadcast television networks. They wanted to retain all rights and control over the show. Beyond finding various platforms for the show, they also expanded content into other mediums, such as comic books, music videos, and merchandise. The success of the show opened up other opportunities for the executive producer, Felicia Day, including more producing, tons of press, acting roles, and voice-over for video games. *The Guild* is a great model for many producers who believe in their project and build a niche audience around it, but who aren't afraid to distribute widely while still retaining complete control of the content.

Broad City is another great example. The series began its run on YouTube for two years before making the shift to Comedy Central with the support of executive producer Amy Poehler. They were able to maintain creative control and their voice, which was essential in retaining the close relationship with their online community. When they knew they wanted to make the shift to TV, they wrote a 20- to 25-minute pilot for the pitch, started a production company, and developed a bigger scope. They treated the web production professionally, making a weekly episode and supplemental video clips in between, writing blogs, doing PR, and paying the crew. The goal for some producers is to make the shift to broadcast television, and they will treat their web show like a TV pilot. For others, they want to be able to continue their brand and have complete independence.

Can It Make Money?

The traditional advertiser-supported television business models are clamoring to keep up with the rapid changes in technology. Networks like ABC, NBC, CBS, Fox, and the CW, as well as many cable networks, are all supported by commercial advertisers. Yet increasingly, viewers are using their DVRs to fast-forward through these commercials. This threatens advertisers and sponsors, who are all scrambling to monetize their Internet presence with product placement, sponsorship, banner ads, embedded ads, and even pre-roll and post-roll—10-second ads that come before and after a program and can't be turned off. Each shows varying success.

Streaming and Web Business Models

Most Americans still pay for TV service from a satellite or cable company. However, the Internet is beginning to disrupt this as the availability of shows increases through streaming services. An interesting fact, however, is that currently the companies providing the TV service in our homes are also the ones providing the fastest broadband access, such as Comcast and AT&T. With the threat of the Internet disrupting their traditional business model, instead of going away, they are now starting their own streaming services, such as Comcast's Peacock and AT&T's HBO Max. In so doing they will control both the Internet access and the content. Some cable networks, like HBO, are keeping themselves desirable by providing unlimited access to their programming, free with an HBO subscription through participating television providers with the launch of HBO Go. This media ecosystem is called "TV Everywhere."

CHAPTER 6 Pitching and Selling the Project

As fewer audiences pay for traditional TV and demand for broadband grows, there are many different models for streaming and web content.

Subscription Video on Demand (SVOD). This business model provides access to a large library of video content to users at fixed price. This is the most popular current business model, providing a range of content and convenience for the consumer. Netflix is considered an SVOD service and is spending billions on creating and acquiring original content, which provides a lot of opportunity for content creators.

Transactional Video on Demand (TVOD). This model provides individual pieces of video content for users to buy or rent. iTunes and Amazon use this model. It delivers higher revenue per viewer and is a more attractive option for niche content or can be used as part of a windowing strategy for newly released films. This model can also be referred to as Electronic Sell-Through (EST).

Advertising Video on Demand (AVOD). This type of business model includes advertising alongside the content. These platforms are typically free or offered in tiered levels of cost, like the streaming service Hulu. The primary revenue source for content creators is from advertisements shown in pre-roll, mid-roll, or post-roll.

YouTube is run by AVOD. If you want to distribute a show on YouTube, you may wish to join the YouTube Partner Program. Your channel must reach 4,000 watch hours in 12 months and have 1,000 subscribers to be eligible. Then you can monetize your channel by advertising revenue, channel memberships, merchandise, super chat and stickers, and YouTube premium revenue. There are two ways to make money based upon advertising—cost per thousand views (CPM) or cost per click (CPC). The viewer must watch the advertisement for longer than 30 seconds or half the ad for shorter videos and/or they must click on the ads surrounding your video.

Mobisodes are also sponsored by advertising. For example, Snap Originals run around two or three 6-second unskippable advertisements per five-minute episode. They are paced to play during the show at an appropriate moment in the narrative. If Snapchat paid for production, they keep all the ad revenue, but if their media partners paid for the production costs, they split it with them.

Branded Entertainment

Another rise in advertising that is especially prevalent in reality television is branded entertainment, which includes sponsorship and product placement. Companies and corporations pay to have their products included in television programming for marketing purposes or quietly have their name attached to the program. *The Amazing Race* has been almost synonymous with Travelocity and *American Idol* with Coca-Cola. Going back to this branded entertainment method from early television, advertisers can increase their exposure and create stronger ties between the product and the program's content without the interruption of the program and the risk of the audience skipping their messages.

Branded entertainment has appeared on streaming services as well, such as Netflix's *Stranger Things*. New Coke was written into the script, so they formed a partnership with Coca-Cola, and the soft drink manufacturer then brought back the drink for a limited run. Their brand was featured in every episode of the third season. Several brands also partnered with Netflix to run promotional campaigns. For example, Baskin-Robbins had *Stranger Things* flavors in all their ice cream shops across the country, Nike made shoes and apparel, IKEA designed a living room display, Burger King sold an "Upside-Down Whopper," and Eggo frozen waffles were advertised through

billboards and social media ads. These brand tie-ins need to be seamlessly woven into the show's story world and be carefully monitored so as to not overwhelm the audience.

Financing Transmedia

One classic linear model to fund a program would be to raise the finance, produce the program, sell to a distributor, raise awareness, sell to the audience, and exhibit the work. A newer, more appropriate grassroots model for transmedia would be to turn these steps into selling a more enticing experience upfront. First raise awareness and build an audience, raise finance and pre-sell to your audience, then make your project, and sell to at least some of your audience and exhibit. Transmedia offers opportunities for advertisers to reach consumers in a way that is more meaningful, blurring the line between an organic extension of the experience and marketing. Transmedia is going to create stronger and longer-lasting relationships with an audience, which is great for fans, sponsors, and investors.

The business models for transmedia are very similar to the streaming service financial models. However, most multi-platform experiences will use a mix of different models. In addition to the previously mentioned subscription-, transactional-, and advertising-based models, there are several other approaches to funding. This could include sponsorship, donations, affiliate marketing, direct sales of the platform itself to third parties, or sales to market intelligence groups of anonymous user data. You could also explore virtual currency or peer-to-peer exchanges, which takes a percentage of user-to-user fees in your transmedia experience's "market," such as the trading of virtual goods or online auctions.

Funding Virtual Reality

Depending on the type virtual reality project and its scale, the budget can get quite large. There are many approaches a producer can take in funding a virtual reality project from the ground up.

Subscription-based. You can submit your app to a subscription-based model like Oculus Store, VivePort, or Patreon. When submitting your application to Oculus, for example, it will first go through a review period. They try to curate their stores for entertainment value, high quality, and utility. The review period consists of three phases, including technical review, content review, and publishing review. The technical review evaluates if your application conforms to their platform and meets performance targets. The content review looks at the overall production value, general purpose and appeal. Lastly, the publishing review makes recommendations for your release. Once your app is available for purchase in the Oculus Store, you will earn revenue from each purchase minus sales tax and Oculus's platform fee of around 30 percent. They will also provide you with metrics to help measure the performance of your app.

Hardware companies' support. Another method for funding your project is to seek support from hardware companies. The hardware companies benefit from ensuring better content for their platforms. Oculus offers several different programs, including Oculus Creators Lab, High School 360 Filmmakers Challenge, Launch Pad, and Oculus Start. There are several other opportunities as well, such as Magic Leap Independent Creator Program, Google Daydream Impact, YouTube VR Creator Lab, Samsung NEXT, and ViveX. For example, ViveX is an HTC Vive VR Accelerator. They support startups by providing expertise, investment, mentorship, education, networking, and support services for areas like accounting, human resources, and legalities.

Grants. Applying for grants is another route you can take to help fund your project. There are many different grants out there, some more specific than others. Do your research and find the most appropriate grants for your project. They include the UNICEF Innovation Fund, Venture Reality Fund, and the Kaleidoscope Fund, which helps secure financing, distribution, and exposure. Some hardware companies also offer grant opportunities, like Unity and Unreal.

Hackathons. Film challenges, hackathons, and incubators are another creative way to get your project off the ground. They can come with monetary prizes, networking opportunities with investors and other creatives, and publicity for your project. There are events at institutions like MIT, a Journalism 360 Challenge, VR Game Jams, and VR Hackathons around the globe.

Investors and crowdfunding. As you can see, there are many different approaches to funding a VR project. Most likely a successful solution would be to utilize any combination of the aforementioned methods in addition to finding interested and relevant investors or initiating crowdfunding campaigns on platforms like IndieGoGo and Kickstarter.

What's Next?

This era is one of genuine transition—many of the old rules no longer apply, but the new rules have yet to be established or formalized. Everyone in the television medium, and those in related emerging media industries, are scrambling to outthink their competitors. As TV becomes more like the web and the web becomes more like television, new strategies, innovative tactics, and visionary thinking will inevitably trample the old models of conducting business as usual.

On a Human Level. . .

Selling your project can feel a lot like selling a part of yourself, and it can be easy to confuse the two. Expect to encounter rejection along the way, but don't take it as a personal affront. Each time that you hear "we've decided to pass on your idea" should motivate you to try even harder the next time. And when someone does give the green light to your project, stay objective and centered. A swollen ego just gets in the way when you have work to do.

SUMMARY

Pitching your project is a vital part of the producing process. There are countless stories of producers whose pitch won enthusiastic kudos from development executives, and got made—or were never heard from again. Yet every time you turn on your TV or computer or game box, it's clear that hundreds of shows did get made. Each went through the pre-production stage, as you'll see in the next chapter.

REVIEW QUESTIONS

1. Define "the pitch." What are its important components?
2. Why is it necessary to research the network, cable channel, online channel, or production company to whom you are pitching your idea?
3. List five potential venues to which you could pitch one specific idea. How are they similar? How are they different?
4. Discuss the benefits of the global marketplace.

5. What is a query letter? Why do you need to write one?
6. Describe the synopsis element of a written pitch. Write a brief example, using an existing script or your own project idea.
7. What is a demo reel? What are some of the ways it can benefit a producer? How might it be detrimental?
8. Define an elevator pitch. Why is it advantageous to have one ready?
9. List five possible venues that can help you increase your breadth of networking connections in entertainment and media industries.
10. Look at your own positive personality traits, and identify those that you can maximize when you give your verbal pitch.

CHAPTER 7

The Plan: Pre-Production

THIS CHAPTER'S TALKING POINTS

I The Script

II The Talent

III The Crew

IV Scheduling the Shoot

V Focus on Emerging Media

In the pre-production phase, hundreds of details come together to form the big picture, like pixels on a TV screen. These details are the essence of production. They add dimension and texture to your project. When you devote attention to these pre-production details—researching, double-checking, and making dozens of careful decisions—you can often save costly mistakes. Planning ahead is easier than going back and trying to cover your mistakes.

I. THE SCRIPT

If you are shooting a narrative script, like a dramatic series or online short, you ideally want the script to be completely finished before you start shooting. The late delivery of shooting scripts can limit everyone's preparation time and slow down the production itself. You do *not* want to realize as you're shooting that an essential story element is missing, requiring a last-minute rewrite and stopping production, even though you're still paying everyone to wait. The more time you can give to your pre-production planning, the better your chances for a seamless shoot.

Maybe you've got a full script that can serve as a blueprint for your pre-production planning. Or perhaps your project is reality-based and you've got only an outline for who and what you hope to shoot. Yet in both cases, you'll carefully review each element before you begin shooting. Both extremes, and every kind of project in between, require pre-production strategies.

Script Breakdowns

Chapter 4 explored the budget ramifications of your project by breaking the script down into specific categories. You can now apply this same breakdown process to pre-production planning.

A breakdown sheet is a valuable tool that helps you organize and categorize your production details—the crew, on-camera talent, locations and sets, props, wardrobe, stunts, explosives, and more.

Each scene requires its own breakdown sheet and includes any or all of the following components:

- The script's title and scene number
- The date of the breakdown sheet
- The page number of the script
- Location: a constructed set or a real location
- Interior or exterior: shooting inside or outside
- Day or night: this determines choices of equipment and gear
- Brief scene description
- Cast with speaking parts
- Extras: any nonspeaking people in the scene or background
- Special effects: from explosions to blood packs to extra lighting
- Props: anything handled on-camera by a character in the scene, like a telephone
- Set dressing or furnishings: on-camera items on set not handled by the character
- Wardrobe: any clothing pertinent to a scene, like an outfit or torn shirt
- Makeup and hair: normal makeup and sfx, such as wounds or aging, wigs or facial hair
- Equipment: audio and video equipment and extras, grip, electric, cables, etc.
- Special equipment: jibs, cranes, a dolly, Steadicams
- Stunts: falls, fights, explosions; may include a stunt coordinator
- Vehicles: on-camera cars or other vehicles in the scene or as background
- Animals: any animal that appears in the scene comes with a trainer, or wrangler, who takes charge of the animal during production
- Sound effects and/or music: anything played back on set, like a phone ringing, music for lip-syncing, or music the actor is reacting to
- Additional production notes

Production Book

All productions involve details—hundreds of them. As you saw in Chapter 4, organizing these details is easier when the producer uses a *production book*. The traditional paper-based production book is kept in a three-ring loose-leaf binder, with dividers for each section. Of course, all-digital production books have become the norm, although many documents still require hard copies because they need signatures. On a small project, the producer keeps her own book and updates it regularly. On a larger production, usually a production assistant (PA) or production coordinator is put in charge of making multiple copies of production books for the key production personnel, giving everyone the same updated information. Refer back to Chapter 4 when compiling your own production book.

Equipment List

Each member of the crew either provides his or her own equipment as part of the contract at an extra rate, or gives an equipment request to the producer, prior to the shoot. Special production equipment needs to be arranged in advance of the shoot and might include:

- Cameras and lens, screens, tripods, batteries, video stock, etc.
- Sound, extra mics, mixers, booms, windscreens, lavs, wireless bodypaks, etc.

- Grip and electric with cables, extra power sources, generators, cords, gaffers tape, etc.
- Walkie-talkies
- A dolly and tracks
- Additional cranes and jibs for cameras
- Steadicam mounts
- Explosive devices
- HMI and other lights, gels, stands, and neutral density gels
- Camera cars
- A video monitor for each camera
- Teleprompters

The Look and Sound of Your Project

After you have organized these components, you can begin to explore the more aesthetic dimensions of your project.

Your *visual approach* provides important clues to the viewer. A narrative drama can reflect a moody noir texture requiring sophisticated lighting and a single-camera film technique; sitcoms are brighter, use more color, and usually take the traditional three-camera approach. A reality show might depend on three or four handheld cameras; an online show can be shot in close up with one video camera. Elements such as lighting, camera lenses and angles, video or film stock, wardrobe, makeup, props, and set design all contribute to the overall visual aesthetics.

Shooting original footage is not your only option. Producers of all programming genres make clever use of components such as stock footage, still photos, archival or historical footage, text, documents, or graphics in post-production either to augment or replace original footage. These elements can also add visual and audio effects and textures to the overall look.

The **audio impressions** you create are no less important. Sound can create subtle, even subconscious effects; though an audience isn't always conscious of what they hear, they get an audio impression. The clarity of dialogue and the ambient background sounds such as birds, traffic, a voice on the radio, a humming freezer, background conversations, all add nuance to the story. The many elements of sound can be designed and enhanced in post-production. Sound design can contribute to your essential narrative beats, or it can be distracting if it is not done well. A professional sound designer is a real asset to your production.

Storyboarding and Floor Plans

The next step is to plan out how you're going to shoot each scene. A scene, for example, might call for one long shot, or it might require master shots, individual close-ups, pans, two-shots, and cutaways. These shots are planned to fit together later in the editing process. By the time you actually shoot each scene, you will have totally planned it out.

Depending on the producer and/or the size of the project, there are a couple of ways in which to plot out each step of the production.

Storyboards are sketches in numbered boxes that illustrate the details of the scene to be shot. They can be simple hand-drawn cartoon-like sketches, or elaborate pictures generated from storyboard software. Each drawing represents a scene or shot number from the script. When the image or camera angle changes, so does the content of the box.

Before the actual shoot, the producer reviews the script, often with the director, UPM, and/or line producer. They storyboard each scene. They detail every camera setup in that scene. Does the camera go in this corner and shoot in that direction? Is it a close-up or a two-shot? Does the shot work in the overall edit sequence? Where are the actors placed? Do any set, prop, or wardrobe details in the shot need special attention?

Most storyboards are minimal black-and-white line drawings, although they can be full-color illustrations, photographs, or even animation. They save time and money by providing a visual synopsis of the scenes to be shot, the look and the feel of the set or location, the location of one character to another and their actions, and even the colors, textures, and mood of a scene.

All these aspects are essential to an art director, production designer, director, producer, the director of photography (DP), and others involved in production. However, not all projects can be storyboarded; many reality-based shows are shot with little or no advance knowledge of the shooting circumstances. And in many television dramas on a tight schedule, the camera coverage can't be planned until the scene is blocked for the camera on the actual day of shooting.

In some case, storyboards, if they're imaginative and descriptive, can prove to be great tools for selling an idea or project. They can be submitted with a script or a pitch to give the clients a clever glimpse into what the project might look like, without having had to shoot a scene or a trailer for a lot more money.

Floor plans provide an overhead view of what you plan to shoot, as well as the space around it. In complex, highly detailed projects, a floor plan can augment or replace the storyboard. It shows where the cameras and microphones are placed, as well as the lights, the actors, furnishings, set walls, and more. A floor plan helps the various department heads see what's needed for that scene, like props, furnishings, and set design. Because a floor plan shows the camera placements and shooting angles, it helps the DP plan how to best block the actors. Floor plans and storyboards both illustrate the shoot and make it easier for everyone involved to visualize the project's vision.

Shot List

When the producer carefully studies the storyboards, she can then put together a *shot list*. This is a detailed list of each shot that's part of a scene or specific sequence. Most shot lists are made on set after a blocking rehearsal; when time allows, they're ideally put together prior to the day of the shoot. The shot list is distributed to the camera and audio crew, as well as to other crew members who are directly involved in the shoot.

The shot list uses a specific language that everyone understands to describe the shot that is needed:

- *ECU*: extreme close-up (eyes or mouth, or part of an object)
- *CU*: close-up (the whole face or entire object)

- **MS**: medium shot (an upper torso or an object in part of its surroundings)
- **MWS**: medium wide shot (most or all of a body or group of objects) that's framed between a medium shot and wide shot
- **WS**: wide shot (an entire body or larger grouping of objects)
- **EWS**: extreme wide shot (many bodies or shots of horizons, buildings, sky lines, etc.)

Production Meetings

No matter where your project will eventually end up—on a major network, online, on a mobile device, in a short film festival—your team is a vital part of making it all come together. You want to encourage good communication and collaboration during the production; one approach is to schedule daily or weekly production meetings.

Production meetings generally include the key people like the producer(s), director, line producer, production manager, and whoever else you want to be involved. Prior to the meeting, you'll create an agenda and make copies of documents or plans to be discussed, including the script or shooting schedule or myriad other details. Two areas stand out as particularly important, regardless of the size of your production.

- The production meeting is called by the producer and invites any key positions (the gaffer, key grip, DP, sound mixer, production designer, wardrobe, AD, etc.), even if your production is a small one. Go through the schedule together, step by step, and discuss.
- If your project is scripted, or benefits from rehearsal time, do a read-through of the script with the cast and crew.

Everyone's encouraged to give notes or comments, while you listen, set priorities, delegate jobs, and generally take care of business. After the meeting, send out a memo and outline what was said and agreed upon. Production meetings can be an excellent forum for complimenting those people who are doing their job well in front of everyone else. If, on the other hand, you have a problem with a specific person, the production meeting is not the place for discussion. Do that later, in private.

II. THE TALENT

The word *talent* covers quite a range. Talent can apply to a world-famous actor, an on-camera news anchor, a game show host. Or, talent can mean real-life subjects in a documentary who have never been on camera before, the man on the street, children, animals, and extras.

Regardless of the genre you're producing, it's virtually impossible to have a project without on-camera talent; he or she is the backbone of your story who can give your project credibility and energy, and provide connection with a viewer.

Casting Talent

Finding on-camera talent—who are talented—can be a full-time job, especially when your project is especially dependent on acting talent, or a clever talk show host, or a gifted professional for a how-to show, or real people with a compelling story. Here are the steps that a producer can take to find just the right person.

Casting Directors and Agencies

Specialized talent agencies and casting directors work with producers and directors to help them find the right face, voice, or special skill for a project. Some casting

professionals work only with actors, others specialize in casting "real people" or extras for a crowd scene or atmosphere.

Casting directors keep files on their clients—the actors' resumes and headshots, possibly a reel with examples of their work—and make sure they're regularly updated. Casting directors are familiar with their clients' skills, what other roles they've played, and their work ethic. A good casting director maintains solid relationships with talent agents, other casting directors, and talent managers and can often help in negotiating overall talent fees and work conditions.

The producer first contacts the casting director and outlines the project's needs. Then the casting director calls agents, places ads, and/or posts notices for a *casting call*. Audition space is rented and times set up. Auditions are held in a rehearsal or casting space; the producer may shoot video and/or stills and reviews them later when he's making final casting decisions.

Guerilla Casting

You may not have a casting director at your disposal or the money to hire one. For low-budget projects, you can post your own notices and hold casting auditions in spaces that are inexpensive or free. So how and where can you find good talent?

- Write a short description of the part(s) you're casting, the audition date, time, and location, and a phone number or email address to get more information.
- Advertise your casting call on casting websites and in appropriate social media groups.
- Many towns and cities have websites with cultural links. Surf these sites for possible venues to post your audition notice or to find talent.
- Post an audition notice in local film, television, and emerging media schools.
- Consult with other producers and directors who work regularly with talent.

Casting Calls and Auditions

You've posted the casting notice. Now, you can begin to cast the parts. Because auditions tend to attract a lot of people, you want a system that helps you to keep track of who shows up, how well they read the part, and how to locate them. In an audition, you and/or your casting director will:

- ***Find a comfortable public space for auditions***. The room should easily accommodate you, possibly a director, assistant producers, and the talent. Check the room temperature, the acoustics, the amount of light, and its overall comfort factor. If needed, set up extra lighting. Supply water and enough chairs. Assign someone other than the producer or director to read any additional parts with the actor. You also want an ample waiting area outside the audition room. Assign a "people person" to the waiting area to keep the talent relaxed. Provide water and snacks.
- ***Schedule the audition***. It helps if you time the reading yourself—read the part(s) and see how long it takes to read it a couple times, then add 5 to 10 minutes for conversation before and after. Consolidate the auditions by scheduling each actor for a specific time. Build flexibility into your plan; working actors often have several auditions a day, and some readings go longer than others.
- ***Keep a log of those auditioning***. List their name, agent (if any), phone number, email address, and the part they're auditioning for. Keep track of the talent's photographs (headshots) and their resumes.
- ***Make the script available***. While they're waiting to read, give actors the pages from the script that they'll be reading (also called *sides*). This gives them time to

get comfortable with the audition material. Or ask them in advance to prepare a monologue for the audition.
- **Shoot the audition**. A filmed audition gives you a chance to review an actor's performance later, and to compare it with other actors' performances. Take close-ups of facial expressions and wide shots for the overall performance and body language. After each actor leaves, make notes and label each headshot to avoid confusion.
- **Be patient with children**. They can be a casting challenge, regardless of their age or professional experience. Children get tired, hungry, grumpy, and nervous. Keep the environment calm and provide games, crayons, and books. Assign at least one PA to keep the kids occupied and the parents calm.
- **Arrange for callbacks**. After the auditions, you've hopefully found actors or talent who you want to see again for a second reading; these repeat auditions are known as *callbacks*. It's not unusual to call an actor back two or three times. The general rule, especially if the actor is a member of SAG, is to pay the actor a fee after three callbacks. When you've narrowed your choices down, audition potential cast members together for a reading. The chemistry between actors can make or break a project.
- **Actors deserve respect**. Few actors are comfortable in auditions, so help them out. Introduce them to key people in the room, make eye contact, make a joke. You'll encourage a much better performance when you treat the talent well. And any talent you have rejected are worthy of a polite phone call or personal email. They may not have been right for this project, but they could be perfect for another one in the future.

Hiring Talent: Union or Non-Union?

The category that covers "talent" is a broad one. It includes actors with major and minor parts, on-camera hosts, narrators, background extras, children, animals, magicians, stunt people, jugglers, nonprofessionals, and "real people."

Many are members of a talent union, though not all good actors are members of a union, and not all union members are good actors. But most experienced and professional actors belong to unions such as SAG, AFTRA, and Actors Equity for theater, that impose specific rules under which the actors work. The producer must honor them or risk hefty fines from the union.

A low budget can limit producers, often requiring them to work with non-union talent, thus avoiding the additional salaries, expenses, paperwork, residuals, pension and welfare, and other regulated working conditions that talent unions require.

On the other hand, an independent producer, production company, network, or studio may take the steps necessary to become a *union signatory*, meaning they've agreed to comply with the guidelines and regulations of the union. And because a well-known actor can be the biggest selling point for your project, it's often worth becoming a union signatory and paying the actors much higher fees in exchange for the benefits you'll see at the box office.

Becoming a union signatory involves taking a realistic view of its impact on your budget. There must be enough money to cover union talent's wages as well as *fringe benefits* (payments that include payroll taxes, pension, health, and other union and/or employee benefits). Each union's website provides the most current and up-to-date information on these costs.

Each talent union has its own guidelines, but most will work with you. Some may make special concessions for student productions, low-budget shows, and affirmative

action contracts, as well as multimedia, emerging media, some educational projects, and Internet projects. The agreements generally include lowering the pay scales and allowing greater flexibility in the overall working conditions. You can find in-depth information on this complex aspect of production by going to the website of the specific union.

Union Actors

Talent unions such as SAG and AFTRA have listed their guidelines, pay scales, and other regulations on their websites, along with the producer's role in honoring these requirements. Most producers work closely with the unions and can negotiate the requirements, which usually include:

- **Rate of pay**. Daily, weekly, or per-picture rates.
- **Per diem**. When on location and away from home, a daily allowance to cover meals, transportation, and other production-related expenses.
- **Speaking lines**. All on-camera parts with or without lines have their own pay scale. Additional recording and rerecording time may also be required at a later date.
- **Screen credit**. The actor's credit itself, its placement on the screen, the order of the names appearance among other actors, and other union or contractual agreements.
- **Turnaround time**. Usually a 12-hour break of time between the end of one shooting day and the call time for the next day. Check the union's website.
- **Meals and breaks**. Talent must have regularly scheduled breaks to eat and to relax.
- **Wardrobe stipends**. A fee paid to actors who provide their own wardrobe.
- **Specific requirements**. Child actors work fewer hours than adults and, if they are absent from school, require a tutor, parent, or social worker to be with them at all times.
- **Benefits**. Additional monies paid to an actor for things like P&W (pension and welfare) and workers' compensation.
- **Travel**. There are specific guidelines detailing an actor's flying status, such as first class only, or no red-eye flights.

Often, there may be a SAG representative on the set. The representative is employed by the union to resolve any contract disputes or member complaints, and deals primarily with the producer on a day-to-day basis in this regard. In some cases, you can work with the talent unions for waivers on wardrobe requirements, turnaround time, stipends, benefits, and other areas.

Non-Union Actors

Actors who are not members of an actors' union deserve the same respect and base salary, whenever possible, as those actors who are protected by their unions. Producers are not required to pay them union benefits, and there are fewer restrictions for on-set hours or turnaround time. Producers do have an ethical responsibility to treat everyone fairly, regardless of their union status.

Real People

The popularity of reality-based programming, and the comparatively low costs of these shows, has increased the demand for talent who are "real people"—couples, singles, old, and young. Most have never appeared on camera and are therefore not union members. In such cases, it's up to the producer to play fair, go over all deal

memos and contracts with the talent involved, and avoid any complications or potential claims later on.

Stunt Actors

Some actors do their own stunts, but most use a stunt double for dangerous action like a fall from a building or a fistfight. If a stunt is dangerous or complicated, a stunt coordinator is hired to plan and oversee the stunt actors' work. Most experienced stunt performers belong to stunt associations covered by SAG.

Extras and Background

Most programs feature people milling in the background, walking on a street, getting into buses, driving cars, or eating at other tables in a restaurant scene. These *extras* add a layer of dimension and credibility to a shot. Depending on the scene, extras can be professionals in SAG or are hired by casting agencies or nonprofessional locals—even friends and family can fill in as background. Extras are scheduled and rehearsed just like actors with larger parts.

Actor's Staff

An actor might bring his or her own people into a production. In certain situations, the production pays these salaries and provides accommodations and workspace. These extra personnel might include:

- *Hair and/or makeup*. Knows the cosmetic (and emotional) needs of the actor.
- *Wardrobe designer or stylist*. Maintains the talent's specific wardrobe "look," keeps track of clothing, and mends and cleans the clothing needed.
- *Wrangler*. Has expertise in training or managing talent, and might be a wrangler for an animal or a child actor.
- *Personal trainer*. Often a necessity when the part calls for an actor's overall health, sex appeal, or specific physical demands of a part.
- *Secretary or personal assistant*. Handles requests for personal appearances, correspondence, and phone calls, as well as production-related details.

Rehearsals

Rehearsals can be viewed as a costly luxury in some budgets, but whenever possible, the producer looks for ways to afford rehearsal time. This valuable time not only gives actors an opportunity to fine-tune their part, but it also serves the director, director of photography, audio engineers, and lighting director in *blocking* or planning their shoot. This saves valuable time on set when the shoot begins.

Rehearsing Scripted and Narrative Content

In actor-driven projects, rehearsal time gives the talent an extra advantage. Actors can get more comfortable with the script, the camera blocking, and fellow actors' individual styles and rhythms.

Depending on the project, the producer either hires a director who works directly with the talent, or rehearses and/or directs the actors himself. Not all projects require or have time for rehearsals before shooting, and not all actors want to rehearse; each has his or her own approach.

In most narrative dramas, commercials, or sitcoms, some directors give actors the freedom to interpret their roles; others prefer to "direct" the actors. Directors know what they want in a performance, and it is their job to motivate actors to explore their

characters' back story, create a specific regional accent, or use distinctive body language to explore the range of their roles.

Rehearsing Unscripted and Reality-Based Content

Whenever possible, documentaries, reality-based shows, talk shows, and sports and live events can often benefit from a technical rehearsal. For example, in planning to shoot a documentary, a producer might go to a location prior to shooting, rehearse her camera positions and moves, and decide where the microphones should be placed in relation to the talent.

Many non-scripted shows depend on special sets such as Tribal Council on *Survivor*, or on *The X Factor* and *American Idol*. The producer employs his "dream team" to run through all the possible challenges they might encounter during the actual shoot. In most talk shows, producers often rehearse with stand-ins, or run through special demonstration segments, musical performances, fashion shows, and the like. Before the show begins taping, the producer does "look-sees" of every component of the show: "host entrance," "guest entrance," "desk cross," and other aspects of blocking and rehearsing.

Blocking

Once the action of the actor or "real person" has been determined, the next step is *blocking* the scene. Blocking looks at the camera's placement in relation to the actors (or their stand-ins) and their sequences of steps and actions: it's like choreographing a shot and involves the DP, director, camera operator, the lighting director (LD) and lighting crew, the audio engineer, and usually the producer.

Blocking considers furniture, props, or greenery in the scene, the relationship between one actor and another, and how the camera can capture it all. Blocking decides what the camera is shooting and from what angle, and spots for cameras and actors—called marks—are usually marked with masking tape on the floor or wall as reminders.

III. THE CREW

Although the actors may reflect charisma on screen, it's the crew who creates the real magic behind the scenes. Your project may require only a small two-person crew, or you might need several camera and audio operators, as well as lighting designers, DPs, set designers, and wardrobe and makeup specialists.

Hiring a full crew can be challenging to both novice and seasoned producers alike. You may have had some experience working on productions where you met professionals whose work you liked. If not, look for creative options. Ask other producers or filmmakers for their recommendations. Contact local production crews or national crew-booking companies and ask for crew reels to screen; these reels reveal a visual or aural approach that could be similar to your vision. Research television, emerging media, and film departments in universities that may have talented students who are eager for an opportunity to augment their experience and may work for lower fees, even academic credit.

> The essential point is that you have to try to gain the trust and the confidence of the client, and all the other parties—from all the audio people, from the staging people, the artist, all the parties involved in this event. You have to gain their trust, showing that you understand what

their issues are and bringing them on board to be on the same team for the overall good of the project.

Stephen Reed, excerpt from interview in Chapter 11

Regardless of the size of your crew, each crew member has his or her own area of specialty. Over time, you'll build your team of experienced, talented, and collaborative crew members who can be trusted and who share your vision. They are, quite simply, your lifeline.

The Key Production Department Heads

Whether your project is large and ambitious or small and controlled, union or non-union—certain areas in every production need at least one person to cover them. In lower-budget projects, one person may cover several of these areas. The key people the producer hires for almost every project are:

- The director
- The director of photography
- The production manager
- The assistant director
- The production audio engineer
- The production designer
- The post-production supervisor

Director

As discussed in other chapters, television—and now, emerging media—is the producer's domain. So, the producer can also be the director, or hires the director, or maps out the desired look and creative approaches of the production.

If a director is hired, she may fill the traditional film director's role, working with actors, the crew, and the producer in visualizing scenes. The director can be a strong creative force in the production, supervising the writing and the casting, rehearsing the actors, and crafting the overall aesthetic approach.

Or, the director might be the technical director (TD) who, in a studio setting, works out of the control room. She is generally assigned to multicamera shoots, such as talk shows and live events, and among other responsibilities, directs each camera and "calls the shots" as they come into the control room, often creating a line-cut, or rough edit, in the process.

Under the Directors Guild of America (DGA) guidelines, the director, the AD (see later), and the technical director fall into a separate fee category and pay scale. Although each project is unique, it thrives when the producer and director cohesively and collaboratively work together.

Director of Photography

The DP is often the first key position to be filled. The DP brings the creative vision of the producer and/or director to life. Whether he actually operates the camera himself, or supervises the camera operator(s), he's mastered the essentials of lighting, formats of video and film, and the use of cranes and dollies. He can bring his own experienced people into the production, and helps outline a shooting schedule. The DP often owns his own equipment or has relationships with equipment rental companies.

Production Manager

The role of the production manager (PM) or unit production manager (UPM) varies in each project, depending on its size and budget. Hired by the producer, the UPM might be in charge of breaking down the script, and creating a schedule and budget from that breakdown. She keeps track of costs and deals with paying the vendors. She might also negotiate with and hire crew members, supervise the production assistants, arrange for equipment, and cover a range of essential details. Depending on the project, she monitors the daily cash flow; makes the arrangements for travel, housing, and meals; applies for shooting permits; oversees releases and clearances; and generally supervises the production activity. In a smaller or low-budget project, the producer or assistant producer doubles as the production manager.

Assistant Director

The assistant director (AD) is the on-set liaison between the director, the producer and/or production manager, the crew, and the actors. He typically plays "bad cop" to the director/producer's "good cop," helps to create the shooting schedule, and keeps the crew in sync with the day's schedule. The AD might also be responsible for timing shows or segments during taping. If there are scenes in which extras appear, he is often in charge of directing their actions.

Production Audio Engineer

The subtleties of sound design can get lost in pre-production planning, so a savvy producer hires an audio engineer who can capture the clarity of dialogue, background sounds, special on-location audio (sirens, birds, traffic, muted conversations), and other ambient audio. She knows how to place and monitor microphones (mics) like booms, wireless, small clip-on microphones (lavs), and windscreens for minimizing wind, air conditioners, fluorescent lights, and other sounds that can cause interference. She either owns her audio equipment or can lease what's needed for the project.

Production Designer

The aesthetic texture, design, mood, and tone are essential elements in every project. From creating elaborate sets to simply rearranging set furniture, the production designer creates a design for the overall look of the show and works closely with the producer and director to create an environment for the action. By finding out what camera shots and angles are planned, he designs what will be seen in the camera's framing. As always, the budget has an impact on these choices, although a clever production designer can improvise and plan carefully. He may do all the jobs himself. Or, he may hire an art director whose job it is to take charge of building and painting the sets, and/or to modify existing locations. Often, a set decorator is also needed to locate items for the set such as furniture, lamps, wallpaper, and rugs. The production designer and/or the art director also decide on carpenters, greens specialists, prop masters, painters, and other support crew.

Post-Production Supervisor

Whenever possible, a producer hires a post-production supervisor. Her overall responsibility is to be well-prepared for the post-production stage, consulting with the producer in making early decisions about post-production details—the choice of editor and the editing facility and the software program that's best for the project; the sound designer and the audio mix facility; the graphics designer and facility; and other post-production elements.

In some productions, the post-production supervisor comes on board during production, sets up systems for screening the dailies, and organizes, labels, and stores the footage and audio elements. She understands the professional standards for editing, including nonlinear editing (NLE) systems as well as online systems and when they can come in handy. She's aware of the many video, audio, and graphics needs and can coordinate them all together. More post-production information can be found in Chapter 9.

Key Players, Key Teams: The Script and the Visual, Aural, and Support Teams

Depending on the size of the production, most if not all of the following positions are hired in the pre-production phase.

The Writing Team

Writers and Revisions

During the writing process, the original script writer(s) might be teamed up with new writers, replaced because of "creative differences" with the producer or writer, or leave the project because of prior commitments. The initial concept of the project can change as part of the creative process, or the client or network makes demands the writer isn't willing to make. Script revisions are generally agreed upon in the writer's contract, either following WGA guidelines or on a fee-per-revision basis.

Researcher

Most projects require some degree of research. A historical storyline, for example, involves details in architecture, costume, or speech mannerisms. A reality-based show hires a researcher to look for background material and find interesting ideas and real-life characters. A quiz show depends on researchers to investigate subject areas for questions and correct answers.

Researchers are valuable components in news or fact-based programs for double-checking sources or backgrounds. They might be professionals, academics, or consultants who specialize in specific areas of knowledge, or who are adept at problem solving. Researchers can also be production assistants or other administrative staff who are assigned to specific research needs.

The Visual Team

 Storyboard artist. Working with the producer or director, and examining each scene of the script, the storyboard artist translates the visuals onto paper, either by hand or using a storyboarding software program. These sketches are generally simple and cartoon-like and show at a glance what needs to be created by the production team.

 Lighting director. The LD works with, or doubles as, the DP. In some cases, the LD is known as the key gaffer or chief lighting technician. He designs the lighting for the production, plans where the equipment is best placed, and decides the best lights to use and their wattage. On set, the LD supervises the rigging of the pipes and the hanging of lights and also recommends scrims, gels, and patches for various lights.

 Camera operator. Either working *with* the DP or *as* the DP, the camera operator shoots the scenes, works with blocking and framing, lighting, and lenses for each shot. She also works closely with the audio engineer to make sure that the best audio goes into the camera and into digital storage.

Assistant camera operator (AC). The AC helps the camera operator, keeps camera batteries charged and available, changes and maintains lenses, and sets up and breaks down the camera equipment. The AC also slates each take, works closely with the script supervisor, is in charge of keeping track of film stock and memory cards, and completes the camera reports for the editor. Some duties may be given to the second AC if one is hired.

Digital asset manager. As digital cameras (like the commonly used, sophisticated Red cameras) and data management become increasingly complicated, it can be worthwhile to have on the set someone to take responsibility for the management, storage, and transport of the digital media that's being created.

Still photographer. The photographer takes a number of still shots during rehearsal and behind the scenes, as well as on set, for purposes of providing publicity stills as well as creating a photographic archive of the production.

Gaffer. This lighting specialist works closely with the DP and cameras to set up lights, adjust them during the shoots, supervise and install various *gels and gobos*, and supervise the electric power sources or generators.

Best boy. An assistant to the gaffer, the best boy (often a female) works specifically with electrical cables and ties them in safely to a power source or generator.

Key grip. This main grip works with the physical aspects of setting up the shoot, which includes rigging light stands and C-stands that hold up silks or *cycs* (hanging background fabric or paper) and installing special equipment such as a dolly and dolly tracks, camera jibs and cranes, and more. The key grip is also primarily responsible for overseeing safety procedures on set, especially in the presence of stunts and pyrotechnics, and supervises the crew of grips.

Grip. A grip's responsibilities include pushing the dolly, operating cranes or camera cars, helping with other equipment needs, and setting up, adjusting, and taking down lights.

The Audio Team

Boom operator. In the audio department, the boom operator works very closely with the camera operator and aims the *boom* (a long flexible pole with a microphone fixed to the end) at the audio source without getting into the camera's frame. Each camera has its own mic and boom operator. A boom can also be a large wheeled stand with a movable arm from which the mic hangs.

Audio mixer. There are often several sources of audio in production. The audio mixer operates the console and separates each source onto a separate audio channel for post-production mixing. The mixer might also "live mix" the sound as it comes into the console; this can make the post-production audio mix easier or, in some cases, unnecessary.

Audio assistant. This member of the audio team keeps track of all audio equipment, changes and labels audio files, separates the microphone and audio cables from electrical cables, places mics on set or on talent, and often tapes the cables down either to hide them from the camera or to prevent people from tripping over them.

The Production and Administrative Team

Production secretary. As the liaison between the cast, the crew, the producer, and the UPM, the production secretary is often in charge of distributing paperwork such as call sheets, contacts sheets, schedules, paychecks, and other duties assigned per project. On smaller projects, the production secretary can also double as receptionist, PA, even handling the catering.

Script supervisor. A vital asset to the director, the script supervisor checks that all the planned shots in the script have either been shot or deleted. She is the watchdog for *continuity*. For example, when an actor wears a red tie in one shot, he needs to be wearing the same red tie in another shot that follows it in the script. Taking continual notes during the shoot, the script supervisor describes each shot in each scene and keeps notes on all takes. She notes gestures or movements (like a hand on someone's shoulder) that need to match another shot. She looks for matching dialects and dialogue, details in wardrobe, hair, and makeup (like matching a bleeding wound from one shot to another), and what lens is used. The script notes also provide important references and directions for the editor to use later in post-production.

Location manager. The location manager looks for and secures locations for the production, negotiates the location agreements and rates, takes care of shooting permits, parking, and on-location catering, and makes sure the location is in good condition after the shoot has wrapped. The location manager is the liaison between the location and the producer.

Catering manager. The catering manager is in charge of providing water, coffee, tea, and snacks at all times, as well as arranging for a healthy hot meal at least every six hours. The catering manager sets up a table, cart, or vehicle for serving food as close to the production action as possible. This area is often split up between *catering* (meals) and *craft services* (or *crafty*) of drinks and snacks.

Transportation manager. The transportation manager (or a key driver called the transportation captain) is in charge of moving the cast, crew, and equipment from one location to another. The production may require the transportation manager to rent the proper vehicles such as mobile dressing rooms, *honey wagons* (portable bathrooms), trucks, or vans for equipment as well as keeping them operational and ready to move. This is a union position, available strictly to the Teamsters.

Second assistant director (2nd AD). This crew member, when needed, assembles the call sheets, sets the call times for the cast and crew, and tells the cast and crew where to show up and at what time. She may also direct any action in the background involving extras.

2nd-2nd AD. If a situation calls for traffic or crowd control, the 2nd-2nd AD may be in charge. He also secures the set in whatever ways are necessary and works with the production secretary to coordinate the actors for their arrival on set.

Production assistant (PA). A necessity in all departments, the PA can be a tremendous asset who contributes both physical labor and administrative help. Most productions have a pool of PAs, assigning them on set, in the office, on location, or wherever help is needed. PAs are on set first, and they leave last. They're available to help in all departments, to do whatever needs doing. Most location PAs must be able to drive often-large equipment trucks, understand local parking restrictions, and be trusted to guard expensive equipment. Office PAs keep track of budgets, copy and distribute the latest script revisions, help with auditions, take care of talent needs, and often go back and forth between the set/location and the main office.

Interns. Often college or high school students can work for a semester on a production for school credit, while learning in the process. Few interns have worked in television production before; they require an intern supervisor to make sure they're doing their assigned tasks and are also getting a positive and organized learning experience. Interns are paying for their internships in school credits, and their energy is important to the production. Like PAs, they're assigned to areas where help is most needed.

> **The Top Ten Most Important Tools for PAs and Interns**
>
> 1. **Mobile device**. Use it as a good communication tool. Get everyone's cell and office number, so you can contact them in emergencies. Don't stay on the phone more than you need to. Make sure you've got text and GPS capacity.
> 2. **Walkie-talkies**. Even better in certain circumstances than mobiles.
> 3. **Meals and snacks**. Feeding people is important, and it makes them like you more.
> 4. **Driver's license**. You could drive for hours, on errands and runs. Have a current license; make sure your company covers you with its insurance. Avoid parking tickets, get to know the area you're driving in, and be comfortable with the vehicle. Keep everything locked up, no matter what.
> 5. **Paperwork**. Write everything down. Carry a notebook with you, and put everything down that you're told to do. Keep copies of everything to avoid problems later.
> 6. **Computers**. Several software programs are standards on a production, such as Excel, Word, Final Draft, and Movie Magic, among others. Learn how to use them!
> 7. **The Internet**. Know how to search for things you need, like equipment, vehicles, venues, and a dozen other things you'll be asked to find out about.
> 8. **Attire**. Pockets in pants and jackets are important for holding phones, pens, stop watches, and other things. Wear comfortable shoes when you're standing or walking a lot, and layer clothing because it gets really hot or very cold on set.
> 9. **Maps**. Get familiar with the city or location you're working in. Know the streets, public transportation, and how to get around easily and quickly. Get a portable GPS system or have one on your phone.
> 10. **Production book**. Get as organized as you can. You'll have lots of information to deal with so when its organized into one production book, it's all right there, in one place.

The Production Design Team

Set designer (construction coordinator). Works with the production designer and creates blueprints for the set(s), hires the crew to construct it, and supervises the assembly of sets, floors, ceilings, or movable set pieces.

Set dresser. Finds, transports, makes, and/or paints all furnishings, including tables, chairs, appliances, or other furnishings that are part of the action on a set or location. May require working in advance of the next day's shoot and being on call during the shoot.

Prop master. Supplies all props that are handled as part of the shoot, such as a paintbrush for a home makeover show or a tissue in a crying scene. He works closely with the script supervisor to maintain continuity.

Assistants. Depending on the project, each of the preceding may have one or more assistants working in various capacities.

Wardrobe designer or stylist. Designs the wardrobe "look" as well as coordinates all wardrobes needed for the shoot with the production designer, buys or rents the wardrobe, measures and fits the talent, keeps all wardrobe elements in the order of the shooting schedule, and regularly cleans and repairs the clothing or costumes. She may sell the wardrobe items after the shoot has wrapped, or handles all wardrobe returns.

Dresser. Works with the wardrobe department to keep track of clothing. Helps the talent change clothing when needed. Some productions may require several dressers who often "swing" between wardrobe, makeup, and hair, unless they are members of a union with regulations that prohibit this multiple workload.

Hair stylist. On set during any scenes that involve talent. The hair stylist may create elaborate high-concept hair styles, design and maintain wigs, or simply be on hand for touch-ups to maintain continuity from one scene to the next.

Makeup artist. Covers a range of needs from applying traditional cosmetic on-camera makeup to creating special effects such as wounds, prosthetics, facial hair, and more. The call time for makeup precedes the shoot time and requires an artist to have an on-set presence.

Additional Production Specialists

Your project might require the hiring of other specialists such as a stunt coordinator, a choreographer, crane and Steadicam operators, on-set tutors, animal wranglers, explosive experts, a teleprompter operator, florists and greens specialists, an on-set nurse, security personnel, and more. Many productions might also call for production support from an accountant, an entertainment lawyer, publicists, and marketing consultants.

The visual effects team. Your project might need a visual effects designer who can create extraordinary effects ranging from magical flying characters to subtle background enhancement. You might want animation or special graphic design for screen credits and a program title, or the illusion of a city blowing away in a tornado. As the producer, you'll make an assessment of your production needs and then consult with the designers prior to the shoot.

IV. SCHEDULING THE SHOOT

You've chosen your crew, and your script or shooting outline is clear in your mind. Now you're ready to map out your *shooting schedule*. By using storyboards and sometimes a scheduling software program, the producer can calculate what gets shot, when, and where. The end result is a concise, clear schedule that everyone involved can understand and follow.

A realistic shooting schedule seldom lets you shoot in the exact same sequence as the script—it's too expensive. Unless the project specifically follows one action from beginning to end, most content is shot out of sequence. How a shoot is scheduled has a direct impact on the budget.

The size of your production crew depends on what you plan to shoot. A high-profile sitcom or multiple-location mini-series or episodic requires a larger, more complex crew structure. A documentary or reality-based show, on the other hand, might need only a compact crew that can move quickly and whose members can competently assume multiple duties.

Before you actually shoot, you'll revise your shooting schedule often, based on the following components that are factored into the production's overall structure.

Shooting Format

Producers today can choose between a provocative range of shooting formats. Very few projects in any medium still shoot on 35-mm film, though there are some big-name filmmaker holdouts like Christopher Nolan and Quentin Tarantino. Most television shows and emerging media content are shot on some format of digital video (DV), including *24P* and *high def* (high-definition). All broadcast-quality cameras now shoot a digital signal, which is then fed into an NLE system. More details of shooting and editing are discussed in Chapters 8 and 9. The rapid expansion of technology in the production of content for TV and emerging media makes almost anything possible.

You can download your video onto the web with a simple click, and you can download video from the web into your computer. If you want to project your finished video piece onto a theatrical screen, it's easier than ever as nearly every U.S. movie theater has converted to digital projection. Yet, because this technology is continually evolving, some formats are not yet compatible with other systems. Some formats and systems will soon be obsolete, and others are already poised to take their place. Your DP or director is an integral part of the format discussion.

Sets, Sound Stages, and Studios

Your project could call for a complex set, built on a sound stage with backdrops, various room sets or exteriors, enough space to build and paint sets, storage for props, areas for wardrobe, makeup, and production offices. Or, your project may require only a simple set on an inexpensive site. And increasingly, virtual sets are important components in television production as well as feature films; these virtual sets are designed and created on computers and then projected behind the action.

Control is the main advantage of shooting on a sound stage. Here, for example, there's a light grid, and the lighting can be regulated without interference from clouds or reflections, and electric power isn't an issue. Outside sounds are nonexistent and no longer an issue. And, there is enough space for talent, meals, equipment, production administration, and other production needs.

A studio or sound stage may come empty, or may be fully equipped with cameras, audio equipment, light grids, and/or crew. Studios have different policies and rate structures. Some may be rented by the half day, whole day, weekly, or for the duration of the project. In most cases, rates can be negotiated.

Because renting a sound stage can be expensive, try to anticipate all related costs. Build in extra time for changes or mistakes, as well as time for the lighting and electric crews to review the sets before the actual shoot. Most budgets factor in rental time *before* the shoot—called load in time—and rental time *after* the shoot, to break down the sets and equipment and to clear everything out of the studio.

Locations

Location shooting can add a specific authenticity and mood to the production. It's generally less expensive than on a sound stage, especially if the location comes with furnishings, props, colors, and/or production space. For example, if you have a certain look you want for a kitchen set, it might be cheaper and easier to find an already-existing kitchen than it is to build one on a sound stage.

But locations can have their downsides, too: space limitations for shooting, production equipment, and areas for the cast and crew. There might be no parking space available, or there is loud construction nearby in the neighborhood. Locations also involve legal agreements, permits, insurance, and fees.

The goal of the production manager and/or producer is to group together all the shots needed in one location before moving the cast, crew, and equipment to the next location. This consolidation is called *shooting out* your location, and is a primary saver of time, money, and everyone's energy.

The producer considers what time is needed to break down the equipment in one location, move it all to the next location, and set up in the new location. That location might be:

- *A static location*, which can be inside someone's home, an office space, a classroom, store, or an outside shot of a building, garage, baseball field, etc.
- *A moving location*, which can include a character on a busy street, shooting a day-in-the-life sequence, or B-roll (extra montage and background footage).

Location Scout

A location scout can be a valuable component in finding just the right location. He's familiar with a range of locations: from a suburban home to an urban loft, from exteriors that match with a set on a sound stage to the right interior that suits the production's requirements. Some locations are free; others charge a fee. It is the job of the location scout or manager to find locations, negotiate the best price, and draw up location agreements. The location manager checks that:

- The locations are right for the project and reflect a look and texture that's compatible with the production. The location scout takes stills or video of the location for the producer.
- A signed location agreement with the owner (or legal representative) of the property is obtained. Some locations charge a fee, but others are free. Verify that the production carries adequate liability insurance to cover any damages in the course of the production. At the completion of the shoot, the property owner signs a release agreement.
- Whenever possible, the locations are close to one another.
- The location can supply adequate electrical power; if not, a generator must be brought in.
- There is enough space to accommodate crew, talent, catering, and equipment.
- The necessary production equipment can fit into the location, and that there are elevators, ramps, and/or loading docks.
- The location can be lit adequately, either with natural light or supplied light.
- The audio in the location has minimal noise interference from traffic, neighbors, animals, conversations, machinery, air conditioning, schoolyards, or construction.

Foreign Locations

Shooting in a foreign location can lend additional depth or mood to the project. Or, it might be part of the show's plotline or theme. Foreign locations can be less expensive if they offer professional local crews with lower pay scales, regional tax incentives, or a strong currency exchange rate. Locations such as Canada, South America, Eastern Europe, Australia, Iceland, and New Zealand can help the producer stretch the budget as well as provide viable locations. In some countries, the weather patterns can also extend a shooting season.

Exterior and Interior Shots

Most producers prefer to shoot their *exteriors*, or outside shots, before they shoot anything else. An exterior may be a master shot of an apartment building, a park, or a crowd shot on a busy street. When these exteriors are shot, the production can move on to the *interior*, or inside shots, with greater security. The exteriors are necessary to establish where an interior shot is taking place. For example, when the outside of an apartment building is shown, we know that the next scene we see inside an apartment takes place in that building.

Cover Sets

Any number of factors can get in the way of shooting your exterior shots. There's a snowstorm or an earthquake, or a freak fire burns down the vacant building you planned to use, or there's a power blackout. Always have a backup plan—how can you use the cast and crew you're paying while you figure out your next move? Your Plan B will almost always be a *cover set*, an alternative *interior* location that has been prepped and dressed for shooting a backup scene. This Plan B will save your project, budget, and reputation.

Day and Night Shoots

A night shoot can be integral to the storyline—it creates dramatic textures and nuance. It can also increase your budget and overall workload. Night shoots require specific lighting and equipment, permits, and traffic routing, and they put an overall burden on scheduling crews who often have to shoot at night as well as in the daytime. Following is a list of ways for the producer to ease this burden.

- The look of nighttime can be achieved by shooting during the day, by blacking out or relighting the windows to give the appearance of night behind the action.
- The producer can schedule all the night shoots consecutively, building in a break for the crew and talent before switching back to a daytime shooting schedule.
- A producer also might divide the day and night shooting into *splits*, a half-day and half-night schedule.

Actors and Talent

Depending on the contract you've negotiated with the actors' unions, actors must be paid overtime after they've worked for a specified number of hours, usually 8 or 10. So, the crew sets up the equipment before the shooting starts, and then breaks it all down after the actors have finished their work. Crews are usually booked for longer shifts to accommodate the talent, so scheduling talent and crew requires a review of the big picture—what needs to be shot and when, what union rules might govern certain decisions, and then balance that with the crew and their needs. This approach also pertains to most non-union shoots.

Other talent-related factors you want to take into consideration when you're scheduling include:

- ***Child actors***. Union rules require that children have a shorter working schedule, and must have a tutor, parent, or social worker with them at all times, especially if the talent is missing regularly scheduled school time.
- ***Animals***. Using an animal in a shoot requires a special trainer who can prompt it to do tricks and stunts, and who supervises the animal between takes. Whenever any animal is on set, the American Humane Association (AHA) must be notified. This mandate even extends to cockroaches.
- ***Extras and crowds***. The producer in charge of the extras will often audition them or find them through other means. Then, she will schedule their call time on set, arrange a comfortable waiting area, give them the proper release forms to fill out, and decide who needs wardrobe, hair, and/or makeup. While they wait for their scene, extras are provided with food, water, and bathroom facilities; they are usually rehearsed before the shoot.
- ***Stunts***. The stunt category can include tripping on the stairs, a car chase, explosions, gunshots, falls from buildings, and fistfights. An effective stunt

requires careful design, test runs, and rehearsals, and is generally performed by professional stunt men and women. Stunt work requires rehearsal time as well as fees and additional insurance.
- **Convenience vehicles**. Some productions require mobile dressing rooms, portable bathrooms, and craft service trucks. The transportation captain is in charge of locating the vehicles, negotiating fees, and arranging for their call times on the production. If extra insurance is necessary, that information is given to the producer, line producer, or UPM.
- **Meals and craft services**. Provide healthy snacks, coffee, tea, and water, and make them available at all times, close to the set or location. Give everyone a complete, healthy meal at least once a day, ideally every six hours.
- **Security/crowd control**. If local police are not available, hire a private security company or assign a strong-willed and muscle-bound production assistant (PA) to keep the crowd at a reasonable distance. If any of the people milling around might be shot on camera, the person in charge posts a notice, stating that people may be on camera and they have a choice to stay and be photographed, or to leave.

The Timing of the Shoot

All the production elements just listed need to be choreographed into a seamless set of movements for each shooting day. For this to happen, the producer coordinates them, taking into consideration the extra time that's needed for the:

- **Art department**. Building, painting, and delivering sets, furnishings, and props.
- **Transportation department**. Vans or trucks for loading and transporting equipment, sets and set dressings, the crew, and the talent.
- **Setup**. Prelighting and camera blocking, loading in sets, equipment, and furnishings.
- **Breakdown**. Disassembling equipment and sets after the shoot is completed, and either taking much of it to the next location, disposing of it, or returning it.
- **Hair/makeup**. Some actors or shots need additional prep time, for example, in aging a young actress, applying wounds makeup, or dressing in elaborate sixteenth-century costume.

As the producer, your objective is to accomplish what you have planned out for each day's shoot—known as *making the day*. You want to keep the production on schedule, so when you're scheduling, always try to pad your schedule with extra time and add money to the budget. This contingency safeguards the production if you should go over budget or need more time than you originally planned.

Some dramatic and episodic TV productions shoot only a few script pages each day; others might cover 10 to 15 pages, even more with some shows. Other platforms have varying schedules—a commercial could be shot in a day or a week; the same with online or mobile content. Compare this to a feature film that might cover only two to five pages a day.

You want to shoot as many scenes or takes as possible in a short time and still maintain quality. But you don't want to sacrifice the people who are working with you to make this work. Unless you have a limited budget or time constraint, try to limit your production days to 12 hours, maximum. Have at least one day off a week, and hopefully two—ideally, two in a row. You don't want to burn out the talent or crew, so whenever possible, give everyone an occasional day off or another perk. And when you can't, make sure you feed them well and thank everyone, often.

Call Sheet

A call sheet is a list of what shots are planned for the following day. The call sheet is distributed at the end of each day for the next day, and may be prepared by the producer, the line producer, the UPM, or the 2nd AD, as decided by the producer in charge.

The call sheet lists what will be shot and who needs to be on the shoot, as well as call times for cast and crew, the location(s) for the shoot, equipment needed, and scene numbers. It's typically distributed to the producer(s), director, UPM, production coordinator, clients, department heads, and whomever else the producer puts on the distribution list.

Production Report

At the end of each day's shoot, a summary of what was shot that day is compiled in the production report (PR). It includes call times, scene numbers, deleted shots, setups, and video and audio reel numbers, along with the crew members involved and the hours they worked, the locations, meals served, equipment and vehicles, and any delays or accidents on the shoot.

The production report is often (but not always) prepared by the same person who is responsible for the call sheet. Occasionally, the script is changed at the last minute, an actor is replaced, or the dailies show that a mistake was made and needs a reshoot. A producer budgets these realities into the schedule to cover any additional shoot days. For every plan A that you schedule, have a plan B, and even a plan C as a backup.

Pre-Production Checklist

As you plan your shoot, double-check what you'll need for your specific project. Look at each item carefully. It may or may not be needed, depending on the genre of your project, the size of your crew, the budget, and needs of each department. You as the producer won't necessarily do every single thing; on larger productions, many of these areas are handled by the head of each department.

> You have to be flexible. Not all producers are flexible, but the good ones are. You have to be creative. Take initiative. Be willing to see the gray when you're telling a story; not everything is always black and white. Find a mentor, someone who has been in the business for a good amount of time, and whose opinion you value. And work on your writing skills; a good writer will have a huge advantage in the job market.
> **Ann Kolbell, excerpt from interview in Chapter 11**

V. FOCUS ON EMERGING MEDIA

> A rigorous, agile pre-production process is key, constantly questioning every decision while making sure all possible outcomes are covered.
> **Fredrik Montan Frizell, excerpt from interview in Chapter 11**

Pre-Production

Producing a successful hit show is definitely within reach for the first-time emerging media producer. With instant access to relatively inexpensive equipment, software, and the web, the playing field is rather level. What can separate your production from

the rest and increase your chances of financial and professional success is careful planning. Workflows for some areas of emerging media, like virtual reality, transmedia, and interactive television, are still being worked out. It helps to have an understanding of the different technologies and tools involved in the different mediums. For more experiential projects, careful planning, pre-visualizations, prototyping, and testing will assist in overall development. Producing for emerging media can be more unpredictable than a traditional television show due to possible budget constraints, technology, and other influences. Don't be afraid to ask questions and communicate from the beginning about items such as the shot breakdown and visualization, requested actors and crew, equipment requirements, and location details. These answers will help you form a budget and schedule and better approach the project as a whole. Breaking your project down into these smaller stages will make it easier to manage.

Production Bible

A "bible" breaks down the story, marketability, and future vision for a series. It typically includes a logline, synopsis, characters, pilot outline, and description of potential future episodes. It addresses how your series is unique, identifies your audience, references other shows or films, defines the overall tone, and describes the characters' primary motivations, complexities, flaws, and choices. It provides a macro view of the first season, outlining the evolution of the character arcs and the major beats of the plot. The pitch package includes an "elevator pitch," the production bible, and a pilot script. It is typically no shorter than six to seven pages in length.

A transmedia bible looks a little different and serves a slightly different purpose. This type of book is used to provide an overview for the many different teams to follow, with more of a focus on the user and design than a traditional TV bible. It lays out the overall story treatment, the business and marketing plan, as well as specifications for functionality, technology, and design. The functionality and technology specs describe the rules of engagement, platforms and channels, system architecture, and user journey across multiple platforms. The design specifications include the overall aesthetic, brand guidelines, user interface, wireframes, and storyboards. The final length and format of a transmedia bible depends on the overall project scale, technical complexity, amount of required design thinking, and the range of content and platforms.

Script

Scripts help get everyone on the same page, from producer to actors, director, crew, and more. The script is a great communication tool and roadmap for the production. The producer is in charge of keeping the production on track and can use the script to help answer any questions related to locations, crew, props, costumes, equipment, and much more. Some scriptwriting software, like Celtx and Final Draft, can bundle into one multi-user file many pre-production tools, like schedules and shot lists, along with the script.

As previously mentioned in Chapter 3, the script formats for interactive television, virtual reality, and transmedia have slight differences. While the heart of the script is still to share the narrative and get everyone on the same page (literally and figuratively), some of these emerging medias have varying requirements. For example, script writing for interactive television is done primarily on unique software such as Netflix's Branch Manager or the open source tool Twine. These interactive nonlinear tools help manage multiple story branches and can be easier understood by various stakeholders in a production. The unique addition to scripts for virtual reality projects is to consider the story in six planes, including the front, back, left, right, up, and down. Writers

will sometimes include a color-coded map of the space on the script, with corresponding colored text to indicate where certain actions, dialogue, and transitions are taking place. Lastly, the special considerations of transmedia scripts clarify the story and experience across the different platforms while highlighting the timing and level of audience participation and engagement.

Storyboard

While the script is the written plan for the production, the storyboard is the visual plan. Much like the storyboards for traditional television series, they consist of images that show framing, shot scales and camera angles. These images can range from stick figures to detailed drawings depending on the complexity of the video and who on the production needs to use it. The storyboard helps the camera operator see your vision, illustrates positions for actors, and reminds you of your vision when you are in the editing process. Visualizing individual elements of each scene and sequence forces you to think about your shots before you ever look through the viewfinder. There are now many terrific pieces of software that allow you to "previz" your production, taking the traditionally hand-drawn storyboarding process into the digital realm.

Storyboarding for transmedia projects can also be designed as walk-throughs of the various platforms to give an idea of the user interface design. The different wireframes will not only show the structural layout but also indicate the dynamic nature of the navigational menus, interactive components, and motion design. Transmedia storyboards can also demonstrate user scenarios, illustrating how a user will come into contact and interact with your project.

Virtual reality storyboards also differ from traditional storyboards because of their unique scale. A typical virtual reality board has one long rectangle, essentially stretching a spherical image into a flat rectangular format. For example, this is the same way a world map displays the spherical Earth. Another approach used is a cube map, where you draw six squares that could wrap into a cube. One side of the cube would represent what is right, left, front, back, above, and below the viewer. Yet another method involves drawing the idea on one circle representing the full sphere. When drawing the circle, imagine the "tiny planet" visual effect that involves stitching together a 360-degree panorama to create an image resembling a small planet. In addition to the circle, include four rectangles offering four different anticipated views from your audience. Since most VR headsets have a 90-degree field of view, these four frames should cover the full 360-degree space. This allows you to map out every unique direction and experience of your story. Your VR storyboard should also include notes about location, action, audio, and duration.

Pre-visualizations using a small self-stitching 360 camera or app have also been used as a technique for virtual reality producers to save time and quickly edit shots together. Some producers even create 3D renderings and animatics to block out scenes.

Shot List

In addition to a script and storyboard, you will want to plan out each shot. In web and mobile video, your budget is usually more limited, not allowing for reshoots or additional footage, so the more advance planning, the better. A shot list can serve as a checklist during production. Plan out whether you will need multiple angles of a shot and what cutaways you might need to completely tell the story or use as filler. If you need inspiration for types of shots, look at your competition, films, other TV shows, and mobisodes, and you will begin to understand what shots are effective for certain subjects, genres, mediums, and devices.

It is important to make sure you have outlined and planned each shot for more complicated shoots like interactive television, transmedia, and virtual reality, to save time and money. The shooting ratio for interactive television and transmedia is much higher due to the number of different branches within a narrative. The same is true for an interactive virtual reality project. At first, shooting for a 360-degree video may appear limiting when you seemingly have less freedom with the number, length, position, and movement of your shots. This makes it more important to plan and capture more variety, ranging from first-person point-of-view to over the shoulder, at various distances and different angles, to drone or walking shots. Virtual reality hardware and software capabilities have improved and have proven that these experiences no longer need to be static.

Talent

When it comes to casting for web and mobile video talent, audiences don't expect glamorous movie stars, and maybe even prefer "everyday people." This doesn't mean you shouldn't hire a professional actor or someone who can connect to the audience. The ideal situation, if it is within your budget, would in fact be to hire professional actors. Since they are being paid and are more experienced, they are more likely to show up on time and come prepared. This will save time in the end and increase the likelihood your video will be anchored by good performances. Producers use different methods of finding talent. One method (the most expensive method, however) is to use a casting agency to help recruit. They have a database of actors, set up auditions and rehearsals, and can handle other related tasks. If you find an actor who is part of the Screen Actors Guild union, be aware that the union sets minimum standards for payment, hours worked, and deliverables. Others may set their price based upon the scope of the production and its level of anticipated distribution.

If you are taking a more grassroots approach to your web or mobile production, you may try casting on your own. Try targeting places like schools, theaters, and professional organizations. You can also try posting ads on Craigslist and other online forums like Backstage. If you don't have much compensation to offer, be very clear with your cast about the value of the project and what you are going to provide. If you cannot offer money, try to make it worthwhile for your cast by giving something back to the talent. This could range from production stills, a copy of the final video, footage for their reels, press, or a service trade. Treat your talent with respect and develop relationships by being upfront about your expectations and the overall time commitment.

Your web or mobile video talent may have little to no experience in acting. This is perfectly fine as long as you prepare them and help them come well-rehearsed. To ensure a smoother shoot and better performance, invite them into the creative process by sharing the production bible, written treatment, script, and storyboard. Spend time with them, answer questions, and provide a comfortable work environment. When you have less control over what your talent wears, ask them to bring an extra set of clothes, with no patterns or logos or white clothing, and with limited jewelry, and let the staff do their makeup.

When you have landed your actors, make sure you have them sign a talent release form. This protects both of you and explains how the video will be used and in what context. It also documents that the person gave permission to appear in front of the camera and doesn't require additional payment. You can find sample forms online and customize them to your needs. It couldn't hurt to have the forms looked over by a lawyer first to make sure everything is done properly. Make numerous copies and bring them to the shoot.

Production Team

Producers for web and mobile video have to wear many hats. Due to a possible small budget, you may also have to play the role of camera operator, sound engineer, lighting assistant, or interviewer. Working this way can be a great learning experience and gives you more perspective when you are able to hire larger crews. Having your hands in everything also saves money and better informs you of exactly what is needed for the production. However, when you take on every task, you may spread yourself too thin and limit your overall production. If you try the one-person-crew approach, and anything goes wrong, which it usually will, it can be very difficult to troubleshoot alone. You may just need someone to watch equipment or lend an extra hand for difficulties that arise on set. When shooting for emerging media, it's advisable to use the buddy system—have at least one other person with you, even if you don't have specific plans for them when you show up to shoot. They will inevitably come in handy. And if you work with a larger crew of skilled people, you can achieve more and learn from each other in the process.

Web and mobile video budgets usually allow for a crew up to five. A standard approach might be a three-person multitalented crew. They need to be comfortable behind cameras, lights, and audio equipment. You may want to use two people you work with on a regular basis and bring audio and camera equipment you are familiar with. Then hire one local person to bring lights and grip gear, which is usually inexpensive to rent locally. It's a good habit to have at least one more crew member than there are cameras when deciding the size of the team. Don't save money by cutting crew, when you can look elsewhere. Try saving costs on travel expenses and consider the time and money you will save on set and in the editing room with a talented team of individuals at your side.

> Roles and teams always differ depending on what you are trying to produce. Today, a dynamic video-based experience is much different from graphics engine-driven content. That said, in my experience, a must-have core for XR is a producer, a storyteller, and a technologist. That core creates a solid tripod to grow into many different team constellations of engineers, directors, artists, photographers, designers, developers, animators, creators, etc.
>
> **Fredrik Montan Frizell, excerpt from interview in Chapter 11**

Creating teams for other forms of emerging media, such as virtual reality, interactive television, and transmedia, differs slightly. There is more emphasis on new tech, and technologists are equally as important in the development of a project as the creatives. A good emerging media producer should be familiar with the different required skill set of a diverse team, as well as understanding both the opportunities and limitations set by the various technologies in a project. They need to keep track of all the moving parts and be able to communicate with the entire production team, including roles such as software engineers and developers. This will ensure that the health and well-being of the story world is being maintained. A typical production bible for a larger transmedia project does a full breakdown of the multidisciplinary team, describing the individual roles and responsibilities for each team lead. This could include a range of roles from producer, writer, director, designer, technical lead, system architect, programmer, business manager, marketer, and so on.

Schedule

The producer needs to develop a production schedule or "call sheet" that contains a list of everything needed and the associated costs. This keeps the production on

schedule and on budget. This list can include an inventory of props, costumes, lights, and cameras and when they are prompted on the schedule. The production schedule also informs actors when they need to be on set and helps anticipate staffing, equipment, and location needs for all aspects of the production. The call sheet also serves as the contact list for everyone involved and contains important logistical information like travel itineraries and addresses of shooting locations.

When scheduling for web and mobile video production, the producer may want to arrange for the shooting of several episodes in a single day. This saves time and money overall. You have to get the crew together and book the location only once. Knowing the release schedule for your web or mobile series will help you determine if it makes sense to shoot in one day. Will it consistently roll out daily? Weekly? Monthly?

Treat your talent and crew well. Consider having a production day of around 10 hours, allowing for 7 hours of shooting and 3 hours of setup, teardown, and breaks. To maximize your day, begin and end with enough help to easily load and unload gear. Make sure to feed people to keep them in good spirits and more productive throughout the day. Also, keep the schedule reasonable and realistic. Don't require people to be there at 5:00 a.m. or stay until midnight. If you treat your crew and cast with respect, shooting will go much more smoothly.

Clear schedules are especially important for multi-channel projects. Producers create timelines noting when different channels need to be created and released, which are dictated by the user journey and key events of the overall story world and narrative. Depending on the complexity of the transmedia project, this could cross different mediums and be split into individual chapters or full seasons being released daily or weekly. Therefore, the chronology of when these events occur is very important and needs to be in place in order to progress the user journey through the experience over time.

Location

The first rule when it comes to selecting a location is to scout it before the shoot. This way you will know what to expect both aesthetically and technically. You will be better prepared to identify the best camera angles, equipment needs, and any potential problems that might arise. When location scouting, document with a small digital camera and audio recorder, or a smartphone. The smartphone can also access the Internet if any questions arise and can download a sun path calculator app that will let you track the sun position for your shooting location. A circuit tester can come in handy as well, so you can guarantee outlets will work and if they are grounded. Logistically, you may want to locate parking, bathrooms, gear staging and craft service areas, and access to the site. Creatively, you should develop a basic floor plan for lighting, props, cameras, and talent positions and plan a shooting order that makes sense.

In order to maximize your time and money when it comes to shooting on location, you need to consider a few things. Each time you have to move equipment, including the cool-down of lights, you lose time because you have to break down and set up again. Properly schedule your shoot so you can knock out similar shots in one setup. Find opportunities where small adjustments in camera location or framing create a different shot. Try different backdrops or shooting before a green screen. You can also consider investing in one more crewmember and set of lights for quicker transitions.

Special considerations need to be made when deciding on a location for a virtual reality 360-degree video shoot. In 360 degrees, you cannot necessarily frame your shot in a traditional sense. Therefore, you need to consider the entire space, including what

is "behind" the camera. Also consider a location that can provide you with consistent lighting and avoid a rainy climate if possible, since you can't cover your camera like you can with a fixed frame camera.

Equipment and Format

After you have scheduled the shoot, arranged your team, and explored the location, you should determine what equipment is required. For a small web or mobile video production, your goal should be to travel light, but you will suffer if you get to the location and don't have what you need. Anticipate what you will bring or rent, organize your equipment, and maintenance-check everything. You will most definitely have cameras, tripods, light kits, microphones, headphones, audio recorders, boom poles, cables, adapters, spare batteries, laptops, and hard drives. Many web or mobile video productions today are using multicamera coverage, since cameras have become much more affordable and it speeds up the post-production process. The editor is provided with multiple angles in nearly real time of each shot and therefore has many more options to dynamically cut the video. This method works really well for performances, interviews, and how-to videos. Figuring out the needs of the project, the gear available, and the budget will help determine the necessary equipment.

In the pre-production phase, it is important to also consider the final format of the web or mobile video. Higher-resolution formats, like 4K and 8K, have more complicated post-production workflows. Producers shooting for the web and mobile will often shoot in a better format than needed, because the final product will be compressed for online distribution anyway. You might also need additional editing and viewing equipment, and more storage and processing power. There will also be an increase in render and encoding time. The viewer may have to wait longer on the receiving end, and you will need to pay more to host the files. But as broadband only gets faster and audiences expect a high-quality image, higher-res formats have become a necessity for most producers. You can read more about formats and codecs in Chapter 9.

Shooting for 360-degree videos requires a little more decision-making and slightly different equipment needs. First, you will need to decide on what 360-degree camera you want, depending on your budget and final platform output. You will also need a smartphone to control your camera remotely, a microphone, tripod, selfie stick for overcapture, stitching software, and editing software. You can try to use natural light in the space or get creative with hiding small lights in the composition. And as with web and mobile production, you will need to determine image resolution, frame rate, and whether to record mono or stereo. For example, if you plan on delivering only on YouTube or Facebook, then mono will work, but if your final delivery is aimed at a more immersive experience on a headset, you may want to go the extra mile and opt for stereo. The producer's responsibility when it comes to equipment includes doing their research, budgeting accordingly, and hiring a knowledgeable and reliable team.

On a Human Level . . .

Even the most experienced producers forget important details in the midst of the pre-production stage—they're only human, and so are you. You're making decisions all the time, and as the producer, you are being asked a hundred questions a day. You can't know all the answers. Yet each day you do learn something new, and learning as much as possible is what a producer does to be successful.

SUMMARY

Your project can only be as good as the people on your team. They are essential to your project and integral to the actualization of your vision. You want to work with

people who believe in your vision, share your work ethic, and are compatible with you as well as with other members of the technical and creative crew. This team can bring your project to life when the production stage begins, as you will see in Chapter 8.

REVIEW QUESTIONS

1. What are the primary elements included in a breakdown sheet?
2. How does a producer benefit by keeping a production book for each project?
3. What is the difference between a storyboard and a floor plan? How do they each augment a project?
4. What steps would you take to cast your project?
5. Who are the key production heads in most productions?
6. What does the location manager contribute to a production?
7. Name five support crew members who you might use in your production.
8. Discuss the pros and cons of shooting on location or on a sound stage.
9. What is the difference between working with child actors and adult actors?
10. Name 10 areas of pre-production that are important to double-check.

CHAPTER 8
The Shoot: Production

Experience is the name everyone gives to their mistakes.

Oscar Wilde

THIS CHAPTER'S TALKING POINTS

I The Producer's Role

II On Set and On Location

III The Camera

IV Lighting

V Audio

VI The Actual Shoot

VII Focus on Emerging Media

I. THE PRODUCER'S ROLE

As the producer, you've carefully developed each stage of your project. Now, you're ready for the actual shoot. Your vision is about to become tangible and visible. Your production schedule might be ambitious, stretching over a few weeks. Or maybe it's a simple, small, and compact two-day shoot. No matter its size, there are always details involved.

When the components are in place, the writer, director, crew, and talent are prepared to collaborate in making this project come alive. The actual shooting, also called *principal photography*, can begin when everything is ready to go: the script has been finalized; the actors have rehearsed, are made up, and are costumed; releases have been signed; the sets are built; the crew has been hired; the equipment is up to speed; all locations are secured; and any other details are all in place.

The Producer's Team

The producer depends on, and is a part of, a team of professionals who are also individuals, each with his or her own style and personality. You want to respect their talents, skills, and moments of real genius, and to be graceful about their human mistakes and mishaps. Successful creative teams often have a history of working together; some producers formed their team early on, as students or interns on a job.

CHAPTER 8 The Shoot: Production

A team can be many people, or just a few; each project's size and budget determine how many people can be part of your team. Your team might be just a cameraperson and an audio engineer with whom you've worked for years, and who give their best every time you shoot together. Or your team may include your client who believes in your vision, or the actors or on-camera talent who always come through for you. Your team often includes other producers, the production manager, designers, editors, whomever is needed for each specific project.

The producer's team succeeds through mutual trust, respect, humor, and a shared vision. The difference between the "creative" and the "technical" teams is a non-issue. You want the people with whom you work to fit both descriptions, translating your ideas with their skills and the tools of their trade into a true synthesis of art and science.

As the producer, you'll usually have the final word in decision-making, factoring in suggestions from the production team, the client's notes and requirements, and your own goals. Only after all these parts of the equation have been factored together do you make final decisions about production.

Production Protocol and Politics

In almost all television and emerging media projects, the producer takes an active part in the actual production. The producer keeps everyone focused on their job, knows who is doing what job, stays on top of what needs to get done, and clearly communicates everyone's area of responsibility.

If a director has been hired, the producer makes sure that all the elements are in place so the director can move ahead. As a producer, you can work closely with your team by:

- Explaining your ideas and the vision of the project.
- Agreeing on the vision and the creative directions it's taking.
- Communicating frequently and openly with your team.
- Listening to ideas and suggestions from your team.
- Nourishing your team with praise, food, and enthusiasm.
- Providing a model of collaboration and mutual respect.

II. ON SET AND ON LOCATION

Action springs not from thought, but from a readiness for responsibility.
Dietrich Bonhoeffer

In the previous chapter, you explored the pros and cons of shooting on a set/sound stage and on location. Each of these options can serve you well, depending on the nature of your specific project and its budget. Now, more producers are looking at another increasingly popular alternative to shooting on sound stages and on location—"building" a virtual location.

Virtual Locations

Shooting on location or on a sound stage each has its advantages and limitations, as we saw in Chapter 7. Maybe neither can be negotiated to fit the budget, or isn't available, or can't be duplicated on a sound stage. You can visualize this location, but you can't find its real-world equivalent. An alternative is to use a virtual location, designed and created through *computer-generated imagery* (CGI) capable of contributing a range of creative images—a futuristic building, a vast country landscape dotted with

sheep, or an ancient battleground with thousands of charging warriors. It all looks real, but it's virtual.

Virtual locations and CGI wizardry can be seen in a variety of looks and uses in most television programs, feature films, high-end commercials, news broadcasts, sports events, and video games, and is continually branching out to all platforms and content.

Building these virtual locations starts with a *blue screen* or a *green screen* background (also called a *chroma key* backdrop), or more recently, a *silver screen* with millions of tiny glass beads that reflect a light ring placed around the camera's lens. These screens can be hundreds of feet long, or simply 8' × 8' mobile traveling screens that can easily be folded up and transported. Whichever screen you decide on is then placed behind the action you're shooting. That action is edited later onto another image that replaces the blue, green, or silver screen.

Other locations can be built entirely on the computer and don't require the shooting of any footage. Often designed and created by a graphic designer or VFX artist, this kind of virtual location can be an elaborate rendition of a futuristic city skyline, a landscape from prehistory, an unknown galaxy. Even an actual photograph, say, of a historical time period, can act as a backdrop for live action or for CGI figures.

III. THE CAMERA

Where observation is concerned, chance favors only the prepared mind.
Louis Pasteur

The camera is the primary tool that producers use to tell a story. Although the use of 16- and 35-mm film is still an occasional presence in television programming, digital video technology has grown at such a rapid rate that the merger of film and video in television has completed. So, for the purposes of this text, digital video is the format of choice. You can consult additional sources and reference material for shooting and/or editing your production in film, and to update information on digital cameras, lenses, and accessories.

The camera operator (also called the *shooter*) forms a close bond with the camera to compose an image that tells a story, and shoots footage that not only looks good but is of high technical quality and can be easily cut together with other footage shot.

Today's video cameras are sophisticated, comparatively inexpensive, and more and more flexible. Most cameras offer creative options such as choices of formats on which to store the footage and audio, lenses, in-camera settings, varying shutter and shooting speeds, and built-in optical illusions.

Shooting With Digital Video

Think back to the Technicolor films from the 1950s. In Technicolor, negatives were processed into three separate red, green, and blue negatives. Ordinary film processing used only one negative with no color separation in the negatives, but the Technicolor prints made from the three-strip process had vivid, memorable color and resonance.

Now, in much the same way, a mid- to high-range video camera separates the light that hits the lens into three components of color: red, green, and blue (RGB). These cameras have *charge-coupled devices* (CCDs) that produce a sharper, higher-quality color picture. Most popular digital cameras capture images using these CCD sensors. However, an increasing number of high-end television and film projects are being shot with cameras that relay on CMOS (complementary metal oxide semiconductor) sensors, a more sophisticated version of CCD sensors.

Digital Storage

Each image with its audio is processed as an electrical signal that can be recorded onto a storage medium like a hard drive device and flash memory cards. Often, the video is fed from the camera directly onto the computer's hard drive.

All these recording formats work. Each has its own creative, technical, and budgetary advantages, and each has its limitations. Superior systems are being developed at a furious pace and undergoing beta and field tests as you read these words. The hot item on today's Top Ten list could be a big yawn tomorrow.

Your final decisions about what cameras to use, and in what shooting format, are best made with your DP or cameraperson. The bottom line is that you want your project to be shot professionally, in the highest-quality video the parameters of your project can accommodate, and for the best cost that you can manage from your budget.

Shooting High-Definition Video

The increasingly advanced digital technology of high-definition video (HD) has created an extraordinary leap in how we view and produce content and programming. HD has been heralded as a revolution because it can "see" better than the human eye with its depth of field, brilliance of color, and image clarity. Often, HD can see *too* much— every petal on a red rose may be crystal clear, but so is every wrinkle on an actor's face, and each badly painted set that might have gone unnoticed in film or standard-definition video.

HD has arrived in full force. In America, the majority of prime time programming is regularly broadcast in HD, as are many local and national sports specials and events, such as the Academy Awards. Compared to the traditional U.S. analog system that broadcasts NTSC programming in 525 horizontal lines, an HD image has either 720 or 1,080 lines, depending on the specific HD format. This difference results in a higher resolution and a clearer picture. Most cameras are equipped to shoot in HD as well as other formats like 2K, 4K, and 6K scans.

HD Systems

Currently, at least 18 versions of HD are used in various parts of the world. Two, however, have emerged as the most popular: 720p and 1080i. There are arguments for each system, though HD sets display both equally well in a widescreen 16:9 format. This shape is rectangular, with more picture space on the sides. Compare the size of this screen to the traditional 4:3 TV set, which is nearly square. The 16:9 format TV set is sold almost exclusively now, and the majority of television-bound programming is shot in 16:9, not 4:3.

- *720p* (1,280 pixels per line and 720 progressively scanned lines). Works well for broadcast, though it's usually not recommended for a project that may be transferred later to film or projected on a large screen.
- *1080i* (1,920 pixels per line and 1,080 actively interlaced lines of resolution). Best used when the final product calls for a "reality" aspect, which looks as if the viewer is seeing it live, in vivid sharp detail.

Shooting in 24p Video

When you shoot in 24p (24 frames per second, progressive scan), the process involves video that runs at 24 fps, the same rate as film, with an intermittent flash of black in every frame cycle. Put simply, 24p has a look that is similar to film. It's softer, it has a film "flicker," the colors appear richer than in video, and because it can be shot in high

definition, it's a popular format with producers who might want the option of transferring their project to 35-mm film for projection purposes.

Before shooting in 24p, talk with your editor and DP. Many cheaper cameras have a 24-frame mode but the camera is actually shooting 30 frames, or 23.97 frames; the shutter is only mimicking 24 frames. If you shoot some of your footage in 24 frames per second, and other footage for the same project in 30 frames, you could find yourself in real trouble when you get into the edit room. Because of certain technical limitations, few NLE systems currently can accommodate both formats at the same time.

The majority of producers, editors, and technical experts agree that most projects should be finished in HD with a 24p 16:9 master. It is the best format for broadcasting, progressive streaming on the web, creating PAL versions for broadcast in Europe and other PAL-friendly countries, and for release on physical media and streaming media. Yet, considering the rapid growth in digital technology, check with your DP or cameraperson for their opinion on your specific project.

Choosing Your Camera

Unless you're shooting on film, cameras today are almost always digital—even the inexpensive home movie cameras. A professional-quality camera is within anyone's budget to purchase, or at least cheap enough to rent, for your shoot. Anything less diminishes the quality of your footage and ultimately does a disservice to your production.

Cameras for Digital Cinematography

This is a category of more expensive and complex cameras, generally focused on independent films and specific television programs with an accommodating budget and other needs beyond the parameters of usual television and emerging media programming.

These cameras tend to have a single-chip CMOS sensor, a successor to the CCD image sensors in most digital cameras. This allows the camera to duplicate the shallow depth of field and overall look of 35 mm, and with some cameras, to shoot in 65 mm. The majority of these cameras can also accommodate professional film camera mounts and lenses. Most capture image and audio onto hard disks and flash memory; some can capture onto 2K, 4K, and 6K files.

Some of the cameras most prominent in digital cinematography are:

- Arri's Arriflex D-20
- Dalsa Origin
- GS Vitec noX
- Panavision's Genesis and Varicam
- Silicon Imaging's SI-2K
- Sony's F23 CineAlta
- Red's Red One, Epic, and Scarlet
- Canon's EOS 50D, 7D, and Rebel T2i DSLRs
- Nikon's D5000 DSLR
- Panasonic's GH2
- Thomson Viper FilmStream
- Vision Research Phantom 65 and Phantom HD

Studio Cameras

It's like a mini *Saturday Night Live* to see them with the cable pullers, everyone getting from Point A, which could be home base, all the way

over to [Point B]. It doesn't sound like a lot, but during the commercial break, that's a fascinating thing to watch.
Laurie Rich, excerpt from interview in Chapter 11

When shooting a talk show or news broadcast, for example, larger digital cameras are the traditional camera of choice. Most are mounted on moving balanced pedestals that keep the camera stationary; these pedestals can glide smoothly around a limited set, with a feature that can tilt the camera up or down. Most studio-based productions require three to six pedestal cameras, as well as one or two cameras mounted on a swooping jib, or crane, that can fly over the audience and onto the set. Some productions might augment the pedestal cameras with a handheld camera that moves freely; all the cameras are supervised by the director from within the control room. Microphones are suspended at regular distances over the audience for their reactions, like laughter and applause.

In a typical multicamera studio shoot, the footage from each camera, as well as the audio from the talent and audience microphones, are all fed into a central control room that is close to the set (or fed to a mobile truck with its own control room). In the central control room the director, producers, technical director, audio mixer, and graphics person all watch each incoming camera feed on its designated monitor. As the crew in the control room records the footage, it is generally edited live. This process is often called *live to tape*, even when what's being recorded is a digital file and not a tape at all, and it's how most studio shows are produced. Any additional editing changes can be made later. Or, it's all recorded and edited at another time.

Time Code

When you're shooting video professionally, the camera "burns" a *time code* (TC) signal onto whatever format you're recording onto and assigns each frame a specific number. You can draw a direct analogy between video and time code in video, and sprocket holes and frame numbers in film. The time code is broken into four sections. If, for example, the time code number is 07:02:45:17, then:

- 07 is the hour.
- 02 is the minutes.
- 45 is the seconds.
- 17 is the exact frame number (there are 30 frames per second); these last two numbers aren't necessary when taking most notes, only in editing when frame accuracy is necessary.

Working with time code is an integral tool for the editor as part of the editing process. It makes the editing frame accurate and exact. TC is also a valuable tool for producers when screening and logging footage prior to the edit session. As seen in Chapter 9, you can use TC numbers to create a storyboard, or *paper cut*, that the editor uses as a "script" for the edit.

Taking Notes With Time Code

To screen your footage, it must first be dubbed or rendered with the time code displayed visually on the top or bottom of the screen; this is called *visible time code*, or *vizcode*. The TC is exactly the same as on your original footage, and known as *matching time code*. As you screen each reel, you'll want to take good notes of what you see and hear; this is called *logging*. As you watch each reel from start to finish, log the TC that describes specific parts of the footage, such as a great cutaway shot, a move from one location to another, the best take of one scene, and so on. Everyone has a

personalized system—some people write the shot descriptions, like CU for close-up, WS for wide shot, and so on. Often people also mark the direction in which the action is going; for example, a bird flying to the right could be marked with >, a pair of eyes looking up is ^, and a camera pan from right to left could be marked as <<<.

From these notes, you can create a paper cut (storyboard) for editing. It includes the TC numbers, scene descriptions, length of scene, and which reel each scene is on. This paper cut is a major time-saver. As you refine your own system, you can read your log at a glance and find your shots.

Setting Camera Time Code

On a shoot, there are two ways to set and record TC in the camera:

1. ***A studio multicamera shoot.*** All the cameras are linked into the "house" TC generator. This sends out *time-of-day time code* (TC that records the actual time of day) to all cameras and recording devices, simultaneously, and is located in the control room on the engineering console. This way, the files from each camera can be "*synced up*" (synchronized) in the edit room. This system is helpful in organizing notes based on the chronology of events that occurred during the shoot. It also simplifies the editing, making it easier for the editor to match up each camera's footage simultaneously. Without this synchronization, the editor wastes time and money going back and forth to each file and trying to keep video and audio in sync. Not all cameras can take in outside time code, especially low-budget cameras, so one way to achieve some loose form of sync, once you've turned all your cameras on, is to keep them all running together. Turn them on and off together on the count of three. You can also use a slate to establish a visual, on-camera sync point. This is how filmmakers at the dawn of the sound era maintained sync between their separately recorded sound and images, and it's still a remarkably effective if old-school way to accomplish the task.

2. ***A single-camera shoot.*** An internal TC generator can be set inside the camera itself. Producers usually start Reel 1 at Hour #1 (01:00:00:00), Reel 2 at Hour #2 (02:00:00:00), and so on. Because there are only 24 hours in a video day, TC numbers beyond 23:59:59:29 don't exist. However, Reel 24 can be set at 00:00:00:00, Reel 25 at 01:00:00:00, and so on. This system helps in logging and screening footage for the edit session later.

Capturing the Image

Prior to shooting, the producer, director, and/or the DP discuss the creative and technical options for shooting each scene. Their decisions work with the narrative flow, affect the style and pace of the program, and ultimately will guide how a viewer sees a story line or character. The perspective of a shot, for example, can convey dramatic tension or character motivation when the viewer knows from whose perspective the story is being told. This perspective is either objective or subjective.

- ***Objective perspective.*** Captures the viewpoint of an unseen narrator or storyteller who is an onlooker, and views the characters from a third-person viewpoint. The shot is often a wider, more distant shot or a two-shot.
- ***Subjective perspective.*** Tells a story from a character's first-person point of view. The shot is closer or tighter, such as a close-up or an over-the-shoulder shot.

CHAPTER 8 The Shoot: Production

When planning a shot, the primary factors that play into capturing the image in the shoot include:

- Framing and composition
- Camera angles
- Camera moves
- Camera lenses
- Camera shot list

Framing and Composition

The primary concept of *framing* a shot involves shooting an image—a person or an object—as well as everything that surrounds or affects the image. An extreme close-up of a face gives one kind of narrative message, and an extreme long shot of the same person tells a different story altogether. Each option frames the image and composes the frame around it.

Composition is the relationship of objects to each other in the frame, or to the shape of the subject being shot. Colors, lighting, scenery, props, and camera blocking all contribute to a scene's composition. This total effect is known as *mise-en-scene*, or the setting up of a scene.

Another important aspect of framing concerns whether your project will be shot and/or viewed on either a 4:3 or 16:9 format. Because both are feasible, consider shooting your primary action in the middle of the frame, with less important details on both sides in case they get cut off.

Camera Angles

Each time the camera moves, and every angle at which the camera is placed relative to what it's shooting, creates a different effect, both visually and thematically. A sitcom can be shot in a fixed frame, using a stationary or *locked down* camera on a tripod, and the actors move only within that framing. A gritty detective drama might use a *handheld* approach, moving fluidly in and out of the characters' faces and actions. Both the genre of your show and its content help determine how you'll shoot it. As you decide on camera angles and movement, keep two things in mind:

- **Viewpoint.** The height of the camera's position determines the viewpoint of the character and gives the viewer a sense of theme and direction. When shot from below, for example, a character has the illusion of superiority, whereas a character shot from above may seem inferior or small. When an actor speaks directly into the camera, the dialogue is directed to the viewer; when the actor looks off to the right or the left of the camera's lens, it appears that he is focusing on something else.
- **Eye-line.** The position of the camera needs to correspond to the character's eye-line, usually in the top third of the frame. The viewer should be able to follow what the actor sees to the actor's eyes. This guarantees that the eye-lines from one character to another match up in editing.

Camera Moves

Your camera can be a flexible tool for capturing the subtleties of an image or the flow of action. The traditional camera moves from which a camera operator can choose include:

- **The tilt**. A camera can maintain the same eye-line and tilt down (giving the impression of the subject looking toward the ground) or tilt up (suggesting that the subject is looking toward the sky). This tilt can also give an impression of a subject's inferiority or superiority to another character or to the viewer.
- **The Dutch (or canted) angle**. Often used in reality shows and interviews, the camera is rotated so that the image itself appears at an angle and creates a sense of intimacy or tension.
- **The pan**. The camera swivels on the tripod or on its axis to form an arc from right to left or left to right. A pan is smooth and even-paced. A swish pan moves faster and can be effective in action sequences or as transitions in editing.
- **The tracking shot**. Also known as a *traveling* shot, it pulls the viewer into the action by using a camera mounted on a dolly that moves either on tracks or on special shock-resistant wheels alongside a moving subject. The same effect can be accomplished by mounting a camera on a crane or a jib that swoops above, into, or away from the action in a scene. Another effective approach is a camera rig (such as Steadicam, Glidecam, and the DvRigPro) that's worn by the camera operator for shooting smoothly in any direction.
- **The zoom**. The camera lens—in a *zoom-in*—moves smoothly into a close-up of a person or object. A *zoom-out* starts close and moves back.
- **Extending the frame**. The camera is locked down and stationary, and it holds on an object or scenery for a few beats, possibly with off-screen sound effects like a ringing phone, or a closing door before or after the character enters the frame from right or left.

Camera Lenses

Another area of discussion with your DP is about what lenses can be used in the shoot. In some cases, a *wide-angle* lens can add a more spacious feeling to a shot, whereas a *fisheye* lens creates a subtle distortion that can be interesting when shooting buildings or interiors that are otherwise mediocre. A *narrow angle* lens can give a clear focus on a small object. Other lenses can add diffusion or hues of color.

Camera Shot List

Prior to the shoot itself, a *shot list* is created and distributed. This is an inventory of each shot needed to be shot for a specific sequence or scene, and it uses specific terms for each camera angle, such as ECU for extreme close up, and so forth. The elements that go into a shot list are discussed and illustrated in Chapter 7.

Today's technology is advancing camera design so rapidly that cameras and their formats can upgrade, or become obsolete, in a matter of months; some formats will survive as others disappear. Ultimately, you'll talk with the DP and director, and often the editor, about which camera options are best suited to your particular project.

IV. THE LIGHTING

Lighting is an essential tool for enhancing the video image. The subtle use of light creates atmosphere and mood, dimension, and texture. It can help to convey a plot line, can enhance key elements such as set color or skin tone, and signals the difference between comedy and drama, reality and fantasy.

Hard Versus Soft

All lighting falls into either "hard," with sharp and distinct shadows, or "soft," with less defined, softer shadows and fewer background images. The intensity and clarity of the bulb, or its diffusion, combines with placement to design a shooting environment.

- *Hard light*. Aimed directly on its subject, with a brighter single-source illumination. The sun is one example. Other hard light is incandescent, ellipsoidal, and quartz.
- *Soft light*. Diffused, created with less intense lamps that reflect or bounce light off a reflector, a ceiling, or another part of the set. Soft lighting effects are enhanced with scrims, strips, scoops, and banks.

Three-Point

Production lighting involves three major lights and their positions in relation to each other (three-point lighting):

- *Key light*. Powerful, bright light that best defines a primary, or *key*, person or object, creating a deep shadow. It is positioned at roughly a 45-degree angle to the subject being shot.
- *Fill light(s)*. Softer light placed at an angle to "fill" any unwanted shadows created by the key light, at about half the key's intensity. It is usually placed opposite the key light at about a 30-degree angle
- *Back light(s)*. Throwing light on the subject from behind, it's positioned behind at around a 90-degree angle; it can also be adjusted higher or lower to create other lighting moods. This helps to create an illusion of depth behind the main subject and brings it forward from the background.

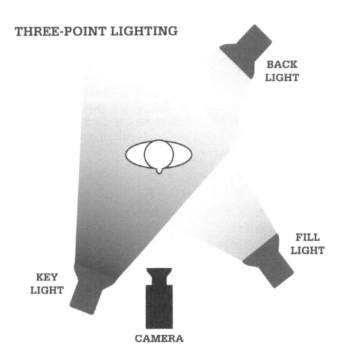

High-Key Versus Low-Key Lighting

Most TV talk shows, sitcoms, variety shows, musicals, and family entertainment use *high-key* lighting: a high ratio of key light to fill light. *Low-key* lighting creates a more dramatic, moody, and textured effect for dramas, documentaries, music videos, and others.

Hot and Cold Lighting

All lights have a color temperature that influences what the camera records:

- *Daylight (outdoor)*. The most powerful and brightest light. Daylight is hot and produces a blue tone on video.
- *Artificial (indoor)*. Considered cold. On video, it creates a reddish yellow cast.

Interior and Exterior Lighting

Everything you shoot is either indoors or outdoors. Each light has its advantages and limitations.

- *Exterior lighting*. As you shoot an exterior (outdoor) scene, you may want the spectacular intensity of the sun at high noon. Or, the scene calls for the moody waning light immediately after sunset, known as the magic hour. Each option has its own effect on an exterior scene. However, outdoor shooting can pose real challenges. Along with the sun's continual movement, its degrees of brightness can fluctuate dramatically through the shooting day. When the sun is your key light, it might need to be partially blocked out or augmented by fill lights or back lights. An exterior set can be shot at night but lit to look like daylight, or vice versa.
- *Interior lighting*. Shooting interior (indoor) scenes poses fewer challenges as video cameras and shooting formats become more advanced and light-sensitive. A camera's iris, for example, can play with light and color and go from automatic to manual. This avoids the camera's normal tendency to focus on the best-lit object in the scene.

Both interior and exterior lighting can be adjusted by using *reflectors* (also called *bounce cards*). These are glossy, white lightweight cards in various sizes that reflect light onto an object or actor. Large *silks* (squares of translucent material) can be strategically hung and positioned to filter the sunlight and maintain lighting consistency. In some cases, a light-filtering paper gel called *neutral density* (ND) is placed onto windows to keep outside light from being too harsh; in other situations, thick dark velvet curtain material blocks out sunlight entirely.

When shooting in video, certain colors or patterns can result in unwanted visuals; they require either careful lighting, or avoiding entirely:

- *Stripes*. A striped shirt, for example, can create a wavy effect on the video, known as a moiré pattern.
- *Red*. Certain bright shades of red can "bleed" and morph into other objects nearby.
- *White*. Too much white can overpower a scene and "blow it out."
- *Blues and greens*. Some shades can blend together and become invisible. Don't dress your on-camera talent in blue, green, or silver if you're using blue, green, or silver screens in the background for any special effects you may be considering.

V. THE AUDIO

Sound design is a highly creative art, and the nuance of sound has a profound, if often unconscious, effect on an audience. The careful recording of audio during production, as well as clever mixing in post-production, can make a visceral impact on the project. What a viewer *hears* has a definitive influence on what he or she *sees*. Sound design is a genuine collaboration between the audio recorded on a location and the extra layers of sound that are added and enhanced in post-production.

Sound Design

An overall choreography of recorded sounds is known as sound design and usually includes:

- ***Dialogue***. Conversation between the main characters in a scene.
- ***Background or ambience***. Muted conversations of extras in the background, barking dogs, sirens, playing children.
- ***Sound effects***. Narrative information, like a ringing phone or an angry shout.
- ***Added audio***. More thematic information, like a musical theme or a "sting."

If you could draw an audio storyboard, you would "see" audio everywhere: the dialogue, conversations in the room, the clatter of plates, and the tip-tap of walking shoes, as well as outside noises like background traffic, singing birds, children playing, sirens, a parade, and planes flying overhead. These all combine to form an essential layer of ambience that complements the visual images. However, these extraneous noises can also be a major interference if they're not what you want to hear.

In most cases, bad audio is a sure sign of amateurism or sheer negligence. For example, a camera microphone, or *mic*, is limited, seldom sensitive enough to accurately capture the sound or to cover all sound emergencies. You'll want your camera to accommodate an external mic, one that the audio engineer attaches. And before each shoot, test the sound from all mics. When you're shooting sync sound—which is most of the time—consult with your audio engineer about the benefits of using a mixer board.

The Four Major Elements in Audio

In recording the audio, the audio engineer takes four major elements into consideration:

- The microphone (or *mic*)
- Acoustics of the location
- Audio recording formats
- The perspective of the audio

Microphones

Mics fall into these primary categories:

- ***Directional mic***. Aimed directly at its subject. Captures only the subject's audio with as little other background sounds as possible. This mic is often a cardioid microphone (so named because of its heart shape) and records dialogue clearly.
- ***Shotgun mic***. Mounted either directly on the camera, at the end of a *boom* (a long rigid pole that can extend as long as 18 feet), or mounted in a pistol-grip rig. It has a selective pickup pattern that records primarily the sound in front of the mic. It can be as far as five feet away from the source of the sound and still

get clean audio. A valuable add-on is a fuzzy *windscreen* around the mic that reduces most wind or breeze interferences.

- **Lavalier (lav)**. Clips onto a collar or tie and picks up dialogue close to the speaker's mouth, isolating it from other audio. A lav also solves the problem of seeing a boom or its shadow in the frame. It can either be *hard-wired* and connected by cable to the camera or sound-recording device, or it can be *wireless* and powered by a bodypack transmitter worn under clothing.
- **Omnidirectional mic**. Sensitive to sound from any direction and source. It records dialogue and also captures all background sounds. This mic works best for recording man-on-the-street interviews and for dialogue where any ambient sound is required.
- **Handheld mic**. In interview situations, it's the most dependable mic because it requires sound pressure only from the person who's speaking into it. A handheld mic can be either directional or omni, and can be hard-wired or wireless.
- **Prop mic**. When it isn't feasible to use a boom or lav, the audio crew conceals a microphone in a prop or on set furniture to hide it from the camera. A mic can disappear inside a plant or a book that's close to the dialogue, be taped under a table, or draped inside a curtain.

The Acoustics of the Location

Audio engineers describe what they hear in very visual terms. One sound can be warm, bright, and round; another is hard or soft, fat or thin. The quality of the recorded sound is controlled to a great extent by the microphones used to capture them. Another important factor of recording sound is the acoustical setup of the location.

Sound waves are like fluid impressions. They can be muffled by surfaces that are soft and spongy, such as rugs, furniture, clothing, curtains, and even human bodies. Sound bouncing and deflecting off surfaces that are hard and reflective, like glass, tile or vinyl floors, mirrors, and low ceilings, creates echoes or distortion.

Some locations can pose a real challenge to an audio engineer. A location might look just great, but it's got challenging audio problems—humming air conditioners, the buzz of fluorescent ceiling lights, ticking clocks, outside traffic sounds. As the producer, you may choose the controlled environment of a sound stage or studio, avoiding unwanted noises. Or, you may want a buzzing, busy background ambience.

Audio Recording Formats

In shooting most video formats, the audio goes through a *single system*. Here, sound is recorded directly onto the memory card, hard drive, or other storage mechanism. In the case of a multicamera shoot, the audio from each camera usually is fed directly to a single recording device. The audio engineer monitors the levels and sound from each microphone onto separate channels for mixing later in post-production.

Because you want professional, broadcast-quality sound, most formats come with four separate audio tracks or *channels*. It is possible to assign microphones to each channel. Now you've got the capacity for stereo recording, with two channels on the left and two on the right. These channels can be expanded later in the audio mix. HDTV broadcasting features the additional capability for 5.1 surround sound, a standard feature on Blu-rays and digital television sets. HD camcorder systems can record audio directly onto HD video with at least two tracks of audio.

The Audio Perspective

In the same way that an image is shot from a visual perspective, dialogue and ambient sound is recorded with an audio perspective in mind. For example, dialogue spoken

by an actor in a close-up shot sounds clear and intimate and appears to be coming from the immediate foreground. Dialogue yelled from across a busy street in a wide shot has a different perspective, coming from the background of the shot, as the distance blends in with the ambient sounds from traffic and other street noise.

It's not always possible to record sound that has the same perspective as the footage. A visual might be a very long shot, say, of two mountain climbers as they reach the summit. The only way to record their dialogue is by using a concealed wireless mic, but doing this could result in audio that sounds perfect for a close-up, though not for a long shot. It can be enhanced during post-production with added sounds like blowing wind and crunching snow.

Recording Production Sound

Audio that is recorded during production on a sound stage or at a location is known as *production sound* and refers to all scripted dialogue, ambient sound, and background noise. If an unwanted sound creeps in, or the dialogue changes after the footage has been shot, most production sound can be rerecorded later in the post-production stage. This is explored in greater detail in Chapter 9.

Portable Recording

Sometimes in addition to recording audio directly with your video file, with sync sound, you may also want to record audio independently—a voice-over, ambient sound like traffic or conversation, music from a performance—and mix it with other audio elements in post-production. Professional digital formats for portably recording isolated audio continue to be improved, though currently, each must be researched carefully to make sure it's compatible with both the video equipment and the editing system you're using.

Digital Recording

Today's most popular digital audio recording formats record onto Secure Digital (SD) cards and can import and export via USB ports into the computer. The device has a built-in mic and can accommodate an external mic as well. It's able to monitor the audio levels and has a time code reference.

In shooting digitally, the audio engineer cautiously monitors any digital distortion caused by audio that may be recorded too hot on the meter, because it's generally unfixable and useless. Loud sounds or high-pitched dialogue can peak the meter in the camera or in the digital recording device, so whenever possible she tests the audio before the shoot and won't allow the meter setting to go over zero. She usually sets the audio at −12 dB and even −20 dB, and she is careful never to let the audio levels hit the top of the meter. She also listens to the camera's audio over the headsets before the actual shoot starts, and she wears them throughout the shoot.

The Challenges of Recording Sound

Whether you're recording audio on a soundproof set or outside on location, there are situations to be aware of, and that you should try either to prevent or avoid altogether:

- ***Obstructions***. Jewelry or clothing can rub or click against a clip-on lav.
- ***Boom pole***. Boom poles vary in length (from a few feet to 18) and in structure. They need to reach long but be lightweight so the boom operator doesn't tire out. Often the actual *handling noise* of the pole itself can create audio interference.
- ***Lights***. Neon or fluorescent lights that are barely audible to the ear can cause a noticeable buzz on the audio track.

- **Appliances**. Certain set pieces or existing appliances on location create their own sounds like a refrigerator, radiators, or an air conditioner.
- **Motors**. Your location might be near a busy street or under an air traffic pattern.
- **Weather**. Thunder, the rustling of wind, even a faint breeze can be a detriment in recording clean dialogue.
- **Neighbors**. A school playground, a lumber yard, an auto repair shop, or a house with a lawnmower can create interfering noises.
- **Construction**. Incessant reverberations from jack hammers or saws can travel into a location or a studio, even from a distance.
- **Nature**. Barking dogs, crickets, cicadas, blue jays, robins—each can be nuisance, or exactly what you need to create an added dimension of reality.
- **Batteries**. If the battery power on a mic's body pack goes out, you've lost your sound. Plan ahead with an adequate supply of charged batteries.

Most of these problems can be avoided with foresight, thoughtful use of microphones, and sound mufflers like moving blankets and microphone windscreens. You don't want to depend on the post-production audio mix to fix your audio problems, but that's where you can often resolve unavoidable audio dilemmas.

Some Sound Advice

Your ultimate objective is to record and mix your audio elements so seamlessly that when you listen to it with your eyes closed, you hear no audio cuts or changes in levels. Any audio transitions from one scene to another should be equally smooth.

Most every challenge in recording production sound has a solution, such as:

- **Record sound effects and ambience separately**. If two characters are walking and talking as they pass an outdoor café, sound is around them, everywhere: the clinking of glasses, passing conversations, church bells, and fluttering pigeons. Whenever possible, record each of these sounds separately. In the audio mix, each is blended with the dialogue to create an overall audio impression.
- **Record room tone**. *Room tone* refers to the subtle, nearly inaudible sounds that are unique to each and every set or location. At either the beginning or end of each camera setup or at the completion of a scene, while the entire cast and crew and equipment is still on set, the audio crew asks for complete silence and records 60 seconds of the sound in the room. In the audio mix, this room tone can fill in gaps in the dialogue or effects.
- **Keep continuity**. Just as a script supervisor maintains visual continuity in a shoot, there is a definite continuity in recording audio, too. The audio levels between actors in a scene, for example, need to be constant and unvarying in volume. Any background or ambient sound is measured for consistency of levels so they don't interfere with the dialogue. When a camera angle changes, its accompanying audio might also be different.
- **Rehearse and re-rehearse**. There is a real difference between setting up audio for one shot in which both actors are walking and talking on the street, and a shot on a set where they're sitting quietly on a couch. Carefully consider how you can record the audio that fits with the visual camera angles and perspectives for each scene.
- **Keep an audio log**. One person on the audio production crew has the job of keeping track of what is recorded on a set or location, including dialogue, ambient sounds, and special effects. This audio log, or *sound report*, lists details that are pertinent to the audio mix in post-production, such as the reel number with

time code numbers (in and out points), the scene number, and the take number with a short description of what's been recorded.
- **Keep your cool**. A lot of details are involved in recording good, clean sound. The best place to learn is on the job, so get familiar with the tools of the audio trade, and keep your focus. Troubleshooting comes with the territory, and so does keeping your cool, all the time.

VI. THE ACTUAL SHOOT

A long-playing full shot is what always separates the men from the boys. Anybody can make movies with a pair of scissors and a two-inch lens.

Orson Welles

Before starting principal photography, the producer checks and double-checks all the legal documents. You'll have copies of signed deal memos with the crew, contracts with the talent, release forms from the extras, and final location agreements—everything's been negotiated and signed.

Following are the key elements in most all shoots.

Arrival of Cast and Crew

Based on their call times, crew members arrive on the set or location. Usually the production department arranges for the transportation department to gather equipment, vehicles, set pieces, and other production materials to be delivered and unloaded early in the shooting day. The actors and talent arrive for wardrobe, hair and makeup, and any time-consuming special effects. Everyone's call time is given to them the night before in the call sheet, or by a phone call, email, or text message from the production department, by either the production manager or the AD.

Wardrobe, Hair, and Makeup

Actors and talent (including minor parts, extras, background people, children, and animals) usually need hair, makeup, and/or wardrobe before they're ready to appear in their scene. They may require only a simple hair comb, minimal makeup, and little or no wardrobe. Or, makeup could involve complex blood or scar makeup, facial hair or wigs, or a complicated period wardrobe such as a historical outfit or costume. The wardrobe, hair, and makeup people stay close to the set for any last-minute extra touch-ups such as a hair combing, powdering a sweaty nose, or adjusting clothing.

Dressing the Set or Location

The art director and his crew *dress*, or prepare, the set or location for the shoot. This can include finishing touches on the set pieces, adding furnishings, props, or greenery, and moving pieces around to accommodate the action or movements of the characters.

Craft Services

The craft services crew have set up and are serving food at least a half hour before the overall call time, and assembled set up a table for coffee, tea, water, meals, and/or snacks for the cast and crew that is close to the shoot. They also serve at least one healthy meal a day or every six hours, depending on contractual agreements and the budget. When you pay special attention to craft services, everyone is happier, more productive, energized, and usually grateful. No matter the size of your production, everyone involved is human, and all humans need food and water on a regular basis.

Even when a project is low-budget, always budget high for craft services and catering. Keeping your cast and crew well-fed and hydrated could well be the most important form of thank you that you can give them—besides a huge lump of cash, of course. Water, good coffee, health teas and bars, fruit, full meals—this epicurean gesture buys you a lot of loyalty when the days get longer than you expected.

Blocking for the Camera

The producer, director, DP, and/or gaffer survey the set or location, review their storyboards, and map out the day's shoot. They plan the placement of the cameras, lights, and audio equipment in a process called *blocking the scene*. Any revisions are determined here—all last-minute changes can slow up production and stress out the crew.

Blocking the Actors

Once the camera movements are decided, the scene is rehearsed for the cameras and lights. Often a stand-in takes the place of an actor in the blocking. Any places for the actors are marked on the floor with masking tape.

Lighting the Set

Properly and thoughtfully lighting a set or location takes time. Depending on the size of the crew, the DP and the gaffer set the lights, replace bulbs, try different scrims and gels, and find various angles that work best. If a stand-in doubles for an actor, the crew can experiment with the lights while the actual actor is in makeup or rehearsal.

Audio Setup

All microphones and recording devices are set up, tested, and rehearsed. The audio may need muffling with heavy *sound blankets* or acoustical equipment. Any mic cables are kept away from electrical cables or wires to prevent interference. If a separate sound mixer is used, it's kept in an area where the audio engineer can monitor the different levels of audio coming from each microphone and keep them all in balance. Any boom shots can be rehearsed with the camera operator so the boom or mic shadows won't enter the camera's frame.

Rehearsing the Actors

Whenever possible, the director or producer rehearses the actors on the set where they will be shooting. This on-set rehearsal gives the talent a chance to loosen up in the shooting environment and become familiar with the script. Sometimes the rehearsal takes place in another area away from the set, which allows the actors to concentrate.

Rehearsing and Blocking the Extras

Any people in the background (called *extras* or *atmosphere*) must be rehearsed and blocked, just like the main actors. A member of the crew, usually the AD, works closely with the extras in rehearsing movements such as crossing the set from one side to the other, chatting and laughing at tables, or walking behind the action. The extras are directed not to look into or at the camera, and they generally only pretend to talk or laugh; usually they're told to move their lips in complete silence. Their audio is recorded later and added into the final mix.

The Technical Run-Through

This final rehearsal checks for technical details of the action being shot. Camera angles, lights, audio mics, dolly moves, the placement of furniture or props—all these are essential steps in the choreography of production. If you're shooting on a location,

cover anything that could be damaged with plastic tarps or moving blankets. Move valuable or breakable items, like plants, furniture, china, and glassware, that are part of the location. Someone is assigned to take careful notes and photographs of each object in its original place so everything can be put back exactly where it was, after the shoot. Leave each location in better condition than when you started.

Security

On any location, there are items of major value that can tempt hit-and-run thieves. Even on busy sets with people everywhere, things get stolen all the time. Hire a security company, or assign crew members like PAs and interns, to keep a constant watch on whatever you don't want stolen or damaged. Insurance doesn't cover everything. When someone is assigned to be on "fire watch," for example, they're responsible for intently watching the back of the truck(s), and allowing only authorized personnel to come and go.

Shooting Publicity Stills

Often, a still photographer is hired to take publicity photographs that can be important to a publicity campaign as well as for archiving the production. The photos can be taken during the technical rehearsal, or, if the photographer uses a camera with a silent shutter, during the shoot itself. A professional still photographer knows how to get great shots without being obtrusive.

Lights. Camera. Action!

All the equipment, the crew, and the talent are in place and ready. Now, it's time for the shoot. The director calls for action and the camera operator and the audio engineer both confirm by saying "up to speed," or "speeding." Then the scene or action can begin.

Slates. Most video and film productions use a *slate*, or a *clapboard*, which is held in front of the camera each time it rolls. Like a small chalkboard, relevant details are chalked on it: the project title, the names of the producer and director, what camera(s) is in use, the scene number, take number, and date. Other video productions might use a *smart slate*, which matches the camera's time code with the audio.

Takes. With few exceptions, a scene is shot several times before it feels right to the producer or director; each attempt is called a *take*. You might run into technical problems like poor lighting, a boom in the shot, a misread line, or a number of other challenges that might occur as part of the production process. Additional takes can cover up these problems, so often a seasoned producer may call for a final take for *safety*, as a contingency.

Each shot in each scene has been planned out with its own camera and lighting angle and often its own lens. Each shot is assigned a description and a specific number on the shot list and production schedule. For example, the close-up of the small child digging in the sandbox might be the third shot in Scene #3. Every time the scene is shot—from "action" to "cut"—it is given a new take number.

Shot coverage. Every shot requires a new setup, usually with new lighting and different camera angles. Whenever possible, get your most important key shots first. Then, as time permits, work down your shot list for any remaining shots you still need. Depending on the creative direction that you want from your project, the general rule of production suggests that you cover one or more of the following shots:

- ***Establishing shot***. This shot, as the name implies, establishes the location of the scene. It is usually a wide shot.

- **Master shot**. It establishes the scene and what's going on in it. It is usually a wider shot of the whole scene that shows its action, the actors' movements, and their relationships to each other. The master shot can then be intercut with tighter angles, such as:
- **Close-up**. A tight shot, usually of an actor's face or an object. It is revealing and intimate and shows more crucial detail.
- **Single**. A shot of one actor, in close-up, medium shot, or wide shot. When editing from one single shot to another, pay attention to continuity of eye-line.
- **Two-shot**. A scene with two actors in the frame. Three- and four-shots have three and four actors in the frame, respectively, and are useful for variation and cutaways.
- **Over-the-shoulder**. The camera is placed just behind the shoulder of one person and focuses on the person she is facing. That person's face is in the frame along with a portion of the listener's shoulder. This shot brings the audience closer to the characters and varies the cutting.
- **Insert**. A shot, usually a close-up, that reveals an important and relevant detail in a scene.

Video monitor. It is vital to have a video monitor on the set. Connected by cable to the camera(s), the monitor shows the DP, director, producer, and other technicians what the camera sees as it's being shot. This can be especially important when shooting HD. The camera operator might not see something on the camera's small viewfinder but can catch it on the larger monitor. It's also an instant playback of what was just shot. The monitor is the centerpiece of the "video village" where one or more monitors are set up for the producer, director, and DP (and often the client or investor) to view the footage as it's being shot as well as to watch playback between scenes.

Audio. Often the sound engineer may hear a problem on her headphones—an airplane overhead, a humming fridge. She'll nonetheless let the scene finish and not interrupt the take. After the director calls "cut," she'll tell him about the problem. Some of the take may still be useable, and production protocol states that it's only the director's call to stop shooting.

Continuity. The script supervisor (or a competent production assistant in a lower-budget production) is a constant presence on the set. He checks to make sure that each shot can match up with the shot that comes before it—and after it—in the script and in editing. If, for example, an actor puts his hand in his pocket in one shot, his hand must still be in his pocket in the shot that will follow it in editing. Because most projects are shot out of sequence, the script supervisor's notes are a major time-saver for the editor and audio mixer. Continuity notes generally include:

- The shot number and description
- The camera and lens used
- The length of the shot itself
- Comments on the action in the shot
- Comments or notes from the director, producer, or DP/camera crew and/or sound mixer

Cover shots. Even the most experienced producers and directors will finish their shoot and go into the editing room, only to realize they're missing an important shot. During production, the script supervisor can avoid this problem by suggesting cover shots, or additional footage.

Audio pickups. Often additional audio needs to be rerecorded—a line of dialogue that was muffled, ambient background noise, or other sound effects. It is easier in the long

run to record it right away. If you wait, the actor may have left the project, or the ambient sounds like heavy traffic or children at play may no longer exist.

And before a scene wraps and sets up somewhere else, the audio engineer asks everyone to say nothing and hold totally still. Then, she records at least 30 seconds of "room tone," which captures the unique sounds that live in each room or location. That room tone comes in handy during post-production, filling in occasional holes in mixing dialogue and other sound tracks from that scene.

> Always pay your sound person well; the audience will forgive a badly composed or out-of-focus shot, but they'll never forgive bad audio.
>
> <div align="right">Michael Moore</div>

When each shot on your shot list has been captured, all the gear is either moved or reset to shoot the next item on the shot list. The camera, lighting angles, and audio are also repositioned.

The Equipment Breakdown and Location Wrap

Everyone is happy with the footage, and the shoot officially wraps for the day. Now, the crew *breaks down*, or disassembles, all the lights, cameras, audio equipment, and whatever else is not needed for the next day's shoot and packs it away. On location shoots, the crew removes all tarps, protective coverings, garbage, equipment, and whatever else remains, and puts items back in their original positions, thoroughly clearing out the location. With all this accomplished, your shooting day is over.

VII. FOCUS ON EMERGING MEDIA
Video
Web and Mobile

When producing video for the web and mobile, you need to keep compression and screen size in mind. Although compressors are getting much better and screens have ever-higher resolution, there are still some helpful techniques to consider in order to provide the most optimal image online. Video has actually proven to look spectacular online. It doesn't need to look like an amateur YouTube video, if you put time and effort into making the right choices for shooting for web and mobile.

The first thing to consider is what type of camera to buy. When you are selecting your gear, remember that it's really just a tool for the story you are trying to tell. Story is still king, and there is always going to be a newer and better camera coming out, so make sure you choose one in your budget that fits the best needs for your production. There are a few categories of cameras that you can consider, including consumer, prosumer, and professional. For good quality web or mobile video, a prosumer camera may best fit your needs. They are semi-professional, cost-effective, flexible, unobtrusive, and have most customizable features, including manual settings for focus, exposure, and white balance. Prosumer cameras also have microphone and headphone inputs.

Another camera to consider is a video-capable Digital SLR, which entered the market as a popular choice for web video and independent filmmakers. These cameras were originally used exclusively for photography and therefore have amazing removable lenses, extraordinary depth-of-field and lowlight performance. The high-definition footage appears very cinematic for such a relatively affordable camera.

There are a number of shooting techniques to keep in mind when shooting for web and mobile. Consider that your video will be viewed mostly on small screens, so shoot more close-ups to engage the viewer and tell your story. Wide-angle shots can lose detail on a smaller screen, and viewers may miss critical information or be less engaged. Compressors can handle a lot these days, but you still may want to avoid unnecessary zooms, pans, handheld shots, and other camera movements unless they are critical to your story. The information in these types of shots is more difficult to compress and produces larger file sizes. If the production can afford it, you may want to consider a hardware encoder in place of compressor software. Auto-focus can also produce unruly results when the camera is constantly shifting focus. In addition to using manual focus, you should white balance and pay attention to exposure settings to produce a good image. Finally, it is important to invest in a good tripod or monopod that is sturdy and tall enough for the environment you will be shooting in. Handheld shooting without a stabilizer, or using a weak tripod, can produce jittery footage, which is unsettling for the audience and is difficult to compress. Many cameras have built-in image stabilizers that can help steady your image. Before you go out on location, be sure to become familiar with all of your gear to ensure a smoother shoot.

Mobile/Vertical

There are additional tips and considerations when shooting for mobile specifically. The biggest difference is unquestionably the vertical frame. Traditional media producers are forced to rethink how to tell a story vertically and how to best utilize the narrower space on the screen. Some producers will still shoot with a traditional wide-screen camera and then essentially have three vertical frames to choose from after they segment the image. When you are shooting with vertical in mind, you are considering the location differently, including spaces like the ceiling and floor. Producers for the show *Dead Girls Detective Agency* shot a lot in stairways and used a lofted bunk-bed to create a two-shot. Most shows shot for vertical viewing utilize the close-up to fill the frame, stack split-screens, and add graphic elements.

360-Degree

When shooting a 360-degree video, you have to consider the entire space around the camera. The frame will include everything in plain sight of the camera, including you, your crew, and equipment, if you don't hide it first. There are many considerations when shooting a 360-degree video. First, you have to decide on your equipment needs and budget limitations.

Cameras. Cameras can range anywhere from $200 to $60,000. They also vary in viewing angles—some including only one ultra-wide-angle lens that doesn't offer the full spherical view, while some setups use two fisheye lenses mounted back-to-back capturing 180 degrees each. Larger setups have multiple cameras mounted, like the traditional GoPro six-camera rig. The number of cameras and amount of viewing area dictates the amount of seamless coverage and overlap you are capturing. When choosing a camera, you will also want to decide on monoscopic or stereoscopic field of vision. Monoscopic is more affordable and can be viewed on YouTube or Facebook and headsets. It is a flat rendering of the 360 degrees and has no real depth perception. Stereoscopic is a 3D rendering of the space, usually shooting with two lenses to shoot each field of vision as a separate input for each eye. These are viewed only on headsets but are much more immersive. Another consideration when it comes to choosing different cameras is the overall ease of use. For example, some cameras come with built-in stitching and editing software, hard drive space, built-in battery, and an application you can use on your smartphone to control the camera remotely.

While you choose your camera, you will want to pay attention to some of the settings options. For example, choosing the right resolution and frame rate can affect the end product. The higher the frame rate, the smoother the video and the more realistic looking in a headset, but then you sometimes compromise resolution. If it isn't an action sequence, you may want to settle with a lower frame rate like 30 fps and gain resolution. Be aware that when you output your 360-degree video, it usually degrades and looks lower in quality after stitching and after the compression by YouTube and Facebook; therefore, you may want to start with the highest resolution that your camera provides. To assist you in your camera setting choices, you should visit the specifications defined by your chosen end platform. For example, YouTube and Facebook have video requirements for file size, file type, resolution, aspect ratio, video codec, frame rate, projection format, and depth.

Tripod. A typical tripod will be of little use for a 360-degree video production because it will be captured on camera and look larger than life due to its close proximity to the fisheye lens. You will want to consider a travel tripod, which usually has a ball head that can be adjusted with a knob instead of a handle sticking out. They are usually more portable and lightweight. You can also consider anything else that would be out of view of the camera or less intrusive in the shot, such as a monopod with legs, light stand, or C-stand.

Lighting
Web and Mobile

Good lighting is a key to successful web and mobile video. If you have a lower budget, you may not have access to a lighting director, gaffer, or fancy lighting equipment. An inexpensive but effective method to light your video would be to invest in a tungsten light kit, which includes three lights, stands, barn doors, gels, and a reflector in a case. This type of kit produces a warm healthy glow and will give you more control and flexibility, allowing you to adjust the light where you want it in the scene. Portable LED lights have become popular due to their affordability, flexibility, and color accuracy. They are also smaller and lighter while still producing a lot of light, and they don't put off the heat that tungsten light kits do. Fluorescent lights are another option, producing an even, soft light while remaining cool to the touch. However, they are more expensive and a little less portable than LEDs. Another affordable creative option for web and mobile producers is a simple Chinese ball lantern. They are flexible and can fill a large area with soft natural light. Depending on your budget and production demands, your lighting equipment can vary greatly. For a web or mobile production, try to choose lights based on performance, price, flexibility, durability, and ease of transport.

In addition to choosing your lighting equipment, you will have to understand the principles of lighting, which are the same for traditional television. A standard setup includes a key light, fill light, and back light to successfully light your subject or scene. One common mistake amateurs make is shooting in low light while bumping up the exposure, which produces a grainy and low-contrast image. Or they do the opposite and flood the scene with too much harsh, unflattering light. Using a flexible light kit, you can carefully try to fill the scene with light rather than flood it. Try to fill in shadows with light, since compressors will remove information from shadowy areas in the image. If you fill in these shadows, the compression will work more efficiently and the final image will look better. Compression can tend to make your final output muddy and a little darker. This is why your original video needs to start out with superb lighting. Compressors don't handle image noise well, so it's also advisable to shoot at as low an ISO as possible. Under a budget, you should choose a location with good natural

lighting, bring bounce cards and fill in shadows where necessary, and carefully set up your own three-point lighting system.

360-Degree

When lighting for 360-degree video, a traditional three-point lighting system no longer applies, because you would see the lights surrounding the camera. Therefore, unless you plan on green-screening and compositing them out in post-production, you will need an alternative creative lighting system. Try to use as much natural light in the space as possible, or try integrating smaller lights into the scene. For example, some crews tape rope lights hidden within a set or attach small lights to the monopod to brighten the scene. Try to maintain a consistent exposure across the camera's multiple lenses. You could place the sun on the stitch line, for example, if using a two-lens camera. Some stitching software also comes with an exposure balance feature. This can be helpful when trying to even out the lighting in post-production.

Lighting in a 360-degree production can also be used conceptually within your narrative. It can be used to help guide viewers through the experience. For example, a spotlight on a main character, a subtle vignette framing a moment, or something bright and eye-catching could help direct the viewer's attention where and when you want it. Some filmmakers will also use intentionally bright practical lights within a scene because it feels more natural to an audience and therefore more immersive.

Audio

Web and Mobile

Sound is an area where you should want to invest in quality equipment. When you have moved on to your latest camera, your microphones will still be with you. If you ever have poor lighting in your video, your sound may still carry your story. One could argue that good sound is more vital than a good image in communicating your story. It is important to start with high-quality audio recording because it is very easy to reduce sound quality in web delivery. An editor might not understand audio filters or audio mixing, compression may reduce quality, and the audience may have poor speakers or be in a noisy environment. All of these factors emphasize the importance of choosing the right microphone and its placement in the scene.

Since producing for web or mobile video can sometimes involve a more grassroots approach, you may be inclined to use the built-in camera microphone, but avoid this urge at all costs. These microphones are usually lower quality and far from your source. Choose a professional microphone with the pickup pattern appropriate to your specific production needs. Possible pickup patterns include omnidirectional, cardioid, or unidirectional. If you want to do a quick field interview, you may use a unidirectional handheld mic and hold it close to your subject; or, if you need to pick up a specific sound from a long distance, you might try a narrow shotgun mic to zero in on the source. An omnidirectional lavalier makes a great choice if you want to get close and hide it on a subject. A wireless lavalier gives you and your subject even more freedom to move around. Each mic has its purpose for your production. It would be in your best interest to invest in all of them, plus quality ear-covering headphones, boom poles, longer microphone cables, and an XLR-mini adapter. Good quality headphones are essential so you can get the right volume and catch any pops, background noise, or interference. Boom poles and longer cables will give you more reach. An XLR-mini adapter allows you to directly plug professional microphones into your camera or audio recorder (if the camera doesn't take XLR cables straight). External audio recorders, like those produced by Zoom and Tascam, are flexible on set and convenient for

transferring your sound separately in post-production. Considering good sound equipment and producing high-quality audio from the start will result in a better compression and ultimately sound significantly better in most environments.

360-Degree

You can't hide anything from the view of a 360-degree camera, including your traditional audio equipment such as long boom poles, shotgun mics, and endless cords. Wireless lavaliers are the obvious winner for recording audio in 360. They are omnidirectional and easier to hide on your talent. Using multiple lavs will allow your editor to target specific surround sound elements to create a more immersive environment. Another backup option for recording audio is to use the camera's built-in microphone for ambient sound, or to attach or hide an audio recorder, which can do spatial recording within the scene.

Audio can be a powerful tool in directing a viewer's experience within your narrative. If the user hears a sound behind them, they are most likely to turn and look at what is making the noise. This is a natural and unobtrusive way to help guide the viewers through your story world. Therefore, considering how to capture these sounds and/or add them in post is essential.

The Shoot

Web and Mobile

For a smoother post-production process, shoot with editing in mind. This includes varying your shots and trying different camera angles without crossing the 180-degree line. Shoot for continuity and it will help speed up your editing process, which is essential for web and mobile video, as it usually has a smaller budget and quicker turnaround time.

Interactive Television

It is important to have a clear pre-production plan going into a shoot for interactive television. Nonlinear narratives have a large number of different directions that a story can go in, which in effect extends the overall production and budget. For example, Netflix's *Bandersnatch* was filmed in 35 days over a seven-week shoot. There were 250 segments of video to cover all the possible scenarios, and they ended up with five-and-a-half hours of program that users could navigate through. The production took the length of time it would have typically taken to shoot around four regular episodes of *Black Mirror*.

The script supervisor had the important role of keeping things straight and keeping the actors and crew informed about what they were shooting. Each scene in *Bandersnatch* was shot with two cameras and broken down into segments as stand-alones in the system. The scenes were also shot multiple times with variations of the script for the different segments. This got quite complex right away, which required the shoot schedule and call sheet to be very clear.

360-Degree

Camera Placement. Beyond choosing your video, lighting, and audio setups, there is a lot more to consider when shooting successful 360-degree videos. You first need to choose where to place your camera within the environment. It is common practice to place the camera at the average height of a viewer near eye level. This approach aims to keep things feeling more natural and less disorienting. However, feel free to explore other options as well and try unique vantage points when applicable. Try a different

point of view, bird's eye or ant's eye, over-the-shoulder, various distances, and unique angles. Also remember to place your camera about three to five feet away from your subject due to the distortion from extremely wide angle lenses.

Entering the Unknown. Because you haven't stitched the final video yet and usually aren't even in the same room as the shoot, it is difficult to know what you are shooting. You can use a remote app on your phone to control the camera. You can also sometimes look at a few monitors that will show the different quadrants of what you are shooting. Or you can have a team do a rough stitch of your video on set and look at it later in the shoot day. This delayed process of seeing your final recording is reminiscent of having to wait to develop and process film.

Stitch Line. When shooting, try to avoid placing important action or subject matter on the stitch lines. A stitch line is the point where the video from each lens meets the other to create the full spherical environment. There is a parallax effect where the different images meet, possibly creating an uneven alignment in the image. Therefore, you don't want to call attention to these areas and make it easier to work with in post-production.

Movement. Traditionally, the advice is to avoid any unnecessary and quick camera movements, which can cause your viewer to lose focus or become disoriented. However, built-in camera stabilization has made more movement possible, but you will still want to maintain a familiar constant and comfortable motion, such as walking speed or riding in a car. Movement can be utilized successfully during transitional moments when changing scenes and locations. You can also use motion to guide the viewer within a scene. For example, if a character or object is moving across the space, then the user will most likely follow that motion.

Longer Takes. Many people have compared 360-degree video production to live theater. There are fewer cuts overall between close-ups, long-shots, multiple angles, and locations. Most scenes in 360 are long takes, and everything is considered a master shot. If one actor misses a line or something unexpected happens in the shooting environment, then a new master shot needs to be captured. This is because there are fewer cuts and more time needed for the viewer to explore the full range of the space.

Shoot Extra. To assist in post-production, you should shoot blank plates of the space with nothing in it. Capture at least one minute of "ambient video" to be used to cover up any potential problem areas you may find later in your frame. For editing purposes, it is good practice to shoot additional footage for each shot you take.

Documentation. It is crucial to take detailed notes on everything during your shoot. There will be longer shots to review and more frame area to consider. There will be no traditional frames and fewer cuts to remind you what you thought was important about each shot. Document how you set up the camera, the lighting and audio choices you made, and stitch line placement, as well as notes for post-production on where graphics and spatial audio cues should be placed. These notes will save you time and money down the road, keeping track of what worked and what didn't work with each shoot.

On a Human Level . . .

The producer is both the leader of the production team and an integral part of it. A producer doesn't need to fully understand the technical details of every crew member's job—that's why you hire these people, after all—but it is important for a producer to have a sense of every stage of the process. For example, you don't have to know

how to operate a camera, but you should be aware of the challenges that face a camera operator, so you can prepare for them and put your camera operator in the best possible position to do good work.

You set the model for clear communication, mutual respect, a relaxed mood on the set, and forgiveness of the occasional human error. Mistakes get made, so move right past them, and avoid making them again. You must stay healthy. During the stress of production, it can be tempting to drink too much coffee and to forget to eat well or sleep enough. But if you go down, so does the production. Find a balance that works for you, and let yourself enjoy the process.

SUMMARY

No matter what your project entails, each shot and each scene is recorded and shot with post-production in mind. No matter how brilliant the scene is by itself, it must be edited with one shot that precedes it and another that follows. The shots must match visually, and the audio must have continuity. Together, they combine to create a narrative flow or storyline, regardless of the show's genre or the delivery system. In the next chapter, you can explore the post-production process that brings the footage and audio elements into a tangible and cohesive form.

REVIEW QUESTIONS

1. Name five leadership qualities a producer brings into the production process. Describe how each one impacts the project.
2. Discuss the advantages of using a virtual location over a sound stage or location. Create a brief story idea in which virtual locations and backdrops are a key feature.
3. Describe the concept of matching eye-lines or draw an example.
4. Draw a simple sketch of a scene, demonstrating three-point lighting.
5. Describe the microphone options available for recording production sound. Pose a situation in which each mic is put to its most efficient use.
6. What are the typical problems you might run into in recording useable audio in an exterior location? In a sound stage? How could you solve these problems?
7. What are the strategies you would find valuable to make the audio recording process easier?
8. Describe the role of the script supervisor and the importance of this job during production.

CHAPTER 9

The Final Product: Post-Production

THIS CHAPTER'S TALKING POINTS

I The Producer's Role

II The Editor's Role

III The Sound Designer's Role

IV Delivering the Final Product

V Focus on Emerging Media

First film, then video, and now emerging media—each has a language with its own vocabulary, tools, and sets of rules. Your vocabulary is the picture, and your sentence structure is the edit. You're telling your story with images, the juxtaposition of these images, fleshed out with underlying aural impressions, and the nuance of graphic design. It's in post-production that the final story comes together.

I. THE PRODUCER'S ROLE

Post-production can be the least understood aspect of the producer's domain. Before starting post-production, you want to study any shortcuts that can make the post-production process more creative and efficient. The producer's job is to know as much as possible about everyone else's job—what they do, the tools of their trade, their rates, the facilities in which they work, and the subtleties of their art. You want to find the most talented and highly qualified people who can work within the limits of your budget. The more prepared you are when you begin post-production, the faster the process will go.

The Post-Production Supervisor

In producing for TV and emerging media, the producer usually supervises the project from beginning to end, including the entire post-production process. A more complex project might require a post-production supervisor who acts as the producer of post-production. She works closely with the producer to maintain the vision of the project and supervises all phases of post-production including editing, mixing, graphics design, final composite, and delivery of the final master to the end user, client, or broadcaster.

The post-production supervisor (or the producer, or the assigned PA) keeps track of:

- All the **footage** that has been shot as well as all the numbered and organized reels or storage devices, screening logs, bins, dubs, and other log sheets.

CHAPTER 9 The Final Product: Post-Production

- Other **visual images**, such as all stock footage, archival footage, animation, graphics, art work, and copies of any related legal release forms.
- All **audio elements**, such as dialogue, background audio, special effects, original and/or stock music, and cue sheets.

So whether you are hiring a post-production supervisor or you're the one in charge, the following guidelines can help you navigate the post-production process.

Post-Production Guidelines

1. Triple-Check Your Legal Documents

The need to legally protect your project never stops. It continues way past post-production, so as you put together all the elements you'll need for your edit and mix, be sure that all your legal ducks are in a row. Do you have clearances for all the music you'll use in the mix? Signed releases for stock footage?

> When I'm drafting contracts, after I'm finished, I will always go back over it, not just for each word, but I have a checklist: Did I do this and did I do this? I make sure that I haven't left anything out.
> **J. Stephen Sheppard, excerpt from interview in Chapter 11**

2. Spend Money to Save Money

You want an editor who has a keen sense of storytelling. You want him to be familiar with the best editing system for your project, someone who has kept up with its technical compatibilities and system nuances. He must be able to deliver a color-corrected, audio-balanced final product that's technically up to specification. You want him, ideally, to have experience in cutting a show that's similar to yours, and you want him to be the kind of guy with whom you can spend long hours or days at a time.

Most editors and editing facilities have demo reels or websites showing their work. If you like what you see, try to meet with the editor before you start shooting. Take a tour of her editing facility. Ask her what you can do to make her job easier. Compare notes on your shooting formats and their compatibility with her editing equipment.

You can save money and time in post-production when you:

- Organize your reels or storage devices and location logs.
- Screen and log your footage.
- Organize editing elements including footage, audio, and graphics.
- Write a paper cut for the edit session.

3. Organize the Components for the Edit

It isn't unusual for a producer to shoot 20 hours of footage, or 50, or 100, for just a one-hour program, especially for reality shows or documentaries. This requires an organizational system during the actual shoot that keeps track of where that footage is stored. It helps when you label each reel (disk, memory card, etc.), including:

- The reel number (Reel 1, Reel 2, etc.)
- The location where it was shot (Studio B, in Central Park, etc.)
- The date of the shoot
- The audio tracks (Track 1 is the lav, Track 2 the boom, etc.)
- The camera it was shot with (Camera 1, Camera 2, etc.) in multicamera shoots

When labeling your memory cards, design an easy system for naming each one. For instance, if you shot in Central Park and used nine memory cards, you might label them CP01, CP02, and so on, to CP09. In a studio setting with several cameras, match the camera number with a card number.

Say you're shooting *The Jane Smith Show*. You use two cameras and change the cards three times. Your first two cards can be labeled JS0101 (Jane Smith-Card 1, Camera 1), JS0102 (Jane Smith-Card 1, Camera 2), and JS0201 (Jane Smith-Card 2, Camera 1), and so on, through the subsequent cards.

This may seem unnecessarily obsessive or too time-consuming. But ask any editor and she'll tell you that she's impressed with your organization, and relieved that she's not spending the extra time looking for shots. Whatever your system, organization like this will pay off a hundred-fold over your producing career.

Reel Log

The producer keeps track of the footage that's been shot in a *reel log*. Whether the footage has been shot on film, on P2 cards, in 2K/4K files, or another storage format, you want to know where everything you've shot is located. During the edit and mix, for example, you may find that you're missing a cutaway shot or need to replace a shot you thought would work but didn't. The reel log provides a fast way to find your footage.

Alternative Sources: Stock and Archival Footage

Using high-quality stock footage not only saves you money but also can add real nuance and production value to your vision.

Often, for considerably less money than shooting it yourself, you can buy the exact shot you want. Stock footage facilities license a wide range of high-quality footage that's been shot all over the globe by professionals who sell the clearance rights to producers. This footage is high-quality and is often shot on 35-mm film and transferred to video, or shot on high definition, or onto 2K or 4K digital files.

The choice of shots is limitless, covering almost any scene description, ranging from field workers in Vietnam to time-lapse footage of Tokyo at night. You can get exotic flamingoes in flight, migrating Monarch butterflies, vintage cars, sleeping babies, couples in love, beaches at sundown. Stock footage can save you considerable time and money, as well as lend real quality to your final product.

Stock Footage Search

Finding stock footage is relatively simple. Go online, and search "stock footage" facilities. There are dozens, offering a range of footage genres. In most cases, you can see all their footage online—it'll be watermarked in some way so it can't be stolen. After you've made your choices and picked the footage you want, you'll then negotiate a fee for the rights to use it in your project.

Stock Footage Fees

The fee for using stock footage depends on several factors. If, for example, you wanted to open your show with a shot of the British Museum, the fee for buying that shot depends on how you plan to use it. If your show is airing on a major network or cable channel, the fee is much higher than if the museum shot is in an educational piece with limited distribution. If it is part of a one-time, non-broadcast project like a training film for an organization, or being used in an industrial film, the fee is more

negotiable and usually lower. If you are buying the exclusive rights to use the shot, the cost is even higher.

Other factors that influence the license fee are:

- The amount of time for which you want the rights (usually from two years to perpetuity)
- The territories (just your country, or a few other counties as well, or worldwide)
- Any special advertising or promotional uses
- The total number of runs (broadcasts)
- Use in emerging media formats

You also want to double-check the clearances on any copyrights and trademarks. In some cases, stock footage may also require you to obtain releases from any talent or people or locations on screen. Music or narration that is mixed into footage also needs to be cleared. You'll find more information on legal clearances in Chapter 5.

Archival Footage

There are hundreds of sources for footage that has a historical context. The archivists will research, gather, and/or clear the rights for historical footage. They may also transfer it from film to video or digital file in whatever format you'll need. As with the stock footage, fees vary and are dependent on their use. Often, the footage may be negotiable, but the underlying music isn't cleared. You want clearances for both images and the music.

Public Domain Footage

When the copyright has elapsed on footage (or a book or picture or painting or music), it is no longer owned by anyone, and its rights are in the *public domain* (PD). You can use it freely, without paying for clearances or royalty fees. Many private companies find and resell PD footage and will charge you fees for their research and duplication.

In the United States, you can access any footage that has been shot by almost any agency of the U.S. government using taxpayers' money, with no clearances or royalty payments. The National Archives, the Library of Congress, the Smithsonian, and NASA, for example, all offer vast footage collections that are available to the public; the only costs to you are for duplication. You can also consult with an independent archival footage expert who can help you locate options from within these vast collections. Other countries have similar sources for footage that is either inexpensive to clear, or it's free.

4. Screen and Log Your Footage

The use of nonlinear editing systems has revolutionized the post-production process. This is good news for producers who want to be creative while staying within their budget. Because of the ease of NLE, it can be tempting for producers to bring all their footage into the editing bay and screen it there, rather than screening it prior to the edit session. This turns the creative process into an expensive administrative swamp that can be time-consuming as well as frustrating for the editor.

A cost-effective method of preparing for editing is to screen and log your footage before the edit session. From these log notes, you can construct a *paper cut*, or an editing storyboard. It's like a shooting script for your editor and the sound designer; it gives them a clear outline of what scenes appear in what order, and where each shot can be found. The paper cut lists time code (TC) locations and descriptions of

selected edits, as well as notes about graphics and audio, and the order in which footage appears in the script.

Ideally, you want to transfer your footage with *matching time code*. This means that the TC on your original footage is exactly the same on your screening copy. It's called visible time code, also *vizcode* or *VTC*, and it is displayed in a small box on the bottom or top of the screen.

Screening Log

As you saw in Chapter 8, time code has eight numbers. For example, 01:03:16:22 is the same as one hour, three minutes, 16 seconds, and 22 frames (i.e., the exact number of that frame).

As you screen your footage, *log* it by taking notes of each pertinent shot and its TC number. Let's say that you're screening Reel 1. You like a specific shot where the actor picks up a cup of coffee, sees a letter on the bed, reads it, then angrily throws his cup against a wall. The action starts at 00:01:03:16 (one minute, three seconds, 16 frames) and ends 10 seconds later (at 00:01:13:16). Your log notes on this scene might look something like this:

Reel #	TC in	Scene description	TC out
# 1	00:01:03:16	(MS) Tom picks up cup, reads letter, throws cup	00:01:13:16

Your reel log details the reel number, the TC numbers for the in-point and the out-point of the scene, the shot's angle (MS, etc.), and a brief description of the scene. If you're logging dialogue, either scripted or unscripted, you might type each word verbatim for an exact transcription. Or, type just the key words and mark irrelevant sections with an ellipsis (. . .). Often, the reels are transcribed by a professional transcriber who makes a note of the TC at regular intervals, usually every 30 to 60 seconds.

A number of logging software programs are available, and NLEs have detailed browsers that allow you to subclip footage and log it as you review it. These programs can cut down your screening time and provide notes for the editor. This saves time, as the logging notes are embedded in the NLE alongside the footage.

The Scope of the Log

Footage is just one of several elements in your project. Other elements include the audio, animation, music, and graphics. As you did with your footage, you'll keep a log for every element on a reel log, and distribute copies to anyone involved in post-production, such as the post-production supervisor, production assistants, the editor, graphics designer, and/or the sound designer.

Your log sheet might include any of these elements:

- Studio or location footage (reel or drive numbers, dates, locations, etc.)
- Stock footage (footage that's been professionally shot for resale, like helicopter shots or time lapse photography)
- Archival footage (historical footage or photographs)
- Graphics (opening titles, closing credits, lower thirds)
- Animation (animated insert segments)
- Audio tracks (anything recorded on the footage audio tracks),
- Additional audio components (music, stings, needle drops, special effects, ADR)

5. Write a Paper Cut

Not every producer has the ability to "visualize" what shots cut well with other shots. But you know what the primary scenes are, and their sequence in the script. Because you've most likely shot your footage out of order from what appears in the script, you'll include all the reel numbers and TCs onto your paper cut, in the order in which they'll appear in the final edited product.

For many producers, the ideal editing paper cut could arguably be called an *80/20 paper cut*. This means that the producer has screened the footage and come into the edit room with a paper cut that provides details for roughly 80 percent of the key scenes, cutaways, and the sequence in which they'll appear in the final edited product. The paper cut also includes reel numbers, TC, and scene descriptions. The extra 20 percent represents extra leeway that the editor can take, making creative and technical choices beyond the written paper cut that enhance the piece and give the editor a chance to add his or her unique signature.

After you've transferred your footage for screening, then screened and logged it, and written a paper cut, you're ready to edit and mix your project.

Remember the earlier scene in which Tom picks up his coffee cup, sees the letter, reads it, and angrily hurls the cup against a wall? Although the footage was shot at different times, on different memory cards or disks, and maybe at different locations, they all cut together as one smooth sequence. The finished paper cut format might look like this:

Reel #	TC in	Scene description	TC out
Reel 1	01 03 16	WS >> MS Tom picks up cup, reads note	01 03 20
Reel 3	03 10 04	CU the note	03 10 08
Reel 2	02 20 25	CU Tom's reaction to note	02 20 30
Reel 1	01 03 21	MS Tom throws coffee cup	01 03 26

In writing your paper cut, you'll find these terms helpful:

Shot. A single uninterrupted segment that is the primary element of a scene.
Scene. A dramatic or comedic piece consisting of one or more shots. Generally, a scene takes place in one time period, involves the same characters, and is in the same setting.
Sequence. A progression of one or more scenes that share the narrative momentum and energy connected by an emotional and narrative energy.

II. THE EDITOR'S ROLE

> You might have a terrific episode, but if people are falling out because there are just too many elements in it, you have to begin to get rid of things.
>
> **Ken Burns**

An editor can be a creative magician, a technical consultant, and an effective arbiter of what works and what doesn't. Each editor has her own strengths and styles of cutting. One editor has an ideal style for MTV, and another editor knowledgeably cuts documentaries for the BBC. An editor might specialize in sports or news, sitcoms, online

content, commercials, music videos. And then there are those few editors who can cut almost anything.

An experienced editor can take disparate shots and elements and weave them together, creating a seamless flow. As a creative artist, he can "paint" a mood with pacing, place a perspective on the action, and signal conflict or comedy. A technically adept editor can design special effects or transitions between scenes, color-correct the footage, and make sure your project conforms to broadcast standards. Often, he can "fix it in post," covering up mistakes or finding solutions to seemingly impossible problems that inevitably pop up in everyone's project.

Working With an Editor

> I first ask [producers] for notes and scripts. If I'm lucky, they'll have those, but more and more producers seem to think that editors wave a magic wand over hours worth of footage, and only the good stuff comes up. I remind them that if we first need to screen, log, and digest the material, and then make an insightful and coherent movie, it's going to take time. For every one hour of footage, it takes at least two or three hours to view, log, and highlight clips. You then need to knock this down into a script with some kind of theme, and only then can you start to edit.
>
> **Jeffrey McLaughlin, excerpt from interview in Chapter 11**

Producers come into an editing room with varying levels of experience in post-production. One producer may have spent hundreds of hours editing and mixing; another has only limited exposure or expertise. Some producers don't have the luxury of extra time, or the foresight to screen their footage, before the edit session. They'll hand over hours of their unscreened footage to the editor and expect her to work miracles without any script or direction.

The producer's role with the editor is highly collaborative. You want to give the editor specific targets for the project, and you also want to create an environment in which the work can get done. When you're in the edit room, the editor needs to concentrate, so keep phone calls and distracting conversations to a minimum. Discourage people from crowding into his space. When possible, encourage creative leeway with different shots or new ideas. Make sure he gets a genuine "thank you" along with plenty of food, water, and coffee during the edit sessions. The editor is one of your most valuable team members.

With the user-friendly, inexpensive, creative, and evolving NLE systems, like Final Cut X, Avid, or Premiere, an entire project can be edited on a laptop. Although we don't recommend them for any level of professional use, some web hosts, like YouTube, have browser-based editing systems embedded in their sites. You can now build a functional edit room in your bedroom, or do a rough cut of your video on an airplane. Many producers do their own rough cut first, working out some of the more obvious problems, then bring that rough cut for the editor to fine tune and take to the next level.

But, not every producer has the technical savvy or creative eye to be a good editor. You want your project to reflect your vision and adhere to all broadcast standards so it can be aired or connected into other platforms. So, how do you find an editor who can satisfy these objectives?

Dozens of websites and television industry directories list professional editors and editing facilities in various countries, regions, and cities. Visit their websites and, when

possible, check out their facilities. Meet them, screen the editor's reels, and discuss what you need for editing your project. You can also:

- Talk to other producers, directors, and writers about editors they've worked with.
- Call regional or local television stations who may "hire out" their editors and facilities for outside work. If not, ask if they can recommend local freelance editors and/or facilities.
- Check with local high schools and colleges that have editing bays for their students. Often, their student editors can be hired for low-budget projects or can work for academic credit.

Working With Editing Technology

> One of editors' golden assets in an edit room is that they were never part of the production process. They weren't shooting the film for four weeks and feeling the "magic" of that process. The war stories the crew told about shooting in the midst of a hurricane or when half the staff came down with food poisoning—they mean nothing to the editor. Editors only see the dailies, and the only "magic" they feel is what comes out of those dailies. If a shot works, they will use it, but if it doesn't, they can easily let it go. The pain, the love, or the cost of any one element means nothing if it doesn't work in the edit. No one [shot] is more important than the whole of the film.
>
> **Jeffrey McLaughlin, excerpt from interview in Chapter 11**

The rapid evolution of post-production technology has brought editing, sound mixing, and graphics into the digital domain. These advances have expanded the producer's horizons. From prime time broadcasts to art gallery installations, from educational teaching tools to high-end commercials, from user-generated content to slick online sites, the creative possibilities of today's digital tools seem limitless.

Yet, the learning curve can be steep. The choices seem endless. The terminology is confusing, and everyone has an opinion. Every six months, new equipment and software flood the marketplace; a system that is state-of-the-art this year is either upgraded or replaced next year.

Nonlinear Editing

Fortunately, there are consistencies between these systems. As you research the right editor for your project, also look at the range of digital *nonlinear edit* (NLE) systems that conform to professional, broadcast-quality standards. These systems work on the same basic principle as editing on film with an NLE system, pieces of footage can be digitally "spliced" together out of order, just like film editing.

Film editing has always been nonlinear, done with tape and scissors, and its pieces cut and taped together by hand. Before nonlinear editing, video editing was linear—electronically edited in an "always moving forward" direction. An editor could start only at the beginning and work toward the end because of the nature of electronic recording. The traditional way of editing video has been to edit in the chronological or *lineal order* that shots appeared in the piece.

Now, editing with digital equipment is done in a cut-and-paste mode, just as with film, except it's edited electronically rather than manually. The popular NLE systems Final Cut X, Avid, and Premiere all work on similar principles. When you can learn one system, it's only a matter of nuance to find the right buttons in the right place on another

system. Premiere and Avid are the systems currently used by most professionals. They offer high-quality options for finishing, are updated consistently, and support more plug-ins. Because these systems are now the pervasive editing modes, we'll be concentrating only on this method of editing and its technology.

If there is one downside to editing on NLE systems, it is the tendency to shoot more footage than is really needed, and to make decisions about your footage in the edit room. This one factor can result in spending valuable time deciding between Take 3 and Take 14 in the editing room, rather than prescreening it. This often translates to spending more money than you budgeted.

Compression

Compression relates to digital video and simply means that the video signal is compressed to reduce the need for extra storage as well as transmission space and costs. Compression techniques involve removing redundant data, or data that is less critical to the viewer's eye. The more the digital signal is compressed, the more distorted the image's details. You can see this effect in pirated copies of DVDs when the picture dissolves or fades to black—the sharpness of the image disintegrates and the pixels become larger.

The Steps in Editing

There are several steps you'll follow if you're editing with a nonlinear system, as described next.

1. Download and Store Footage

Before you begin editing, your footage must first be transferred, or *downloaded*, into the NLE. Memory cards have eliminated the need to transfer footage in real time, but the process of transferring footage from a memory card to a computer's hard drive can also be a time-consuming one.

2. Make the First Rough Cut

After all the footage, audio, and graphic elements have been loaded into the NLE, the editor cuts together her first rough cut—a basic edit. It forms the core of your finished piece and reflects all the basic editing decisions. Over time, and as part of the creative editing process, this rough cut changes and evolves, but it's this first cut that shapes the project.

Some editors refer to the rough cut as a *radio edit* or an *A-roll edit*. This describes the process of first laying down all the sound bites, with video, and listening to it as much as watching it. This helps make sense of the project's narrative viewpoint and its pace.

The next step is to make it visually interesting by editing in all the video footage. But each project is unique, and it dictates its own approach to the rough cut. In a music video, the editor first lays the music down and then cuts the footage to synchronize with the musical beats.

In some programs, the narration is laid down first. Then, the footage is edited to fit the narration. If the narration, or the voice-over, hasn't been finalized, you can record the script by using a *scratch track* as your cue. This preliminary scratch track of narration, read by you or by someone else, helps set the timings and beats for your rough cut. It is replaced later by a professional narrator. Regardless of what your particular project calls for, your rough cut clearly shows what works and what doesn't, what shots cut well with other shots, and the total running time (TRT) of this first pass.

3. Mix the Rough Audio

Throughout the editing process, the editor works closely with the audio tracks: she's separating them, balancing out levels, and keeping track of where everything is in the computer. She may do all the rough audio mixes as well as the final mix. Or, she'll do just a rough mix and then give all the tracks to an audio mixer or sound designer in an audio facility who'll do the final audio mix.

Most editors lay out their audio tracks like this:

Track 1:	Narration
Track 2:	Sound on tape/digital file
Tracks 3 & 4:	Stereo music
Track 5:	Sound effects
Tracks 6, etc.:	Overlapping audio, music, or dialogue

Styles of Editing

> Looking at a first assembly is kind of like looking at an overgrown garden. You can't just wade in with a weed whacker; you don't yet know where the stems of the flowers are.
>
> **Walter Murch, editor**

What *is* editing? Essentially, certain shots take on specific meanings when they are juxtaposed with other shots. This juxtaposition is editing. It can manipulate time and create drama, tension, action, and comedy. Without editing, you'd only have disconnected pieces of an idea floating in isolation, looking for a connection.

Whether it's for TV, the Internet, podcasts, mobisodes, or a 50-monitor video wall, editing in today's media world still follows classic editing guidelines. These were established by American director D. W. Griffith, and Russian directors V. I. Pudovkin and Sergei Eisenstein early in the last century. These pioneer filmmakers realized a century ago that film possessed its own language, with rules for "speaking" that language. They set the standards for editing that are used today by virtually all editors, no matter what the format.

During the production phase, the producer and director shoot their footage with carefully chosen camera angles and movements that tell a story from a certain narrative vantage point. The editor then takes this footage and—consulting with the producer, editor, and/or the post-production supervisor—makes artistic decisions about how to cut the footage together. Some styles of editing include the following.

> *Parallel editing.* Two separate yet related events appear to be happening at the same time, as the editor intercuts sequences in which the camera shifts back and forth between one event and another.
>
> *Montage editing.* Short shots or sequences are cut together to represent action or ideas, or to condense a series of events. The montage usually relies on close-ups, dissolves, frequent cuts, and even jump cuts to suggest a specific theme. For example, a single mother on the run from a hired killer moves to a small town with her child. A montage might show them happily moving into their new home, shopping for groceries, unpacking boxes, hanging clothes in the closet, and snuggling in bed on their first night together—all this in about a minute, and with underlying music usually fraught with some kind of emotional

guidance. This montage effect gives the viewer a lot of information in minimal screen time.

Seamless editing (aka Continuity Cutting). This style of editing is used in many dramatic series, some sitcoms, and feature films. The viewer is unaware of the editing because it is unobtrusive except for special dramatic shots. It supports the narrative and doesn't distract with effects. The characters are the focus, and the cuts are motivated by the story's events. Seamless editing motivates the realism of the story and traditionally uses longer takes, match cuts rather than jump cuts, and selective audio that can act as a bridge between scenes.

Quick cut editing. This style of editing is highly effective in action and youth-targeted programming, originated primarily by MTV in its infancy. It's used in music videos, promos, commercials, children's TV, UGC, and in programs on fashion, lifestyle, and youth culture. It combines fast cuts, jump cuts, montages, and special graphics effects.

Techniques in Editing

An editor looks at the footage with the producer, then edits the shots together to get from one shot to the next, telling the story. These editing techniques might include:

Cut. A quick change from one shot with one viewpoint or location to another. It's almost always better to use a cut rather than a slower transition like a dissolve or wipe. On most TV shows there is a cut every five to nine seconds, and much faster in some shows. A cut can compress time, change the scene or point of view, or emphasize an image or an idea. Most cuts are usually made on an action, like a door slamming or a slap to the face.

Match cut. A cut between two different camera angles of the same movement or action in which the change appears to be one smooth action.

Jump cut. Two similar angles of the same picture cut together, such as two close-up shots of the same actor. This style of editing can occasionally be edgy or make a dramatic point, but it can also signal poor editing and continuity.

Cutaway. A shot that is edited to act as a bridge between two other shots of the same action. For example, an actor may look off to the distance; a cutaway shows what the actor sees. A cutaway also helps to avoid awkward jumps in time, place, or viewpoint and can shorten the passing of time.

Reaction shot. A shot in which an actor responds to something that has just occurred.

Insert shot. A close-up shot that is edited into the larger context and provides an important detail of the scene. When an actor, for example, reads a sign on the door, a shot of the sign itself then is inserted into the edit.

Editing Pace and Rhythm

The genre of your program, and the footage you have shot, can both dictate the editing pace and rhythm. For example, an editor can start with longer cuts, then make more frequent cuts that surprise the viewer or build suspense. This rhythm can create excitement, romance, and even comedy.

Editing to Manipulate Time

Few shows on television, online, or on other platforms are viewed or seen in real time. What the viewer sees is known as *screen time*, a period of time in which events are happening on screen: an hour, a day, or a much longer time span. There are several

devices that an editor can use to give the viewer an impression of compressed time or time that has passed or is passing.

Compressed time. The condensing of long periods of time is traditionally achieved by using long dissolves or fades, as well as cuts to close-ups, reaction shots, cutaways, montages, and parallel situations. Our experiences as a viewer can then fill in gaps of time.

Simultaneous time. Parallel editing, or cross-cutting, shifts the viewer's attention to two or more events that are happening at the same time. The editor can build split screens with several images on the screen at once, or can simply cut back and forth from one event to another. When the stories eventually converge, the passage of time stops. A show like *24* is an example.

Long take. This one uninterrupted shot lasts for a longer period of time than usual. There is no editing interruption, which gives the feeling of time passing more slowly.

Slow motion (slo-mo). A shot that is moving at a normal speed and then slowed down. This can emphasize a dramatic moment, make an action easier to see at slower speed, or create an effect that is strange or eerie.

Fast motion. A shot that is taking place at a normal speed that the editor speeds up. This effect can add a layer of humor to familiar action or can create the thrill of speed.

Reverse motion. By taking the action and running it backward, the editor creates a sense of comedy or magic. Reverse motion can also help to explain action in a scene or act as a flashback in time or action.

Instant replay. Most commonly used in sports or news, a specific play from the game or news event is repeated and replayed, usually in slo-mo.

Freeze-frame. The editor finds a specific frame from the video and holds on it or freezes it. This effect abruptly halts the action for specific narrative effects. A freeze frame can also create the look of a still photo.

Flashback. A break in the story in which the viewer is taken back in time. The flashback is usually indicated by a dissolve or when the camera intentionally loses focus.

Editing Transitions

A simple cut is a transition from one shot to the next—it's abrupt and quick. Some storylines require another kind of transition from one shot or scene to another that signals going from one idea to another, moving from one location to the next, or one action that changes to another. These transitions can be achieved in the editing by selectively using any of the following transition devices:

Dissolve. When one image begins to disappear gradually and another image appears and overlaps it. Dissolves can be quick (5 frames, or 1/6 of a second), or they can be slow and deliberate (20 to 60 frames). Both signal a change in mood or action.

Fade outs and fade ins. There are two kinds of fades. A fade out is when an image fades slowly out into a blank, black frame signaling either a gradual transition or an ending. A fade in is when an image fades in from a black frame introducing a scene. A fade out or fade in can also be effective from a white blank frame rather than a black one; like a dissolve, this editing transition also works to show time passing or to create a special "look."

Wipe. An effect in which one shot essentially "wipes off" another shot. There are dozens of wipes available in editing systems, though a professional editor uses

them sparingly. Examples are page and circle wipes, sliding an image from right to left or vice versa, and breaking an image into thousands of particles. A wipe can be effective, or it can be a distraction; overuse of wipes can be the mark of an amateur.

Split screen. The screen is divided into boxes or parts. Each has its own shot and action that connect the story. The boxes might also show different angles of the same image, or can contrast one action with another. It works as a kind of montage, telling a story more quickly. The split-screen device can be done cleverly, though too many moving images can also strain the viewer's attention span.

Overlays. Two or more images superimposed over one another, creating a variety of effects that can work as a transition from one idea to the next.

Graphics, Animation, and Plug-Ins

Most programs or content include graphic elements of some kind. These graphics can be a simple show title and closing credits, or they can be complicated animation sequences and special effects within the program itself. Graphics can be generated in the edit session with programs such as After Effects and Photoshop, or might be created by artistic designers in a graphic design facility. Graphics, however, can be expensive and usually require extra consideration in your budget. Following are a few examples of graphics you might use in your project:

Text. Almost every show has opening titles (including the name of the show) and a limited list of the top creative people (such as the producer, writer, director, actors, etc.); these are called *opening credits*. Titles that appear at the end of the show are called *closing credits*, and they list the actors' names and roles, or positions on the production, as well as other detailed production information. Words that slide under someone on screen and spell out a name, location, or profession are called *lower thirds* because they're generally inserted in the lower-third portion of the screen.

Opening and closing credits might be superimposed over a scene from the show, or on top of stills, background animation, or simple black. Some projects require subtitles for foreign languages or close captioning for the hearing-impaired. As the producer, you're responsible for double-checking all names, spellings, and legal or contractual information for the lower-thirds and final end credits.

Animation. Simple animation can be created easily and cheaply by using software like After Effects. More complex animation is created by an animation designer who uses storyboards and narration, and who manages an impressive crew of people who draw, color, and edit animated sequences.

Motion control camera. Special computer-controlled cameras that shoot a variety of flat art such as old newspapers, artwork, and photos, sometimes called title cameras. They are designed to pinpoint detail and to create a sense of motion for otherwise static material with zooms, pans, and other camera moves.

Design elements. Some project genres—documentaries, news shows, commercials, educational, and corporate industrials—depend on the use of various design elements to add depth and information to the content. These elements include logos, maps, diagrams, charts, and graphs as well as historical photographs, still shots, and illustrations.

The look of film. Falling loosely into the graphics realm, there are several postproduction processes that give video the appearance of film by closely mirroring the color levels, contrasts, saturation, and grain patterns of film at a fraction of the cost and time of film.

CHAPTER 9 The Final Product: Post-Production

- ***Color-correction.*** The process of reducing or boosting color, contrast, or brightness levels can be done by using color-correcting tools such as Flame or After Effects.
- ***Retouching.*** This plug-in process offers a gamut of tricks that can enhance an image, like "erasing" a boom dangling into the shot, or a wire holding up a prop. However, the time involved can be costly.
- ***Compositing.*** Two or more images are combined, layered, or superimposed in the composite plug-in process.
- ***Rotoscoping.*** Frame-by-frame manipulation of an image, either adding or removing a graphic component. Human action can be rotoscoped as can the blemish erased from a celebrity's face with this plug-in process.

The editing process is vital to the ultimate success of your project. It is aesthetic, intuitive, and often technically challenging. Yet, the visuals are only one half of the picture. The second half is the enhancement of audio with its many layers of nuance and possibilities.

III. THE SOUND DESIGNER'S ROLE

The sound designer, like the editor, can perform small miracles by manipulating audio to create an emotional impact on the viewer. The sound designer adds another dimension to your vision by raising or lowering levels of dialogue or ambient sounds, removing distracting background hums, adding sound effects and Foley, and adding the right musical elements. His expertise lends a higher production quality to your finished project.

In a less complex project, the video editor can mix all the audio requirements and components in the edit session. However, some projects have more complicated audio elements that require an audio facility for additional work and refining. Here, the *audio mixer*, sometimes called the *sound editor* or *sound designer*, takes over. An audio facility might be a simple, room-sized studio with one or two sound editors who work on audio equipment that synchronizes TC in computers. It could also be an elaborate, theater-sized studio with several audio mixers and assistants, extensive equipment, and a setup that could be quite costly. Before you book time in an audio facility, discuss your project's audio needs and their possible costs.

The sound designer works with two contrasting "qualities" of sound (direct and studio) and approaches them differently, both aesthetically and technically:

- ***Direct sound***. Live sound. This is recorded on location and sounds real, spontaneous, and authentic, though it may not be acoustically ideal.
- ***Studio sound***. Sound recorded in the studio. This method improves the sound quality and eliminates unwanted background noise, and can then be mixed with live sound.

Working With the Sound Designer

As the producer, you want to work closely with the sound designer: supply the necessary audio elements and logs, then discuss the final cut of your piece; offer your ideas and ask for suggestions. In the first stages of an audio mix session, you and the audio crew sit in a *spotting* session during which you review each area of your project that needs music and effects for dramatic or comedic tension. In this session you're listening for variations in sound levels, for hums and hisses, and anything else that wasn't caught in the rough mix. The sound designer can mix tracks, smooth out dialogue,

equalize levels and intensity of sound, and add and layer other elements like music and effects that all contribute depth to the project.

The spotting process takes time. So does the mixing, or *sweetening*. You're paying for each minute, so based on what you decided to do in the spotting session, discuss with the audio facility how much time you will need to book. Often, an audio facility is willing to negotiate a flat fee for the whole job. You may have booked only 6 hours but the actual mix ran 10, or vice versa; it not only cost you more money but placed a real strain on the facility—they may have booked the studio for another job after your estimated six hours was scheduled to end.

Working with the sound editor is much more effective if you can:

1. **Be prepared.** When possible, send a rough cut of the project to the sound editor before the mix session. Come to the mix with a show rundown that lists important audio-related details like transitions and music. Provide a music cue sheet that lists all the music selection titles, the composers and their performing rights society affiliation, the recording artists, the length and timing of each cue, the name and address of the copyright owner(s) for each sound recording and musical composition, and the name and address of the publisher and company controlling the recording.

2. **Be patient.** At the beginning of the mix, the sound editor needs to do several things before the actual mix can begin, including separating the audio elements, patching them into the console, adjusting the gear, and finally, carefully listening to everything. Be patient during this stage and don't put pressure on the process.

3. **Be quiet.** Although you may have worked with these audio tracks for days in the editing room, it is the first time the sound editor has heard them. Keep your conversations, phone calls, and interruptions to a minimum.

4. **Be realistic.** Your mix may sound excellent in the audio mixing room because the speakers are of professional quality and balanced, and the acoustics are ideal. But most TV shows and online projects are played on TV sets or computer monitors with mediocre speakers. Many of the subtler sound effects you could spend hours mixing may never be heard, so listen to the mix on small speakers that simulate the sound that the end user will hear.

The Technology of Audio Mixing

The digital revolution has provided a wealth of creative and technical opportunities for the producer. Images and sound can interact in dynamic new ways that were previously difficult to achieve if not impossible. Digital sound offers an unparalleled clarity of sound. There is no loss of quality when dubbed, and because digital requires less storage space than video, it often doesn't need compression.

By editing sound in the NLE domain, the audio mixer can work freely with sound in the same way an editor can play with visuals: sound elements can be cut, copied, pasted, looped, or altered. Digital audio is easily labeled and stored, making it more efficient to keep audio in sync and to slide it around when needed. Most sound tracks are now prepared on a multitrack digital storage system. The popular professional options include:

- DAW (digital audio workstation): Programs such as Pro Tools
- Digital multitracks: Programs include DASH 3324 or 3348
- Analog multitracks: 24-track Dolby SR or A

Often the editor can handle the entire audio mix in the NLE system. In other situations where the mix is more complex, the picture is first *locked*, or finalized, and then the audio tracks are exported, usually to a DAW. The tracks are either married to the video or are separate. In the DAW, for example, the sound designer uses software such as Pro Tools and digital storage techniques to: focus on specific tracks; clean up audio problems; and record and add narration, music and special effects (*M&E*), and dialogue.

This process gives the sound editor an impressive range of options: moving the tracks forward and backward, looping music, and extending dialogue and effects. Finally, when everyone's satisfied with the audio, the track is ready for a *lay-back* where the final audio mix track is married to the picture using TC. The piece can be delivered in stereo, mono, 5.1, or in all versions.

In some projects, the audio can work well for a 5.1 audio system sound mix. This gives you five full channels (left, center, right, right rear, and left rear) plus one low-frequency effects channel. The result is an impressive clarity and fullness of sound that 5.1 audio lends to a final product.

The Creative Components in Sound Design

Just as visual components are edited together, so audio elements are mixed together to create new layers of sound. In larger, more complicated audio mixes, each of the following components might be supervised by an expert who specializes in that specific area. The sound designer works with any or all of these components:

- Dialogue
- Sound effects (SFX)
- Automatic dialogue replacement (ADR)
- Voice-over (VO) or narration
- Foley
- Music

Dialogue

Dialogue is the primary audio element. Words spoken between two (or more) actors or people onscreen is called dialogue. Sometimes it's recorded with background ambient sound, although usually it is recorded in isolation from other audio.

Sound Effects

On a set or on location, any background sounds that surround the dialogue are ideally recorded separately. These sounds include blowing wind, singing birds, insects or tree frogs, water lapping on shore, traffic, children playing, glasses clinking, and so on. These existing effects are known as *wild sounds*, or recorded sounds that will later be synchronized to the footage. If the sounds don't exist on that location, the sound editor can search through prerecorded sound effects available from a sound effects library. These options can range from a door slam to the howl of a monkey. Producers often buy libraries of sound effects and stock music that offer thousands of audio options, and their royalty fees are covered in the initial cost.

Automatic Dialogue Replacement (ADR) or Dubbed Dialogue

After all their scenes have been shot, actors may need to rerecord lines of dialogue, or add a line written after the shoot was completed. In the recording studio, actors read their lines, keeping them in sync with their on-screen lip movements. Another option is to record new lines that will be mixed into the program later, either over a cutaway or

in a long shot if their lips don't match the new lines. Actors might also read a script in a different language that is later dubbed over the original track. Often, a *loop group* of people is brought into an ADR session to create crowd sounds like background conversations, laughter, mumblings, or yelling that will be mixed into the dialogue. This area of ADR is called *walla*, which is intentionally unintelligible so audible words won't intrude on the dialogue.

Voice-Over (Narration)

The narrator who reads a script or commentary adds another layer to the audio. Narration can introduce a theme or link elements of a story together. It adds extra information with an air of authority and helps interpret ideas or images for the viewer. Often, an on-camera character speaks over the picture in the first person as though she is directly speaking to the viewer. A minor character can tell the story in the third person, or an unidentified narrator who is not on camera can distance the viewer from the image by adding an objective voice to the story. Narration is generally recorded in a separate audio session and mixed in later over the picture. Voice-over can be dialogue that is shot originally on-camera and later played over another picture. For instance, we see a two-shot of a mother who is reading aloud to her child. That shot cuts to a CU of the child's face while the mother's audio continues over the picture. Her audio is the voice-over; on a script, it is written as VO.

Foley

Foley are the sounds of an actor's movements, hands clapping, rustling clothing, a kiss, quiet footsteps, or a fistfight. If these sounds can't be found in a sound effects library, they can be created by the Foley artist who uses audio props, tools, hands, feet—objects and devices that create the right sound effect. They're recorded separately in an audio facility, often in sync with the action, and then mixed with other sound elements.

Music Options

- ***Original***. This is music that's been composed specifically for a project. It may include themes for the opening and closing, and/or for the body of the show; its emotional direction can highlight the action, characters, and their relationships. The composer is familiar with the creative and technical process and either hires the musicians or creates the music alone or with a partner. A composer can use computer language known as musical instrument digital interface (MIDI). It is capable of simulating a range of music from a single guitar to an entire orchestra. The final score can go straight from the computer into the mix.
- ***Stock***. This is music that has been specifically composed and recorded to be available for multiple uses. The composers use audio sampling and composition software and sophisticated equipment to create vast libraries of engaging and effective music that is both versatile and inexpensive. Stock music is a creative alternative used in every genre from corporate videos, documentaries, news, and commercials, to talk shows, sitcoms, online and UGC, even drama. It's less expensive than hiring a composer, and the negotiated rights can be either exclusive or shared, depending on your budget and the end use. Stock music houses can be researched and located by an online search, and most offer samplings that can be downloaded from the Internet.
- ***Prerecorded***. The source of this music could range from a popular song to an obscure album, but a strong soundtrack adds an extra appeal to your project.

Regardless of the source, you'll first need to clear all music rights, a time-consuming process that is reviewed in Chapter 5.
- **Music cue sheet**. Regardless of where your music comes from, you'll make a *music cue sheet* that lists every piece of music, its source, its length, and who holds the rights.

Stylistic Uses of Sound

In addition to creating a clear audio track for your project, manipulation of sound can create stylistic impressions for the viewer. Here are a few classic examples.

- **Diegetic**. Music that the characters in the scene hear. They're playing a guitar, or they're in a club with a jazz band playing behind the action.
- **Non-diegetic**. Music not heard by the characters that is added later, such as a soundtrack.
- **Sound bridge**. Audio elements, dialogue, sound effects, music, and narration can act as a transition between one shot (or scene) to the next.
- **Selective sound**. Lowering some sounds in a scene, and raising others, can focus the viewer on an aspect of the story, such as heavy breathing or quiet footsteps.
- **Overlapping dialogue**. In natural speech patterns, people tend to speak over one another and interrupt. Yet dialogue is usually recorded on separate tracks without this overlap. The sound editor can recreate this authentic-sounding effect in the mix and can also separate dialogue tracks that are too close together. Conversations between several people, like those in two different groups, are often recorded on separate tracks so they can be woven together in the mix for a natural sound.

The Steps in Mixing Audio

Steps in audio mixing vary from project to project. During your video edit session, the editor separates the dialogue, music, effects, and other audio elements onto various tracks or channels. Depending on the complexity of your project, the editor can mix the elements in the edit room or do a preliminary mix that needs to be completed in an audio facility. During the mix, all the separate audio elements are blended together into a final mix track that is then "married" to the picture and locked in.

The Final Cut and Locked-in Audio

Before the final audio mix begins, make sure that all the video and audio edits have been agreed upon by the clients and other creative team members and won't require any further changes. Any revisions involving audio after the picture is locked can mean costly remixes.

Sound editors take varying routes in mixing, and each has a unique style of approaching the process. Depending on the complexity of the project, any or all of the following components are part of an audio mix.

- **Dialogue**. All dialogue is cleaned up and extra sound effects or extraneous noise are either deleted or moved to separate effects tracks. Any ADR, narration, or voice-overs are also laid onto their own tracks.
- **Special effects**. Any special effects tracks—wild sound, ambience, prerecorded effects, and Foley—are separated, cleaned up, and each put onto its own channel. Ideally, there is ample room tone from each location that can fill in any gaps in the audio.

- **Music tracks**. The music is generally the last element that is mixed into the audio. All the musical tracks are separated and divided into two categories: *diegetic* or *source music* (music the characters or actors hear on screen, like a car radio) or *underscore music* (music that only the audience hears, such as an opening theme).
- **5.1 Audio**. The term 5.1 refers to the positions in a five-speaker setup in which speakers are placed to the right, center, left, right rear, and left rear of the TV set. This kind of mixing is also called AC3 and Dolby Digital, and it is prominent in Blu-rays, theatrically released films using SDDS and DTS systems, and in some TV broadcasts. A specially equipped television set is required to hear 5.1 audio at home.
- To achieve a full 5.1 sound mix, the audio is synchronized and downconverted to 29.97, taken into editing, and then transferred as open media format (OMF) files into the audio mix. Here, the elements are synced up, mixed, and sweetened to a downconvert of the assembled HD master that can be used for HD distribution or converted to standard definition. However, because each of the five channels delivers sound to a specific spatial position, extra time is needed in the audio sessions to deliver a multi-channel mix that works in this medium.

IV. DELIVERING THE FINAL PRODUCT

As the producer, you want to deliver a project that's the highest possible quality. It may be run on a network, sold to a distributor, seen online, or used for training and education purposes. All these venues require broadcast-quality work that adheres to certain technical standards.

The Client Deliverables

Most clients are very specific about what they expect as a *deliverable* or final product. Deliverables are generally part of your overall contract with a client, so you want to find out exactly what their expectations and specifications are. Ask for these deliverables in writing so there are no mistakes. The most common requirements for deliverables include:

- **Video format**. If your project is being broadcast, it is usually evaluated by a station engineer to make sure it meets broadcast standards. You may be asked to provide a clean copy of the show that has no text superimposed on it.
- **Audio format**. This might include separate mono mixes and stereo mixes, or a 5.1 mix, an M&E mix, special tracking, levels that are constant or undipped, and often one mix in English and another in a different language.
- **Length**. The required program length can be quite specific. For example, some American public television stations set a standard half-hour length at 26:46 minutes, and a one-hour show at 56:46 minutes. In most cases, PBS show lengths are six seconds less to accommodate a PBS logo. Commercial stations may require a half-hour show to be 22 minutes, while premium and cable channels are less demanding. Most nonbroadcast projects are more flexible.
- **Abridged versions**. You may need to provide an edited version of your project in which any nudity, violence, or offensive language has been censored. This version can be required by airlines, certain broadcasters, and foreign distributors.
- **Subtitling**. Written text under a picture that translates only those words being spoken on screen from one language into another; for example, the French translation of an American production. However, song lyrics or sounds are seldom subtitled.

- **Closed captioning.** Also called close captions, this method of supplying visible text under a broadcast picture is mandated by law to be built into all American TV sets sold after 1993. These sets are designed with a special decoding chip that translates all the audio on the screen into text, such as spoken dialogue, and describes unseen sounds like a dog bark or a knock at the door. Especially designed for the hearing impaired, closed captioning is also useful in loud public places, when learning a language, and when the dialogue isn't clear. The text usually appears in white letters in a black box at the bottom or top of the screen. It is decoded in the TV set or with a special decoder box attached to the set. Most streaming channels also now require closed captions.

All these deliverables are those most commonly required in television and emerging media projects. They should be clearly stated in all contract negotiations and included in your post-production budget.

> Be in control, but allow creativity and open up your budget for that extra time. As a producer, your golden rule is to always be prepared. You are in a creative business, so sometimes even the best preparation is not enough. At that point, look to the future and learn from your mistakes.
>
> **Jeffrey McLaughlin, excerpt from interview in Chapter 11**

V. FOCUS ON EMERGING MEDIA
Editing
Web and Mobile

Editing for web and mobile video has the same ultimate goal as in more traditional media—to shape a coherent story and engage the audience. Editors decide what is essential to the story, how to enhance the story, how long it needs to be, and what to leave out. The best way to effectively make these tough decisions is to be as organized as possible throughout the process and to begin the production with high-quality and thoughtful work. Label, categorize, and keep track of each transferred digital file. You can speed up the editor's job by providing her with quality footage and sound, a variety of shots, shots for continuity, and a reasonable shooting ratio.

Choosing the right technology will make the editing process easier and faster. The advent of affordable and nonlinear editing software and digital video has directly influenced the rise of web and mobile video. However, there are several options for editing software on the market and different considerations to keep in mind when choosing the right package for your production needs. While using free editing software might seem initially appealing, you may find that you quickly outgrow the limited features of these programs. Sony, Avid, Adobe, and Apple have varying packages for professional and prosumer markets. The most financially sound option might be to buy a post-production bundle that also includes sound editing, graphics, and color correction like Adobe Premiere or Final Cut X. Then, when you are ready to upgrade to the professional level, the interface will already be familiar. Avid is the most robust professional editing software to consider. It is one of the longest-lasting editing solutions on the market and can be applied to anything from broadcast news to feature films. If your ultimate goal is to work in a larger professional house, you may want to learn Avid. Factors that can help you decide which way to go are cost, interface, supported formats, multicamera editing capability, and customer support. Try to learn a program fully, and it will make the editing process more efficient and easier if you do want to

shift between programs later. People learn software better by needing to accomplish a task, becoming more focused and motivated in the process.

One of the big differences between editing for web and mobile video compared to television is the length of the final product. Web video is typically between 3 and 10 minutes long, while mobisodes run around 5 minutes. Webisodes, mobisodes, and podcasts are on-demand and not time-based like traditional TV. They aren't restricted to fitting a 30-minute time slot. The content and the audience's experience dictate the runtime. People are traditionally watching on smaller devices, maybe on the go, and could possibly have a slower bandwidth, all of which cater to telling a story in a shorter format. If your story is longer and more complicated, consider breaking it into shorter episodes and choosing a video player that plays the videos automatically in succession. Go into the editing process having a target length and allot time for titles, credits, and advertisements. Keep your edit short, simple, and to the point. Trim the fat and keep only the elements essential to the story, while lowering production costs. The goal should be to produce more quality episodes with less work.

To assist and enhance an edited sequence, editors will sometimes use transitions, graphics, titles, and effects. But keep in mind, transitions and effects will be affected by compression. Just as an unstable shot or constant camera movement can result in a loss of information and larger file size during compression, so can transitions, especially a dissolve. If you want to play it safe, you may want to effectively use the traditional "hard cut" or "fade-to-black" to tell your story.

When using graphics and titles, make sure you choose a consistent style and legible font for visibility on the web and mobile devices. In general, the simplicity of sans serif typefaces work better for onscreen readability. Be wary of using too many templates or presets for your titles. Audiences will appreciate originality in your design. When producing a series for a mobile phone specifically, consider integrating graphics that reflect the device itself, such as chat bubbles, video-chat screens, GPS maps, popup notifications, and so on. This will create a more intimate and realistic show-watching experience.

Interactive Television

Almost every aspect of an interactive television production is inherently more complex. This definitely holds true for the editing phase of a project. Using the interactive film *Black Mirror: Bandersnatch* again as a pioneer example: it took about 17 weeks to complete the edit, cutting approximately five hours of footage down to around two-and-a-half hours. An average viewing experience of the interactive film is 90 minutes, with some scenes remaining undiscovered by the viewer. With two cameras for each shot, there ended up being a 6:1 shooting ratio. This editing phase took roughly five to seven weeks longer than a show of similar duration, with the editors having to work with 250 segments of video to cover all of the possible scenes and scenarios. Some segments had upwards of 14 cuts, while some had much fewer, but each of these segments had to be tracked and organized very carefully throughout the entire process.

One of the biggest considerations during the edit was to keep an eye on the big picture, while making sure each narrative thread was coherent. While focusing on the big picture, they needed to make sure there weren't too many recaps during the experience and that they were placed carefully within the story's complex structure. They also had to ensure that the performances maintained empathy with the viewers and that there was a sense of engagement overall. There was no time restriction on length,

but they had to keep an eye on it and make sure it felt tight but not rushed. There were originally more segments in the script becoming overwhelming to experience, so they combined, trimmed, and eliminated some. Most importantly, the editor kept track of these changes—making notes, updating spreadsheets, and making sure they had the latest cuts in the nonlinear narrative visualization software, Branch Manager. Uploading edited segments to this interactive branching interface, the editor and other production leads were able to experience entire narrative threads instead of just individual segments in isolation. In order to streamline the workflow and keep track of everything, the original script was divided into eight sections, containing segments which were each assigned a unique number. Keeping track of these segments by their corresponding numbers within Branch Manager became essential to the workflow. Before beginning to cut, the editor broke down the entire script, creating spreadsheets for each of the eight sections. He wrote descriptions of every possible permutation to give himself a deeper sense of what was involved in each thread.

Another essential aspect of editing for a nonlinear branching narrative is developing a seamless experience between segments and choice points. The editor has to cut the opening of different segments to match up with the previous shot or choice point. They tried to use point-of-view shifts, lighting techniques, aspect ratio shifts, and audio cues to help make the join between segments feel more seamless. The right visual flow of movement coming in and out of these decision moments had to feel uninterrupted, so Netflix worked on their own software to compress and pre-load multiple versions of scenes without buffering.

Bandersnatch was edited on Adobe Premiere, which allowed the editor to open more than one sequence at a time. This allowed him to switch between different versions of a segment with ease. Another advantage to this software is the dynamic workflow between it and Adobe After Effects, for testing out VFX and graphics. For example, they were able to quickly mock up the interface of the choice point screens and make adjustments on the fly.

360-Degree Video

One of the most time-intensive phases of a 360-degree video production is in post-processing. Early planning and testing during the pre-production and production phases are critical to save time later. You can stitch footage on the fly during the shoot to see what you are capturing and shoot extra blank plates so your editors, colorist, and VFX artists have a clean slate to work with. When planning your shoot, you can also consider shooting with editing in mind in order to guide the viewer through the narrative. For example, you can end a scene with a character facing a specific direction and then start the next scene with the action happening in that direction. This assists with continuity and eye tracing. Another trick you can plan for in the editing phase is called forced perspective. This allows you to choose the center point at the start of each new shot and have that be the first thing the viewer sees regardless of where they were previously looking. In order to guide the viewer's attention, you can also use graphics and text, which will stand out in a scene. You can choose to include one title or have more than one copy within the scene to ensure people won't miss it.

In addition to guiding a viewer's attention throughout the narrative, there are other important considerations during the editing phase. The use of smooth transitions when changing scenes is critical to not disrupt the experience. Half-second cross-dissolves have proven successful, fluid, and capable of minimizing distractions. You can also try fading in and out from black, iris wipes, or light leaks and rays. The other main difference when preparing for your edit in 360-degree is to capture longer shots than

you normally would. Videos on YouTube and Facebook can have quicker cuts but may need to be longer for headsets. Some creators may even do two different versions for both. Either way, the first shot will most likely be longer in the edit to allow people time to acclimate to the new immersive environment and give them a chance to look around.

When it comes time to edit a 360-degree video, there is a unique process you will want to follow, which may vary depending on your camera, stitching and editing software, and final platform of choice. However, even with these differences, there is a general flow to the post-production phase.

- *File Management*. You are capturing a large amount of data, which is often stored across several SD cards for the different lenses. Therefore, it is crucial to stay organized throughout the process and log footage accordingly. Also include any supplementary files associated with each shot, which could include spatial audio cues or help calibrate the camera for stitching.
- *Stitching*. The point at which the video from different lenses meet each other to create a sphere are considered to be stitch lines. Many affordable 360-degree cameras come with built-in stitching software, but some require you to do it manually with separate stitching software.
- *Overcapture*. When stitching you will typically choose whether you are working with 360-degree video or overcapture. With overcapture, you can crop out a fixed frame video or image out of the larger 360 degrees.
- *Editing software*. After you have stitched your video, you can edit your footage directly in a program like Adobe Premiere or Final Cut Pro X.
- *VR view*. You can choose if you want to watch your edit in VR mode, equirectangular mode, or work inside a VR headset.
- *Rotate shot*. To ensure where your audience is looking, you can rotate the beginning point of your shot by adjusting the "rotate sphere" tool.
- *Horizon*. Creating a more natural and immersive experience, adjust the alignment of your horizon-line and make sure it is straight.
- *Exposure*. Color correction, sharpening the image, and adjusting the exposure settings across the different shots and lenses are all important to a more seamless and natural story as well.
- *Remove tripod*. After you have cleaned up the image, you should remove the tripod and any other unwanted objects in the frame.
- *Titles/graphics*. When inserting text and graphics into your 360-degree sphere, you need to distort it to match the curvature of the sphere to make it appear flat in the immersive experience. Some software will do this for you with a "plane to sphere" tool, and some require plugins to add to the 360 viewer.
- *Transitions*. You may want to add 360-video specific transitions to your edit to create a less jarring experience for your viewer. Make sure you use 360-video transitions and not traditional ones, or you may see lines and artifacts in your sphere. Cross-dissolves and fade-to-black are the most natural transitions to employ between scenes.

Sound Design

Sound design is a huge component of the post-production process. Creatively, sound can be used to alter the viewer's perspective, create emotional impact, and transition between scenes. Especially in 360-degree video, audio is important in directing the audience's attention. If the viewer hears a sound behind them, they will likely want to turn around to identify its source. Therefore, recording and placing spatial audio cues are integral to the storytelling process.

In post-production, technically, the sound can be adjusted for better performance by filtering unwanted noise and leveling the volume. This volume adjustment is especially important for web and mobile video, since the audience is commonly using headphones tucked in their ears, or in contrast, using a small device in a noisy populated area. When editing, test the audio by listening through headphones and a variety of speakers and devices. Also note that most web and mobile audio is delivered in mono, so you might want to mix down tracks into a single track and listen carefully to the results.

Aesthetically, narratively, and thematically, the choice of music is an extremely important one in completing the video. When producing a lower-budget emerging media project, be aware of the many options under fair use such as public domain, license-free, royalty-free, Creative Commons, and original music. Each of these has individual limitations of usage. Music with a Creative Commons license is a great source you should consider if you are under a tight budget. Creative Commons provides high-quality music that isn't overplayed, but be sure to read over the various licenses and their conditions to make sure you have the right permissions. Free Music Archive is another great comprehensive online source that provides audio for creative use under many different rights and licensing agreements that you will need to confirm before usage. Original music is a great way to ensure being free from copyright issues. This can also be an affordable option if you find someone local or who wants to use your video as a promotional opportunity. You could also try your hand at loop-based composing on inexpensive sound editing tools.

Final Deliverables

The final delivery for an emerging media project can be a bit more complicated than traditional TV. There are many aspects to consider while trying to deliver high-quality video to your target audience. The most important thing you can do in the process is begin with high-quality sound and image, a great story, and a clear set of goals. If you know your audience, genre, distribution range, and finance plan, then all of this will inform how to share your finished video.

Hosting. One of the first considerations when planning the final stages of an emerging media project is deciding on a host for your video. You may choose a host that has a widespread, reliable, low-bit-rate distribution model across all platforms, or one that focuses strictly on delivering the highest quality video to a more targeted audience. When deciding on a host you also need to be aware of the technical requirements and limitations. Some will be more affordable and possibly free, but may come with more limitations. You need to balance the needs of your project with the cost of the hosting. Keep the following features in mind when deciding on a host:

1. Quality of video
2. Bandwidth
3. Other hosted videos
4. Storage
5. Accepted file formats
6. Codec
7. Video player
8. Customer support
9. File organization
10. Privacy settings
11. Pay versus free model
12. Analytics

Compression. When you upload your video to a host, they will most likely re-compress it to fit on their server, even after you have just compressed it in order to transfer it to them. Some hosts have made their encoding practices public knowledge, and it's worth taking the time to encode your video to their standards, since you would do it with more care than they would. The world of compression is a tricky one, and the less compression you can do, the better, because quality is lost in each compression. Compression works by removing information from files to make them smaller and easier/faster to view on the final platform, while trying to maintain as much quality as possible. A compression algorithm decides which pixels to keep and which to remove. This algorithm is called a codec, which is short for "coder-decoder" or "compression-decompression."

There are a number of codecs to choose from, and there is no one right answer for all projects. Some popular video file formats are Moving Pictures Expert Group 4 (MP4), QuickTime (MOV), and Audio Video Interleave (AVI), all of which have unique qualities. As an extension of the MPEG-4 family, H.264 AVC (Advanced Video Coding) is the current favorite video compression for producing high-quality video files while maintaining a small size. This format is used not only in podcasts, web video, mobile devices, 360-degree video, and YouTube but also broadcast TV, Blu-ray discs, and PlayStation. HTML5 has the capability to deploy embeddable players across multiple platforms and browsers. YouTube and Vimeo offer HTML5 video, which currently supports multiple video formats.

After rendering 360-degree video, the resolution can become noticeably worse when viewing it online or in a headset. For example, a camera may have a 1080p resolution, but in a headset will look more like 480p with blurrier edges. This is because you are having to stretch an image across a wider frame, especially if fewer lenses were used. Therefore, the higher initial resolution you capture, the better. You also need to add metadata to your video for YouTube and Facebook to be able to read it and display it as you intended. Without this metadata, their players will display your video as a flat 2D frame.

As you can see, there are many things to consider when thinking about resolution, compression, and choosing the right codec. It involves extensive trial and error, and each case is unique depending on the footage and the goals of the final video. There are some transcoder and converter tools out there that can help you discover the right codec for your needs. Adobe Media Encoder and Handbrake are both affordable choices. This software will help you test and compare results and will provide good presets. While trying to move through this vast ocean of hosting, codecs, formats, and compression tools, keep a few things in mind during your approach. What is the portability of the file across different platforms? What is the compatibility between applications, players, devices, and browsers? Is everything affordable? Does the final quality fit your audience's needs? If you can answer these questions, figuring out your resolution and compression needs will be quicker and easier.

There are a few other tips worth mentioning during the compression phase that may help you produce high quality in a smaller file size.

1. *Frame size.* It is helpful to determine the size of the finished video. You will likely use a widescreen 16:9 aspect ratio for web and a vertical 9:16 for mobile. Typically you should keep the project in the aspect ratio in which you shot it. You can also follow the sequence presets in your editing software to assist you. However, in the compression phase, you can consider shrinking the frame (the size, not the aspect ratio). It dramatically reduces the file size.

2. ***Pixel aspect ratios.*** This is the ratio of the width of an individual pixel to its height, and it is important to consider when taking into account the delivery format of the final video. Different platforms require different pixel aspect ratios.

3. ***De-interlace.*** Videos produced for television are often interlaced to produce smoother motion, but should be progressive for computer playback. To prevent getting a pixelated image from interlaced video, you can run a de-interlace filter through your editing software.

4. ***Audio sample rate.*** Audio is extremely important but also produces quite large files. You can often get away with lowering the sample rate and producing a smaller file size without noticeable change.

5. ***Frame rate.*** Another space-saver worth trying is reducing the frame rate, which results in less information to encode and may be acceptable viewing on the web or a mobile device, especially in projects with little visual motion.

6. ***Color and exposure.*** To ensure better-looking images, you may also try adjusting the brightness, contrast, and saturation levels throughout the process, since video sissgnals and computers operate on slightly different RGB models.

Test often! Test your video in multiple formats using different codecs and players on various platforms, devices, and browsers.

On a Human Level...

Finishing the post-production process is a kind of triumph in its own right. It signals your project's completion, and it's the result of the teamwork and collaboration of everyone involved. Allow yourself time to celebrate that teamwork. And resign yourself to the fact that every single time you watch it, you'll see something you'd like to change, or wish you'd done differently. Editing is never really "finished"—you merely reach a point where you stop working on a project. Any edit can always be improved, but at some point you just have to tell yourself that you are done.

SUMMARY

At this stage, you may have a tangible product you can see on the screen. You have delivered all the final dubs to the client, and said goodbye to the editor and audio mixer. But your project itself isn't really finished. As you'll see in Chapter 10, there are more details to wrap up, as well as guidelines for getting exposure for your project and for yourself.

REVIEW QUESTIONS

1. What is the producer's role in post-production? How is it different from that of the post-production supervisor?

2. Name four important legal documents that are essential to check prior to the post-production process.

3. Why is time code so important in the editing and mixing of a project?

4. Describe the uses and the differences between stock footage, archival footage, and footage that is public domain.

5. What can you do as a producer to prepare for the edit session? For the audio mix?

6. What would you look for in hiring an editor? How could you find one in your area?

7. What audio elements are needed in mixing most projects?

8. Briefly describe the audio mixing process.

9. Name three deliverables that are required in most contracts.

CHAPTER 10

It's a Wrap! Now, the Next Steps

THIS CHAPTER'S TALKING POINTS

I It's a Wrap!
II Professional Next Steps
III Festivals
IV Grants
V Publicity
VI Starting Your Own Production Company
VII Focus on Emerging Media

I. IT'S A WRAP!

After you've completed all the stages of post-production, your next step is to *wrap* the project and tie up all the loose ends. There are dozens of details to clear up. Some can be fun, many are tedious, but they all add up to a list of finalized elements that help your project succeed as well as mark you as a producer who gets things done. These steps can include any or all of the following:

- ***The wrap party***. Your entire team has dedicated considerable time and energy to your project. You can say thank you by throwing them a great wrap party. Usually it's informal, and only the cast and crew are invited. It can be held at a restaurant, a bar, or on set; you can have it elegantly catered, or just serve beer and pizza. It's money well spent when you can show your team how valuable they are to you.
- ***Final budget and billings***. When all the final bills have come in, you want to review each one for accuracy. Clients can make mistakes, and when they do, it's usually in their favor. Check your bills against your purchase orders. Compare your original estimated budget with what you actually have spent on the project. As discussed in Chapter 4, the estimates can be different from the actuals.
- ***Petty cash and receipts***. This area often is underestimated, throwing your budget off target. If, for example, you've doled out $1,000 of petty cash, you want to have $1,000 worth of matching receipts.
- ***Complimentary copies***. A surprising number of professionals seldom see their finished work or their name in the credits. It shows your respect when you send copies of the final product to the cast and crew. If dubs are a drain on your

budget, make sure that at least the key department heads and primary talent each receives a personal copy.

- *A screening party*. Unlike a wrap party, this event is more formal and carefully planned, essentially a premiere of your project for the press, clients, top talent, and potential investors, buyers, or distributors. Generally, you rent a screening room or theater and distribute a press kit (see Section II) to attendees. The project may be introduced by you or another project representative and then screened. Usually wine and cheese is served before or after. A screening party can be a great opportunity to mingle with the press and potential buyers.
- *Thank-you notes*. Other than cold cash, nothing goes farther than a personal thank you. Send notes or emails to the cast and crew, and to the client or investors, as well as to editing and audio facilities, locations, and others who helped you in the project.
- *Update your production book*. The binder/file in which you've kept all your notes is a valuable tool for future projects. As you are wrapping the project, go through your production book (refer back to Chapter 4) and update any notes, contact information, contracts, and budgets while they are fresh in your mind.

II. PROFESSIONAL NEXT STEPS

Seasoned and experienced producers are no different from a motivated first-timer—they'll take advantage of a few simple tricks of the trade to build and expand their careers. They also realize that no matter what project they are working on now, they'll soon be looking for their next job. As a producer of any kind of TV or emerging media project, you want people to know about you and the quality of your work. Following are just a few directions you can take to reach these objectives.

Create a Resume

There are dozens of resume formats and templates that you can use for your own resume. Whatever style you choose, your resume ultimately reflects you both professionally and personally. In the television and emerging media industries, "real-world" experiences are a plus, so include any internships, jobs, and production work you've done, no matter how insignificant they seem to you. Mention skills such as fluency in a foreign language, your talents in computer graphics, skateboarding, or working in a summer camp—these are aspects of your uniqueness that make you stand out and can be valuable to a potential employer.

You want your resume to look professional. Use a simple 10- or 12-point font, allow for white space so the information isn't crowded, print it with a good printer, and use quality, noncolored 8½" × 11" paper. Be brief and use action verbs for impact. Limit any personal information, don't include your salary history or requirements, and mention that you have references available if needed. Most software word processing programs feature templates for resumes, and the Internet has hundreds of sites that offer examples and constructive advice.

Build a Demo Reel

The purpose of a demo reel is to reflect your professional abilities, your creativity, and your technical know-how. Each producer's demo reel is unique, because it reflects his or her specific vision and talent. The demo reel contains short clips and excerpts of one's best work. They can be edited to a music track with quick cuts, or are clips strung together with special effects and wipes. Because most people won't view more than three or four minutes, put your best work at the beginning and at the end. Be

objective about your choices. A demo reel should open and close with graphics that include your name and contact information. It should be easily accessible via your website.

Make a Short

Your long-range goal may be to produce a dramatic series or a two-hour documentary special, but in the meantime, start by producing a short. Usually 5 to 30 minutes long, a short is easier than a full-length project to conceptualize and produce, to raise funds for, and to enlist people's help for production and post-production. A good short is an excellent calling card that can be put onto YouTube and your website, entered in festivals, shown to potential clients, or broadcast on channels that showcase shorts in their programming. Some of the cable and premium channels often air short pieces called *interstitials* in between their regularly scheduled programs to fill the time gaps. Other channels specialize in shorts.

> **Top Ten Helpful Hints for Creating a Short Film in Both Narrative and Unscripted Formats**
>
> 1. Avoid the overuse of voice-over narration to carry your vision. Think about narration as a means to introduce your story, or express salient points, but do not allow the focus of your project to be the voice-over.
> 2. The first few minutes of your project are integral in creating the tone. Think about your opening very carefully, and stay away from traditional and oversaturated openings, such as "alarm-goes-off-character-wakes-up" or "pan-across-a-mantle-of-photographs," for example.
> 3. Consider the running time of your project while it is still in the concept stage and have a clear idea of content versus running time. The longer your project, the stronger your story should be. Remember, it's all about the story, regardless of whether it is narrative or documentary.
> 4. Particularly with documentary projects, think about your story progression. You still should have an idea where the film is "going." Twenty minutes of talking heads interspersed with archive footage does not a documentary make. What is your viewer going to learn/experience by the end of the film, and how do we get there?
> 5. Montage sequences serve a very specific purpose to move the story ahead in an expedient manner. Regurgitating previously viewed shots simply for the sake of putting them to music is not in your best interest and detracts from the overall impact of the film.
> 6. Speaking of music, the use of songs should not undermine the visuals but enhance them. Too many filmmakers who grew up as part of the MTV Generation cavalierly use song lyrics to express their vision. This is not a music video.
> 7. Your main credit sequence should not imitate a feature film. A 10-minute short with a 2-minute main credit sequence is unnecessary. Give "credit where credit is due" in the end credits! If you produce a lavish opening credit sequence, make sure it matches the style of the film and does not jar the viewer when it goes from credits to first shot.
> 8. The one-character documentary has its own set of challenges. A producer may think someone's life is unique by the hurdles he or she has overcome or something in his or her life that warrants capturing the experience, but others should as well. Before you produce a film about a friend or relative, keep your audience (and

> objectivity) in mind. Is this person interesting enough on camera to sustain a viewer's attention for 10, 20, or 30 minutes?
> 9. One of the most exhilarating aspects of short-form filmmaking is that "there are no rules." Don't feel confined by the structure imposed by features. Programmers are looking for creativity, new voices, and a captivating story supported by visual imagery.
> 10. Finally, be aware that you're not going to get rich from a short film. Your goal should be to produce a project that accurately reflects your talent and the ability to create and complete a vision. A common and accurate descriptive is that a short film is your "calling card."

Network and Make Contacts

Agents and managers can certainly be helpful, especially if you're already successful. But, if you're still on your way up the ladder, most producers find work opportunities from the people they know—colleagues, fellow producers, members of professional organizations. You want to meet people at the top of the ladder, or who are on their way up. You can find them in TV and emerging media industry organizations, on websites and blogs, in classes and internships, and at festivals.

If there are no festivals in your area, start one: create a festival theme and focus, find a local movie theater or screening facility, get a couple of like-minded people to help you, study models of successful festivals, and throw a fundraising event to get you started. Or, start one online.

Find a Mentor

A mentor or advisor is a valuable asset for a beginning producer, someone who has worked hard to achieve success and understands the importance of giving back to people who are on their way up. Mentors can be found in the workplace, in television, emerging media, and film-oriented organizations, and in the classroom.

You may also know *about* a person whose work impresses you and who models success in ways you admire. Take a chance, request a meeting. Because you've already carefully thought about how she can be of benefit to you, you can explain your position and how you would like to be mentored. Do you want to work alongside her? Can she give you valuable advice, internships, or contacts? Be respectful of her time and keep the meetings brief. If she agrees to work further with you, always let her call the shots about scheduling time, place, and duration of your meetings.

Take on Internships

A good internship can give you invaluable learning experience, and great contacts. Most producers in television started their careers as an intern or production assistant. Whether you're doing an internship for school credit or simply for the experience, keep in mind that an intern who regularly shows up on set or in the production offices becomes a steady, dependable presence. Producers and directors start to depend on the intern, and over time, they give him more work and more responsibility. Often a valued intern is offered employment after a few months or when an entry-level job opens up. At the end of the internship, he can ask for a letter of recommendation or a referral to another internship.

CHAPTER 10 It's a Wrap! Now, the Next Steps

As an intern, you're an asset to the project. You're giving them your energy, education, and unique skills. If you've done other internships, you're also sharing your experiences. You want to be punctual, keep your word, and anticipate what needs to be done before you're told. Your behavior in the workplace is appropriate, and you're respectful of everyone in the workplace. You may only be photocopying dozens of full-length scripts, but do it with a smile. In return for your time, you're exposed to professionals who model both positive and negative learning experiences, as well as having on-set duties or sitting in on meetings.

And, unlike a full-time job, you can leave an internship guilt-free if it isn't a good match. In some cases, the internships aren't well organized, and you can feel as though your time isn't being fully utilized. Ask for more work. Look for areas in which you can be helpful; often, taking that initiative is really appreciated.

> Internships fill the void between the dream of the industry and the reality of it. They are a safe space between the educational environment and the professional one. They give an important educational experience, one that represents a transitional reality not available in school, one that you can sample, and one that you can easily retreat from at the end of the semester. A trial run without a penalty. More important, internships can allow you to learn what you really *don't* want to do.
>
> **Sheril Antonio, excerpt from interview in Chapter 11**

Get Experience

You may not want to commit to a formal internship, but you do want real-world experience. Most cities and towns have local production companies and TV stations where you can volunteer your services in exchange for a chance to be part of the action and learn in the process. Often colleges and universities with TV, emerging media, and film departments have bulletin boards on which students can post notices about their upcoming projects that you might be able to work on for more experience. You can also post your own notice, offering your services. Meanwhile, buy or rent a prosumer camera and make your own projects.

Take a Course

Depending on your location, you can find courses, seminars, or programs that can expand your knowledge in the area of producing. You may not be interested in directing or editing, for example, but the more you know about how these jobs are performed, the better producer you can be. The course instructor may be actively involved in the profession that she is teaching and can hook you up with internships, jobs, and/or networking opportunities. Your classmates, too, could be valuable members of your future production team. Look into classes in universities with continuing professional studies for producing, business writing, public speaking, marketing and sales, computer science, graphic design, editing, and even foreign languages. Each of these areas improves your overall skill set and increases your marketability as a producer.

Stay Current

By subscribing to online news letters and publications that report on both emerging media and television, you can familiarize yourself with the latest trends as well as with financial, legal, technological, and creative directions. Although the sheer amount of

information and names can be overwhelming at first, you'll eventually connect the dots.

Get a Job

Producers often started off as interns, production assistants, personal assistants, or secretaries. Other producers came from careers as lawyers, writers, accountants, and even actors. If you're starting out in the business, look for an entry-level job in a network, production company, online startup, entertainment law firm, or other areas of the media industry that can help you build up your producing skills and contacts.

If you've got strong office skills, you can often find temporary jobs in entertainment and communications companies. In larger cities, temp agencies specialize in providing staff for short-term jobs such as receptionist, secretary, assistant, and so on. If you like the people at the company and they like you, they'll keep you in mind when a job opens up. If it isn't promising, you can simply go back to the temp agency and ask for a different job.

Ten Ways to be a Great PA and Keep Moving Up

1. Be prepared to work for little if any money at first. You'll make it eventually.
2. Be willing to work long, long hours.
3. Always keep a smile on your face, as hard as it may be.
4. Work hard! Go above and beyond your duties.
5. Know everyone's name and their position on the production.
6. Never complain. No task is too small, even if it is.
7. Remember that everyone has been where you are, even if they act like they haven't.
8. Ask questions and show a genuine interest in the business. Most people like to talk about what they do for a living.
9. Listen carefully, and know that watching is a learning experience.
10. When you have a choice, work for the right people. Your gut instinct usually lets you know if they're a good fit or not.

Becky Teitel and Jonna McLaughlin, former PAs

III. GRANTS

Why do you need grant money? You might be looking for money to edit and mix the footage you have already shot but can't afford to finish. You could want an entire project to be funded, or you simply need the donation of services, like post-production work or legal advice.

Most private funding is awarded to nonprofit organizations with a 501(c)(3) status, so you as an individual grant-seeker can usually apply for grants through an umbrella organization that has the required nonprofit status. If you qualify, you might be able to establish your own company with 501(c)(3) status. The Internet offers a range of sites that can give you more information on this process.

Guidelines From Funders and Grant-Makers

Funders and grant-makers can be an important resource for you as a producer. They have gone to considerable lengths to set up their foundations, define their goals, and

make money or services available to the public. Most foundations insist that you stick closely to their required proposal format; their guidelines outline all the requirements, so study them closely. Each granting foundation establishes very specific goals, with their objectives and a set of guidelines that include these elements:

- *General purposes*. The history and background of the foundation, and the primary purposes of establishing the grant.
- *Current program interests*. The themes, subject matter, and shared assumptions of the projects that the foundation seeks to promote and encourage through its funding, as well as specific eligibility components.
- *Grant-making policies*. Specific restrictions, limitations, and parameters regarding the conditions for which funds, services, and endowments are awarded.
- *Application process*. Components required by the foundation, such as a letter of inquiry, a detailed proposal, the grant-seeker's qualifications, a project budget and the amount being requested, proof of nonprofit status, and other aspects of future accountability.

Grant writing is a highly valuable skill, but one that almost anyone can acquire with time and practice. You want to focus your energies on targeting the right funding sources, and on writing the grant itself. You can explore the process through foundation centers, websites, and specialized directories and publications.

Preparing and Writing a Grant in Five Steps

The grant-writing process can truly challenge the patience of a first-time grant writer. It can be time-consuming, it requires you to maintain an uncomfortable objectivity to your own work, and it involves copious paperwork. Each grant has its own specific guidelines and objectives that require intensive research. But when you can feel the rhythm of the process and explore the many grants for which you qualify, your efforts could well pay off.

After you have researched and targeted the specific grant-makers who might be responsive to your proposal, you'll follow these basic steps to write and apply for a grant.

1. Describe Your Project

- Write a brief mission or vision statement that clarifies the goals of the project.
- Assign the project a specific genre, discipline, and/or geographic area.
- Clarify the project's goals and how the funding can promote those goals.
- Draw up a grant-writing schedule that includes the planning, proposal writing, submissions, and anticipated start date for the project.

2. Find and Contact the Funders

- Consider applying to many funders, not limiting the search to just one or two.
- Carefully review the objectives and priorities of each funder.
- Determine what amounts the funder awards, and what funds they have previously issued and to whom.
- Ask the funding organization for their proposal guidelines and application specifics.
- Locate a project officer at the granting organization who can answer questions, such as how the proposal review process is conducted, and if there might be any budgetary limitations or requirements that aren't outlined in the guidelines.

3. Review the Guidelines for the Proposal

- Look carefully at the guidelines for details that include eligibility qualifications, timetables, deadlines, budget information, and the specifics for formatting the proposal.
- If not outlined in the guidelines, inquire about the goals of the funder, the various award levels, and any contact names and addresses for submission. Ask about the notification process and the date of the notice.

4. Write the Proposal

Structure the format for the proposal by following the guidelines provided by each funder; often a deviation can disqualify a proposal. Traditionally, it includes a narrative, an estimated budget, an appendix of supporting material, and an authorized signature of the grant-seeker.

- **The narrative**. This opens the proposal and states what is needed and how it can be approached. Provide your goals and objectives, and reasons why the funder should support your proposal. Delineate your approach for setting and meeting these goals, an outline of the process, and the personnel needed to accomplish the goal. The narrative also provides a schedule of activities, workflow, and projected results, as well as pertinent information about the grant-seeker that assures the funder that you can assume all responsibilities. As with any professional project, you want to make sure that the narrative is well written and reflects the tone of the project as well as your own ability to carry it through. Any grammatical mistakes or spelling errors can cast doubt on your professionalism. Give it a subtle personality.
- **The project budget**. A carefully planned budget reflects the goals and sensibilities of the grant-seeker and gives the funder an indication of how well a project might be managed. The budget needs to be detailed and consistent with realistic prices and rates. It should request a specific amount needed to get the job done. Often, funders supply a budget form that you must fill out in order to meet their specifications.
- **Supporting materials**. A funder often requests a compilation of supporting materials that is then organized into an appendix. This could include sponsoring agencies or institutions, advisory committees, charts and tables, biographies on key personnel, letters of recommendation, any pertinent newspaper articles and positive reviews, endorsements, and validating certification that can lend credibility to the grant-seeker. Most foundations also require proof of your tax-exempt status or that of your umbrella organization.
- **Authorized signature**. Funders require the signature of the grant-seeker who may be awarded the grant and who is responsible for the funds.

5. Follow through

- Keep a log of the funders that you have contacted, when they were contacted, and their deadlines for your submission of grant applications.
- Keep track of their notification dates; know when to expect a letter of either rejection or acceptance from each funder.
- If possible, ask for feedback on the proposal and ways in which it could be improved for a follow-up submission if it's not accepted the first time around.
- Ask if they can recommend other funding sources that might be better suited to your project.

These are the five most fundamental steps that explore grant writing—yet each grant has its own unique guidelines and expectations. Take advantage of courses and

IV. PUBLICITY

> Today's wind is one of spectacle. It may not be of our making. Its origins may not be the pure lands of the Enlightenment but instead the commercial barrens of advertising and entertainment. But use it we must, for without the wind, we are becalmed, stuck, going nowhere.
>
> **Andrew Boyd and Stephen Duncombe, "The Manufacture of Dissent: What the Left Can Learn From Las Vegas"**

Unless you create projects solely for your own enjoyment, you want people to see your work. You want it to reach out and communicate your ideas to a viewer. You want to win festival awards, secure distribution, be seen via broadcast or narrow cast, and to attract the attention of potential buyers. You want to earn your living, and even enjoy some profit along the way.

As the producer, you are the liaison between your project and the end buyer. It's important to make people aware of your work. This is where publicity comes into the picture. Hiring a publicist can be an excellent way to get the word out on you, but it's also expensive. Often, you can do just as good a job as a professional, and for free. Following are a couple of tips for getting the word out about you and your project.

- ■ *Define your audience*. It's easier to focus your publicity when you know your audience. If, for example, you're promoting a children's television program, you want children and their parents and teachers to know about it. So target your publicity to parenting magazines, PTAs, online sites, teachers' publications, school fairs, libraries, family-focused festivals and events, and other child-oriented possibilities. Every genre of programming has an audience—find them, and involve them in your project.
- ■ *Write a press release*. A good press release can make your project newsworthy. A press release provides information that is interesting enough to be repurposed for news sources like local or national newspapers, local TV news stations, magazines, websites, or other audiences. A press release is simple, direct, and brief—a few well-written lines are more effective than a long-winded description. And a well-written press release makes a newspaper editor's job a lot easier.

A Sample Press Release

You might want to issue a press release about your project, your new production company, or even your latest festival nomination. A finished press release is folded in thirds so that it can be opened and read more easily. Whether mailing or emailing a press release, give the recipient time to respond before you follow up.

Here's a brief checklist of the elements included in a press release.

> **FOR IMMEDIATE RELEASE.** This is standard wording, in all caps, that appears in the upper left-hand margin under your letterhead.
> **Contact information.** Skip two lines, then list the name(s) and title(s), email, and telephone and fax numbers of the primary contact person.

Headline. Skip two more lines, use a boldface type, and briefly describe your news in a headline language that grabs the reader's attention.
Dateline. This gives the release date, and often the city and state from where you've issued the release.
Lead paragraph (introduction). The first one or two sentences of your opening paragraph are crucial. They keep the reader interested—or not. Like any compelling narrative, use clear language, action verbs, and few adjectives. Present highlights.
Supporting text (body). Ideally, try to fit all the information into one paragraph, and focus on the areas of what, who, where, when, and why.
Boilerplate. Additional information on the person, company, or organization issuing the release.
Recap. You can restate your news in the lower left-hand corner of the last page. For example, you might include the date a program is airing, the festival screening, a release date for your DVD, or the location of your new production company.
End of release. Three number symbols (# # #) follow the last paragraph of the release itself, centered, and indicate that the press release has ended.
Media contact information. The name, address, email address, phone number, and any other pertinent information for the media relations representative or other contact person.

Press Release Formatting

A press release generally includes these formatting components:

- *Paper*. Use 8½" × 11" high-quality, white or cream, printed on only one side.
- *Typeface*. Use 12-point Times New Roman or Courier, in upper- and lowercase font, except in the IMMEDIATE RELEASE line (always written in all uppercase letters).
- *Margins*. All sides of each page have 1½-inch margins.
- *Headlines*. Use a bold typeface to draw attention.
- *Continuation*. Finish the paragraph on one page, rather than carrying it over to the next page. When the word "more" is placed between two dashes (—more—) and centered at the bottom of the page, it lets the reader know that another page follows. But try to keep it to one page.

Some Other Thoughts on Generating Buzz

Contact your local press. Your project may have a human-interest story behind it—how you originated the idea, the use of local talent, interesting locations, unraveling an unsolved mystery. Most local newspapers, magazines, online sites, and business publications gravitate toward a good story that is compelling to their readers. Research these publications and look for a newsworthy aspect about your project that could be of interest. Find out, by calling first or through your research, just who's the right person to receive your letter of inquiry that briefly outlines your idea.

Get someone important attached. If your project has garnered praise in a newspaper review or won a festival award, you might consider taking it to a well-known actor, producer, or director who would be willing to sign on as an executive producer. This lends it extra credibility for publicity and investors.

Ignore your own hype. It can be tempting to believe that you actually *are* as cool as your own PR says you are. Keep an objective frame of mind as you do your job, and maintain your own emotional anchor.

Know when to move on. You may have to face the candid truth that a reasonable amount of time has passed, but your project still hasn't sold, or the deal you were offered wasn't nearly what you had hoped for. Chalk it up to experience, and give yourself validation for having learned so much. You are a creative and motivated person, and you've got new projects ahead of you, so take a deep breath and move on.

VI. STARTING YOUR OWN PRODUCTION COMPANY

Some producers prefer working within the structure of an existing network or production company, and others are more comfortable working for themselves. Maybe you've considered starting your own production company, giving you the creative and financial freedom of being your own boss. Or, you've found the perfect partner with whom you can coproduce your ideas. Possibly, you'll form a company solely to produce one specific project, or you may want your company to develop and produce several ideas.

The Realistic Components of Being Your Own Boss

By starting up a production company, you're automatically adding another large chunk of work to your already overbooked life. The many details of running a production company can fall between the cracks during production, so before you rush into what can be a demanding challenge, focus for a moment on these questions.

- **Do you have the right personality?** Some people are happiest when they can work within the comfortable structure of an existing company, with regular coworkers and realistic hours and working conditions. Others like to set their own deadlines and goals as well as take the risks that could go along with that freedom. Examine your own personality traits, and ask yourself if you've honestly got the motivation and energy to be self-employed. Can you devote way more than 40 hours a week, and possibly a six- or seven-day work week? Consider taking on a partner whose strengths and character work well with yours, or who is adept in areas you're not, like administration or pitching or budgeting. Sometimes a partner can come in with funds and specific abilities, but if there isn't a positive chemistry between the two of you, it's not worth the trade-off.
- **Can you support the business for a period of time?** A startup company needs money to cover initial costs such as office space and furniture, phones, computers, high-speed Internet, faxes, utility bills and deposits, and printing stationery and business cards. If you're hiring other people, they need to be paid while you look for clients and jobs. You have your own personal rent and expenses to cover, too. Explore these realities by creating a spreadsheet that lists your realistic income potential and weigh them against your planned expenses. Come into a business with enough money to cover your expenses for at least six months to a year.
- **What investors could you bring into the business?** You may not have a large cache of personal funds with which to start your business, so look for friends, family, colleagues, and private investors who might invest in your business. You can consult with an attorney and/or accountant to prepare an *investment offering* that details your cash flow projections and notes, how the funds will be used, tax consequences, and a projection of returns on the investment. This document also includes information about the producer's team, the manager of the project, and other details. You can grow your business from these investments without giving up ownership and personal control. If you have a good credit rating, business

integrity, and expertise, and have compiled a strong business plan, you may qualify for funds from a lending institution. In order to receive these funds, you may be asked to offer up security, like a home, a boat, or land.

- **What do you bring to the business?** Take an objective look at yourself: have you got the skills, personality, experience, and endurance to run a business? And, to be a creative producer at the same time? Just like a good story needs a hook to capture our imagination, you want to identify your own company's hook or "brand" and then build on it. Maybe you are an excellent administrator who can spot good talent, or you are a creative and inventive hyphenate—a producer-director or writer-producer. These are attributes that you can use to market yourself or your business.
- **Who is your competition?** As clever and energetic as you may be, there are other companies out there competing for the same clients. You want to be genuinely confident that you can maintain an advantage over other businesses by delivering better services, reasonable rates, and star treatment.
- **Can you create a demand for your services?** Promoting your business is a huge part of success, so get the word out about your new company. This requires advertising, press releases, making a lot of cold sales calls, talking to all your friends and business acquaintances, and thinking of clever approaches to connect with potential clients.

An Independent Production Company Checklist

If you've answered these last few questions honestly and still want to forge ahead, you're clearly prepared and on your way to making it happen. This mini-checklist details the main components that are part of creating and forming your production company:

- A **company name**. Sometimes it's used just for a specific project, or it covers all the work you do.
- A dependable and reputable **entertainment attorney.**
- An **accounting service** or a good accounting spreadsheet program for doing your own payroll, taxes, and production expenses.
- An **insurance policy** that covers liability and other production-related coverage.
- A **legal structuring of your company**, such as general partnership, incorporation, sole-proprietorship, or limited liability company (LLC)
- An **office location** that ideally includes parking, proximity to a roadway or public transportation, adequate utilities, and a welcoming neighborhood; also look into zoning requirements, local taxes, rents, and lease options. You can *invest* in your office space and buy it outright. Or, you *rent* space to cover the production only, or for an ongoing business. It needs furniture and equipment like phones, computers, faxes, printers, kitchen appliances, and a cleaning service.
- A company **website** that's easy to navigate, is competitive in design, reflects your company's attitude and product, and is consistently updated.

Study the winners. Look closely at companies similar to yours, or to what you hope yours will grow into, that are successful. Read their promotional material, research their client list, see how they solve their clients' problems and what has helped them succeed. This applies to success in general—read biographies and research elements of success that appeal to your personal goals and what you think you can adapt to your own style.

Keep It All Legal

You don't want to ignore the legal issues involved in starting a business. Meet with an accountant and/or attorney before you officially open your doors for business.

Depending on where and how you plan to set up a business, there are several elements to carefully research first:

- **Business license**. Most towns and cities, counties, states/provinces, and/or countries require a license to operate a business within their boundaries.
- **Business organization**. Options include general partnership, limited partnership, sole proprietorship, limited liability company (LLC), or incorporation, and each choice affects issues like taxes and liability. Each country has its own options, but most fall in these general areas.
- **Certificate of Occupancy (C of O)**. Some U.S. city or county zoning departments require this document if you plan on moving your business into a new or used building.
- **Business name**. When an American company's name is different from the name of the owner, this fictitious name needs to be registered with the county. It doesn't apply to a corporation doing business under its corporate name.
- **Taxes**. Depending on the country, state, or province, as well as a company's legal structure, its owner could be responsible for withholding money from an employee's wages for taxes. In the United States, the owner pays state and federal (and sometimes city) income taxes and Social Security insurance, known as FICA. If you're self-employed, you pay your own FICA. Businesses are required by the state to pay unemployment insurance in some cases, as well as state and federal income taxes and, in some cases, city income taxes on their company's earnings. If a business employs three or more people, it must provide workers' compensation insurance to cover accidents incurred on the job.
- **Business insurance**. Coverage for a business is essential. Insurance coverage might include protection against fire, flood, earthquake, and hurricane, as well as additional insurance that covers theft or damage of property, equipment, and automobile, or interruption of business. In some cases, insurance is needed to cover an officer or director of a corporation—or you—who could be held personally liable on behalf of the company.
- **Federal Employer Identification Number (EIN)**. A one-of-a-kind number in the United States that the IRS assigns to a business by which it is identified and accessed, somewhat like a Social Security number for a business. More information can be found at the IRS website, www.irs.org.

Dealing With Clients

The word "client" casts a wide net. A client can be a major network, a producer you're working for, a nonprofit funding group, a government department, or your rich brother-in-law. A client pays the bills, gives you creative direction, and has demands that must be met in order for you to be paid. No matter how independent a producer you might hope to be, there is always a client. And the client is always right.

Keep Your Clients Happy

Getting clients is hard enough, and keeping them can be even harder. The television and emerging media industries make, and spend, billions of dollars, pounds, and Euros to get ahead, and this competition can be either chilling or exhilarating. But the harsh truth is that few of us are truly irreplaceable, and most clients can usually find a better deal somewhere else. You want to make yourself valuable to them. Create a plan that can make your clients feel valued. Take a genuine interest in their goals and ideas, be collaborative, and earn (and keep) their trust. Thank them for their business by treating them well. And even when you don't actually like your client, they don't have to know that, and you still want to treat them with respect. Never gossip about a

client, and never burn a bridge. The media production industries are smaller than you think, and it could easily come back to haunt you when you least expect it.

Negotiate

If you've got a client who can provide you with steady business, consider bringing your rates down and negotiating a long-term deal. However, if a client tries to consistently nickel-and-dime you, the price of your sanity may not be enough of a trade-off. There is a subtle difference between the two. Your intuition is usually right when you listen to it.

Ask Questions

Often a client has great ideas and directives, but they aren't clearly stated. Don't hold back: ask for clarification. Take notes and then write a memo to the client after the meeting, detailing what you think was said. This way, if there is still confusion, changes can be made by both you and the client.

Keep a Paper Trail

In the midst of virtually every project, there's chaos no matter how well-planned. Things are promised, and somehow forgotten, or one budget number turns into another. Save all your emails, as well as interoffice memos, deal memos, contracts, and agreements. In each meeting and for every phone call, take notes and date them. In your daily calendar, keep track of times and dates of meetings, and who attended. This kind of attention to detail and backup documentation usually prevents disagreements or future litigation.

Simplicity Is the Key

It could benefit you to subcontract your work rather than hire full-time employees, and to hire employees and crew on an as-needed basis. Technology has made it feasible for a producer to run a successful business by just using cellular technology and a laptop, and to work from a home office until your projects and budgets allow for expansion.

For a larger project, or if you're consistently getting work and need the space, consider working out of a turnkey office space that you can rent on a monthly basis. And, on each project, hire a team of the most experienced freelancers you can find. This includes writers, other producers, graphic designers, salespeople, production coordinators, PAs, and interns; all work on a per-project, freelance basis. In most cases, you agree only on a salary and pay them that amount. They're responsible for paying their own taxes and insurance. You work out reasonable rates with them, give them credit whenever possible, and have a collaborative, fun time in the process.

And, when the project is over, everyone moves on to their next job.

> You try to get across that "we've got certain things we have to accomplish, we understand that you have certain things you have to accomplish, let's work together to see how we can do as much of that as possible" and find ways where we can compromise as necessary. It's as much about personal relationships and schmoozing as it is about, technically, how you're going to achieve whatever it is that you need to do.
>
> **Stephen Reed, excerpt from interview in Chapter 11**

CHAPTER 10 It's a Wrap! Now, the Next Steps

VII. FOCUS ON EMERGING MEDIA
Getting Seen

Your web video is finally done. You planned it, produced it, edited it, compressed it, and found a host for it, but this is definitely not the end of your web production journey. The toughest, most important challenge in web video is getting your work seen. With so many videos being posted daily, this is no easy feat. Three hundred hours of video are uploaded to YouTube *every minute* of the day. There are many principles and techniques you can consider that with time, drive, and energy will help you increase your video's visibility.

First of all, you must believe in your project and have enough interest in it yourself that you will be motivated to share it with others. Try to stand behind your project and figure out the best way to communicate the concept with others. Keep it short, simple, and to the point so people will want to share it. Avoid making it feel like an advertisement and keep it engaging from start to finish. And don't stop at one video—be prolific and have a lot of content ready right out the gate. To gain fans early on, promote your video before it even comes out. You can try documenting and sharing the behind-the-scenes footage, cutting a trailer/teaser, tweeting regularly, posting images on Instagram, or starting a blog and Facebook group.

Target Audience

One of the best things you can do throughout the distribution process is target your audience. You can host your video with similar genres and share it with online communities you know would be interested. Helpful resources you can use when identifying your audience are called analytics tools. Your host may provide these tools, or you may need to consult outside sources like Google Analytics. Collected stats and viewing patterns can help you see how your video is doing and will provide useful information for potential sponsors or advertisers. At the very basic level, you will find out how many viewers watched your show. At a more advanced level, you will also learn about their demographics, where they watched it, when they watched it, and how much of it they watched. This can help you know who to target, when to target them, and what is working and what isn't within the show's content. Don't just target your audience and leave it at that. Try to build a lasting, meaningful relationship with them and maintain the subscribers you have. Interact with them through forums and feeds and social media channels. Watch other shows that they like, build a solid brand and website for your video, and make it easy for them to subscribe and share with others.

Promotional Website

If you have a great title, thumbnail, easily navigable website, and good video host, then you're moving in the right direction. The title and the thumbnail are usually the first impression people have of your video, and you only have a few seconds to grab their attention and make them want to watch. The title acts as a headline and tells people what the show is about. Being short and succinct is a good approach to take, especially since some aggregators have character limits and you don't want people guessing what your show is titled. The thumbnail is similar in function and acts as a tiny billboard, giving people a sneak peek at what they might see. Your thumbnail needs to stand out among thousands on video sites and needs to be eye-catching.

In order for people to easily find you, you should consider having a home for your video. Developing your own website gives you a brand people can identify with and allows your video to shine without the competition of other thumbnails on the same

page. To help attract viewers, search engines, advertisers, and press, provide additional information about the show and the creator, subscriber links, a good video player, keywords, advertising, and photographs. Consider also uploading to YouTube, Vimeo, Amazon, and iTunes and linking out to other video hubs to draw more traffic to your website. Make your website design innovative but also really clear and easy to use for your audience.

Search Engine Optimization

Your personal site and your video should be as easy as possible for your potential audience to find. By better understanding and utilizing search engine optimization, you will have a higher rate of success. Search engines do not index the video content itself, but rather the text attached to the video. Therefore, the text you include with your video becomes extremely important. This text can be keywords found in tagging, descriptions, transcriptions, and so on. When tagging a video, only use the most essential words to accurately describe its content.

Another important strategy for helping your site get discovered is building a network around it. The greater the number of websites that link to your site, the higher its search ranking. Develop relationships with similar websites, blogs, and podcasts in the hope they will link back to you. Include a link to your site when you comment or post on a forum or blog. Search engines like finding several threads to your site and like sites that are active and updated frequently. They are also more likely to find you if you include yourself in their site's index. You can go to any search engine and add your URL to their site index tool. It may take a while, but keep checking back and see if the results change. There are dedicated video search engines you can target as well.

Social Networking

Another key strategy in helping your video find an audience is developing a strong social media marketing plan. It is a great way to reach out to your audience and make them feel more connected to you, your show, and each other. You can communicate with them through email, Twitter, Instagram, comment threads on your site, Facebook, and so on. Be careful not to overdo it, however—you don't want to irritate your audience by blasting out the same information at the same time every day on every platform. You will want to strategically stagger your messages and to be creative and caring with your approach. You can even use scheduling applications like TweetDeck and scheduling tools within platforms to make posting easier for you. And make it easy for your viewers to share your videos by adding social media icons to your website and shareable links. You want them to share your video on their social media with just the click of a button.

Twitter. Twitter is an essential tool to help promote your show. It is a short-messaging service of 280 characters or fewer that allows people to share and follow one another's activities. You can post quick updates about your show through text, photo, or video (even during the production stage, right from the set) and it can reach any follower through the app on their mobile device or computer instantaneously. Twitter makes it easy to have short but engaging dialogue with your fans.

Facebook. Facebook is another important social media facet of your project's identity, since it has around 2.5 billion active monthly users worldwide. Set up a Facebook page for your series, which is very flexible and allows you to share and interact with your fans. Populate it with updates, events, photos, video, and other supplementary material about your series. Become an active member of other similar Facebook

groups in order to network and attract other potential viewers. Invite everyone you know to like and follow your page.

Instagram. Finally, the other crucial platform to integrate into your social media marketing strategy is Instagram. It has over 1 billion users worldwide with the largest population in the United States, and it reaches a slightly younger demographic than Facebook. This will allow you to cast a wider net when advertising your show. There are a few helpful tips for developing your Instagram account and strategy.

- ***Business profile***. Create a business profile for your series, which will provide you with analytics and insights and allow you to add contact information and a call-to-action for your followers to click on.
- ***Bio***. In 150 characters, describe your series while including hashtags about your show, a call-to-action, and a trackable link to help monitor the behavior of your channel's traffic.
- ***Profile picture***. The profile picture can get quite small when it is viewed in the scrollable feed or stories. Therefore, make sure you have a clear and eye-catching image that works at various sizes.
- ***Captions***. This text helps frame your post and engage with your audience. You can have approximately 2,000 characters, but an average of around 150 characters feels about right. Try to include a call-to-action such as "check out our bio" or pose a question. Make it unique by injecting a little personality into it and adding between five and nine hashtags.
- ***Hashtags***. Using hashtags will help your post become visible and discoverable by a wide audience. Write hashtags that are relevant to your post and keep them simple and concise. More specificity in your niche content will be more successful than generic, broad tags. This will help you focus on your target audience and not get lost in the wide abyss of posts. To avoid your post looking like spam, try preceding the hashtags with a series of dots—one per line, or add your hashtags as a first comment on the post.
- ***Content***. Grab your audience's attention by including high-quality photos, images of people, or video clips. This type of content has proven to be scroll-stopping.
- ***Engagement***. One of the best ways to gain a new audience is to engage with them. In order to maximize this potential, use the platform to its fullest. Try sharing features on your Feed, give updates on your Stories, interact with fans in real time using Live, and show ancillary videos on IGTV. It is also important to respond to followers' comments on your posts, follow other accounts, "like" and thoughtfully comment on other posts, and be an active participant on the service.
- ***Timing and frequency***. Lastly, know when and how often to post. Data suggests the best time to post is generally between Tuesday and Friday, from 9 a.m. to 6 p.m. People are most likely to check their social media when they wake up in the morning and again after they finish work. The release plan of your emerging media project will dictate how often you should post. Some brands post daily or near-daily, but you could have a long-term strategy where you post more frequently as the premiere of your project nears.

Cross-Promotion

You can see videos with content similar to yours as competition or as an opportunity to promote your video to your target audience. Consider building relationships with other producers and implementing cross-promotion. You can advertise each other's

shows, provide links, build a channel together, comment on each other's blogs, or actually contribute to the production or content of each other's shows. And don't be afraid to bridge the gap between traditional media and emerging media to promote your video. You can gain popularity by writing for a magazine or blog, serving as a forum moderator, or interviewing with journalists.

Press

While traditional media helps generate buzz about traditional television, it greatly increases exposure to emerging media projects as well. Target the press that you suspect might be most interested in your series. Look at what they have written about in the past. Provide them with a clear description of your show, photos for their use, contact information, and a biography. The easier you make their job, the more likely they will want to tell your story. Don't overwhelm or annoy by sending out hundreds of press releases and constantly bombarding them, but don't be shy, either. Seize the moment by presenting your project when it is relevant. For example, if your subject relates to politics, it could be released in a time leading up to an important election. Once you have gotten a foot in the door with the press, maintain a good relationship and they will most likely revisit you. You can share relevant stories that might be of interest to them and comment on their articles.

Word-of-Mouth

It definitely doesn't hurt to have many friends in media and in your everyday life. Sometimes promotion can come down to good old-fashioned word-of-mouth marketing. At its most basic level, this involves nothing more than one person communicating to another, or sharing something via social media. Word-of-mouth is a reliable method of marketing because people usually know and trust the source. Chatting at the water cooler, or its virtual equivalent—commenting, sharing, liking, or following on Facebook or Instagram—will spread word about your project very quickly. Then it's your job to communicate with, maintain, and grow the community.

On a Human Level...

The changing dimensions and details that are involved in producing for TV and emerging media never end. These learning experiences continue getting better, and you bring them with you into the next production. For those of you who savor the never-ending possibilities that are inherent in producing, and in life, each new phase is a journey. You may well have found a profession that is rich in potential and tailor-made for your unique skills and personality.

SUMMARY

Over the last 10 chapters, you have explored the myriad elements that play integral roles in taking a project from its beginnings to its very end. Each chapter offered ideas and details pertinent to the producer—each is part of the process called "producing."

The final chapter of this book is designed to give you yet another perspective. In Chapter 11, you'll meet people with diverse ideas, advice, and experiences. These experienced TV and emerging media producers and industry professionals actively produce in television and emerging media. Each contributor talks about his or her area of expertise, and each conversation provides its own unique lens into this job call producing. After all, a good producer learns from the best.

CHAPTER 10 It's a Wrap! Now, the Next Steps

REVIEW QUESTIONS

1. Name three key aspects of wrapping a project. Why are they important?
2. Create your own resume. Ask two people to critique it for you.
3. What steps could you take to promote your project? To promote yourself as a producer?
4. Discuss the components of an effective press kit.
5. Research the foundations that award funds and services. Pick one and write a brief report on the organization's requirements.
6. What three areas of publicizing your project are you most comfortable doing? Why?
7. Write a sample press release announcing an imaginary news item you want to promote.
8. List the pros and cons of starting your own production company.
9. Outline your own professional next steps.

CHAPTER 11

Conversations With the Pros: Producing in the Real World

In this chapter, an impressive array of producers and industry professionals share their professional practices and their personal odysseys; each chronicles that search for bliss that Joseph Campbell speaks about. Through sit-down interviews, emails, faxes, Skype sessions, and transcontinental phone calls, each person shared his or her unique story with us; each injected moments of rich dimension into the preceding chapters. Their collective interviews form a body of work that is so interesting, it had to become a chapter all of its own.

The contributing producers, academics, and industry professionals are:

- Sheril Antonio: New York University, Associate Dean
- Sharon Badal: Tribeca Film Festival, Programmer for Shorts Program
- Michael Bonfiglio: Executive Producer/Producer, nonfiction and documentary
- Sheila Possner Emery: Former Producer, *The Dog Whisperer*
- Kim Evey: Vice President, Year of the Monkey Productions; former Co-Producer of *The Guild*
- Jordanna Fraiberg: Head of Development, Insurrection Media; Executive Producer, *Dead Girls Detective Agency* and *Tiny Pretty Things*
- Fredrik Montan Frizell: Producer, Technologist, and Managing Director, emerging technology
- Barbara Gaines: Former Executive Producer of *The Late Show With David Letterman*
- Spencer Griffin: Head of TV Development, Just for Laughs; former Executive Producer/Vice President of Production, CollegeHumor
- Richard Henning: Audio Engineer
- Tricia Huetig: Senior Interactive Producer, MetaLab; formerly Wieden + Kennedy
- Ann Kolbell and Matthew Lombardi: Producers, NBC and CBS
- Jeffrey McLaughlin: Senior Editor/Director of Post-Production
- Russell McLean: Producer, *Black Mirror: Bandersnatch*; Interactive Consultant, Netflix
- Brett Morgen: Producer/Director, documentaries for theatrical release and television
- Stephen Reed: Executive Producer/Producer, live events
- Tom Sellitti: Former Supervising Producer, *Rescue Me*
- J. Stephen Sheppard: Entertainment Lawyer
- Mark Verheiden: Executive Producer/Writer, *Swamp Thing, Ash vs. Evil Dead, Daredevil*
- Lance Weiler: Writer, Director, and Experience Designer for film, TV, and interactive games

CHAPTER 11 Conversations With the Pros: Producing in the Real World

- Justin Wilkes: Executive Producer/Producer, TV series, features, and documentaries
- Scott A. Williams: Executive Producer, *NCIS*; former Executive Producer, *Bones*
- Bernie Young and Laurie Rich: Former Executive Producer and Executive in Charge of Production, *The Martha Stewart Show*

SHERIL ANTONIO
Associate Dean for Film, Television, and New Media at New York University's Tisch School of the Arts

Authors: Let's address the classic argument: is television an art form or merely a craft? What is it about television that creates such controversy?

Sheril Antonio: My ideas about this question have changed somewhat as I've had new experiences, some of which have been quite profound. Today, television is many different things to many different people at once: art, craft, silly-putty, company, a device that provides worldwide information and education on myriad subjects, and that's how I think television should be. That is in fact what makes it important and so popular.

I think of the difference between my childhood television experiences versus today. In the 1960s and 1970s there was one TV in our home, no remote, and only 13 channels. Television was not on during the day and when we watched, it was as a family, in particular the news, *The Carol Burnett Show*, or *The Flip Wilson Show*. There were shows I watched alone before the news if I finished my homework, shows like *The Addams Family* or *Batman*. Today, each of our homes has two TV sets and everyone watches what they want.

The controversy about whether it is art or craft stems from the fact that television is seen as a piece of technology, and in terms of content, is not "one" fixed aesthetic or practical thing, not definable by one pedagogy, genre, age group, or format. Thus, those who think of it as caviar—maybe your BBC, Public Television folks—speak about viewing selectivity, and those who feel it is just crap complain about it. Most of us fall in between and watch the range of things from art to commerce. Television is both art and craft.

Before, I spoke about the fact that it had the characteristic of an appliance, something that everyone has and controls, thus it had become mundane, innocuous even, more like a piece of furniture which would encourage people to think of it as craft. However, as it turns out, I've never seen folks gather around an appliance laughing, crying, getting information, hooting or rooting for something or someone, or using it as a means to combat loneliness. I'm also more aware of the fact that television goes to places where other mediums don't—like hospitals, the dentist's office, and schools. There they take on new meaning for those offering its services and for those watching it.

It has the ability to give personal meaning to your individual needs or to allow large groups of people to share the same event or images, particularly in a crisis or disaster. I recall Princess Diana's funeral, the *Challenger* explosion, and of course 9/11; you knew most of the nation and maybe the world was watching the same thing you were. That's an intense and meaningful thing. Yes, it has a very different relationship with each of us, but its great power still lies in that fact that it has a way of connecting us individually to something important, or bringing us together around a particular subject.

AU: *As you've mentioned, TV is like a family member. You can argue with it, you can disagree with it, you can even turn it off, but it's still part of our daily life.*

SA: Indeed, television *is* important to us, and there is one easy way to find out what it means to you. Spend some time in a place without a TV or try not turning it on for a week. I had the opportunity to do that recently and it was eye opening. I knew how much TV meant to me and what an essential part it played in my day and life, but I was amazed at how much I relied on it for a variety of things. The most intense realization was that in a significant way I felt quite cut off from several things; news, weather, and entertainment, or distraction. And in the quiet moments I realized it also provided some strange form of companionship. TV, as it turns out, provides us with the security that other folks are out there, often telling us things we want to know. Sometimes it gives quick information we don't have time to pursue.

AU: *In your position at NYU, what do you suggest that a student of producing look for in getting an education?*

SA: Education has to be about excellent education, no matter what the geographical location, tuition cost, or pedagogy of the institution. It is our moral imperative as educators to provide the highest level of education to students, no matter what the school. The most important element, though, is that producing students need to be where other students are making films, videos, radio, music, animation, television, web-media, as well as studying the business and the history of each medium.

He or she has to look for a place where they can be engaged, where the whole of the process is taking place so they can be plugged in to a variety of experiences and exercises. I've watched this play out at NYU over the last few years. We had business students from the Stern School of Business wanting to be producers, so they were paired with filmmakers from Tisch to create projects together. This was so successful that the leadership of both schools got together and created a dual-degree program to facilitate this pairing, this vital experience while at school so that they are more than ready when they enter the business.

A producer is making something that is for a "market" or a particular group, without a doubt. That product can be informative, shocking, comfortable, funny, or challenging. Producers need to get involved in whatever they find value in doing. In television producing, it is important not to be in a vacuum, given the variety of channels and individual tastes that exist in the population. The educational institution must provide ways for producers to see how different people interpret the same assignment, understand that there are different ways of seeing, different ways of mixing the stew to get the desired results, and provide different working groups to shake things up a bit.

They also have to be in the room when this production is viewed by an audience of other students in their class, their faculty, or strangers at festivals to see how it reads out in the world. That is vital. Getting feedback is an essential part of this kind of laboratory setting. You can't take these kinds of risks in the real world. Educational institutions are sites for rapid and compressed learning in certain fields such as television.

AU: *How valuable are internships?*

SA: Critical! Vital! Essential! Internships fill the void between the dream of the industry and the reality of it. They are a safe space between the educational environment and the professional one. They give an important educational experience, one that represents a transitional reality not available in school, one that you can sample, and one that you can easily retreat from at the end of the semester. A trial run without a penalty.

More important, internships can allow you to learn what you really *don't* want to do.

AU: *In your experience in working with students who are on a producing track, do you notice any shared traits or commonalities?*

SA: While the personalities of producers vary, they have several things in common: they don't just tolerate chaos, they love it! They can work with almost anyone and have a great deal of patience. They love doing lots of things at once and engaging with and organizing people. They each operate at a different pace and engage different stylistic methods; but they are problem-solvers, it has to be second nature to them.

Producers also have the ability to see where things can go wrong and plan for it. They are facilitators and therapists and have the creative meter to see the project through from the widest perspective and the finest of details. In television, the producer is king, while film is the director's domain. Television has a different way of reading audiences, advertisers, networks, cable stations, time slots, etc. It's not a job you can be engaged in if you don't have the passion, energy or interest.

AU: *How important is it for a television producer to have a knowledge of television history?*

SA: Critical! As far as I'm concerned, you can't say you love a field and not have any interest in its history, its evolution, its mistakes, and its accomplishments. You can't be cutting edge or do anything new if you don't know what came before. You have to be curious about how things worked years ago, how they work in other countries, what traditions and formats were used and why. Being informed is being serious about what you are doing. One of the things NYU does is to require that students not only participate in a production-heavy curriculum but in history and critical studies as well.

There is an intellectual aspect to all forms of art and media. This is a vital matter when it comes to television. One has to know where it is placed in the larger world, especially in times of crises, such as 9/11 or a war. One has to observe trends and ask who television is representing, all the time. For me, the most critical aspect of television is the flow of information. You have to do some work, to sort out history in the making and see how things are being reported. I still believe that television is probably better with the past than it is with the present or the future. Sometimes I think reporting has turned into "convincing," "predicting," or "wishing."

I'm always interested in the today of television, the really strong work as well as the trendy programs. It all has value. Television producers have to know it all, past and present, to know how to do what they want to do best.

AU: *Here's the classic question: does television reflect our culture, or is our culture shaped by television, or do we need to care?*

SA: This is a really important question. We most certainly should care whether television reflects or shapes our culture. We have to care! Last time we spoke about how D.W. Griffith's film, *The Birth of a Nation* caused an increase in lynchings and clan membership in the early 1900s. Right now we are at war and heading towards another election. So the question is most important, and we should be thinking about this all the time with regard to the vital issues facing our nation—like the war, the election, the economy, healthcare, and global politics.

What still worries me is when television is shaping without consciousness. Whether the producers are not conscious or the viewers are not conscious, does not matter. It's the same problem.

AU: *How important is the choice of schools for a producing student?*

SA: You will end up where you are meant to be, no matter what school you go to. Having said that, it is clear that some schools have geographical advantages, some schools are better connected, and curriculum and faculty are at the center of the

educational experience. Given that the success of any student comes from that student's innate skills and talents, the selection of a school is important. We don't teach talent, we teach craft that unleashes talent.

When schools do well getting alumni into the business, I think it has a lot to do with their admissions policy and financial aid. Both can allow them to "attract" good students, the best students. So the simple answer is, any good school with a full curriculum that engages the student completely in all aspects of creative projects will forge a good producer. We all know the so-called "top" schools, and everyone tries to say this one or that one is good at this or that. The truth is we are all in the same business, and we all want the same thing and do our best to achieve it. I think where we do compete is for good students, since that's what makes or breaks us, that's where our long-term reputation comes from. Students need to look for a place where they can find the best experiences all around, inside and outside the classrooms.

AU: *What are the essential points that you would emphasize to your students about producing for television?*

SA: I would emphasize being as conscious a creator as you are a spectator; be informed about your subject, no matter what it is, and be passionate about whatever you decide to do. You see, if you are passionate and really invested in what you are doing, and say it fails, then you know you did the best job. Also, for any artist/creator, the spectator is someone that you should keep in mind all the time: whom am I making this for and why? Just as directors study the work of other directors, so should producers. Look at a variety of producing styles, the cutting-edge ones, the standards, and the old timers. There is no one way of doing things any more, and most successful folks these days are doing a variety of things, changing all the time and not getting stagnant. And, pick a school that has many industry guests coming to events and classes so you can talk to some of these folks. Their story won't be your path, but you will undoubtedly learn some vital bit of information from this "insider" that would never occur to you.

AU: *What do you feel the role of ethics plays in a producer's job description?*

SA: Ethics are crucial in any and all job descriptions. I think of it as having integrity, a sense of responsibility, and a conscious desire to connect in a meaningful way to a portion of the viewing audience. Given our discussion about television reflecting versus shaping, I think we can see immediately that ethical decisions pop up all the time. Notions of ethics have several levels of importance. One is that you have to know the ethical and political landscape of the different networks and various cable stations, the ethics of the various time slots. Obviously, the "after-school" programs will have different limitations from "late-night" shows.

Two, you need to study the differences between them and where they each have boundaries. I remember one issue that stood out to me was when Whoopi Goldberg's show was cancelled because she was too "political" and as a result lost Slim Fast as a sponsor. These are real decisions that are connected to real money.

And, finally, knowing all this will help you either conform, or know just how far you can go. I'm not sure if there is a document for television but I always show my students the one for film, *The Production Code of Ethics—1934*. It is a telling document if you want to know the "ethics" or politics as the case may be, of the time. As a viewer it is important to me, very important, especially when watching news, election coverage, to know the "ethics" of the network or the reporter.

AU: *What's important to you about this vast subject of producing for television and emerging media?*

SA: I remember something my mother always told me: never give anyone anything you would not want for yourself or your family. That's what I have to say about producing for television. That's not to say you can't challenge or shock folks, let them know things that are going on that we all deny or ignore. Television is a formidable cultural, political, social, economical tool. I actually think it should be studied in all schools and colleges. It is the single most important vehicle for the dissemination of the so-called American Dream. Now, with the cable stations, we have very different versions of the dream, in many different languages, age groups, etc. We even have shows mocking the dream, shows like *The Office* and *The Simpsons*. Television producing is an important job, I don't think people know how important it is.

AU: *What is your sense of the explosive advances of digital technology?*

SA: Amazing! The whole interactive nature of television now is part of why I think it's so important. Its status, power, and reach have to be discussed. We can now vote on issues with our cable remote, go online and communicate with a program's personnel while the program is in progress, and feel very much that we have a voice that is immediately reflected in real time.

SHARON BADAL
Tribeca Film Festival/Short Films Programmer; NYU Professor/Producing for Film; and author of *Swimming Upstream: A Lifesaving Guide to Short Film Distribution*

Navigating the film festival labyrinth . . . for most new producers, entering their project into the film festival circuit represents their first foray into the "real world" of the entertainment industry. Most of these initial projects involve the short film format that is less than 40 minutes. As one of the Programmers for the Tribeca Film Festival, I have watched literally thousands of short film submissions over the past several years, in addition to the shorts I watch from my students at New York University, where I am a full-time faculty member of the Tisch School of the Arts Undergraduate Department of Film and Television.

With my eyesight still intact, I offer the following Top Ten Helpful Hints for creating a short film in both narrative and unscripted formats:

1. Avoid the overuse of voice-over narration to carry your vision. Think about narration as a means to introduce your story, or express salient points, but do not allow the focus of your project to be the voice-over.
2. The first few minutes of your project are integral in creating the tone. Think about your opening very carefully, and stay away from traditional and over-saturated openings, such as "alarm-goes-off-character-wakes-up" or "pan-across-a-mantle-of-photographs," for example.
3. Consider the running time of your project while it is still in the concept stage and have a clear idea of content versus running time. The longer your project, the stronger your story should be. Remember, it's all about the story, regardless of whether it is narrative or documentary.
4. Particularly with documentary projects, think about your story progression. You still should have an idea where the film is "going." Twenty minutes

of talking heads interspersed with archive footage does not a documentary make. What is your viewer going to learn/experience by the end of the film, and how do we get there?

5. Montage sequences serve a very specific purpose—to move the story ahead in an expedient manner. Regurgitating previously viewed shots simply for the sake of putting them to music is not in your best interest and detracts from the overall impact of the film.
6. Speaking of music, the use of songs should not undermine the visuals, but enhance them. Too many filmmakers who grew up as part of the MTV generation cavalierly use song lyrics to express their vision. This is not a music video.
7. Your main credit sequence should not imitate a feature film. A 10-minute short with a 2-minute main credit sequence is unnecessary. Give "credit where credit is due" in the end credits! If you produce a lavish opening credit sequence, make sure it matches the style of the film, and does not jar the viewer when it goes from credits to first shot.
8. The one-character documentary has its own set of challenges. A producer may think someone's life is unique by the hurdles he/she has overcome or something in his/her life that warrants capturing the experience, but others should as well. Before you produce a film about a friend or relative, keep your audience (and objectivity) in mind. Is this person interesting enough on-camera to sustain a viewer's attention for 10, 20, or 30 minutes?
9. One of the most exhilarating aspects of short-form filmmaking is that "there are no rules." Don't feel confined by the structure imposed by features. Programmers are looking for creativity, new voices, and a captivating story supported by visual imagery.
10. Finally, be aware that you're not going to get rich from a short film. Your goal should be to produce a project that accurately reflects your talent and the ability to create and complete a vision. A common and accurate descriptive is that a short film is your "calling card."

As a producer, you are the ultimate creator and decision-maker on the project. Make certain that the decisions you make result in the best film that you can create.

MICHAEL BONFIGLIO
Producer (including *Metallica: Some Kind of Monster*, *Iconoclast*; *Addiction*)

Authors: The projects you've worked on cover quite a spectrum. What's your role?

Michael Bonfiglio: I work as a documentary producer, primarily in cinéma-vérité films. I work for @radical.media, a multifaceted international production company that specializes in television commercials but includes divisions that create a variety of other forms of media. I've been working in documentaries for more than a decade, having worked my way up as an intern for directors Joe Berlinger and Bruce Sinofsky (*Metallica: Some Kind of Monster*, *Paradise Lost*, *Brother's Keeper*), whom I now produce for. Working with Joe and Bruce is my main job within the larger umbrella of @radical.media.

As Joe and Bruce's producer, I am responsible for a wide and varying set of tasks, which really run the gamut between coordinating and line producing to generating ideas for new projects, getting projects financed, and helping shape the films creatively. I've also been involved in PR and distribution for our projects.

We usually operate with a skeleton crew, so I wear a lot of hats. Every project with us is different, so I am very fortunate in that my role is constantly changing and evolving, and I have a level of freedom that I enjoy. The flipside is that since our projects are not terribly heavily financed, on any given day I also find myself doing work that would probably be considered the duties of a PA. That said, working with filmmakers of Joe and Bruce's caliber ensures that I very rarely find myself working on things that bore me or that I am not happy to be involved in.

AU: *The demands of your job, of any producer's job, are extensive. How do you juggle your work pressures and still keep a perspective on your personal life?*

MB: This is a fantastic question, and one that really should be part of the larger cultural debate, not just in regards to producing for television. I'm a working guy in the relatively low-paying documentary field, not some big Hollywood producer who buys properties and gets them set up, so work for me literally means making the money to pay my rent and hopefully start chipping away at my debt—it's not some glamorous situation.

The "entertainment business" (which is such a regrettable term for the unfortunate reality) is however, a pretty cutthroat field. It's also somewhat capricious and you're constantly at the whim of networks, studios, or whomever it is you have convinced that your project is the best, or, in the case of an assignment, that you're going to do the job better than anyone else.

A guy I know says, "You're only as good as your last project," which is also a reality that creates a great deal of pressure, though this is often self-imposed, too. I do think this is a good thing in many ways, because it forces you to always push yourself to make everything you do better than the last thing you did. That said, you make choices. I often find myself neglecting my personal life and my personal projects in order to do the best that I can at my job. My girlfriend is always saying, "When you're on your deathbed, are you *really* going to regret not going in to the office/making that phone call/writing that email, etc.?" And she's right. I don't usually listen, though, largely due to the tenuous nature of my work, but also because of a personal need to do my best work.

Back to my initial point, though, I don't think that this quality is specific to producing. Cell phones, email, and other technological advantages have made it nearly impossible to get away from work, and corporate downsizing and our out-of-control consumer culture (and in New York City, skyrocketing rents that are pricing regular people out of town) have made it almost a necessity to work harder and more often than ever before (well, maybe not *harder*—I wouldn't make that argument to a dairy farmer, say, or the immigrants who built the railroads).

Technology has also blurred the line between when you are working and when you are not. Even in the short time that I have been in this field, I have experienced a tremendous difference in this regard. But this is really true in most fields—my father works for the phone company and was never home when I was growing up because he was always working. There are tons of people like him who probably regret those decisions who I could learn from, but the need to keep one's career together is really a necessity, not completely a choice. It certainly is true in producing, but it's far from exclusive to it. It hasn't always been that way, and it's not like that everywhere in the world, which is why I wish it were part of our larger social discourse.

AU: *Who might be your historical counterparts, in your area of producing?*

MB: The clearest historical counterparts to the kinds of work that I do are the cinéma-vérité films of the 1960s by people like Pennebaker, Leacock, Robert Drew, Albert and David Maysles, Chris Marker, and Frederick Wiseman. On any given project, though, I've taken inspiration from all kinds of places, though it may not be obvious to anyone but me—feature films, television shows, paintings, photographs, books, and life experiences.

AU: *What are your speculations on this intriguing world of emerging media?*

MB: I have positive and negative feelings about the future of television. With every step forward, there seems to be a step backward. As media consolidation puts control into the hands of fewer and fewer corporations, there have been some alarming trends. The bottom line is all that matters at the networks, to the detriment of the viewing public.

The perceived power of right-wing groups who try to censor voices on television is also pretty terrifying. The prospect of "branded entertainment" is awfully unseemly, as well. For someone whose livelihood hinges upon working in the field, the decreases in production budgets for documentaries is also a bummer. However, these decreases are largely due to the greater number of programming outlets that are fighting for the same number of viewers, which is a good thing. There are now more places where you can make things, and that has opened up the field to some truly original voices.

Before the rise of cable, shows like *South Park*, *The Daily Show With Jon Stewart*, *The Sopranos*, and pretty much anything on the Cartoon Network's Adult Swim never would have made it to the air. The increased need for content has also allowed for an expansion in the industry that has allowed more people to actually have jobs in it, and advances in technology have made it easier and cheaper to create things of good production value, so the type of person who can get his or her voice heard is no longer an archetype. So I guess I am cautiously optimistic about the future.

AU: *What do you wish someone had told you early in your career?*

MB: That there's no secret formula. I didn't actually set out to do this, and it's far from the career goals I am still hoping and working to achieve, but here I am doing it. It's not rocket science—you just have to learn from your mistakes, rise to the challenges in front of you, and be willing to ask someone who knows better than you when you need to. And there's *always* someone who knows better than you.

AU: *And your Top Ten list? What would that look like?*

MB: My own Top Ten list of things a producer of documentaries should know are:

1. There's no substitute for a good story.
2. Working with great people is better than working with a lot of money.
3. How to write.
4. How to use as much of your production gear as possible (just in case).
5. How to budget (and stay within it).
6. If you're traveling with equipment, show up really early at the airport.
7. If you're going on location somewhere, it's best to have someone local on the crew.
8. It's never going to be the way you expect it to be.
9. It's okay to ask for advice.
10. Everything takes longer than you think it will.

CHAPTER 11 Conversations With the Pros: Producing in the Real World

AU: If you were to be a guest lecturer in a producing-for-television class, what would you tell the students?

MB: Don't do this work if you want to get rich and/or famous, or you think it's a glamorous, cool-sounding job. Chances are, it won't work out that way anyway, but if that's the reason you want to do this work, please don't. As corny as it sounds, it really is a privilege to create and help create mass media, and there is a responsibility inherent in that, not only to the people who are seeing your work, but to your own soul.

There's not much you can do about what other people are creating, but there's almost always something you can do about what *you* are doing.

SHEILA POSSNER EMERY
Producer, *The Dog Whisperer*

Authors: The Dog Whisperer airs on Nat Geo, sells on DVDs, plus you've got pet products, books. Talk about the business model you've built.

Sheila Possner Emery: That evolved very slowly. Our partners, MPH, had a lot of the business experience so they very carefully and slowly developed the business. We knew that he was going to "be" somebody, and that there was an incredible market for anything to do with cats and dogs. There's 69 million dogs in America. The dog industry is bigger than the entertainment industry in revenue.

Our first product was the DVD *People Training for Dogs*, and we've only sold it on the Internet, yet we have sold over 100,000 copies. So, as we progressed through the seasons, by the end of our fourth season, it became evident that there was a need for dog-related products. We're in the process now of branding Cesar. He has his own brand of dog food, dog beds, dog toys, and dog vitamins—and dog water.

AU: Every producer wants a piece of the pie, somewhere along the line. Have you worked out a deal in order to do that?

SE: Yes, we're all partners. In our producing, it's a team effort, so that the building of a good team is paramount for success. If you have somebody who's really good at business, or on the creative end, or is good at relating, that's a good mix of talent.

AU: There are five of you. What is each person's job?

SE: Kay and I teamed up with MPH—that is the production company, with the editing facilities and the office. They have the infrastructure. MPH is Jim Milio, Melissa Peltier, and Mark Hufnail. Jim is one of the writers on the show and he sometimes directs. Melissa also writes; she was the writer of the two best-selling books, and Mark Hufnail is the business contract brain of the outfit.

AU: As for you and your partner, Kay. Who does what?

SE: We ask people to send in videos showing their dog's behavior, and showing them. We all screen the videos . . . there will usually be a couple of us screening. There's a coordinating producer and an associate producer, so one day somebody's out with the field, segment producing—and if we're in the office and there's a bunch of material to screen, two people usually go through it and pick out the best stuff. So once we have a pile of the best possibilities, then Sue Ann Fincke—she's the supervising producer and the director who directs 95 percent of the stories—she'll come in and we'll all discuss the choices.

We analyze the story—how many pit bulls have we already done? Or poodles. Maybe we just did a poodle story, so even though there might be a good piece on a poodle, we might not shoot that story because we've already done something similar. When we're looking at the material, we're looking at the dog, what breed is it, have we ever done this breed before. And we're also looking at the problem. Is it another aggressive pit bull? We've already done that one. Unless there's something about the people: is the problem really about the dog, or about the people?

And it's a mix of all those elements. Let's say someone's got a great personality and we think that they'd be a great interview, and is interesting to watch. It's a mix of the dog, the problem and the people—and also the location in the country because in the last two seasons, we've traveled to New York, Florida, Seattle, San Diego, Nebraska, Atlanta, the Chicago area—so, if we've already been to Chicago and we get a reel from Chicago, then that's not going to work this time around.

AU: *Does the same crew travel with you to all these locations, or do you pick up local crews?*

SE: We have an incredible crew. It's very small and everybody is superb at what they do.

So one of the most important things is that the crew has to be very calm/assertive because they can't add any energy into the mix. One of the things that's different about our show than just about any reality show, is that what Cesar is focusing on is energy: the dog's energy, and the owner's energy. What he is doing is creating balance between the dog and the owner, so the crew has to be very neutral. They can't get afraid or have any kind of an emotion that the dog can pick up on and that would affect how it's behaving.

Everyone is very respectful and kind to the dog owners. They are just regular people, and we're going into their house. It's very emotional a lot of times—they're usually at their wit's end, they're desperate, and here we are. There's two cameras in their home, so we want to put them at ease. In the end, usually people will say it's the most fun they've had in their entire life, spending the day with Cesar Millan. Because they do love their dogs, and they see miracles happen before their eyes—and that's what he does.

It's really amazing. I have to say, for four seasons I still haven't gotten used to, "Oh, there's just another miracle." I keep trying to come up with stories that will stump him, but he's just a genius with dogs—and people.

AU: *Let's talk about a basic belief that a producer has a certain kind of a personality. What are your own personality traits that help you as a producer?*

SE: I think enthusiasm and passion and persistence. For me, persistence has been number one. You just have to keep going, no matter what. And, being a creative problem solver, resourceful.

AU: *What do you think the role of ethics plays in being a producer?*

SE: I've worked in production on and off for over 25 years—on feature films and television and documentaries—and I've been disappointed many times in terms of ethics. Our success on *Dog Whisperer*, and our initial success in getting Cesar to sign with us, was that we went to see what he needed to feel comfortable. And we gave it to him. I told him, "If you give us this free option and tomorrow Steven Spielberg comes and says, 'I want to make a movie about you,' we're not going to say no—I'm not

CHAPTER 11 Conversations With the Pros: Producing in the Real World

going to stand in the way of your success. We want to get your message out—what we believe in about you. We think what you do is incredible but we're not going to stand in the way."

We aren't big producers ourselves. My partner, Kay, was a producer in Canada and she had her own shows—a lot of other shows—and this is really my first show as a producer. I think the reason that Cesar eventually signed with us was because we made it comfortable for him. We wanted him to be himself. We didn't want him to have to be somebody else, we weren't going to mold him into somebody. So I don't know if that's ethics, but I think it's a sensitivity to whoever it is, and to your talent. It may sound a little hokey but I think being honest is a good way to be in life. It works.

There are a lot of unethical people out there. They're dealing with large sums of money, and that kind of money has a tendency to not bring out the best in people (laughs). The dogs—they know. They don't care if you're a big TV producer or if you sell doughnuts—they know if you've got weird energy or not.

AU: *What was your start in producing, prior to Cesar and his dogs?*

SE: I'll give you the fast version of a long story. I was at UCLA studying Interpersonal and Mass Media Communications, and I saw how the media influences our lives—what we think and buy and eat. I was very idealistic, and wanted to produce socially significant films. I just woke up one morning and said that—like that's what I want to do! So I got on the phone and started calling production companies. Plus, in my film class at UCLA, a talent manager came and spoke and I asked him afterwards to give me a name of a director that directs like a European. You know, like I'm a sophomore in college. That's what I wanted . . . a European director—not like some crummy old American [laughs]. And he gave me a name and I just kept calling this movie director's manager, until finally one of them said I should get in the Screen Extra's Guild because then I can be on the set, and get insurance, and meet people and ask questions.

So I was an extra. I got into the Screen Extra's Guild and every show that I was on, I would talk with the producer and the director, and tell them what I wanted to do, and see if they had a job, and I just kept talking and talking and calling. I called Ray Stark. I called him every single day for I think three months. Finally he said, "Who is Sheila Possner and what does she want??" (laughs). Somebody had told me that he made *Funny Girl* and I liked that movie so I just kept calling and calling and calling him, till he gave me a job on a feature as a production assistant. Finally.

And when I got one job, then I just kind of bounced around between different jobs and I was always starving. Then, you get on a show and they pay you $200 a week, and it would be over and then do it over and over again. And I said, OK, I've had it. My career has been in and out of TV and film. I got to the point where I just couldn't take it anymore. I'd try to be normal and do something else and then I'd just come back to it again. I moved to New York and worked on a couple more films and then I came back to L.A. to do the Peter Stark Producing Program.

Actually, [laughs] I gave Ray Stark the idea for that program. One day, I was talking to him and I said, "You know, wouldn't it be great to go to school and learn how to do all this?" I was so frustrated, you know, trying to make something happen, and to learn. It was so hard as a production assistant to get up the ladder. This was back in the '70s, when there weren't a lot of women in the business. When I was working on one of Ray's films, I would write him letters and I'd say, "This is what I learned today." It was so emotional for me, I'd call him and I'd give him my progress report, this is

what I learned today. When I came back off the film, I told him, "Ray, there needs to be some kind of a program that you can go to, and learn producing."

And that was it. He never said anything to me. Then I moved to New York and was working as a temp when I looked at *Variety* and I saw this tiny one-inch ad—it was complete serendipity that I happened to pick this up—and there it was, the Peter Stark Producing Program at USC. Of course I applied, and I was in the second class that they had there.

AU: *Where did you go from there?*

SE: From there, I moved to Spain. I worked on a lot of different films, like *Paris, Texas*—that was my art film. I worked for Hal Ashby, and then I got into television because film was just so slow. I saw the show on TV, *Heroes, Made in the USA*, and this is my quality of persistence. I just saw the show, saw who produced it in the end credits, called him up and said, "I love your show—I'll work on it for free." And that was how I got started in TV. I worked for free, and then the next season they hired me.

That's how I got into reality TV. *Heroes, Made in the USA* was all about heroes and it's so positive—it was just my thing. It's the best job I ever had in my life. It was just wonderful. From there, I worked on all the junky reality shows that you can work on. And then I got on *Rescue 911*, which was a really good show. After that, I couldn't think of any more ideas, so I left America and lived in Barcelona, Spain, for eight years.

AU: *And what made you come back?*

SE: In Barcelona, I helped start the Barcelona Film Commission, and I got into international TV sales, and going to the markets—MIP and MipCom. They needed people who knew television, and who could speak English. That was really great. I came home because I saw into my future in Spain. There were a lot of women in their forties who were foreigners, who were single and broke. We all had fun but OK, I've had enough fun. I'm done here. Eight years . . . that's a long time.

AU: *Are you finding that some of your material is now going into the emerging media world?*

SE: Oh yes. The international phone rights are taken, and they're working on that. There are so many different avenues for the webisodes. Cesar did some "webinars" where people would pay a fee for what would be like a live seminar. I know there are all different kind of plans of what to do with Cesar in the new media. We're entertaining the idea of him going, well, everywhere.

AU: *All of a sudden, it's possible to do anything with one basic idea.*

SE: Right. Because of the technology. These digital cameras now? People can make a show—make a movie. That's what I like. The industry is just so hard to get into, you know, unless you have a lot of money. Now, people that have an idea of some kind of media that they want to share can put things on YouTube—the sky's the limit now. It's wide open for people to be as creative as they can possibly be.

AU: *All this is truly wonderful, but when you're through work, you go home to a second life with a very small person.*

SE: Oh my God. That's my two-year old.

AU: *How do you find your balance in all of this?*

SE: Well, it's really great that you asked. I have to say that's where my attention is right now. It's balancing, because working in television is very tiring, and I have *two* jobs.

CHAPTER 11 Conversations With the Pros: Producing in the Real World

Plus, we have Millan, Inc., which is the company and I'm in meetings for that, and then the show itself. There are no excuses, I have to be on top of it because this is a team effort, and everybody has to do their part, and nobody really cares if you were up half the night.

That's the thing about TV: if we're lucky enough to have a show, you have to go with it—because as an independent producer, it's like now, the money is here now, but when we're done, then what? So there's that, and then I have a two-year old who keeps going every day and I don't want to look back in 10 years, and go, what happened? I wasn't there, so fortunately we go to music class once a week and we go to Mommy and Me, and I'm going to work it out in the fifth season to maybe have a four-day work week, and work some from home.

I'm definitely committed to having it work out. I'll be a much nicer wife, and I'll be there for my son if I'm not working so much. You know, we've been shooting for nine months straight, and we're all stressed. We're tired; everybody's tired and I'm tired-er than they are [laughs]. But I'm committed to making it work—and reading books on how to do it. Believe me.

AU: *The more you have to do, the more you can get done?*

SE: I think that's true, but then if you go over the line, you just can't do anything. Sometimes I come home and I just think—I can't believe what I did today. The multitasking, the number of people that I spoke to on the phone, and the energy that it takes to get new projects going. You can't take your eye off of anything!

AU: *Knowing what you know—as a producer and a person—what advice would you share?*

SE: I would encourage people to follow their dreams. See, I'm a big believer in personal growth. I did Landmark Education for over 25 years, but I think do anything that causes one to be more effective as a person.

And, to be a good producer—I mean a *good* producer—you're going to be as evolved as possible. I would encourage people to do some form of personal growth—whatever kind—and be available to themselves to make something happen. To be really "in" the possibility of what's possible and to really make a difference. Because I look at media, and I look at movies that are beautiful and the acting is incredible. But the story? It's not inspiring.

No, I would encourage people to make media that makes a difference. To not be dependent, to be independent. Buy a little camera and go make something. Take a class on how to write a good screenplay. Stay true to their vision of what they want to do and hopefully, I would say, how to be worth the energy and effort that it takes to get something done. But I really think that's the most important thing, because you study and be up on all the different ways that people can see a project, looking at all this new media. It's tremendous, now, the possibilities that are available to people.

AU: *You started out in this business wanting to make films that have something to say, something socially relevant. Clearly, you still believe that's possible.*

SE: When we first started, our first season, we would shoot two stories in one day. We didn't have a motor home, so Cesar would change clothes on the street. I did his makeup, and I remember putting all the powder and stuff on the hood of somebody's car parked on the street. Now, here we are—four seasons later—we have a motor home now, and a lot more. It really changes if you can hang in there, it gets better.

I really believe that. If you have a good idea, go and shoot it. You don't need all the equipment and everything that was needed so many years ago. Now you can make it happen. You know, hook up with good people that you admire and that you can learn from. That's challenging, it takes some effort. You want to create an environment that makes it as fun and wonderful as possible.

AU: *How much do people skills enter into producing?*

SE: I think it's really important—one of the most important qualities in a producer is the ability to get along with people. You have to get along because you need to work with people of all different kinds of temperament, and must get along with everyone. Everyone!

KIM EVEY
Vice President, Year of the Monkey Productions, and Co-Producer, *The Guild*

Authors: With a background in acting, you are also the producer of two of your own original web series, and co-producer of the popular web-series, The Guild. What brought you to producing?

Kim Evey: I started as an actor and writer—I was the producer of my first web series by necessity. When Felicia Day showed me her script, I said, "I will help you." Friends said they would act, and I said I would produce. I didn't really know at that point what that meant except that I would help in any way I could.

AU: *Did she come to you specifically because she knew you had done a web series before or because you were friends?*

KE: She came to me initially because we were buddies. We were in a self-help group together. A group of friends formed a once-a-week meeting where we would get together and share our goals. Hollywood is a place where there is a lot of space between people. There are a lot of people like us who felt like they should be doing something, but it takes discipline. If you have no accountability and only the desire to write a script, it can sometimes be difficult to actually sit and write. However, this group created an environment where you can say, "Next time I see you I will have 10 pages written." That was how it really started.

So Felicia had written a script for *The Guild* as a TV show and then brought it to our group and said, "Here, I don't know what to do with this." People in TV were telling her that it was too niche, but that they liked it. I said that we should put it on the web and I would produce it.

AU: *How is the production of your show different now from what it was in the earliest episodes?*

KE: We grew immensely over the last four years and five seasons. We are about to go into season six. We transitioned from a group of friends who had similar skill sets who wanted something fun to do on the weekends to an actual working crew with sometimes as many as 35–40 people on set. We know how to make a film. We can shoot it, essentially, the way you would shoot a feature. The script is broken up into episodes, but the script for a complete season is usually 110 pages long. You have to shoot it based on the availability of locations and actors.

AU: *Do you write the whole thing first and then decide how to break it down into episodes, as opposed to writing one episode at a time?*

CHAPTER 11 Conversations With the Pros: Producing in the Real World

KE: Felicia outlines the entire season. She knows what all the character arcs are going to be and what everyone is going to be doing. She then outlines every episode because she has an *a*, *b*, and *c* storyline going. She writes it specifically that way. That's the difference between our web series and a feature film. She also writes conclusions for episodes to get people excited for what's going to happen next.

AU: *Why do you think* The Guild *became so hugely successful while so many other web series have failed?*

KE: I like to think of *The Guild* as a phenomenon in web series. Like any phenomenon, there were a lot of combinations of luck and skill involved. There were a lot of people at the right place at the right time. It started off with somebody who is a great actress, creating a great character for herself, who is really engaging. We had a script that was about a subject that connected to a lot of people. At the time of our debut in 2007, about 10 million people played online role-playing games on a daily. It was really mainstream.

At the time of our debut, nothing existed like *The Guild*. There was no narrative content *about* people who gamed, produced *for* people who gamed. We had a series of exceptional quality that filled a void for millions of people, who didn't even know they wanted it until they saw it. That is really the secret of its success. It is not a generic comedy about a person in a workplace or about an average somebody who is a screw-up. It is specifically about gamers.

AU: *Did the whole geek-chic thing, that reached its apex with* The Big Bang Theory, *help you find an audience?*

KE: We predate *The Big Bang Theory*, actually. It premiered on CBS on September 24, 2007 and *The Guild* premiered on YouTube in July of 2007. I remember thinking that I hoped they would be respectful of geeks and not ridicule them. They do a bit, but it does not come from a mean place. It's a good show.

I think *The Guild* is what it is because Felicia is a member of the community that she is writing about and it is based on the very real people she interacts with. It comes from a place of love even though the characters are often ridiculous.

AU: *Is your budgeting and your financing structure different from a regular television series? Is there something unique to web series about how the finances are handled?*

KE: We were able to link up with Microsoft for the first five seasons of our show. That was another thing that was a "right place, right time" thing. The Xbox 360 was launched in 2005, and in 2007 they were starting their Xbox Live Marketplace. The technology had come to a point where they were able to stream shows and were looking for original content. *The Guild* was a show about gamers, so it was a really good fit. They came to us and said that their audience would appreciate us, since it is a video game platform. It was a really good match.

In terms of the way it is structured, we budget it out like it's an independent film.

AU: *Was that idea to get a corporate sponsor there from the beginning?*

KE: We knew that we wanted it. We financed the first three episodes ourselves and then the rest of the first season our fans actually paid for through PayPal. We wanted to make more, but didn't have the money, so people started donating!

AU: *You were one of the earliest crowdfunders then?*

KE: I think so. It was before Kickstarter because we had to use PayPal. It was very surprising that it worked out that way. We could have continued to do that if we had to, but we really wanted to start paying our cast and crew. It wasn't like Kickstarter is today, where you can ask for $100,000 and get it. It was just that if people had any extra cash to give us, we said it would be great. At the time, we needed to feed all the people who were working for us for free, pay the makeup girl because she was using her own kit, and pay the sound guy. Everyone else was pretty much volunteering.

AU: *How did you structure distributing across multiple channels? Did that work with Microsoft?*

KE: We wanted to own our IP because we understood early on that the way you get people invested in something on the Internet is to be the captain of the ship. We wanted to be able to make the decisions about when it was coming out and how to interact with the audience. We didn't want to make a deal giving up the rights to distribution.

Microsoft was really understanding of us having our own distribution company. They could see that we were doing really well. They just wanted to read the scripts to make sure they were not pornographic, and other than that we could just go for it. The trade-off was that there was a specific window of time where we had to go to Xbox.com. After that period of time would expire, then we could do what we wanted with the series. We also were able to distribute and sell DVDs. Microsoft had an exclusive window, but it worked for us.

AU: *Has there been an opportunity to take the show into another medium, or have you determinedly kept it a web series?*

KE: There have been other opportunities and other readings. We see it in a certain medium, but we wonder what other people see it as. The possibility for moving it to another medium is on the table.

AU: *How important is social networking for your series, and do you play an active role in it?*

KE: I don't have that active a role because Felicia is the real lifeline to the community. She was an early user of Facebook and Google+ and was basically raised on the Internet. She is used to being online. The social network is hugely important. It makes people feel invested in the show because there is a dialogue between the creator and the audience, but she also connects with them because she plays World of Warcraft and so do the fans. It has been a huge part of why the show has been successful. Once we finish the web series, it is edited, and ready to be distributed, only 25 percent of the work is done. The other 75 percent is advertising, social media, and building a relationship with the audience. You want to make sure there is a genuine relationship with them because there are different feels to each network. There is a different feel to Twitter or Facebook. We want to look at these networks as real communities, and be careful not to just say, "Hey guys, watch my show, thanks and goodbye." It takes a lot of work. That is one reason Felicia has been so successful, people understand that she is genuine and not just using social media to promote her show.

AU: *Is there a part of the producing process you like better than others?*

KE: I love being in production. I love producing shows. I love the process of pre-production, assembling your crew, and figuring out where you are going to shoot. I love working with other people. It is really exciting to me. Our series is small so I do several jobs at once, and I love that. There has never been a point where I have had just one job.

CHAPTER 11 Conversations With the Pros: Producing in the Real World

It's a lot of work—a season takes about 12 weeks, we do about an episode a week. It can be overwhelming, but very rewarding.

AU: *Do you think that web series are a good place to learn producing precisely because you do have to do so many different things?*

KE: Yes, totally. We have really creative assistants on our series and they can move up the ladder quickly. In a corporate structure, you won't get to that point for years as a producer. When you produce for the web you can do it tomorrow. It is a great opportunity.

AU: *Do you have any ideas about how web and television are going to interact in the future? Have you noticed trends?*

KE: I have found that the difference between web and television is that the web is interactive consumption and television is passive consumption. The big overhaul won't happen until the kids who grew up with the web are adults. As long as there are people who just know television as passive entertainment and just want to watch their shows and not engage with them, there will be a form of that kind of production. Also, TV is always going to be long form and the web is likely going to continue to be short form. But there is an interactive element to a web show.

AU: *Is the success of a series, from the point of view of an advertiser or sponsor, measured by something like cataloged views or hits or site visits? Is that how you talk about success of a show and what it means to people who have a financial interest in it?*

KE: It is hard for advertisers to understand that it has such a long tail. *The Guild* gets new viewers that watch the entire series every day. I don't know how many people it is, but I know that every day it is discovered. That kind of long-term rollout is hard for the advertiser to process. I am telling them that initially it will have 300,000 views, but in a year it will have 1,000,000 views.

AU: *Have you sponsors urged you to cast celebrities on the show?*

KE: There are brands that right now don't really know what they want. It is very different to have a celebrity endorse something on the Internet versus getting them to endorse it on television. On the Internet, if a celebrity tells you to buy something, you aren't necessarily going to go out and buy it. On the Internet, celebrity has not yet trumped community. It is a very interesting phenomenon. For most celebrities, it seems like their name alone is not enough to get people to watch something on the web.

AU: *It will be interesting to see how web media evolves, as the industry figures out how to measure profit, accountability, and new ways to make money.*

KE: I think the thing that is interesting for us is that we have survived one wave, and right now I feel we are in the second wave. The first wave was in 2007 when people started using the web for more than cute little videos. That was the year I had a meeting at Sony about my web series. MySpace, which was around before Facebook, started getting really, really big. You could use MySpace and YouTube to blow up overnight.

A lot of companies that we took meetings with to get money didn't make it through the first wave. It is very interesting to still be around after they have failed. Now we're in a second wave of companies doing this. The first wave was much smaller. Corporations were wondering what people wanted, then they made deals and made shows, but it didn't work out for a lot of shows.

But now the Internet is working. We have so many celebrities coming into the web space now. Tom Hanks has a show on Yahoo, which is a huge deal. As a celebrity you can now be successful on the web, but you need the right platform. Simply being a celebrity isn't enough.

We are part of a YouTube initiative where they spent $100 million or more on content channels. They went to free rental media and stars like Madonna, Shaq, and Jay-Z. On the other hand, there are producers like us. They gave everyone money and asked us to make premium content for them.

This does a couple of things. This puts them in the original content game. They are a serious player now, along with Hulu, Netflix, and very soon Amazon, and possibly Yahoo, which are all creating their own content. In creating their own content they are overhauling how their analytics work.

Popularity used to drive analytics. If you had the most views, you rose to the top. That meant there were certain ways you moderated the system. You could have a provocative title and people would click, but the content could be whatever you wanted. You would click on a video with 1.3 million views that sounded interesting, but it would be a terrible video. It propagates.

They changed their system so that now engagement is more important. Things that people are watching all the way through are the highest-ranked videos now. They look at how much of a video you watched and see how engaged you were. There are premium channels that want to make channels targeting specific genres, or verticals, as they call them. There might be a channel about sports that is targeted towards people who typically like sports. The possibilities seem endless.

JORDANNA FRAIBERG
Head of Development at Insurrection Media; Executive Producer, *Dead Girls Detective Agency* and *Tiny Pretty Things*

Authors: Your vast career spans development and production for television, film, and digital platforms. Drawing from your experience in each of these areas, do you have a sense of where television production is heading?

Jordanna Fraiberg: People crave stories that reflect their experiences, struggles, and aspirations, and with more globalized distribution, not only are we going to see an increased viewership, but also a more diverse and discerning programming that reflects these types of people on screen.

AU: *What do you call this unique new category of television for mobile? How does the content and approach to storytelling differ from traditional television?*

JF: It's just another way to distribute content. The key in short form is to apply the integrity of the best writing and filmmaking to a smaller budget and a smaller visual canvas. The key is to still tell a compelling character-driven story that feels layered and complete, even if short.

AU: *What techniques and considerations are important when shooting vertical video?*

JF: You need to think about composing the frame differently, look for ways to fill it in visually interesting ways from top to bottom, rather than on the horizontal. The ceiling can become your friend in set decoration for visual variety. Close-ups are also

CHAPTER 11 Conversations With the Pros: Producing in the Real World

effective, and masters, while useful for establishing a place, don't tend to move story as effectively on a vertical screen.

AU: *How do you budget for a mobile project, and what is a typical budget range?*

JF: There is no typical range (besides small, unless you're QUIBI), but a good rule of thumb is trying to go non-union to keep costs minimal, and to have MFN deals for cast. Always try to put it all on screen. Have the cast use their own clothes, tricks like that out of student film handbooks.

AU: *How long is a typical episode for mobile, how many episodes are there in a season, and how often are they released?*

JF: This is still a bit of the Wild West, but episodes of 5–10 minutes, and a season of 6–10 episodes is a good range depending on the show. Make the episodes as tight and short as possible, and think about your audience in terms of pacing of your cuts to keep them engaged when there is already so much competition for attention on a mobile device.

AU: *How do you develop a release strategy, and what metrics do you use to measure the success of your projects?*

JF: This is always network dependent and they tend to keep this process and data confidential.

AU: *Why do you think mobile series are popular, and who are the typical audiences?*

JF: There is a growing audience that has come of age engaging in media of all kinds through their phones, but there has been a lag in both attention and resources devoted to creating high-caliber shows in this space until now. With the growing number of people with access to data globally, the demand for mobile content is higher than ever. This audience tends to be millennials and Gen Z in the U.S., but I would suspect it's older internationally, where mobile service is older and more integrated.

AU: *In such a fast-paced industry, how do your digital projects evolve with changing technologies, platforms, and audiences?*

JF: Great writing for its intended platform and audience always wins the day. A great story can live in many different iterations, so the key is to have an undeniable understanding of your character and theme, and how to adapt it into different mediums and formats.

AU: *You also have experience as a young adult novelist publishing books with the Razorbill/Penguin. How does this influence your role as a producer of scripted content for over-the-top digital platforms?*

JF: Once again, it boils down to the essential components of a story and a creator's vision: what is the world, the character, the themes, and issues that need to be explored to manifest these ideas? Having gone through that ideation process myself as a novelist, and also as a feature film executive, I try to approach developing story, no matter the format, in a similar way. Helping a creator access their core beliefs and characters they envision, and guide them along the way to bring it to fruition.

AU: *What skills and traits do you think a successful producer should possess?*

JF: There are so many facets to producing, and many roles to fulfill, which is why you often see many producers credited on a show. For me, producing is about finding and connecting to an idea, a book, a world, a creator that inspires me, and working

together with a team to bring that story—usually a scripted series—to life. To life means: creatively developing it until it's ready to pitch to networks, and in success, selling the show, putting a writer's room together, and overseeing the hiring of cast and crew to maintain the creator's vision from start to finish. So what skills does this require? Passion, commitment, flexibility, creative thinking, empathy, but also conviction that you will succeed even if it seems impossible.

FREDRIK MONTAN FRIZELL
Producer, Technologist, and Managing Director (including Highfield, Within, Here Be Dragons, and MediaMonks)

Authors: You have co-founded and worked at leading innovative creative technology studios, producing award-winning immersive projects in extended reality (XR), while pushing the boundaries of storytelling. Can you tell us more about your journey into this ground-breaking field and why you gravitated towards it?

Fredrik Montan Frizell: For as long as I can remember, I've been drawn to different technologies, how they work and how they may be able to be put together in a different way than first intended. It wasn't until I was connected with storytellers that my passion for telling stories, served by cutting-edge technology, were shaped. Since then, I've been fortunate to have the opportunity to build versatile teams and produce at companies whose focus has been innovation-driven first-class work. I've always felt we owe it to the industry to push the needle forward to do greater good in all things we take on.

AU: *You have produced projects for different stakeholders and areas of the industry such as television, film, commercial advertising, nonprofit organizations, and immersive live events. What are the key considerations for a producer working in these different realms?*

FMF: Every project is unique, and XR is no exception. This final frontier of mediums combines technologies, skills, and opportunities like nothing that came before it, making it the ultimate proving ground for a multidisciplinary production team. As an XR producer, make sure you understand and have experience from all realms of production—film, TV, interactive, editing, spatial audio, visual effects, VR, AR, theater and experiential-type projects. Once you understand the building blocks and flows for each, you'll start to see how the entire spectra of production works, and you'll be well prepared and adapted for pretty much any type of XR production.

AU: *What was one of your favorite productions, and why?*

FMF: Rather than looking back, I tend to favor the ones in development where you get to apply learning from all your previous projects. For me, today, it has culminated into creation of AI-powered photorealistic digital humans indistinguishable from a real person. Powered by an artificial brain comprised of an advanced neural network trained on vast amounts of data in whatever category desired. Capable of having millions of personalized real-time autonomous conversations at the same time through live text and video chat. Blurring the lines between a digital and a real human whilst providing superhuman know-how and assistance. The technologies to create this are here, and I'm thrilled to see how it will further push humans and XR experiences forward.

AU: *What roles make up a team for an immersive storytelling production, and what does the development process look like from start to finish?*

CHAPTER 11 Conversations With the Pros: Producing in the Real World

FMF: While the language of extended reality is still being written, years of experience have taught us a lot about what makes it work. While these are largely "soft values" and not necessarily of a technical nature, they fundamentally dictate what our tech approach should strive to enable. What XR ultimately should achieve is a sense of presence, and to accomplish this a lot of things must align. For example: realism, comfort, experience absorption, the importance of craft and the narrative. The effect of aiming too high is that the production runs the risk of becoming nothing more than a tech demo. It's important to understand that as amazing as the technology is, it's always there to service the experience, not the other way around. Ultimately, it's about hacking the human senses and doing justice to the medium by crafting an extended reality.

Roles and teams always differ depending on what you are trying to produce. Today, a dynamic video-based experience is much different from graphics engine-driven content. That said, in my experience, a must-have core for XR is a producer, a storyteller, and a technologist. That core creates a solid tripod to grow into many different team constellations of engineers, directors, artists, photographers, designers, developers, animators, creators, etc. The process is also unique for each project and can at times even stifle innovation when followed too closely. A rigorous, agile pre-production process is key, constantly questioning every decision while making sure all possible outcomes are covered. Most often, this results in creating highly detailed and accurate rapid prototypes or pre-visualizations of the entire experience before the main production begins.

AU: *What are the primary differences between being an XR producer and a traditional television producer?*

FMF: Extended reality holds the promise of transporting the user through time and space like nothing before, but success in achieving this is by no means a given, and the number of disciplines that must be mastered and combined are far greater than for any other medium. An XR producer often has to invent their tools, processes, and workflows. XR requires a wider understanding of what elements are needed to deliver your particular project, how that specific element is produced and how that fits with the overarching workstream(s). With a holistic grip on the full range of challenges and opportunities of the medium, you will be able to lead the work from initial concept to final distribution, leaving no stone unturned in your drive to achieve the full potential of XR.

AU: *What are the limitations and possibilities of XR for both content creators and audience?*

FMF: Apart from adoption, the biggest limitation is probably our imagination, which in itself is also the biggest possibility. Whether the projects call for 360° CGI, real-time game engines, live action, VFX, or a combination, an XR producer needs to be deeply versed in all aspects of the XR production pipeline. But beyond hacking the latest tech, XR is a sensory experience, which means the ones and zeroes will accomplish nothing without a profound understanding of human perception. XR is not another screen, it's an experience. The possibilities have never been greater than what they are today on the hardware, content, and audience fronts. It is an amazing time to be alive. If you can imagine it, there's probably a way of creating it.

AU: *You worked on XR projects for traditional television networks like SyFy, FX, Fox, Discovery, and USA, on shows like* Nightflyers, Legion, 24, TRVLR, *and* Mr.

Robot. *How do you see television integrating more of these interactive experiences in the future?*

FMF: All previous mediums have had a cognitive step between perception and translation. XR is the first medium to remove this cognitive step. As we move away from screens and into spatial computing, I think we'll see more universes being created for users to step into and be part of the story, even affecting the outcome. The perceived realness and emotional impact of extended reality hinges on much more than creative content. It is high-end, truly professional-grade craft, in all facets of XR production, that properly conveys an experience to the user and makes it enjoyable and believable.

AU: *At the heart of what you do is creative technological innovation. As a pioneer in this evolving industry, how do you continue to stay ahead of the curve?*

FMF: It's a team effort but inspiration is all around us, from established creators to teenage developers turning an industry upside down with new lines of code. Make sure your feed and subreddits are filled with your aspirations. Align yourself with people who are passionate, experts and leaders within your field of interests.

AU: *What advice would you give to an aspiring producer today?*

FMF: Always strive to go beyond what's already been produced and do it better than everyone else before you. Make yourself uncomfortable, take risks, inhabit a "can do" and positive attitude. Spend a lot of time on building and maintaining trust within your team. Ask yourself, is there a different, more efficient way of going about this? Be prepared to adapt and change your view many times before you find the right path. Work hard on maintaining your relationships, don't burn bridges. The people you meet early in your career will be important down the line.

BARBARA GAINES
Executive Producer, *The Late Show With David Letterman*

Authors: As an Executive Producer, what is it that you do?

Barbara Gaines: This is a question my mother went to her grave asking. "What exactly do you do? Did you talk to any celebrities? What can I tell my friends?" There are actually nine "Emmy eligible" producers, and four of us are executive producers.

AU: *And your day-to-day job? What does that look like?*

BG: First thing in the morning, I send an intern for coffee. I have a Starbucks and cereal for breakfast. Then I participate in a production meeting where the staff discusses the bones of the show and I make determinations about how much time things will take. I ask for a certain number of segment questions/acts of comedy accordingly. Back in my office, I discuss or write notes to Dave about the bones of the show and make adjustments according to his desires. I go over the jokes for the Act One comedy segments and pitch/cut jokes accordingly, and discuss with the head writers how to change the comedy to suit Dave's needs.

Throughout that process I answer budget questions, personnel questions, scheduling questions, and listen to people complain about their coworkers. Around 12:30, I revise the official rundown for the day's rehearsal, with all of the elements to be rehearsed or pretaped filled in. Then I meet with people from the talent department about future bookings and have a nice lunch.

CHAPTER 11 Conversations With the Pros: Producing in the Real World

Around 2:00 I go down to the stage for rehearsal where I watch the material the writers have cut, see the graphics married to the jokes for the first time, or listen to the stage manager stand in for Dave. While I'm in rehearsal, I try to get more answers from Dave about how he feels about the show.

Then I come up to my office. I read and answer even more email about booking, budget, and personnel problems. I make a revised rundown as a guide for the pitches in Dave's dressing room. I may have a light snack. Around 4:20 I go to Dave's dressing room and continue to discuss the elements of that night's show, including guest segment notes/questions. Around 4:45 I participate with the Head Writers/Producers in pitching the comedy to Dave. Then I make a list of suggestions from those pitches and choose a running order for the comedy in Act One. Dave looks at it, asks for changes, and I make adjustments.

Then I go down to the show and set the desk and stand at the podium onstage so that I can produce the show. I talk to the control room about segment orders and running times and make decisions on the spot about what to do in the next segment. I tell Dave what I think we should do during the commercial breaks and try to take care of problems that arise during the taping. Then I come upstairs and start to choose edits for the show. I give the edit room ins and outs and show the edits to Dave and discuss with him their merits and make changes according to his desires. I eat a nice dinner at my desk. I may also listen to staffers complain again, read and answer yet more email with questions and concerns about bookings, budgets, and staff issues. And also get the information from the writers about what they plan to do the next day and make a rundown for the production meeting.

Then I put the show to bed and remain vaguely nauseous at the thought that someone may (and half the time will) call me between 11:35 and the end of the show's broadcast (12:37) to tell me about things that were wrong (which I'll then fix for West Coast feeds).

AU: *People think of the show as a late-night talk show, but you think of it as a variety show. What's the difference?*

BG: I would most certainly call the show a variety show (not a talk show). A talk show is one that is built around talk—we always felt our show was built around comedy. I would call *SCTV* and *Saturday Night Live* sketch shows. And for that matter, I would not call Dave Letterman a talk-show host, I would call him a broadcaster. *Donahue, Oprah, The View*—they are talk shows.

And while there are a hundred syndicated and local talk shows, the variety show is not as easy. Just ask Joey Bishop, Jerry Lewis, Chevy Chase, and Arsenio Hall—the legends. I think the idea of a "talk show" came in the early '60s when shows began to drop the sketches and the jugglers and just talk to people. In some way I suppose, after the years went by, the talk shows started to add back music, comics, and then with us, the sketch as well. Carson, the greatest of them all, did comedy bits but not to our extent.

AU: *In 2002, the show won an Emmy and you went on stage to accept it on behalf of the producers' team. Can you remember what you said?*

BG: It went like this: "I started as the receptionist on Dave's morning show over 25 years ago. We've all worked for Dave forever [*turned to other producers*] which I think shows what kind of man Dave is, that he inspires that kind of loyalty. Dave always says, 'All credit to the team.' We're just a very small part of that team. And we,

of course, say all credit to Dave. This [*held up the Emmy Award*] is all Dave. We want to thank our very wonderful staff and crew; they are the hardest working group of men and women in the world. They're up there [*pointed to the balcony*]. And we'd like to thank the Academy for thinking that after 20 years on the air; we still put on a quality show. On behalf of *The Late Show*, thank you very much."

AU: *This interview wouldn't be complete without asking the obvious: What are the Top Ten Things that an executive producer needs to know?*

BG: The Top Ten things you need to be a good executive producer:

1. Loyalty to the host and show that borders on insanity.
2. A long fuse.
3. A small ego.
4. Attention to detail.
5. Organizational ability.
6. Ability to make a split-second decision.
7. Learn to take a joke.
8. Pick your battles.
9. Good listening skills.
10. Snappy dresser.

SPENCER GRIFFIN
Head of TV Development, Just for Laughs, and former Executive Producer and Vice President of Production, CollegeHumor

Authors: How did you get your start at CollegeHumor, and could you describe the positions you held along the way?

Spencer Griffin: I started off at CollegeHumor as a post-production coordinator. I came in just as they had just gotten a television show on MTV, and they needed someone to come in to help on the website and television show. On the website, we were making 2–3 videos per week and now we make 10–15 per week, to give you an idea of how much we have grown in the last four years. From there I became the director of programming because we were making a lot more content. I was in charge of making sure videos were being released on time and finding the most effective way to get our content out there.

I became the director of operations as I was slowly starting to take over creative content and some matters of production. I was still working on programming, but also making sure we were running our video production in the most productive way. Now I am the executive producer and vice president. When I was just executive producer, I was fully in charge of production. Now that I am also vice president and in charge of original content, I am overseeing production in both and basically assisting in all aspects of our content. I don't deal too much with the creative side. The writers are all in New York. But I do work on all of our talent and help oversee post-production and as much writing as I can from L.A.

AU: *How did CollegeHumor get its start? What makes it unique and successful?*

SG: CollegeHumor got its start in 1999. Two sophomore friends started it with pictures and articles. Then we started making original videos. That really changed the game for

CHAPTER 11 Conversations With the Pros: Producing in the Real World

CollegeHumor.com, becoming our big staple now and the principal focus for our company. We are trying to make the funniest original videos with the highest production value we can. We are unique in our production value, which has been at the forefront of web content. We were the first widescreen player on the Internet. We were one of the first people to start shooting on the RED camera and now we exclusively use the RED and 7D. Not a lot of other sites were doing that when we started.

We also have a very focused comedic effort. Other sites can be all over the place, whereas everything goes through a funnel for us. If you like the CollegeHumor schtick, you are going to come back for more. That's as opposed to other sites like FunnyOrDie.com, which are very funny, but where there are many different comedic stylings coming through. At CollegeHumor we try to make it one voice and one brand, or at least a voice coming out of a brand.

AU: *And you have episodic shows within?*

SG: We do a lot of one-off sketches just like any sketch show, but we also have web series. We do serialized one-offs, which makes us unique. You can come in at any point and don't have to have watched any episode before or after, which is really nice.

AU: *How do you budget and finance when producing for the web, and how do you market and distribute your content?*

SG: Our company goal is to create the best comedic content on the web and give it to our fans and viewers wherever they are. It is on our site, YouTube, and an iTunes podcast. We do a lot on Tumblr, Facebook, Reddit, StumbleUpon, Digg, etc. That is our strategy. We will come to you.

We are a publicly traded company, so we are very transparent in our budgeting. We don't use fancy budgeting software because our budgets are so small. We use a very fun budgeting program called Microsoft Excel, and we have uniform budgets. You can't make a video of ours without using our template. This is something we have really standardized over the last couple of years. We want our viewer to have a similar experience. When they come to CollegeHumor.com, they know they are going to find high-quality and very funny stuff.

From a production standpoint, if you are a freelancer, you are going to have the same experience as our staff. It is the same call sheet, and we are going to pay you the same thing every time out. No matter what producer or director works with CollegeHumor, we want them to have the same experience. We want them to have the same food on the craft services table. They are going to get to the set the same way. You know what you are going to get from us as a freelancer, which I think is very valuable.

Oftentimes media people assume producing web video is like the Wild West and is just a bunch of kids running around town. I don't like to do it that way. I like to bring as much professionalism to each production as possible. We do everything with permits. We don't pay anybody in cash and we use a payroll system. There is paperwork to fill out every time you work with us. It is as professional and legit as possible.

AU: *That's great. That is in contrast to the silly, funny videos you produce. They can trust in the system.*

SG: Exactly. We aren't trying to cheat anybody, and we aren't asking favors. We don't ask people to just come run sound for us. We deal with the Department of Labor and everybody gets at least minimum wage. We are legit.

AU: *And they are paid through whom?*

SG: Entertainment Partners, which is a payroll company.

AU: *Do you get large talent sometimes? Do you treat them the same way?*

SG: We have gotten John Stamos, Regis Philbin, Hugh Jackman, and John Mayer, and we do the same thing. We treat them a little special, because they are special people, but they get the call sheets and scripts. We want to make it a fun experience for them, but a professional one as well.

AU: *Do they usually approach you, or do you approach them?*

SG: We do it both ways. Sometimes people come to us wanting to make a video and sometimes we target people. Our main goal is to make the best content we can. We are happy to work with really talented people no matter what. I would say 75 percent of the time we are reaching out to people and 25 percent of the time they come to us.

AU: *Many famous performers are making videos with FunnyOrDie.com or CollegeHumor.com now. What is the appeal for a famous person?*

SG: We did a great video with Ariel Winter where she played *Dora the Explorer* and it was a huge success for us. It got over 1 million views in under 24 hours and something like 5 million views in four days. It allowed her to play an action star, which she doesn't get to do on *Modern Family*. Some of the talent get to do something that no film studio or television show is going to cast them in and they get to have a lot of fun. Simon Pegg and Nick Frost worked on a *Star Wars* parody, which they haven't gotten to do on their other projects. These are just two-minute videos that only take a day, so it is at a low cost for them to do something that is exciting for them. For other people, it is to show they have a funny side, like John Stamos. He was on *ER* forever, but it was all serious.

AU: *What is the difference between producing for TV and web, and what was that transition to MTV like?*

SG: We were online for three years doing original content before we had a TV show. The TV season was only six episodes long for us and then we went back to full Internet production. We are very fortunate that we determine the creative content. We work together as a company to put the best content out there. Producing for television, there are a lot of other voices in the room, including the executive producers, studios, standards of practice, and legal. There are all these other people who have an opinion. Whereas in producing for emerging media, you can find the right home. It is really your voice, and I love that about CollegeHumor. We get to make what we want and don't have somebody in an office 3,000 miles away telling us what we should be making.

We can put it on the Internet and people can watch it whenever they want. There is more control when it is on-demand content. On television you have to appease the studio because they are releasing it to the world at a specific time on a specific network. I think that is great and I would love to work with MTV again, but that is what separates us. On television you are making content for a studio first, not for the fans first. That is how it seems to me, in my limited experience. On CollegeHumor we are making it for the fans first, and we are the studio and the network all at once.

AU: *What was the appeal to go to MTV with a series? Why did you do that at the time?*

SG: I think it's because everybody wants to make television and movies still. That's the dream for everyone.

AU: *And you wanted a bigger audience?*

SG: We find different audiences on CollegeHumor.com and YouTube.com. Those are different audiences for us. YouTube is much younger. Our median age is 28. We are 65/35, males to females, which is more females than one would imagine.

I think we wanted to make a television show, and we were excited about that. We still are excited and are going to make more television shows and movies. That is an exciting and different way of delivering our comedy to the world.

AU: *What was your movie?*

SG: We did a movie called *Coffee Town*. It was produced by CollegeHumor and written by Brad Copeland, who worked on *Arrested Development*. It is a small independent comedy/heist/love story. It is really good!

AU: *Do you think you will ever produce longer segments because of the nature of this merge between standard television and the web?*

SG: I think we will if the concept is justified. So much of what we do is sketch comedy, and we really like two-minute sketches. I think the Internet likes that, too. If it was television, maybe we would do it longer, but I don't know. We let the creative drive what we do. We did a 30-minute episode of *Jake and Amir* that we released on iTunes. We had a story that fit that length and we were excited to experiment with a longer segment. I think it went pretty well.

AU: *What advice do you have for aspiring web producers that are going to be reading this book?*

SG: My advice is to make as much content and get as much experience as you can. YouTube didn't exist when I was in college. People who are aspiring web producers are now competing with 22-year-olds who have a college degree in film or cinema and have made 65 shorts.

In just a few years, the level of quality in our interns has dramatically increased because of the accessibility of Final Cut Pro and RED cameras. There is some 20-year-old kid at NYU that owns his own RED. So that exists in the world. I was a theater major because I didn't know how I could afford film. I did theater because it was cheaper. Now people can make their own films.

If you want to make web content, you have to practice. When you are starting out, it doesn't have to be a perfect script. However, it does require good production value, and the only way to get good production value is to practice. You have to teach yourself and do it as much as possible. Get a few of your friends together, split the cost of a decent camera, and make a sketch group.

AU: *What are the pros and cons of your job on a day-to-day basis?*

SG: The pro of working on emerging media is that I work on 50 projects a month. This is opposed to working with television where you are working on one show for nine months with multiple episodes. I work on 50 unique little projects every single month. It changes every day. There are new ideas every day, new crews, and new writers. That is all really exciting.

We work with a lot of young, hungry filmmakers, which is really fun. People in new media aren't these old grizzled people, who have been making television for 40 years. We have people in their twenties, who love to work and their priority is making the best content they can. I really love that.

Our budgets are so small that we have constant creative problem-solving. We don't have the budget to actually shoot in Las Vegas, so we have to make a beach in L.A. look like Las Vegas somehow. It is really interesting to watch people creatively problem-solve and achieve very high production value for very little.

We are making up the rules as we go, which is fun. We don't have to go through the process of lawyers, studios, and all the stuff you normally use to make television. We get to do whatever we want and we get to figure it out. All these processes for casting, budgeting, and shooting, we have developed ourselves.

AU: *Are there any cons?*

SG: Our budgets are small. My mom doesn't know what the hell I do. The church she works at in western Iowa doesn't allow CollegeHumor.com. I tell her to look at it at home, but she doesn't have the Internet at home. If you work on a show like *Two and a Half Men*, everyone knows what it is. The only other con of working in emerging media is that people assume you are making cat videos, doing student film-type work, or you are an amateur. People making emerging media are professionals, even though they may be sometimes barely paying their rent. They bring a professional attitude to the set every day. That is something that I would love to get the word out about more: working with emerging media is professional, but you just don't get paid as much. There are a lot of hard-working, very talented people out there. It's an exciting medium.

RICHARD HENNING
Audio Engineer

Things a producer should understand about working with a small crew:

1. While working on a large production can be fun and exciting, like the circus coming to town, with everyone busy, busy with their areas of expertise, a scaled-down crew of producer, cameraman, and soundman has its own set of challenges and rewards. A smaller production team has the ability to stealthily slip in and out of locations with a minimal amount of disruption and clamor, which is especially valuable in documentary, news, and "behind the scenes" shooting.
2. Many of the specialized jobs in the larger productions are absorbed by the three key players on a smaller job:
 - The producer might double as the art director and craft services department.
 - The cameraman is also the lighting department.
 - The soundman may be the gaffer and transportation department. On a smaller shoot everyone crosses over to assist the others when needed, something which is taboo on larger union shoots, where a soundman wouldn't even think of touching a light, and a producer wouldn't powder a guest's shiny nose, and could be penalized for doing so.
3. The relationships between a successful team of producer, cameraman, and soundman are more intimate, with a knowledge of each other's needs, limitations, and working styles, for they usually have less time and fewer hands to get the job done.
4. When a producer hires a cameraman (or "DP", director of photography), the DP will hire the soundman, usually someone he has worked with before so they are

an experienced team. The DP can also find any additionally needed personnel such as a lighting designer or teleprompter operator.
5. It's key that the producer choose a DP who is not only skilled in his job, but is someone who is easy to communicate with and is flexible under sometimes tense or hurried working conditions. A simpatico working relationship goes a long, long way in making the shoot run smoothly and efficiently.
6. When a producer first starts working with a new cameraman, a monitor is essential to check the footage to see if you're both on the same page. Once a good working relationship has been established between the producer and camera team, and the producer has been satisfied that the cameraman has understood, executed, and, hopefully, enhanced her vision, she can lose her dependence on the monitor, and develop the trust and shorthand necessary to expedite the shoot.

TRICIA HUETIG
Senior Interactive Producer, MetaLab; formerly at Wieden + Kennedy

Authors: What does being a digital producer mean?

Tricia Huetig: Every producer comes with his or her own history and experience, which allows them to lend different strengths to projects. Some come from a web/interactive specific background, while others are hybrids of various digital media.

AU: What brought you to producing?

TH: I studied various forms of multimedia in college and have always been interested in producing applications and interactive material. As that medium changed from CD-ROMS to web applications, I followed the technology. As far as falling into the specific role of a producer, it happened naturally as my on-the-job responsibilities started requiring those responsibilities. I liked it, so I went with it.

AU: What projects/campaigns/clients have you worked on or with?

TH: I worked with Nike on their 6.0, Vintage Running, Boots, Sportswear, Nikestore.com, and Nike+ campaigns. I worked with Target on their Back to School, Back to College, 2-Day Sale, Target Baby, and City Target campaigns, and on their social channel development. With Laika, the animation company that produced the hit film *Coraline*, I worked on promotions for their Summer 2012 movie *ParaNorman*, as well as ParaNorman.com, the Stop-Motion Zombie Lab, their social channel development, theatre and OOH motion posters and various online teaser trailers. I also worked with Kraft on a Velveeta campaign, and I've worked with a number of local Oregon brands, like Timberline Lodge, Portland Timbers, and Forktown Food Tours.

AU: Can you describe what a typical day would be for you?

TH: I generally arrive at the office between 8:30 and 9:30 a.m. The day revolves around meeting with creative teams, developers, designers, technologists, strategists, media people and several other team members who may play a role in a project. The role of a producer changes so greatly, based on the project and team, that it's impossible to define the role with a statement to encompass all duties. The purpose of a producer is to find creative ways to get things done on time and on budget, and to try to keep everyone engaged and focused on priorities.

Every day is a juggling act, and no two days are the same. Being a producer encompasses being strategic and having a lot of common sense. You have to be able to be flexible and turn on a dime. I am generally exposed to a lot of stress and conflicting opinions on how things should be done, and do my best to stay emotionally grounded. Problem solving is a skill that is applied every step of the way. Because there is never a project without a problem to be solved.

I have interactive producer friends who work in much more structured and corporate environments that are able to adhere to a more rigid process with defined daily expectations. They arrive to work and leave the office about the same time every day. I can only imagine this to be less stressful with bonus personal time, but also a drier work setting with less creative material.

AU: *How do you think production for web differs from TV?*

TH: People watch TV, people interact with web. There are not a lot of similarities in the physical production of a TV spot versus a web experience other then making sure your target audience is being addressed at all times. A TV spot ships when it's finished and is considered a done deal. A website is launched, and can continue to be tweaked and updated for as long as there is a need to do so.

AU: *How do you budget and determine the creative direction of a project?*

TH: A client may come to the table with a specific budget for a project. They may also offer an amount for an entire campaign, in which it is up to our team to decide how best to allocate it across all platforms, giving the most money to channels we feel will best suit the creative approach.

AU: *How do you deal with copyright issues for the web?*

TH: I engage our Business Affairs department to make sure our work is not infringing on existing copyrights. We have amazing lawyers that will apply deeper research when needed to let us know if we are at risk for releasing something that could have legal implications.

AU: *What knowledge of interactive and web development is required of your job?*

TH: We are expected to understand as much technology as our brains will hold. I am not able to write complex code, but I ask enough questions to understand the nature of the language and technology that is being used.

AU: *What traits are required of a successful digital producer?*

TH: We need to know how to manage people, personalities, deadlines, money, and make good decisions. We need to have a strong understanding of other roles that are available to us and make smart decisions about what stage to engage them.

AU: *What outside resources do you rely on as a producer and how did you develop these resources?*

TH: I frequently hire outside developers and broadcast teams. A company that I hire will have a great portfolio that supports the specific creative vision we are looking to achieve. Word of mouth and a consistently reliable reputation will go very far for a vendor. We usually review potential partners as an internal team, to make sure everyone is on board with the decision. Often, we will pitch more than one vendor and review their approach before making a decision.

AU: *What members of a team are you typically leading? Who is involved in a project?*

CHAPTER 11 Conversations With the Pros: Producing in the Real World 275

TH: I typically collaborate with art directors, creative directors, copywriters, technologists, user experience and information architecture, designers, digital strategists, analytics and media experts, developers, testers, account managers, project managers, business affairs, copyediting. I'll also work with post-production, like sound design, editing, and motion design, if a project requires it. I'll also often work with other producers who may be assigned to other pieces of the same campaign.

AU: *What do you see as the future of advertising campaigns?*

TH: Social channels have had a huge impact on how brands communicate ideas, and I don't see that going away anytime soon. People love having their identity associated with an idea and saying they were one of the first to use, share, or assist with producing content for it.

AU: *What advice do you have for students interested in pursuing producing as a career?*

TH: Keep up with technology and find new ways to use it. Once something has been done once, it's old news. And fight for what you believe in, but also be prepared to make compromises. Producing is just as much about learning how to form relationships with people as it is about making sure a project gets done on time.

ANN KOLBELL
Supervising Producer (Peacock Productions, NBC News)

MATT LOMBARDI
Producer (CBS Evening News with Katie Couric)

Authors: You've both kindly agreed to be interviewed together because your career paths have intersected for years. Let's go back to before you met.

Ann Kolbell: My career in television began, interestingly enough, through radio, when I interviewed Jane Pauley, then anchor for the *Today Show*, for a public radio program I was hosting in Ann Arbor, Michigan. I created the opportunity to meet her because I was looking to move to a television producing job.

AU: *And you knew what producing was, as an actual job description?*

AK: Yes. I developed a series called *Women in Broadcasting*, which gave me an opportunity to talk to women broadcasters. Jane Pauley was one of the women I interviewed, and it was a really good one because I was well prepared. By the end of the interview we had established a good rapport, and I grabbed the chance to pitch myself as a prospective producing colleague. I outlined a job proposal that I thought might appeal to Jane. I had identified what I thought might be a need, and then speculated on how I might be helpful. I had read an article about Barbara Walters and her assistant producer who was described as Barbara's right hand with responsibilities of a substantive editorial nature. I figured that Jane, having been on the job for only two years at that point, probably hadn't yet formed a relationship like that with anyone yet. Plus, I had already been working seven years and had a resume and experience of my own to offer. As it turned out, I was right. Jane and I hit it off, kept in touch, and I started working with her six months later. We worked together for the next 24 years until the end of her NBC News career.

AU: *What were you hoping you would be doing with Jane then? What did you propose?*

AK: I was interested in content, specifically, news content. I knew how to organize things, I was reasonably smart, and I knew how to research. I think those were some of the skills I offered up.

AU: *Did you start off as a producer?*

AK: Because of personnel considerations, I was initially hired as a researcher, but eventually I became a producer.

AU: *Your turn, Matt. How did you start as a producer?*

Matt Lombardi: I carried my tape recorder with me everywhere as a kid. I had this odd fascination with recording things and playing them back. I taped everything. I even brought my video camera to school. By the time I was old enough to try and figure out what I was supposed to do for a living, all I really knew was I wanted to continue this process of recording something and making it into something else. Film school was sort of a logical step in my mind because I was working in a movie theater at the time. I thought, "This is how you go to Hollywood, you work in a movie theater and go to film school." I enrolled at the School of Visual Arts in New York City. While I was there, my parents were sort of kicking me in the butt, saying "You really ought to have some plan after school" and I had none. They suggested I get an internship somewhere. So, ironically, at the same time I'm excelling in my career at the movie theater (I'm now the manager hiring box-office cashiers), one of the applicants said, "I can't work on Fridays because I have an internship at NBC." I said, "That's interesting. I'm actually looking for an internship, how do you get one?" She said, "It's easy, they'll hire anyone for free."

So I got an internship at NBC, but I was late getting to the party because it was the end of August, when the internships for the fall are already taken. So they said, "We've got one left and it's at the *Today Show*, have you ever watched it?" I said no. And they said, "It's yours if you want it. Take it or leave it." So I took it. Around my first week, I met someone named Ann Kolbell—who is my partner in this interview—who was working for Jane Pauley. But within a week of my starting, Jane announced she was leaving the *Today Show* after 13 years.

AU: *How did you and Ann begin working together?*

ML: This was in October of 1989. Talk about identifying a need! Ann identified a need for someone to answer the phones, which were going crazy because Jane had just made this announcement and the mail is pouring in, literally by the buckets full, every day. It was impossible for anybody to keep up. So I was the intern, I met Ann, and she basically brought me into Jane's office and gave me five buckets full of mail and said, "Please sort these. If the phone rings, answer it." The real breakthrough was three months later when Jane was actually going to leave the show. Ann hurt her back, and couldn't be in the office for Jane's last week. And Ann said, "I'm going to need help. I know you have school and two jobs, but if you can be 'me' for the next month and extend your internship into the next semester, you will have a job when you graduate from school." She guaranteed it. So there you go. I graduated on a Friday and started on the payroll at NBC on the following Monday.

AU: *Can you describe your jobs?*

ML: When I was a *Dateline* producer, I sort of likened my job to making movies because your role is very much like that of the director. Producing for TV and

producing for film are very different. A lot of people say they're the same; I think they're very different, especially in news. What's unique about producing for news is you really have the entire finished product from the time it's budgeted, researched, to the time it's shot, to the time it's written and, ultimately, to the time it's edited and aired; it's your baby. From conception to the broadcast, you're really responsible, in some way, for every bit of it.

From the moment a story is assigned, you are responsible for conceptualizing it, trying to figure out what it's ultimately supposed to be, and hopefully being open to it changing if that's editorially what's supposed to happen, budgeting for it responsibly, then getting it on the air. Currently, I am a producer for the *CBS Evening News With Katie Couric*, and although the mission of the show is obviously different than that of a news magazine, the process of producing is not very dissimilar.

AU: *Matt, how similar is the TV producer's job to the film producer's?*

ML: Between film and TV? Well, I've never been fortunate enough to follow my dream of producing for film, but from what I understand, producers for film have limited control over the film in that, at a certain point, the director is the person who really controls the editorial content of the film. He controls the editing and the shooting; specifically "the look" of each shot is the director's.

A list of duties for a film producer can be anywhere from the budget, to scouting the locations, to hiring the crew and casting the film. But ultimately, at some point, the producer is going, "Well okay, Mr. Director, we brought you all this wonderful stuff, now go make a film out of it." With producing for TV, the final product is, ultimately, your whole responsibility. The producer's cap is a big one because you have responsibility for the entire thing, which is more fun, I think. For me, particularly at *Dateline*, I was half living my dream because I could sort of control all these little movies I made. It was fun, in that every segment is different so you never really had a chance to get bored, at least I didn't for that reason.

AU: *You are both producers. You've worked with one another for years, and you work with dozens of other producers from all areas of film and television. What traits or personalities do they share, if any?*

AK: In terms of personality traits, a producer is likely a person who is probably pretty organized because that's important to the job. Not everybody's methods are the same, but most producers have a system that somehow works for them. They are probably detail oriented. And many are good collaborators.

ML: To produce anything, I think you need to have some communication skills because you end up turning over a lot of work to other people. When you go out on location, you're trusting a cameraman and a soundman. You are not operating the equipment; you're turning it over to them, and hoping that what you have asked this crew to capture is what will ultimately wind up on the screen. You're putting your faith in those people. It happens to be unique to news where the producers have to turn over the editing of the piece to another person, in this case, an editor. Graphics—once again—you're not physically designing the graphics. Someone else is designing the graphics. So you need to be able to communicate an idea to a series of individuals who, hopefully, will be able to interpret your vision and translate it onto the screen.

Even in the research stage, it's almost impossible to do all the research yourself, so at some point, you have other individuals who are pulling research for you. You have to be able to trust that those people are finding the information that you want. I think

all producers are control freaks, and the irony of that is that you really don't have control over any of it. The entire thing at some point is turned over to different people and you're hoping and praying that it comes back to you in the way you envisioned it.

And even when it goes on the air, you've turned it over to someone in a control room somewhere. You have to pray that the settings are right, that the vector scope is the way it's supposed to be, and that the luminescence level is where it's supposed to be. You go home and watch it on the air and you cringe sometimes because you realize that something was way off. It's weird stuff like that you really have no control over.

AK: Keep in mind what Matt's talking about is taking place in a network environment. Obviously, at a local station, you are doing a lot of these things yourself so you're not turning it over. I think that's important to remember. And nowadays at the networks, there's less of a reliance on full crews; we're seeing more and more of the digital journalist—the one-person band who produces, shoots, and edits her own work [also called a "preditor"]. The digital journalist is likely the network model for the future.

ML: If you look at *60 Minutes* now, the style of the way they tell stories is almost identical to the way it was 30 years ago. The biggest change is they went to shooting it on film to video, which I think was a big leap for them. I mean this technically. Visually, the show looks exactly the same. As one example, if I did a profile of Bob Dylan, which they did a while back, I'd probably have about 40 edits in a two-minute period. Because I would be cutting to music, I would probably have a shot change on almost on every downbeat, every drum roll. Because I grew up on MTV, that's how I'm used to seeing things. In contrast, *60 Minutes* would probably have 40 edits in a 10-minute profile.

AU: *You've both talked to hundreds of students in producing for television classes. What insights and advice have you shared with these students?*

AK: You have to be flexible. Not all producers are flexible, but the good ones are. You have to be creative. Take initiative. Be willing to see the gray when you're telling a story; not everything is always black and white. Find a mentor, someone who has been in the business for a good amount of time, and whose opinion you value. And work on your writing skills; a good writer will have a huge advantage in the job market.

ML: You have to have the willingness to collaborate, and definitely the ability to tell a story. At the end of the day, you're telling stories. You have to be able to structure a story so that someone knows what you're talking about. In the news field, the challenge for a news producer is that 9 times out of 10, you are writing a story for someone else's voice. One of the functions of a news producer is to write a story and collaborate with the on-air talent. If you don't have the writing skills to write a story and collaborate with someone who may have a different vision for that story, you're not going to be very happy.

JEFFREY MCLAUGHLIN
Senior Editor, Director of Post-Production, All Mobile Video in New York City

Authors: As an editor, you have been a great resource in the writing of this book's chapter on post-production. You give the art and process of editing a lot of thought, don't you?

Jeffrey McLaughlin: I've worked with producers who think that after they write the story, raise the money, and shoot the project, they've won the war. Little do they know that the real mission has just begun.

CHAPTER 11 Conversations With the Pros: Producing in the Real World

Editing is part of the process, and in my estimation, the most important part of the process. Don't celebrate too much at the "wrap party" on the last day of shooting, because there is still much work to be done.

AU: *What are the main qualities that a producer should look for in an editor?*

JM: Each editor is different. In terms of "a style," most editors fall into one of these three categories. Then off those categories, there are numerous combinations and degrees.

Category 1 is the storyteller. This is a classic editor who is able to take footage and script and tell a story. He or she is "an author of images." If you need someone who can sit through hours of footage and come up with a cohesive story with a good pace, this is your candidate.

Category 2 is the graphic artist. This category did not exist a few years ago. An editor always edited, and a graphic artist always designed. Now, that line between these two is fading. An editor's style has as much to do with their look as their pacing. Editing is not always storytelling as much as it's the layering of images and graphics. This editor doesn't see story as much they see energy and image. I was critical of this non-narrative style for years, but have grown to appreciate it when it is done well.

Category 3 is the technical editor. This is an editor who isn't always the go-to person for creativity, yet is often the one every producer should worship. They are important in the pre-production stage as well as the post-production stage. No matter how creative you may be, the final look of your project better be technically solid.

Recently, a fourth group of editors has begun to take shape. They are producer/editors or "preditors"—one person who writes, produces, shoots, and edits a project. Traditionally, roles between producer, writer, cameraman, director, and editor were more defined. Within the last few years with the influx of inexpensive cameras and edit systems that are also very easy to master, many people are becoming one-man bands.

This is both good and bad. In the past, the edit room was a place where magic could happen (if you were lucky) because the editor had a fresh eye that wasn't emotionally attached to the footage or the shoot. Though one person alone can also be a creative process, in our industry it's beneficial to have the input of others' creative visions, too.

AU: *So in knowing this, how does a producer find the right editor?*

JM: Look at the project first, then look at your own skills. How creative are you in making editing decisions? Are you organized? Do you have the time or the budget to experiment? What "type" of editing style will benefit your vision? The obvious choice would be an editor who possesses all skills equally, but that's not always possible. Plus, each project is different and each project needs a different style. Look at your project and your skills and keep these categories in mind when interviewing editors.

Another factor in choosing your editor is based on organization. If you and your project are totally unorganized, make your first priority an editor who is obsessive-compulsive. If you do have an organized work style, look for someone who is looser and less predictable, and probably more creative.

Communication skills between the producer and the editor are a must. After your marriage, your relationship with your editor is going to be the most stressful relationship of your life. Think about it: you and this editor will be sitting in a room together for 10 to 12 hours a day, six or seven days a week, till the project has been completed. You are going to be sharing your dreams with this editor, and he or she is going to disagree with almost everything you want to do.

It can get rough in an edit room, but like a marriage, it's all about trust. Make sure your editor trusts your vision, and vice versa. The final result always looks better when there's peace in the house. The TV and emerging media business is a collaborative world. Listen to your vision and follow that vision, but look to the editor for outside help. You can get so engrossed in your idea that you may need a new more objective voice.

AU: *What has been your career path in editing?*

JM: I have been editing since 1976—I started editing in film, on a flatbed. Now, I edit in video, on whatever tools come my way that can make editing better, easier, and cheaper. I became an editor because I felt that it was the single most important step of the whole filmmaking process. It was also a job where my OCD tendencies actually worked in my favor.

I don't prefer one software program or one product over another. I found out through the years that the process is always getting better. To adopt one edit system over another works for individual projects, but not for career decisions. Editing is always changing, and there is always a newer software out there that could benefit a project.

AU: *What do producers need to know when they come into the post-production facility?*

JM: Walking into the final stage of your project—editing—without any preparation is a mistake many producers make. Planning the budget, the script, and the shoot are obvious to every producer, but planning, or at least being aware of, some issues you will face in post-production are just as important. No matter how good your budget is going along, or how good the script is, or how magical the shooting may have felt—you eventually have to put all the pieces together and make it work. You can blow a good film in the edit room, or you can save a bad one.

One of editors' golden assets in an edit process is that they were never part of the production process. They weren't shooting the film for four weeks and feeling the "magic" of that process. The war stories the crew told about shooting in the midst of a hurricane or when half the staff came down with food poisoning—they mean nothing to the editor. Editors only see the dailies, and the only "magic" they feel is what comes out of those dailies. If a shot works, they will use it, but if it doesn't, they can easily let it go. The pain, the love, or the cost of any one element means nothing if it doesn't work in the edit. No one thing is more important than the whole of the film.

AU: *When you were a student studying filmmaking and editing, what were some of the lessons then that have stuck with you?*

JM: It's really important to understand the unique vocabulary of television and film, and now, emerging media. As you develop your skills as a producer, be aware of the medium that you are working in and the visual and audio vocabulary that is part of the process.

The history of editing has always fascinated me. In 1918, I think, a Russian filmmaker, Lev Kuleshov, realized that film possessed its own language and its own grammatical rules for that language. He conducted an experiment in the use of montage that's come to be called the Kuleshov Effect. This was a short film sequence that began with a neutral expression close-up of a man, an actor from the day. Kuleshov then intercut this same neutral shot back and forth between shots of a bowl of soup, an old woman lying in a coffin, and a little girl playing. The filmmakers showed these sequences to audiences and asked them to comment on the actor's performance.

The responses of the audiences were that the actor's face showed hunger, sorrow, and joy. The varied reactions were caused by the juxtaposition of the neutral expression with other shots—the soup, the coffin, the girl. The conclusion of this experiment was that film has its own language. The juxtaposition of images creates a meaning. Editing creates the meaning. The audience feels the emotions through the relationship between shots. I read about this experiment at age 21, and it changed my life. I saw the power of editing and realized what it could do. It's a communications tool with endless potential if you understand how to use it.

AU: *How important is telling the truth in editing?*

JM: Whether you're a producer of documentaries, a narrative filmmaker, or a TV commercial producer, you have the power to tell the truth, or make it up. For example, most Americans think of the Civil War as it was portrayed in *Gone With the Wind*. The facts of John F. Kennedy's assassination are now deeply rooted in Oliver Stone's film, *JFK*.

What are your responsibilities to the truth? If you are searching for truth, you have to tell the truth. It is easy to slant your side. If you are interpreting the truth, you are making propaganda. History paints this picture of the German filmmaker, Leni Riefenstahl, as the master of evil propaganda. Her films portrayed Hitler and the Nazis as heroes. She was able to do this because she understood editing. She only showed what she wanted you to see. A "well-edited" documentary can make any war seem justified or evil. TV commercials can make beer and high-fat hamburgers seem like something we have to eat. As a producer, you can take a stand, and be aware of your power and the different rules that TV images and their juxtaposition can follow.

AU: *When you start a project with a producer, what is involved in that process?*

JM: Often I try to meet with producers prior to the edit, but often I come into the project after it has been completely shot. I usually meet the producers on the first day of editing when they show up with a suitcase of footage. They tell me how much time they have booked to edit the piece, yet usually don't realize how much footage they have shot. Sometimes they have roughly a hundred hours' worth of film that they want to cut in the next two weeks.

I first ask them for notes and scripts. If I'm lucky, they'll have those, but more and more producers seem to think that editors wave a magic wand over hours' worth of footage, and only the good stuff comes up. I remind them that if we first need to screen, log, and digest the material, and then make an insightful and coherent movie, it's going to take time. For every one hour of footage, it takes at least two or three hours to view, log, and highlight clips. You then need to knock this down into a script with some kind of theme, and only then can you start to edit.

Many producers don't get this, especially if they're new at the job, or when there's a time deadline. Editing doesn't start until you have control of the script and the images. Screening and taking notes of the footage is a major part of this process, and it has to be dealt with before you structure the project. Editing is not an abstract art where you throw paint on a canvas until it looks good. Editing works best when it's planned out.

AU: *The budgeting process for post-production can be an area that the producer gets nervous about—even the most experienced producer can get bogged down here.*

JM: Budgets can be real, but they fall apart when producers lose control of the project. They have to find a fine line, for example, between allowing some experimentation but

not too much. A producer wants to give both the client and the editor the control they demand, while maintaining the overall vision of the project.

How do you play the middle? Know your clients, know your post-production people. Be in control, but allow creativity and open up your budget for that extra time. As a producer, your golden rule is to always be prepared. You are in a creative business, so sometimes even the best preparation is not enough. At that point, look to the future and learn from your mistakes.

The biggest mistake producers make in budgeting is the fact they don't budget enough for post and tend to hope that things will work out at the end. One example is a producer who spent $5,000 on a helicopter shoot for 10 seconds of footage, yet didn't have even $5,000 in her budget for the entire post-production budget. I don't get it. How could a 10-second shot equal the entire editing process?

AU: *Conventional wisdom assures us that a good story is always at the core of editing a project. How do you tell that story as an editor?*

JM: I'll give you an example. One of my favorite films of all times was made by Steven Spielberg when he was 25. It was called *Duel*. It's a story of a man driving his car who is being followed by a giant black tractor trailer—period. The entire plot is this one sentence, yet it is a great 90 minutes of nonstop tension and action. The guy in his car, played by Dennis Weaver, has one goal: to escape from this truck on his tail. That's it. But the editing created conflict, tension, split-second timing, and so on, and made this a classic.

AU: *You work with producers each day. What advice would you give a producer who is starting out in the business?*

JM: The easiest way to become a great producer is to work harder than any other producer. Try some writing, try directing, and definitely, try to learn more about editing. A good producer will try to walk in everyone's shoes. Sit behind an edit console and edit for 20-hour days for a couple of weeks and you will learn as much about how to produce your next project as you will about editing. Know the process—you don't have to necessarily master it. In the end it gives you more freedom and control over your project. And as with any job in TV, don't look at producing as a job. Look at it as part of your life.

AU: *What do you most appreciate and hope for in a producer?*

JM: I like anyone who respects me, laughs at my jokes, and asks me how my kids are doing—simple people skills.

There are many producers out there who lack creative talent. That's not necessarily a problem. It only becomes a problem when this lack of creativity turns into giving me attitude. An example is the producer who has no idea of what he wants, or how to take his footage and make it into a coherent idea. Sometimes, these producers try to mask the fact that they are essentially creatively clueless, or don't understand much about editing. So they'll give the editor no guidance and no real concept, and I've got to start from scratch and make something out of it all. You learn to accept this, it's part of the job.

If, as a producer, for whatever reason—like a time crunch or limited budget—you have to walk into an edit room totally unprepared, just admit it up front. Seek advice from the creatives around you and give them a semi-solution, or some direction. But don't give them attitude.

RUSSELL MCLEAN
Producer, *Black Mirror: Bandersnatch* and Interactive Consultant, Netflix

Authors: Many of your projects have been in visual effects, animation, and music videos. Can you describe the positions you have held on your career path and how working in these positions differs from a traditional television producer's role?

Russell McLean: The role of a producer varies massively, and a lot of this depends on the different types of experience an individual producer brings to a project. I started out producing music videos for bands such as Snow Patrol, Belle & Sebastian, Muse, REM, and Paul McCartney. The directors I was working with in music videos started moving into commercials, and I continued to work with them there. In commercials I tended to produce projects that were a mix of live action and animation or VFX. This led to working on specific animation sequences in dramas, which in turn led to being asked to be the VFX Producer on *Black Mirror*, which I did for two seasons. When *Black Mirror* sent me the treatment for *Bandersnatch*, it was well-suited to a producer with my VFX background as it was quite a technical film to produce. It also benefited from my relationship with the director David Slade, who I have worked with since the days of music videos at the start of my career.

Producers can bring experience from any discipline, such as acting, writing, finance, or production. The important thing is to understand your strengths and weaknesses and build up your team to compliment these.

AU: *You worked on the Emmy award-winning film* Black Mirror: Bandersnatch. *How would you describe* Bandersnatch, *and how did it come to fruition?*

RM: *Bandersnatch* is an interactive film utilizing an innovative form of television storytelling that invites viewers to control the story they're watching. Set in mid-1980s Britain, the plot follows Stefan, a painfully awkward 19-year-old video game developer who has plans to make a video game based on a book where your choices determine the story. The early decisions are seemingly inconsequential, but these quickly escalate into more and more meaningful choices as the viewer takes control of the story. As the pressures of mapping out the increasingly complex multiple paths of the game overwhelm Stefan, his grip on reality begins to unravel and he becomes convinced that he's not in control of his own choices. Which he isn't.

Netflix [was] looking to find projects for the interactive platform and thought it might be something that Charlie and Annabel, the *Black Mirror* showrunners, might have ideas for. After their initial meeting, Charlie and Annabel thought that interactive wasn't really for them. They felt it risked being a bit gimmicky, but when they had the idea for *Bandersnatch*, they realized that it could only be told as an interactive film.

AU: *Was this the first interactive content on Netflix?*

RM: This is actually the fifth. There were four others before, but they were all kids' animation titles. So this was the first live action one and the first one that was aimed at an adult audience. *Puss N' Boots* was a simple branching structure. Each one has gradually gotten more developed and pushed things forward. And then after *Bandersnatch*, there was a *You vs. Wild*, which was a Bear Grylls program aimed at the teen market, and that's been very successful as well.

AU: *Why do you think interactive content started in this family genre?*

RM: I think it was easier to control as an animation project. It would always be a bigger investment for an adult live action production, which has a higher cost, so they needed to be confident that the system would work. With *Bandersnatch*, we were building the tools to make the production as we were going, so Netflix had confidence that we would be able to achieve what we needed to achieve by the end of the year, but the tools weren't quite there at the beginning of the year.

AU: *What phases are involved in the unique production process of* Bandersnatch?

RM: As far as shooting, *Bandersnatch* faced the same challenges as any film. The unique challenges were in the writing, planning in pre-production, and then in the editing and post-production. When writing the script, Charlie Brooker had to learn how to code in HTML, which is a new step for most writers. We had a script which would crash if we'd left out a ";" or ")." At times it became too complicated to understand every aspect of how the script worked, and so you had to trust the rest of the crew to do their side and focus on your own area.

AU: *Was there a huge team of developers, and were they with your studio or Netflix's studio? How do you navigate that as a producer? How much of the technology guided the production?*

RM: The engineers and the technology side of it were all in the Netflix headquarters in Los Gatos from the beginning. I started in January of 2018, and from that point I was having weekly calls with the design team in Los Gatos about what our constraints were and what they could achieve. That was a constantly moving line as we would come up with new narrative ideas that we wanted to try and achieve. There were a few things they said "no" about, but generally they were like "we'll try," and they did try. We were always at the risk of battling buffering and spinning wheels, which would have taken viewers out of the story, so we were always trying to work out what our limitations were on that side. They were also writing a piece of software called Branch Manager, which they started writing when we started writing the script in January and that became this great tool for us during the edit. We got our first version of that at the end of our shoot, but you could really start to play the branching narratives and drop video in. But we didn't have that at the beginning, so Charlie was writing in an open source software called Twine, which was great. It worked for us, but it was quite tricky getting final draft scripts and stuff into Twine, so we could properly show the cast and crew how the story was going to work. All that process is much easier now.

AU: *Did the number of branching narratives increase the amount of production dramatically?*

RM: Yeah, there are more pages to shoot. And the writing process is more complicated. Five weeks before our shoot, the script was 109 pages, and then by the time of our shoot it was 157 pages. So our shoot expanded to seven weeks. The actual pages of script to shoot and what you're doing on a shoot day is the same as any other shoot day, really. It's just that the number of shoot days expands and then the cast and crew all need help to know where you have come from before a scene, and where you go at the end of that scene. It's that writing process that I think is a challenge, and we kept wanting to add things to resolve stories. As things move around, you have to do other bits to make it all make sense and try to get a satisfying experience to every viewer no matter what choices they make—that's the kind of puzzle to solve. It becomes quite complicated.

AU: *How many variations of the story are there? How many different endings?*

RM: Netflix is saying mathematically there are like a trillion permutations or something like that, but I still don't quite believe that math. There are five groups of endings, but within some of those groups there are multiple different endings depending on what choices you made earlier in the film. There's one group of endings where different visitors come to Stefan at his house, and ultimately those could lead to 15 different endings depending on what you've chosen before. It becomes a sort of philosophical "what do you mean by an ending question?" I think the easiest way of explaining it is that there are five different endings, and then there are other endings, which aren't really endings because you get pushed straight back into the story. There are definitely times with earlier versions of the edit where the viewer felt like they were in a kind of maze and didn't quite know how to get out, so we were trying to avoid people feeling like that.

AU: *What did you do right on* Bandersnatch? *What was the magic formula for the success of this production?*

RM: Charlie and Annabel, our showrunners, have worked together for such a long time, and it all works well with *Black Mirror* as a format, which they're very up to speed with. It definitely helps that Charlie has got a big knowledge of gaming and games. It also helps that Annabel doesn't really have a big knowledge of games. So she's always focused on keeping it in the cinematic world. That kind of creative relationship was absolutely crucial to putting it together. The other thing that worked is we had a really great cast in this case, as well as having a great director. All the traditional cinematic things were well put together. Believable characters and believing in Stefan's character no matter which direction you take him in. I don't think we ever broke his character. We certainly tried not to. When you go down different routes, it's all different aspects of that same person, and I think that truthfulness is important to keep. If you've got choices which are totally opposing choices for a character, then why would one person make those two decisions? So you've got to be careful to not break the character. Maybe that's the key bit of advice.

AU: *How does the producer's role for interactive content differ from a producer's role in a traditional linear narrative? What are some of the main challenges and rewards?*

RM: Working on *Bandersnatch* was a mix between producing a normal film and working on a software development project. We worked very closely with the engineers at Netflix, as what they could achieve would directly affect how we went about telling the story. As a producer, you would normally not have any contact with that side of a studio.

The main reward working on a project like this is managing to piece together all the different parts of the puzzle. We are giving up a huge part of the storytelling to the viewer, and our challenge is to try and make it rewarding to all the viewers, no matter what choices they make.

AU: *Now that you have experienced this type of interactive production, what have you learned about the process?*

RM: Writers need to engage with the process in the same way. There's certainly advice you can have around how you write choice points and testing those as well. What worked quite well with *Bandersnatch* was keeping the story going through the choice points and making it feel quite seamless. You don't quite know where the transitions are, and that just needs some prep and thinking about it up front. You want to have enough narrative carrying on through the choice points, but you don't want too much crucial information going on because people are thinking about what they are

choosing to do, so it is getting that balance. Writers have to have a brain for this kind of story, but at the same time the essentials of building characters, settings, and the key bits of story are the same as any other project, but there are more elements to keep a handle on.

AU: *Can a project like this get away from you, and how does a studio respond to that?*

RM: Netflix is a great partner for this kind of thing, and this was essentially an experiment for them as well. There were things we didn't know we were going to encounter, so when we came up against challenges that we weren't expecting, they were quite supportive of that, so when the shoot extended they were into helping with that. For various technical reasons, we had to duplicate some of the final footage in order to make the flow all work, so we ended up with 5.25 hours of footage to deliver, and that obviously cost more in post-production, sound, and grading, but they understood that. It would be hard to do on the cheap—this kind of production. You do need to have someone that can support it.

AU: *How did you measure the success of the audience's experience of* Bandersnatch *after its release? And how does this feedback help you prepare for future interactive productions? Were you surprised by any audience responses?*

RM: Netflix definitely measures it, but they don't share too much of that with the producers as far as numbers of people that watch it, but they do share which choices were more popular or had more engagement.

It was amazing to watch the reaction to the film around the world after it was released. The audience really enjoyed piecing together the puzzle themselves. There has been so much to learn from the audience reaction. People will react to the same choices in completely different ways. Some will try to make very logical decisions, some emotional decisions, and about 30 percent of people will try to do the exact opposite of whatever they think we as creators are trying to force them to do! We really have to accept that as creators, we are giving up control.

I really thought that because there's only one remote control, watching this would be an individual experience. The most surprising thing was how enjoyable a viewing experience it was for a couple or group. And in the case of the teen titles, they are very rewarding experiences between parents and their children. They interact in different ways with each other than how they are used to while watching TV. There's much more engagement.

AU: *How as a producer do you address success rates on these different audiences? Do you conduct user testing on these interactive projects or do beta testing?*

RM: Not outside of our production group. We do focus groups after the show is released to see how people are watching it. That's really interesting and is something we're learning from all the time to see how people react to choices. It is interesting that people are enjoying watching stuff together, where I thought it would be a very individual experience. Rather than a couple sitting on the sofa and one person looking at Twitter, they are both engaged with the film together and working out what choices to go for.

AU: *Is that concept maybe similar to early network television, when something was on every week and the family gathered around the television?*

RM: I think so. There's that thing where we all sit down and we all watch the same thing rather than you all go to your own room and watch your own thing. With *You vs*

Wild, the Bear Grylls program, it's a really great kind of parent-child experience. It's fun for an adult to watch and it's quite fun to see, discuss, or argue with your child on what is the right choice to make. It's a very leveling experience.

AU: *Do you think interactive content has high repeat value?*

RM: *Bandersnatch* has a high repeat value. As you're watching, depending [on] how long you carry on watching for, you're taken back into bits of story you haven't seen before. It's performed very well. At the end of one ending or viewing, if no one wants to go and explore more of that story, you've sort of failed. It might as well just have been a linear experience. You want people to go, "What would have happened if I had made different choices?"

AU: *At the time of this book, your current position is as an interactive consultant for Netflix. How did you find yourself working in the interactive realm of television, and what exactly is an interactive consultant?*

RM: After the success of *Bandersnatch*, Netflix is moving forward with more live action interactive shows. My role now is to help the producers of those shows through the interactive process from script through to final delivery. And at the same time help Netflix scale up the production process.

AU: *What does "scaling up" mean in this context?*

RM: There's a lot of engineering that went into *Bandersnatch* on the Netflix side and so it's trying to make that process smoother, so that less bespoke work is needed for each production and that they can handle more interactive shows in an economic way. It's the way that Netflix communicates with content producers and what information that they give out. There's a lot of information to take on for a new producer, and you don't need to have all of that information on day one. So it's working out the stages of onboarding people.

AU: *What advice you would give to a new interactive producer?*

RM: It is really difficult to put it into a couple of lines. There's so much to learn. There's many things that are similar to games roles, writing for games, or composing for games, it's a similar kind of head space to writing an interactive TV thing. I think the advice would be to have a willingness to give up control, but to try and keep those pieces together. You've got to accept that people are going to make choices you weren't expecting and there's going to be things that people won't see that you spent a lot of time and love on, and that's part of the experience.

AU: *Do you see other streaming services trying interactive? What is the future for interactive television?*

RM: I don't know whether Amazon, Disney, or anyone else have anything like this in the pipeline. Certainly Netflix has got quite a lot of projects in the pipeline. *The Unbreakable Kimmy Schmidt* is the next live action adult one, and it's very funny as you would expect from Tina Fey. It is totally different [from] *Bandersnatch*, which is refreshing as well, and I think it could definitely work for other genres. I think *Bandersnatch* was the first to reach an audience that wouldn't normally play games or have a games console. But I think interactive games and real-time rendering games like *Death Stranding* will become more and more cinema-like and potentially they will become more streaming as well. On the interactive side, I think that's going to be where games and film collide. That's going to become more of a gray area. I think it is important for Netflix that they are making films. We're not trying to make games.

AU: *What is that line? How do you maintain it?*

RM: I don't know. It's amazing the motion capture stuff and the real-time rendering of games these days is pretty incredible. That will carry on, so maybe people can actually properly control a character that they play in a film. The challenge with *Bandersnatch*, which I think David Slade, our director, did a great job with, was making it feel like a cinematic experience and keeping that kind of tension and build of the characters within the various strands of the story and keeping most of those strands working, which was always the intention to keep it in the film realm.

AU: *In addition to working with interaction, you have been a producer on several other episodes of* Black Mirror *for Netflix. How does working with a streaming service as your distributor differ from traditional broadcast or cable networks?*

RM: *Black Mirror* started out on Channel 4 in the UK. The move to Netflix, after Channel 4 decided not to commission a new season, was one of the best things that could have happened to really develop *Black Mirror*. The stories resonate so well with a truly global audience, which Netflix can reach. And being able to have the films be whatever length they need to be to tell the story is perfect for this kind of anthology. And not having to watch adverts is great for both producers and the viewers.

AU: *With an increasing emphasis on cord-cutting and the availability of more streaming subscription services, how do you see television evolving in the near future?*

RM: It's becoming a very competitive marketplace out there for the new subscription services. Viewers will pick and choose the services they want to subscribe to. Cable was never a big thing in the UK, but our traditional broadcasters are increasingly doing co-production deals with streaming services in order to afford the high production values that are demanded by the viewers. This is only a good thing for viewers. The quality of TV these days is so high like *Chernobyl* and *Succession* and all these shows. It's great viewing compared to some of the shows we were stuck with in the '80s.

AU: *Is that your positive outlook on the large number of streaming services? We are in a new Golden Age of Television, therefore paying for all these different streaming channels is worth it?*

RM: But also you can choose what you pay. I imagine people will probably not subscribe to more than three. And then some of them like Apple TV you will get free with your iPhone or whatever for a year. There will be tie-ins like that. What is quite good with a lot of them, they seem to be monthly so you can choose to have them for a month or cancel them if you don't really want to pay for a few months. You will cancel them if you don't like the content as well, so it's really up to the studios to make sure they are staying on top of their game.

AU: *It does seem to push the competitive nature and quality*.

RM: What was exciting when *Bandersnatch* came out is that it does come out in 190 countries at the same time. There's no film that has ever come out in that many countries. You're seeing this reaction around the globe and it's in 27 different languages. There's all of that localization that goes on as well. It's amazing when stories do resonate in that many different countries. That's another challenge for producers, too; you can tell a story that's set in Germany or a very local story, but in order to justify the bigger spend it needs to appeal to a bigger audience as well, but people are keen to watch stories from Turkey, Germany, or France.

AU: *Do you have any words of advice for aspiring producers entering into this new television landscape?*

RM: When I started out as a producer, music videos were a great area in which to experiment and learn new things. Whilst videos are still a great area for this, you can also pick up the tools to film very cheaply and experiment with drama, too, on a low budget. Find like-minded people to make films with. And say "yes" to as many opportunities as possible.

The people you meet and grow with will become part of your support network as you go through your career. And people are always keen to share or show off their knowledge and wisdom! Never be afraid to ask questions when you don't know something. Producing is about continually learning new things.

BRETT MORGEN
Executive Producer, Producer, and Director (including *The Kid Stays in the Picture, Chicago 10, Nimrod Nation*)

Authors: Brett, how do you decide if a project is better suited for television or for theatrical distribution?

Brett Morgen: Sometimes you don't know when you start a show if it's going to end up on television or go theatrical. Often, people set out to do it for television, and the story takes on a sort of life of its own and you finish the piece and say, "Hey, this has theatrical potential." Most of the time, though, you know if it's intended for television or for theater when you start a production, and you need to be aware because the transition from TV to theater is so expensive. For example, if you're doing a television production, for an hour-long show, you'll do a one-day or two-day sound mix, tops! And a five-day sound mix is almost unheard of. I'll spend six weeks to three months doing a sound edit or a sound mix on a theatrical. In television, the bandwidth is so small that very few sounds cut through, so it's a waste of time to even try a complex mix.

On television, your work is being seen by more people. I remember when *The Kid Stays in the Picture* went into theatrical release, we did 1.5 million dollars which at the time was, I think, the fifteenth highest earning theatrical documentary. But when it premiered on HBO, we had 1.6 million people watching it that first night, which was five times the amount of people who actually saw it in theaters. Then in subsequent viewings, we added it all up and it's probably now 30, 40 times the number of people who saw it in the theaters.

When you have a message you're trying to get across, you're much better off being on television than being in a movie theater, especially with a smaller type movie, say, about Romanian street children. You know people aren't going to pay to see it in a movie theater. Ultimately, however, if you're trying to get your message across, you're better off doing it as a fiction film anyway. Take a movie like *Hotel Rwanda*. Far more people will see *Hotel Rwanda* than will ever see a documentary about Rwanda.

I do think there are a lot of creative advantages to television—the immediacy, the amount of financing, funding—making it vastly superior to film, particularly now in cable television.

AU: *When you develop a television project, do you want it on HBO or a major network?*

BM: I think more people still watch the networks than anywhere else. In terms of sheer eyeballs, networks are the best, but getting a project on the networks is very

challenging if not impossible. In terms of documentary—cable, premium, or PBS—I think it's a toss-up between HBO and PBS. I think HBO appeals more to our egos as filmmakers. It's sexier. However, PBS is available in every household in America. Their viewers are different in terms of social activism. On PBS you'll reach the grassroots; you'll reach your core audience a lot easier than on HBO. But then again, HBO is an easier exercise. If they're into your project, they'll finance it and there you go. I think a lot of filmmakers have qualms about PBS in terms of their national distribution and promotion. I did a series for PBS that ran at a different time on a different day in every city, and it was a nightmare to promote.

I think the most important thing for young producers, for television producers, is to understand that you can take the same pitch to about nine different places, but you need to alter that pitch for each place. So I think a lot of times when people come up with ideas, it's really helpful to know to whom you're pitching. Know which networks serve what audience, and is there a way to change certain aspects of your pitch so it appeals to different networks.

AU: *Do you think of yourself more as a producer or a director, or both?*

BM: Well, in television I'm more of a producer because as a member of the Director's Guild, it's very difficult for me to work in nonfiction on television and basic cable. It's almost impossible. Economically, what I'll do now is come up with ideas for shows and hire them out for people to do. I'm not even a showrunner anymore. I basically am a creator at this point.

AU: *Expand on that job description, please.*

BM: I would hire what is called the "showrunner," someone who is essentially going to take the project over. At the end of the day, the show would probably say, "Created by Brett Morgen," and then I would be one of a number of executive producers. My job is to find the right people to run that show who can implement and protect my vision for the program. My job then becomes to put that in motion—make sure the script is tight, oversee the casting, and oversee the editing. The showrunner is technically the director and I'm the executive producer.

AU: *Where do you make your money in this structure?*

BM: You can't start a series and then bail out after the first season and think you're going to get rich by taking some sort of royalty. If I didn't direct commercials, then I would be the showrunner. I'd come up with an idea and I'd be the showrunner and I would make my living that way. At the end of the day, I'm just a guy who likes to watch television. I feel that there are certain programs that aren't on the air that I'd like to see, so I try to push those through.

AU: *As a producer, how involved are you in the budget—not only creating it but the day-to-day supervision of it?*

BM: I'm very involved in creating the budget. I work with the line producer in shaping the original budget. Once the budget is approved, I want to know that we're on budget, and if we're not on budget, why are we not on budget and how can we get back on track. But the line producer is dealing with all financial issues. I like to keep my role, at that point, more administrative and creative, dealing with the network, answering questions that the line-producer might have. But I don't want to know about the day-to-day.

AU: *Do you tend to hire the same people from one production to the next? Do you have a team?*

BM: You know, if they're good, if they're talented, often they don't want to be hired to do the same job. I find that anyone I work with, whether they're associate producers, line producers, editors—unless they're directors or executive producers—everyone wants to be in the cat-bird seat, everybody wants to be in the position of power. If it's a theatrical movie, it's the director or producer, and if it's a television show, it's the executive producer. So everyone else, for the most part, is working to get to those places, so if you have someone that's really talented—if it's the line producer on one project—chances are that on the next project, they're not going to want to take a line producer credit, they're going to want full producer credit, and you've got to decide if you want to go there or not. So I find it really hard to maintain. I just lost my editor who I've been working with for years because he's now becoming a director, and my old line producers are now producers. But it's incredibly helpful to have a team around that you trust and respect.

AU: *Do you think there is a producer's personality?*

BM: There are so many different types of producers. In television, there are people who are really brash and confident and charismatic. Then there's soft-spoken but talented producers. The key is to exude confidence. When you ask someone to give you more than one million dollars, they need to share your confidence, understand that you're professional and trustworthy. Most producers who work in television tend to be very authoritative, very strong personalities who are generals with their team.

AU: *How much do you think that "people skills" connect with producing?*

BM: I think a really good producer is someone who knows how to sweet-talk people to get what they want. And I think, you know, just as in life, if you treat people with respect, they give it back. Some people work better under threat and intimidation, and some people do their best work feeling valued all along, so it's tough to say. I know one television producer, this guy could sell anyone anything. He's a showman. And then there are people who are just very quiet and soft-spoken who happen to do really good work.

AU: *You're a former NYU film student. What's your advice for students starting off in television producing?*

BM: Something I already said: know your audience. When you come up with an idea, know the answer to "Who is this for?" You have to have a certain sense of responsibility with money. TV is a business and therefore you don't want to pitch a show that's going to cost $300,000 and sell it for $300,000. There's no profit in it. Try to keep costs down.

The most important thing is to know your audience, and also know that probably any idea you have, there are a hundred other people with that same idea and you'd better have something unique and special about your particular take on it. There is not an original idea—there hasn't been since I've been around. There are just reinterpretations of things, and particularly nonfiction, where you can't copyright an idea.

I did a film about the Chicago Seven, from the 1960s. I can't prevent anyone else from doing a film about the Chicago Seven. What's going to make my film different from the next person is my take on the events from back then, and my package that I put together. I have a very unique spin to my movie, and so therefore if somebody else happens to do a film on the Chicago Seven, I'm not really going to be too bothered by it. When you go to pitch, chances are they've already heard it—unless you've got something very specific about a very specific person, they've heard the pitch. So why are they going to hire you? You have to make sure to give them a reason.

STEPHEN REED
Executive Producer, Producer, and Producer/Director (including the Newport Jazz Festival)

Authors: Because you produce in so many different genres, what kind of producer do you usually think of yourself as being?

Stephen Reed: I overlap between executive producer and producer these days. In the past, I've been a line producer, and an executive in charge of production. One is often a more glorified term for the other.

AU: *What area of producing, what genre, are you most comfortable working in?*

SR: The things I like doing best are these big music productions of live events. Sometimes we do them as live broadcasts, and sometimes we do them live-to-tape for a quick delivery. Sometimes they're heavily edited. At the Newport Jazz Festival one year, we shot about 10 hours of music and 20 hours, maybe, of B-roll, and interviews. And all this gets condensed. The 10 hours of music is actually five or six cameras, for each hour. So you're dealing with a huge amount of material to cull down to a one-hour program.

There are two challenges in this: capturing everything right in the first place, and then an enormous post-production editing process to bring it down to a one-hour finished program.

I've also produced a few commercials, I've done music videos, and I've done some documentaries, as well as live satellite feeds, award shows. We even did boxing. We did Golden Gloves boxing over several days, many hours of live broadcast boxing. And then we cut that down to four to six hours, as another program for an HD channel.

AU: *Do these larger, live events pose certain challenges to you as a producer?*

SR: I guess the challenge is understanding what the event is, and who our client is, and, is that client the same person that's putting on the event? Which is sometimes the case. Is the client a broadcast partner in an event that someone else is putting on? And what is the relationship there? Often, I'll produce the event specifically for television, and then I produce the television coverage as well. That's the ideal situation because you plan the whole event in the way it's going to run, in the venue, in the available camera positions, set design, lighting.

The ideal situation is designing the whole event for television, because all of those things are taken into account, right from the beginning. It's clear that television is the priority. The live audience, while you want to accommodate them, is not the priority. The other extreme is when you're brought in to cover an event that's already planned and is going to be happening anyway, and we have to cover it for television. Sometimes we have a really cooperative relationship with the producer or promoter of a live event. And sometimes we don't. So you've got to be sensitive to that relationship and that audience.

AU: *This is all live, with no chance to do another take. How do you avoid feeling pinned against the wall?*

SR: You try not to come up against the wall. You try to avoid that part right from the beginning by going in and meeting with the people who are running the event—understanding what their priorities are and what their necessities are, letting them know that you understand what those are, and trying to debunk their preconceptions about what it means to have a television crew come in and disrupt everything to cover their event.

CHAPTER 11 Conversations With the Pros: Producing in the Real World

I've found that many times the perception going in is that *these television guys* are a "pain in the butt" and they think they're going to control everything and run everything, and that it's all about them and they run roughshod, and they're not very nice about it. Maybe it's just my personality, or maybe because I do a lot of music and have done a lot of music, but I'm aware of that preconception and I do my best to go in the opposite direction so that people feel comfortable. You try to get across that "we've got certain things we have to accomplish, we understand that you have certain things you have to accomplish, let's work together to see how we can do as much of that as possible" and find ways where we can compromise as necessary. It's as much about personal relationships and schmoozing as it is about, technically, how you're going to achieve whatever it is that you need to do.

AU: *Let's take the Newport Jazz Festival as a working example. How do you set up an event that is so massive? Are you essentially the director as well as the producer?*

SR: Yeah, I'm essentially the director. I don't do the multicamera live directing in the truck. But I have all the other responsibilities of the director. I do all the interview stuff. I direct, generally, all the B-roll shots, knowing where that's going. I do the host stuff, I write the voice-over as needed. So, I usually have a concept of how we're going to pull the show together a little bit and try do it differently each year, although I never know what kind of music I'm going to get.

So you want to have a loose plan in mind. We usually know how many artists we're going to shoot, but we don't know how well their sets are going to turn out and how we're going to juggle that whole balance. All of the direction of that show from the start to the finish, with the exception of calling the cameras live, is what I do. Even to the point of once we've selected a song, we go back and take out all of the isolated shots, and recut the entire show anyway. So we don't even use the line cut.

A couple of examples: If you want to put a jib in the audience to get some nice big sweeping shots, that's uniformly rejected because the jib could, conceivably, interfere with someone in the audience's view of the stage. So they won't allow that. We had a heck of a time trying to clean up the stage a little bit at the festival. There are a lot of hangers-on around the stage area. Which leads to a lot of clutter in the background of the shots, which detracts from what you're trying to do in focusing on the artist. So we tried to clean up the stage with design elements, keeping more people off the stage . . . things like that.

There are only 20 minutes between sets. An entire band is taken off stage, a new band is put on stage, people are scurrying around putting microphones in place, and so on. We also have only 20 minutes to get set up between each artist. We don't have any influence on how microphones are positioned, for example. Sometimes we can position a mike so that it's still just as effective to capture the music from an instrument or a singer, but it's not in the way of the camera angles that you're able to get.

The more cameras you have, the more positions you have, and the more flexibility with moving the cameras around, the more you can compensate for those things. But then again, we're getting into, "Are we interfering with the audience's appreciation of the show by distracting their eye or their focus, or actually being in front of them?" Those kinds of issues we juggle back and forth, and we compromise and try to still come out with as good a show as we possibly can.

The essential point is that you have to try to gain the trust and the confidence of the client, and all the other parties—from all the audio people, from the staging people, the artists, all the parties involved in this event. You have to gain their trust, showing that

you understand what their issues are and bringing them on board to be on the same team for the overall good of the project.

AU: *On a live music event, capturing the audio must be a huge challenge.*

SR: Here's how it works. There are a lot of different audio requirements for putting on a concert. First of all, the musicians on the stage have their own monitors that allow them to hear their own music being played back to them. Every single person on the stage has to have a mix so that they can hear themselves, know if they're in tune, and hear the rest of the musicians clearly and plainly, despite where they may be located on the stage. The microphones all go to a central place, then are divided into different purposes.

But our primary objective is to do an adequate mix for the musicians on the stage. That's the stage mix. Then there's a split of that audio that goes out to the center of the house where somebody else is mixing the sound for the audience. There you want a much more full, balanced mix than you would for the individual musicians on the stage. The singer primarily wants to hear himself or herself louder than they would in a normal mix, but that's not an appropriate mix for the house. So you've got five or six different mixes, depending on how many musicians you have on stage. Each one wants their own kind of mix featuring themselves. The house gets a different kind of mix.

The third split goes to the television truck, where we mix. Here, we do two things: The number one priority in the Newport show, which is a heavily posted show, is to get the multitrack recording done properly. It's usually 24 or 32, sometimes as much as 48 individual tracks that we're recording. That's the number one priority there. The number two priority of our TV truck mix is to get a rough mix, for reference purposes, that we use for post-production to decide what goes into the show and to cut the whole show together. Only at the very end do we go back to those multitracks, and mix the music that ends up being the show. That's how the ultimate audio ends up getting done. But right now, with the way I've described it to you, you have three splits.

My audio guy says every year, "Hey, don't use anybody's first song if you can possibly avoid it," because he's always trying to figure out where everything is and get his tracking down. We have no opportunity to do a sound check ahead of time, so the first song is always the sound check. The trouble is that the artist usually wants to start with a bang and capture everyone's attention. Frequently, the coolest song is the first one, and you want to use it.

It's all so second nature to me that I kind of forget that not everyone knows all these things. But it also relates to your point that a producer is a producer is a producer. Which is true in many ways. But there are so many nuances for different kinds of things, like getting the crew there, getting the facilities, thinking to the punt. That's transferable. But things like this, if you haven't done this kind of show multiple times, you're not even going to be aware of what the issues are, let alone how to handle them. So in some ways, that producer, producer thing is accurate. But there are a lot of exceptions.

TOM SELLITTI
Supervising Producer, *Rescue Me* (FX)

Authors: What are you looking for in a location?

Tom Sellitti: There are a lot of logistics that go into it. We want to make sure that the location will work for the scene, creatively as well as practically. The look of it needs

CHAPTER 11 Conversations With the Pros: Producing in the Real World

to fit into our show organically. We want to make sure that we can get good looks and camera angles. We also want to make sure it's available for our schedule and that it is going to work for our production. It should be easily accessible with room for our trucks in the surrounding area. You have to be aware of the neighborhood as well. Some are more friendly than others, and we need to take that into account also.

AU: *You use an approach called* cross-boarding *when you shoot. Can you explain it?*

TS: What we do is take two scripts together and we shoot it like a film. It's just a more efficient way to shoot, especially when you are on location as much as we are. We'll take two scripts—and one director directs two episodes—so that one director will do both of them. We will schedule them so that when we have a scene that takes place in a particular location, then we'll shoot everything that takes place in that location for both scripts. Consecutively. So if we have a day's worth of shots in the two scripts at one location, we'll do it all in one day. We'll have the actors change clothes from whatever particular scenes are for whatever episodes. When we did *The Job*, we used to cross-board four episodes at a time and that would get a little confusing. But this isn't so bad. It's just a matter of keeping continuity correct. A lot of that falls on the script supervisor, at least production wise, but the actors seem to handle it, no problem.

AU: *How involved do you get in post-production?*

TS: I'm involved in a large portion. I'll watch dailies, give notes on rough cuts, speak to the studio and network about notes. I'm involved in the music that we will put into an episode.

AU: *What's your relationship with your directors?*

TS: We give them the freedom to do their thing. You try to hire people that are adding something, so you never want to hold anyone back. We will watch to make sure their choices fit in with our show and, for the most part, support them as much as possible. If something seems out of place, we will step in at that point.

AU: *Speaking of personalities, is there a producer personality? Do you have one?*

TS: I don't think that I have the typical producer's personality. Every producer I meet is different. Some of them are crazy Type A personalities, some are very laid back, some are jerks. It has a lot to do with the way a person handles pressure and stress. Me, myself? I am pretty laid back. I guess the common denominator is that a producer makes things happen, so in that sense I do have the producer personality.

AU: *You don't seem to mind the pressures.*

TS: To us, it's something we want to do, and we are of the mindset that we can do whatever needs to be done, at least creatively, and we find a way to do it. Whatever it takes . . . there is always a way to compromise, and get what you need. We hire good people to work on our shows because they like to work on our shows. We treat them well, and that plays a big part in it, too.

AU: *You've been doing this for a while now. Looking back, what do you wish someone had told you way back then?*

TS: I wish someone told me it's not as easy as it sounds. There are some things that you need to know—things that are helpful. That you have to be flexible. You have to be willing to roll with the punches, you have to believe in what you are doing and believe you can do it. If someone is telling you something is impossible, it is usually not. Anything is possible. There are some things that are impossible for budgetary reasons,

but there are always compromises and ways to make your vision come to life. I think you need to treat the people around you right.

The way that we work, most people don't think of us as difficult producers (when I say us, I mean Jim and Dennis and Apostle). For one of the other shows that we are doing, I was going to a sound mix and when I got there, the production supervisor was laughing. She was talking to the sound mixer and she said one of the producers was coming over to listen to the mix and he said, "Oh, the suits," and she said, "No, these guys are not the suits, it's the last thing they would be." We are pretty down to earth and just normal—we like to have fun while we are doing it. We pretty much see ourselves as just like everyone else on the crew.

AU: *Can you find some balance in your life with the kind of schedule you have?*

TS: I try. My wife says I don't . . . but I do. I do a lot of stuff. I have a wife, I have two sons. I box. I play hockey. When we are not in production, we come to work at 10 o'clock and stay until 7 or 8. And the rest of the time, we try to do normal things like go out on the weekends. But when we're shooting, it is harder. On the other hand, some of our projects are easier. So you do lose a little bit of your life during the week. But we shoot five days and we don't shoot on the weekends, so you get your time on the weekend.

AU: *So you have created some semblance of balance.*

TS: We try. Sometimes it feels like it is not balanced, but we know the work that has to go into it to be successful, and how to put out a good product and make things run properly, and we try to be responsible. It would be easy to say I want to do this, and I am not going to go to work. But you wouldn't get anything done.

J. STEPHEN SHEPPARD
Entertainment Lawyer, Partner, Cowan DeBaets Abrahams and Sheppard

Authors: What does an entertainment lawyer do?

J. Stephen Sheppard: I can tell you what *I* do. Different entertainment lawyers do things differently. One of my partners is an entertainment lawyer, for instance, and functions in a mixed bag of semi-agenting, and semi-producing, and semi-deal-making business affairs, and what I call opportunity creating—introducing one party to another party. A lot of entertainment lawyers function that way, and I do a certain amount of that.

My practice tends to be a little more traditional lawyering. I negotiate and draft contracts, which is itself kind of unusual. Many senior lawyers have other people do the drafting and then they fix it. I don't like to do that. The value lies in getting it said right, and I believe that I need to do most of that myself, and I am good at it. I negotiate, I draft, I review materials for libel and privacy issues, mainly for documentaries. I work with insurance brokers to get insurance for films. I also negotiate contracts between producers and distributors, networks or distribution companies.

If I have a relationship that is useful, I can make an introduction. I'll call a network and say, "You should take a look at this project," or "I've got this client who is making this great movie," so that is sort of a little agenting. I never like to hold myself out as that; it's not my principal job as I see it. I also do some business counseling—what is the

smartest, best way to come at this project? I'm often regarded by my clients as their "smart friend." It is business counseling, it's strategizing.

AU: *Do you simply make the introduction, or do you follow a project through distribution?*

JSS: It really depends on the client and the project. I had a new client in yesterday with a new project, really interesting project, at square one. It's beyond the idea stage, they've already made good progress in terms of creating access to the subject, but that is as far as we've gotten. We talked about what steps were necessary, and what kind of documents were necessary to get the project started, and what their ideas were for what the project should be. They saw it as a documentary series. I suggested this project should go to such and such a network. I pointed out that they should be prepared to think about this as a one-off single special because, though we may be very intrigued about the subject, I wasn't sure that it could support a series.

When other clients come to me, this advice is not what they are looking for. Or the deal is already done and it's just doing a contract or production legal work, and doing every release for network nonfiction. Production legal work can involve making distribution contracts, acquiring rights and life rights—it really is driven by what the client needs and what the project needs.

AU: *At what point in the development of a project do people usually go to a lawyer?*

JSS: Certainly, at some point in the course of the life of a project, when you have to start dealing with third parties, with other people. If a book, for example, is going to be the basis of a movie, or if there is somebody's story, somebody's life rights, or if you need to get particular access to a building—these are all obvious triggers for a conversation with a lawyer. When you start dealing with third parties, you have to make arrangements with them, and you have to get certain rights or permissions or clearances from them. That's when it probably makes sense to start talking to a lawyer and make sure that you are getting what you need—and that you are not getting more than you need, and not overpaying for what you need.

AU: *Are there situations in which a producer wouldn't want to involve a lawyer?*

JSS: That is an interesting point, I hear it all the time and it pains me to hear it—this notion that bringing in a lawyer is a hostile, aggressive, negative thing to do. It is not, it doesn't have to be, and it certainly shouldn't be. Anyone starting off as a producer really needs to get over that. A lawyer who knows what he or she is doing, and is good at it, is there to effect a simple agreement that is really fair to both people.

I always tell clients that the best deals are deals where both sides are just a little unhappy. As long as both sides are just a little unhappy, then neither one got every single thing they wanted, which means there was compromise and that it is probably a fair deal. That's the way a good lawyer should come at this. You are here to get it done. You as a producer, and whomever you are dealing with, are going to be better off in the long run if you have done it right in the beginning.

I'm asked the question, "Can any contract can be undone?" And the answer is "Probably," if someone is inventive or hostile enough to do it. Let's say that you make an oral handshake deal with Jane Doe to do a movie about her. You don't want to bring in a lawyer, because that feels like a hostile thing to do, so you both agree that that is just fine and you make the movie and you've spent time, money, and energy and you've made the movie. Then, Jane Doe says, "I've changed my mind, I don't want you to do this, and I don't like it." You are stuck. Whereas if you have a simple

agreement up front, it is harder for the other person to do that. Is it impossible? No, it's just harder because then, you are both relying on this agreement.

AU: *How does a producer find a good lawyer?*

JSS: It's not black magic. You meet with somebody and you get a sense of what kind of person they are, if they understand you and they get what you're talking about, and see how you want to come at this. I have people who haven't retained me, because they want some kind of red meat killer who grabs the other guy by the throat. That is not the way I function, but if that is what the client wants, then he is in the wrong place and he knows that. I am not offended when somebody says, "You're not mean enough for me."

For a young/new producer, there is an organization here in New York, and I think it exists in many cities, called Volunteer Lawyers for the Arts (VLA). That is exactly what they do. They make legal services available to people in the arts who can't afford to pay for them; whether they are young producers, or authors, or dancers, or whatever. They are all volunteers, they're very good young lawyers who work in big law firms and make their services available on a *pro bono* basis. Law schools very often have programs. It's great experience for the students, and it creates some kind of access to lawyering.

AU: *What are the most important legal areas that producers should know about?*

JSS: In any business or project, there are a certain number of hot-button issues that need to be paid attention to. An obvious example is rights. If you are dealing with existing material, you have to get the rights. If you are dealing with a person, you have to have a release and get permission to tell his or her story.

Another hot-button issue is collaboration; if you have a partner, look at the terms on which that partnership is supposed to operate—who is in charge, how are the decisions made, how does the money get split up, who get what kinds of credit? What happens if it doesn't work out? At what point do you walk away, and who gets to walk away with what? At that point there will have been time, money, and talent invested in coming up with a treatment, a demo, a something.

Insurance is a big item. Sometimes it's as simple as calling your neighborhood broker, someone who knows what they are doing. It may be as simple as calling and saying, "I need an insurance package for this project," and you'll get one. There are other instances where it may be more complicated than that but insurance is a big area. There is a bundle of insurance coverage that a picture needs. It needs liability insurance, it needs property insurance, general liability if you smash your camera through someone's plate glass window, or if someone trips over a cable, or if you've rented a car and have an accident during production. Then, there is producers' liability, or Errors and Omissions, that protects against claims arising out of the content and copyright trademark, and libel and privacy claims.

If you are doing a larger picture, there are union issues and guild issues. It's not so much a function of the size of the project, it is more about the people involved. I am involved now with a project of relatively modest budget, a television project, but it needs to be done with guilds, so there are WGA issues, and DGA issues, and SAG and AFTRA issues, which then throw off another bundle of residuals and pension and welfare issues.

AU: *What does a producer need to know about financial markets and financing?*

JSS: A producer needs to know a good lawyer or a good financial advisor, in all areas of financing an independent film. It is a very highly specialized area. I've done a fair

CHAPTER 11 Conversations With the Pros: Producing in the Real World

amount of work on a network that is producing pictures in Canada. This is its own whole universe; there are very specific rules and requirements that you have to comply with in Canada for the benefits, which are all sorts of really good subsidies and tax credits. For a general-purpose discussion like this, that is almost too complicated. It really depends on the project, the producer, and the producer's access to money and ability to raise money.

AU: *What is a producer's rep, and what do they do?*

JSS: They serve a variety of functions. They can help [in] securing financing, and they can help find distributors. They sell the film to distributors; they will get it into festivals. They can function earlier in the process to find coproduction financing and pre-sales, obviously before it has been shot.

AU: *From your viewpoint as a producer's lawyer, what skills should a producer have?*

JSS: I'll tell you what I respond to in a client: someone who asks the right questions. Having some common sense about the questions to ask is enormously valuable because if there's a problem, and nobody thought to ask the question and I never had the kind of information that I would need in order to think about the question myself, then you find yourself trying to solve the problem after it happens—and that can be really difficult.

My job isn't to say, "No, you can't." It is to say, "Here is how," or "Let's solve this problem." But very often, all I can do is say, "Here are the risks and you have to make the decision. This is a business decision, it's not a legal decision." In that situation, having a client, a producer, who listens and is thoughtful and makes a decision is pretty good for both of us.

AU: *What is the function of a copyright?*

JSS: When someone writes a book or writes a play or makes a movie, or paints a painting, the law creates a certain right that it calls "copyright," for this purpose. This says that the creator of the material is the only person that can do anything with it. He/she/it (if it is a company) is the only person who can sell it, can make copies of it, can do anything with it, so anybody else who wants to do anything with that thing needs the permission of the author/the creator to make copies of it, to make different versions of it, to translate it, to do anything.

And that right, that control, is called "intellectual property," and it applies to the proceeds of somebody's work that gets manifested into some content. And that intellectual property is an intangible. You can own that book, that is tangible, but you have no right to do anything with the contents of it. You can't make a xeroxed copy of it, you can't make a movie of it, you can't do anything with the content of the book unless you buy it from my client.

AU: *How can producers protect their work?*

JSS: You secure copyright. Securing copyright is very easy. You put a copyright notice on it, a little "c" in the circle and the year, date, and your name, and you put it on the film or script or whatever. That tells the world that somebody owns it. So, if anybody else wants to do anything with it, they have to get the permission of the guy whose name is on the copyright. You take a couple copies of it, and you fill out a form that has about eight questions on it. You send it to the Library of Congress with whatever the filing fee is, and it gets registered. Then, anyone who looks at the copyright registry knows it's yours.

AU: *Can you protect your work by mailing it to yourself?*

JSS: Before 1976, that was a useful device because of the way that the copyright law was structured, but now it is not at all meaningful. The only reason it has any meaning is if it is important to identify a specific date in which something was created. That is a very simple method—mail it to yourself and get a mail receipt.

You're never protecting ideas; you can only protect the *expression* of an idea. So, the business of mailing something to yourself is of limited use. The Writers Guild Registration has certain value within the Writers Guild, but mostly it's from the perspective of identifying a date. If you are sending a treatment or script to the WGA, you are going to put a copyright notice on it anyway. It's the copyright notice that really gets you what you want. As soon as it is in some sort of tangible form, you're entitled to copyright, and you get it by putting a notice on it, and it doesn't matter if it's published or not.

AU: *Can you explain the meaning of fair use?*

JSS: Fair use was a concept that the courts developed under the pre-1976 law. The way I think and talk about it is as a concept of a "permitted infringement." You are using somebody's copyrighted material without his or her permission. Under certain circumstances, the court said that they were going to allow that, that fair use is a defense to what would otherwise be a copyright infringement. The things that the courts look at to see if something qualifies for this fair use defense are: How much footage or material did you take? What was the purpose for which it was taken? Was it scholarship and review, or educational, or was it commercial? Does the use in any way supplant or interfere with the sale of the original?

In 1976 when Congress passed the law, they built fair use into the statute, into the copyright law. So there is a provision in the copyright law that lays out four or five tests for fair use. They made it clear from the language that these tests were not the only tests; there may be other factors that one might look to determine if something is fair use. It looks at the quantity of the use, relative to the whole, and the purpose of the use.

If you are writing a book review, you can quote big chunks of the book, which might look like you are taking a lot of the book except that relative to the whole, it is not so much, and that it is a review. Parody is another element of fair use. Parody is a whole world unto itself. The parody defense is sort of like fair use, except that usually if there is a parody, you are taking the whole thing. If it is a song parody, you are going to use the whole song, it's not like you are taking just eight bars. That is a whole different set of tests.

AU: *Are copyright laws the same in all countries?*

JSS: There are differences, but there are international conventions that help to smooth out these differences. When the copyright law changed here in America in 1976, one of the big reasons for the change was that we were the only country, among those that paid attention to copyright, that measured the term of copyright by years from that mysterious moment of publication. Everywhere else in the copyright world, they measured the term of copyright by the life of the author plus 50 years. When we changed the copyright law, we got rid of the whole term of years with renewals, and we went to the life of the authors—plus, the number of years keeps changing.

AU: *What does Right of Publicity mean?*

JSS: Right of Publicity exists in some states, but not all states. Some states recognize what is called the Right of Privacy. It is variously defined in various places, but

basically it means the right to be left alone. You have the right not to have your name and face and your stories told without your permission, to a certain extent. It depends on who you are, on the circumstances, if it's a public event. In New York, for example, the Right of Privacy is fairly limited. It implies almost exclusively to somebody's name and likeness in advertising. The Right of Privacy is what is called a personal right—once you die, it's gone. There is no such thing as the invasion of privacy or libel of a dead person; when somebody dies, they are fair game.

The Right of Publicity is a relatively new extension of the Right of Privacy that doesn't exist in New York. It exists in a number of states, most notably in California. It is a property right as opposed to a personal right. It has to do with using a person's identity for commercial purposes to sell goods, so that it was created in California largely to protect celebrities. And because it's a property right, it carries over after the death of the person and, in that way, protects dead celebrities. The key is that the name has to have value and has to have been exploited commercially during the person's life.

AU: *What is the ultimate goal of a contract?*

JSS: The ultimate goal of a contract is to articulate to the parties what the understanding is between them in such a way that you never have to look at it again. It's to describe the understanding between the parties. It's a very valuable process. What happens in drafting contracts is that I will write something down and send it to the client, or to the other side, and very often they say, "I can't agree to that," so it's a very good thing that we wrote it down that way. So then we change it to what you can agree to or what you think you are agreeing to.

AU: *Is an oral agreement legally binding?*

JSS: Sometimes. Samuel Goldwyn once said an oral agreement isn't worth the paper it's written on. Yes, oral agreements can be binding, they can be enforceable, but they are harder to enforce because if there is any dispute as to what the understanding was, there is no piece of paper. With an oral agreement, one person says, "I agreed to this," and the other guy said, "well, I only agreed to that." There is something called the statute of frauds, which requires that certain kinds of contracts must be in writing. Copyright licenses must be in writing; any license of intellectual property must also be in writing.

AU: *Do student producers need a lawyer for their projects?*

JSS: If you are making a $15,000 movie as a thesis project, then maybe not. But if you have any notion of ever doing anything with it beyond showing it to the department, then you probably will need to get a lawyer involved at some point because nobody will distribute it unless they know that you have all the rights and clearances that you need, and that there won't be a bunch of claims flying in as soon as this thing ends up on television somewhere.

AU: *When would a producer involve a lawyer if she wanted to shop it around to festivals?*

JSS: Earlier rather than later. I recognize the financial implications of that bit of advice, but that is the truth—that's when you should do it.

AU: *How are lawyers paid for their services?*

JSS: Variously. Some lawyers charge by the hour. Sometimes with a production, with a producer, the lawyer will be a budget item; there will be a line item in the budget that covers legal services. Lawyers may get a percentage, almost like a commission on

some of the afterlife uses, so when you are finished with the production, the line item will cover the production legal services. But it very well might be that once the picture is shot, and there is a distributor and the lawyer is making a distribution deal, he may get some sort of percentage of what the producer gets.

AU: *How do you handle the pressure that must surely come with the territory?*

JSS: When you have been doing this for a while, you know what you are looking for and what you need to pay attention to. When I look at contracts, I actually read them, and I pay a lot of attention to them, but I know what I am looking for. I know with respect to any given project where the problems might be, what won't be a problem, or what I know may be a problem but nobody is going to be able to do anything about it anyway.

I have been doing this for longer than 20 minutes, so I bring a body of judgment to it that is mostly pretty good, most of the time. Do I worry about missing stuff? Sometimes. When I'm drafting contracts, after I'm finished, I will always go back over it, not just for each word, but I have a checklist: Did I do this and did I do this? I make sure that I haven't left anything out. Do I ever make mistakes? I'm sure that I do. Not bad ones, but I do. I'm not always calm, sometimes I yell, but I know that I'm good at it because I've been doing this a long time and I have pretty decent judgment, and not just about the specific words in a contract but about people and their relationships to people and the business they do. You just sort of develop a feel for it.

MARK VERHEIDEN
Writer and Producer, TV series and streaming series

Authors: *You are a writer and producer of many popular television series, including* Smallville, Battlestar Galactica, Heroes, Falling Skies, Hemlock Grove, Constantine, Daredevil, Ash vs. Evil Dead, *and* Swamp Thing. *Many of these series originated in the world of comics. Can you share your origin story and how you found yourself producing these shows?*

Mark Verheiden: Short version, I grew up in Portland, Oregon, where I was a die-hard comic book and movie fan and did a lot of writing for fan groups and film publications, eventually studying filmmaking in college. I moved to Los Angeles in the 1980s hoping to break into screenwriting, and sold a couple super-low-budget scripts, but my real break came when some friends in Oregon started Dark Horse Comics. I created a comic book character for them called *The American* that I eventually set up as a film, attached as the screenwriter, with Warner Bros. From there I started writing features, including *The Mask* and *Timecop*, eventually working on over 20 feature projects. A couple years after *Timecop*'s release I was brought on to develop a TV version for ABC, which only ran for nine episodes but started my career transition from feature writer to television writer/producer, where my affection for comics and science fiction has served me well.

AU: *Some of your series, like* Hemlock Grove, Daredevil, *and* Swamp Thing, *were distributed on streaming subscription services, while the others were available on cable networks and major networks. When you develop a television project, what type of platform do you prefer, and what are some of the main differences between them?*

MV: From a production standpoint, I've found very little difference between producing an hour episode for network, cable, or streaming. Creatively, I prefer the latitude you get in terms of content in cable and streaming, in terms of language and adult themes.

CHAPTER 11 Conversations With the Pros: Producing in the Real World

I especially like no commercial interruptions. Financially, however, streaming platforms often treat writer/producers differently than traditional outlets like networks, in terms of residuals and episodic fees (what we're paid to write an episode) and even pension benefits. Also, long lead times can mean you're making less money than if you were on a regular weekly show, since most producers are paid by the episode. A year spent making 24 episodes is far more lucrative than a year spent producing 13.

That said, the other difference between network and cable/streaming is audience. Obviously Netflix and other streamers don't release audience information, but strictly anecdotally, you're generally going to get fewer eyeballs in these other arenas. Exceptions do exist, like *The Walking Dead*, *Game of Thrones* and I'm sure some Netflix shows like *Stranger Things*. So it's a bit of a trade-off, but all in all, the creative freedom enjoyed off-network and the shorter orders make sense to me.

AU: *Can you explain the differences in the pitch process for the different avenues (streaming, cable, broadcast TV)?*

MV: I should note that I have worked exclusively in drama, so the rules of pitching comedy, animation, or whatever may be different. That said, except for having more creative latitude in terms of subject matter (a show like *Ash vs. Evil Dead* would never have existed in a network-only world), the pitch process hasn't really changed much since I started. It's about explaining the concept, your vision for the show, the characters and where the stories will lead. We can include more bells and whistles these days, thanks to technology ("look books" with graphics that help present the look and design of the project, etc.), but otherwise it's about the material and the people.

AU: *Where do you think the television industry, with the increasing emphasis on streaming services and cord-cutting, is heading? How will these changes impact producers, content, and consumers?*

MV: I wish I had an answer, because I'd like to know myself! This is truly a golden age of content production (not sure we can even call a lot of it "television" anymore) and as the major studios form their own independent streaming units, like Disney, NBC, WB with HBO Max and the rest, there is more need for writers and producers than ever. In terms of consumers, that's the big question mark. How much are people willing to pay every month for content, and which of the providers will survive? Because it is going to be quite a battle in the marketplace.

AU: *Do you consider yourself a writer or a producer first, and how do those two positions overlap in your various projects?*

MV: I always see myself as a writer first, but producing is how you can have an impact on the final written product. Unlike feature films, where the director guides the process, writer/producers are the creative guide in television. And the jobs overlap on every front. Working through a budget can dictate how a story is presented, casting decisions can impact how a character evolves, a rainy day can require hasty rewrites . . . dealing with that is all part of the writing/producing job.

AU: *Your producer role has varied from executive producer, showrunner, consulting producer, to supervising producer. Can you describe the key differences in responsibilities between these positions?*

MV: Your role can vary depending on the needs of the show, regardless of title, but the showrunner is considered the one in charge, guiding the creative direction of the show and dealing with the multitude of issues involved in getting things made. After that, the titles are sort of a hierarchal scale, with executive producer highest on the totem pole,

followed by co-executive producer, supervising, then producer. Depending on the show, any of these producers can be responsible for supervising "their" episodes (usually ones they've written, but not always), or running the writer's room when the showrunner is away, doing rewrites, sitting on set, sitting in the edit, helping spot music, the whole nine yards. There is no set guide defining the roles in each of those titles, it's more or less up to the showrunner. Also, producing titles are not just for writer/producers; they often also include the non-writing line producer (the person who keeps the production running on time), the post-production supervisor, and other important members of the production staff.

AU: *How do you decide what projects to take on?*

MV: When I was first starting out, it was about breaking in and establishing myself, so I would look at the project and the people, but sometimes you have to take the bird in the hand. I've been incredibly fortunate that most of my earlier jobs (*Smallville*, *Battlestar Galactica*) were totally in my wheel well. These days, I always look at the people involved first—life's too short to work with monsters. Then I look at the project. I have been fortunate that my more recent efforts have been no-brainers to a certain extent. All were great properties, and I was working with Steven Spielberg and Graham Yost on *Falling Skies*, David Goyer and Daniel Cerone on *Constantine*, my friends at Marvel on *Daredevil*, Sam Raimi, Rob Tapert and Bruce Campbell on *Ash vs. Evil Dead*, and James Wan and Gary Dauberman on *Swamp Thing*.

AU: *What are the key traits any successful producer should possess?*

MV: Producing is about people management as much as the creative, so learning how to guide people toward the result you're seeking is critical. Patience can be a virtue. Also, producing a television series is literally a 24/7 job when you're in production, so you have to be prepared to put in the long hours to stay on top of things.

AU: *How can a producer stay relevant in this fast-paced industry, where production and distribution strategies, not to mention audience tastes, are constantly evolving?*

MV: I think it's important to keep developing your skill set, and understand what's working and what's not working in the marketplace. Maintaining good relationships is important; it's a business where popping off in anger can feel good for the moment but can come back to haunt you. When I'm looking to hire someone, you can bet I check on their past performance, and if your reputation is "trouble," then that's a problem.

For me, it's also been about leaning into my creative strengths. As much as I love cop procedurals, I know deep down that's just not a world where I would be comfortable as a writer/producer. I've always loved comics and science fiction and horror, so the fact that the business has evolved to support more shows in those genres has been a lucky break.

AU: *As a producer, what have been your biggest challenges and your most rewarding moments?*

MV: Challenges are constant, and some of them are external, like balancing a "life" and family against the rigors of a very demanding job. In terms of production, though, I'm fortunate to have enough experience to recognize the difference between an emergency and an EMERGENCY. And surviving the experience is about addressing issues as they come up as best you can. I've been blessed to work as a writer/producer for 31 years now, in a business that can be quite cutthroat and complicated. In that time I've been involved in shows that I am extremely proud of and made a lot of great friends on both sides of the camera, and I like to think I've

treated people the way I would want to be treated myself. So the reward is in the work and the experience.

LANCE WEILER
Writer, Director, and Experience Designer for film, TV, and interactive games

Authors: You are a filmmaker, writer, producer, and speaker. You are also notable for your unique approach to storytelling with the merging of technology. How did you become interested in this new form of storytelling? What led you down this path?

Lance Weiler: I got to a certain point where I felt like I was limited by running times, three-act structures, and commercial breaks when I would write for television. I started to see more and more happening in digital space that was really quite exciting. It was real time, it was nonlinear, it was like a living, breathing organism, and I was drawn to that because of the ability to scale the stories I wanted to tell, but also to look at what it really meant to tell a story in the twenty-first century. A lot of people talk about participatory culture and the idea of collaboration, and I was interested to see, in a world where everybody feels like they are their own media company, what it means to actually create stories in the twenty-first century. I started to explore that concept in my own work.

It started before that when there weren't really terms for it. I was kind of just doing it anyway. I did it with the first film I made, called *The Last Broadcast*, which became the first all-digital-release motion picture. It was the first desktop feature film, and we made it for a ridiculously low sum of money. Technology was there already, but it was there in a way that we were experimenting with the blur between fact and fiction in terms of the storyline of the work we were doing, but also looking at it in terms of how can we actually reach more people with this work. When I did the film *Head Trauma*, it became more about reinterpreting what a feature film was and taking it out and doing these live participatory experiences around it. In the last year or so, I have broke entirely. I decided to do a participatory storytelling trilogy, which consists of land, air, and sea. "Robot Heart Stories" was the first part of that, which was the air one, "Wish for the Future" was the second part, which was land, and the last one was "Message in a Bottle," which was sea. I was looking at how I could build storyworlds.

What's exciting about the work is it feels like it's the silent film era. When silent films started, they were just "point the camera at the stage and shoot the actors on the stage." I feel like we are at the moment where someone realized we can take it off the tripod, take the camera outside, and start to shape the grammar of cinema. I feel like we are at the same place now with new forms. Story is the same, but the telling is what's changing.

AU: *For now, people are calling this new form of entertainment "transmedia." Can you describe what transmedia encompasses and what the benefits are of this type of storytelling?*

LW: I look at this idea of pervasive stories and the ways that they can be all around you, and I think the way in which technology can help to improve the personalization of it, improve the discovery of it, can improve the social aspects of it. I think all those things point to a really exciting way of telling stories that have more of an impact or have more purpose in the world. What's interesting about that concept of transmedia is that it's this idea that stories can be fluid. I almost feel like I am storytelling agnostic.

It doesn't matter to me what the platform is, it doesn't matter to me what the medium is. I want to be able to tell fluid stories. In some ways the transmedia aspect is about bridging across all these various devices.

At Columbia I teach a grad course that's called "Building Storyworlds: The Art, Craft, and Business of Storytelling." There have been all these things historically that have been disruptive throughout entertainment. A lot of the time they have been positioned around the emergence of new formats, but now what we have is this disruption affecting everything from publishing to news to gaming to music to film and television. That presents a really interesting opportunity and then at the same time taps into this idea that you are seeing more people who are becoming generalists than they are specialists. If you look at the emerging creative class of people, they are cross-disciplinary. They can pick up a camera, or they can use a compositing program, or they might be able to color-correct. There is a big DIY thing there, partly because of the democratization and commodification of that technology.

The promise of transmedia is that if media consumption is changing and devices and screens are coming into people's lives from every direction, then naturally the way stories are going to be told is going to change, too. If you look at the rise of short fiction or novellas, they came about when public transportation really opened up. There was a reason to sit on a bus and read something that was shorter. A lot of times new forms come from the reality of the consumption and how people are choosing to use those devices. I think the idea of laying a story layer over the real world is pretty exciting, so story can actually have an ongoing presence in ways it never could before. For example, Broadcaster, which uses geo-locational storytelling, is an app wherein you travel to a city and it pings you with all these oral histories and stories about buildings and restaurants and meals and the people that live there, just laying this layer of story over the real world. People who take the time now to understand story, understand the role of data within storytelling and understand that those formally known as the audience are actually a type of collaborator are going to do well in this new paradigm.

AU: *How do you get started with a transmedia project? What is the most challenging aspect to planning a transmedia project?*

LW: It all starts with the story. There is a tendency, and this is true of making films when new cameras and new software come out, to become enamored with those things. And those things would dictate how producers would tell their stories. It was almost like a distraction. It's not about a checklist. There is no magic bullet for it. It really comes from, "What is that story that you want to tell and why do you want to tell it?" I am constantly striving for simplification within the design that I do. What's critical is finding a way to make what you are doing clear, running it through a filter and asking, "How does this best serve the story?"

One of the things that really liberated me was not to focus so much on character and focus more on what the themes were. Once I embraced those themes, then all of a sudden I could have all kinds of characters. I could have things that didn't even involve a character. I could have whatever I wanted. I could have these participatory hooks that allowed audiences to have their own stories, but didn't necessarily step on the canon of what I was trying to do with the characters that I had worked hard to build. I think the easiest place to start is the story. Don't use this newfangled shiny thing called transmedia as a distraction from the work that you need to do in order to make your story great. If anything, you have to spend more time to make it resonate and make it impactful.

AU: *I read that one of your first films reached $4.5 million with a budget of only $1,000 and became the first film to be transmitted digitally to theaters. How do you properly budget, finance, and distribute a transmedia project?*

LW: It really comes back to the core of the design and learning how to work within your limitations. For a lot of people who step into this area, who don't come from an interactive background, who don't know how to code, think they have to do it all themselves. Sometimes it's just finding good partners and good people to collaborate with. The beauty of producing now is that the teams are changing drastically. I always have a creative technologist that I work with. I always have somebody that deals with community management. I have digital strategists and a transmedia unit that will shadow certain things that I'll do. These are new emerging roles.

Once you assemble your team, it's just basic process. If you can schedule and budget for a film, you can schedule and budget for an interactive project. You need to have the right variables and you need to get the right information. Keep in mind that it always takes longer than you think. You want to really take the time to nail down your scope and be able to communicate that so everybody is clear on the deliverables.

AU: *What are the possibilities of transmedia in television?*

LW: The fact that it's reoccurring and the emergent second screen opportunities will allow television a great deal of potential. Television has always been good, at least when something is successful, at merchandising certain analog-based things. Now I think there are ways that you could start to see really interesting licensing opportunities and new ways of merchandising. You've seen it in the past within virtual spaces. Back in the day people were selling real estate in something like Second Life and actually making money from selling real estate that didn't even really exist. It sounds absurd, and Second Life is its own thing, but it's all about markets emerging to create opportunities that aren't expected. Natural behavior of wanting to own something, wanting to have status, wanting to have wealth, whatever it is, these drivers carry over into these new emerging opportunities.

In terms of second screen, which is really rudimentary right now, it has not necessarily let the audience in in a way that I think they are ready for it. It's still fighting itself. It's fighting itself where it feels like the show is the most important thing. Second screen right now is so caught up in the social aspect and so caught up in being a servant to the actual show that it's missing larger opportunities to really connect with people and to tell stories that stretch beyond merely servicing the TV show.

AU: *What advice do you have for aspiring producers?*

LW: A lot of people are always going to tell you that something is impossible. When we went to make *The Last Broadcast*, people told us it wasn't possible to cut a film on a desktop computer, or to make a movie for under $1,000, or to release that movie into theaters digitally. Many people want to play devil's advocate. Don't sell yourself short by caving into that fear of failure. Rather, embrace failure because failure helps you to become a better storyteller, a better producer. Fail quickly, learn from it and move on.

The other thing is to develop good peer networks. The people you are in school with now, collaborate with them, or just speak with them and gain insight from each other's experiences. I think sometimes there is this desire to be so focused on where you are going that you miss the people who are around you who are in the same position that you are in. You don't value them as much as you value that people who have succeeded, and it's like you are looking for this magic bullet, this magic solution, this

button. "How do you become successful? Oh, you just go push that button." That does not really exist. And don't forget to have fun. Realize that it takes a lot of time, a lot of effort, and that you must be tenacious and thick-skinned. But it's also a lot of fun.

JUSTIN WILKES
Executive Producer, @radical.media

Authors: How do you define your job?

Justin Wilkes: I love this question because my mom still asks me this every day: "So. You direct the actors?" "No, Mom." "You work the camera?" "No, Mom." "You do the editing?" "No, Mom." There's no simple answer, at least not one that I've ever heard. The best description is (which I can't even take credit for, but since the person who said it is a good friend of mine, I can rip him off): The producer is like the air traffic controller. Your job is to land the plane.

Getting into producing is a funny thing, and you'll find it's the only profession where you don't really have to do anything to get the title. If you look at a list of every producer on the planet, you'll find that only the smallest percentage of them actually do what I'd consider producing. This is bizarre to me because you can't just wake up one day and say, "I'm a cobbler." First, you have to become an apprentice and work for many years studying the craft. Then finally, after many pairs of shoes, you finally earn the right to call yourself a cobbler. Not so with producing. Anyone can be a producer. You can have money and call yourself a producer. You can have an idea and become a producer. It's truly the easiest title in the world to assume. But I don't suppose you'd be reading this book if the title was all you were interested in. My personal story is that I worked my butt off and did any job I could get my hands on. I got my current job by sitting on the couch in reception until they hired me.

AU: *What do you do as an executive producer, and what have you worked on?*

JW: As an executive producer in @radical.media's entertainment division, I develop and oversee an assortment of projects ranging from episodic television, one-offs, and feature film projects. It's not as glamorous as it sounds. On any given project, it involves everything from writing, developing, being a liaison to the client/agency/network, scheduling, budgeting, line producing, and overseeing the editorial.

Some of @radical.media's credits are the feature films *Jay-Z in Fade to Black*, *Metallica: Some Kind of Monster*, the Academy Award-winning documentary *Fog of War*, and the Grammy Award-winning *Concert for George*. Our television credits include *Iconoclasts* on the Sundance Channel, *The Exonerated* for truTV; *Nike Battlegrounds: King of the World* for MTV, and *The Life* for ESPN.

AU: *The pitching process is an integral part of the producer's job. What's your approach?*

JW: I believe there are two main parts to a good pitch. Getting in the door, and then delivering once you get in the door. Both are critical, and both require some thought and strategy. Fortunately, we're at the point as a company where we have a reputation for our past work and we've developed relationships with many people at most of the major networks and studios. However, there are still plenty of times where we'll cold-call an assistant to set up a meeting with a development or programming person at a network. Whether there's a relationship or not, it usually takes multiple calls and

persistence to actually schedule a meeting (not to mention the constant *rescheduling* that often occurs after an initial time is set).

Now for the pitch itself. We're big fans of not sending our pitch materials ahead of time and instead showing up with a simple, but well art-directed pitch book that takes the reader through the concept. We'll usually talk through the pitch and refer to the book as we go. Occasionally, we'll use a piece of video or still photos to capture the essence of what we're presenting.

The power of a pitch book shouldn't be underestimated. Basically, until your show is produced, the pitch book *is* the show. Everything from the overall look and feel, to the writing, to the design should be reflected in the book. It becomes a great presentational tool and a great way to solidify your own vision of the project.

AU: *What is it about producing that's so attractive to you?*

JW: I love bringing talented people together. There's no greater feeling than standing on a shoot, sitting in an edit session, or watching the final product on TV, knowing that you as the producer pulled together an incredible, hard-working group of people to create it.

AU: *What is it about producing that you don't love?*

JW: I hate how slow development takes. I hate raising money. I hate people who say they're going to do something and then don't.

AU: *What does the future of television look like from your perspective?*

JW: There will be a continual increase in channels and other methods of delivery. You'll receive so much content through your cable, satellite dish, Internet, cell phone, car, washing machine, and toaster that you'll finally turn the damn thing off and read a good book. In the world of advertising, we're seeing a return to one of the earliest forms whereby a brand goes beyond sponsorship of a program and actually owns the content embedded within it.

AU: *What would be on your Top Ten list of what a producer should know?*

JW: OK. Here goes.

Top Ten List of What a Producer Should Know:

1. You're always going to come in over budget, so budget accordingly.
2. The network/client will always ask you to make an impossible change at the last minute and you have to make it possible.
3. Put your day-to-day problems into a larger project context when making decisions.
4. Lawyers and agents are not producers. Many would like to be. Many others think they are. But they're not.
5. Your lawyer works for you (not the other way around). Best advice I ever got from another producer.
6. You set the vibe for the entire production. If you yell, others will yell. Lead by example.
7. Great ideas are easy to come by. Actually *making* great ideas is the challenge.
8. Learn every job. A good producer knows how to shoot, edit, gaff, grip, and hold a boom. Not only do people in those positions respect you for knowing something about their craft, but also it is invaluable when you're figuring out production logistics and budgeting.

9. Craft services is the key to success.
10. Don't date the PA. I know you want to. But don't do it.

SCOTT A. WILLIAMS
Executive Producer, *NCIS* and former Executive Producer, *Bones*

Authors: What's your particular job on a show?

Scott A. Williams: As the ranks of being a television writer go, from staff writer on up, by the time you reach co-executive producer, it's where you have the most responsibility, short of being the actual showrunner or executive producer. One of the luxuries of being the co-EP is that you are not the one under the hot spotlight. You're just to the left of the spotlight. Which is a double-edged sword, really. While the showrunner has final say over all decisions, he or she also has the most pressure. A good co-EP wants most to serve the showrunner, and by extension the show, but the pressure's dialed down considerably. I have the showrunner to deal with, but the showrunner has EVERYONE ELSE to deal with, like network, studio, actors, etc. Hopefully, I'm taking some of that burden off. A good Co-EP is the showrunner's right-hand. You learn to be a good lieutenant, not the general. You learn to carry out the show's vision, while lending your own creativity to it.

In television there's a saying: You've got to feed the monster every eight days. Every eight days, you've got to have another great script ready to be shot. So I'm constantly conferring with the showrunner: "What do you think about this or that story?" If they like it, we'll pursue it with their personal spin or wants. I'm in there always making sure that we as a staff are ahead of the curve on stories and scripts. We have a staff of nine. That's a lot of people up there to be in one room, breaking one story, breaking one episode. So we'll break it up into two rooms, even three, so that we're constantly ahead of schedule. When we've got episode 10 about to shoot, we've got to be coming up with episodes 11, 12, and 13. We've got to be talking about all those things at once. The focus for me is to just always keep the writers' room going and make sure that new stories are constantly being generated. That's the responsibility that Hart gives to me.

AU: *You had a staff of nine writers on* Bones. *Does each have a specialty? Say, is one a forensics expert, maybe someone else is good at dialogue, another is sort of a relationships person—how do you allocate writing assignments?*

SW: When you put together a staff, you try to do that. I've heard it described as assembling a really great dinner party. You want people who can inspire one another creatively. And generally, this means a good mix of experiences and backgrounds. For example, every staff I've been on has had at least one lawyer. We have a great lawyer on our staff now. He no longer practices law, but he practiced for years, then went into writing. He's the guy that we're always able to turn to for accurate legalese. I've learned a lot over the years just from experience on television, but if you need a legal question answered, you turn to him. And yes, there's also the medical person. I worked on a staff that had a doctor; if you work on a show like *ER*, you're going to have doctors who are on the staff who know all the medical stuff.

That's not to say we don't have researchers as well. It really helps to have a wide range of strengths and experiences on your staff. If you're writing a *CSI* show, you might have writers that are more technical working with you on a day-to-day basis, but

if you're writing a more character-driven show, you obviously want writers great with character. Ideally, you want to be that well-rounded writer who does it all pretty well.

AU: *So many scripted shows now are "ripped from the headlines." Where do you go for your stories?*

SW: It's pretty hard not to rip from the headlines today. It's pretty competitive in terms of trying not to tell a story you've seen on another show. Every crime show I've been on, for instance, has done their "buried alive" episode, with the ticking clock to save that person who's been buried alive. Any actual crimes having to do with finding lost remains or deteriorated bones, we're all over those, obviously. Often, too, we start off with the real crime that we see as a jumping-off point, but the final episode is not at all reminiscent of the actual crime. I was on the show *Without a Trace* for a season, and that's a terrific show that's generally not about its lead characters. It's about the people who go missing and their lives, so you tend not to have as many personal main character arcs on a show like that as we did on *Third Watch*, for one.

AU: *Programmers today are increasingly being pressured to get the advertising message into the body of the show rather than in the commercial breaks. Have you had to deal with anything like that yet, or do you see it looming ahead?*

SW: I think product placement is the way it's all going to go eventually. Depending on technology, we're going to go to our computer to buy a sweater that one of the characters on the show is wearing. Absolutely. We have never been asked to product-place on any of the shows that I've worked on, but I do know we get good deals if we use a certain cell phone on a show, or there's a certain gadget that they want promoted. The GE products at NBC—I can't say they're not featured in a show on occasion, or that GE's friendly and they'll give us X amount of microwave ovens for this appliance store scene. But I do think the wave of the future is going to go in that direction. Since we're able to fast-forward through commercials, it's all headed toward emerging media. At some point, nobody's going to have a TV at home anyway. It's all going to be on computer or cell phones.

AU: *As a writer, do you see a distinct difference between television and film?*

SW: What's fun about a film is that it's your own little world, and you're getting to create every little aspect of it. But you hand your screenplay into the studio, and the system now is that they just throw more writers at it. The script gets rewritten to the nines. I've rewritten people, people have rewritten me, which is just fine, that's just the movie biz. In television, I find it more rewarding, because you write something and it's being shot in a couple of weeks. It's a great, great feeling to write and rewrite and create with real live actors and directors and technical people on a real live set. And in a few more weeks, it's airing on television—so your rewards are more immediate.

Television's great for that. Obviously, when you see a great movie, you say, "Ah, I gotta do one of those." But I'll go back to full-time feature writing when I retire from television. The rigors of television are so demanding that you rarely have time to write independently. I tried to do it for a few years where I would moonlight with features, but that can burn you out in a hurry.

AU: *That brings me to the question of maintaining balance. How do you balance real life with work life?*

SW: Balance? Oh, I've heard of that [laughs]. It comes and goes. There are times in television when you're completely overwhelmed. You've got to pump it out every eight days, and it's not always great. You get scripts thrown back at you by the networks

sometimes. You get a ton of notes at all times. You're having to please a lot of different people, and you have fights, but you have to pick your battles.

Depending on the show you're on, some shows work late into the night. Me, I want to be home for dinner with my family. Life's too short to live it at work. But there's still a job to do and that monster to feed, so I do have dinner with my family, and I kiss my daughter goodnight and then say goodnight to my wife, and I close my office door and I'm back to writing. There's always the next script. It's a rare occasion that you have the weekend where you don't have to spend some time sitting down writing. Weekends? What are those?

There's such demand placed on having to put out a script every eight days. That is, unless you're a savant like David Kelley, who pumps these things out by himself and really quickly. Kelley delegates really well in terms of having people handle a lot of the other responsibilities, so he's free to write. But most showrunners and exec-producers and co-EPs that I know have so many other responsibilities they can never be doing just one thing.

Balance is a hard thing to achieve, but it's a must. You learn to appreciate free time like never before. Sometimes, it's like, I'm sorry, I've got to put this down and clear my head for a weekend, and just go away with the family. Do something that's not work-related or you'll just go crazy otherwise. For me, it's just time with my wife and my daughter. Plus I like playing sports, running around. People say, "What's your hobby?" and I say, "Writing is my hobby, and I'm lucky they're sort of paying me for it."

AU: *For anyone thinking of getting into producing content for television or some future permutation of TV, what would you want them to know?*

SW: I've worked with USC Film School grads, and I've worked with people who worked at 7-Eleven in Texas. I myself got out of college and I tended bar in New York and L.A. for a total of about 12 years—that's including college—and I wouldn't necessarily recommend that path for anyone, but I do know that experience is a huge part of why I'm here. David Milch hired me not only because he liked my writing, but because I had lived a life.

So whenever I get a 22-year-old kid fresh out of film school who says, "I'm ready to write television," I tell her or him that yes, there are people who can do it. J.J. Abrams was one young wunderkind who came out of college, but if you look at his earliest work, it's clearly the work of someone who was fairly naive about life. He learned on the job, and he'd probably be the first to tell you. *Regarding Henry* was a fine film, but it was still life according to a 24-year-old.

There is no wasted job, no wasted time for a writer. Life experience is everything. Without it, what is there to write about? If you're working at a McDonald's and you're an aspiring writer, you can write the greatest story about the French-fryer that anyone ever wrote. When I was in my twenties, I was in a very big hurry—I wanted to succeed yesterday. But what I know now is "get a life," continue to work out there in the world, continue to write, and know that everything you do is material for your work.

I thank God for those 12 years behind the bar because I have a catalog of Runyon-esque types forever in my head. I've seen people at their worst and at their best—under the influence of alcohol and not. Every little experience adds up to the writer I am now. I've worked with people who ascended as professional students, and I find that they're the first people who'll usually say, "Oh, people wouldn't say that," or "Oh, that wouldn't happen." The worst thing I hear is "I don't buy it—I don't buy that that

could happen." Are you kidding me? In a world where anything is possible, you can make anything happen on the page. You can make anything believable and real, because all things are possible in this world.

When I deal with people who are professional students, they may certainly know things that I don't, but it's still no substitute for living a life, and being out there in the world. Every experience has value and worth in your writing.

BERNIE YOUNG
Executive Producer, *The Martha Stewart Show*

LAURIE RICH
Executive in Charge of Production, *The Martha Stewart Show*

Authors: Bernie and Laurie, thanks for taking the time to share what you each do on The Martha Stewart Show. Let's start with you, Laurie. As the executive in charge of production, what areas of production are you in charge of?

Laurie Rich: We need to complete an order of shows every year. Every show is different—when we did *Rosie* [*The Rosie O'Donnell Show*], it was 195 shows. We've been producing 180 shows during the course of the season, doing anywhere from five to six shows a week.

Many weeks we shoot six shows, and that's not easy. We're live usually three days a week and then we do afternoon shows on those weeks. The days are usually Tuesday to Thursday, we all kind of prefer that. It's good to have a Monday to prep and a Friday to prep, but it's not always the case. A lot of it depends on Martha's schedule. Occasionally we need to put in special shows at times like Halloween. Our schedules fluctuate around the special shows.

It takes a village or an army to produce this kind of show. It's very unusual because it's not a talk show, and it's not a variety show, it sort of falls in the lifestyle category—that's probably the best way to describe it because there's a little bit of everything. There's crafting, there's cooking, we have gardening segments, we have animal segments, and we have some fashion shows. Every single one of those segments is well-produced—each needs to look fabulous.

AU: How many producers work for you at one time? Are they on staff or freelancers?

LR: Most are staff people, though occasionally we'll pick up freelancers in the art department. Or, if a producer is not around or ill for a period of time, we'll need to go with a freelancer. Most are staff—there are even some shows where one segment may have more than one producer.

If we have a celebrity guest, there may be a producer who's working with the celebrity, prepping them—maybe they're doing a gardening segment or they're going to cook with Martha—while other producers are working on the different elements of the gardening or cooking or the crafting they're doing.

I think what goes on behind the scenes is what makes the show very unusual and very special. With the producer comes a lighting designer whose cues and different looks depend on what we're doing that day. There's an art department staff, which is

a very large one because they're responsible for dressing not just that segment but the entire look of the set each day, and that can change, depending on the seasonal requirements, depending what's going on that day. And we do special theme shows, so that's also very unusual. Then there's the directing team—our directors have to take the camera shots, make sure it's all perfect, make sure the graphics look great. You've got the support of the production team in the background, making sure that everything else in the promo looks fabulous, making sure the feeds are leaving the building properly, to the transportation of the guests and the audience members getting to the studio each and every day, so that security knows what's going on. That's what I'm saying, it takes a village here to get each show done.

AU: *Bernie, you're the executive producer of the show. Just how many staff do you work with to make this show happen?*

Bernie Young: About 70, I'd say. You know, there is so much coordination that goes into producing this show, and it's Laurie's department—the production department—that is responsible for the coordination of the show on that stage. The stagehands, the directing team, the art department, the set design, the producers, in and out—it is a real ballet. And when it's live, anything can happen. Hopefully we've thought about it, we've anticipated the timing and the changes that could occur, so when Laurie says it takes a village, it truly does. Everybody knows their role, and the coordination of that is really key. So the more successful shows have the best coordination. I think our team is second to none.

LR: And Bernie's the man who heads the whole village up. He's mayor of the village!

BY: It's always interesting. This is a very unique show. It's unique because the company is unique. The fact that the founder, Martha Stewart, had a vision for what her business could and should be is what we carry out. So, to start as a caterer and build a business based on making your life better, improving things in ways you would never think about makes our lives really interesting and unique.

We look at those areas in which Martha's interested and make them come to life on television. For our show, someone in her corporation has already thought about an idea, somebody's done the research and development, someone else has photographed it, has already written a story in one of the publications. We bring it to light here, on the show.

We're not recreating the wheel. We know what the brand is, so let's sell the brand. We do that every day, and we do that while we're trying to entertain the audience and keep them interested. Hopefully everybody's learning something because after all, Martha is a teacher and she wants to learn, too.

AU: *How do you measure who and what your audience and their demographics are?*

BY: We've been lucky. We have a very honest audience who tells us what they think. Occasionally we'll ask our viewers questions online and they tell us what they like, what they'd rather not see more of, what they'd like to see more of, how it impacts their life and, quite frankly, they really like the "how-to" segments—they want to learn, they want to see how Martha does all the things she does. They have followed her for 25 years or so in everything she's done.

AU: *Laurie, you've built what is essentially a core set for the show that you can then add design elements onto. What might change on this set from one show to another?*

LR: We have the home base kitchen area, where you see Martha at the beginning of the show and where, when she has celebrity guests, the cooking takes place. We have

CHAPTER 11 Conversations With the Pros: Producing in the Real World

a real working prep kitchen which everyone loves. Sometimes, we'll have celebrities in that kitchen, or we'll do various segments in there. There's work going on there all through the show, before the show, after the show—it's also where they prepare and test recipes for future shows.

Then we have the craft area which is next to the home base; it's where crafty segments take place. We have a swing area where our beautiful greenhouse was set up by a greenhouse company. And we can do anything in this area—from music performances to fashion shows. Often, the stacking of the show is what determines where the segments get produced during the course of the program.

It's a great studio—it's so large. There are very few like it in New York. We're very lucky that we have that. To watch the cameramen moving from Position A to Position B during the course of a commercial break—particularly during the live shows because we have a very finite period of time, just two minutes for them to move—it's always incredible. It's like a mini *Saturday Night Live* to see them with the cable pullers, everyone getting from Point A which could be home base, all the way over to the potting shed. It doesn't sound like a lot, but during the commercial break, that's a fascinating thing to watch.

AU: *How many cameras do you use?*

LR: We have seven cameras. We have a jib camera, a Steadicam, three pedestal cameras, and two handhelds.

AU: *How many overhead microphones do you hang above your audience?*

LR: I don't know the number, but a lot—they need to catch the ambient audience applause. All of our guests have wireless lavs on them.

AU: *Your show has a better sound quality to my ears than most live-audience shows do.*

LR: We can totally credit that to our sound engineer who not only does our daily show but also created the sound design on the show. In the past, we've had musical performances, very popular people who have been on shows all over the country who have come on our show and have commented on how wonderful the sound is. Everyone does a fantastic job. We're very proud of that.

AU: *Laurie, how did you get into producing as a career?*

LR: In my case, this is not what I was going to do. I was going to dance in musical comedy. I ended up at Hunter College here in New York, and they couldn't find me an internship in my interests, so they suggested that I meet this gentleman who was the arts editor for WCBS television in New York. I met with him and he wanted me to work with him every day. I wasn't sure that's what I wanted, but when I walked into the news room at WCBS, I fell in love with it. I don't think I left there for about seven months.

And that's how I wound up in the business. I worked at a local station for years, producing. I started out as a production secretary—which they don't have anymore—even though I flunked my first typing test so I didn't get the job. I was brave enough to go to a secretarial school where they put headsets on me; I had to learn how to type with someone talking in my ear. Then they called me back again because they'd given the job to someone else who dropped out. I did every crummy job there was to do back then and worked my way up the ranks.

AU: *Would you recommend this route to someone else?*

LR: I do, but not everyone has that attitude that, "I'll just come in this door and take this job." Very often I'll speak to somebody for a PA position and they say, "Oh that's not what I want to do, I want to be an assistant talent booker" or "I want to be on the producer team." I do think that folks who have gone up through the ranks can really appreciate what everyone else around them does. They get a much better picture of the overall picture of how everything gets produced, how the show gets put together.

People have started as interns and receptionists, then moved up to be APs and EPs and other producers, and I think they're terrific. Someone may start out as a PA and then two months later, they're a producer on a show—it happens.

AU: *Bernie, what was your path to producing?*

BY: I started as a personal manager. I would represent talent. One of the first talent I managed was Ben Vereen. I got very lucky with Ben because he did everything—from television to film. So I got a chance to watch Bob Fosse put together *All That Jazz*. I got the chance to talk with producers all the time, and learned about what they did. I'd ask them a lot of questions and annoy them.

In the comedy business, a number of my clients had series TV, and Rosie O'Donnell was one of my clients for over 22 years. My actual production experience started with her talk show—by then, I'd been around all these shows and certainly understood what it took to put a show like that together and what everybody did. So coming in, although it was my first real production, hands-on production experience, I had seen it from another angle. I was absolutely prepared for it and enjoyed it.

To see it from the outside looking in, it was always exciting to me. Anything in this business that helps you learn, to me, is always interesting. It's never the same, it changes every day. It's not a job where you go, "Okay, I've got to do that for another eight hours." You know what's coming, it's always about being prepared for what could happen. *The Rosie O'Donnell Show* is where I met Laurie, and we worked together for six years.

Then this show came along. My production experience was always about knowing what everybody did on the show. From Day One, I wanted to know everyone—the PA up to the EP—to understand their responsibilities, what do they do on a daily basis. I believe that you're always better off when you know exactly what it is you're responsible for.

I got lucky in this job, to have been able to coordinate a great staff like this and to help to make this show come together, each day.

REVIEW QUESTIONS

1. Choose two producers from this chapter and compare and contrast their views on the qualifications and responsibilities of a producer.
2. Examine the roles and skill sets of various types of producers (e.g., line producer versus supervising producer).
3. How does a good producer prepare for post-production?
4. From your perspective, what should a good producer's chief concerns be?
5. Research the concept of "convergence" and discuss its current and future effects on television.

6. What genre most interests you? Research two notable producers and their projects in that genre and briefly discuss what made them stand out.

7. What are five internship opportunities available to you? Get the contact names and addresses for these possibilities.

8. Who do you know? You may know someone, somewhere, who works in media. If so, arrange for an interview. Ask what his or her responsibilities are now, and the steps taken to get to this position. Write a brief report, or shoot a short piece, on this process.

9. Design a pitch for a specific project and examine its possible outlets (broadcast network, cable channel, streaming, emerging media, pay-per-view, film festival, direct-to-video release, etc.). Explain how you would tailor your pitch for each outlet.

10. Research the pilots created for your favorite channel in the last season. Look for patterns between the shows that were picked up for air versus those that were not.

SAMPLE FORMS

Because today's producer is likely to work in television, emerging media, and/or film, the following resources generally apply to all venues. All of these sample forms are good examples of documents that would be filed in your *production book* (see Chapter 4). Although most of these forms would be created during the pre-production stage of your project, we have organized them here into development, pre-production, production, and post-production to stress the stage at which they are most employed.

Development

1. Submission Release
2. Writer's Deal Memo
3. Certificate of Authorship
4. Non-disclosure Agreement

Pre-Production

1. Pre-Production Checklist
2. Breakdown Sheet
3. Storyboard
4. Project Costs Summary
5. Budget Estimate
6. Project Budget
7. Equipment Rental Log
8. Cast Deal Memo
9. Crew Deal Memo
10. Crew Data Sheet

Production

1. Shooting Schedule
2. Daily Cost Overview
3. Call Sheet
4. Talent Release
5. Extras Release
6. Crowd Release
7. Location Agreement
8. Petty Cash Report
9. Reel Log
10. Expense Report

Post-Production

1. Screening Log
2. Editing-Paper Cut
3. Music Cue Sheet

SUBMISSION RELEASE

From the owner/rights holder of written Material to a network, production company, producer, or other development entity.

I am voluntary submitting to you written material ("Material") that is titled _____ _____ for you to read and evaluate in order to obtain your comments and suggestions ("Comments"). I warrant that I am the author of the above Material and/or that I am the present and sole owner of all right, title and interest in this Material; that I have the exclusive unconditional right and authority to submit this Material to you upon the terms and conditions set forth as follows, and that no third party is entitled to payment or other consideration as a condition of the use of said Material.

I acknowledge that you regularly receive submissions of formats, stories, ideas, manuscripts, plays, screenplays, and other sources for possible development in media formats, and that new ideas for content and programming are constantly being submitted to you or being developed by you. I recognize that many stories and ideas are similar, and that different stories and ideas may often relate to or share one or more common underlying themes and story elements. I realize that you may have previously had access to, and/or may have independently created or have had created, ideas, themes, formats, stories, suggestions, screenplays and/or other materials which may be similar or identical to the theme, plot, idea, format or other element of the material now being submitted to you by me. I understand and agree that I will not be entitled to any compensation because of the use by you of any such similar or identical material.

I understand that you have no obligation to read and evaluate this Material or to notify me of its evaluation, if any. In the event that you should select the Material for further development, I understand that a separate contract will be executed that stipulates all terms and obligations on the part of all parties involved, and that said contract will incorporate this release by reference.

I understand, in the absence of the acceptance by me of each and all of the provisions of this release that you would refuse to accept or otherwise evaluate this Material. I will indemnify and hold you harmless from any and all claims, expenses, losses, or liabilities that may be asserted against or incurred by you at any time in connection with the use of said Material, including without limitation those arising from any breach or alleged breach of the warranties and promises given by me in this release, including reasonable attorneys' fees and other costs incurred defending against the same.

I acknowledge that the submission of the Material to you may expose it to others, and I specifically release ("*Production Company/Producer*") from any and all liability, direct or indirect, resulting from the improper use by any other persons or entities of any similar ideas, formats, stories, suggestions and the like relating to this Material. I have retained at least one copy of said Material, and release you from any and all liability for loss or other damage to copies of said Material submitted to you. I agree that you shall not be obligated to return the Material to me, and I release you from all liability if the Material is lost, misplaced, stolen or destroyed. This release extends to ("*Production Company/Producer*"), its agents, associates, employees, officers, directors and volunteers.

I agree that should I sell the Material to you, a condition of the sale will be that you receive a credit in the end credits of any program made from the Material. I acknowledge that the Material was created and written by me without any suggestion or

request from you that I write or create it. You agree that you will not use the Material or any part thereof unless you either:

- Enter into an agreement with me granting you the right to use the Material; or
- Determine in good faith that you have the independent legal right without my consent to use all or any part of (or any features or elements in) the Material either because (i) I do not own or control such Material or such features or elements, or (ii) the Material or features or elements used by you and claimed by me to be the Material or embodied in the Material is in the public domain, is not new or novel, is not legally protected or protectable, or was independently developed by you or obtained by you from other sources including your own employees.

You may, however, reprint or publish extracts from your Comments as examples for educational and/ or promotional purposes, provided that neither I nor the title of my Material is identified. I further understand that you may make similar comments on other materials, and acknowledge that the copyright and ownership of the comments themselves (as distinct from contributions or changes to my Material, including story changes, that may be made pursuant to the Comments) remains with you. In no event, in the absence of any agreement between us, shall any agreement to use or compensate me for the use of the Material or any other Materials, features or elements claimed by me to be embodied in the Material, or any other obligation, be implied.

If I should claim that you have used all or any part of the Material or any features or elements in the Material, or breached any alleged agreement to use or compensate me for the use of the Material or any of its features or elements, I undertake the entire burden of proof of originality, copying, similarity, and all other elements necessary to establish your liability. I agree that my submission of the Material shall in no event give rise to a presumption or inference of copying or taking or that anyone in your organization, other than the particular individual to whom the Material is delivered by me, had access to the Material or examined same.

If I should bring any action against you for wrongful appropriation of the Material or any of its features or elements, or any breach of any alleged agreement to use or compensate me for the use of the Material or any features or elements thereof, or any claim based, in whole or in part, on the submission of the Material or any other matters or events relating to or based in whole or part on the submission of the Material, such action shall be limited to an action at law for damages which damages shall in no event under any theory exceed the Flat Deal Screen Minimum Compensation for a High Budget Photoplay as set forth in the current Writer's Guild of America Theatrical and Television Minimum Basic Agreement, and that I shall in no event be entitled to an injunction or any other equitable relief. Should I be unsuccessful in any such action, I assume, and agree to pay you upon demand, all of your costs and expenses entailed in defending or contesting such actions.

I further agree that as a condition precedent to any such action, I will give you prior written notice, specifying in complete detail the grounds on which I will base such action and that any such action shall be and is hereby forever waived and barred unless duly filed by me within six months after you first publicly release or use the Material (or any claimed features or elements thereof) or ninety days after you notify me in writing that you deny liability to me, whichever is earlier.

This agreement supersedes any and all prior and contemporaneous agreements between the parties. Any change hereto shall not be effective unless made in a

writing signed by both parties. This Agreement may be executed in counterparts, and/or by fax.

(Author name and signature) _____

Signatures of co-author(s) _____

Address _____

City and State _____

Phone # _____ Email_____

WRITER'S DEAL MEMO

This confirms our agreement to hire you:

Name _____

Address _____ Phone _____

Loanout/corporation name _____

Address _____

SS# or Fed ID # _____ Guild/Union _____

Screen credit/billing _____

For the writing of _____

In a project tentatively titled

To be aired on: Network ____ Cable ____ Non-broadcast ____ Internet ____ Other____

Date(s) of hire: From _____ to _____

Compensation _____

Terms of payment _____

Additional terms of employment _____

Agent _____

Agent office ph# _____ Mobile _____

Agency name _____

Agency address _____
_____ Ph#_____

The compensation acts as payment in full for all services rendered during the period of employment, and all rights granted to the producer and/or production company.

Accepted by (writer name) _____ Date _____

Writer signature _____

Employer/production company name _____

Address _____ Ph # _____

Producer _____

Approved by _____ Date _____

CERTIFICATE OF AUTHORSHIP

The undersigned, _____ ("Writer"), certifies the following:

(1) That the screenplay, treatment, idea, or other format ("Material"), titled "_____ _____", and all literary material of all of the results and proceeds of the Writer's services in connection with it, was written solely by the Writer as a work-for-hire, specifically commissioned by _____ ("Owner") for use in connection with the production of a television show/motion picture/project ("Picture"), with the Owner being deemed the author of the Material.

(2) That the Material is wholly original and has not been adapted from any other literary, dramatic or any other material of any kind or nature, excepting only incidental material which is in the public domain throughout the world; that the Material does not contain any material which copies or uses the plot, scenes, sequences, story or characters of any other literary, dramatic or other work; that the Material does not infringe upon any statutory or common law rights in any other literary, dramatic or other materials; that no material in the Material is libelous or violative of the rights of privacy of any other person and the full use of the rights in the Material granted to the Owner will not violate any rights of any person, firm or corporation, and that the Material is not in the public domain in any country in the world where copyright protection is available.

(3) That the Owner owns, throughout the world, in perpetuity, all right, title and interest in and to the Material and any and all parts thereof, including, but not limited to all motion picture rights, television rights, video rights, publication rights, and merchandising and commercial tie-in rights. Such rights include all rights in and to the title by which the Material is now, was or may later be known, its theme and the characters, story, ideas and all other elements it contains or is contained in any version now or later created, sequel rights in the Material, and the rights to secure copyrights in the Material and any Picture or other use which is based in whole or in part upon the Material, of and for the benefit of the Owner.

(4) That the Owner has the right, but not the obligation, to use the name of the Owner and/or the name, likeness and biography of the Writer as the author(s) of the Material on the screen and in advertising and publicity in connection with the exploitation of any Picture produced which is based in whole, or in part, on the Material or in connection with the exploitation of any of the rights granted hereunder.

(5) That the Owner may make any changes in, deletions from, or additions to the Material or any photoplay, production or other material based on the Material which the Owner in its sole discretion may consider necessary or desirable. The Writer expressly waives, for himself/herself, his/her heirs, assigns, executors and administrators all rights of "Droit Moral" or any similar right under any law or legal principles.

(6) That with respect to any compensation or other consideration due the Writer in connection with the Material or his/her services relating to it, the Writer agrees to interact solely with the Owner and will not assert any claim or demand against any assignee, grantee or successor in interest of the Owner.

(7) That the Owner may assign, transfer, license, delegate or grant all or any part of the rights, privileges and property relating to the Material to any person, firm or corporation. This Certificate of Authorship shall inure to the benefit of the parties hereto and to their respective heirs, successors and assigns.

(8) That in the event of any act or omission of the Owner or any successor of the Owner constituting a violation or breach of the agreement between the Owner and the Writer, the Writer shall be limited to remedies at law, if any, to obtain damages, and the Writer shall have no right to rescind all or any portion of such agreement or to enjoin or restrain the distribution or exploitation of the Picture or any material based in whole, or in part, upon the Material.

Writer (Print name) _____

Signature _____ Date _____

Address _____

City and State _____ Phone _____

SS# _____ Guild/union affiliation _____

Owner/Company name

Address

City and State, Contact numbers

Authorized signature/Owner _____

NON-DISCLOSURE AGREEMENT

The "Employee" whose signature follows, agrees that from time to time (he/she) may need to disclose to other (company) employees confidential information or trade secrets generally regarding "the Material" (a project in development, idea, concept, or other confidential Material).

The Employee agrees that (he/she) shall not disclose any information concerning the Material unless it conforms to this agreement. The Employee shall limit disclosure of any information concerning the Material to the officers and employees on the management team of (company). All confidential material shall be put into writing prior to any disclosure, placed in a sealed envelope, and labeled "CONFIDENTIAL."

The non-disclosure obligation shall terminate to any particular piece of information if any of the following occurs:

- The confidential information becomes known to the public without the fault of the party receiving disclosure, or;
- The information is disclosed publicly by the party disclosing, or;
- A period of (number) of (months/years) passes from the disclosure, or;
- The information loses its status as confidential through no fault of the party receiving disclosure.

In any event, the obligation of non-disclosure shall not apply to information that was known to a party prior to the execution of this agreement.

Employee (Print name) _____

Employee signature _____ Date _____

Employee address _____

City and State _____ Phone _____

Company/Employer name _____

Company address _____

Authorized signature _____ Date _____

PRE-PRODUCTION CHECKLIST

Not all items listed are needed in every project. Check the list to see what works for you. Or, it may be handled by a department head.

Pre-production offices (if not provided)

- Rent office space for the duration of the project
- Arrange for phones and a fax line, cell phones, pagers, and walkie-talkies
- Arrange for computers and laptops, color printers, copy machines, and paper
- Order stationery, business cards, and envelopes
- If not provided, rent office furniture, tables and chairs
- When needed, get insurance to cover any of the these things

Primary above-the-line

- All deal memos and/or contracts with the producer, writer, director, the DP, art director, and major talent are completed and signed

Insurance

- Research and obtain general liability and workers' comp insurance
- When needed, add extra insurance riders for stunts, explosives, etc.
- If necessary, obtain Errors and Omissions insurance
- Research and obtain additional insurance if shooting in foreign countries

Scripts

- All story rights are registered, secured, and the contracts signed
- Finalize the script
- Draw up a shot list
- Duplicate script
- Distribute script and revisions to relevant cast, crew, clients

Get completed and signed copies of:

- Contracts involving the producer, director, writer, DP, and other key people
- Contracts and releases (including union paperwork) for all talent, including on-camera actors, hosts, narrators, voice-overs, animals, and extras
- Contracts and releases or work permits for minors
- Deal memos with crew members and production staff
- Location agreements
- Shooting permits
- Certificates of insurance (general liability, possibly Errors and Omissions)
- Music or stock footage clearances
- Car service vouchers
- Catering services menus and contracts

Keep and/or distribute multiple blank copies of:

- Shooting schedule (daily, weekly, or per-project)
- Scripts and any changes or revisions
- Contact sheet for cast and crew with cell phones, pagers, home phones, email, and other contact info—be aware of confidentiality issues, like Social Security
- Personal release forms
- SAG guidelines, contracts, Taft-Hartley report forms, and time sheets
- Maps or driving directions to locations or set
- Workers' compensation accident report forms

- Call sheet
- Daily/weekly production report
- Contact sheet
- Location agreement
- Petty cash report forms and envelopes
- Sign-out sheets for walkie-talkies, cell phones, equipment, raw stock, etc.

Script breakdowns

- Storyboards and/or floor plans
- Locations
- Sets
- Talent and cast, background extras
- Stunts
- Animals and children
- Special visual and audio effects
- Transportation, travel
- Vehicles for production and picture
- Second-unit shoots
- Special equipment
- Hair, makeup, wardrobe

Talent and cast

- If needed, find and work with a casting director for casting all talent
- Audition and hire all major and minor talent, extras, and background
- Audition and hire animals and their trainer or wrangler
- Audition and hire children
- Audition and hire extras and background
- Have the proper releases, union paperwork, and/or deal memos that each of the people mentioned (or their guardian) will sign and return
- Schedule rehearsals
- Schedule fittings for wardrobe, hair, and makeup
- Schedule special needs for actors: dialogue or dialect coach, music, or choreography such as dancing or fighting

Locations

- If needed, hire a location manager
- Scout new locations, photograph them, and agree with the director or producer on locations to secure
- Prepare and complete all location agreements with property owners
- Obtain any necessary certificates of insurance to distribute to location owners
- Get any needed shooting permits
- When necessary, arrange for fire safety and/or police officers
- If needed, hire or assign security personnel for traffic and crowd control
- Prepare and distribute driving directions or maps to location(s)
- Arrange for all parking and permits, and post notices in neighborhoods where a shoot is taking place
- Assign areas to be set up for dressing rooms, catering, hair and makeup, wardrobe, extras, animals, vehicles, special equipment, and children and parents
- Scout the location for nearby parking lots, restaurants and delis, emergency medical facilities, lodging, and other on-location amenities, and provide relevant information about them to crew and cast
- If needed, supply air conditioners, heaters, and/or fans

- Have an alternative site ready as a cover set in case of an emergency
- When necessary, arrange for a crew to clean up after the shoot
- After the shoot, walk through the property with the owner and get a location release signed and dated by the owner

Sets and sound stages

- Scout and research sound stages, buildings, and other places that can comfortably and creatively work for the shoot and the budget
- Check the sound stage for adequate power supply, sound-proofing, heat and air conditioning
- Check that the space has adequate loading areas for equipment and vehicles, and elevators for moving equipment up or down stairs
- Find space for dressing rooms for the talent, holding areas for extras and audience participants, a space for meals and snacks, production office(s), set construction and painting areas, and rooms for hair, makeup, and wardrobe.

Cast and crew amenities

- Provide special areas for cast and crew to sit down, eat, and relax between takes
- Arrange craft service for cast and crew including coffee, tea, milk, water and snacks at all times, and a healthy meal every six hours
- Supply hydraulic chairs for hair and makeup
- Provide cast and crew directors' foldable chairs
- Arrange for special area(s) designated for animals and their wranglers, for children and their parents, and for extras

Transportation vehicles

- Star dressing room vehicle(s)
- Equipment vans for camera, grip and electric, audio and sound equipment
- Production trailer(s)
- Hair, makeup, and wardrobe trailer(s)
- Craft services and/or catering truck
- Honey wagon(s) (portable toilets)
- Props and/or furnishings truck
- Trucks for delivering sets, set pieces, and dressings
- Cars or vehicles featured or used in the production

Production equipment

- Camera(s) and related equipment
- Lighting, rigging, gels, cables, and related equipment
- Video assist monitor and cables
- Steadicam package
- Dolly and tracks
- Cranes, condors, and jibs
- Grip and electric equipment
- Microphones, wireless lavs, booms, windscreens
- If needed, VTR or DAT recording device
- Walkie-talkies and headsets
- Generator(s)
- Folding tables and chairs for catering, equipment, and administration

Production materials

- Raw stock for video or film to cover all shooting days and extra contingency
- Light gels and special lighting gobos
- Camera filters and lenses
- Still film and/or Polaroid film
- Batteries for all battery-powered equipment
- DAT and/or DA88 tapes
- Sound blankets (moving blankets)
- Blue screen or green screen for special effects
- Backdrops, cycs, and/or black duvateen fabric
- All furnishings and set dressing
- All props, including food, weapons, books, and objects handled by actors
- All materials needed in hair and makeup
- All wardrobe and accessories
- Cell phones or phone cards
- Portable coffee makers and hot water kettles
- First-aid kit, aspirin and Tylenol, and bandages
- Flashlights and extra batteries, matches
- Laptop computer, portable printer/copy machine for on-set use
- Office supplies, like pens and pencils, tape, blank paper, staples, paper clips
- Several rolls of gaffers' tape (duct tape)

Post-Production

- If needed, interview and hire a post-production supervisor
- Create a post-production scheduling calendar with editing and mixing dates
- Interview editors, and visit edit facilities, view their demo reels
- Negotiate with editing facility and/or editor for rates and schedules
- Set up accounts with post-production facilities to be used
- Repeat thesesteps with the audio mixing facility and audio sound designer
- Repeat these steps with graphics and design facilities and designers
- If needed, research and hire a composer for original music for scoring
- Or, research and negotiate with stock music facilities for using stock music
- Prepare a rough post-production schedule
- Make tentative bookings ahead of time for all post-production facilities and crew
- If needed, find a motion control camera and a creative operator for shooting stills, flat art, and for building certain special effects
- Research stock footage facilities, view reels, and negotiate for needed images or footage

BREAKDOWN SHEET

Breakdown Page #_____
Scene #_____ Page #_____

Project Title_____

Location/Studio_____ Set_____

Int_____ Ext_____ Day_____ Night_____ Dawn_____ Dusk_____

Scene Description_____

Cast	Extras/Background	Stand-Ins
	Stunts	**Wardrobe**
Props/Set Dressing	**Hair/Makeup**	**Special Makeup EFX**
Cameras	**Special Equipment**	**Cranes/Grip/Electric**
Transportation	**Visual EFX**	**Music/Audio/Sound EFX**
Wranglers/Animals	**Other**	**Production Notes**

Prepared by _____ Date_____

STORYBOARD

Project Title:
Scene/Page #:
Date:

Producer:
Editor/facility:
Notes:

AUDIO DESCRIPTION	LENGTH		VIDEO DESCRIPTION	REEL #	TIME CODE		GRAPHICS/TEXT
	Video				In	Out	
	Audio						
Take #							

PROJECT COSTS SUMMARY

Project Title:		
Production Company:		
Job #:		Date:
Director:	Producer:	DP:
# Days Pre-Production:	# Days Prod:	# Days Post-Prod:
# Days Build/Strike Set:	# Studio Days:	# Location Days:
Notes:		

	BUDGET CATEGORY	ESTIMATED	ACTUAL
A	Script and Rights Development		
B	Fees: Producers, Director, Crew		
C	Pre-Production/Wrap		
D	Location and Travel		
E	Props, Wardrobe, Animals		
F	Studios and Soundstages		
G	Set Construction		
H	Equipment		
I	Video and Audio Stock		
J	Miscellaneous		
K	Talent		
L	Editorial and Deliverables		
	Grand Total		
	Contingency (%)		

BUDGET
Estimate

Project Title
Date

I. PROJECT SUPERVISION (# of days)
 Executive Producer _____
 Producer _____
 Production Coordinator _____
 Production Assistant _____
 D.P.—Technical Scout _____

 Total I $_____

II. CREATIVES (fees)
 Writer (Script and revisions) _____
 Director (# days for prep, shoot, and/or post-production) _____

 Total II $_____

III. TALENT (# days, rehearsal & shoot)
 Casting Director _____
 On-camera Union Principals (#) _____
 Pension & Welfare, Fringes _____
 Agents' Fees _____

 Total III $_____

IV. VIDEO SHOOT—LABOR (# days & location)
 Director of Photography _____
 Camera Operator (s) _____
 Gaffer (s) _____
 Engineer/Operator _____
 Utility _____
 Technical Director _____
 Audio Engineer _____
 Grip (s) _____
 Makeup and Hair _____
 Wardrobe _____
 Script Coordinator _____
 Production Assistant _____
 Overtime (# hours per crew member) _____

 Total IV $_____

V. PRE-PRODUCTION & WRAP
 Messengers _____
 Shipping _____
 Phone/Fax/Cell Phones/Walkies _____
 Casting _____
 Casting Facilities _____
 Production Insurance _____
 Legal Fees _____
 Accounting/Payroll _____

 Total V $_____

VI. LOCATION EXPENSES
Van Rental _____
Parking, Tolls and Gas _____
Craft Services/Meals _____

Total VI $_____

VII. Equipment Rental (# days)
Camera Rental (Full Packages) _____
Sound Rental _____
Lighting Rental _____
Grip Rental _____
Switcher Package _____
VTR Rental _____
Dolly/Jib/Crane _____
Teleprompter and Operator _____
Production Supplies _____

Total VII $_____

VIII. RAW STOCK
Video Stock—# _____
Audio Stock—# _____
Photo _____

Total VIII $_____

IX. AUDIO RECORDING
Production Sound/Wild Track _____
Music (Original and/or Stock) _____
Music Rights–Limited _____
Misc. Audio Elements _____

Total IX $_____

X. POST-PRODUCTION
Off-line Edit (# hours/days)
On-line Edit (# hours/days)
Additional Graphics/Video Effects _____
Audio mix/sweetening (#hours/days) _____
Miscellaneous Dubs and Masters _____
Working Meals _____

Total X $_____

TOTAL COSTS $_____

Note: *This estimate is based on preliminary data provided by the client, and does not necessarily reflect the final costs. This estimate represents approximately plus or minus 10 percent of the final total.*

Estimate does not include the following costs or expenses:

PROJECT BUDGET

Project Title: _____ Length:____

Days/wks for: Pre-prod: #_____ Shoot: #_____ Post-production: #_____

		ESTIMATED				ACTUAL			
		Days	Rate	OT Hrs	TOTAL	Days	Rate	OT Hrs	TOTAL
A.1	**SCRIPT & RIGHTS**								
1	Story Rights (Incl. Options)								
2	Writer								
3	#2 Writer								
4	Researcher(s)								
5	Consultant(s)								
6	Title Search								
	Sub Total								
A.2	**DEVELOPMENT**								
7	Consultancy Fees and Expenses								
8	Research Expenses								
9	Schedules and Budgets								
10	Proposals								
11	Office Rentals								
12	Office Supplies								
13	Secretary(s)								
14	Assistant								
15									
16	Location Survey(s)								
17	Travel and Accommodations								
18	Legal Fees								
19	Accounting								
20	Development Expenses								
21	Storyboard Artist								
	Sub Total								
	Total for A								
B.1	**PRODUCERS**								
23	Executive Producer								
24	Supervising Producer								
25	Producer								
26	Co-Producer/Producer								
27	Associate Producer								
28	Line Producer								
	Sub Total								

		ESTIMATED				ACTUAL			
		Days	Rate	OT Hrs	TOTAL	Days	Rate	OT Hrs	TOTAL

Sample Forms

		Days	Rate	OT Hrs	TOTAL	Days	Rate	OT Hrs	TOTAL
B.2	**DIRECTORS**								
30	Director								
31	1st Ass't. Dir.								
32	Dir of Photography								
33	Script Continuity								
	Sub Total								
B.3	**SHOOTING CREW**								
35	Production Manager								
36	Production Coordinator								
37	Production Secretary								
38	Production Ass't #1								
39	Production Ass't #2								
40	Production Ass't #3								
41	Production Intern #1								
42	Production Intern #2								
	Sub Total								
B.4	**CAMERA CREW**								
45	Camera Operator #1								
46	Camera Operator #2								
47	Camera Operator #3								
48	Specialty Camera/Steadicam								
49	Utility/Cam. Ass't #1								
50	Utility/Cam. Ass't #2								
51	Still Photographer								
52	Mobile Crew								
53	2nd Unit								
	Sub Total								
B.5	**AUDIO CREW**								
54	Boom Operator #1								
55	Boom Operator #2								
56	Boom Operator #3								
57	Recordist								
58	Mixer								
59	Location Sound								
	Sub Total								

		ESTIMATED				**ACTUAL**			
		Days	Rate	OT Hrs	TOTAL	Days	Rate	OT Hrs	TOTAL
B.6	**LIGHTING CREW**								
62	Head Gaffer								
63	Gaffer #1								
64	Gaffer #2								
65	Best Boy								
66	Electrician								
	Sub Total								

B.7	GRIPS CREW								
68	Key Grip								
69	Ass't Grip #1								
70	Ass't Grip #2								
	Sub Total								

B.8	MAKEUP CREW								
72	Makeup Artist								
73	Specialty Makeup								
74	Assistant								
	Sub Total								

B.9	HAIRDRESSING CREW								
77	Hair Stylist								
78	Specialty Hairdresser								
79	Assistant								
	Sub Total								

B.10	WARDROBE CREW								
82	Wardrobe Supervisor								
83	Wardrobe Assistant								
	Sub Total								

		ESTIMATED				ACTUAL			
		Days	Rate	OT Hrs	TOTAL	Days	Rate	OT Hrs	TOTAL
B.11	ART DEPARTMENT CREW								
87	Art Director								
88	Production Designer								
89	Assistant #1								
90	Assistant #2								
91	Prop Master								
92	Prop Assistant								
93	Production Ass't								
	Sub Total								
	Total Fringes								
	Total for B								

C.1	PRE-PRODUCTION & WRAP EXPENSES	ESTIMATED	ACTUAL
96	Auto/Van Rentals		
97	Airfares: # of People x Amt. Per Fare		
98	Per Diems: # of People x Amt. Per Day		
99	Messengers		
100	Shipping and Trucking		
101	Taxis and Transportation		
102	Home Econ Supplies		
103	Telephone, Cable, Fax, Cellular		
104	Working Meals		
105	Misc. Expenses		
	Sub Total		

C.2	CASTING		
108	Casting Director		
109	Casting Prep x Cast x Callback		
110	Audition/Casting Facility		
111	Working Meals		
112	Misc. Expenses		
	Sub Total		
	Total for C		

D.1	LOCATION & TRAVEL EXPENSES	ESTIMATED	ACTUAL
114	Location Fees		
115	Shooting Permits		
116	Car/Van Rentals		
117	Bus Rentals		
118	Dressing Room		
119	Restroom Vehicles		
120	Other Vehicles		
121	Trucking		
122	Customs		
123	Excess Baggage/Air Freight		
124	Limousines/ Car Service		
125	Taxis and Transportation		
126	Parking, Tolls and Gas		
	Sub Total		

D.2	LOCATION-RELATED COSTS		
130	Air Fares: # People x Cost Per Fare		
131	Per Diems: # People x Cost Per Day		
132	Breakfast: # People x Cost Per Day		
133	Lunch: # People x Cost Per Day		
134	Dinner: # People x Cost Per Day		
135	Craft Service		
136	Security		
137	Kit Rental		
138	Art Work		
139	Gratuities		
140	Location Expenses (cleaning, electricity, etc)		
	Sub Total		
	Total for D		

E.	PROPS, WARDROBE & ANIMALS		
142	Prop Rental		
143	Prop Purchase		
144	Wardrobe Rental		
145	Wardrobe Purchase		
146	Wigs and Facial Hair		
147	Prosthetics and Effects		
148	Picture Vehicles		
149	Animals and Wranglers/Handlers		
150	Color Correction		
151	Instruments/Kits		
	Total for E		

F. STUDIO/STAGE RENTALS & EXPENSES	#	RATE	ESTIMATED	#	RATE	ACTUAL
155 Rental for Build: Days						
156 Rental for Build: O.T. Hours						
157 Rental for Pre-Lite: Days						
158 Rental for Pre-Lite: O.T. Hours						
159 Rental for Shoot: Days						
160 Rental for Shoot: O.T. Hours						
161 Rental for Strike: Days						
162 Rental for Strike: O.T. Hours						
163 Generator and Operator						
164 Security						
165 Power Charge and Bulbs						
166 Misc. Studio Costs						
167 Working Meals						
168 Craft Service						
Total for F						

G.1 SET CONSTRUCTION MATERIALS	ESTIMATED	ACTUAL
173 Set Dressing: Purchase		
174 Set Dressing: Rental		
175 Props: Purchase		
176 Props: Rental		
177 Lumber		
178 Hardware		
179 Paint		
180 Kit Rental		
181 Special Outside Construction		
182 Special Effects		
183 Trucking		
184 Messengers/Shipping		
185 Kit Rental		
186		
187		
188		
Sub Total		

G.2 SET CONSTRUCTION CREW	# DAYS	RATE	O.T.	ESTIMATED	ACTUAL
189 Set Designer					
190 Set Artist					
191 Grips					
192 Electricians					
193 Teamsters					
194 Strike Crew					
195 P.A.'s					
196 Virtual Set					
199 Set Preparation					
200 Inside Props					
201 Textures/Modifications					
Sub Total					
Total Fringes					
Total for G					

H.	EQUIPMENT RENTAL COSTS	QTY	RATE	ESTIMATED	ACTUAL
202	Cameral Rental				
203	Audio Rental				
204	Lighting Rental				
205	Grip Rental				
206	Grip Truck				
207	Steadicam/Rig				
208	Generator				
209	Jib arm/Crane/Cherry Picker				
210	Dolly				
211	Camera Car				
212	Helicopter				
213	Production Supplies				
214	Teleprompter				
215	Walkie Talkies				
216	VTR Rental: w/ or w/o Playback				
	Total for H				

I.	VIDEO & AUDIO STOCK	QTY	RATE	ESTIMATED	ACTUAL
222	DV				
223	Beta SP				
224	High Def				
225	Memory Cards				
228	Audio Stock				
230	Transfer to Dailies/Screeners				
231	Transfer Audio				
	Total for I				

J.	MISCELLANEOUS	DETAILS	ESTIMATED	ACTUAL
233	Petty Cash			
234	Air Shipping			
236	Phones and Cable			
237	Accountable Cash (under $15)			
238	External Billing (computer, etc)			
239	Special Insurance			
	Total for J			

K.1	TALENT COSTS	QTY	DAYS	RATE	O.T.	DBL	TRAVEL DAYS	ESTIMATED	ACTUAL
244	On-Camera Talent #1								
245	On-Camera Talent #2								
246	On-Camera Talent #3								
247	On-Camera Talent #4								
248	On-Camera Talent #5								
249	On-Camera Talent #6								
251	General Extras								
253	Hand Model								
254	Voice Over								
255	Stand-In(s)								
256	Mileage								
257	Fitting Fees (SAG) x hr								
259	Audition Fees (SAG)								
	Sub Total								

K.2	TALENT EXTRAS	ESTIMATED	ACTUAL
262	Payroll and Pension and Welfare Taxes (%)		
263	Wardrobe Allowance: # of Talent x # Garments x Fee Per		
266	Other		
267			
	Sub Total		

K.3	TALENT EXPENSES		
268	Per Diems: () People x () Amt. Per Day		
269	Air Fares: () People x () Amt. Per Fare		
270	Taxis and Car Service		
271			
272			
273			
	Sub Total		
	Total for K		

L.1	EDITORIAL COMPLETION	RATE	HRLY	WKLY	O.T.	ESTIMATED	ACTUAL
274	Post-Production Supervisor						
275	Editor #1						
276	Editor #2						
277	Edit System Rental						
278	P.A.						
279	Digitize Footage						
280	On-Line/Conform						
281	Tape Stock						
282	Dubs						
284	Stock Footage						
285	Still Photographs						
286	Animation						
287	Art Work						
288	Motion Control Camera						
290	Stock Music						
291	Original Music						
292	Sound Effects						
293	Needle Drops						
294	Dubbing Studio						
295	Mixing Studio						
296	Narrator						
297	Narration Studio						
298	Working Meals						
299	Expenses						
	Sub Total						

L.2	EDITORIAL DELIVERABLES	QTY	RATE	ESTIMATED	ACTUAL
301	Client Screening Facility				
302	Video Air Masters				
303	Video Air Protections				
304	Client Dubs				
306	Captioning				
307	Sub-Titles				
308	Duplication				
309	Labeling and Packaging				
310	Shipping				
	Sub Total				
	Total for L				

EQUIPMENT RENTAL LOG

_____ Project
_____ Job #
_____ Date

Date	Rental Company	Equipment Description	Qty.	Rate	Dept.	Rental Dates Start - End

CAST DEAL MEMO
This confirms our agreement to hire you:

Name _____

Address _____ Phone _____

Loanout/corporation name _____

Address _____

SS# or Fed ID # _____ Guild/Union _____

Screen credit/billing_____

For the role of _____

In a project tentatively titled _____

to be aired on: Network ___Cable ___ Non-broadcast ___ Internet ___ Other_____

Under the following conditions:

Date(s) of hire: From _____ to _____Total _____

Days for: Travel _____ Fittings _____ Rehearsal _____Shoot _____ADR_____Other_____

For # _____ of hours/days @ $_____ per hour/day Overtime @ $_____

For a flat fee of $ _____

Weekend rates _____Holiday rates _____

Other _____

Terms of payment: _____

Per diem @ $ _____ Mileage allowance @ $_____per mile

Wardrobe rental $ _____ Per day $_____ Per week $_____Per project $_____

Car allowance $_____ Per day $_____Per week $_____ Per project $_____

Terms of payment _____

Dressing room _____

Travel and Hotel arrangements _____

Other _____

Agent _____
Agent office ph# _____ Mobile _____
Agency name _____
Agency address _____
_____Ph#_____

Manager_____
Manager office ph# _____ Mobile _____
Management company _____
Company address _____
_____Ph#_____

Publicist_____
Publicist office ph# _____ Mobile _____
PR firm name _____
Firm address _____
_____Ph#_____

I agree to keep the producer advised as to where I can be reached by telephone within a reasonable time, and agree to the dates of employment and to the terms of compensation as stated above. The compensation acts as payment in full for all services rendered during the period of employment, and for all rights granted to the producer and/or production company.

Accepted by (talent name)_____Date _____
Talent signature _____

Employer/production company name _____
Address _____ Ph #_____
Producer _____

Approved by _____ Date _____

CREW DEAL MEMO

This confirms our agreement to hire you:

Name _____

Address _____ Phone _____

SS# or Fed ID # _____ Guild/Union _____

Screen credit to read _____

For the position of _____

In a project tentatively titled _____

Under the following conditions:

Date(s) of hire: From _____ to _____ Total _____

For # _____ of hours/days @ $ _____ per hour/day Overtime @ $ _____

For a flat fee of $ _____

Weekend rates _____ Holiday rates _____

Other _____

Terms of payment: _____

Additional compensation may include:

Per diem @ $ _____ Mileage allowance @ $ _____ per mile

Equipment rental $ _____ Per day $ _____ Per week $ _____ Per project $ _____

Car allowance $ _____ Per day $ _____ Per week $ _____ Per project $ _____

Travel and Hotel arrangements: _____

Other _____

Accepted by (employee name) _____ Date _____

Employee signature _____

Employer/production company name _____

Address _____ Ph # _____

Producer _____

Approved by _____ Date _____

CREW DATA
sheet

Project _____ Date _____

Name	Position	Dept.	Deal Memo	Budget Acct. #	Start Date	Wrap Date	Total Days	Under/ Over

Sample Forms 347

SHOOTING Schedule

Producer _____ Director _____
Project Shoot _____ # Days _____ From __/__/__ To __/__/__

Project Title _____ Episode # _____ Date _____

Day/Date	Set/Scene Description	Day/Nite	Int Ext	PG #	SC #	Cast	Extras	Stand Ins	Location	Props	Make Up	Wardrobe	Vehicles

DAILY COST OVERVIEW

Date and Day:	
Shoot Day #:	Start Date:
Scheduled Finish Date:	Rev. Finish Date:
Producer:	Director:

	# On Call Sheet	# Shot	# Ahead/Behind
Scenes			
Pages			

Cost Category	Budgeted/Scheduled	Actual	Over/Under
Shooting Hrs.			
Overtime Crew			
Overtime Cast			
Extras/Stand-Ins			
Catering			
Meal Penalty			
Video Stock			
Extra Expenses			

Today's Total _____
Previous Total _____
Grand Total _____

NOTES

Prepared By: _____ Approval: _____

Call Time:

Date:

Call Time:

Shoot Time:

Project_____
Job #_____
Shoot Day #_____ Day #_____ Of Total Days_____
Producer_____ Director_____

Breakfast_____ Lunch_____ Dinner_____ Weather_____

Address Set/Location	Day/ Nite	Scene Numbers	Cast # (Below)	Pages	Notes (Extras, directions, etc)

#	Cast Name	Role	Call Time	M-U Wrdrb.	On Set	Notes
1						
2						
3						
4						
5						
6						
7						

Crew Position	Name	Phone	Call Time	Crew Position	Name	Phone	Call Time

Notes

Equipment	Supplier	Phone	Call Time	Equipment	Supplier	Phone	Call Time

Notes

Prepared by _____ Approved by _____

PERSONAL RELEASE
The signing of this release confirms our agreement as follows

The (*Producer/Production Company*) and its affiliated entities and/or licensees intend to include film and/or video photography and sound recordings of me (*Footage*) in connection with the production, distribution, promotion, advertising, and exhibition of (*Program title*).

I hereby consent to (*Producer/Production Company*)'s inclusion (or in the *Producer's/ Production Company's* sole discretion, exclusion) of said Footage, in whole or in part, in connection with said Program title, and to the right to use, license, edit, advertise, exhibit and otherwise exploit the Footage, my performance therein, and my name in connection therewith in any and all media now known or hereafter devised in perpetuity throughout the universe, without any additional payments or obligation to me, and as (*Producer/Production Company*)'s sole discretion determine. [*In exchange for the granting of these rights, I agree to accept payment to me of the sum of $_____.*]

I acknowledge that said Footage and its use as set forth herein does not constitute defamation of me, invasion of my privacy, nor tortious exploitation of my personality, and hereby waive any and all such causes of action.

In granting this release, I understand that (*Producer/Production Company*) has relied hereon in producing, promoting and advertising the Program and Footage and will incur substantial expense based upon such reliance. I warrant that I have not been induced to execute this release by any agreements or statements made by (*Producer/ Production Company*) or its representatives as to the nature or extent of (*Producer/ Production Company*)'s proposed exercise of any of the rights, licenses and privileges herein granted to (*Producer/Production Company*).

Executed this ___ day of _____, 2_____

Please print name

Signature

Authorized signature/guardian

Production Company/Producer
Company name and address
Contact information

Extras Release

FOR GOOD AND VALUABLE CONSIDERATION, the undersigned person(s) grant to (the "Production Company") _____ and to its licensees, assignees, and other successors-in-interest, all rights of every kind and character whatsoever in perpetuity in and to my performance, appearance, name and/or voice and the results and proceeds thereof (the "Performance") in connection with the television program, motion picture or project entitled "_____" (the "Picture").

I hereby authorize the Production Company to photograph and record (on videotape, film, or otherwise), the Performance; to edit the same at its discretion and to include it with the performances of others and with sound effects, special effects and music; to incorporate the same into the Picture, trailers or other programs related to the Picture; to use and to license others to use such records and photographs in any manner or media whatsoever, including without limitation unrestricted use for purposes of publicity, advertising and sales promotion; and to use my name, likeness, voice, biography or other information concerning me in connection with the Picture, commercial tie-ins, merchandising and for any other purpose associated with the Picture. I further acknowledge that the Production Company owns all rights to the results and proceeds of my services rendered in connection herewith.

Name	Address	Signature	Date

CROWD RELEASE
IMPORTANT NOTICE
YOU HAVE ENTERED AN AREA WHERE VIDEOTAPING IS TAKING PLACE AND YOU MAY APPEAR IN THE PICTURE.

By entering this area, you grant to (production company) the right to photograph you and record your voice without compensation in connection with the video: (name of project) and its distribution and exploitation. You release (production company) and its licensees from all liability. (production company) assumes no responsibility for injury to your person, or damage or loss to your property.

The use of camera or audio recording equipment is prohibited. Thank you.

STANDARD LOCATION AGREEMENT

As Property Owner or authorized representative of (Property name) _____

Located at (Address) _____

I/We do agree with (the Producer/Production Company)_____

- To give the Producer/Production Company permission to enter and use the Property at the address above for the purpose of photographing and recording scenes to be used in a project entitled _____
- Use of the premises includes permission to park vehicles at or near the premises, to bring personnel and equipment (including props and temporary sets), and any additional materials and supplies onto the premises. The Producer/Production Company agrees to remove all the above as well as any debris after completion of work, and to restore the Property as nearly as possible to its original condition, excepting ordinary wear and use.
- The Owner does hereby warrant that he/she has full right and authority to enter into this agreement concerning the above-mentioned premises, and that the consent of no other person, company, or organization is necessary for the Producer/Production Company to enjoy full rights and use of this Property.
- The permission is granted to begin on (date) _____ and to continue until the completion date of (date) _____
- Should the weather prohibit filming, the alternate date is from _____ to _____
- Special Conditions: _____

- Any photographs, film, video, and sound recorded on the premises shall be the exclusive property of the Producer/Production Company and no claim shall be made against the Producer/Production Company.
- The Producer/Production Company's remuneration (Location Fee) to the Owner of $_____, and payable immediately upon completion of filming, is accepted as full, final and all inclusive payment for the above use.
- The Producer/Production Company has no obligation to photograph or include the above premises in the completed project.
- The Property shall be under the complete control of the Producer who will have exclusive right of that site, from the beginning of construction (if needed) to completion of all photography and removal of all construction (if any), for the dates stated. The Owner of the Property grants rights that include the right to photograph all structures and signs on the property, including exteriors and interiors.
- During the filming and recording on the Property, the Producer/Production Company agrees to indemnify and hold the Owner harmless from any claims and demands of any members of the cast or crew of the production that may arise from personal injuries or death suffered while working on this Property.
- The Owner agrees to notify the Produce/Production Company in writing within fourteen (14) days of completion of use of the premises of any damage claimed to have arisen from the Producer's use of the property.
- The Owner indemnifies and holds harmless the Producer/Production Company from all losses, costs, liability, damages, or other claims that arise out of any false statements or representations made in this agreement.

Printed name of Property Owner

(or authorized representative) _____

Signature of Property Owner

(or authorized representative) _____ Date_____

Producer (or Production Company representative) _____

Company address _____

Ph# _____ Email _____ Cell Ph# _____

Approved by _____ Date_____

PETTY CASH REPORT

Name _____
Project _____ Date _____
_____ Job # _____

	Date	Paid To	Purpose	Acct. #	Net Amt	Tax	Total
1							
2							
3							
4							
5							
6							
7							
8							
				Column Subtotals			
				Totals			
				Cash Advanced			
				Check/Cash Enclosed			
				Check/Cash Due			

Approvals:		Received By (signature):
Prod:	UPM:	Check ___ Cash ___ Received:
Dept:	Acct:	Check #:

Notes:

REEL LOCATION LOG

Project _____ Job # _____

Producer _____ Date_____

Reel #	Date Shot	Shoot Location	Storage Location	Reference #

EXPENSE REPORT

Name _____ Date _____

Project _____ Job # _____

Note: *Please number and attach corresponding receipts on separate sheet*

Receipt #	Date	Description	Transportation	Lodging	Meals	Other	Total
		Column Totals					
						Sub-Total	
						Less Cash Advance	
						Total Due	

Additional Notes:

Employee Signature ___ Date _____

Approval _____ Date _____

SCREENING LOG

Project _____
Job # _____
Date _____

Tape #	Time Code In	Time Code Out	Duration	Shot Description

Sample Forms

EDITING-PAPER CUT

Project _____
Job # _____
Producer _____
Date _____

Tape #	Time Code		Video/Audio Description	Duration
	In	Out		

Music Used: _____
Animation/Graphics Used: _____
Editor: _____ Facility: _____

MUSIC CUE SHEET

Series Title: _____ Series Genre: _____
Episode #/Title: _____ Length: _____ Orig. Airdate: _____
Production Company: _____
Address: _____ Phone #: _____
Producer: _____

Cue #	Cue Title	Use Code *	Timing	Composer	Affiliation	%	Publisher	Affiliation	%

*** Use Codes:** TO = Theme Open/Main Title BI = Background Instrumental
TC = Theme Close VI = Visual Instrumental
LO = Logo VV = Visual Vocal
BV = Background Vocal

Index

A

ABC (American Broadcast Company) 27, 31, 38
A-B-C structure 57
above-the-line budget costs 81–82
abridged version, as client deliverable 216
accountability, as leadership skill 14
accounting fees 87
acoustics 184
actors: auditions 147–149; blocking the actors 188; as budget line 85; child actors 162; non-union 89, 150; shooting schedules 162–163; staff 151; stunt actors 151; union 149–150; *see also* extras; talent
actual budget costs 83
added audio, as component of sound design 183
administrative teams 156–157
Advanced Video Coding 42
advertising: advertising campaigns, 275; as budget line, 88; *see also* sponsorship
advertising video on demand (AVOD) 139
aesthetic funding 55
AFTRA (American Federation of Television and Radio Artists) 89, 115, 149–150, 298
agents 61–62
Alexanderson, Dr. E. F. W. 24
ambience: as component of sound design 183; recording ambience 186
American Federation of Musicians (AFM) 115
American Film Institute (AFI) 90
Amusing Ourselves to Death (Postman) 19
analog multitracks 212–213
analytical learning style 13
ancillary revenues 116
Angel Investors 92–93
animals and shooting schedules 162
animal wranglers 78, 144
animatics 79
animation: as budget line 86; editing 210–211
Antonio, Sheril 22–23, 229, 245–249
appointment viewing 20
archival footage 200–201
Aristotle 73; *Poetics* 57
A-roll edit 206
art department and timing of shoot 163
artificial lighting 182
aspect ratios 21, 179
assistant camera operators 156
assistant directors 154
assistant producers 11
associate producers 11
attorneys *see* lawyers
audience demographics 314
audio assistants 156
audio engineering 272–273
audio engineers 184
audio impressions of a project 145
audio logs 186–187
audio mixers 156, 211
audio mixing 212–213, 215–216
audio perspective 184–185
audio pickups 190–191
audio recording during production phase 183–187; for 360-degree video shoots 195; acoustics 184; audio recording formats 184; for live music events 294; microphones 183–184; perspective of the audio 184–185; sound design 183; for web and mobile 194–195
audio sample rates 223
audio setup 188
audio teams 156
audio tracks 207
auditions 148–149
auditory learning style 13
augmented reality (AR) 43, 47–48; *see also* Extended Reality (XR)
automatic dialogue replacement (ADR) 213–214
A/V script format 59

B

background, as component of sound design 183
back light 181
Badal, Sharon 249–250
Baird, John Logie 21–22, 23, 24, 25
Baker, Russell 23
Baldwin, James 56
bank loans 90
barter, as moneysaving strategy 93
BBC (British Broadcasting Corporation) 25, 27, 32, 33
below-the-line budget costs 82
Berle, Milton 28
best boys 156
Big Three networks 31, 37, 38
Black Mirror: Bandersnatch 71, 218–219, 283–289
blocking for the camera 152, 188
blue screens 174
Blu-ray 125
Bonfiglio, Michael 250–253
Bonhoeffer, Dietrich 173
boom operators 156
bounce cards 182
Boyd, Andrew 233
branching narratives 45, 46, 219, 283–284
Branch Manager (software) 219
branded entertainment 139–140
brand licensing 105
Braun, Karl 21
breakdown: breakdown sheets 78–79; breakdown sheet sample form 330; and timing of shoot 163
broadband 15, 42, 138, 170
broadband producers 15
broadcast networks as potential market 123
Brokaw, Tom 111
Brooker, Charlie 71, 284
budget costs: actual 83; estimated 82–83; post-production phase 81; pre-production phase 80–81; production phase 81; researching budget costs 83–84
budgeting process 76–89; budget lines and categories 84–88; cross-boarding 79–80; detailed budgets 84–89; for emerging media 94–95; estimating costs 82–83; moneysaving strategies 93–94; post-production phase 281–282; producer's role 290; production books 77–78; researching costs 83–84; script breakdown 78–79; shooting schedule 79; storyboarding 79; three-part budget 80–81
budgets: budget lines and categories 84–88; budget sample forms 333–334; budget templates 84; budget top sheet in written pitches 131; final billings 225; for mobile series 263; for transmedia 96; two-part budget 81–82; for virtual reality 96; for web production 259, 269, 274; working budgets 84
Bullitt, Mrs. A. Scott 28–29
Burns, Ken 203
business skills 9

C

cable television: competition with networks 38; introduction of 30; niche programming 35–36; as potential market 123–124
Caesar, Sid 29, 30
call sheets 164; call sheet sample form 349–350
camera angles in scripts 60
camera operators 155, 174
camera placement 195–196
cameras 174–180; digital cinematography 176; digital video 174–175; high-definition video 175; stationary 179, 180; studio cameras 176–177; for 360-degree video shoots 192–193; and time code 177–178; 24p video 175–176
camera shots: camera angles 179; camera lenses 180; camera moves 179–180; camera shot lists 180; framing and composition 179; planning 178–180
Campbell-Swinton, A. A. 24
canted angle 180
Carson, Johnny 21
casting: as budget line 85; cast deal memo sample form 343–344;

casting calls 148–149; casting directors 147–148
catering managers 157
CBC (Canadian Broadcasting Corporation) 26, 32
CBS (Columbia Phonograph Broadcasting System) 23, 31, 38
certificate of authorship sample form 323–324
Certificate of Insurance (COI) 88
Certificate of Occupancy 237
character-generators 34
child actors 162
children's television 35, 39; interactive television 45–46
chroma key backgrounds 174
client deliverables 216–217; for emerging media 221–223
closed captioning 217
close-up shots 190
closing credits 106, 116, 210
CNN (Cable News Network) 37
codecs (coder-decoders) 222
collaboration: with directors 295; legal issues concerning 298; with partners 253–254; as people skill 12, xiv; with production team 274–275; in writing process 61–62
CollegeHumor 268–269
color-correction 211
color television, introduction of 30
commercial breaks 56–57
commercial television, formation of 27
commitment, as leadership skill 14
communication skills 13
community antenna television (CATV) systems 33
compensation, as component of contracts 112
completion bonds 114
complimentary copies 225–226
compositing 211
composition, camera shots 179
compressed time 209
compression: digital video 206; hosting platforms for emerging media 222–223
conflict management 13
contacts see networking
content, global demand for 51–52
contingencies as budget line 88
continuity: audio 186; during a shoot 190
contracts: and ancillary revenues 116; client deliverables 216–217; common contracts 111; entertainment lawyer's perspective 301; final review of 116–117; and financing 113; and insurance coverage 114; and MFN (most favored nation) clauses 113–114; review of 114–117; step deals 112–113; three-phase deals 112
convenience vehicles and shooting schedules 163
Coolidge, Calvin 135
co-producers 11
coproduction financing 113
copyright: copyright issues 274; copyright law 63–64, 99–100; copyright symbol 100; copyright terms 100–101; and emerging media 117–119; entertainment lawyer's perspective 299; international law 300; and online media piracy 118–119

Copyright Act 101
costs: actual budget costs 83; estimated budget costs 82–83
courtesy credits 93–94
cover letters for pitches 126–128; sample cover letter 127–128
cover sets 162
cover shots 190
craft services crew 187–188
Creative Commons license 103
creative teams in written pitches 131
creativity 8
credibility, as leadership skill 14
credit cards 90
credits, on-screen 116, 210
crews 152–159; audio team 156; as budget line 85; crew data sheet 346; crew deal memo sample form 345; production department heads 153–155; visual team 155–156; writing team 155
Cronkite, Walter 31–32, 34
cross-boarding 79–80, 295
cross-cutting 209
cross-promotion in emerging media 241–242
crowdfunding 91–93, 259–260; for virtual reality 141
crowds: crowd control and shooting schedules 163; crowd release sample form 353
C-stands 156, 193
cue sheets 107
cut, as editing technique 208
cutaway, as editing technique 208

D
dailies 280
daily cost overview sample form 348
daily fees 82
DAWs (digital audio workstations) 212–213
daydreaming, as leadership skill 14
daylight 182
day shoots 162
deal memos 111
deferred payments 93
de-interface filters 223
delegation, as leadership skill 14
demographics in written pitches 131
demo reels 122, 135, 226–227
design elements, in editing phase 210
development phase: sample forms 319–325; scriptwriting 62–68; see also writing process
DGA (Directors Guild of America) 89, 115, 153, 298
dialogue 213; as component of sound design 183; dubbed 213–214; in final cut 215; overlapping 215
diegetic sound 215
digital animation producers 15–16
digital asset managers 156
digital cinematography 176
digital content producers 17
digital media and copyright 117–119
Digital Media Receiver (DMR) 42
Digital Millennium Copyright Act (DMCA) 118
digital multitracks 212–213
digital producer 16–17
digital production 273–275
digital projects and fair use 102
digital recording 185
digital storage 175
digital technology, emerging media and television 41–49

digital video 174
digital visual effects producers 15
directional microphones 183
direct mail as potential marketing tool 125
directors: as budget line 85; casting directors 147–148; director employment contracts 111; directors of photography 153; role in pre-production phase 153
Directors Guild of America (DGA) 89, 115, 153, 298
direct sound 211
Disney, Walt 35
dissolve 209
distribution phase 7, 225–235; complimentary copies 225–226; emerging media 239–242; final budget 225; petty cash 225; publicity 233–235; screening parties 226; wrap parties 225
documentaries 250–253; television 34–35
Documentary Filmmakers' Statement of Best Practices in Fair Use 101–102
documentation during production phase 196
dolly tracks 156, 180
DP (director of photography) 153
dramatic plotlines 57
dressers 158
dubbed dialogue 213–214
DuMont, Allen B. 27
DuMont Television Network 27, 28, 31
Duncombe, Stephen 233
Dutch angle 180
DVD/Blu-ray as potential market 125
DVR (Digital Video Recorder) 42

E
editing: editing styles 207–208; editing techniques 208; graphics, animation and plug-ins 210–211; for interactive television 218–219; interview with Jeffrey McLaughlin 278–281; nonlinear 205–206; steps 206–207; 360-degree video 219–220; and time manipulation 208–209; transitions 209–210; video 154–155; for web and mobile video 217–218; see also post-production phase
editing-paper cut sample form 360
editors, role in post-production phase 203–211
Ed Sullivan Show 29
education, formal, for producers 229
80/20 paper cuts 203
EIN (Federal Employer Identification Number) 237
electronic news gathering (ENG) 35
elevator pitches 133–134
emerging media 252, 256; actual shoot 191–196; budgeting process 94–95; and copyright 117–119; distribution phase 239–242; final deliverables 221–223; genres defined 55–56; hosting 221; overview 40–49; pitches 136–141; post-production phase 217–223; pre-production phase 164–170; roles for producers 14–18; target audiences 239
Emery, Sheila Possner 3, 253–258
emotional intelligence 13
employment for producers 230

Index

entertainment lawyers 62, 98–99, 296–302
equipment: as budget line 86; equipment breakdown 191; equipment lists 144–145; equipment rental log sample form 342
Errors and Omission (E & O) insurance 88, 298
establishing shots 189
estimated budget costs 82–83
ethics 248, 254–255; and leadership skills 14
Evey, Kim 258–262
executive producers 10
expense report sample form 358
Extended Reality (XR) 43, 47–48, 264–266
extending the frame, as camera move 180
exterior lighting 182
exterior shots 161–162
extras: and blocking 188; and casting 151; extras release sample form 352; and shooting schedules 162
eye-line and camera angles 179

F

Facebook 193, 220, 222, 240–241
fade outs and fade ins 209
fair use 101–102, 300
Farnsworth, Philo T. 21, 22, 24
fast motion 209
Faulkner, William 120
FCC (Federal Communications Commission) 26, 27; FCC guidelines 30–31
Federal Employer Identification Number (EIN) 237
fees, as component of contracts 112
festivals, production of 292–294
field producers 12
fill light 181
film, appearance of, in video 210
film festivals 249–250
film production contrasted with television production 3
final audio cut 215–216
finance charges as budget line 87
financing for projects 89–94; crowdfunding 91–93; funding sources 89–90; self-funding 90–91
First International Congress of Electricity 23
first rough cut 206
5.1 audio 216
flashback 209
flat fees 82
floor plans 146
Foley 214
footage: screening and logging 201–202; stock 200–201
foreign locations 161
formats for scripts 59–60
Fox Broadcasting Company 37, 38
Fraiberg, Jordanna 262–264
frame rates 223
frame size 222
framing, camera shots 179
freelancers 12
freeze frame 209
Frizell, Fredrik Montan 164, 168, 264–266
funders see grantwriting
funding and contracts 113
fundraising for projects see financing for projects

G

gaffers 156
Gaines, Barbara 10, 266–268
Gardner, Howard 13
genres, defined 55–56
global learning style 13
global markets in written pitches 131
goal-oriented work style 13
Goethe 133
Golden Age of television: 1950s 28–32; with streaming services 44–45
Goleman, Daniel 13
grants 90; funding for virtual reality 141
grantwriting 230–233; contacting funders 231; guidelines from funders 230–231, 232; project description 231; proposal writing process 232; recordkeeping 232
graphics, editing 210–211
green screen backgrounds 174
Griffin, Spencer 268–272
grips 156
guerilla casting 148
The Guild, web series 258–262
guilds see unions

H

H.264/MPEG-4 AVC 42
hackathons 141
hair and makeup: as budget line 85–86; and timing of shoot 163
hair stylists 159, 187
handheld microphones 184
hard light 181
hardware company support for virtual reality 140
HBO 289–290
HD (high-definition video) 175
HDTV (high definition television) 21, 38
Henning, Richard 272–273
high-key lighting 182
history of television 21–40, 247, xii; digital television (1990s) 37–39; early history 21–26; future of television 40; Golden Age of Television (1950s) 28–32; during and immediately after World War II 26–28; television in transition (1970s) 35–36; television merging with electronics (1980s) 36–37; Television Society (1960s) 33–35; twenty-first century television 39–40
Homer Simpson 36
honesty, as leadership skill 14
The Honeymooners 30
hosting, for emerging media 221
hosting choices for web videos 95
HTML5 42
Huetig, Tricia 273–275

I

IATSE (International Alliance of Theatrical Stage Employees) 89, 115
ideas: and budgeting process 67–68; as first stage of production 5, 56; idea protection and contracts 110–114; as initial stage in scriptwriting 52–53; and inspiration 8; marketing of 64–66; protection of 63–64, 98–105; and writing process 68–74
I Love Lucy 30, 32
immersive technology see Extended Reality
independent contractors 12
independent producers 12
IndieGoGo 91–92
indoor lighting 182
in-kind donations 94
insert shots 190, 208
Instagram 241
instant replay 209
insurance: Certificate of Insurance (COI) 88; completion bond 114; Errors and Omission (E & O) insurance 88, 298; legal issues 298; liability insurance 88, 114; for production companies 237
Intellectual Property Law 99–105; avoiding copyrighted material 102–103; copyright law 99–100; copyright terms 100–101; entertainment lawyer's perspective 299; fair use 101–102; orphan work 104; postal registration 105; public doman 104; trademark 103–104; WGA Registration 104–105; work-for-hire agreements 101
interactive media 283–288
interactive producers 16–17
interactive television (ITV) 41, 45–46; editing 218–219; producers 16; the shoot 195; writing process 71–72
interior lighting 182
interior shots 161–162
International Alliance of Theatrical Stage Employees (IATSE) 89, 115
international markets 121, 126
internships 157, 228–229, 246; tools for interns 158
investors: Angel Investors 92–93; private 89–90; for virtual reality 141
Ives, Dr. Herbert 24

J

Jenkins, Charles Francis 22, 23, 24
job-seeking for producers 230
Jonathan Winters Show 30
Jones, Laurie Beth 53
jump cut, as editing technique 208

K

Kennedy, John F. 98
key grips 156
key light 181
Kickstarter 91–92, 136
Kindem, Gorham 2
kinescope 22
kinesthetic learning style 13
Kolbell, Ann 164, 275–278
Kovacs, Ernie 30

L

The Late Show With David Letterman production process 266–268
lavalier microphones 184
lawyers: entertainment 62, 98–99, 296–302; selection of 114
leadership skills 14
learning styles 13
legal documents: checking, post-production 199; review of 114–117
legal fees 87
lenses, camera 180
liability insurance 88, 114
licensing 105–106

Index

licensing deals, streaming services 137
life balance 256–257, 296, 311–312
lifelong learning 4, 52, xi
lighting 180–182, 188; for 360-degree video shoots 194; hard 181; high-key contrasted with low-key 182; hot and cold 182; interior and exterior 182; soft 181; three-point 181; for web and mobile production 193–194
lighting directors 155
line producers 11
listening skills 14
literary releases 111
literary rights 106
live events, production of 292–294
live music performances 108
local television stations as potential market 124
location: as budget line 85; for emerging media production 169–170; location managers 157; location scouts 161; location selection 294–295; during production phase 173
location agreements 115; location agreement sample form 354–355
location shooting 160–161; day and night shoots 162; foreign locations 161; location scouts 161; moving locations 161; static locations 161
location wrap 191
locked down cameras 179, 180
log lines 129
Lombardi, Matt 3, 54, 275–278
longer takes during 360-degree shoots 196
long form contracts 111
long take 209
lower thirds 59, 210
low-key lighting 182

M

Madison Avenue 29, 33–34
magic hour 182
makeup: at location of shoot 187; makeup artists 159
"making the day" 163
managers, working with 62
Marconi, Guglielmo 23
market descriptions in written pitches 131
marketing: as budget line 88; market research 121
master shots 190
master use licensing 107
match cut, as editing technique 208
matching time code 177
McCarthyism 32
McLaughlin, Jeffrey 204, 205, 217, 278–282
McLaughlin, Jonna 230
McLean, Russell 4, 283–289
meals: as budget line 86; and shooting schedules 163
mentors 228
microphones 183–184
mixed reality (MR) 43, 47–48 see also Extended Reality
mobile producers 17
mobile production: audio production 194–195; lighting 193–194; the shoot 195
mobile series 262–264; writing process 70–71

mobile video: budgets 168; editing 217–218; overview 46–47; production 191–192
montage editing 207–208
Moore, Michael 191
Morgen, Brett 8, 110, 122, 289–291
most favored nation (MFN) clause 113–114
motion control cameras 210
motion picture studios as potential market 123
motivation, as leadership skill 14
movement during 360-degree shoots 196
Movie Magic Budgeting software 76
The Moving Image: Production Principles and Practices (Kindem) 2
moving locations 161
MTV 37, 270
multimedia producers 16–17
multiple intelligences 13
multitasking 2, 4
Murch, Walter 207
Murrow, Edward R. 32
music: as budget line 86; music cue sheet 107, 215; original 214; prerecorded 214–215; stock music 214
music cue sheets 107, 215; music cue sheet sample form 361
music events, production of 292–294
music licensing 87
music rights 106–109
music tracks 216

N

NABET-CWA 89, 115
narration 214
National Endowment for the Arts (NEA) 90
National Endowment for the Humanities (NEH) 90
National Science Foundation (NSF) 90
NBC (National Broadcasting Company) 22, 23, 27, 30, 31, 38
needle drops 109
negotiation, as moneysaving strategy 93
Netflix 283–286; and content submissions 69–70; Interactive Television 46; pitches to 136–137; as streaming service 44–45
network footage clearances 109–110
network television 31, 289–290; see also Big Three networks
neutral density (light-filtering paper gel) 182
news production 275–278
night shoots 162
Nipkow, Paul 21, 24
non-diegetic sound 215
non-disclosure agreement sample form 325
nonlinear editing 205–206
non-union talent 89, 150; see also unions
nonverbal communication 13
NTSC (National Television System Committee) 26

O

objective perspective 178
objectivity, as leadership skill 14

office overhead as budget line 86
omnidirectional microphones 184
online media piracy 118–119
online producers 16–17
on-screen credits 116
opening credits 210
option agreements 64
oral agreements 301
original music 108
orphan work 104
OTT (Over-the-Top Content) 41
outdoor lighting 182
outlines, for scripts 58
overlapping dialogue 215
overlays 210
over-the-shoulder shots 190

P

pan, as camera move 180
paper cuts 203
parallel editing 207, 209
Pasteur, Louis 174
Patent and Trademark Office 104
patience, as leadership skill 14
pay or play clauses 111
payroll services 87
PBS (Public Broadcasting System) 35
people skills 12–14, 291, xi
Pepper, Steven C. 55
period pieces, as budget line 86
permission for use 105–110; licensing 105–106; literary rights and clearances 106; live music performances 108; music licensing 106–107; music venues 107–108; network footage clearances 109–110; right of publicity 110; stock footage 109; stock music 109; working with music composers 108
persistence of vision 21
Perskyi, Constantin 23
personal balance, as leadership skill 14
petty cash 87; petty cash report sample form 225, 356
PGA (Producers Guild of America) 115
pilots, television 66–67
piracy, online media 118–119
pitches: cover letters 126–128; demo reels 135; elevator pitches 133–134; emerging media 136–141; follow-up 134–135; and international markets 126; legal protection 132; and networking 122–123; overview 120–121; with a partner 134; persistence 135–136; pitch creation 126–132; pitch reels 135–136; potential markets 123–126; presentation 133–135; researching pitches 121–126; streaming services 136–137; verbal pitches 120, 133; video pitches 131–132; written pitches 120, 128–131
pitch process 303, 308–309; pitch meetings 65–66, 133; pitch reels 135–136; videos for crowdfunding 92
pixel aspect ratios 223
place shifting 20
plagiarism 110, 132
planning as second stage of production 5–6
platform selection for transmedia projects 73–74
plotting 57–58

Index

plug-ins, editing 210–211
political and social issues 31–32, 34, 37, 53, 247
POP (pitch on paper) *see* written pitches
portable recording 185
Portapak video camera 35
postal registration, in lieu of copyright 105, 299–300
Postman, Neil 19
post-production: post-production supervisors 12, 154–155, 198–199
post-production budget costs 81, 86
post-production phase 6–7, 198–223; editing process 278–281; editing styles 207–208; editing techniques 208; editor's role 203–211; for emerging media 217–223; final product 216–217; footage, screening and logging 201–202; paper cuts 203; post-production guidelines 199–203; producer's role 198–203; sample forms 359–361; screening log 202; selection of editors 199; sound design 211–216, 220–221; steps in editing 206–207; stock footage 200–201; *see also* editing
preditors 11, 279
premium cable channels as potential market 124
pre-production phase 5–6, 143–171; audio team 156; casting 147–151; crew 152–159; for emerging media 164–170; location shooting 160–161; pre-production budget costs 80–81; pre-production checklist 164, 326–329; production and administrative team 156–157; production design team 158–159; rehearsals 151–152; sample forms 326–346; scheduling shoots 159–164; scripts 143–147; talent 147–152; timing of shoots 163; visual team 155–156; writing team 155
press releases 233–234, 242
pre-visualization for virtual reality 166
principal photography *see* shooting
private foundations 90
private investors 89–90
problem-solving 3
process-oriented work style 13
Producer: A Memoir (Wolper) 2
producer-editors 11, 279
producer fees 82
producers: attributes of good producers 3–4, 10, 268, 274, 277, 282, 291, 295, 304; as budget line 84–85; career arc of 7–8; choice of schools 247–248; collaboration with sound designers 211–212; defining roles 1–3; education 246; job descriptions 9–12; job satisfaction 4; as multitaskers 2, 4; production team 172–173; professional development 226–230; role during production 172–173; role in post-production 198–203; title of producer used deceptively 9; titles 10–12, 308; and variety of roles 1–2, 4–9, xiv; working with editors 279–280
Producers Guild of America (PGA) 9, 115
product, final, as fourth stage of production 6–7

production, five stages of 4–7
production assistants 157, 158
production audio engineers 154
production bibles for emerging media 165
production books 77–78, 144, 226
production budget costs 81
production companies, startup 235–238; client satisfaction 237–238; initial considerations 235–236; legal considerations 236–237
production companies as potential market 124
production crews 254
production designers, role in pre-production phase 154
production design teams 158–159
production managers 11
production managers, role in pre-production phase 154
production meetings 147
production music 109
production phase 172–197; actual shoot 187–191; audio 183–187; cameras 174–180; for emerging media 191–196; interactive television 195; lighting 180–182; production protocol and politics 173; role of producer 172–173; sample forms 347–358; on set 173–174; 360-degree shoots 195–196; web and mobile 195
production reports 164
production schedules in written pitches 131
production secretaries 156
production sound 185
production specialists 159
production teams 156–157; for emerging media 168
product placement 139–140, 311
professional development for producers, 226–230; demo reels 226–227; employment 230; formal education 229; internships 228–229; mentors 228; networking 228; resumes 226; shorts 227–228; volunteering 229
project budget sample form 335–341
project costs summary 332
project development 5
prop masters 158
prop microphones 184
proposals *see* written pitches
public domain 100, 104; public domain footage 201
public foundations 90
publicity for emerging media 239
publicity stills 189
public television as potential market 124

Q
query letters 126–128
quick cut editing 208

R
radio edit 206
RCA (Radio Corporation of America) 22, 23, 25, 27, 34
reaction shots 208
reality-based content 152
reality programming 39–40
recording sound, challenges of 185–186
Reed, Stephen 152–153, 238, 292–294, xi

reel logs 200; reel log sample form 357
reflectors 182
rehearsals 151–152; on-set pre-shoot 188
relationships, and leadership skills 14
researchers on the writing team 155
research fees 87
resumes 226
retouching 211
reverse motion 209
Rich, Laurie 176–177, 313–316
Right of Publicity 110, 300–301
Rights and Clearances Departments 109
room tone 186
Roosevelt, Eleanor 25
Rosing, Boris 21, 24
rotoscoping 211
rough audio 207
rough cut 206
Rowan and Martin's Laugh-In 29

S
SAG (Screen Actors Guild) 82, 89, 115, 149–151, 298
Sarnoff, David 23, 25
Saturday Night Live 29
scheduling for emerging media production 168–169
scratch tracks 206
Screen Actors Guild (SAG) 82, 89, 115, 149–151, 298
screening logs 202; screening log sample form 359
screening parties 226
screenwriting *see* writing process
script breakdowns 78–79, 143–144
scripts 56, 310–311; as budget line 85; commercial breaks 56–57; components of 60; for emerging media 165–166; formatting a script 58–60; length 56; plotting 57–58; in pre-production phase 143–147; and rehearsals 151–152; revisions 155; script formats and styles 58–61; script supervisors 157; spec scripts 60–61
script supervisors 157
scriptwriting: and budgeting 78–79; competition and the marketplace 52; idea generation 52–58; for Interactive TV 71–72; for mobile series 70–71; for streaming services 69–70; for transmedia 73–74; for virtual reality 72–73; for web series 69
seamless editing 208
search engine optimization 240
second assistant directors 157
second assistant directors 157
security: as budget line 86; on location 189; and shooting schedules 163
segment producers 11
self-distribution as potential marketing tool 125–126
self-funding 90–91
Sellitti, Tom 76–77, 294–296
senior producers 11
session producers 12
sets 160; set construction as budget line 85; set designers 158; set dressers 158
setup: and timing of shoot 163
Sheppard, J. Stephen 89, 105, 111, 199, 296–302

shooters *see* camera operators
shooting: shooting formats 159–160; shooting schedules 79, 159–164; shooting schedule sample form 347; shooting schedules for emerging media production 168–169; as third stage of production 6; timing of shoots 163; *see also* production phase
short film production 227–228, 249–250
shot coverage 189–190
shotgun microphones 183–184
shot lists 146–147; camera 180; for emerging media 166–167
showrunners 10–11, 290, 310
silent film era, parallels with emerging media 305
simultaneous time 209
single shots 190
sitcoms, screenwriting 58
slates 189
slow motion 34, 209
SmartTV 41
Snap Originals 46–47
social and political issues 31–32, 34, 37, 53, 247
social media platforms 46–47
social media producers 17
social networking 240–241; and digital copyright 118; web series, *The Guild* 260
soft light 181
sound: mixing audio 215–216; stylistic uses 215
sound blankets 188
sound bridge 215
sound design 183, 211–216, 220–221; *see also* audio production
sound designers 211–216
sound editors 211
sound effects 186, 213; as budget line 86; as component of sound design 183
sound engineers 190
sound reports 186–187
sound stages 160
sound waves 184
special effects: as budget line 86; in final audio cut 215
spec scripts 60–61
split screens 210
sponsorship 139–140, 259, 261
staff as budget line 85
staff producers 11
star value 129
static locations 161
step deals 112–113
still photographers 156
stitch lines 196
stock footage 87, 109, 200–201
stock music 109
storyboards 79, 145–146; for emerging media 166; storyboard artists 155; storyboard sample form 331
storytelling: branching narratives 45, 46, 219, 283–284; centrality of 51; in emerging media 305–306; storytelling as editing 279, 282; and synopsis 130; and television 41; transmedia storytelling 73–74
streaming services 288; business models 138–139; ideas and script development 69–70; overview 44–45; pitches 136–137

studios 160; studio cameras 176–177; studio sound 211
stunt actors 151
stunts 162–163
stylists 158
subjective perspective 178
submission agreements 65
submission release 110; submission release sample form 319–321
subscription-based funding for virtual reality 140
subscription video on demand (SVOD) 139
subtitles 216
Sullivan, Ed 29
supervising producers 11
Swimming Upstream: A Lifesaving Guide to Short Film Distribution (Badal) 249
synchronization licensing 106–107
syndication as potential market 124–125
synopsis, written pitches 129–130

T
takes 189
talent: for emerging media during pre-production phase 167; and shooting schedules 162–163; talent perks as budget line 85; talent release forms 167, 351; union contrasted with non-union 89; *see also* actors
talent agencies 61–62
talk shows contrasted with variety shows 267
taxes for production companies 237
teamwork 12
technical directors 153
technical editors 279
technical run-through 188–189
Teitel, Becky 230
television: and advertising 29, 33–34; as art form 245; contrasted with film 3, 277, 311; contrasted with theatrical production 289; contrasted with web production 270–271, 274; and culture 247; delivery systems 40; and emerging media 41–49; future directions 309; genres defined 55–56; influence of politics 31–32, 34; rating system 38; and storytelling 41; as unique medium 19–20; value of to society 246; *see also* history of television
The Texaco Star Theater 28
text, in editing phase 210
thank-you notes 226
360-degree video shoots 96, 166, 169–170; audio production 195; cameras 192–193; editing 219–220; lighting 194; the shoot 195–196
three-part budgets 80–81
three-phase deals 112
three-point lighting 181
tilt, as camera move 180
time code 177–178
time management 251, 256–257
time shifting 20, 42
title pages, written pitches 129
TiVo 42
Toast of the Town 29
top sheet, budgets 84
tracking shot 180
trademark 103–104
traditional film script format 59

transactional video on demand (TVOD) 139
transcription as budget line 87
translation as budget line 87
transmedia 305–307; business model 96; financing 140; ideas and script development 73–74; overview 48–49; platform selection 73–74; transmedia producers 17; transmedia production bibles 165
transportation: as budget line 86; and timing of shoot 163; transportation managers 157
treatments, for scripts 58
tripods 179, 180, 192, 193
The Tunnel documentary 34
TV Guide 29
Twain, Mark 54
24p video 175–176
Twine 71, 284
Twitter 240
two-part budgets 81–82
two-shots 190

U
UHF (ultra-high frequency) channels 31
Ultra-High-Definition Television 42–43
unions 9; and contracts 115; union actors 149–150; union fees 82; union issues 298; union members 89
unit production managers 11, 154
unscripted content, in rehearsal 152
user-generated content (UGC) 44, 102; and digital copyright 117–118

V
V-chip 38
VCR (video cassette recorder) 36
verbal communication 13
verbal learning style 13
verbal pitches 133
Verheiden, Mark 41, 68, 136, 302–305
vertical video 262–263; overview 46–47; writing process 70–71
VFX (visual effects) producer 15
VHF (very high frequency) channels 31
video game producers 15
video monitors 190
video pitches 131–132
video production for web and mobile 191–192
videotape, first use of 30
viewpoint and camera angles 179
virtual locations 173–174
virtual reality (VR) 43, 47–48; budgeting process 96; funding for 140–141; and pre-visualization 166; producers 16; storyboards 166; writing process 72–73; *see also* Extended Reality
visible time code 177
vision, human, and television viewing 20–21
vision statements 53
visual effects (VFX) producers 15
visual impressions of a project 145
visual teams 155–156; visual effects team 159
VOD (video on demand) 42; as potential market 125
voice-over 214
volunteering for producers 229
Volunteer Lawyers for the Arts 99

W

wardrobe: as budget line 86; at location of shoot 187; wardrobe designers 158
web business models 138–139
web channels 43–44
web producers 16–17
web production: audio production 194–195; lighting 193–194; the shoot 195; video production 191–192
web series: contrasted with television 261; expanding into other markets 138; *The Guild*, Kim Evey 258–262; idea and script development 68–69
websites, promotional 239–240
web video: budgets 168; editing 217–218
weekly fees 82
Weiler, Lance 94, 305–308
Welles, Orson 187
Westworld 49
WGA (Writers Guild of America) 61, 64, 89, 115, 117, 298; WGA Registration 104–105
White, E. B. 26
wild sounds 213
Wilkes, Justin 2, 132, 308–310
Williams, Scott A. 12, 52–53, 55, 310–313
willpower, as leadership skill 14
wipes, as editing transitions 209–210
Wolper, David L. 2
word-of-mouth promotion 242
workers' compensation 88, 114
work-for-hire agreements 101; for composers 108
World's Fair, Paris 1900, 23
wranglers 151, 159
wrap parties 225
wrap-up *see* distribution phase
writer employment contracts 111
writer/producers 54
writers: as budget line 85; working with producers, pre-production 80–81; written pitches 120, 128–131
writer's deal memo sample form 322
Writers Guild of America (WGA) 61, 64, 89, 115, 117, 298; WGA Registration 104–105
writing process 54–62, 310–311; and collaboration 61–62; commercial breaks 56–57; idea generation 52–53; length of script 56; plotting 57–58; revisions 155; script development 62–68; script formats and styles 58–61; spec scripts 60–61; television contrasted with film 54–55
writing teams 61, 155
written pitches 120, 128–131

X

XR (extended reality) 43, 47–48, 264–266

Y

Young, Bernie 4, 313–316
Your Show of Shows 29
youth market 37; and YouTube 44
YouTube 43–44, 95, 262; and advertising video on demand 139

Z

zoom, as camera move 180
Zworykin, Vladimir 21, 22, 24